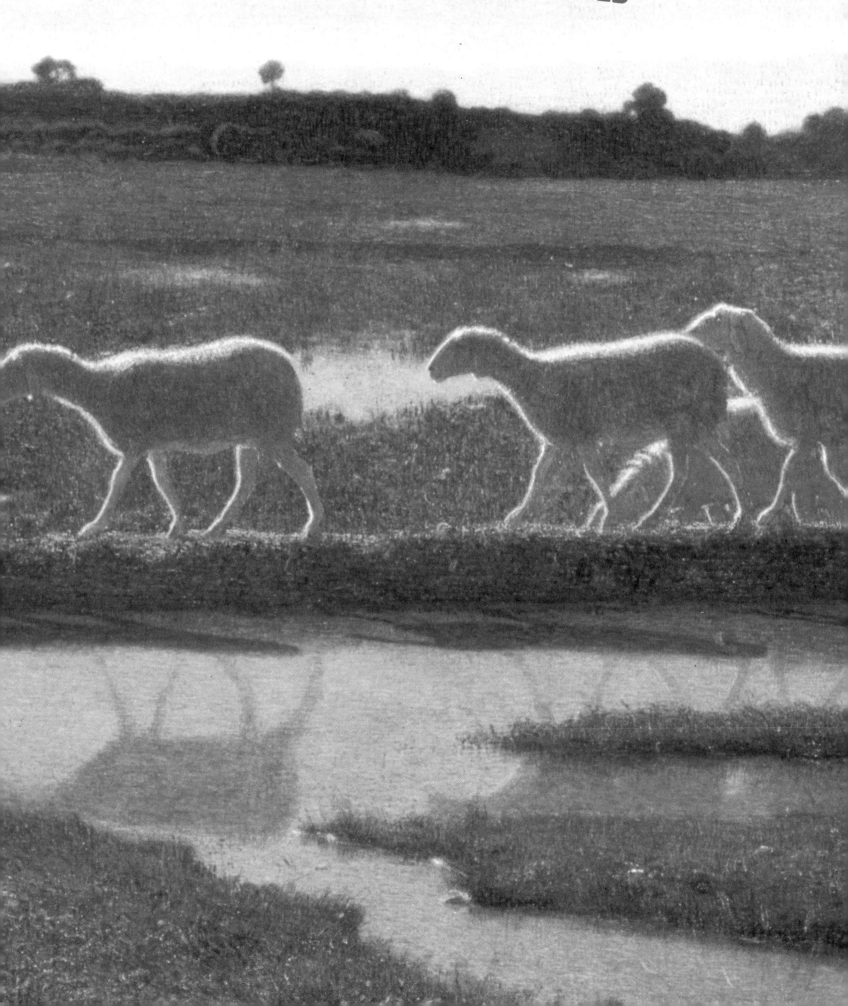

LOST PARADISE

LOST PARADISE

SYMBOLIST EUROPE

THE MONTREAL MUSEUM
OF FINE ARTS

The exhibition *LOST PARADISE: SYMBOLIST EUROPE*
was presented at the Montreal Museum of Fine Arts from June 8 to October 15, 1995.

Co-ordination: Rosalind Pepall
Designer: Jean-Pierre Viau
Educational Material and Audio-guide: Hélène Lamarche
Audiovisual Programming: Diane Chayer St-Louis

The following have taken part in preparing this exhibition:
Pierre Archambault, Majella Beauregard, Rodrigue Bédard,
Jeanne Frégault, Christine Guest, Simon Labrie, Marthe Lacroix,
Simone Lecours, Brian Merrett, Annie Michaud, Claude Paradis,
Marie-Claude Saia, Elaine Tolmatch, Anne Troise, Karen Zimmer.

Insurance costs have been provided for by the Department of Canadian Heritage
under the Insurance Program for Travelling Exhibitions.

This catalogue has received funding from the Volunteer Association of
the Montreal Museum of Fine Arts.

Legal deposit – 2nd quarter 1995
Bibliothèque nationale du Québec
National Library of Canada

ISBN: 2-89192-194-1

Distributed by:
McClelland & Stewart Inc. in Canada
St. Martin's Press in the United States
Fourth Estate Ltd. in the United Kingdom

THE MONTREAL MUSEUM OF FINE ARTS
P.O. Box 3000, Station "H"
Montreal, Quebec H3G 2T9

PRINTED IN CANADA

Endleaf illustration:
Giuseppe PELLIZZA DA VOLPEDO
The Mirror of Life (detail),
1895-1898
Turin, Galleria Civica d'Arte
Moderna et Contemporanea

The exhibition *LOST PARADISE: SYMBOLIST EUROPE*
was organized by

Pierre Théberge, C.Q.
Director of the Montreal Museum of Fine Arts

Chief Curator

Jean Clair

Curators

Guy Cogeval
 France, Germany, Italy, The Netherlands, Poland, Switzerland, the United States

Louise d'Argencourt (until April 1993)
 Belgium, England, the United States

Constance Naubert-Riser
 Austria, the Czech Republic, Germany, the Scandinavian countries, Switzerland,
 the United States

Rosalind Pepall
 Decorative Arts

Ulrich Pohlmann
 Photography

Assistant Curator

Gilles Genty
 Illustrated Books

Contents

The numbers in boldface refer to illustrations.

Acknowledgements

The exhibition's Curators wish to thank
the following for their kind co-operation:

AUSTRIA
Hans Dichand, Vienna
Gerbert Frodl, Österreichische Galerie im Unteren Belvedere, Vienna
Sabine Grabner, Österreichische Galerie im Unteren Belvedere, Vienna
Julius Hummel, Vienna
Hofrat Pausch, Österreichisches Theater Museum, Vienna

BELGIUM
Jean-Pierre Babut du Marès, Namur
Mr. and Mrs. C. Baeyens-Wolfers
Marguerite Coppens, Musées royaux d'Art et d'Histoire, Brussels
Lieven Daenens, Museum voor Sierkunst, Ghent
L. De Coninck, Musées royaux d'Art et d'Histoire, Brussels
Patrick Derom, Brussels
Mme Gillion-Crowet
Gisèle Ollinger-Zinque, Musées royaux des Beaux-Arts de Belgique, Brussels
Brita Velghe, Musées royaux des Beaux-Arts de Belgique, Brussels
Eliane de Wilde, Musées royaux des Beaux-Arts de Belgique, Brussels
Mr. and Mrs. Wittamer-Decamps

CANADA
Joyce Banks, National Library of Canada, Ottawa
Maria Brendel, Montreal
Caroline Fréchette, Montreal
Peter Kaellgren, Royal Ontario Museum, Toronto
Alison Matthews, Toronto
Irena Murray, Blackader-Lauterman Library
 of Architecture and Art, McGill University, Montreal
Douglas Schoenherr, National Gallery of Canada, Ottawa
Ann Thomas, National Gallery of Canada, Ottawa
Shirley L. Thomson, National Gallery of Canada, Ottawa

CZECH REPUBLIC
Ladislav Daniel, Národní galerie, Prague
Eva Neumannova, Palais Kinsky, Prague
Tomas Rybicka, Galerie moderního umění, Hradec Králové
Mme Wittlich, Palais Kinsky, Prague
Petr Wittlich, Carolinum University, Prague

DENMARK
Marianne Ertberg, Museum of Decorative Art, Copenhagen
Kaspar Monrad, Statens Museum for Kunst, Copenhagen
Vibeke Woldbye, Museum of Decorative Art, Copenhagen

ENGLAND
Malva Croal, City Art Gallery, Manchester
Ann Dumas, London
Simon Edsor, The Fine Art Society, London
Jane Farrington, Birmingham Museums and Art Gallery

David Goodwin, Tate Gallery, London
Halina Graham, Cecil Higgins Art Gallery, Bedford
James Graham, Cecil Higgins Art Gallery, Bedford
Francis Greenacre, Bristol Museums and Art Gallery
Margot Heller, Southampton City Art Gallery
Richard Jefferies, Watts Gallery, Compton
David Fraser Jenkins, Tate Gallery, London
Susan Lambert, The Victoria and Albert Museum, London
P. Spencer Longhurst, Barber Institute of Fine Arts, Birmingham
Adrian Mibus, London
Hilary Morgan, Watts Gallery, Compton
Edward Morris, Walker Art Gallery, Liverpool
Peter Nahum, London
Jennifer Opie, The Victoria and Albert Museum, London
Godfrey Pilkington, London
Pam Roberts, The Royal Photographic Society, Bath
Alex Robertson, Leeds City Art Gallery
Julian Treuherz, Walker Art Gallery, Liverpool
Eric Turner, The Victoria and Albert Museum, London
Catherine Whistler, Ashmolean Museum, Oxford
Christopher Wilk, The Victoria and Albert Museum, London
Christopher Wood, London

FINLAND
Berndt Arell, Turun Taidemuseo, Turku
Christian Hoffmann, Turun Taidemuseo, Turku
Soili Sinisalo, Ateneum, Helsinki
Helmiriittat Soriola, Ateneum, Helsinki

FRANCE
Pierre Arizzoli-Clémentel, Musée des Arts décoratifs, Paris
Lucile and Paul Audouy, Paris
Georges Barbier-Ludwig, Musée de l'École de Nancy
Jean-Claude, Luc and Yann Bellier, Paris
Marie-Hélène Bersani, Mobilier national, Paris
Thérèse Burollet, Musée du Petit Palais, Paris
Dominique and Claire Denis, Saint-Germain-en-Laye
Philippe Durey, Musée des Beaux-Arts, Lyons
Daniel Imbert, Musée du Petit Palais, Paris
Geneviève Lacambre, Musée Gustave Moreau, Paris
Isabelle Lainé, Musée national des monuments français, Paris
Alain Lesieutre, Paris
Henri Loyrette, Musée d'Orsay, Paris
Günter Metken, Paris
Dominique Morel, Musée du Petit Palais, Paris
Jean-Luc Olivié, Musée des Arts décoratifs, Paris
Hélène Pinet, Musée Rodin, Paris
Evelyne Possémé, Musée des Arts décoratifs, Paris
Andrée Pouderoux, Bibliothèque nationale de France, Paris
Philippe Thiébaut, Musée d'Orsay, Paris
Marie-Paule Vial, Musée des Beaux-Arts, Marseilles

GERMANY
Ingeborg Becker, Bröhan Museum, Berlin
Jo-Anne Birnie Danzker, Villa Stuck, Munich
Volker Duvignau, Münchner Staatsmuseum, Munich
Barbara Eschenburg, Städtische Galerie im Lenbachhaus, Munich
Ute Eskildsen, Museum Folkwang Essen
Irmela Franzke, Badisches Landesmuseum Karlsruhe
Monika Gallasch, Munich
Gisela Götte, Clemens-Sels-Museum, Neuss
Norbert Götz, Münchner Staatsmuseum, Munich
Christoph Heilmann, Bayerische Staatsgemäldesammlung, Munich
Carl Benno Heller, Hessisches Landesmuseum Darmstadt
Annegret Hoberg, Städtische Galerie im Lenbachhaus, Munich
Rüdiger Joppien, Museum für Kunst und Gewerbe Hamburg
Michael Koch, Bayerisches Nationalmuseum, Munich
Georg W. Koltzach, Museum Folkwang Essen
Aimee Lefnaer, Munich
Christian Lenz, Bayerische Staatsgemäldesammlung, Munich
Ekkchard Mai, Wallraf-Richartz-Museum, Cologne
Harald Marx, Galerie Alte Meister, Dresden
Johana Müller-Meininger, Münchner Staatsmuseum, Munich
Hans Ottomeyer, Münchner Stadtmuseum, Munich
Helmut Ricke, Kunstmuseum Düsseldorf
Peter Schmitt, Badisches Landesmuseum Karlsruhe
Heike Schröder, Württembergisches Landesmuseum Stuttgart
Dietmar Siegert, Munich
Gabriele Uerscheln, Clemens-Sels-Museum, Neuss
Renate Ulmer, Museum Künstlerkolonie, Darmstadt

ITALY
Ferdinando Arisi, Galleria d'Arte Moderna Ricci Oddi, Piacenza
Maria-Teresa Fiorio, Galleria d'Arte Moderna, Milan
Rosanna Maggio-Serra, Galleria Civica d'Arte Moderna e
 Contemporanea, Turin
Bruno Mantura, Galleria d'Arte Moderna, Rome
Riccardo Passoni, Galleria Civica d'Arte Moderna e
 Contemporanea, Turin
Carlo Sisi, Galleria d'Arte Moderna, Florence

THE NETHERLANDS
Ronald De Leeuw, Van Gogh Museum, Amsterdam
E. J. Van Straaten, Kröller-Müller Museum, Otterlo

NORWAY
Knut Berg, Nasjonalgalleriet, Oslo
Arene Eggum, Munch-museet, Oslo
Jan Ake Petterson, Rasmus Meyer Collection, Bergen
Tone Skedsmo, Nasjonalgalleriet, Oslo
Gerd Woll, Munch-museet, Oslo

POLAND
Mme Harazinska, National Museum of Warsaw
Agnieszka Ławniczakowa, National Museum of Poznań
Kazimierz Nowacki, National Museum of Cracow
M. Rostorowski, Muzeum Czartorizki, Cracow
Marian Soltysiak, National Museum of Warsaw

SCOTLAND
Michael Clarke, National Galleries of Scotland, Edinburgh
Hugh Stevenson, Art Gallery and Museum, Glasgow

SWEDEN
Görel Cavalli-Björkman, Nationalmuseum, Stockholm
Jonas Gavel, Göteborgs Konstmuseet, Göteborg
Ragnar von Holten, Nationalmuseum, Stockholm
Ulf Linde, Thielska Galleriet, Stockholm

SWITZERLAND
Sigrid Barten, Museum Bellerive, Zurich
Josef Helfenstein, Kunstmuseum Bern
André Kamber, Kunstmuseum Solothurn
Peter Killer, Kunstmuseum, Olten
Aljoscha Klee, Bern
Christian Klemm, Kunsthaus Zürich
Dora Lardelli, Saint-Moritz, Musée Segantini
Claude Ritschard, Musée d'art et d'histoire, Geneva
Katharina Schmidt, Kunstmuseum Basel
Dieter Schwarz, Kunstmuseum Winterthur
Roland Wäspe, Kunstmuseum St. Gallen

UNITED STATES
Jane Adlin, The Metropolitan Museum of Art, New York
Pierre Apraxine, Gilman Paper Company, New York
Kevin Avery, The Metropolitan Museum of Art, New York
Gary Baker, The Chrysler Museum, Norfolk
Frederick R. Brandt, Virginia Museum of Fine Arts, Richmond
Susan Caroselli, Los Angeles County Museum of Art
Mark Clark, The Chrysler Museum, Norfolk
Verna Curtis, Library of Congress, Washington
Malcolm Daniel, The Metropolitan Museum of Art, New York
Lisa Dennison, The Solomon R. Guggenheim Museum, New York
Sarah Faunce, The Brooklyn Museum
Barry Friedman, New York
Denis Gallion, New York
Gloria Groom, The Art Institute of Chicago
Anita Gross, The Wolfsonian Foundation, Miami
Mr. and Mrs. Charles Hack, New York
Wendy Kaplan, The Wolfsonian Foundation, Miami
Robert Kashey, Sheperd's Gallery, New York
David McFadden, Cooper-Hewitt Museum, New York
Barbara Macklowe, New York
Matilda McQuaid, The Museum of Modern Art, New York
Daniel Morris, New York
Maria Morris Hambourg, The Metropolitan Museum of Art,
 New York
Steven Nash, San Francisco Museum of Art
Stuart Pivar, New York
Terence Riley, The Museum of Modern Art, New York
Carmen Ruiz-Fischler, Museo de arte de Ponce, Puerto Rico
David Ryan, Norwest Corporation, Minneapolis
Hiromi Shiba, Museo de arte de Ponce, Puerto Rico
Perrin Stein, The J. Paul Getty Museum, Malibu
Gary Tinterow, The Metropolitan Museum of Art, New York
Mr. and Mrs. Thomas Williams, San Francisco

as well as Paul and Ellen Josefowitz
Samuel Josefowitz

Lenders to the Exhibition

The Montreal Museum of Fine Arts is grateful to the institutions and individuals whose generous loans have made this exhibition possible.

AUSTRIA
LINZ
Oberösterreichisches Landesmuseum
VIENNA
Galerie Würthle
Gemäldegalerie der Akademie der bildenden Künste
Graphische Sammlung Albertina
Historical Museum of the City of Vienna
Julius Hummel collection
Österreichische Galerie
Österreichisches Theater Museum im Palais Lobkowitz

BELGIUM
ANTWERP
Museum Plantin-Moretus
BRUSSELS
Bibliothèque royale Albert 1ᵉʳ, Cabinet des estampes
 and Archives et Musée de la littérature
Musée d'Ixelles
Musées royaux d'Art et d'Histoire
Musées royaux des Beaux-Arts de Belgique
GHENT
Museum voor Schone Kunsten
Museum voor Sierkunst
MORLANWELZ
Musée royal de Mariemont
NAMUR
Jean-Pierre Babut du Marès
OSTEND
Museum voor Schone Kunsten
VERVIERS
Musées communaux

CANADA
HAMILTON
McMaster University
KINGSTON
Special Collections, Queen's University
MONTREAL
Mr. and Mrs. Michal Hornstein
McGill University, Blackader-Lauterman Library of Architecture
 and Art, and University Libraries Department of Rare Books
 and Special Collections
The Montreal Museum of Fine Arts
OTTAWA
National Gallery of Canada
National Library of Canada

TORONTO
Art Gallery of Ontario
Royal Ontario Museum
Joey and Toby Tanenbaum collection
Thomas Fisher Rare Book Library, University of Toronto

CZECH REPUBLIC
BRNO
Moravská galerie
HRADEC KRÁLOVÉ
Galerie moderního umění
OSTRAVA
Galerie výtvarného umění
PARDUBICE
Východočeská galerie
PLZEŇ
Zapadočeska Galerie
PRAGUE
Museum of Decorative Arts in Prague
Národní galerie

DENMARK
COPENHAGEN
Museum of Decorative Art
Ordrupgaardsamlingen
Statens Museum for Kunst
FREDERIKSSUND
J.F. Willumsens Museum

ENGLAND
BATH
The Royal Photographic Society
BIRMINGHAM
Birmingham Museums and Art Gallery
LEEDS
Leeds City Art Galleries
LIVERPOOL
National Museums and Galleries on Merseyside, Walker Art Gallery
LONDON
Peter Nahum at The Leicester Galleries
The Royal Watercolour Society
Tate Gallery
The Victoria and Albert Museum
OXFORD
Ashmolean Museum
WARRINGTON
Warrington Museum and Art Gallery

FINLAND
HELSINKI
Ateneum
KOKKOLA
K.H. Renlundin Museum

The exhibition *LOST PARADISE: SYMBOLIST EUROPE* enables us, who stand on the threshold of the millennium, to look back at the late nineteenth century, that other fin de siècle, through the prism of a major intellectual and artistic movement: Symbolism.

We are most grateful to Jean Clair for agreeing to direct this study and for selecting the distinguished advisory panel of Guy Cogeval, Constance Naubert-Riser, Rosalind Pepall and Ulrich Pohlmann.

We are very proud of the exceptional contributions made by all of them over the past four years towards producing this outstanding exhibition. We are also grateful to Louise d'Argencourt and Gilles Genty for their contribution to the preparation of the exhibition.

Our warmest thanks are due to the many lenders from public and private museums and collections in Europe, the United States and Canada for agreeing to allow their works to be incorporated into the show. It is thanks to them that this reappraisal of the Symbolist movement is so wide in its scope.

We also wish to thank Jean-François Barrielle, director of the art books department of Éditions Flammarion, who early on provided encouragement for us to pursue our research on the exhibition.

We received generous financial support from a number of companies – Air France, Ernst & Young, Fonorola, Goldman Sachs, Lancôme and Peerless Carpets – as well as from the Volunteer Association of the Montreal Museum of Fine Arts. We are most grateful to all these sponsors, and to *La Presse* for its supportive coverage.

Thanks are also due to those government sources, particularly the Quebec Ministère de la Culture et des Communications and the Conseil des arts of the Montreal Urban Community, whose annual operating grants enable the Museum to organize large-scale exhibitions such as this. Financial support was also provided by the Ministère du Tourisme du Québec and the Government of Canada through the Insurance Program for Travelling Exhibitions.

We are deeply appreciative of the unfailing support of the members of the Board and of the Programming Committee throughout the organization of the exhibition.

Finally, we are especially grateful to the Museum team for its efficiency in helping to mount this project under the leadership of Rosalind Pepall, the co-ordinator. Their dedication and sense of responsibility are beyond praise.

Pierre Théberge, C.Q.
Director
The Montreal Museum of Fine Arts

15

LOST PARADISE

JEAN CLAIR

Symbolism spanned a clearly defined period, from September 18, 1886, the date of Jean Moréas's manifesto, to 1905, the year of the first manifestations of the new "avant-garde" movements. Caught between the end of Naturalism and the start of our own era of modernity,[1] Symbolism was like Janus: looking back towards the past with a nostalgia that unexpectedly revived a host of divinities, angels and heroes whose wings and haloes Courbet and his friends thought to have amputated and doused for good ("I paint what I see. I have never seen angels."); looking forward to the future with anxiety, refusing to acknowledge the triumphs of scientific progress or the achievements of a now universal technology. Painting and sculpture can create through allegory the most improbable chimeras. Thus did the bicycle unite with winged gods that celebrated its grace and lightness; thus did the motorcar rear up, a reinvented Pegasus, a four-stroke phaeton crossing the star-studded heavens; thus was the digging of the Simplon Tunnel hailed by sprightly Minervas lauding this victory of man's luminous genius over darkness. And, more generally, the whole of turn-of-the-century poster art was shot through with similar couplings, evidence of the mysterious marriage between Art and Science. Somewhat more problematic, given the new iconographical repertoire of telegraph poles and wires, was the resuscitation of the classical allegory of Good Tidings, of the *Bonus Eventus*[2] once proclaimed by the angels. In his *Histories*, Herodotus tells how the Ephesians, besieged by Croesus, dedicated their city to Artemis and, in order to harness the goddess's power, stretched a wire between her temple outside the walls and the city's fortifications. Long before Chappe and Edison, the human mind had conceived the dream of the telegraph.[3] How, though, could the early messengers' luminous wings be replaced by the dull hardware of the Telegraph and Telephone Company? Right at the height of the Symbolist movement, Toorop in Holland and Puvis de Chavannes in his paintings for the Paris Hôtel de Ville pictured poles and wires among fields of narcissi, while later Marcel Duchamp, at the end of his career but still under the spell of the melancholy telegrams of Jules Laforgue, inserted these same poles into his *Large Glass*, in order, as he put it, to diffuse by electricity "The Commandments of the Bride". A *Bride*, indeed: in 1912, Symbolism's Immaculate Virgins, its "endless Eves", had definitively espoused the new century with ardour and conviction, giving birth to future "Eves" who seemed rather to prefigure the robot of *Metropolis* than to reiterate the nebulous creatures spawned by Burne-Jones and Fernand Khnopff.

Should we not, in fact, see Symbolism as the most direct heir of *Naturphilosophie*? From Goethe's scientific writings to Steiner's, from the reveries of Swedenborg to those of the

1. Although the adjective *moderne* first appeared in the French language towards the middle of the twelfth century, the noun *modernité* was not employed until Châteaubriand used it in *Les Mémoires d'outre-tombe*. Baudelaire was the first (in "Peintre de la Vie moderne") to make it central to the demand for and proclamation of a new aesthetics. See H. R. Jauss, "La Modernité dans la tradition littéraire et la conscience d'aujourd'hui", in *Pour une esthétique de la réception* (Paris: Gallimard, 1978).

2. See Dora and Erwin Panofsky, *Pandora's Box: The Changing Aspects of a Mythical Symbol*, 2nd edition (New York: Bollingen Foundation/ Pantheon, 1962), pp. 27-28.

3. Quoted by Alberto Savinio, "Divinità per telegrafo", *Torre di Guardia* (Palermo, 1977), p. 195.

Rosicrucians, the European sensibility was governed by a single idea, the very idea that, through the spread of Wagnerism, became the source of Symbolism. But the inter-connectedness of the world, the unique symbiosis between man and nature that Romanticism had celebrated to the point of postulating (*viz.* in the work of Novalis, Runge, Kerner and Stifter) the spirituality of plants (which were said to think, suffer and recollect like humans), of suggesting that odours are not recognized by us but remembered, in some inner way, through the empathy of selective affinities, that colours are reflected in us according to an order other than the one discovered by Newton – in sum, the continuous interwoven grid linking realm to realm, mineral to vegetable, vegetable to animal, the *bios* that was energized and inhabited by complex "correspondences", which gave meaning to each of its phenomena, all this began to dissolve and come apart under the staggering blows dealt by Positivism. The Symbolist movement, in fact, merely attempted to save what it could. Jules Verne often used humour to highlight those moments when man's primordial confidence in his environment, what we would call today his ecological niche, previously seen as the perfect reflection of his own subjectivity, began to give way to the pessimistic, bitter and disenchanted questioning of a world now foreign, indifferent and governed by laws quite alien to himself. As in *Le Rayon vert*, for example, when Miss Campbell's raptures over the stormy sea threaten to rival the poetry of Coleridge or Wordsworth: "The sea really doesn't have a particular colour. It is nothing but a vast reverberation of the sky . . . It can best be grasped when it is really rough, when it is dark, livid, threatening." Then comes the voice of the old scientist, breaking the spell: "The sea! A chemical combination of hydrogen and oxygen, with two and a half percent sodium chloride! There is truly nothing finer than the grandeur of sodium chloride!"

It was to halt the growing ascendancy of a world evidently disillusioned and godforsaken, but also devoid of all magic, good or bad, that Symbolism employed its sorcery – visual, musical and poetic. Could words, colour, sound, succeed in reuniting what science had torn asunder? It was art as the final bastion against loss of meaning, art for art's sake as the ultimate response to the emptiness of appearances.

A question often asked of students when discussing Art Nouveau also arises in relation to Symbolism: Was it a decadent movement or a modern one? To what extent was it, like the Nazarene and Pre-Raphaelite movements that preceded it, a movement of *renovatio*. To what extent, through its chromatic and formal audacities, one of *innovatio*? Was it the conclusion of the nineteenth century or the beginning of the twentieth? Couched in these terms, the question becomes gratuitous. An illustration of the fundamental Nietzschean idea that modernity is simply the most acute fear of decadence, Symbolism grew out of a *Kulturpessimismus* that undoubtedly saw the end of the century as a decline, but a decline of unrivalled brilliance. It was a movement in which nostalgia and neophilia were inextricably interwoven.

The geographical boundaries of Symbolism are also well defined and its principal proponents accurately catalogued. Are we still convinced of its purportedly Eastern origins? In any case, Paris was clearly not the movement's capital. Despite Mallarmé and a few others, from Moréas to Viélé-Griffin, despite the Nabis and Gauguin, despite Maurice Denis, Paris

remained at the periphery of Symbolism and not at its centre. If focal point there has to be, then Brussels is the obvious choice: capital of a Lorraine situated halfway between the Germanic and the Latin worlds, gravitational centre linking the German, Austro-Hungarian and French empires, it acted as a ramp, a thoroughfare. Flemish-born writers like Rodenbach, Max Elskamp, Verhaeren and Maeterlinck all spoke admirable French, but gave voice in a language coloured by German Romanticism. And the same was true of the painters, from Khnopff to Spilliaert. They were to Symbolist aesthetics what Grevisse, Tobler-Lommatzsch and Saussure were to the French language: more Catholic than the Pope, outsiders more concerned with linguistic purity than the natives themselves, border guards, protectors of grammatical and lexical orthodoxy. But it was also they, these interpreters of cultural inflow, who set the tone, who propagated – especially Les XX – the spirit that pervaded the Munich and Vienna secessions. Finally, to indicate the full extent of a movement that soon spread across the whole of Europe,[4] we must stress the contribution of the Slavic world, of Russia, and the Baltic countries, of Lithuania, Poland, and of course, Scandinavia. In these countries barely touched by Impressionism, the transition from Naturalism to the literate and cultivated painting that Symbolism strove to be was very smooth. Far from the naïve – or at least simple – empirio-criticism of Monet's disciples, far from the Impressionism of minor sensations, which invariably amounted to nothing more than a play of decorative effects,[5] Symbolism, from Edvard Munch to Marcel Duchamp, proclaimed the right of painting to remain "intelligent", to be, as it had been in the past, the object of a *legend*: that which must be read if its message is to be grasped, understood with the mind and not simply experienced through the senses.

This need for a narrative art, for an art that informs and exalts, was all the more acute once it had been identified as a weapon in the rise of nationalism and the struggle against foreign influence. The visual heritage of legends, sagas, stories and epic poetry was explored and re-exploited by painters and sculptors with the same fervour that Herder, at the dawn of Romanticism, had delved into the treasures of vernacular language to glorify German nationalism.

But let us look at the question in even broader terms. As a general attitude of mind, symbolism is as old as humanity itself: with the desire to represent, by a sound, an image, an object, even an odour, the reality of something no longer perceptible, came the development of language, so quintessentially symbolist in the strict sense – *sym-bolon* – in that it establishes an apparently necessary link, either natural or arbitrary, between the world of signs and the world of objects or ideas.

An examination of Symbolism as a movement – born during the nineteenth century, at its height at the fin de siècle and gone by the outbreak of the Great War – requires first that we attempt to explain why the universal and abiding disposition of the human mind to symbolize was laid claim to at that particular moment in history by a major current in Western thought, was illustrated in a circumscribed body of work, was exalted and systematically explored. Why? And why there? None of the few and already remote exhibitions devoted to European Symbolism[6] attempted to define the Symbolist episteme with any

4. And later, as this exhibition shows, to the United States and Canada.
5. This analysis was made by Robert Klein in his "Notes sur la fin de l'image", in *La Forme et l'Intelligible* (Paris: Gallimard, 1970), p. 375.
6. For example, the most recent, *Le Symbolisme en Europe*, shown in Rotterdam, Brussels, Baden-Baden and Paris (1975-1976).

precision, but limited themselves to simply lining up, alphabetically or chronologically, both creators and works.

Antithetical pairs such as idealism and realism, spiritualism and positivism, individualism and collectivism, fantasticism and rationalism cannot explain adequately either the distinction between Symbolism and Romanticism or Symbolism's comprehensive nature. In fact, of all the movement's features, this last was the most truly innovative. Symbolist ideology, which influenced literature, music, the visual arts, architecture, furniture design, the decorative arts – even the humanities and pure sciences – was actually the last great *style* (in the sense that Meyer Schapiro uses the word)[7] to have come out of Europe, the last generalized attempt to respond to the crisis affecting every facet of intellectual endeavour, whether in the realm of aesthetics or of knowledge. Final flare of *Naturphilosophie*, Symbolism was the last movement to provide a general explanation of man's position in the natural world, to offer a unified vision in which the human being and the total world organism, the *Gesamtorganismus*, were seen as interdependent. And if the Wagnerian notion of the total artwork, the fusion of all the arts and all the great myths, was the ideal towards which it strove, it was because, faithful to the notion of *sym-bolon*, Symbolism saw it as the only way of combatting the compartmentalization, the fragmentation of knowledge that increased as science advanced, and the steady crumbling of confidence as the few remaining corners of darkness were illuminated by the light of Reason.

But what, precisely, was it a response to? The only opposing of antithetical pairs that seems relevant here is the one that contrasts symbolism – that which *unites* mind and world – with its opposite, diabolism (*dia-bolos*), literally that which *divides*, separates, opposes. The "diabolical" approach is the one that offers an indefinite *analysis* of the constituents of the world, an infinite dissolution of primal unity: it is the negation of the world's coherence, of its intelligibility. The symbolic approach, on the other hand, is the attempt to regain this lost unity, the effort to attain the greatest possible degree of integrity; its aesthetic ideal can only be the total work of art, the *Gesamtkunstwerk*.

One cannot but wonder, then, about the basic fact that the diabolical – Faustian? – element was one of the permanent and constitutional features of the Symbolist movement, reappearing regularly like the second side of a coin. It was present in the work of the proto-Symbolists – Goya, Fuseli, Blake – and became more widespread among the post-Romantic generation – Baudelaire, Rops, Barbey d'Aurevilly.[8] But it also re-emerged at the latter end of the movement, with the followers of the Golden Dawn. This swinging back and forth – diabolism/symbolism, separation/reunion, luciferism/redemption, decadence and fall/rebirth and salvation – was actually a manifestation of the crisis mentioned earlier, marked by the disruptions in the usual structure of language (visual, plastic, musical, etc.) accompanying the emergence of the new techno-scientific culture that had developed between the Enlightenment and the first Industrial Revolution. This new culture no longer posited language as a *link* – either analogical, as during the Renaissance,[9] or logical, as during the classical period[10] – but as the *dissolution* of these links in favour of a formalized and autonomous discourse, developing quite independently of any connections between man and his inner self or man

7. See Meyer Schapiro, "Style", in *Theory and Philosophy of Art* (New York: George Braziller, 1994), pp. 61ff.

8. See Mario Praz, *La Carne, la morte e il diavolo nella letteratura romantica* (Florence: Sansoni, 1966).

9. See Michel Foucault, *Les Mots et les Choses. Une archéologie des sciences humaines*, "Les signatures" (Paris: Gallimard, 1966), p. 40.

10. *Ibid.*, "La représentation du signe", p. 72.

and the external world. The sign became more obscure, evolving into an analytic tool, an agent operating upon reality; it no longer symbolized immemorial ties, either natural or rational, that man, through his use of language, had come to believe joined him to the world. And this was the source of the endless stream of criticism and rejection, from Baudelaire to Léon Bloy, directed at Progress. From them, but also from creators such as Delacroix, De Quincey, Oscar Wilde and Huysmans, came the violent denunciation of science and technology. Diabolism, the exaltation of Evil, is the force that leads to the dissolution, the unbinding of the old relationship of confidence that existed between man and the world, between man and colours, shapes, odours, fruits and clouds; it is everything that reduces all those realities through which we grasp the pleasure of the *moment* to formulas, diagrams, equations.

Symbolism, by contrast, was a final and desperate attempt to restore the natural and ancient links that man, as a thinking being, had established with the world. First of all, with Wagner and Nietzsche, it was a massive reminder, a monumental recapitulation of the whole of man's fabulous, legendary, *mythical heritage*, so rich in tangible proof of the existence of these links. Then, with the great sensualists like Baudelaire and Debussy, it became an exploration of the *correspondences* that, in human physiology, are evidence of the harmony that exists between our senses and the outside world. Finally, it was the search, conducted at the frontiers of the normal and the pathological, for those *border states* of consciousness that offer inklings – regardless of all the disintegrations and uncertainties of the feeling, thinking subject – of that irreducible heart of our being that we call variously the "spirit", the "mind" and the "imagination".

Like the Romanticism of which it was the direct descendent, Symbolism was rooted in the cult of the Self. But it remained distinct from it to the extent that this cult – the obsession with the individual mind, dandyism, the exquisite extenuations of eccentricity – became the only possible response to the threat posed to fin-de-siècle man's narcissism by the invasion of an autonomous technical world that functioned quite separately from him and that was neither the reflection of his being, nor even the instrument of his power, but the cause of his extinction. The hypertrophy of the Self advocated by Symbolism was rather the response, in the realm of artifice – of painting, sculpture, music and poetry – to actual disintegration in the realm of physical and psychological reality, of which this Self is the victim.

In 1917, Freud pointed out that during its history, human narcissism has undergone three profound humiliations.[11] The first, the cosmological humiliation, came from man's discovery that he was not the centre of the universe: the abandonment of geocentrism cast man out from the heart of creation. The second, the biological humiliation, came with the publication of Darwin's writings: man was not made in God's image but was the dubious and fortuitous result of the evolution of species. The third humiliation was psychological: the discovery of the unconscious (which, we should recall, predated Freud's theories) showed that man is not even master in his own house; his ego is nothing but the exposed area of a vast submerged psychological continent of which he knows nothing. If we accept the analysis offered by Freud – *perhaps the last of Symbolism's intellectual heirs* – we can see his work as an attempt to heal the wounds inflicted on narcissism by the swift advance of scientific

11. Sigmund Freud, "Une difficulté de la psychanalyse", in *Essais de psychanalyse appliquée* (Paris, 1952), pp. 141ff.

knowledge (Darwin was only a little older than Freud). And it was artistic activity, rather than scientific investigation, that was needed to effect a successful cure by restoring man to the three crucial positions he was conscious of having lost: to the centre of the cosmos through the reactivation of the *myths*, beliefs and religious syncretisms that had been the source of this pre-eminence; to the top of the biological hierarchy through the exercise – unique in the animal kingdom – of his capacity for abstract thought and his awareness of his own *death*; and to the heart of his own self through the *presentiment* of the most deeply buried secrets of his soul. After the collapse of religion and politics, it was art, in the final analysis, that was selected *in ultimis* by the science of the mind to serve as the "satisfaction through phantasy", the "mild narcosis", the "sedative"[12] that would assuage modern man's wounded pride. It is a solution that bears a striking resemblance to Symbolist ideology.

As a form of resistance to the negative effects of scientific progress, then, art acquired an importance unprecedented in any other century: the practice of art became a *cult*, and its practitioners wise men (Victor Hugo), initiates (Schuré) and high priests (Péladan). In the end, it was the ritualized practice of art as the substitute for a fast-waning religion that would lead to the *regeneration* of humanity: the ideology of the new man – which emerged at the dawn of the twentieth century and which assumed subsequently so many different guises, all rooted in Symbolist theories – nourished the various branches of modernist thought and took on forms both regressive (in Fascism and Nazism, for example, whose Symbolist component, disseminated through magazines like *Ostara*, has often been underestimated) and progressive (socialism, anthroposophy and naturism).

This brief analysis has shown us a Symbolism that began with the *waning of culture*, and the associated recourse to the treasures of fable and religious syncretism, and ended at the dawn of the twentieth century, with the emergence of an impulse *towards regeneration*. We have also seen how, in the interim, faced with the knowledge that the Self was *beyond recovery*, inherent "unknowability" – as writers of the time, from Ernst Mach to Freud had proclaimed – the search for identity and the need to construct a social consciousness encouraged the move towards independence and the *regaining of the homeland*. It was this shrinking of the self, moreover, experienced as the agony of a being hitherto sovereign over both itself and the universe, that, aided by the spread of Darwinism, sparked the reactive idea of a vital and profuse explosion, of the *cycles of life* in infinitely renewed forms, giving birth pell-mell to marvels and monsters, leaving far behind imaginings of the worst horrors and allowing glimpses, behind the veil of appearances, of the existence of worlds invisible, or, as Marcel Duchamp would soon put it, "extra-retinal".

This movement of expansion, of even greater diffusion, led Symbolism to occupy *new territories*, to employ new methods – not just the illustrated book, typography, but also theatre, dance, the newborn art of photography, and, from the minute it first emerged in 1895, film. We today still owe much to all these creations – far more than we once thought.

J. C.

12. See Sigmund Freud, *Civilization and Its Discontents*, trans. Joan Riviere, rev. and ed. James Strachey (London: The Hogarth Press and the Institute of Psycho-Analysis, 1973), pp. 17ff.

I. *The Waning of Culture*

A scene from Alfred Hitchcock's *Rebecca*

In a relatively candid interview he granted Peter Bogdanovich,[1] Fritz Lang paid an unexpectedly emotional tribute to his contemporary Alfred Hitchcock. The German filmmaker spoke in particular about a scene from *Rebecca* (1940) in which the Manderley housekeeper shows Mrs. de Winter (played by Joan Fontaine) the clothes and furs of Rebecca, first wife of the master of the house, saying that he admired this scene more than any other and that he had tried (in vain, he thought) to recreate it in his film *Secret beyond the Door* (1946). There was nothing random about this tribute. The scene in *Rebecca* provides a marvellous synthesis of *fetishism* (rustling silk, luxurious fur) of objects once belonging to a woman now dead, an *oppressive place*, the creeping influence of *evil* on the consciousness, and the heroine's *desire for oblivion* – all four, key elements of Symbolism. This exquisite interplay of themes was bound to appeal to the creator of the frankly Symbolist *Frau im Mond* (1928), with its ecstatic Wagnerian ending. This kinship between two films at first sight so dissimilar is only one of thousands of examples that could be adduced to illustrate what might be called the survival of Decadentism or even the areas of transference of Symbolism into the modern era. In fact, the art of the 1880s and 1890s, which in mid-twentieth century may have seemed outdated and quaint with its parade of knights, sphinxes, femmes fatales and incubi, had retreated underground, survived and adapted.

André Breton's admiration for the art of Gustave Moreau is a matter of record, as is the debt owed and owned by such Surrealist painters as Magritte and Delvaux to their Belgian Symbolist elders Frédéric, Mellery and Degouve de Nuncques. However, little or no attention has been paid to the channels whereby the Symbolist sensibility infused the tradition of gothic and fantasy films, especially those made in English-speaking countries.

Symbolism has been misunderstood because attention has mainly been focussed on its decorative surface. All too long, the tendency of many idealist artists to be at once committed to and scornful of Symbolist dogma has not been taken sufficiently into account. Hence, for years it was hard to imagine Erik Satie, that musical revolutionary, composer of such key avant-garde works as the *Gymnopédies* and *Parade*, committing himself to creating for Sâr Péladan and his Rose + Croix movement three ceremonial fanfares, a "Christian ballet", *Uspud*, and incidental music for the Sâr's play *Le Fils des étoiles* (a Chaldean "Wagnérie"). It was equally unimaginable to think of Alfred Jarry, who broke every single one of the centuries-old rules of the theatre with his *Ubu Roi* (1896), involved in the launching of *La Revue blanche* and in the esoteric circles of Symbolism's devotees.[2]

1. "Fritz Lang en Amérique", interview with Peter Bogdanovich, *Cahiers du cinéma* (Paris: Éditions de l'Étoile, 1990), p. 77.
2. "We have experimented with *heraldic* scenery, that is, designing a single uniform awning for a whole scene or act, so that the characters move harmonically over this heraldic field." Alfred Jarry, "De l'inutilité du théâtre au théâtre", *Mercure de France*, September 1896.

The Waning of Culture 23

Octave Mirbeau's concern for literal realism is expressed in his *Journal d'une femme de chambre*, together with his fulminating reviews of Decadent painting, that of Burne-Jones especially:

> Oh! their beanpole princesses with faces like poisonous flowers, wandering in their galvanized iron gowns up cloudy stairways and across terraces lit by a sickly moon! Oh! their women-loving women, fishing-rod skinny, who walk without legs, gaze without eyes, speak mouthless, love sexlessly, who under mechanically cutout foliage hold their flat hands forever drooping at the wrist in the same never-ending gesture! And their heroes stinking of sodomy, neurosis and syphilis![3]

Does this mean that Mirbeau, like Zola, was opposed to Symbolism? Is he a modern because he rejected the idealist tendencies of the nineties? To assume so would be to ignore the fact that the concentric pyramidal structure of his novel *Le Jardin des supplices* is, with its gyrating setting and its cumulative macabre and hallucinatory details, one of the finest achievements of Symbolism. Is it not rather the case that Symbolism is even more itself when it *upsets* reality, when it looks back in a time lag more or less removed from verifiable, quantifiable reality?

Thus it is with Edgar Allen Poe's manic scientism as he invites us into his inextricable psychological mysteries: it is the more disturbing that he shows strange events occurring within a realistic context that we think we recognize. And even a writer as conservative as Villiers de L'Isle-Adam delighted in depicting in great detail all the sexual aberrations that the Victorian era had tried in vain to repress. The power of Maeterlinck's theatre derives from his use of the simplest, most everyday language possible to sound the soul's unfathomable depths. In much the same way, his contemporary Fernand Khnopff presents, in his Bruges canals, empty churches and women's faces hard and cold as marble, a portrait of the Belgium of his time that is nonetheless timeless and placeless. And somewhat later the great Malczewski, an ardent patriot in an era when Poland was divided among three great empires, creates in his paintings a *Polonia infelix et magica* constructed out of fragments of the present that coalesce into a completely dreamlike unreality, an expression of the stream of consciousness.

To a great extent, then, this period was fraught with a looming doubt as to the future of civilization at the very time when technological and industrial progress was an article of communal faith. It was precisely in this rift, in these areas of uncertainty, these suspended moments between the past and the future, that one of the primary components of the Symbolist sensibility flourished: the notion of the waning of culture, leading to the creation of a disenchanted world in which the ancient myths resurface, together with religious feeling and a powerful resurgence of Satanism and black magic.

Edward BURNE-JONES
Lancelot at the Chapel of the Holy Grail,
1890s, Southampton City Art Gallery

3. Octave Mirbeau, "Des Lys! des Lys!", *Le Journal*, April 7, 1895; reprinted in *Des artistes* (Paris, 1986), pp. 198-199.

Nostalgia for the Past: Myths

Ancient myths made a triumphant reappearance at the turn of the century, when various schools of thought rejected the modern world, with its poverty, divisions and conflicts, and harked back to an idealized Golden Age or an idyllic Middle Ages. In his *Past and Present* (1843), the historian Carlyle, conscience-in-chief of Victorian England, deplored the deterioration of labour relations in the middle of the century of capitalism and doubted whether any contemporary heroes could be found to lead the democracies. These considerations inclined him to look sentimentally back to the blessed days of William the Conqueror, "a resident House-Surgeon, provided by Nature for her beloved English People",[4] and to cite with approval the paternalistic aspect of feudal relationships, so diametrically different from the notion of individual freedom in the Age of Enlightenment. William Morris, founder of the arts and crafts movement, leading thinker of the Pre-Raphaelite Brotherhood and a confirmed socialist, pushed this line of reasoning even further in such controversial lectures as "Art under a Plutocracy" (1883) and "Useful Work versus Useless Toil" (1884). "I hold that the condition of competition between man and man is bestial only, and that of association human," he claimed with passion.[5]

As a reader of Marx, he was aware that art is inextricably linked with working conditions and that on-the-job relations were in need of sweeping change if art was to be reborn as the true expression of a nation's genius. The concept of history is therefore not incompatible with the blossoming of an art based on ideas and unreality.

It has long been recognized that a work of art is not necessarily any the more representative of its time for being linked to contemporary reality. The observation of daily life in all its raw truth, a concern for the excitement of the moment, the capturing of every slight vibration of colour and light, certainly enabled artists – in particular the Impressionists – to make huge strides in the mid-nineteenth century. But it is also true that a *Judith* by Moreau or one of Böcklin's mermaids tells us just as much about the aspirations of the time as a *Gare Saint-Lazare* by Monet does. It was to some extent the excesses of Positivism and the Realists that impelled the Symbolist generation to seek out ancient mythologies.

The rediscovery of mythology was not in fact unknown in the arts of the West, and the academicians of the nineteenth century were foremost in paying homage to this tradition; but although classical mythology was not forgotten, it was drawn upon mainly as a source of more or less learned literal references, to be cluttered in a welter of archeological detail. When Gustave Moreau painted his enigmatic *Oedipus* that was so popular at the 1864 Salon, the subjects proposed to the young candidates for the Prix de Rome in painting were Sophocles Accused by His Sons, The Death of Priam, Veturia at the Feet of Coriolanus and Joseph Making Himself Known to His Brothers, the last vestiges of a moribund school of historical painting handed down from David. Symbolism, on the other hand, was concerned with *looking afresh* at myths and systematically rereading them in an objective manner. For Gustave Moreau, the meaning of a myth was the starting point for the poet's imagination, for the awakening of private longings that lay buried dormant in his consciousness:

4. Thomas Carlyle, *Past and Present* (London: J.M. Dent & Sons, 1941), p. 207.

5. He went on: "I think that the change from the undeveloped competition of the Middle Ages, trammelled as it was by the personal relations of feudality, and the attempts at association of the gild-craftsmen into the full-blown *laissez-faire* competition of the nineteenth century, is bringing to birth out of its own anarchy, and by the very means by which it seeks to perpetuate that anarchy, a spirit of association founded on that antagonism which has produced all former changes in the condition of men, and which will one day abolish all classes and take definite and practical form, and substitute association for competition in all that relates to the production and exchange of the means of life. I further believe that as that change will be beneficent in many ways, so especially will it give an opportunity for the new birth of art, which is now being crushed to death by the money-bags of competitive commerce." William Morris, "Art under Plutocracy", in *On Art and Socialism: Essays and Lectures*, selected with an introduction by Holbrook Jackson (London: John Lehmann, 1947), p. 139.

For me one impulse is dominant: I am drawn with passion to abstraction. I am interested, deeply interested, in expressing human feelings, human passions, but I am drawn to paint not so much these states of heart and soul as their *interior brilliance*,[6] those flashes of light that have no apparent source, that have something godlike in their apparent insignificance, that when expressed in marvellous, purely plastic form open up magical, perhaps even divine, perspectives.[7]

This is a particularly inward-looking concept of inspiration, which Redon would not have rejected. The artist takes upon himself the task of providing for his fellow men an evocative expression of a deeper reality, of revealing the themes human history is made up of (death, destiny, desire and so on) more eloquently than in the mannered, archaic form of the myths that encapsulate them. Thus, in **The Poet and Pegasus**, Redon uses a combination of the winged horse and the artist to symbolize the absolute freedom of inspiration; his liking for entangled shapes, his preference for suggesting rather than naming things, make him one of the forerunners of abstract art.

Moreau's **Fairy and Griffins** (1876) brings together quite brilliantly the body of an apparently cold and inaccessible woman and the griffin, a mythical beast of Persia, guardian of fabulous treasures in Greek myth and a way of depicting the devil in medieval legend, whose vigilance must be eluded if access is to be gained to the beloved. The closeness of the two beings symbolizes the hybrid nature of the femme fatale, who is both desirable and dangerous.

The same artist's **Salome Dancing before Herod** (1876), similar to the Louvre watercolour that so fascinated Des Esseintes, is yet another variation on the theme of the cruel and capricious little princess, a major obsession of the period, handled by Flaubert, Laforgue and Oscar Wilde. The latter in particular interpreted Salomé's confrontation with Jokanaan as a quest for the absolute, as a laughable and repellent attempt to establish a dialogue beyond the grave, an Oriental, biblical version of Wagner's *Liebestod*.

Moreau, like Redon and Delville, was haunted by the figure of Orpheus, archetypal representative of the poet misunderstood by his contemporaries. Pierre-Amédée Marcel-Béronneau, one of Moreau's students, created an impressive and terrifying Orphic scene in 1899: as the androgynous poet sings, he averts his eyes from a Hell swarming like a sewer with serpents, thorn bushes, tormented bodies and monsters of all kinds, a flood of slime worthy of a Max Ernst *Temptation of Saint Anthony*. In a style closer to the restraint of Puvis de Chavannes, Alexandre Séon painted in 1883 a solitary **Orpheus**, a beautiful youth weeping over his sorrows against a huge block of stone close to the riverbank (Séon, an intimate of Sâr Péladan, had naturally turned to the Orphic mysteries in his search for the ideal).

An admirer of Austrian culture and especially of Gustav Klimt, Luigi Bonazza created his masterpiece with the **Orpheus** triptych (1905), a tremendously decorative canvas in which the Pointillist technique accentuates the fatal sensuality of the subject. While photography has since then made the most of this elegiac theme, it cannot be denied that the American F. Holland Day was obsessed with it: his *Nude Youth with Lyre* and **Nude Youth with Lyre in Grotto** (1907) are also variations, moving and elegant, on the sibylline Song of Orpheus.

6. Emphasis added.

7. Gustave Moreau, *L'Assembleur de rêves. Écrits complets de Gustave Moreau* (Fontfroide, 1984), p. 29.

The art of the Swiss painter Arnold Böcklin shows the resistance German classicists put up against the Realism of their peers and in particular against the Impressionism imported from France. His 1885 **Silence of the Forest** (which he had considered calling *Solitude in the Forest*, a resoundingly Germanic title) presents an ugly, rough-looking unicorn coming out of the undergrowth, more like a workhorse ridden by an Amazon. The creature's wild-eyed stare reinforces the effect of a sudden and terrible apparition (one is fleetingly reminded of Fuseli's *The Nightmare*), harking back to the fascination felt by German artists such as Caspar David Friedrich and Moritz von Schwind for the unfathomable mysteries of the forest. Böcklin's unicorn has a presence quite different from the elegant, remote icon of Armand Point's 1896 **Lady with a Unicorn** and Arthur Davies's minimalist **Unicorns** (1906), in which the creatures are just compositional elements in a landscape.

Other hybrid and legendary beings dear to the Symbolists included mermaids, whose melodious but deceitful siren song enraptured Ulysses. The dim, mysterious atmosphere of the third of Debussy's *Nocturnes*, *Sirènes* (1899), expresses his generation's enthusiasm for the theme, while Burne-Jones's mermaids have a timeless quality rendered even more enigmatic by the less polished style of the artist's later years.

The Symbolist era also saw a revival of pre-Christian myths, a probing of the depths of the collective unconscious, a source of insights amazingly new yet deep-rooted in folk memory. Attention was already focussed on the sagas in the Age of Enlightenment: a vital role was played by the Swiss academic Bodmer in Zurich, and later by the painter Fuseli, in the modern rediscovery of one of the best known of Germanic epics, *Kriemhild's Revenge*. In 1831, Carlyle published a commentary on the *Nibelungenlied* in the *Westminster Review*.

These unique cycles of Germanic epic poems, these songs from a distant past, were bound to appeal to Richard Wagner, yet another dream weaver. His penchant for synthesizing myths was first apparent with *Lohengrin*: Elsa – the protagonist whose questioning of the mysterious swan knight, whom she loves, destroys their marriage – is a reinterpretation of the myth of Semele, who was also guilty of disastrous curiosity. "Myth is the primeval, anonymous poetry of the people," wrote the composer,

> and we find it throughout the centuries, continually rediscovered and reworked by the great poets of cultivated ages. In myths, human relationships are almost completely divested of their conventional appearance, understandable to abstract reasoning alone, and reveal what is basically human, eternally understandable in life. They show these truths in a concrete form that precludes all falseness, and this is what gives to all real myths their specificity, their individuality recognizable at a glance.[8]

Wagner did not set out just to de-obfuscate myths (in this regard his tetralogy is an accomplished synthesis of Bodmer's chaotic *Kriemhild's Revenge*); he also formulated a world vision, based on the ancient (and very un-Marxist) notion of cyclical history: the ring stolen from the Rhine Maidens in the first scene of *Das Rheingold* is restored to them at the end of the *Gotterdämmerung*; meanwhile Valhalla has fallen and the twilight of the gods has come. As Theodor W. Adorno caustically noted, Wagner did not *develop* his characters; rather, he endowed them with a relentless logic that is continually challenged, time being the only

8. Quoted by Baudelaire in "Richard Wagner et *Tannhäuser* à Paris", *Œuvres complètes*, vol. 2 (Paris: Gallimard, 1976), pp. 791-792.

15

17

16

23

element that changes the outcome. Wagner's operas, permeated with a sense of the sacred, "unfold like acts of worship that can be repeated, leading the hearer continually back to their pantheistic essence and thus cancelling out any possibility of variation, that is to say, of freedom".[9] The Symbolist generation was sympathetic to this subtle manner of letting destiny play its part, of postulating a nonhistorical universe in which the omnipotence of the contract implies a widespread anarchy (a view of the world already proposed by Schopenhauer).

At the risk of looking like a traitor in the eyes of his countrymen, who were still smarting from France's defeat at the hands of Prussia in 1870, Fantin-Latour was one of Wagner's most enthusiastic admirers. He created many works based on the operas, some in the form of lithographs such as **The Invocation of Erda**, executed after his first visit to Bayreuth in 1876, others as paintings, including a splendid **Prelude to "Lohengrin"** (1882) in which the rays of light shed by the Grail illuminate the whole composition. Influenced by figures like Delacroix and Berlioz, and convinced of the theory of correspondences between painting and music, Fantin-Latour constructed the most balanced of Wagnerian worlds, pregnant with mystery and an underlying Romanticism.

The English artist Aubrey Beardsley created an even more unique world with his flamboyantly Japanese techniques based on strong black and white contrasts, a perverse use of the *horror vacui* and a wealth of grotesque detail. His well-known **Siegfried** (1893) presents Wagner's hero as a beautiful Mantegna-style youth, with a dragon of Oriental fantasy overhanging a black lake shot with weird reflections. **The Third Tableau of "Das Rheingold"** (1896) provided him with the opportunity to juxtapose, against a coal black Nibelheim, Wotan in white and Loge in black, both confronting Alberich metamorphosed into an incredible Art Nouveau serpent, an unexpected predecessor of the sea monster included by Klimt in his *Hope II*. In **The Fourth Tableau of "Das Rheingold"** (1896), Beardsley portrays Wotan and Loge ascending to Valhalla in a style characterized by great purity of line and a certain sly humour. Other artists inspired by Wagner's epic cycle include Hans Thoma, Odilon Redon, James Ensor and Franz von Stuck. Rudolph Maison was an inveterate Wagnerite. His **Wotan**, a small sculpture in bronze, is shown slumped ("Furchtbare Not!") in a huge primitivist throne, clearly linked to the then-burgeoning Celtic Revival.

This appetite for ancient legends, the temptation to push back the boundaries not of space but of history in search of new sensations, had an eventual influence on the aesthetics of interior decoration. The struggle to assert national identity in countries like Ireland, Finland and Norway, often entailing a demand for political independence, gave new life to the native cultures that had preceded the international Gothic, Italian Renaissance and Neoclassical styles in more remote regions. In Russia, the Abramtsevo group was formed in about 1880 under the patronage of the rich merchant Momontov. Its painting studios and carpentry shops attracted artists like Vasnetsov, Vrubel and Golovin, all fervent advocates of the native Russian style with its floral decoration, carved wooden animals and rainbow-coloured tapestries.

The Finnish painter Akseli Gallen-Kallela illustrated the great Finnish epic the *Kalevala*, which recounts the adventures of the heroes of Karelia, and his friend Sibelius

9. Theodor W. Adorno, *Versuch über Wagner* (Frankfurt, 1952), chapter 8.

based the *Kullervo Symphony* (1892), his earliest large-scale orchestral piece, on the poem. Gallen-Kallela's best-known work is still ***Lemminkäinen's Mother*** (1897). Based on a tale from the *Kalevala* that is a Northern version of the Orpheus myth, this painting suggests a certain sympathy with the Synthetism of the Jugendstil. Gallen-Kallela set out to make his country house, "Kallela", a complete work of art, designing the architecture, interior and furniture himself in a primitivist Nordic style.

Gallen-Kallela's Norwegian neighbour Gerhard Munthe took his inspiration for a series of watercolours executed between 1892 and 1895 from Viking ornamental patterns. From the *Horse of Hades* to ***The Suitors***, the works display the same repeated primitive geometric shapes, natural elements synthesized to an extreme degree and clearly defined areas of vivid colour not unlike the yet-to-be-invented comic strip.

The Scottish painters George Henry and Edward Atkinson Hornel paid homage to the prevailing taste for primitivism with ***The Druids: Bringing in the Mistletoe*** (1890), depicting customs known throughout the Celtic world in a dreamlike, pre-Expressionist procession. In every country in Europe, folklore and folk arts were being rediscovered. Early in this century, the Hungarian composer Béla Bartók travelled through the country districts of Pannonia and Transylvania collecting traditional music. In France, the Pont-Aven group, following Gauguin, found in Brittany a source of primitive inspiration, its influence to be seen even in Sérusier's ***Daughters of Pelichtim***, which depicts a biblical story.

Medieval legends were also an important source of inspiration for Symbolism. The Pre-Raphaelites were the first convincing illustrators of the Arthurian cycle and the mystical quest for the Holy Grail. It might even be said it was their attachment to this topic that led them from the "realist" Pre-Raphaelitism of the 1850s to a more idealized style. Morris's *Queen Guinevere* (1858) became an icon for the burgeoning Symbolist school, a moving and tangible evocation of consumptive beauty destined for inexpressible sorrows. In his student days at the Collège Sainte-Barbe in Ghent, Maurice Maeterlinck had been surrounded by reproductions of the remote princesses of Rossetti and Burne-Jones, and their influence on him is apparent in the characters he created, Mélisande and Alladine. The Princess Maleine, however, is an echo of Maid Maleen in Grimm's *Fairy Tales* with additional Shakespearean characteristics – a good example of the complex strategies of indirectness always implicit in Symbolism.

Beardsley's *Morte d'Arthur* continues the medieval revival school of book illustration as exemplified in the work of Walter Crane and William Morris. On the other hand, ***Guinevere's Redeeming*** (1905), a statuette in bronze, silver and ivory by Reynolds-Stephens, derives from the twilight phase of Pre-Raphaelitism, while Jan Preisler's ***Adventurous Knight*** (1898) falls midway between British ideals of knightliness and international Wagnerianism. ***Isabella and the Pot of Basil*** (1897), by the American painter John Alexander, is a reinterpretation, after Holman Hunt, of a macabre story from Boccaccio's *Decameron* in which a young woman keeps beside her, buried in a pot of basil, the severed head of her dead lover.

41

43

42

95

47

48

59

Time, Death, Progress

Does this return to myth correspond to an exorcism of the modern world with its vulgarity and industrialization? Oswald Spengler seemed to take this viewpoint in *The Decline of the West*: "Machines are diabolical: this conviction has never failed to be part of true faith . . . Everything that is important about a machine is hidden from view. We sensed the demon within the machine, and we were not wrong. In the eyes of a believer, the machine is God dethroned".[10] William Morris used more temperate language: "The beauty of life is endangered in our time when we allow machines to be our masters, rather than our servants."[11]

Progress is occasionally depicted in the Symbolist pantheon, so long as it is treated allegorically. G. F. Watts was particularly adept at translating concepts into painted images – *Hope*, *Love and Death* – and his ***Time, Death and Judgement*** (about 1865-1886) is a modern allegory rendered in the manner of fifteenth-century Italy.

Puvis de Chavannes, "the lonely Puvis", demonstrated an awareness of current events in ***The Balloon*** (1870) and *The Carrier Pigeon* (1871), paintings executed during, and commemorating, the dark days of the Prussian siege of Paris. ***The Balloon*** incorporates numerous elements from the current reality: fortifications, cannon, tents, bayonets, not to mention the hot-air balloon that carries the hopes of the besieged. Towards the end of his life, Puvis included a telegraph pole in *Physics*, a panel designed for the Boston Public Library (1896) as well as in murals at the Hôtel de Ville in Paris. Toorop followed his lead in ***Time and Eternity*** and *The New Generation*, using the telegraph pole as a symbol of the speed of contemporary relationships.

Spilliaert, always attracted by the uncanny, could not help giving his ***Dirigible in Its Hangar*** (1910) the air of a living creature with its eerie snout poking out. Previati offered a distant, day's-end view, in wonderful golden light, of a ***Railroad on the Pacific*** (1916).

In some cases, Symbolism came down to street level. It had great influence on the poster artists of the time – Bradley in the Modern Style and Metlicovitz in the Jugendstil, or Stile Liberty, for example – and poster art to some extent accustomed the public to the techniques of Symbolism, whether Synthetist, Cloisonnist or graphic art.

The Mystic Mirror

The decadent conscience seemed to come to terms with what should have been its obverse: a turning back to God. From Huysmans to Oscar Wilde and Léon Bloy, many were the apostles of decadence who took the path of religious commitment. In Catholic Europe, it was a time for a defusing of tensions, and the Pope took the lead. After the extremely reactionary pontificate of Pius IX, the accession of Leo XIII (1878-1903) signalled a new open-mindedness towards the modern world. His encyclical *Rerum novarum* (1891) tackled the problems of management-labour relations; it had been preceded by *Sapientiae christianae* (1890), which inveighed against Positivism and its view of man in society. Thus, the Symbolist ethic found

10. Oswald Spengler, *Der Untergang des Abendlandes*, published in English as *The Decline of the West*, trans. Charles Francis Atkinson (New York: Knopf, 1939).
11. William Morris, 1947.

271, 60

61

62

68

70

common ground with the Church. In reaction against the mechanistic notion of progress and a general loss of religious faith, many artists expressed a belief – one which went hand in hand with their interest in ancient myth – in an eternal underlying truth. Twenty years earlier, it would have been unthinkable for avant-garde artists to express themselves in religious compositions, and Manet's *Christ with Angels* (1864) appeared to be an isolated instance, an exercise in style. Yet by the mid-1890s, Maurice Denis could state: "Its unconquerable spiritual beauty is complemented by the perfection of the setting; the pleasing relationships imply truth from above, while the just proportions express concepts; the harmony of forms and the logic of Dogma are seen to be as one."[12]

Denis's ***Easter Morning*** (1893), very Fauve in its violence of colour, shows how power- 93 fully a belief in the mysteries of religion can be expressed by a vision bordering on the abstract.

In the same manner, Denis's ***Sacred Heart Crucified*** (1894), with its slender 91 mourning figures and pervasively composite colours (especially mauve, the sign of mourning) is a striking harbinger of Expressionist art, as a comparison with Franz von Stuck's fine ***Golgotha*** makes clear. In Brittany, Gauguin painted *Jacob Wrestling with the Angel* (also 83 known as *The Vision after the Sermon*, 1888), *The Yellow Christ* (1889) and *Christ on the Mount of Olives* (1889). His later ***Young Christian Girl*** (1894) fuses a primitivist style (the 81 child's huge hands, the citrus yellow area of the dress) with influences from European painting, in this case the Northern Renaissance and Holbein in particular. Holbein and his *Dead Christ* may well have also been the source of the very Cloisonnist ***Christ in the Tomb*** 86 (1895) by Filiger, one of Gauguin's companions in Brittany and a friend of Alfred Jarry. Ranson's ***Christ and Buddha*** bears witness to the predominance of the Syncretist approach 90 among the Nabi group.

Beside these models of simplicity and restraint, Henry De Groux's *The Mocking of Christ* (1890) gives an impression of pandemonium. Not content with showing two or three ruffians jeering at Christ, in the tradition of Caravaggio, De Groux has conjured up a fearful whirlwind of monstrous beings attacking the Redeemer. The sketch displayed in the exhibition also expresses this violence that compelled Léon Bloy to admiration and Debussy to tears. In contrast, Carlos Schwabe's ***Virgin of the Lilies*** (1898) looks like an illuminated 94 holy picture.

The renewal of Christianity in the late nineteenth century – far from making do with a sentimental *Virgin of Consolation* by Bouguereau or one of Béraud's images of Christ as a dinner guest in a middle class home – became the vehicle for an increasingly wholehearted Synthetism. Moreau's ***Angels of Sodom*** (1885) are vague ghosts floating in a totally abstract 97 space, sketched in a rough medium. The Dutch artist Thorn Prikker, attracted by the redemptive quality of suffering, like his contemporary Toorop, reduced human and plant forms to their basic lines combined into networks containing the Pointillist substance of his painting (***Descent from the Cross***, ***Laid in the Tomb***, 1892). And lastly, the Polish artist 85, 84 Malczewski created one of the most dreamlike landscapes in early twentieth-century painting with his ***Spring: Landscape with Tobias*** (1904): only the flight of two storks ruffles the sky, 331 while the two main figures are lost in the immensity of fields stretching into the distance; the

12. "Notes sur la peinture religieuse", in Maurice Denis, *Le Ciel et l'Arcadie*, ed. J.-P. Bouillon (Paris: Hermann, 1993), p. 35.

vanishing traces are arranged in geometric perspectives somewhat reminiscent of the Belgian painter Spilliaert's moonstruck landscapes.

Satanism

Satan was master of ceremonies throughout the century of industry and capitalism triumphant. Not the inflated figure of Gounod's *Faust*, but Milton's fallen Angel, prey to dark melancholy:

> . . . for now the thought
> Both of lost happiness and lasting pain
> Torments him; round he throws his baleful eyes
> That witness'd huge affliction and dismay.[13]

He is the apostle of forbidden beauty and unbridled imagination, the one Baudelaire describes with enthusiasm in his *Journaux intimes*: "I can scarcely conceive of a type of beauty that does not incorporate *Unhappiness*. Given this idea (others might say 'obsessed by it'), I would obviously find it hard not to conclude that the most perfect type of male Beauty is *Satan* – Milton's Satan."[14]

The figure of the demon is one of the oldest images in the world, invariably depicted as a leering creature with the body of a he-goat and found in every civilization on earth. Satanism, perhaps stimulated by the increase in religious feeling of which it is the unthought negative, was the real phantom that haunted Europe in continual resurgence from Lewis's *The Monk* (1795) to the fantastic tales of Poe ("The Devil in the Belfry") and including the gory imaginings of Pétrus Borel ("His speciality was *Lycanthropy*. Without Pétrus Borel, there would have been something lacking in Romanticism.")[15] Symbolism's marked predilection for the fantastic in many cases forged a natural alliance with the cult of Satanism.

In the paintings of James Ensor we find, alongside his grotesque masks, pullulating hordes of demons, especially in his version of Christ tormented by the legions of Hell, as it were the image of the artist prey to the stupidity of critics. The Russian Mikhail Vrubel was even more obsessed by the figure of the Demon in the sensualist and egotistic version of Lermontov's poem "The Demon". A stronger odour of brimstone pervades the Czech Váchal's ***Invokers of the Devil*** (1909), which alludes almost openly to the spiritualist ceremonies he frequented.

A section of the middle classes, in fact, avid for stimulation, had turned to the Black Mass, of which Huysmans has left one of the most vivid descriptions in all literature:

> A wave of wild hysteria followed the sacrilege and brought the women to their knees; while the choirboys glorified the high priest in his nakedness, women flung themselves upon the Eucharistic Bread and, crawling on their bellies at the foot of the altar, clutched at it, tearing away dripping gobbets of it, then drank and ate the divine filth.[16]

13. *Paradise Lost*, lines 54-57.
14. Quoted in Mario Praz, *The Romantic Agony* (Oxford University Press, 1933; reissued by Fontana Books, 1962), p. 46.
15. "Sur mes contemporains : Pétrus Borel", in Baudelaire, 1976, vol. 2, p. 155.
16. Joris-Karl Huysmans, *Là-bas* (1891), chapter 19.

This deliberate disordering of reason and the senses was naturally linked to overexcited and abnormal sexual urges, which seemed primarily attracted to death and putrefaction. In his series *"The Satanic Ones"* and illustrations for **Les Diaboliques**, Félicien 131-140, Rops proved to be the perfect interpreter of this trend. A fine draftsman and an atheist 122-130 fascinated by religious ritual, he created one of the most obscene mythologies in all Symbolism: blind Fortuna holding a pig on a leash, a bacchante impaled on a herm. This image of bestial love triumphant recalls Mirbeau's words in *Le Calvaire* (1887): "This was love daubed in blood, drunk with filth, Love of the self-abusing furies, Love accursed, that clamps on man its predatory mouth and sucks out his veins, empties his marrow, strips his bones."

When the language and the iconography become this challenging, it is clear that the Decadents' interest in Satanism could easily extend to an argument of a profoundly moral nature, which is not the least of the ambiguities of Symbolism.

G. C.

Ancient Myths

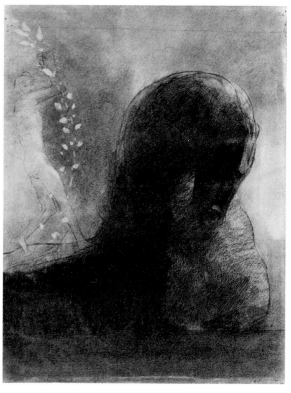

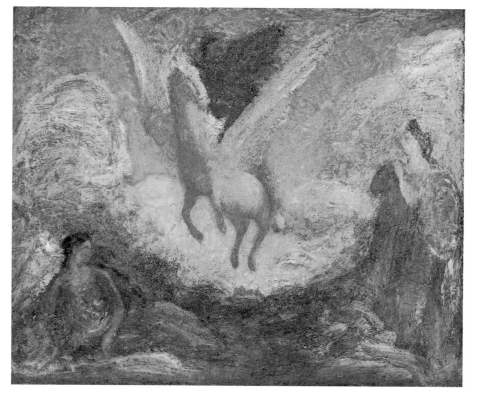

1 (cat. 346)
Odilon REDON
The Poet and Pegasus, 1891(?)
Ottawa, National Gallery of Canada

2 (cat. 366)
Albert Pinkham RYDER
Pegasus, 1901-1918
Washington, National Museum of American Art, Smithsonian Institution

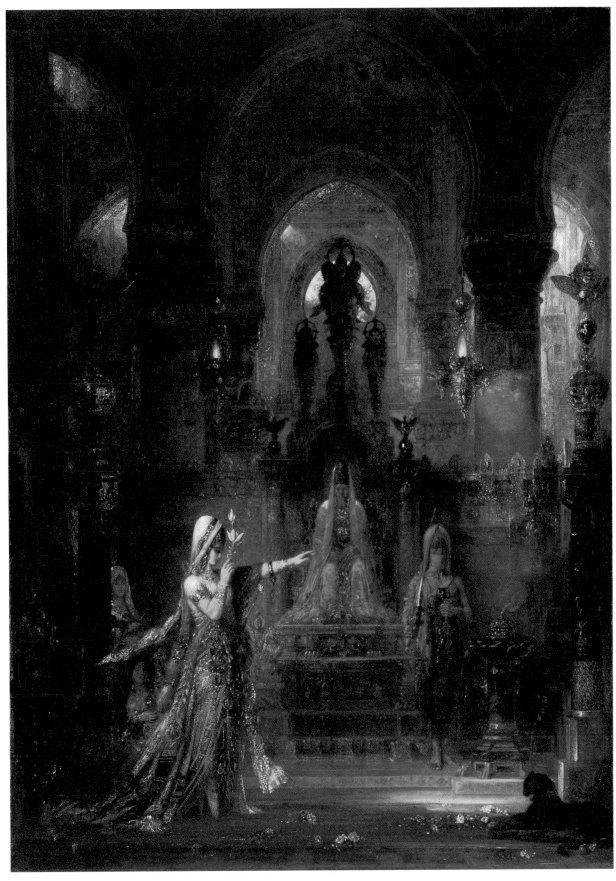

3 (cat. 286)
Gustave MOREAU
Salome Dancing before Herod, 1876
Los Angeles, Collection Armand Hammer

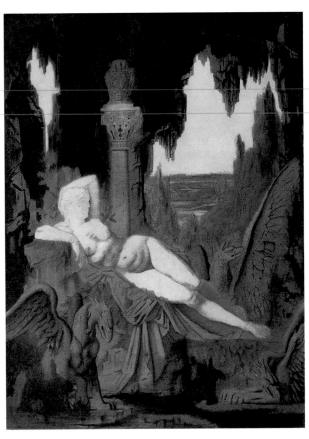

4 (cat. 282)
Gustave MOREAU
Fairy and Griffins, undated
Paris, Musée Gustave Moreau

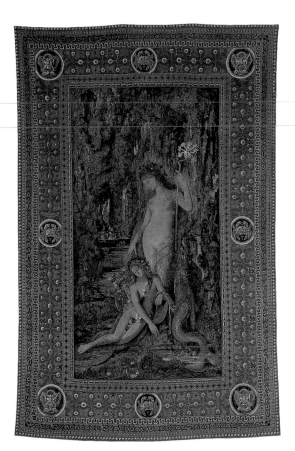

5 (cat. 283)
Gustave MOREAU
The Siren and the Poet, 1895-1899
Paris, Mobilier national

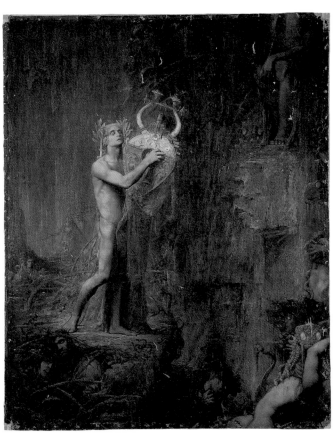

6 (cat. 17)
Pierre-Amédée MARCEL-BÉRONNEAU
Orpheus in Hades, 1899
Marseilles, Musée des Beaux-Arts

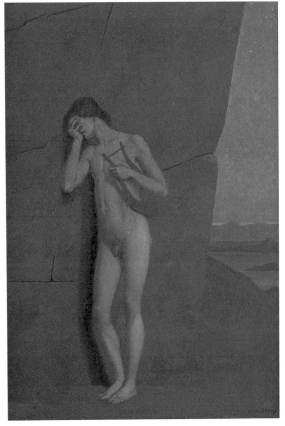

7 (cat. 390)
Alexandre SÉON
Orpheus, 1883
Saint-Étienne, Musée d'Art moderne

8 (cat. 27)
Luigi BONAZZA
The Legend of Orpheus
1905
Triptych, oil on canvas
Centre panel: 146 x 166.5;
side panels (each): 145 x 76 cm
Società SOSAT,
on deposit at the Museo d'Arte Moderna e Contemporanea di Trento e Roverano

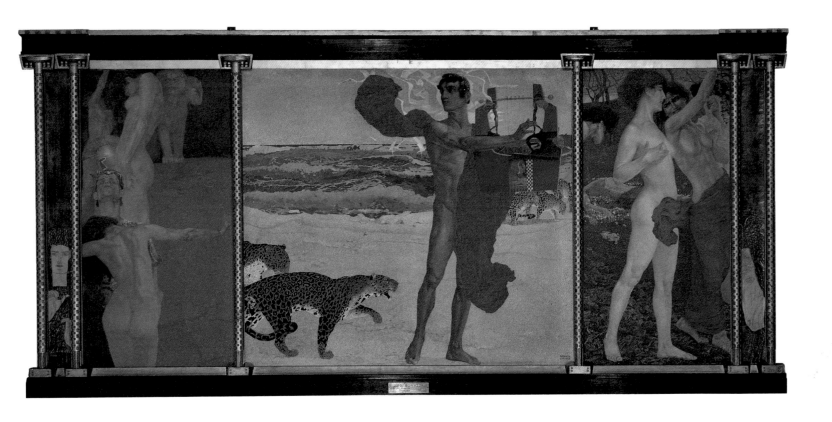

The fact that this painting was shown at both the Milan International Exhibition in 1906 and at the Vienna Secession exhibition in 1907 demonstrates clearly the twin currents in Bonazza's work. After studying in Italy, he moved to Vienna, where he enrolled in the Kunstgewerbeschule and studied under Frantz von Matsch. The love of panoramic triptychs found among Italian Divisionists like Gaetano Previati and Giovanni Segantini here co-exists with a very Viennese taste for "mosaic" decorativeness. Despite the paucity of preparatory sketches, it is known that the triptych was executed slowly, over a two-year period. As it was inspired primarily by Ovid's *Metamorphoses* and Vergil's *Georgics*, a voyage along the Istrian coast was necessary to complete the painter's research.

The centre panel shows Orpheus taming the wild beasts with his singing and imploring Hades for pity. Of the side panels, framed in bronze and ivory, that on the left depicts Eurydice coming up from the underworld, that on the right, Orpheus being torn to pieces by the bacchantes, enraged at his indifference to them. These three episodes from the legend of Orpheus do not, however, constitute a continuous story, and their separateness is emphasized when they are reproduced individually. Although all three panels show a uniform Pointillist handling, the one on the left could be read as a tribute to Klimt's staircase decoration for the University of Vienna (1900).

G.C.

9 (cat. 69)
Frederick Holland DAY
The Vision ("Orpheus" Series)
1907
Platinum print
23.9 x 18.7 cm
Bath, The Royal Photographic Society

This almost surreal composition is from the "Orpheus" cycle Day photographed between 1905 and 1907 in the idyllic surroundings of Five Islands, Maine. At the entrance to a cave among jagged rocks, Orpheus is having a fantasy-reverie that takes visible form as the colossal profile of the face of a beautiful youth. In the iconographic context of the Orpheus legend, it is uncertain whether this image refers to the entrance to the underworld or the invocation of Orpheus's lost beloved, Eurydice. Day's unique attempt to transpose lyrical moods into photographic images was accomplished through montage and dissolving two negatives. He achieved the soft-focus effects with the aid of an uncorrected Pinkham & Smith lens.

U. P.

11 (cat. 62)
Frederick Holland DAY
Untitled (Silhouetted Youth Standing on Boulder at Shore), 1905
Washington, Library of Congress

10 (cat. 63)
Frederick Holland DAY
Nude Youth with Lyre in Grotto, 1907
Washington, Library of Congress

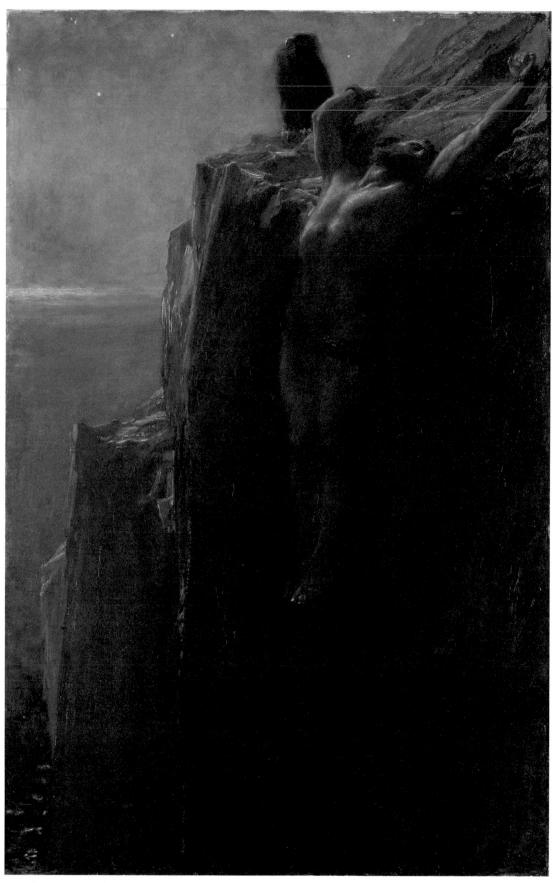

12 (cat. 353)
Briton RIVIÈRE
Prometheus, 1889
Oxford, Ashmolean Museum

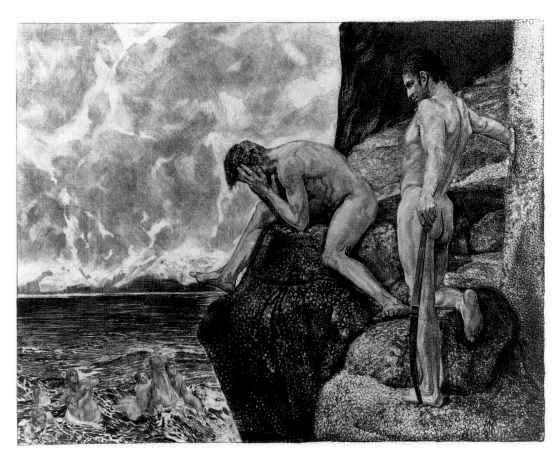

13 (cat. 209)
Max KLINGER
Prometheus Unbound, 1891-1894
Leipzig, Museum der bildenden Künste

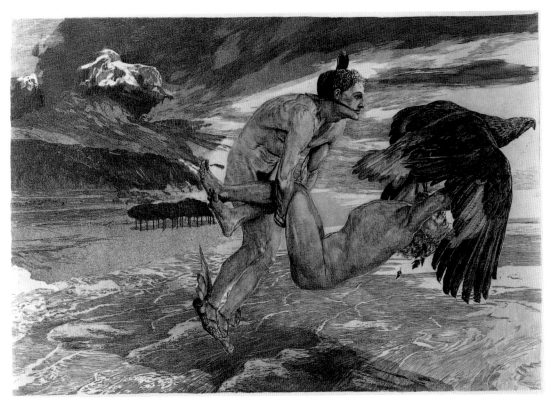

14 (cat. 211)
Max KLINGER
Prometheus Abducted, 1894
Leipzig, Museum der bildenden Künste

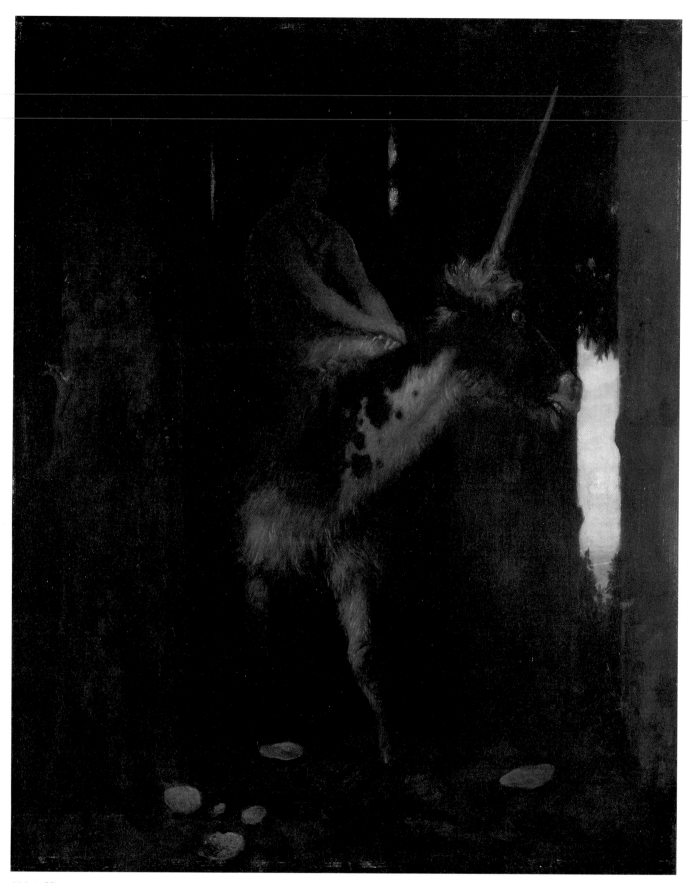

15 (cat. 23)
Arnold BÖCKLIN
The Silence of the Forest, 1885
National Museum of Poznań

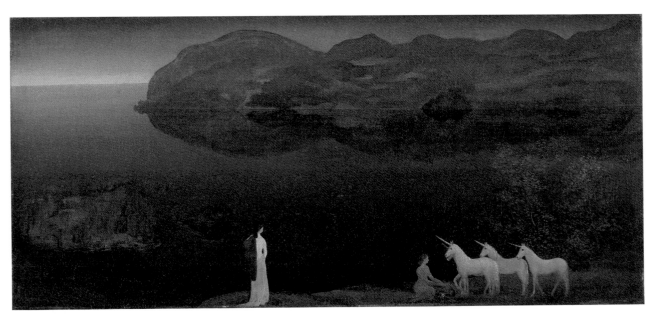

16 (cat. 56)
Arthur B. DAVIES
Unicorns, about 1906
New York, The Metropolitan Museum of Art

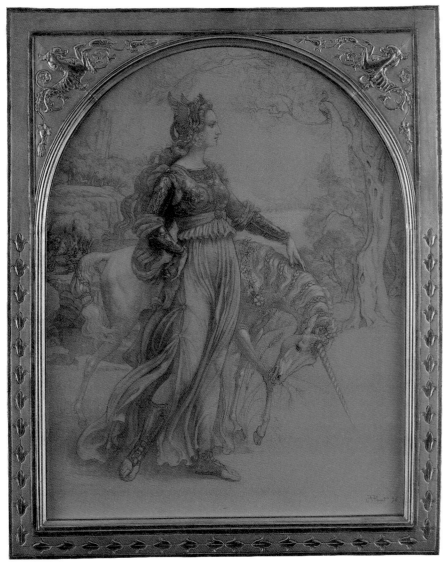

17 (cat. 322)
Armand POINT
The Lady and the Unicorn, 1896
Paris, Lucile Audouy collection

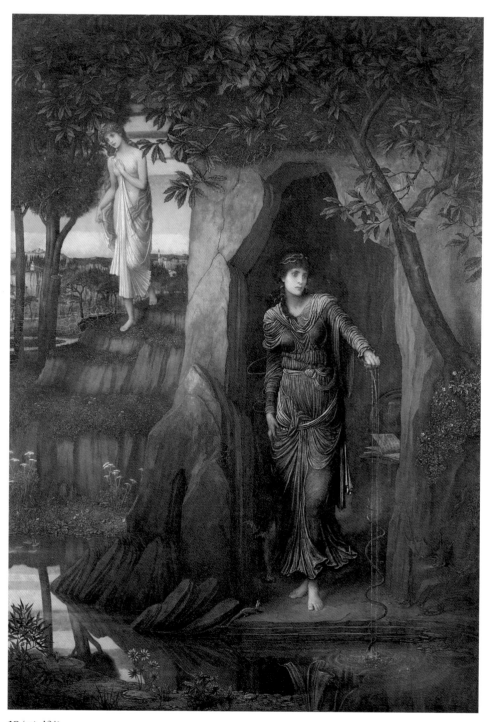

18 (cat. 421)
John M. STRUDWICK
Circe and Scylla, 1886
Liverpool, Sudley Art Gallery

19 (cat. 39)
Edward BURNE-JONES
The Story of Perseus, 1875-1876
London, Tate Gallery

20 (cat. 203)
Paul KLEE
Pessimistic Symbol of the Mountains, 1904
Kunstmuseum Bern, Paul-Klee Stiftung

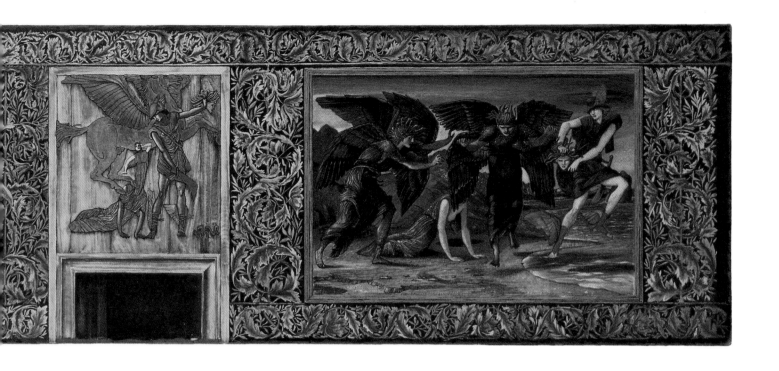

21 (cat. 203)
Paul KLEE
The Hero with a Wing, 1905
Kunstmuseum Bern, Paul-Klee Stiftung

22 (cat. 453)
Hans VON MAREES
Sketch for "The Rape of Ganymede", 1886
Dresden, Staadliche Kunstsammlungen

23 (cat. 38)
Edward BURNE-JONES
The Sirens
1870-1895/98
Oil on canvas
213.4 x 305.9 cm
Sarasota, The John and Mable Ringling Museum of Art

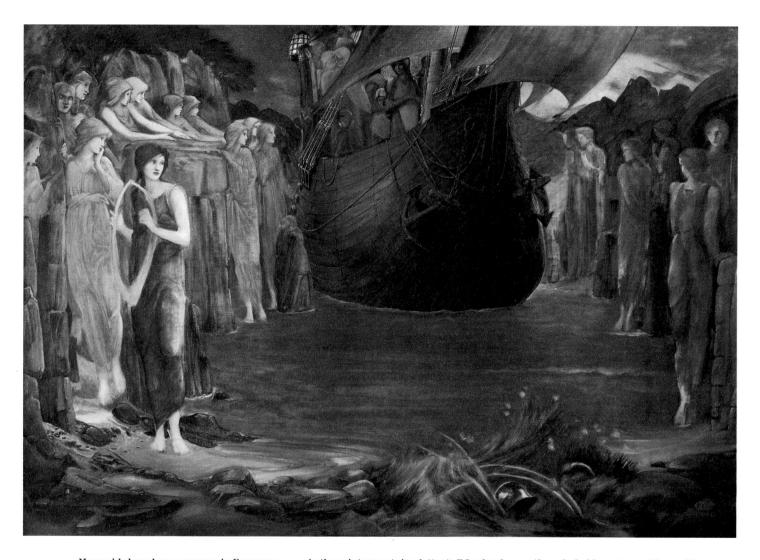

Mermaids have been common in European folk art from time immemorial; they are found in Norse saga and Greek mythology. Sea monsters, sometimes resembling harpies, they lured sailors with their melodious singing, only to eat them. This painting, begun in 1870, underwent a number of changes before its completion in about 1895-1898. Unlike Böcklin, Burne-Jones was faithful to the Greek tradition that depicts mermaids as having human, not monstrous, bodies. *The Sirens* is a painting from which all violence, all reference to the mermaids' evil powers, has been banished.

As the painter wrote in a letter to F. Leyland: "It's a sort of *Mermaids Land*, I don't know when or where; not Greek sirens but any sirens anywhere who lure men to their doom. There'll be a beach where they gather, looking out from the rocks, and between the crags a great sailing ship full of warriors; it will be dusk. The men and the women will look at each other, but I can't tell what is really happening." Literary antecedents to this picture can be found in works by Swinburne and William Morris. Book XIV of Morris's narrative poem *The Life and Death of Jason* (1867) deals in depth with

these hybrid creatures. Mermaids appear again in fin-de-siècle literature and painting as the embodiment of the destructively fatal woman. For Burne-Jones, they provided an excuse for equivocal atmosphere and unspecified revelations.

G.C.

Northern Myths

24 to 43

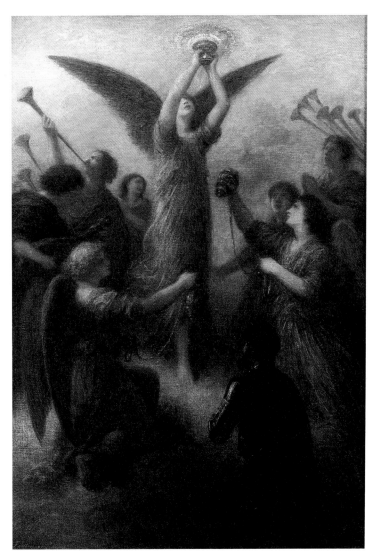

25 (cat. 110)
Henri Jean Théodore FANTIN-LATOUR
Prelude to "Lohengrin", 1882
Private collection

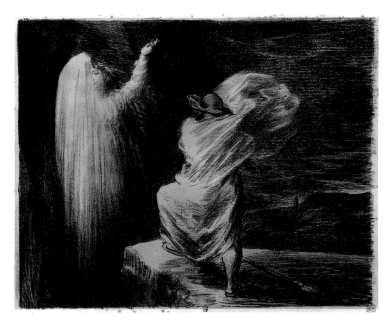

24 (cat. 109)
Henri Jean Théodore FANTIN-LATOUR
The Invocation of Erda, 1876
Paris, Bibliothèque nationale de France, Cabinet des Estampes

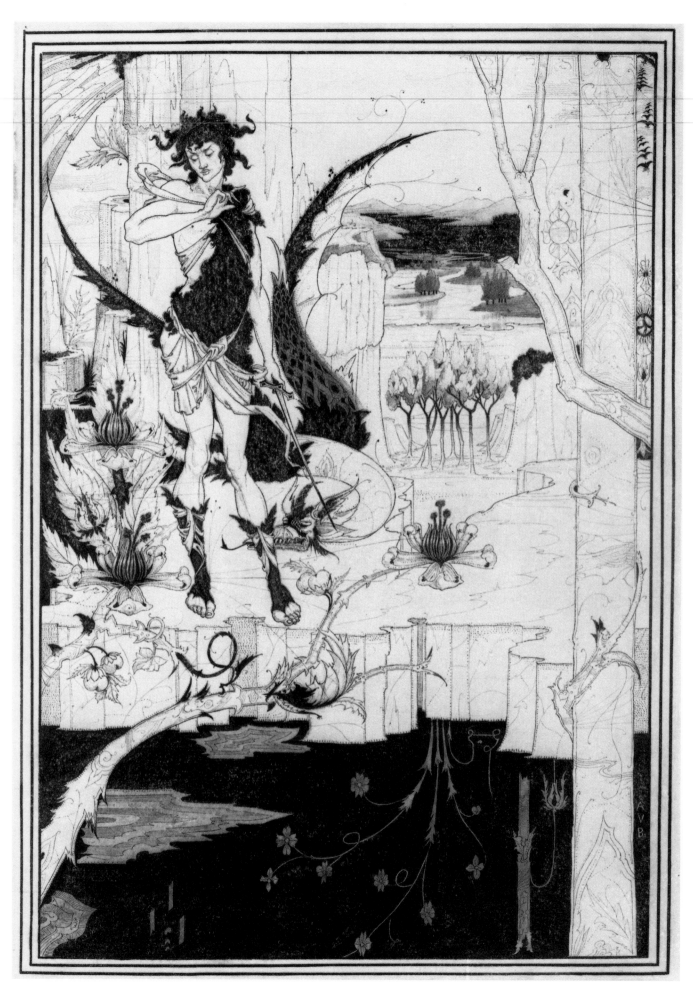

26 (cat. 12)
Aubrey BEARDSLEY
"Siegfried", Act II, 1893
London, The Victoria and Albert Museum

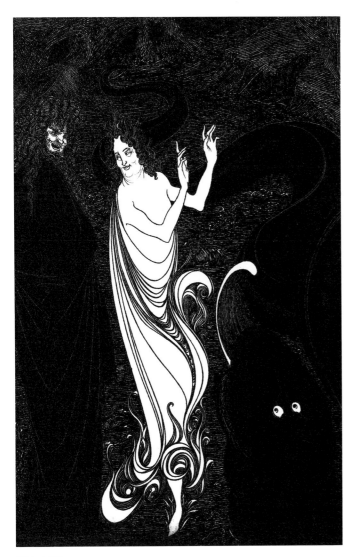

27 (cat. 14)
Aubrey BEARDSLEY
The Third Tableau of "Das Rheingold", 1896
Providence, Rhode Island School of Design

28 (cat. 13)
Aubrey BEARDSLEY
The Fourth Tableau of "Das Rheingold", 1896
London, The Victoria and Albert Museum

29 to **38** (cat. 216)
František **KOBLIHA**
The "Tristan" Cycle, 1909-1910
Prague, Národní galerie

29

30

31

32

33

34

35

36

37

38

39 (cat. 114)
Alexander FISHER
"Wagner" Girdle, 1896
London, The Victoria and Albert Museum

The Death of Tristan *The Rhine Maidens* *Tristan and Isolde and the Love Potion*

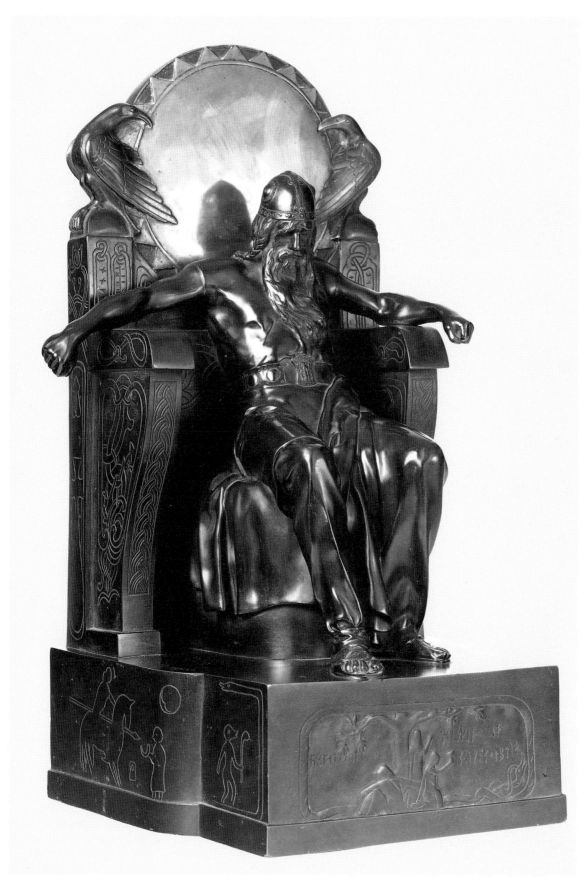

40 (cat. 255)
Rudolf MAISON
Wotan, 1890
Munich, Münchner Stadtmuseum

41 (cat. 126)
Akseli GALLEN-KALLELA
Lemminkäinen's Mother
1897
Tempera on canvas
85 x 118 cm
Helsinki, Ateneum, Antell collection

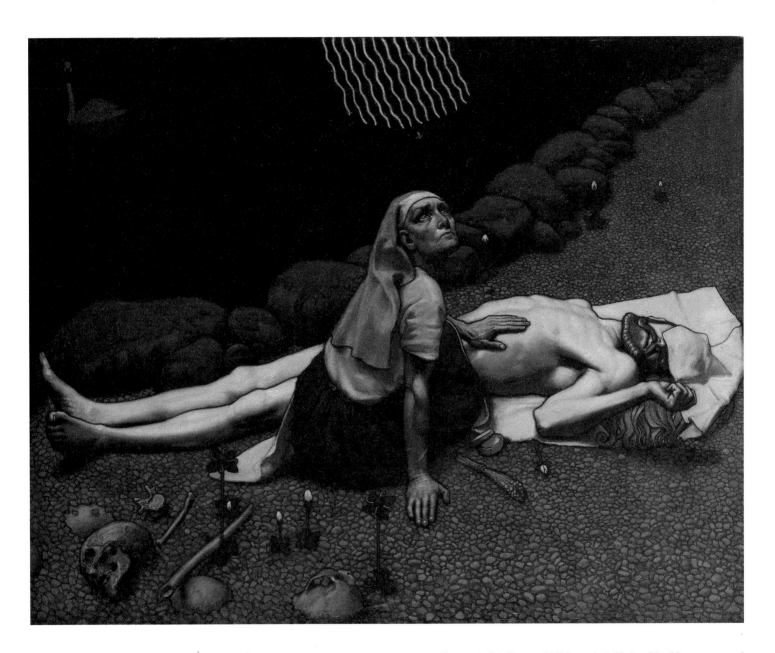

The great Finnish epic *Kalevala* (Land of Heroes), compiled and transcribed from oral tradition and published in 1835, inspired many literary (Aleksis Kivi) and musical (Jan Sibelius) works. Here, the painter offers a striking image of an episode from the narrative that recounts the prehistory of his people: the death and resurrection of the poet Lemminkäinen. Lemminkäinen languishes on the blood-stained banks of the River Tuonela, where he had sought to discover the secret of life after death by attempting to slay the swan guarding the Kingdom of the Dead. As Gallen-Kallela makes clear in his notes on the hero, in spite of the picture's apparent realism each detail embodies a facet of its mystical Symbolism: "He is there, lying on the ground, on the banks of the black river on which the disdainful-necked swan still floats. The shimmering sunbeams express the hope of his mother, who sends a bee to collect the balm at the rays' source. Bitter, poisonous weeds with black berries and livid blossoms emerge from the earth around the corpse."[1] The artist's mother served as model for the figure of Lemminkäinen's mother, and it is altogether probable that Gallen-Kallela identified with the hero.[2] And then, the work possesses an underlying political dimension.

At this period, Finland had been annexed by Russia and was under its domination. Gallen-Kallela was an ardent defender of his country's national identity, and the "Kalevala" cycle was part of a current in Finnish Symbolism that revived traditional narratives in an attempt to undermine foreign power. The work is remarkable for its spare style and its attempt to achieve something of the authenticity of primitivism.

C. N.-R.

1. Quoted by Salme Sarajas-Korte in *Lumière du Nord*, exhib. cat. (Paris: Petit Palais, 1987), p. 124.
2. Kirk Varnedoe, *Northern Light* (New Haven and London: Yale University Press, 1988), p. 90.

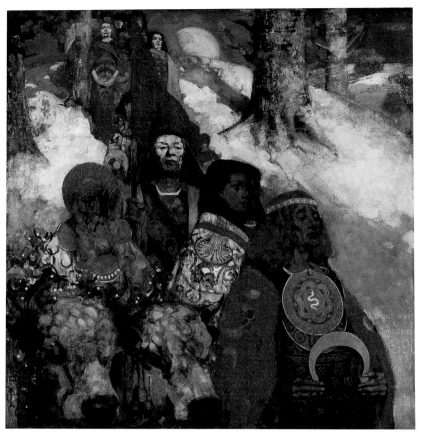

42 (cat. 153)
George HENRY and Edward Atkinson HORNEL
The Druids: Bringing in the Mistletoe, 1890
Glasgow Art Gallery and Museum

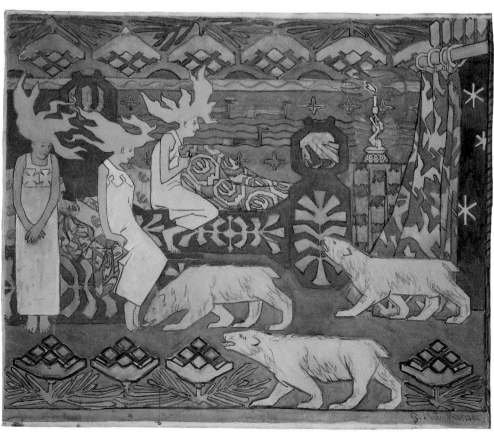

43 (cat. 308)
Gerhard MUNTHE
The Suitors, 1892
Oslo, Nasjonalgalleriet

Medieval Legends

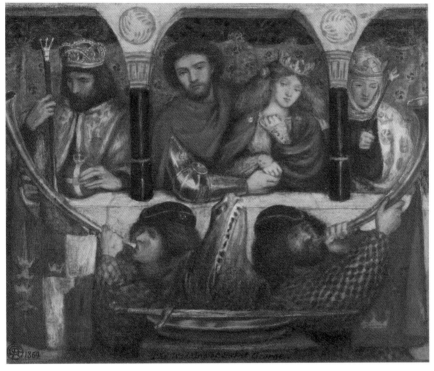

44 (cat. 364)
Dante Gabriel ROSSETTI
The Wedding of Saint George, 1864
New York, Stuart Pivar collection

45 (cat. 481)
Philippe WOLFERS
"Monnaie du pape" Cup, 1899
Ghent, Museum voor Sierkunst

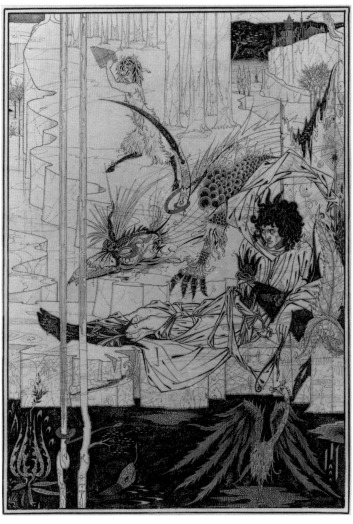

46 (cat. 11)
Aubrey BEARDSLEY
How King Arthur Saw the Questing Beast, 1893
London, The Victoria and Albert Museum

47 (cat. 351)
William REYNOLDS-STEPHENS
Guinevere's Redeeming, 1905
Warrington, Museum and Art Gallery

48 (cat. 324)
Jan PREISLER
The Adventurous Knight, 1898
Plzeň, West Bohemian Museum of Fine Arts

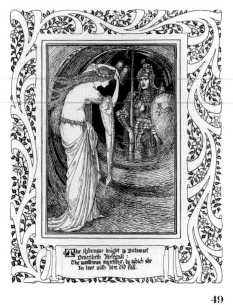

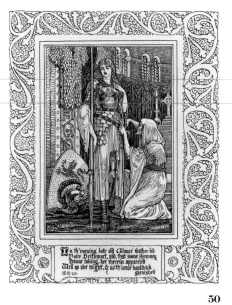

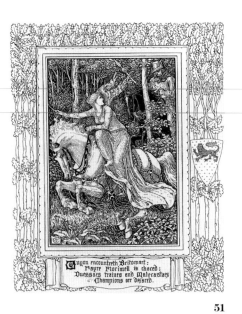

49

50

51

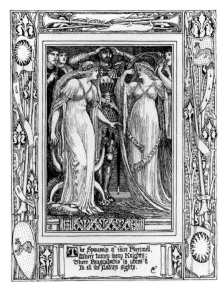

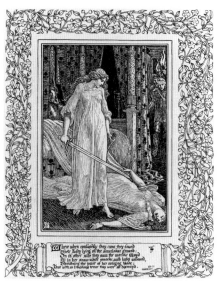

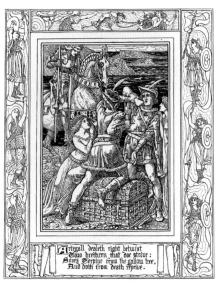

52

53

54

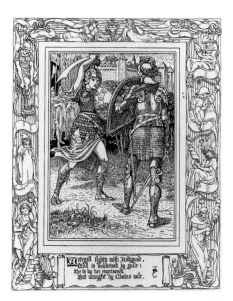

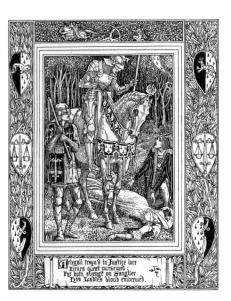

49 to 57 (cat. 52)

55

56

57

Walter CRANE
Nine Illustrations for Spenser's "Faerie Queene", before 1895-1896
Ottawa, National Gallery of Canada

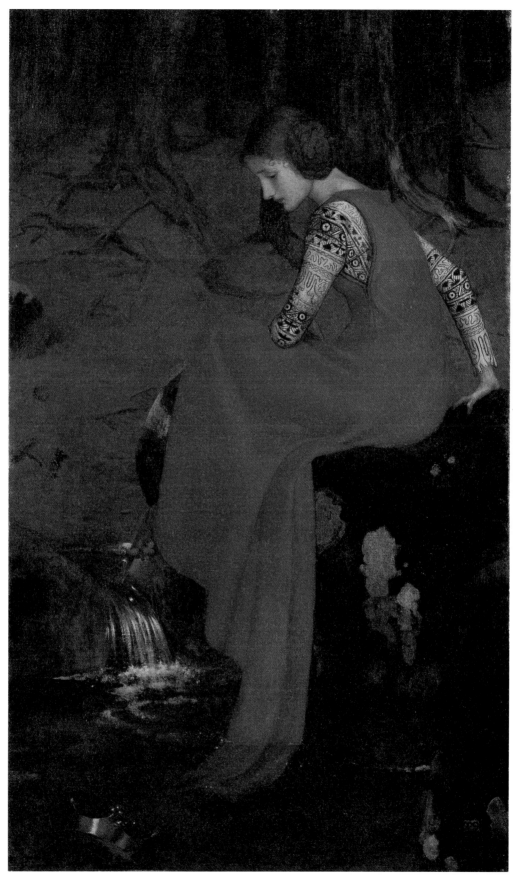

58 (cat. 419)
Marianne STOKES
Mélisande
Cologne, Wallraf-Richartz Museum

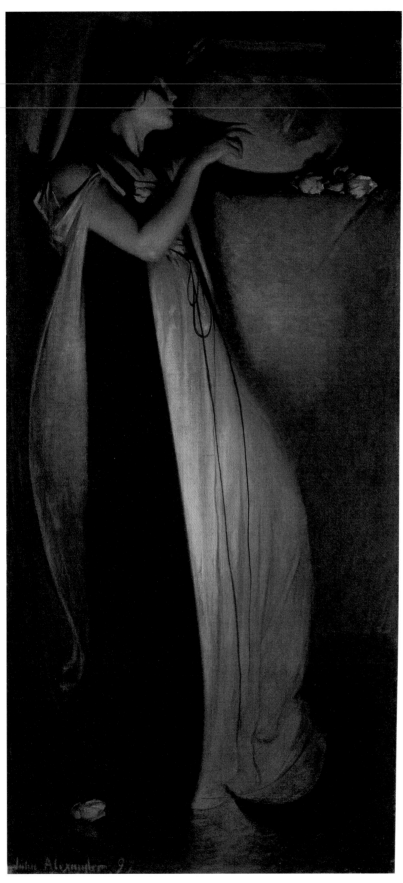

59 (cat. 1)
John White ALEXANDER
Isabella and the Pot of Basil, 1897
Museum of Fine Arts, Boston

Time, Death, Progress

60 to 73

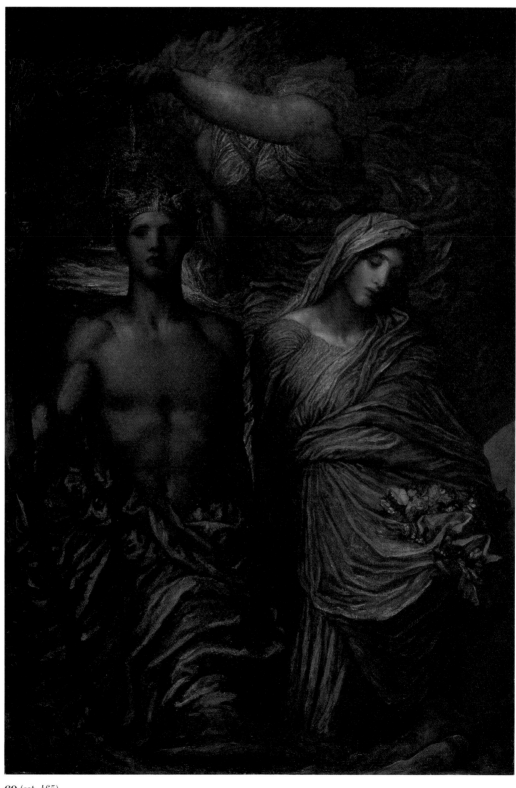

60 (cat. 465)
George Frederick WATTS
Time, Death and Judgement, about 1865-1886
Ottawa, National Gallery of Canada

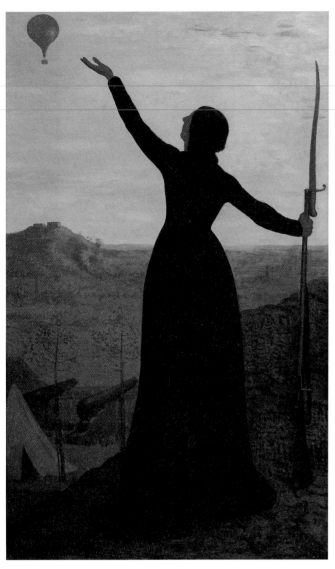

61 (cat. 333)
Pierre PUVIS DE CHAVANNES
The Balloon, 1870
Paris, Musée d'Orsay

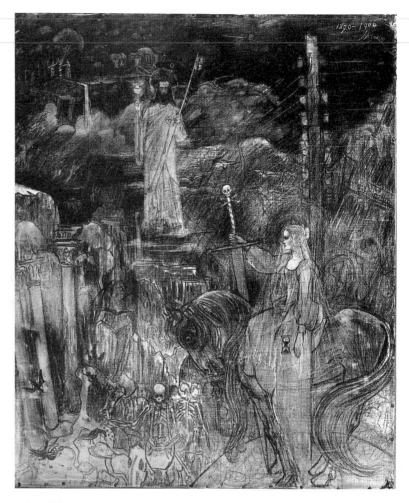

62 (cat. 431)
Jan TOOROP
Time and Eternity
Neuss, Germany, Clemens-Sels-Museum

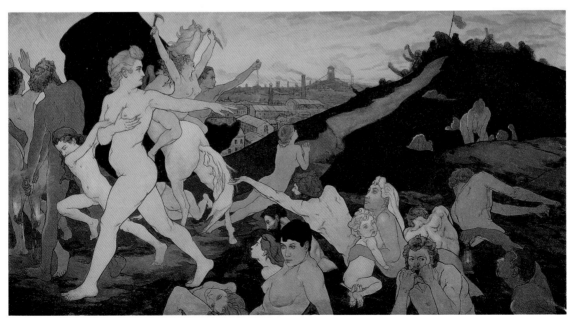

63 (cat. 270)
Charles MAURIN
The Dawn of Work, 1891
Saint-Étienne, Musée d'Art moderne

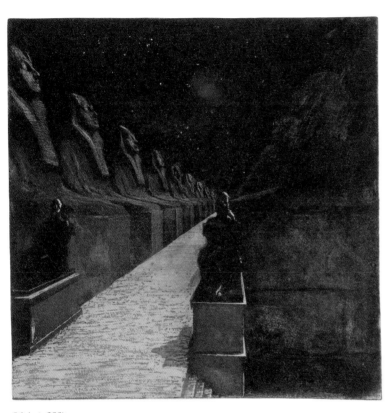

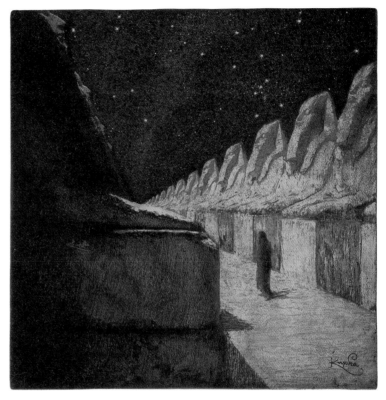

64 (cat. 233)
František **KUPKA**
The Way of Silence I, 1900
Prague, Národní galerie

65 (cat. 234)
František **KUPKA**
The Way of Silence II, 1903
Prague, Národní galerie

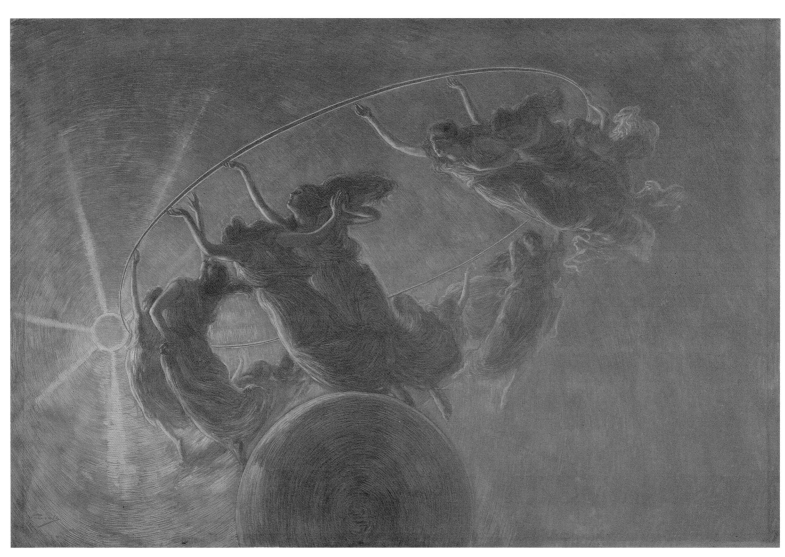

66 (cat. 328)
Gaetano PREVIATI
The Dance of the Hours, about 1899
Cariplo S.P.A.

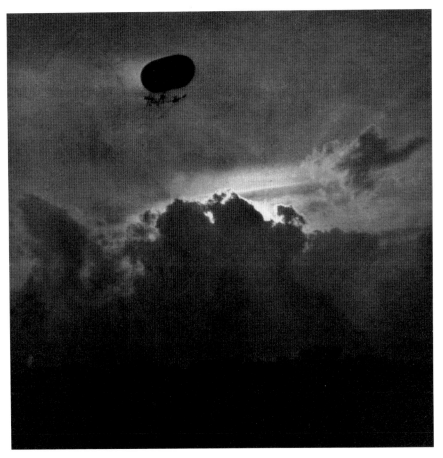

67 (cat. 417)
Alfred STIEGLITZ
A Dirigible, 1910
Ottawa, National Gallery of Canada

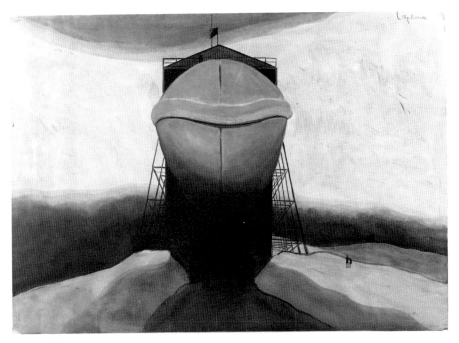

68 (cat. 401)
Léon SPILLIAERT
Dirigible in Its Hangar, 1910
Brussels, Musées royaux des Beaux-Arts de Belgique

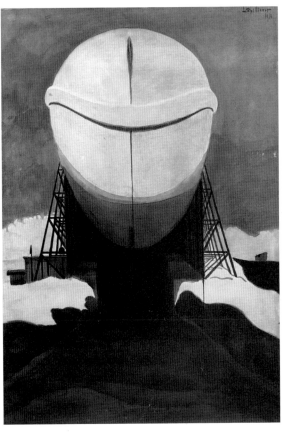

69 (cat. 402)
Léon SPILLIAERT
Dirigible in Its Hangar, 1910
Brussels, Musées royaux des Beaux-Arts de Belgique

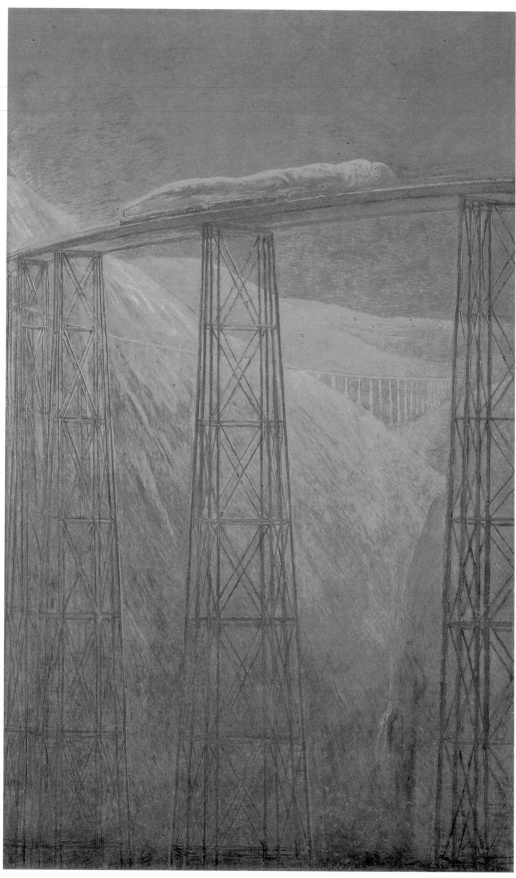

70 (cat. 326)
Gaetano PREVIATI
Railroad on the Pacific, 1916
Milan, Camera di commercio di Milano

71 (cat. 33)
Vladimir Jindrich BUFKA
Evening Train, 1911
Brno, Czech Republic, Moravaská galerie

72 (cat. 88)
Pierre DUBREUIL
Ferris Wheel, 1900-1905
Paris, Musée d'Orsay

73 (cat. 142)
Melvin Ormond ("Ivanhoe") HAMMOND
The Hand of Man, 1909
Toronto, Art Gallery of Ontario

The Mystic Mirror

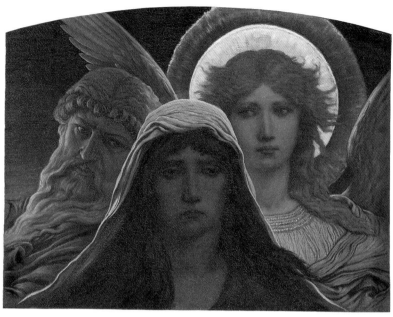

74 (cat. 445)
Elihu VEDDER
The Sorrowing Soul between Doubt and Faith, about 1887
Ithaca, New York, Cornell University, Herbert F. Johnson Museum of Art

75 (cat. 478)
Henry WILSON
Brooch-Pendant, about 1900-1905
London, The Victoria and Albert Museum

76 (cat. 385)
Giovanni SEGANTINI
Ave Maria in Transshipment, 1886
Private collection

77 (cat. 348)
Odilon REDON
Mystical Flowers, undated
Iowa City, University of Iowa Museum of Art

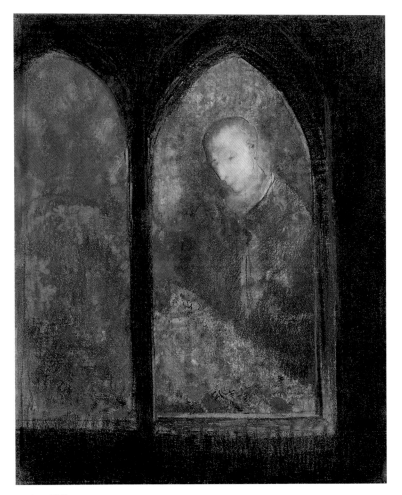

78 (cat. 343)
Odilon REDON
Gothic Window, 1900
Indianapolis Museum of Art

79 (cat. 41)
Julia Margaret CAMERON
The Shadow of the Cross, 1865
London, The Victoria and Albert Museum

80 (cat. 75)
Henry DE GROUX
The Mocking of Christ (Study), 1889
Avignon, Fondation Flandreysy-Espérandieu

81 (cat. 129)
Paul GAUGUIN
Young Christian Girl, 1894
Williamstown, Massachusetts, Sterling and Francine Clark Art Institute

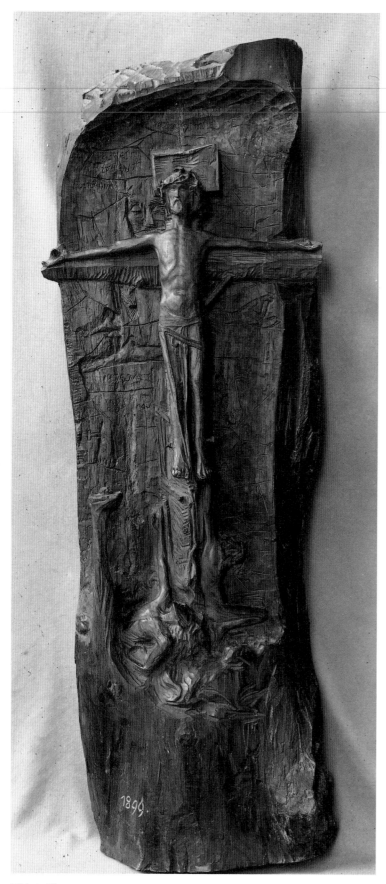

82 (cat. 19)
František **BILEK**
Crucified, 1899
Prague, Národní galerie

83 (cat. 459)
Franz VON STUCK
Golgotha, about 1917
The Brooklyn Museum

84 (cat. 426)
Johan THORN PRIKKER
Laid in the Tomb, about 1892
Otterlo, The Netherlands, Kröller-Müller Museum

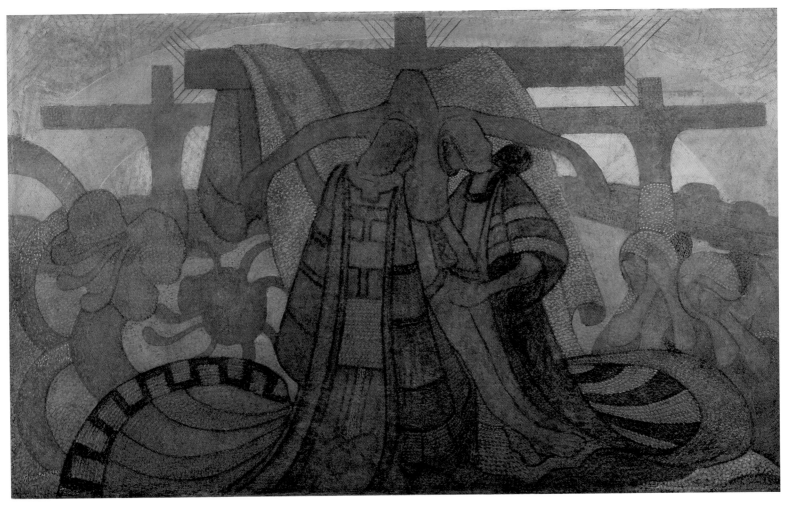

85 (cat. 425)
Johan THORN PRIKKER
Descent from the Cross, 1892
Otterlo, The Netherlands, Kröller-Müller Museum

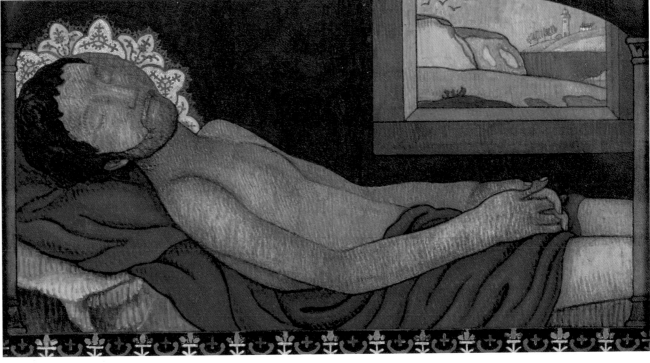

86 (cat. 111)
Charles FILIGER
Christ in the Tomb, about 1895
Saint-Germain-en-Laye, Musée départemental Maurice Denis « Le Prieuré »

87 (cat. 71)
Frederick Holland DAY
The Seven Last Words of Christ
1898
Platinum prints
13 x 10 cm (each)
Norwood, Massachusetts, Norwood Historical Society

In the summer of 1898 near Norwood, Massachusetts, F. Holland Day took approximately two hundred and fifty photographs of individually arranged scenes from the Bible. One of the highlights of this series is this seven-part tableau, *The Seven Last Words*, in which each of the (self-) portraits is attributed one of the sentences from the New Testament spoken by Christ on the cross: I. *Father, forgive them, they know not what they do*; II. *To-day thou shalt be with Me in Paradise*; III. *Woman, behold the son; son, the mother*; IV. *My God! My God! Why hast Thou forsaken me?*; V. *I thirst*; VI. *Into Thy hands I commend my spirit*; VII. *It is finished*. In an original framed version of this series, which has not been located, these words are contained within the classicist entablature, and the photographs, separated from one another by pilasters, resemble a frieze on an ancient sarcophagus. According to information

provided by Frederick H. Evans, while taking the photographs, Day arranged a mirror in such a way that he could constantly monitor the expression on his face. Formally, this representation of Christ is related to the iconographic tradition of Baroque images of the Passion. E. Clattenburg (1975) has already pointed to the stylistic influences of the Italian Baroque painter Guido Reni, in particular his *Crucifixion* in San Lorenzo in Lucina and his *Ecce Homo*.

Around 1900, the tableau was rejected by some as a cheap imitation of the German tradition of death images (Joseph Keiley), while others, like Steichen, judged it to be a successful photographic transposition of a religious theme.

U. P.

Baltimore, University of Maryland

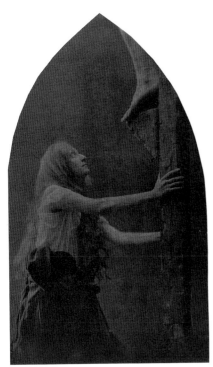

88 (cat. 58)
Frederick Holland DAY
Christ's Entombment, 1898
Bath, The Royal Photographic Society

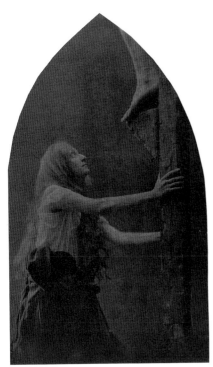
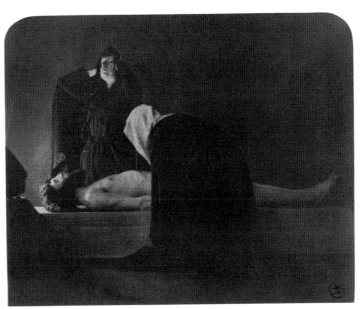
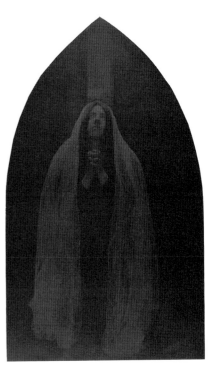

89 (cat. 89)
Pierre DUBREUIL
The Entombment of Christ, 1900
Museum für Kunst und Gewerbe Hamburg

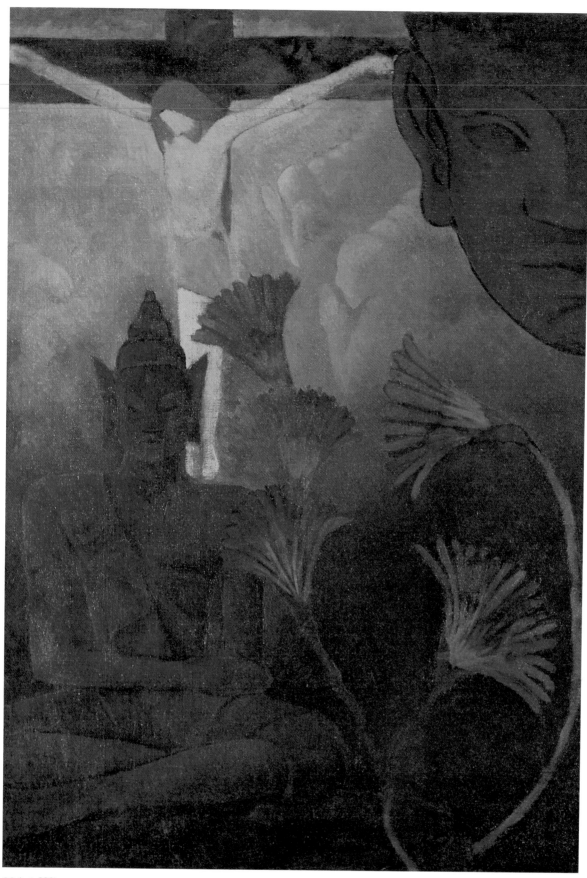

90 (cat. 336)
Paul RANSON
Christ and Buddha, about 1890-1892
Private collection

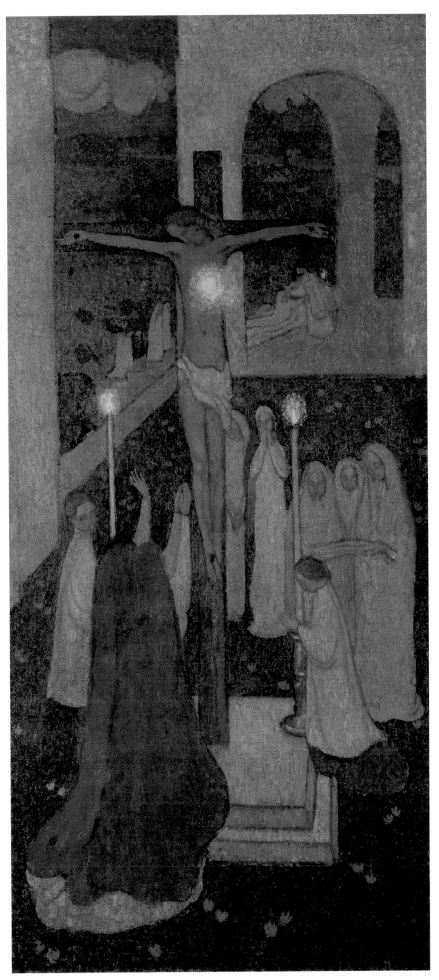

91 (cat. 83)
Maurice DENIS
The Sacred Heart Crucified, 1894
Private collection

92 (cat. 81)
Maurice DENIS
A Tree-lined Road, about 1891
Saint-Germain-en-Laye, Musée départemental Maurice Denis « Le Prieuré »

93 (cat. 84)
Maurice DENIS
Easter Morning, 1893
Private collection

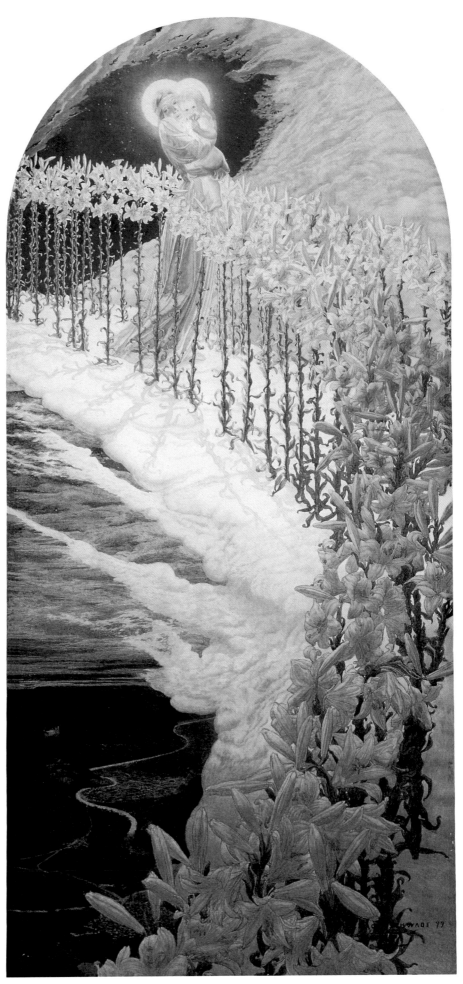

94 (cat. 375)
Carlos SCHWABE
The Virgin of the Lilies, 1898
Amsterdam, Van Gogh Museum

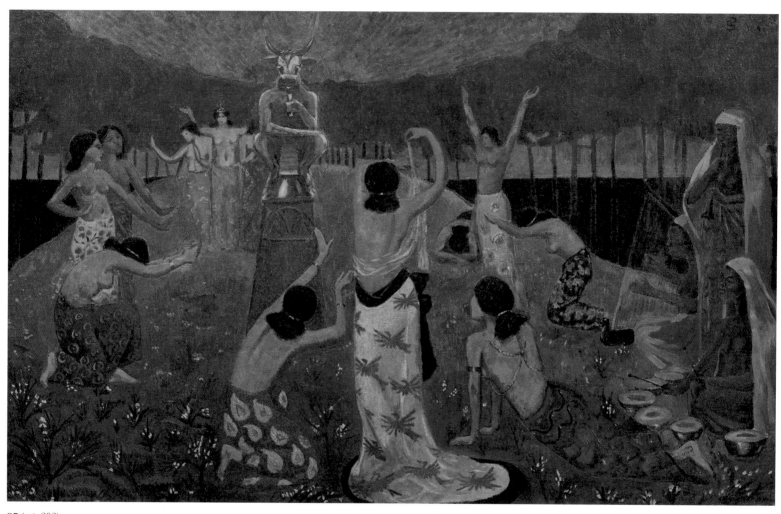

95 (cat. 393)
Paul SÉRUSIER
The Daughters of Pelichtim, 1908
Paris, Musée d'Orsay

96 (cat. 337)
Paul RANSON
Nabi Landscape
1890
Oil on canvas
89 x 115 cm
Josefowitz collection

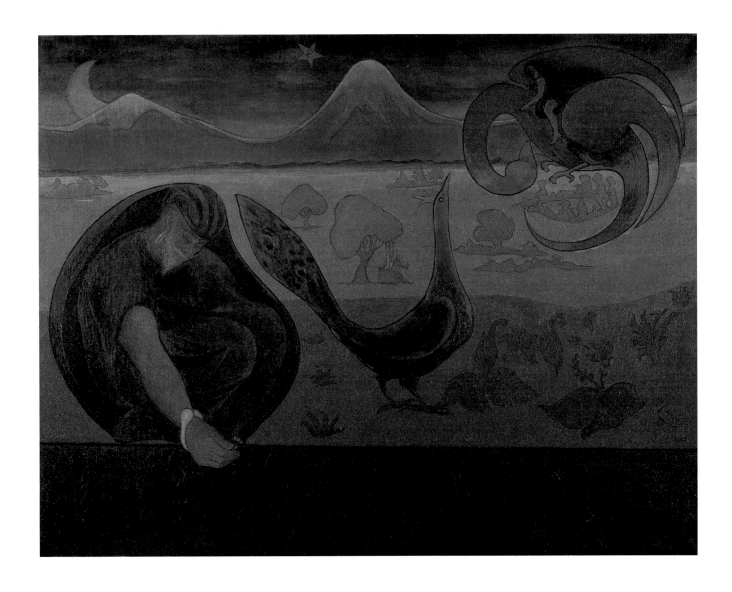

Besides Sérusier, Paul Ranson was probably of all the Nabis the most interested in philosophical speculation and esoteric meditation. We know he was an assiduous reader of Édouard Schuré's *Grands Initiés* and of Papus's *Traité élémentaire de science occulte*, and this is apparent in many details of the painting: the bearded man curled up like an egg who seems to symbolize the mythical birth of heroes in the *Grands*

Initiés (such as Rama), as well as the figure behind, astride a mysterious bird with vivid plumage. Quite apart from the numerous cabalistic signs to be found here (an investigation of which would certainly confirm Ranson's penchant for religious Syncretism), the organization of the composition, dominated by a series of arabesques, allows for a reading quite independent of any decoding of its literary

sources. The restricted palette and the separation of space into uniform strata of colour constitute a radical affirmation of the essentially subjective nature of this work.

G.C.

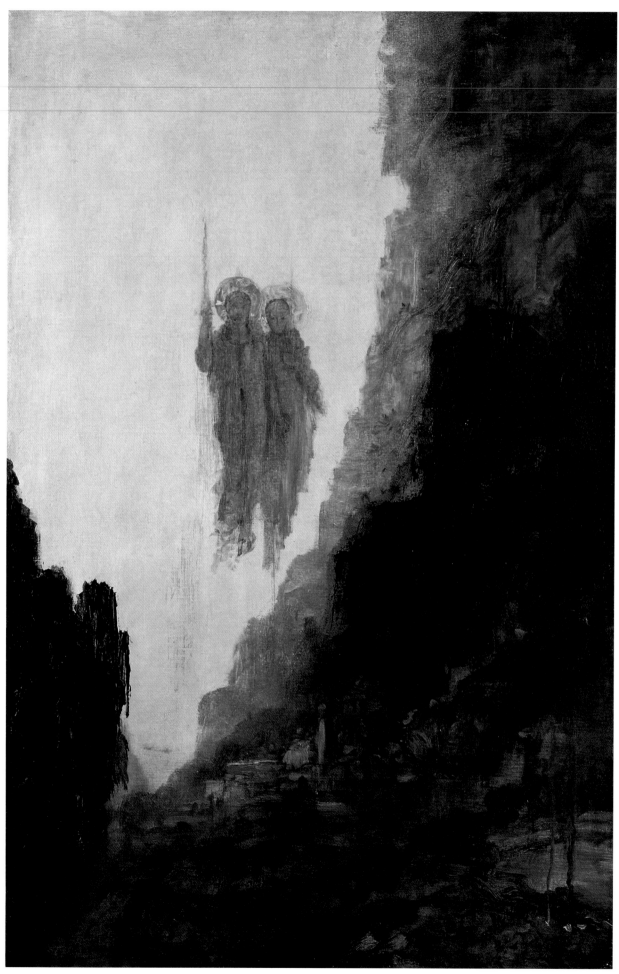

97 (cat. 285)
Gustave MOREAU
The Angels of Sodom, about 1885
Paris, Musée Gustave Moreau

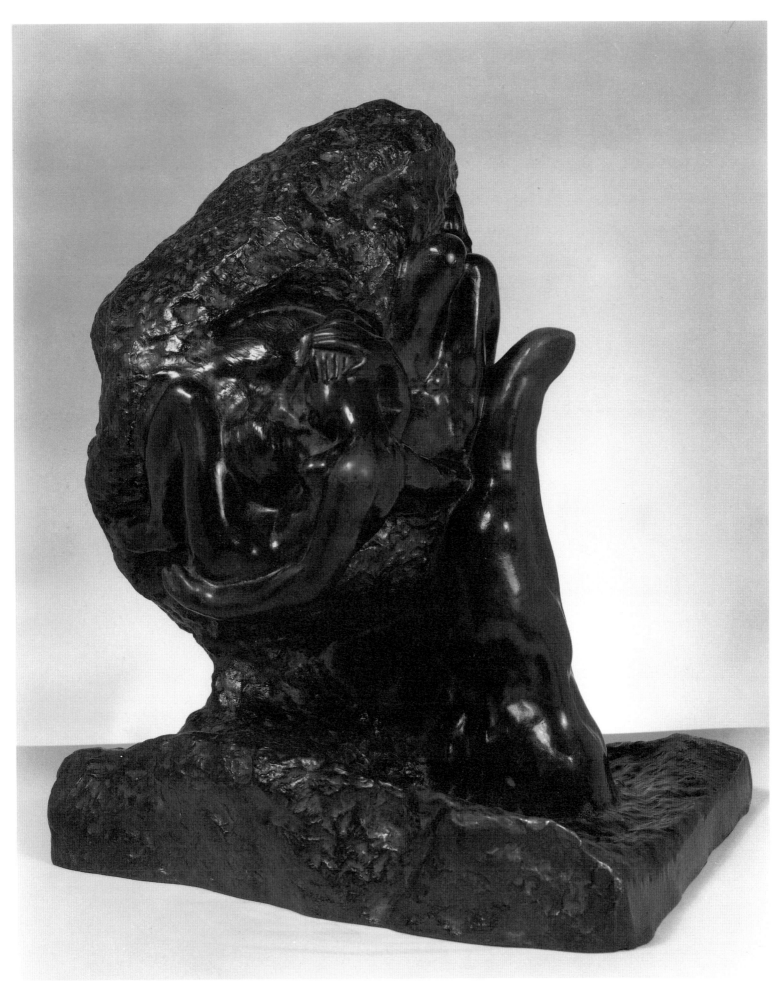

98 (cat. 356)
Auguste RODIN
The Hand of God, 1898
Philadelphia, The Rodin Museum

Satanism

99 to **140**

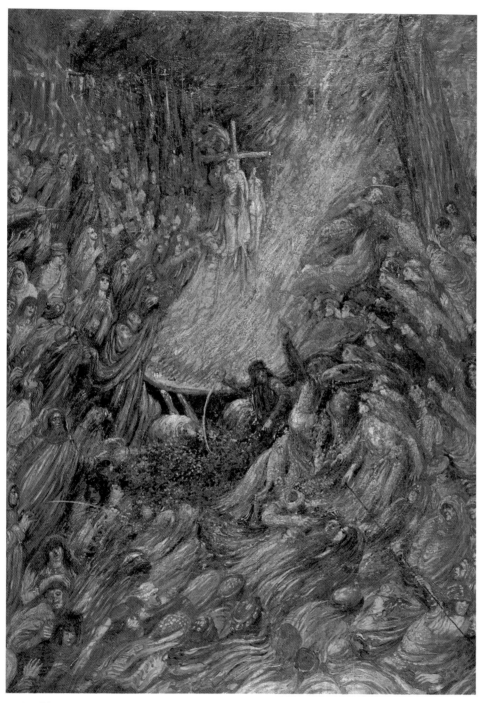

99 (cat. 74)
Henry DE GROUX
The Auto-da-fé
Toronto, Joey and Toby Tanenbaum collection

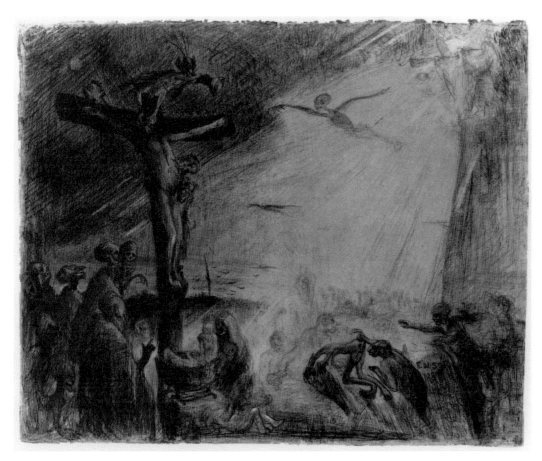

100 (cat. 98)
James ENSOR
Satan and His Fantastic Legions Tormenting the Crucified Christ, 1886
Brussels, Musées royaux des Beaux-Arts de Belgique

101 (cat. 97)
James ENSOR
Demons Teasing Me, 1889
The Hearn Family Trust

102 (cat. 437)
Josef VÁCHAL
Invokers of the Devil
1909
Oil on canvas
95 x 94 cm
Hrádec Králové, Czech Republic,
Galerie moderního umění

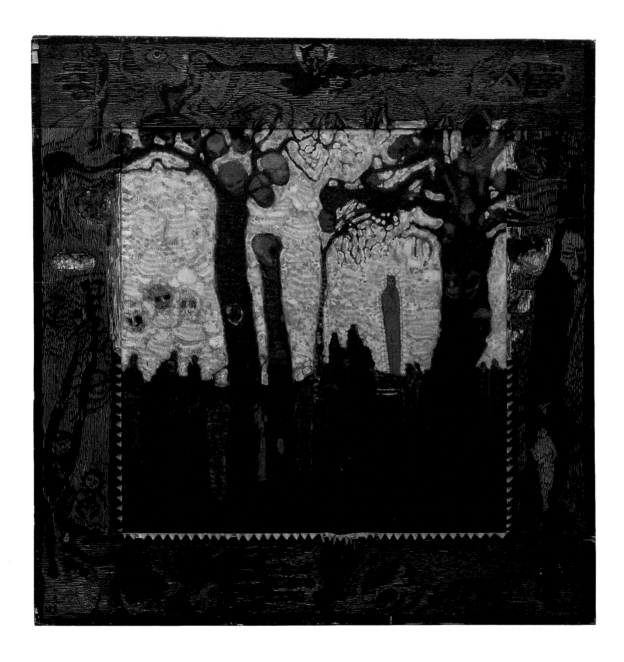

This early work by Váchal typifies both the vitality of late Czech Symbolism and the individualistic approach of the artist. Váchal had joined the Prague Theosophical Society in 1903 and was an attentive reader of *The Secret Doctrine* by Madame Blavatsky, who founded the movement. His interest in occultism and unorthodox cults is at the root of this strange painting, whose hallucinatory images flow over onto the frame, carved by Váchal himself. The chromatic organization allows us to identify the roles played by the various elements of this extraordinary scene. The leader of a secret sect, in the centre of a small group of blue-robed followers, conducts a ritual invocation of Satan. The latter, dressed in red and surrounded by an aura, emerges from a landscape filled with trees bare except for a series of green human heads, representing the presence at this secret ceremony of souls from the Beyond. Other more ephemeral faces float in the incandescent yellow sky. The painting, which may have its source in the spiritualist seances that Váchal attended regularly or in the hallucinations he suffered when younger, is one of his most important works. It expresses the spiritualist notion of interdependence between the material and spiritual realms, and the idea that they can communicate through magic. Váchal, like Kobliha, was a member of the Sursum group, which organized the final events of Czech Symbolism: an exhibition in Brno in 1910 and another in Prague in 1912.

C. N.-R.

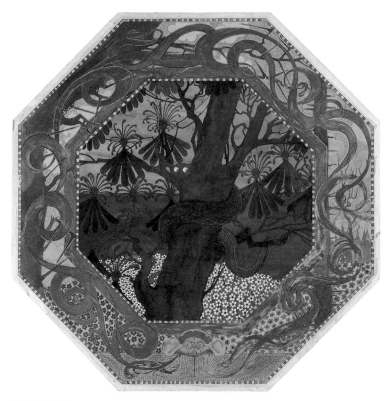

103 (cat. 420)
Carl STRATHMANN
Design for a Plate, about 1897
Munich, Münchner Stadtmuseum

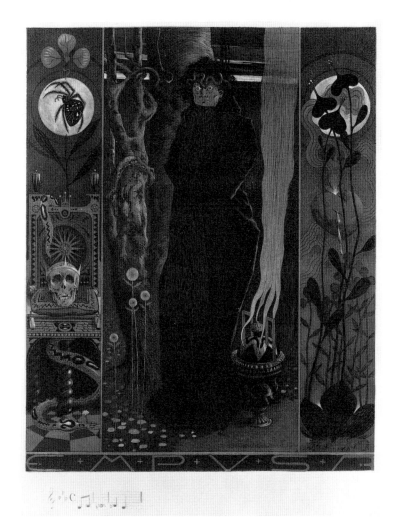

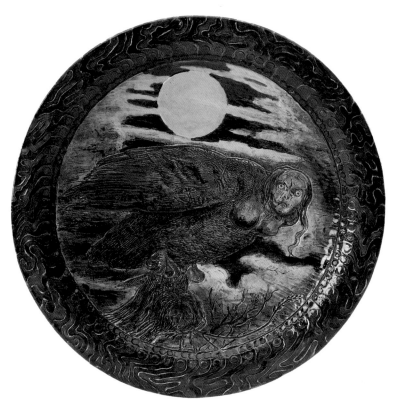

105 (cat. 371)
C. H. SCHMIDT-HELMBRECHTS
Empusa, 1896
London, The Victoria and Albert Museum

104 (cat. 424)
Hans THOMA
Plate with a Harpy, about 1901
Badisches Landesmuseum Karlsruhe

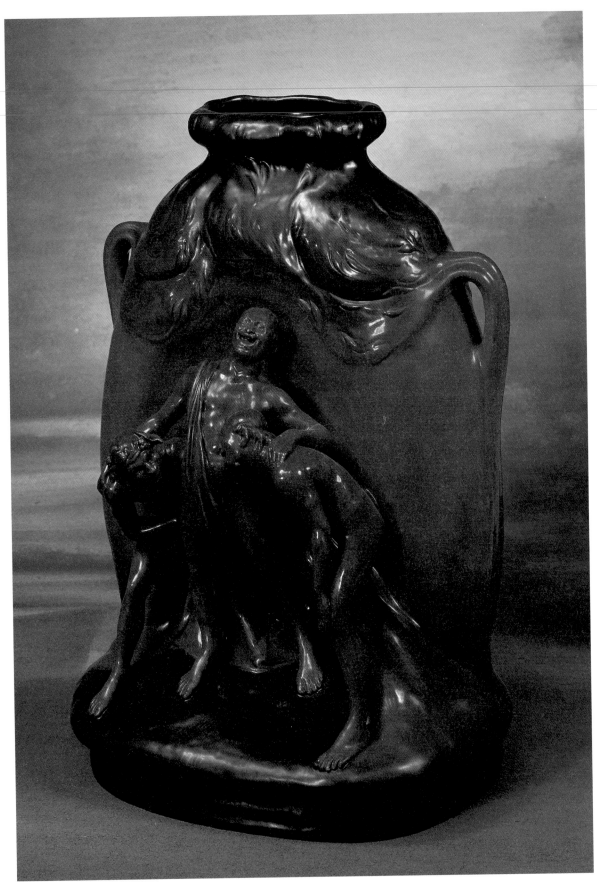

106 (cat. 484)
Vilmos ZSOLNAY
Dante's Inferno
Ghent, Museum voor Sierkunst

107 (cat. 132)
Paul GAUGUIN
Parau na te varua ino
(Words of the Devil)
1892
Oil on canvas
91.7 x 68.5 cm
Washington,
National Gallery of Art

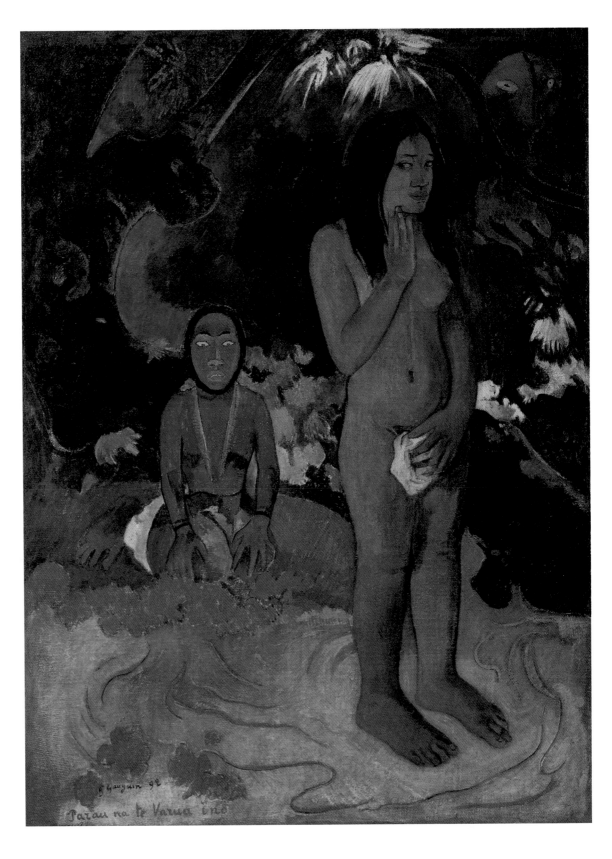

If one were to go solely by the title of this work and Gauguin's well-known enthusiasm for Tahitian mythology, the painting might easily be an illustration to a mysterious folk tale full of demonic apparitions and baleful revelations, a forerunner of the *Primitive Tales* of 1902. The haunting presence of the almost deformed male figure, a faint echo of the *Portrait of Meyer de Haan* (1889), and the nakedness of the woman whose posture is not unlike that of the guilty Eve in Masaccio's frescoes, imbue the canvas with a greater complexity of meaning. In it, a bare two years after painting *The Loss of Virginity* (1890-1891), Gauguin seems to be returning, in a more oblique way, to the question of woman's development and the transition between adolescence and adulthood; the immaculate white cloth held by the girl and the distant look in her eyes, as if she were hypnotized by some irresistible force, suggest a surge of still-unrecognized desires, of a carnal love as yet unconsummated. The metaphorical equivalent of the irrepressible power of these desires is seen in the strange undulating lines of bright red in the lower part of the composition, echoing the red flower held by the girl in *The Loss of Virginity*. The artist does not indicate what social or moral transgression has occurred here, but the stance of the girl as a guilty Eve suggests that the painting's subject might well be Original Sin.

G.C.

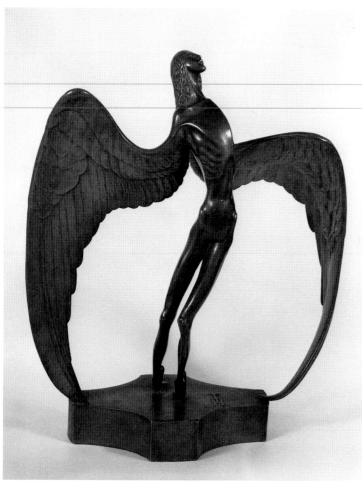

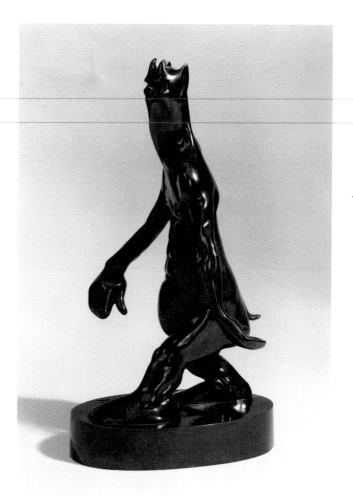

108 (cat. 150)
Thomas HEINE
Angel, about 1905
Frankfurt, Museum für Kunsthandwerk

109 (cat. 151)
Thomas HEINE
Devil, about 1902
Private collection

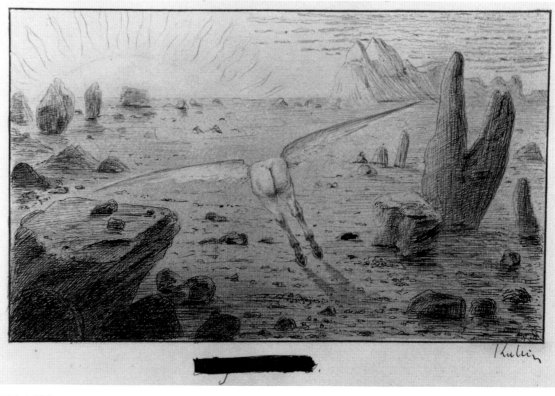

110 (cat. 221)
Alfred KUBIN
The Moment, 1900
Linz, Landesgalerie am Oberösterreichischen

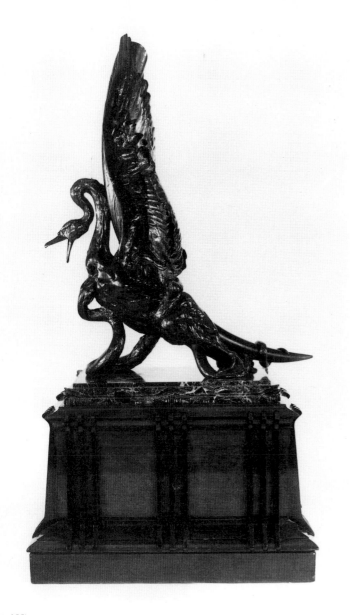

111 (cat. 483)
Philippe WOLFERS
The Swan Song, 1898
Richmond, Virginia Museum of Fine Arts

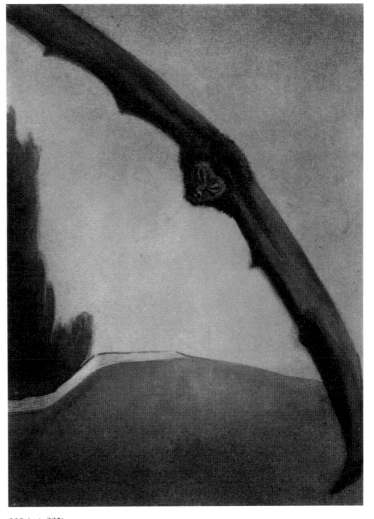

112 (cat. 225)
Alfred KUBIN
Cemetery Wall, 1902
Linz, Landesgalerie am Oberösterreichischen

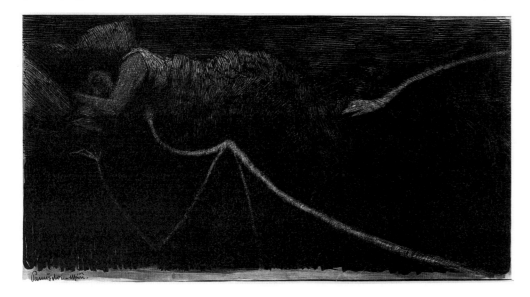

113 (cat. 315)
Jaroslav PANUSKA
Vampires, 1899
Hradec Králové, Czech Republic, Galerie moderního umění

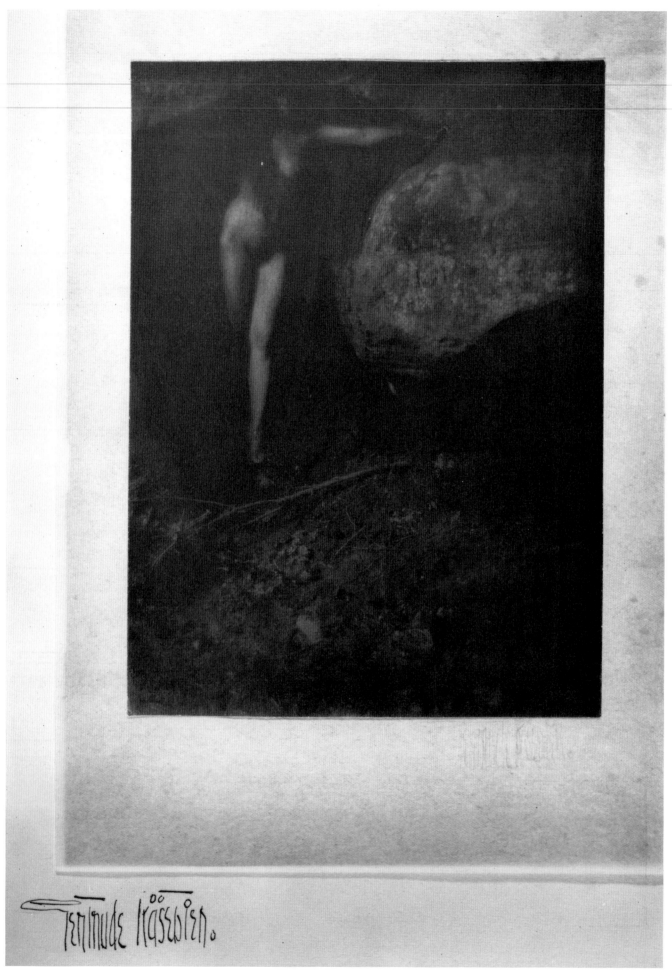

114 (cat. 182)
Gertrude KÄSEBIER
The Bat, 1902
Paris, Musée Rodin

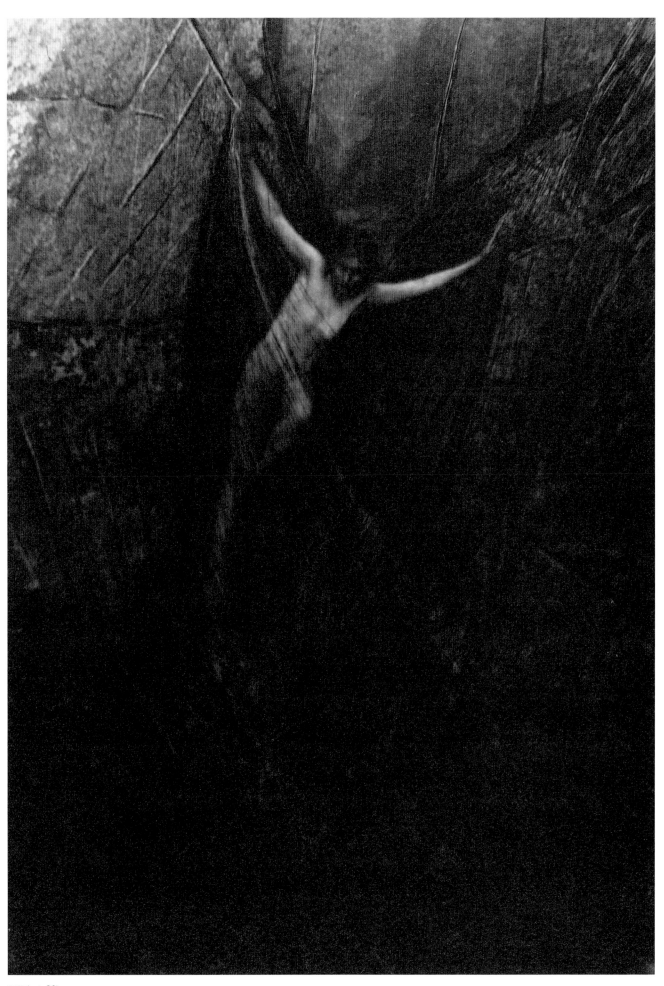

115 (cat. 30)
Anne W. BRIGMAN
The Spider's Web, 1908
New York, The Metropolitan Museum of Art

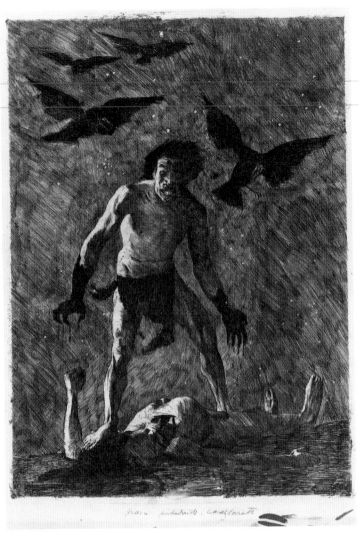

116 (cat. 51)
Lovis CORINTH
Cain, 1911
The Montreal Museum of Fine Arts

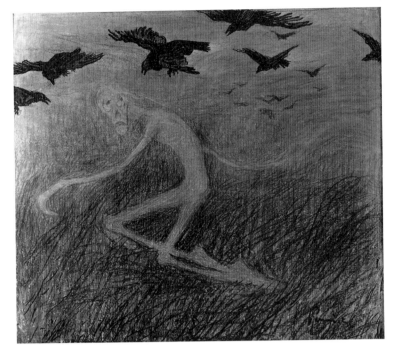

117 (cat. 314)
Jaroslav PANUSKA
Dead Man Hunted by Ravens, 1898
Pardubice, Czech Republic, Východočyeská galerie

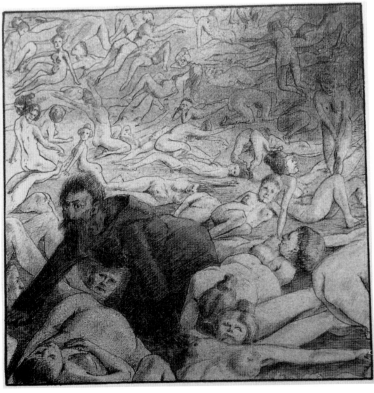

118 (cat. 224)
Alfred KUBIN
The Temptation of Saint Anthony, 1899
Vienna, Galerie Würthle

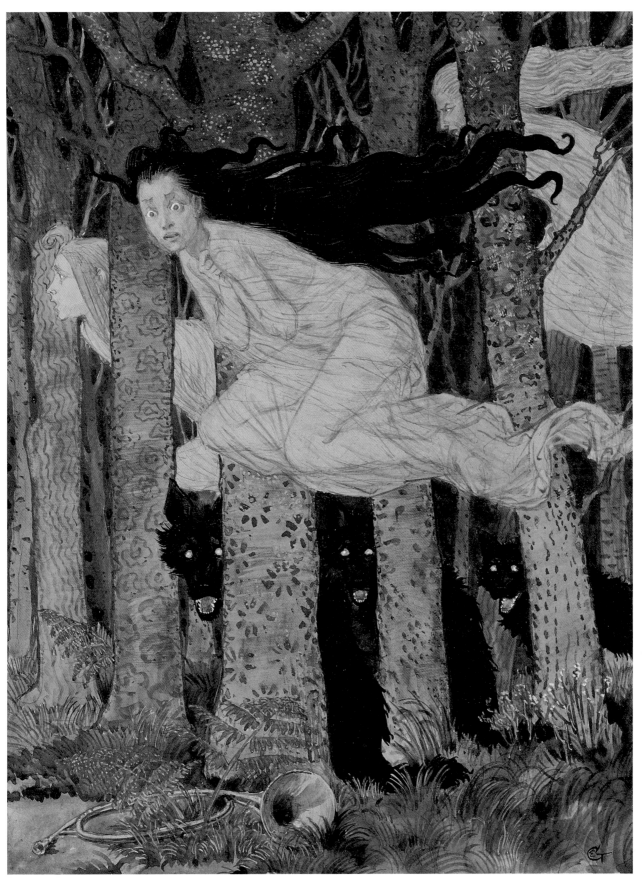

119 (cat. 134)
Eugène GRASSET
Three Women with Three Wolves
Paris, Musée des Arts décoratifs

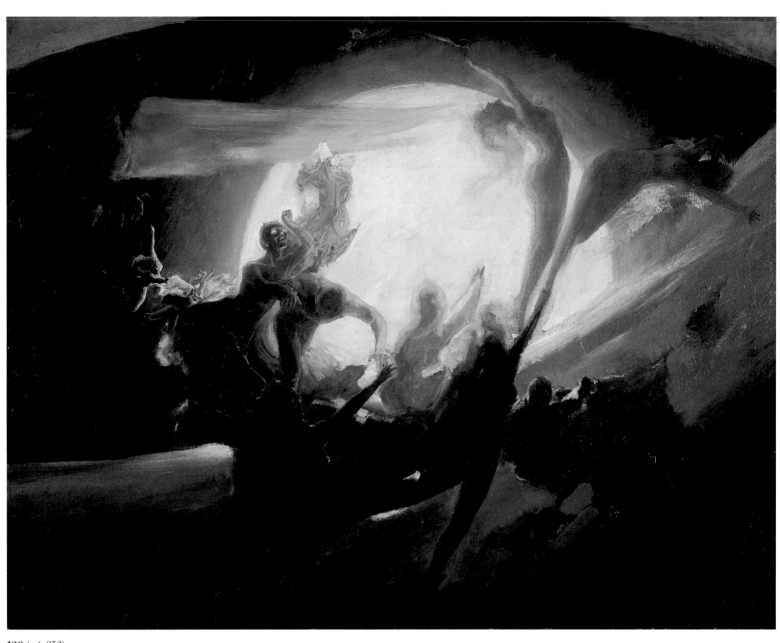

120 (cat. 352)
Richard RIEMERSCHMID
Cloud Phantoms (Version II), 1897
Munich, Städtische Galerie im Lenbachhaus

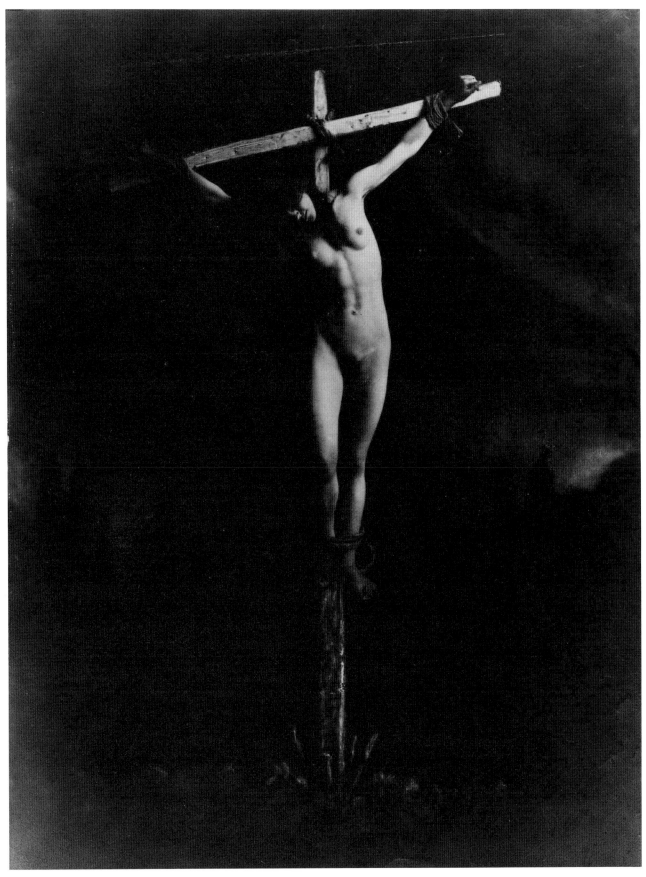

121 (cat. 87)
František **DRTIKOL**
Study of the Crucifixion, about 1914
Museum of Decorative Arts in Prague

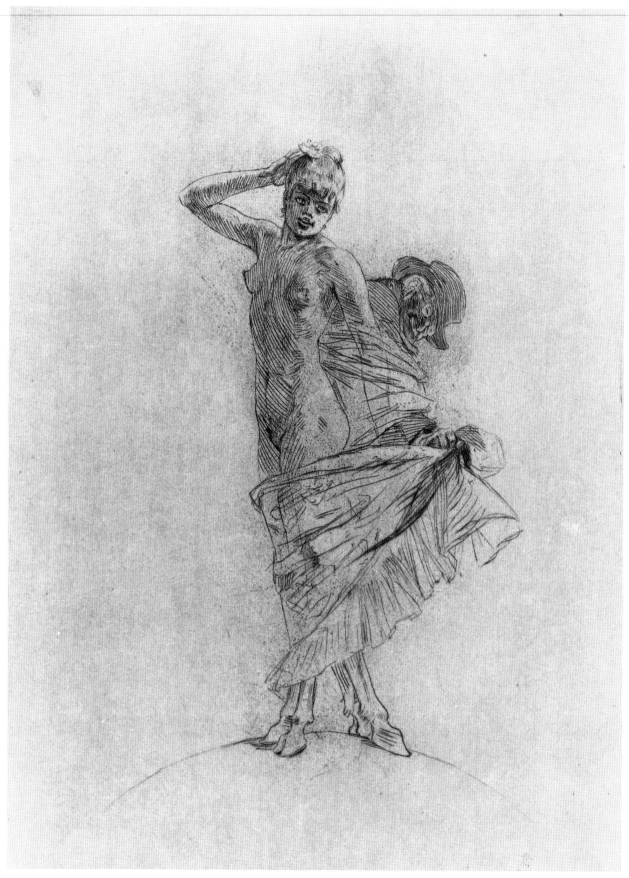

122 *Theft and Prostitution Dominate the World*

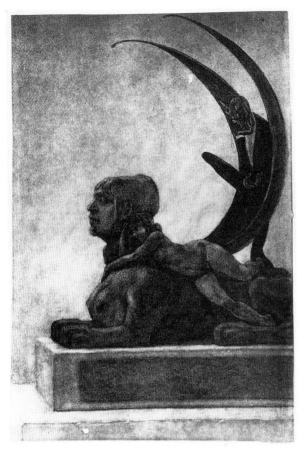

123 *The Sphinx*

124 *Beneath the Cards of a Game of Whist*

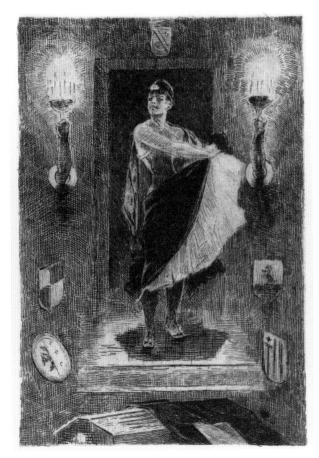

125 *A Woman's Revenge*

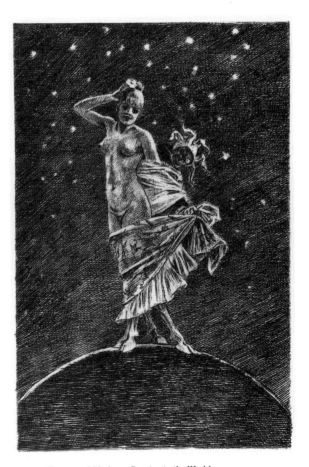

126 *Women and Madness Dominate the World*

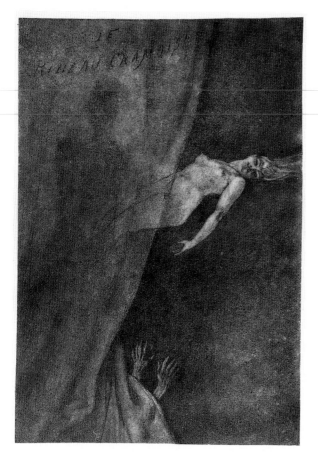

127 *The Crimson Curtain*

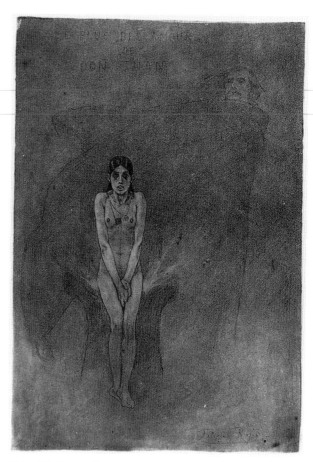

128 *The Greatest Love of Don Juan*

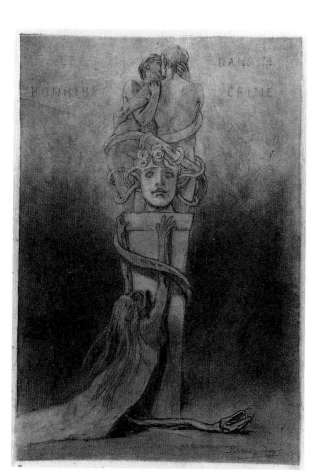

129 *Happiness in Crime*

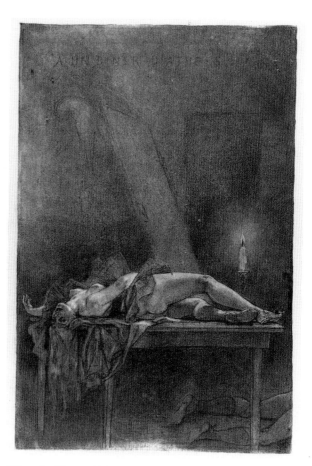

130 *At a Dinner of Atheists*

100 *LOST PARADISE*

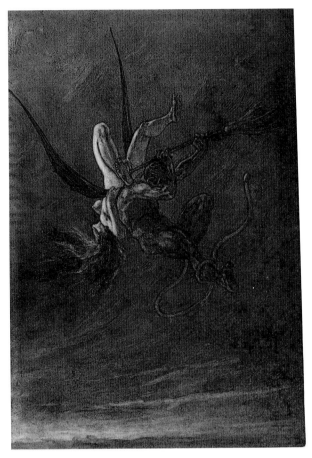

131 *The Abduction*

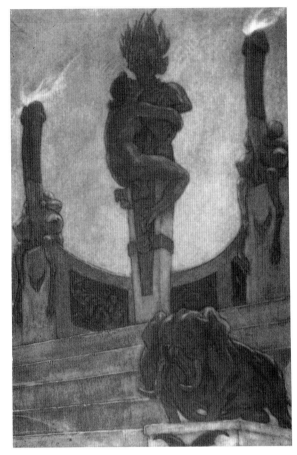

132 *The Idol*

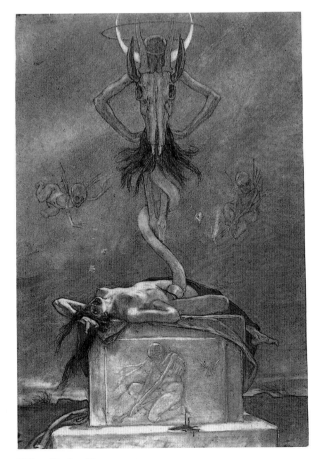

133 *The Sacrifice*

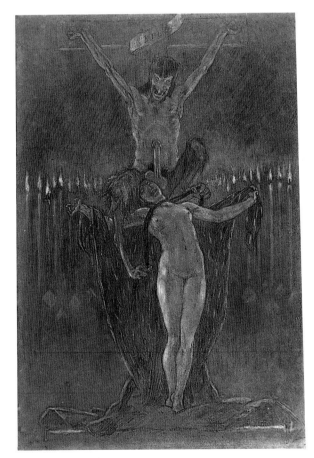

134 *Calvary*

135 to **140** (cat. 16) **Valère BERNARD**, *Six Engravings*, Marseilles, Musée des Beaux-Arts

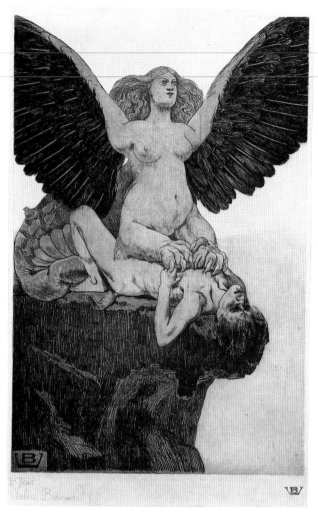

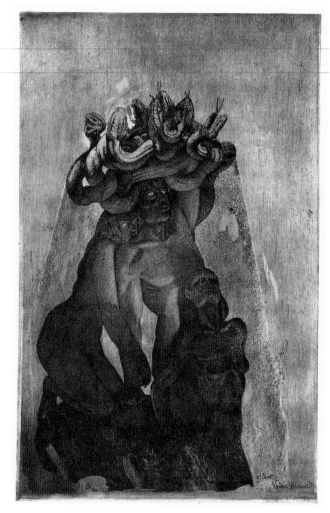

135 *The Sphinx*

137 *Figures (Medusa)*

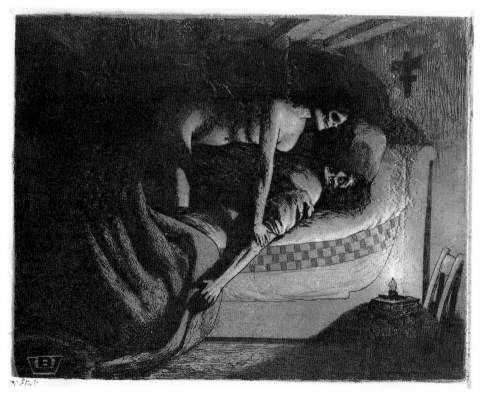

136 *A Man in Bed with a Skeleton*

138 *Nightmare*

140 *Horned Woman with Claws*

139 *Study for a . . . Lesson*

At the Threshold of Symbolism
Van Gogh's *Sower*
and Gauguin's *Vision after the Sermon*

DEBORA SILVERMAN

Art is an abstraction; derive this abstraction from nature while dreaming before it.

Paul Gauguin[1]

My attention is so fixed on what is possible and really exists that I hardly have the desire or the courage to strive for the ideal as it might result from my abstract studies . . .
I do not invent the whole picture; on the contrary, I find it all ready in nature, only it must be disentangled.

Vincent van Gogh[2]

In the summer of 1888, Vincent van Gogh and Paul Gauguin – in close contact through correspondence and deliberating the final arrangements for their impending collaboration in Arles – each undertook a distinct pictorial experiment. Both regarded their experiments as particularly challenging, emphatically modern and singularly "symbolist", a term they first attached to specific paintings made between that July and November. Van Gogh's inaugural "symbolist" venture produced *The Sower*, a labourer striding through a sun-saturated landscape as he tosses seeds from his bag into a plowed field. Gauguin charted out his "path of symbolism" in a "religious painting", *The Vision after the Sermon: Jacob Wrestling with the Angel*. Similar to Van Gogh's *Sower* in size, but radically different in form, meaning and function, Gauguin's *Vision* captures Breton peasant women transfixed in prayer. Heads bowed, eyes closed and hands clasped, they project their inner vision onto a dream landscape, rendered, Gauguin explained in a letter to Van Gogh, as a "non-natural" field of "pure vermilion".[3] The broad mass of bright red, enveloping the static figures as it signifies the externalization of their inner vision, provides a formal medium for Gauguin's goal of depicting the crossing of the divide between material reality and the realm of the supernatural.

Underlying the divergent "symbolist" agendas of Van Gogh's *Sower* and Gauguin's *Vision after the Sermon* are a number of points in common. Both painters set their artistic experiments in pre-industrial peasant communities. Both employed formal innovations, particularly the evocative power of colour, as vehicles for what Robert Goldwater has described as a distinguishing feature of Symbolist art: to move painting beyond anecdotal realism towards a more direct, and more universal, mode of discourse.[4] And both painters pressed their art into the service of a sacred, eternal and invisible world beyond the self and the senses.

While neither Van Gogh nor Gauguin adhered to an institutional religion, each transposed to his painting career the

1. Gauguin, letter to Émile Schuffenecker, 1888, quoted in Robert Goldwater, *Gauguin* (New York: H. Abrams, 1983), p. 26.
2. Letter to Émile Bernard, late October 1888, in Vincent van Gogh, *The Complete Letters of Vincent van Gogh*, 2nd edition (Boston: New York Graphic Society, 1978), vol. 3, p. 518.
3. Quoted in Richard Brettell, Françoise Cachin, Claire Frèches-Thory and Charles Stuckey, *The Art of Paul Gauguin* (Washington: The National Gallery of Art, 1988), p. 103; p. 104 for "the path of symbolism".
4. Robert Goldwater, "Symbolic Form – Symbolic Content", in *Acts of the XXth International Congress of the History of Art*, vol. 4 (Princeton, 1963), pp. 91-133. See also *Art Journal*, vol. 45, no. 2 (Summer 1985), special issue on "Symbolist Art and Literature", ed. Sharon Hirsh.

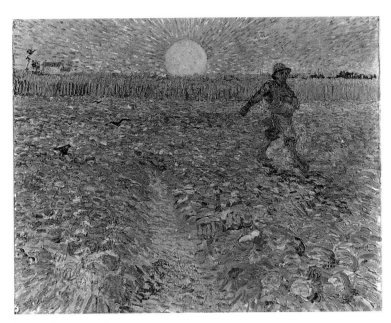

Vincent VAN GOGH
The Sower, 1888
Otterlo, The Netherlands, Kröller-Müller Museum

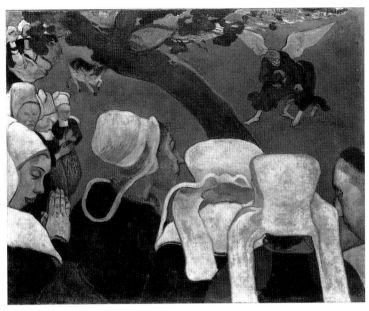

Paul GAUGUIN
The Vision after the Sermon: Jacob Wrestling with the Angel, 1888
Edinburgh, The National Galleries of Scotland

indelible stamp of his religious formation. Van Gogh, a Dutch Reformed minister's son, and Gauguin, schooled in a French Jesuit seminary, inextricably linked their art and their identities to a larger, purposive and transcendent order, and each gave symbolist painting a role hitherto located in their respective religious doctrines: that of mediator of divinity.

The differing forms of that mediation of divinity expressed in Van Gogh's *Sower* and Gauguin's *Vision after the Sermon* reveal the disparities between the two painters' symbolist projects, and the divergent religious legacies that shaped them.

While both artists linked their paintings to an "aspiration for the infinite", the 1888 canvases show they were ready to proceed on "the path of symbolism" in different directions: Gauguin by dematerializing nature in a flight to metaphysical mystery; Van Gogh by naturalizing divinity, in the service of a "perfection" that "renders the infinite tangible to us".[5]

Van Gogh's and Gauguin's divergent conceptions of art – as sacred embodiment and as transcendent idealism – were set in cognitive styles forged early in their particular religious and educational formations, which have received scant attention from scholars. These discordant formations provided each artist with different sets of culturally transmitted resources and constraints, which structured their radically different attitudes towards reality. From his Jesuit training, Gauguin assimilated a profound receptivity to idealism, a presumption of man's supernatural destiny and of material reality as a spurious way station to divinity, and a fluency with visual memory and interior visualization. Van Gogh, by contrast, absorbed from his Dutch Reformed Calvinism a number of powerful cultural barriers to idealism and consolidated, long before he chose the vocation of art, historically specific values of enacted faith, the primacy of sight and a receptivity to nature as a source of immanent divinity.[6] *The Sower* and *The Vision* set the stage for a collaboration that would be strained not simply by personal and temperamental incompatibilities, but

5. Letter to Bernard, late July 1888, in Van Gogh, *Letters*, vol. 3, p. 503.
6. Gauguin was a boarding student at the Petit séminaire de la Sainte-Chapelle in Orléans from 1859 to 1862, where he was taught by the Bishop of Orléans himself, Msgr. Dupanloup. A national Catholic educational reformer, Bishop Dupanloup devised a new curriculum and catechism at the Petit séminaire, which I believe had a profound impact on Gauguin's receptivity to subjectivist, idealist and antirational definitions of reality and self-expression. Van Gogh, by contrast, was raised in his parents' version of Dutch Reformed Calvinism, the Groningen School Theology, also known as the Evangelicals, which stressed the humanist imitation of Christ through enacted faith, service and the sanctification of labour. Van Gogh studied in the Tilburg state high school under C. C. Huysmans, a painter and arts and crafts reformer who, like a William Morris of Holland, encouraged his pupils to "learn how to see" and to integrate beauty into everyday objects. These anti-idealist tendencies were amplified by Van Gogh's exposure as a theology student to a religious reform movement within Dutch Calvinism called "modernism", which promoted antisupernaturalism and a belief system based in nature, emanation and human expressive consciousness. For a detailed discussion, see Debora Silverman, *Weaving Paintings: A Life of Vincent van Gogh* (forthcoming), Chapter 8.

by more profoundly irreconcilable mental frameworks that implied different conceptions of the status of the self, the value of the image and the meaning of the visible world.

In part, the dissimilar symbolist agendas of the two canvases expose the different artistic ideals and practices each painter had established before their affiliation. *The Sower* expressed powerful continuities with three unifying concerns that had guided Van Gogh's stylistic development since his apprenticeship in the Netherlands. First, the choice of subject, inspired by Millet's *Sower* of 1850, reaffirmed Van Gogh's commitment to depict the strain of human labour and the integrity of humble people. From the diggers of The Hague and Etten to the weavers of Nuenen, the Arles *Sower* extended Van Gogh's attempt to realize what he defined as "the very core of modern art": *"a peasant's figure in action"*.[7] Accordingly, Van Gogh reworked the painting to emphasize the sower's moving stride across the field.[8]

Second, *The Sower* reaffirmed Van Gogh's persistent expressions of personal identification with labourers, derived partly from his Calvinist belief that active work was the source of grace and partly from his Evangelical ideal of the sanctity of humble labour. Convinced that he looked "more or less like a peasant", "only peasants are of more use in the world", Van Gogh set out on daily treks to the Arles fields, where he engaged in long hours of "hard, close work" in "the full sun".[9] In describing his work on *The Sower* to his brother Theo and Émile Bernard, he recounted the exhaustion he surmounted, painting under the glaring sun with the "mistral raging".[10] To withstand the mistral's gusts, Van Gogh demonstrated his artisanal ingenuity as he devised a mechanism for anchoring his easel: he proudly explained to Bernard that he was able to complete *The Sower* only because he had staked his easel down by ramming the legs into the ground and then tying them to adjacent iron pegs driven deep into the soil.[11]

And third, the Arles *Sower* reaffirmed Van Gogh's pattern of regarding the act of painting as visually equivalent to the labour and pre-industrial methods he so deeply admired.[12] He worked and reworked the image to give his brushwork "firmness" and wrestled to build up a colouristic field of "heightened structural density".[13] The bristling textural quality of the flecks of broken colour, applied in multiple layers, gave the canvas its palpable roughness and animation. The physical exertion expended on the canvas surface grew more intense in the furrow cut through the field in the centre of the picture, and in fact, some months later Van Gogh commented, "I am plowing

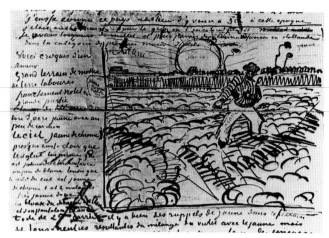

Vincent VAN GOGH
Sketch of "The Sower", in a letter to Émile Bernard, 1888
Correspondance générale de Vincent Van Gogh

on my canvases as they do on their fields."[14] The separate paint strokes, thickly applied to the stubble, ripe stalks, flying seeds and sun's rays, unite in Van Gogh's aspiration that a painting of a rural subject should "have a rustic quality" and "smell of the earth" and "hard and coarse reality".[15]

7. Letter to Theo, summer 1885, in Van Gogh, *Letters*, vol. 2, p. 402 (emphasis his). The Arles *Sower* of 1888 returned to the Millet subject Van Gogh had attempted numerous times between 1881 and 1884. For discussion and illustrations, see Louis van Tilborgh, "The Sower", in *Van Gogh and Millet* (Zwolle: Waanders, 1989), pp. 156-177.

8. For discussion of the alterations between the two states of the *Sower* painting, see Ronald Pickvance, *Van Gogh in Arles* (New York: Metropolitan Museum of Art, 1984), pp. 102-103; and Evert van Uitert, Louis van Tilborgh and Sjaar van Heugten, *Van Gogh: Paintings* (Milan: Arnoldo Mondadori Arte, 1990), pp. 128-129.

9. Van Gogh, *Letters*, vol. 3, p. 226; vol. 2, p. 591. The religious sources underpinning Van Gogh's identification with labour are complex, deriving not from a unitary Calvinism but from a number of competing sources within Calvinism that Van Gogh absorbed in the Netherlands and Great Britain. The importance of these religious legacies has been re-emphasized in Tsukasa Kōdera, *Vincent van Gogh: Christianity versus Nature* (Amsterdam and Philadelphia: John Benjamins, 1990), especially Chapter 1. On the centrality of Van Gogh's parents' Groningen Theology of service, as well as the pre- and post-Arles patterns of association with weavers and peasants, see Debora Silverman, "Weaving Paintings: Religious and Social Origins of Vincent van Gogh's Pictorial Labor", in Michael S. Roth, ed., *Rediscovering History: Culture, Politics, and the Psyche* (Stanford: Stanford University Press, 1994), pp. 137-168, and Silverman, forthcoming. For an analysis of the significance of the populist religious tradition of John Bunyan that Van Gogh assimilated during his English period, see Debora Silverman, "Pilgrim's Progress and Vincent van Gogh's *Metier*", in *Van Gogh in England: A Portrait of the Artist as a Young Man*, exhib. cat., selected by Martin Bailey (London: Barbican Art Gallery, 1992), pp. 93-115.

10. Van Gogh, *Letters*, vol. 3, p. 493.

11. *Ibid.* The ingenuity and flexibility of this system recalls Van Gogh's other craft tool, the perspective frame, built in collaboration with a carpenter and blacksmith in The Hague in 1882. The frame was adjustable and operated outside by being staked into the ground and secured on its frame with adjustable iron pegs, illustrated and described by Van Gogh in *Letters*, vol. 1, pp. 431, 433, 383, 432. Van Gogh was still using the perspective frame in Arles, and during the time he was working on *The*

While extending earlier ideals and practices, *The Sower* also marked a point of departure, for the composition coheres not only through its rough textrous physicality but through the blazing sunlight that seems to saturate every pore of the canvas. In this combination of grounded peasant work and immaterial irradiation, Van Gogh located a new theory of art and an attitude towards reality that he assigned to "symbolism".

The letters about *The Sower* register Van Gogh's definition of its "symbolist" features. To Bernard, he noted how, at work in the fields, he was beset by "memories of the past" and "a longing for the infinite, of which the sower, the sheaf are the symbols".[16] Rather than ascribing *The Sower* a literary meaning derived from Christ's parable, Van Gogh interpreted the symbolic quality of the subject in the more inclusive terms of "longing for the infinite", the aspiration towards an eternal order beneath surface appearances.[17] What visual techniques were appropriate to convey this "symbol" of the infinite lodged in a peasant figure? Not the subject alone, Van Gogh claimed, but the linkage of the subject to a theory and practice of

expressive colour promised *The Sower*'s new symbolic statue. He called Millet's *Sower* "a colorless *gray*"; "what remained to be done" was the large-scale striding figure "in color".[18] Paradoxically, in his ambition to "modernize Millet", Van Gogh turned to Millet's predecessor, Delacroix, whose expressive complementary colour laws he had studied but not systematically applied to a major canvas.[19] The way Van Gogh invoked Delacroix's colourism is significant: he turned to the evocative forms of a religious painting for the revitalizing colour scheme of his *Sower*. Writing to Theo as he worked on the picture, Van Gogh juxtaposed Delacroix's *Christ Asleep during the Tempest* and Millet's *Sower* as "absolutely different in execution". He went on, "Christ Asleep in the Tempest – I am speaking of the sketch in blue and green with touches of violet, red, and a little citron-yellow for the nimbus, the halo – speaks a symbolic language through color alone."[20]

In planning *The Sower*, Van Gogh would apply what he considered Delacroix's "suggestive color"[21] to a Millet-inspired peasant subject by composing the painting in two interlinked contrasting colour zones, the "upper half predominantly yellow and the lower part in complementary violet";[22] by continuing the juxtaposition of colours along a slender painted yellow and violet frame;[23] and by transferring the luminous citron yellow of Christ's nimbus to the sun.[24]

Sower, he was giving a new friend, Paul Milliet, art lessons and training in perspective with the frame. This is also discussed in Van Gogh, *Letters*, vol. 3, p. 493.

12. By 1885, Van Gogh had begun loading the pigment in rough-hewn, bricklike applications, choosing deep earth tones and mudlike colouring, and applying colours as fibres and paint strokes as threads to the canvas so as to intersect like the woof and weft of weaving a coarse fabric. The emergence of this form of pictorial labour is discussed in Silverman, 1994, and Silverman, forthcoming.

13. "This blasted mistral makes it very hard to get one's brushwork firm"; Van Gogh to Theo, in *Letters*, vol. 3, p. 57; the compositional alterations on *The Sower* towards heightened density are discussed in Pickvance, 1984, pp. 102-103.

14. Van Gogh, *Letters*, vol. 3, p. 226.

15. *Ibid.*, p. 233.

16. *Ibid.*, p. 492.

17. Van Gogh was certainly familiar with the Parable of the Sower (Matthew 13:2-9, 18-23; Luke 8:4-15; and Mark 4:13-20), and it is significant that he does not invoke the biblical precedent explicitly. See Van Tilborgh, "The Sower", p. 156. For accounts of the "religious overtones" of the image, see Evert van Uitert, "Van Gogh's Concept of his *Oeuvre*", *Simiolus*, vol. 12 (1981-1982), p. 239; and Judy Sund, "The Sower and the Sheaf: Biblical Metaphor in the Art of Vincent van Gogh", *Art Bulletin*, 70 (1988), pp. 660-676.

18. Van Gogh, *Letters*, vol. 2, pp. 597, 591 (emphasis his).

19. Van Tilborgh, "The Sower", p. 177.

20. Van Gogh, *Letters*, vol. 2, p. 597.

21. *Ibid.*, vol. 3, p. 44.

22. Van Uitert *et al.*, 1990, p. 128.

23. Pickvance, 1984, p. 103.

24. In another version of *The Sower* painted in November 1888 (F450), Van Gogh used the disk of the sun as a halo for the sowing figure, placing it directly behind him. According to Kōdera, this sun-as-halo may have originated in Van Gogh's exposure to images of the sower and the sun and to depictions of solar festivals in the illustrated magazine *Le Courrier français* of 1886. However, Van Gogh's earlier invocation of Delacroix's exemplary "symbolic color" in Christ's aureole as a model for the evocative colourism of the July 1888 *Sower* suggests a more obvious and fundamental transposition of religious precedent to a rural form and content. For Kōdera's argument, see Kōdera, 1990, pp. 27-39, especially pp. 30-33.

Eugène DELACROIX
Christ Asleep during the Tempest, 1853
New York, The Metropolitan Museum of Art

Van Gogh experimented with this "symbolist" melding of peasant activity and transfigurative light even as he resisted the pull towards idealism and the revival of religious art. During the months he worked on *The Sower*, he clarified some of the differences that would deepen during his collaboration with Gauguin. Writing to Bernard in late July 1888, Van Gogh urged his friend to forgo the fantasy and aestheticism of Baudelaire for what he considered a perfection and completeness that render "the infinite tangible".[25] The examples he cited of this "infinite tangible" – Millet, Courbet and the Dutch school – departed resolutely from the unreal realm he ascribed to religious painting. He made exception for Rembrandt and Delacroix, whose work may have encompassed occasional religious subjects but differed absolutely from "all the rest of religious painting". When Rembrandt painted angels, Van Gogh asserted, he painted his self-portrait in a mirror, a humanized supernatural figure he "knew" and "felt". For Delacroix, the choice of a Christ figure was subordinate to the evocative form devised to represent him in a bright yellow and "luminous" radiance.[26]

This critique of religious art, in conjunction with the conception and stylistic framework of *The Sower*, captures the essence of Van Gogh's emergent symbolism in a theory and practice of embodiment and emanation. *The Sower* exemplifies Van Gogh's ideal of an art rooted in the indivisible union of tangibility and the infinite in its depiction of redemptive production physically enacted by its peasant subject, technically emulated by the painter's coarse and effortful brush, and transcendently charged by its blasting illumination. The canvas's horizontal and vertical zones yoke the realms of human action and celestial power: as the sower casts seed into the bare earth split open in the centre foreground, the erect stalks at the back of the field, drenched by vitalizing sun, signal the end of the cycle yielding the fruits of labour. The painter, through his interlocking design and matched yellow dabs for seeds and shafts of sunlight, ties the two realms together and absorbs the power of each, the agent of irradiation and germination. Van Gogh's artist, like the sower, embodies matter; his was a nature not to be overcome, but poised to be "disentangled" and realized. And his artist, like the sower's sun, activates emanation of the eternal in the tangible; he floods a dense, materialized light that penetrates every ground and grain of the picture plane. *The Sower*'s paradigmatic status was recapitulated in the very process of preparing the ground of artistic production in the sower's

fields. Resisting the blast of mistral by ramming, clamping and tying his easel down with rope, stakes and iron pegs, Van Gogh applied his sparkling streaks of colour to a canvas anchored from flight, embedded deep in the soil.

At the same time Van Gogh was striving to render the tangibility of the infinite, Gauguin pressed his art into the service of visionary incorporeality. Pictorial, personal and ontological factors, which combined to endow *The Sower* as a symbolist image weighted down from flight, made of Gauguin's *Vision after the Sermon: Jacob Wrestling with the Angel* a symbolist image released into the weightlessness of the dream, what Gauguin called "freeing painting from its chains" – "the shackles of verisimilitude" and materialism.[27]

Gauguin's symbolist experiment, like Van Gogh's, was related to pre-existing ideals and practices. The appeal of the subject of *The Vision*, which Gauguin said represented the scene enacted within the praying women's imaginations, had precedents in his work. In 1881, for example, while exhibiting with the Impressionists and training alongside Camille Pissarro, Gauguin presented a distinctly anti-Impressionist motif in a large oil named *La petite rêve*, a depiction of his daughter Aline asleep, prefiguring his "later preoccupations with the world of the unconscious" and the "interior life of human beings".[28] And in letters of January 1885 and August 1888 to his friend Émile Schuffenecker, he registered artistic attitudes and an epistemology that set the framework for the exploration of the different levels of reality given form in *The Vision after the Sermon*. The 1885 letter proposed an art directed towards the mediation of a mystical reality beneath appearances, capable of conveying what he called "phenomena which appear to us supernatural, and of which, however, we have the *sensation*".[29] In August 1888, Gauguin goaded Schuffenecker to subordinate nature to the imperatives of the artist's dream, as he edged towards the primacy of a subjectivist antinaturalism as the core of modern art and the

25. Van Gogh, *Letters*, vol. 3, p. 503.
26. *Ibid.*, p. 504.
27. Quoted in Mark A. Cheetham, *The Rhetoric of Purity: Essentialist Theory and the Advent of Abstract Painting* (New York: Cambridge University Press, 1991), p. 4; see also p. 7.
28. Belinda Thomson, *Gauguin* (London: Thames and Hudson), p. 25; Charles Morice, cited in George Hamilton, *Painting and Sculpture in Europe, 1880-1940* (Harmondsworth, England: Penguin, 1967), p. 84.
29. Quoted in Linda Nochlin, ed., *Impressionism and Post-Impressionism, 1874-1904: Sources and Documents* (Englewood Cliffs, New Jersey: Prentice-Hall, 1966), p. 158 (emphasis his).

equivalent of divinity: "Art is an abstraction; derive this abstraction from nature while dreaming before it . . . This is the only way of rising toward God – doing as our Divine Master does, create."[30]

Gauguin's *Vision after the Sermon*, a religious painting in a dream landscape, thus extends attitudes already consolidated in his evolving aesthetic. Yet, it also represents a self-conscious break with his previous style, training and subject matter, which he characterized as a turning point in his development.[31] *The Vision* deploys a new arsenal of visual forms designed to "offer salvation from the ontologically wanting world of appearances" in order to mediate a realm beyond perceptual experience.[32] The Impressionists, Gauguin later explained, "heed only the eye and neglect the mysterious centers of thought".[33] Abandoning his Impressionist canon, Gauguin celebrated his *Vision* as a first step along "the path of symbolism", a path ascending towards a dematerialized purity he now proclaimed as "fundamental to my nature".[34]

In mid-August 1888, then, while Van Gogh was mired in "clods of earth" and "hard, close work" in the fields, an imperturbable Gauguin began composing *The Vision after the*

Sermon in the hush of religious meditation: his subject was a group of Breton women withdrawn into an interior vision inspired by a sermon. While the kneeling figures at the left look down, eyes closed and hands clasped in prayer, the central figure looks up and across a diagonal tree to where the vision of Jacob wrestling with the Angel is projected, as if it were really taking place in the distance. As Gauguin explained in a letter to Van Gogh, "The landscape and the fight exist only in the imagination of the people praying after the sermon, which is why there is a contrast between the people, who are natural, and the struggle going in a landscape which is non-natural and out of proportion."[35] Gauguin constructed his *Vision* as a mystical encounter between the natural and the supernatural, the conduit between them being the fusion of the artist's dream and the peasant's visionary faith.

Like Van Gogh, Gauguin elaborated new visual techniques to convey the form and meaning of his inaugural symbolist venture. Composed of two overlapping zones of pictorial space, the vividly coloured *Vision* is devoid of a middle ground, thus confounding traditional perspective. The praying women are assembled in the foreground along the edges of the canvas; the central figure focusses on the two biblical characters behind a tree that cuts across the canvas at a diagonal. Gauguin's use of the tree as an asymmetrical flattening device was inspired by Japanese prints; its use as a boundary separating the two levels of reality in the picture is his invention.[36] The treatment of the tree exposes it as a permeable border, befitting the theme of the interpenetration of reality and apparition. Distending upward and lacking a visible base, the tree appears to float; its one point of fixity is formed not by an anchoring middle ground but by the white bonnet of the figure in the foreground, to which it appears to be stuck, further compressing the picture space.

A second element of Gauguin's antiperspectivism formalizes the drift of the natural into the supernatural. In setting the scale and proportions of the figures, Gauguin scrambles the logic of illusionism to bring the distant realm closer, creating a picture space that tilts up and presses forward. This breach of traditional adjustments of scale is particularly apparent in the triad of: the women in front; the cow at the left; and the Angel and Jacob beyond the tree. The three women in front are rendered in large dimensions; the Angel and Jacob, in the distance, do not diminish proportionally. While closer to the women in space, the cow appears much smaller in scale than Jacob and the Angel; its placement

30. Quoted in Goldwater, 1983, p. 58.

31. On completing the painting, Gauguin explained that "this year I have sacrificed everything – execution, color – for style, because I wished to force myself into doing something other than what I know how to do." Quoted in Brettell *et al.*, 1988, p. 103.

32. Cheetham, 1991, p. 17, recovering Gauguin's intellectual debt to Neoplatonist philosophy. Cheetham's effort to take Gauguin seriously as a thinker is important, though I believe he oversecularizes Gauguin's modernism and ignores the pre-existing religious mentality that facilitated Gauguin's receptivity to Neoplatonism in the 1880s.

33. Quoted in *ibid.*, p. 4.

34. Letter of October 16, 1888, to Schuffenecker, quoted in Brettell *et al.*, 1988, p. 104.

35. Quoted in *ibid.*, p. 103.

36. *Ibid.*, p. 104; Hamilton, 1967, p. 84. To be sure, Van Gogh and Gauguin shared this admiration for Japanese prints, and indeed, Gauguin may have seen Van Gogh's adaptation of Hiroshige's *Plum Trees – Japonaiserie: The Tree* (1887) – before beginning work on *The Vision after the Sermon*. Yet, Van Gogh and Gauguin translated their common interest in Japanese prints into their own idioms. Unlike the diagonal slicing of Gauguin's tree in the *Vision*, Van Gogh's *Japonaiserie* was an exercise in viewing juxtapositions of near and far, and looking through keyholes in the branches or flanked branch frames. This type of viewing accorded well with Van Gogh's pre-existing interest in such juxtapositions in seventeenth- and nineteenth-century Dutch painting, as well as with the framed and telescoped viewing structured by his own perspective frame. More generally, Van Gogh assimilated Japanese prints to enhance his paintings' surface textures; in Paris he attempted to emulate the rough fabric surfaces of the Japanese crepons with his brush stroke. Rather than texture, Gauguin celebrated the flatness and unmodulated colour areas of woodblock prints. On the multiple possibilities of the Japanese model, especially the juxtaposition of near and far, see Kirk Varnedoe, *A Fine Disregard: What Makes Modern Art Modern* (New York: H. Abrams, 1990), pp. 55-78. On Van Gogh's emphasis on Japonism as texture, see Silverman, 1994, and Silverman, forthcoming.

recapitulates the weightlessness configured elsewhere in the painting.[37] Although visually the animal's body shares the women's "natural" space, the rearing head, blocked from view by the tree, has migrated to the spiritual realm occupied by Jacob and the Angel. Like the tree, which hovers as if unrooted, the cow floats into the ethereal spheres. Gauguin's transformation of a lumbering creature into an airy messenger of incorporeality offers one of the clearest signs of *The Vision*'s thematics of supernaturalism.

Gauguin's most conspicuous innovation in *The Vision after the Sermon* is the antinaturalist palette, applied in unbroken colour masses outlined in black, resembling medieval enamelling or stained glass. The outlines intensify the bright colours, as well as flattening the painting's surface.[38] Like the spatial zones, the colour range conforms to Gauguin's poles of "natural" and "non-natural", with black and white chosen for the "natural" elements, and multicoloured tones for the "non-natural" ones. The Breton women, Gauguin explained in a letter to Van Gogh, wore "very intense black clothes" and "yellow-white bonnets, very luminous". The tree, rendered in dark hue, ascends to brighter colours: as its foliage spills into the area near the Angel and Jacob, Gauguin introduces a sparkling green, converting the density of leaves into the ethereality of what he called "greenish emerald *clouds*".[39] Gauguin adds another colour sign of the tree's dual position in the natural and non-natural realms of experience: while the edge of the tree trunk towards the women is outlined in black, the edge nearer Jacob and the Angel glows orange. But the most startling aspect of *The Vision* is the dazzling expanse of unreal red – "pure vermilion" – that renders the heavenly ground permeating the picture plane as it fills the consciousness of the praying women. The red spreads in a broad field of largely unmodulated colour, thinly and evenly applied with a fluid brush that rarely breaks the canvas's uniform surface. The picture's highest point of luminousness, as well as the most saturated colouristic hub, lie in the Angel and Jacob characters. Gauguin described Jacob's robe as "bottle green" and the Angel as dressed in "violent ultramarine blue". The eye quickly settles on the Angel's wings, painted with "pure number 1 chrome yellow"; the Angel's hair modulates to "number 2 chrome", and the feet are "flesh orange".[40] These gradations of intense yellow to orange, reinforced by the flashing orange edge of the tree and the brilliant red of the surround, make the Angel radiate light and heat from an invisible source, a flushed treatment that contrasts sharply with the faces of the praying women: drained of flesh colour and highlighted with frosty white, the women appear as dissipated "masks of meditation" riveted to a blazing site of heated light.[41]

A religious painting born in repudiation of Impressionist facticity, *The Vision after the Sermon* captures the essence of Gauguin's emergent symbolism in a theory and practice of dematerialization. Indeed, *The Vision*'s subject and form are a pictorial realization of Gauguin's clarion call in August 1888 for art as an abstraction derived "from nature while dreaming before it": taking the raw material of the sermon they have heard and the natural scene before them, transforming it and projecting it outward, the praying women enact Gauguin's charge. The resulting vision places the women in the position of the artist that Gauguin asserted arises from this exercise of the primacy of creative abstraction over nature – this "way of mounting toward God" – and the women are physically and spiritually poised in the picture plane to fulfil this act of ascent.

Van Gogh's and Gauguin's symbolist projects of 1888 display striking contrasts. Although both artists used the peasant figure and initiated their experiments in pre-industrial rural communities, they construed peasants, and incorporated them into their innovative art, in dissimilar ways. *The Sower* expressed Van Gogh's abiding definition of modern art as linked to the exertion of peasant labourers. In depicting lowly labour, Van Gogh attached himself to those he considered the true servants of God, whose worthiness surpassed a self-taught painter struggling with inner and outer pressures for justification.

Gauguin, by contrast, approached the peasant not as a vehicle for self-justification, but as a means of metaphysical

37. As Gauguin commented, "The cow under the tree is tiny in comparison with reality, and is rearing up." Quoted in Brettell *et al.*, 1988, p. 103.

38. See *ibid.*, p. 104. The critic Édouard Dujardin characterized Gauguin's *Vision after the Sermon* as the emblem of a new style he dubbed "cloisonnism", resembling the cloisonné technique in enamelling, "whereby metal partitions or *cloisons* are used to divide one area of brightly colored enamel from another". Thomson, *Gauguin*, p. 67. Gauguin's experiments with thirteenth- and fourteenth-century glass design and its translation into oil are noted by his contemporary, the painter A. S. Hartrick in *A Painter's Pilgrimage through Fifty Years* (Cambridge: Cambridge University Press, 1939), p. 34. On cloisonnism, see the discussion of Gauguin in Bogomila Welsh-Ovcharov, *Vincent van Gogh and the Birth of Cloisonnism* (Toronto: Art Gallery of Ontario, 1981), pp. 168-226; and Henri Dorra, *Symbolist Art Theories: A Critical Anthology* (Berkeley: University of California Press, 1994), p. 102.

39. Gauguin, quoted in Brettell *et al.*, 1988, p. 103.

40. *Ibid.*

41. The terms of Brettell, *ibid.*, p. 104, who does not, however, discuss the contrasting colour ranges between the women and the supernatural figures and terrain.

and metapsychical extension. His peasants do not work – they dream; they do not expend bodily action, but compress mental space. And even when they were engaged in physical work, Breton peasants appeared to Gauguin as vessels of pious resignation, unmarked by signs of outdoor exposure:

> There is something medieval looking about the peasants here in Brittany . . . Their apparel, too, is little short of symbolic . . . Look how the bodice forms a cross in back, how they wrap their heads in headscarves, like nuns . . . Still fearful of the Lord and of the parish priest, Bretons hold their hats and tools as though they were in church.[42]

If Van Gogh maximized both his labour and that of the subject depicted in *The Sower*, Gauguin, ever on the alert for a "glimpse of the dream", promoted *The Vision* as an effortless transcription of the dissolving powers of mind over matter: "Go on working, *freely and furiously*, you will make progress . . . Above all, don't perspire over a picture. A strong emotion can be translated immediately; dream on it and seek its simplest form."[43]

Formally, *The Sower* exemplifies Van Gogh's expressive imperative of marking the canvas with tangible signs of a labour equivalent to that of his subject. The physicality of his loaded brush unifies the painting in intersecting units of horizontal ground and vertical crops drenched with radiant flecks of light. The spatial organization and format emphasize a visual interaction of density and the movement enacted by the subject, reproduced by the painter's animated brush. The furrow unfolding kinetically from the picture's front edge to the middle ground already traversed by the striding sower immediately opens up the space and forcefully pulls the viewer in.

Where Van Gogh reworked his sower to render the stride more convincing, Gauguin's pursuit of translating "strong emotion" and the lineaments of the dream yielded figures in trance-like stillness. The large heads and truncated bodies of the Breton women splayed out against the front edges of the canvas accord with their dissociated state of pure consciousness, split off from anchorage in corporeal reality. The two women on the right with their backs to the viewer are faceless, and their enormous white bonnets appear improbably anchored to them, like giant wings at rest. The other earthly components of *The Vision*, like the floating tree with its vaporous leaves and the dainty cow, enhance the panoply of figuration as an experiment in abstracted antinaturalism.

It is in the handling and application of the brush that Van Gogh's and Gauguin's emergent symbolisms diverge most tangibly. Van Gogh's sculptural brush yielded a thick sediment of colour by building up individual sticks of paint in the foreground field, and bristling, abraded bars of ripe crop in the background. He reworked the canvas to reinforce it as a surface of "heightened structural density"; the application of paint in sticks and fibrous blocks exemplifies how Van Gogh realized in his symbol of "longing for the infinite" a record of his "hand-to-hand struggle with nature",[44] a nature wrestled, penetrated and "disentangled".

By contrast, Gauguin's smooth, attenuated brush, aspiring to the fluidity of the dream projected from his subjects' inner consciousness, glided across *The Vision* in an unbroken surface of rhythmic linear banding and broad masses of colour. Pigment melts into the canvas rather than augmenting it by amassing a second layer, as on the coarse canvas of *The Sower*. The areas of white defining the Breton women's headgear spread with the delicacy of chalk rather than oil. The daring red of the dreamscape appears not moulded but aqueous, level as a sheet of ice.

Gauguin achieved his flattened, lissome surface as deliberately as Van Gogh had calibrated his brushwork for maximum density. By 1888, Gauguin had devised a number of techniques to "mute the surface" and "enhance the flatness" of the image: his own formula for a matt, white primer; thinned oil paint; and a wax finish instead of varnish.[45] The primer created "a highly absorbent, chalklike surface" that registered the thinned paint in a distinctive manner. As Reinhold Heller has put it,

> no trace of a sculptured surface texture appears, and instead a very thin matte finish is made, its sheen diminished even more by the fusion of the paint substance with the absorbing, chalky primer . . . With its colors melting into the canvas itself, moreover, the physicality of the image disappears.[46]

42. Letter to Van Gogh, Le Pouldu, October 20, 1889, quoted in Françoise Cachin, *Gauguin: The Quest for Paradise* (New York: Abrams, 1992) p. 142.

43. Gauguin, letter to Schuffenecker, 1885 (emphasis his), quoted in Nochlin, 1966, p. 159. Gauguin's phrase the "glimpse of dream" is quoted in Cachin, 1992, p. 144.

44. Letter to Bernard, 1889, in Van Gogh, *Letters*, vol. 3, p. 522.

45. This analysis is drawn from an extremely interesting article on Symbolist surfaces by Reinhold Heller, "Concerning Symbolism and the Structure of the Surface", pp. 148-149 in the special issue of *Art Journal* cited in note 4 above. It is one of few articles that explore the formal mechanisms of 1880s Symbolist pictorial innovation within a comparative context.

46. *Ibid.*, pp. 148, 149.

"Sculptured surface texture" and "physicality" are precisely the formal vehicles the brushwork of *The Sower* exploits to "render the infinite tangible"; Gauguin's strategies to attenuate and suppress these potentials of oil paint brushed onto canvas exemplify his ambition to weaken materiality's hold on consciousness, to invert outer and inner reality, and to repudiate the "disentangling" encounter with the stuff of nature in favour of a transcendent abstraction.

The artists' choice and application of colour also accord with their respective materialist and idealist orientations to the sacred. Van Gogh, seeking to modernize Millet, turned to the evocative colourism of Delacroix's laws of simultaneous contrast, which as Van Gogh knew, had a scientific foundation posited by the chemist Michel Chevreul, Director of the Gobelins Tapestry Works, who urged painters to approximate the operation of coloured light in nature by juxtaposing complementary hues. While conceding some departures from these laws, Van Gogh's attempt to render *The Sower* in interlocking zones of violet and yellow complementaries, including their rearticulation along the painting's frame, indicates his interest in an optically based formula for heightened luminosity. This naturalistic element of his symbolist colourism is analogous to his other inspiration from Delacroix for *The Sower*: the transfer of the radiant yellow halo from the *Christ Asleep during the Tempest* to the glowing disk of his *Sower*'s sun, a secularized source of sacred light.

Gauguin's palette in *The Vision* moved away from natural optical laws to a supernatural effulgence. Rather than trying to match the interaction of coloured light he had assimilated from Impressionism and Chevreul's model, Gauguin invented a chromatic key modulated to the contours of inner vision, which led to an inversion of Van Gogh's colour choices. Van Gogh, redirecting the intensity of Christ's nimbus to the sower's domain, reserved the brightest colour and fullest light for the sun saturating the fields, which he painted in high-keyed "chrome yellow, number 1". Gauguin employed exactly the same colour for his Angel's wings, reserving the radiant high point of his *Vision* for the supernatural realm. The surreal red of the dreamscape serves to further diminish the colour of the human figures in the foreground; the women's black and white costume and faces rendered in low flesh tones covered over with pasty white pale in comparison with their Technicolor vision.[47]

Yet another formal feature reveals the disparity between Van Gogh's and Gauguin's symbolist orientations. Compo-sitionally, both paintings cohere in two main spatial zones. In *The Sower*, the horizontal plowed field in front interlocks with the vertical crops and sun at the back, mediated by the figure of the sower, who moves towards the viewer in a diagonal swath. As Van Gogh lures the eye to retrace the sower's forward steps, he also impels the eye into a corridor that shoots dramatically into the distance: the furrow at the extreme front edge of the canvas creates a recessional thrust that immediately embeds the viewer in clods of earth, as it directs the eye further into depth towards the distant, blazing sun. The sun's position at the recessional centre of the horizon suggests that Van Gogh may have situated it with the aid of his perspective frame. Further evidence for this perspectivally correct impulse is provided by the trees originally flanking the sun but eventually painted over.[48] Van Gogh's spatial organization constitutes a three-tiered play on perspectival dynamics, summoning viewers into the picture plane and inserting them into all levels of the animated, worked space: he coaxes the eye to follow the path of the sower, to propel down the runner of the furrow and to alight unavoidably on the pivoted centre of the sun at the exact horizon point at the back. Back to front, front to back and diagonally across, Van Gogh incorporates viewers into *The Sower* canvas, enlisting them as active participants in his artistic practice of sacred embodiment.

If Van Gogh arrayed *The Sower* with perspectival signposts, Gauguin's *Vision after the Sermon* dramatizes a spatiality of obstruction. *The Vision*'s two zones, conveying Gauguin's conception of different levels of reality, are bisected by the tree, which acts not as a passageway into the distance but as a hurdle. Where Van Gogh's figure of the sower moves towards the viewer, whose eyes are simultaneously riveted in the open furrow, Gauguin's women visionaries – backs towards the beholder and flat against the edges of the canvas – impede the viewer from entering their mesmeric, spiritual field. The women's meditative isolation from one another is restated in their positioning as stalwart gatekeepers of the recessional

47. For Van Gogh's choice of colours, see Van Gogh, *Letters*, vol. 3, p. 492; for Gauguin's, see Brettell *et al.*, 1988, p. 104.

48. Van Gogh often relied on anchoring trees or posts to flank objects depicted in the picture plane during his Hague period, in reference to his own framed view through the posts of his perspective frame. On the melding of Van Gogh's staked perspective tool and flanking compositional format, see Silverman, 1994, and Silverman, forthcoming.

space the beholder desires to penetrate. Where Van Gogh's *Sower* could serve as a primer on the workings of orthogonals and converging horizon lines, Gauguin's *Vision* shatters the rules of perspectival illusionism. The weightless cow, rootless tree and floating women at the left upper edges break with the conventions of pictorial organization. The biblical figures at the back appear to tilt up and out from their shallow space. And rather than pulling the viewer in towards a target, as Van Gogh moves the beholder through the worked field to a stasis on the sun, Gauguin catapults the background forward, suppressing perceptual exertion for a sudden dissolution of material reality by the imperious permeation of the dream.

Gauguin and Van Gogh conceived of different settings for these paintings. Gauguin wished to see his in a Breton church, returning his depiction of popular piety to the place where his subjects worshipped. "I wanted to give it to the Church of Pont-Aven," he wrote to Van Gogh in September 1888. It "would be all right in surroundings of bare stone and stained glass," he noted, and indeed a pair of stained glass windows in the apse of the Pont-Aven chapel portray angels whose unscrolling wings and radiant colour scheme harmonize with *The Vision*'s.[49] One can imagine how Gauguin's painting might have functioned as part of a mutually reinforcing and interdependent field of religious experience, much like that analyzed by Michael Baxandall for an earlier period, where sermon, gesture and painting operated as indivisible and interacting steps in a communal choreography of worship.[50] While the curés in Pont-Aven and the neighbouring village of Nizon refused the offer to hang *The Vision* in their chapels, Gauguin's conception of its religious role highlights his deter-

mination to link his artistic vision to the elemental visual faith he imputed to Breton peasants.[51]

Van Gogh's comments on *The Sower* also suggest his interest in a reciprocal connection with his peasant subjects, but unlike Gauguin, in construing a function for his symbolist experiment, he focussed not on worship but on work. In describing *The Sower* to Bernard, he related it to traditional popular prints that combine prototypes of reverent toil with information on farming: "I would much rather make naïve pictures out of old almanachs, those old 'farmer's almanachs' in which hail, snow, rain, fair weather are depicted in a wholly primitive manner."[52] In seeking to hang *The Vision* in a village church, Gauguin hoped to commune with what he called the "very rustic, very *superstitious*" simplicity of Breton peasant faith.[53] Van Gogh's discussion of *The Sower*'s function pointed to another kind of word-image interaction: a community storehouse of pictorial and verbal information to aid farmers' proficiency at cultivation.

When Van Gogh and Gauguin began working together in Arles in the fall of 1888, their incompatible conceptions quickly surfaced. "In general, Vincent and I agree on very few topics, especially not on painting," Gauguin wrote to Bernard in November.[54] Yet, the two artists did engage in a short and intense, if strained, period of reciprocal influence. Gauguin urged Van Gogh to relinquish the model and paint from imagination. Van Gogh produced only one such painting, the *Memory of the Garden at Etten*. Gauguin executed a companion scene, *Old Women of Arles*. Gauguin's motif is from "one of the gardens opposite the Yellow House".[55] The garden's bench, pond and path are depicted, but barely recognizable in an arbitrary, unmodelled rendering. The women's procession moves from the distant path to a foreground bush, shaped like the artist's profile and with a definable eye at its right.[56] In the back left, a trunkless, rootless tree is intimated by gossamer branches. The delicate leaves melt into a green bench below, which, cut off at the top of the painting, tilts up and hangs, its wispy legs as weightless and insubstantial as the feathery cow at the upper left of *The Vision after the Sermon*. Gauguin applied the paint in thin layers and light strokes in the *Old Women of Arles*. Its strong canvas was from a twenty-metre roll he purchased in Arles, coarse burlap of "heavy, textured weave".[57] Before painting on it, Gauguin primed the surface to disguise its rugged texture. When the thinned oil paint was applied, it "was permitted to seep into the fabric" and produce a filmy matt effect, like a fresco, which

49. Gauguin's proposal of the chapel site is in Bretall *et al.*, 1988, p. 103; a description of the church windows and their possible harmonization with *The Vision* is suggested by Ziva Amishai-Michels, *Gauguin's Religious Themes* (New York: Garland 1985), p. 28-29.

50. See Michael Baxandall, *Painting and Experience in Fifteenth-Century Italy* (London: Oxford University Press, 1972).

51. The episodes of the offers and explanations to the curés, and their perplexed and diffident reactions, are noted in Brettell *et al.*, 1988, based on Bernard's rendering, which can be found in his "L'aventure de ma vie", Introduction to *Lettres de Paul Gauguin à Émile Bernard, 1888-1891* (Geneva: Cailler, 1954).

52. Letter to Bernard, June, 1888, in Van Gogh, *Letters*, vol. 3, p. 492.

53. Quoted in Brettell *et al.*, 1988, p. 103 (emphasis Gauguin's).

54. Quoted in *ibid.*, p. 113.

55. Pickvance, 1984, p. 217.

56. Pickvance, *ibid.*, disagrees with the writers who have interpreted the bush as bearing the features of Gauguin's profile. Whether the bush precisely resembles Gauguin or not, it does configure an eye on its right side. Gauguin thereby invests a natural form with an animate quality, another indication of his conviction that there are "supernatural phenomena" of which we nevertheless "have the *sensation*".

Vincent VAN GOGH
Memory of the Garden at Etten, 1888
Saint Petersburg, Hermitage Museum

Paul GAUGUIN
Old Women of Arles, 1888
The Art Institute of Chicago

diminished the "physicality of the image" and enabled it to "relate more to the non-corporeal realm of ideas . . . as the true subject matter of painting".[58] The dissimulation of the graininess of the canvas is particularly striking in Gauguin's rendering of the women's shawls, which presumably protect them against the harsh mistral winds. Yet, like the immaterial "cloak for the idea", Gauguin treated the women's shawls not as textiles of some consistency, but as wispy coverings for a realm of irreducible essences. The second woman in the procession wears a shawl whose thinness is emphasized by an almost transparent brushwork that lets the matt canvas underneath show through – a double layer of pictorial dematerialization.

While *Memory of the Garden* amplified Van Gogh's symbolist conception of evocative form, it also demonstrates the obstacles to his embrace of the incorporeal idealism that came so easily to Gauguin. "Gauguin gives me the courage to imagine things, and certainly things from the imagination take on a more mysterious character," Van Gogh wrote to Theo, describing his work on this painting.[59] Yet, his venture into the realm of mystery and imagination quickly alighted on memories of real things and people that could be rearticulated by internal scrutiny even when no external models were present. Van Gogh wrote that the painting was "a memory of our garden at Etten, with cabbages, cypresses, dahlias, and figures".[60] The figures of the old woman and the younger lady in coloured shawls were suggested by his mother and sister

Wil, although he himself said they were more impressions than exact likenesses, and that the juxtapositions of meandering lines and bright colour contrasts may "fail to give the garden a vulgar resemblance, but may present it to our minds as seen in a dream, depicting its character, and at the same time stranger than it is in reality".[61] To be sure, the *Memory of the Garden* went beyond the limits of a specific site and memory. As scholars have noted, the image is a composite, "in which the physical features of the gardens of Arles pure are blended with memories of the gardens at Nuenen and Etten that Van Gogh had known in his youth".[62]

One of Van Gogh's most "abstract" compositions, the *Memory* nonetheless reaffirms the core principles of his sacred realism. While the painting essayed a Gauguinesque tactic of obstructed horizon and obliterated recessionals, the dense, textrous paint application and fascination with the fibrous quality of canvas expose the distance between the *Memory of the Garden* and Gauguin's *Old Women of Arles*.

57. Gauguin, quoted in Brettell *et al.*, 1988, p. 112; see also Heller, 1985, p. 148.
58. This discussion of the primer, the fusion of medium and support, and the dissimulation of paint structure relies on Heller, 1985, pp. 148-149.
59. Quoted in Pickvance, 1984, p. 214; see the letter to Theo, about November 1888, in Van Gogh, *Letters*, vol. 3, p. 105.
60. Van Gogh, *Letters*, vol. 3, p. 104.
61. Letter to Wil, *ibid.*, pp. 447-448.
62. Brettell *et al.*, 1988, p. 117. See also Pickvance, 1984, p. 216, who notes that the "memory" of the family gardens is "evidently a conflation of those at Etten and Nuenen".

Gauguin invented procedures to smooth down his abraded burlap surface, which enabled the thin colours to melt away into the chalky ground. Van Gogh, by contrast, executed the *Memory of the Garden* by building up a thick patterned deposit of laced colour strokes.

While the shawls draped on the figures in Gauguin's female procession in the Arles garden are thinned pretexts for the incorporeal, the shawls in Van Gogh's *Memory* reconstitute the physicality of his paintings emulating weaving. Preoccupied from his earliest apprenticeship with woven subjects, Van Gogh packed the shawls not only with reminiscences of those in his Hague drawings, but with the lessons of the Nuenen hand-loom weavers. When he described the

younger woman as wearing a "Scottish shawl" of "green and orange checks", he recalled the plaid cloth he had watched being woven in Nuenen.[63] The *Memory of the Garden at Etten* also returned to the visual techniques that had accompanied Van Gogh's persistent presentation of woven objects: the articulation of texturally heightened paint surfaces as pictorial equivalents to the woven cloth represented. The entire surface of the *Memory* bears a thick, raised, grainy deposit replicating the woven qualities of the shawls depicted and re-emphasizing in its coarse facture the woven surface to which it was applied.

The formal coherence of the *Memory* points to Van Gogh's resistance to freeing painting from the penetrative encounter with matter and suggests he recorporealized in paint sediment the missing presence of the model, "the possible and the true". The differences between Van Gogh's and Gauguin's paintings of 1888 are rooted in the cultures that formed them and offer two historically specific responses to the paradox at the heart of all Symbolist painting: how to link the seen and the unseen, the visible image to an invisible domain inaccessible to artist and spectator.

D. S.

63. The description of the chequered "Scottish shawl" in the *Memory* is in the letter to Wil, in Van Gogh, *Letters*, vol. 3, p. 447. For the Hague shawls see, for example, the 1882-1883 pencil and lithographic chalk drawing of *Girl with a Shawl, Half Figure* (F1008); and the 1882 pencil, ink and watercolour *Old Woman with Walking Stick and Shawl* (F913). On the selection of woven objects during the Hague period, and the persistent reliance on woven colour schemes, brushwork and compositional formats in Van Gogh's later periods, see Silverman, 1994, and Silverman, forthcoming.

Music for the Eye
Richard Wagner and Symbolist Painting

GÜNTER METKEN

An exhibition on Edvard Munch and Alban Berg in Chicago and the realization that Anton Webern's String Quartet (1905) was inspired by Giovanni Segantini's *Triptych of Nature* have shown that Symbolist painting influenced the genesis of modern music.[1] On the whole, however, things developed in the opposite direction: it was music, and particularly Richard Wagner's music, that prompted painters to cast off the shackles of academism and to opt for the expression of meaning. It is this emancipation of art through the Wagnerian notion of the *Gesamtkunstwerk*, the "total artwork", that concerns us here.

We know how freely Wagner treated the sources of his librettos, from the *Nibelungenlied* to Wolfram von Eschenbach's *Parzival*. He did not hesitate to launch critical barbs at the authors of the Middle Ages – often quite sharp ones. His main concern was not historical accuracy but the overall concept of the work. He was, by his own admission, an enemy of historicism. The central episode of his opera *Tannhäuser* is based on a contest between minnesingers that actually took place at the Wartburg, a castle near Eisenach, in Thuringia; and yet, the composer rejected the idea of a set that was a replica of the still-existing room in which the contest was held. In 1862, after *Tannhäuser* had opened at the Paris Opera, Wagner visited the recently restored castle and examined the murals with which Moritz von Schwind had decorated the large room, using the *Sängerkrieg* theme as a pretext to pay tribute to the Grand Duke currently in power. The paintings show Elizabeth, in the pose of the Virgin holding out her mantle as a refuge for the oppressed, defending the vanquished Tannhäuser against attacks from his rivals, the other poets.

For Wagner, by contrast, Tannhäuser symbolized the artist who deliberately places himself on the fringes of society, ready to strike fearlessly at its taboos. The composer's assessment of the paintings was, moreover, far from enthusiastic: "I went to see the partial restoration of the Wartburg initiated by the Grand Duke and I also looked at the rooms containing Schwind's frescoes. The whole set-up left me completely cold."[2]

He disapproved for similar reasons of the drawings and paintings of scenes from his operas that Louis II commissioned from Kaulbach, Piloty, Genelli and Echter, which he saw as too slavishly literal in their reconstruction of events. Such works, he wrote the King in his letter of acknowledgement, would be in keeping with the music of Peter Cornelius and represent something of a return to the ideas of classical Antiquity. But had he not proved with his "music dramas" that it was possible to borrow subjects from the Middle Ages that were both nobler and broader in scope? Wagner nevertheless saw in the linear Neoclassicism of Bonaventura Genelli the promise of an art capable of integrating the main features of mythology into the modern era. He also admired the paintings of Anselm Feuerbach. Still, a painter ready to share his own vision had yet to be found.

Wagner did not have especially marked artistic preferences. For him, the visual arts were there simply to serve his own creative endeavour. This explains his strong desire to gain the collaboration of Arnold Böcklin, whom he wished to engage to create the sets for his Bayreuth dramas. It was not to be. A painting called "*Sieh! es lacht die Aue*" was executed in 1887, however, whose springlike atmosphere conjures up the Good Friday Spell; its title comes from a dialogue between Parsifal and Kundry.

1. The exhibition *Violent Passions: Edvard Munch and Alban Berg* was held in the prints and drawings department of the Art Institute of Chicago January 1994. For details of Weber's inspiration, see Günter Metken, "L'élévation en musique : Anton Webern et Segantini", *Revue de l'art*, no. 96 (1992), pp. 82-84.
2. Oswald Georg Bauer, "Die Wartburg – ein deutsches Kulturdenkmal", *Tannhäuser* programme booklet (Bayreuth Festival, 1977), p. 59.

The group of friends who gathered in Dresden on November 17, 1845, to hear Wagner read his *Lohengrin* libretto included painters as well as musicians and writers. In Paris, Gustave Doré attended Wagner's lectures frequently, and, if we are to believe the evidence of some of the artist's preliminary drawings for woodcuts, it seems likely that he was influenced by this contact. Later, when the composer had at last achieved success, he socialized with the most famous artists of the period. He was a visitor at the Munich home of Franz von Lenbach, who painted his portrait and that of his family. He visited Hans Makart's studio in Vienna, in the hope that the painter might work on the sets for Bayreuth. In fact, Makart was present along with the rest of Europe's elite at the opening of the first festival and there received a salutary shock sufficient to push him beyond his refined *pompier* art. In 1883, as a tribute to the musician, who had recently died, he painted eight apparently uncommissioned scenes derived from *Der Ring des Nibelungen*. These large grisailles, most of which are now in the museums of Riga and Kiev, are musical rather than illustrative. The freedom of expression they embody is quite foreign to the rest of this painter's eclectic oeuvre.

In Berlin, Wagner met Adolf von Menzel, whose works include a sketch of the composer made at Bayreuth during a rehearsal. In 1882, Renoir met Wagner by chance in Palermo – where he was completing the orchestration of *Parsifal* – and painted the composer's portrait.

From these various friendships, these various relationships with major artists, it is impossible to derive much about the precise nature of Wagner's own tastes.[3] It is clear that he had no greater contact with the avant-garde of his time than he had with the literary productions of his contemporaries. Confronted with masterpieces from the past, he was much more likely to appreciate pleasing technique or harmoniously blended colours than any expression of character. Titian's *Assumption* in Venice and Leonardo's *Last Supper* in Milan were, for him, the very apotheosis of art. We must recognize, in short, as did Nietzsche, Thomas Mann and Adorno, that Wagner was a dilettante. He was not attuned to any specific type of art. For him, it all had but a single goal – to serve his music, the "analogy with language" (Adorno) and its power of

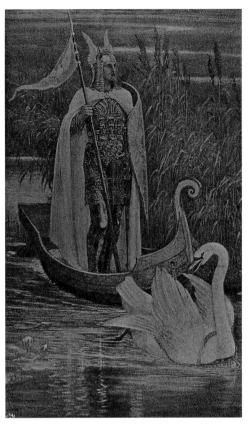

Walter CRANE
Lohengrin, 1895
Location unknown

mimicry; everything was aimed at reinforcing its "intelligibility" (Nietzsche). We should add to these views, however, that of Claude Lévi-Strauss. The French ethnologist always acknowledged Wagner as the father of his structural analysis of myths:

> Music no doubt also speaks; but this can only be because of its negative relationship to language and because, in separating off from language, music has retained the negative imprint of its formal structure and its semiotic function . . . In music, the coalescence of a global metaphorical significance around the work makes up for the missing aspect.[4]

It is clear, in fact, that by so vigorously defending the synthesis of all the arts, Wagner encouraged the painting of the late nineteenth and early twentieth centuries in its struggle towards freedom of expression and emancipation from the subject.

Baudelaire and "Wagnerian Painting"

Romanticism saw music and painting as two arts capable of mutually supporting and stimulating one another – even of speaking on each other's behalf. Since the French Revolution,

3. Hartmut Zelinsky, *Richard Wagner – ein deutsches Thema. Dokumentation zur Wirkungsgeschichte Richard Wagners 1876-1976* (Frankfurt am Main).
4. Claude Lévi-Strauss, *Mythologiques IV, L'homme nu, finale* (Paris: Librairie Plon, 1971). Quoted in English from *The Naked Man: Introduction to a Science of Mythology: 4*, trans. John and Doreen Weightman (New York: Harper & Row, 1981), pp. 647-648.

the arts had no longer been subject to the constraints imposed by royalty and religion. But specialization brought isolation, and this led some artists to seek a new synthesis. It was music, at once concrete and intangible, similar to language but appealing to the emotions, that would henceforth serve as the organic link between the arts. Painter Philipp Otto Runge interpreted this idea by conceiving of a new form of art, one liberated from the restrictions of society and representation and now aimed, like music, at reflecting the impulses of the heart and the soul.[5] Standing before Raphael's *Sistine Madonna* in Dresden, Runge realized that "a painter is also a musician and an orator". He likened the execution of his series "Die Tageszeiten" [The Hours of the Day] to the "composition of a symphony" and called upon architecture to supply the structuring context:

> On the subject of my four paintings – both the biggest and all the others still to come – in sum, when everything has been fully developed, I've a feeling that the whole thing will become a painting-poem, simultaneously abstract, fantastic and musical, with choirs, a composition for three arts combined, for which architecture will have to furnish a very special edifice.

Caspar David Friedrich was thinking along similar lines when he requested a musical accompaniment for four of his landscapes exhibited in Saint Petersburg; and so was Adalbert Stifter, painter and writer, when he asked himself, "Would it not be possible, by using lighting and colour simultaneously and successively, to create music for the eye, just as we use sounds to create music for the ear?"[6]

But it was the poet Baudelaire, inspired by the music of Wagner and the painting of Delacroix, who would develop a full-fledged system based on the notion of "correspondences". Turning his back on reality and all forms of realism, he recognized no authority higher than the imagination. In this artificial circle, words, scents, sounds and colours interact. In a letter to Wagner dated February 17, 1860, Baudelaire, opium-eater, wrote that the "Introduction of the Guests" in *Tannhäuser* and the "Marriage Feast" in *Lohengrin* seemed to him "comparable to those stimulants that speed up the pulse of the imagination" and caused him to see a variety of colours. He continues thus:

> To use a comparison borrowed from painting, I imagine a vast extent of red spreading before my eyes. If this red represents passion, I see it change gradually, through all the shades of red and pink, until it reaches the incandescence of a furnace. It would seem difficult, even impossible, to render something more intensely hot and

yet a final flash traces a whiter furrow on the white that provides its background. That, if you will, is the final cry of a soul that has soared to a paroxysm of ecstasy.

Baudelaire's 1861 study of Richard Wagner and *Tannhäuser* contains the profession of faith that might be expected of a poet who took refuge from the commonplace behind the bulwark of synesthesia and who, like Edgar Allan Poe, considered that poets make the best possible critics. While using this opinion to defend his own theory and cause, Baudelaire wished also to see it applied to the composer Wagner:

> For what would be really surprising would be if sound were incapable of suggesting colour, colours incapable of evoking a melody, and sound and colour incapable of translating ideas; for things have always expressed themselves through reciprocal analogy, since the day God decreed the world a complex and indivisible whole.[7]

In fact, since the Paris premiere of *Tannhäuser*, Wagner had become the centre of a movement defending the synthesis of the various arts. The mouthpiece of the group was the *Revue wagnérienne*, founded in 1885, whose aim was to publicize both the master's music dramas and his theory of the "total artwork". It was not long before his ideas were taken up by poets, among them Mallarmé, Verlaine, and even Claudel and Valéry, whose literary careers were just beginning. But it was above all painters who rallied to Wagner's call. Since Whistler's *White Girl (Symphony in White No. 1)* (1862) and Monet's *Green Harmony* (1872), they had been seeking chromatic resonances and musical combinations that would help make images the vehicle of emotional expression, suffuse them with spiritual values – become, in short, the interpreters of widely accessible ideas and symbols. The time had come for painting to at last abandon its age-old habit of copying and accede to absolute power; instead of reproducing objects, its role was now to stimulate emotion: this, at least, was the categorical claim of poet Arthur Rimbaud. A sentence of Wagner's, written in colour on the wall of Marie Henry's inn at Le Pouldu, served as a slogan for Gauguin and the young men who gathered around him there in 1889-1890. Other painters, like

5. Jörg Traeger, *Philipp Otto Runge und sein Werk* (Munich: Prestel, 1975), pp. 130-132.
6. Werner Haftmann, "Über die Funktion des Musikalischen in der Malerei des 20. Jahrhunderts", in *Hommage à Schönberg* (Berlin: Nationalgalerie, 1974), p. 14.
7. Charles Baudelaire, "Richard Wagner et *Tannhäuser*", *Curiosités esthétiques. L'art romantique* (Paris: Édition Henri Lemaître, 1962), p. 696. Baudelaire's letter to Wagner is quoted in English from *Selected Letters of Carles Baudelaire* (Chicago: University of Chicago Press, 1986), ed. and trans. Rosemary Lloyd, p. 146.

Gustave Moreau and Odilon Redon, adopted the same approach, inspiring critics to describe the works they exhibited at the Salon of 1885 as "symphonic painting" and even "Wagnerian painting".

In 1886, Redon executed a lithograph for the *Revue wagnérienne* entitled *Brünnhilde* and, six years later, another called *Parsifal*. This latter work illustrates better than any how the goal was harmony on a spiritual level rather than a direct rendering of the music. Redon's Parsifal is a symbol, an ideal of purity, of crystalline clarity. He is a knight from the world of childhood rather than a character from an opera. Redon's aim was to create symbolic characters with specific personalities that were clearly illustrated by the drawing, and he studiously avoided the superimposition of several themes. His harsh judgement of the work of Henri Fantin-Latour can be taken as a warning:

> Laborious and painstaking research has led this artist to attempt the interpretation of music through painting; but he forgets that no colour can translate the world of music, which is uniquely and exclusively internal and without support in nature. Having obviously failed, he tries to compensate by expressing his feelings through lithography, creating drab, lifeless sketches based on the poems of the musician Wagner.[8]

Many lesser painters of the period succumbed to the temptation to employ themes of this type, no doubt encouraged by the fashion for imbuing paintings with a certain tone by associating them with the name of a composer. For example, a highly suggestive work by the Post-Impressionist Fernand Khnopff is entitled *Listening to Schumann* (1883). Later, between 1907 and 1909, the Symbolist painter Lévy-Dhurmer executed a triptych dedicated to Beethoven (Paris, Petit Palais) that shows the composer's face flanked by two female nudes: on the left, *The Appassionata*, and on the right, *The Ode to Joy*. According to Camille Mauclair, the aim of this painting was "to translate through the poses of a female nude all the emotions of a symphony, to turn a palpitating torso into a complete synthesis of rhythms and feelings, to treat the body like a language".[9]

Henri FANTIN-LATOUR
Prelude to "Lohengrin", 1882
Paris, Bibliothèque nationale de France

The dominant figure of this aesthetic revival in fin-de-siècle Barcelona was Eusebi Güell, a textile industrialist and fervent Wagnerian. Between 1885 and 1889, he had a house built on Carrer Nou by Antoni Gaudí. The Palau Güell is built around a central music room that occupies three floors and is lit from the top by a glass cupola. The whole edifice recalls the Temple of the Grail in *Parsifal*, thought by some to be based on the Catalonian monastery at nearby Montserrat, and the architecture reflects the Wagnerian notion of redemption – "the emergence from darkness into light".

The visionary paintings of the American Albert Pinkham Ryder have only recently been rediscovered. Ryder (1847-1917) had a predilection for literary themes, which he explored using a mysterious chiaroscuro to suggest the demonic forces of nature that keep mankind in a state of almost mythical dependence. Two paintings based on Wagner represent the high point of his work. *The Flying Dutchman*, from 1887, shows the empty ship at the mercy of the elements. Recounting the inspiration for *Siegfried and the Rhine Maidens*, Ryder said, "I had been to hear the opera [*Götterdämmerung*] and went home at about twelve o'clock and began this picture. I worked for forty-eight hours straight, without sleep or

8. Odilon Redon, *À soi-même, Journal 1867-1915* (Paris: José Corti, 1961), pp. 156-157. Redon's diary has been published in English as *To Myself: Notes on Life, Art and Artists*, trans. Mira Jacob and Jeanne L. Wasserman (New York: George Braziller Inc., 1986).
9. Camille Mauclair, *Autour de Lévy-Dhurmer, visionnaires et intimistes en 1900* (Paris: Grand Palais, 1973), p. 58.

James ENSOR
At the Conservatory in Brussels, 1890
Liège, André Joiris collection

already been studying music for eight years, mostly in Germany, when he decided to become a painter. The parallel development of a number of separate voices, which is an innovative feature of his symphonic poems entitled *The Sea* (1907) and *The Poet of the Cosmos*, can also be perceived in his paintings. While Kandinsky, and to some extent Klimt and Matisse, were attempting to create a music from colour, in Čiurlionis's work, painting is in perfect harmony with the constructive thinking of the composer. This complete concordance does not reside simply in the fact that his cycles of paintings bear musical names, like "Prelude and Fugue" and later "Sonata", but is also due to their fundamentally musical structure: they include polyphonic motifs that echo one another, the dialectic of the fugue; and continuous melodic lines that rise to a final climax. The themes that inspire the various "Sonatas" – summer, the sun, springtime, the stars and the sea – intertwine and endow these paintings with a glimmer of the harmony of the spheres imagined by Pythagoras.

food."[10] *Götterdämmerung* was first performed in New York in 1888 and the entire *Ring* cycle the following year. In the painting, Siegfried meets the Rhine Maidens while hunting, and they demand that he give them the ring. But it is the menace of Nature that dominates this moonlit night. Man, even in the form of a virtually invincible hero like Siegfried, is helpless against natural destiny.

In Belgium, then a crossroads of Europe, Wagnerian ideas had a profound effect. In 1890, James Ensor showed a painting at an exhibition organized by Les XX under the innocuous title of *At the Conservatory in Brussels*; the work, however, was actually a bitter satire of musical life in the Belgian capital. In it, we see – and almost hear – *Die Walküre* being played so execrably by the Conservatory musicians that the composer, depicted in a painting-within-the-painting, is reduced to blocking his ears. In some works, Ensor identifies with Christ on the cross; here, he identifies with genius, seen as a victim of bourgeois indifference.

For the Brussels Symbolists, the characters of Wagner's operas possessed an erotic and esoteric significance closely linked to the mystagogy of Sâr Péladan and the doctrine of the Rosicrucians. Notable among them were Jean Delville, creator of a *Tristan and Isolde* and a *Parsifal*, and Henry De Groux, who painted a well-known *Lohengrin* (1908).

The approach of Lithuanian painter Mikalojus Čiurlionis was both more modest and more genuinely original.[11] He had

Moscow – "The Tuning Fork for My Painting"

Of all artists, it was Kandinsky who felt the interdependence of painting and music most keenly and expressed it most strikingly. For him, colour and sound had equal status as the foundations of "the spiritual in art". He attempted to reveal this reciprocity in his scenic poem *Der gelbe Klang* and his 1922 design for a music room in Berlin.

The circumstances under which Kandinsky experienced the revelation of this "aural vision" are of particular interest to us. In 1913, he "cast a backward look"[12] over the conditions that had led to the development of his abstract paintings, which, to emphasize their similarity to music, he initially called "compositions" and assigned opus numbers. Werner Haftmann has spoken of these works as "translations of the Wagnerian music drama into the language of painting".[13] One of Kandinsky's recollections concerns a youthful experience that affected him deeply – a sunset over Moscow, which he describes as if it were a symphonic poem:

10. Elliott Daingerfield, "Albert Pinkham Ryder, Artist and Dreamer", *Scribner's Magazine*, vol. 63 (March 1918), pp. 380-384; quoted here from Lloyd Goodrich, *Albert P. Ryder* (New York: George Braziller, Inc., 1959), p. 115.
11. Gytis Vaitkunas, "Die Musik und die Malerei", *Mikalojus Konstantinas Čiurlionis* (Dresden: VEB Verlag der Kunst, 1975), pp. 90-102.
12. Wassily Kandinsky, *Rückblicke* (Bern: Benteli, 1977). This and other remarks of Kandinsky's are quoted in English from *Kandinsky: Complete Writings on Art*, vol. 1 (1901-1921), ed. and trans. Kenneth C. Lindsay and Peter Vergo (Boston: G.K. Hall & Co., 1982). "Reminiscences", pp. 360, 361, 363, 364, 366, 382.
13. Haftmann, 1974, p. 18.

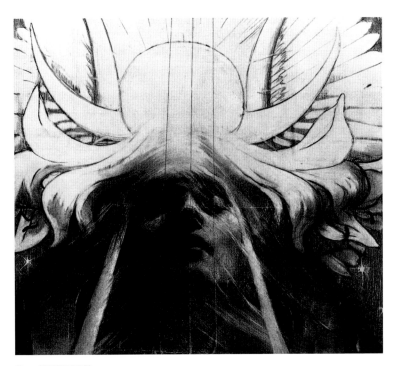

Jean DELVILLE
Parsifal, 1890
Brussels, private collection

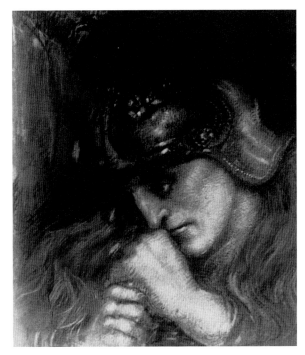

Henry DE GROUX
Lohengrin, 1908
Brussels, private collection

The sun dissolves the whole of Moscow into a single spot, which, like a wild tuba, sets all one's soul vibrating. No, this red fusion is not the most beautiful hour! It is only the final chord of the symphony, which brings every color vividly to life, which allows and forces the whole of Moscow to resound like the *fff* of a giant orchestra.

It was in vain that the artist – at that time a student of law and economics – tried "to capture on canvas the 'chorus of colours'". His eyes were soon to be opened, however, by two events – events, he says, that "stamped my whole life and shook me to the depths of my being. These were an exhibition of French Impressionists in Moscow – first and foremost, *The Haystack* by Claude Monet – and a performance of Wagner at the Court Theatre – *Lohengrin*."

The opera, which struck him as a precursory manifestation of the resonant image he was seeking, reinforced his conviction that painters are just as capable as composers of creating an intangible world:

> *Lohengrin*, on the other hand, seemed to me the complete realization of that Moscow. The violins, the deep tones of the basses, and especially the wind instruments at that time embodied for me all the power of that pre-nocturnal hour. I saw all my colors in my mind; they stood before my eyes. Wild, almost crazy lines were sketched in front of me. I did not dare use the expression that Wagner had painted "my hour" musically. It became, however, quite clear to me that art in general was far more powerful than I had thought, and on the other hand, that painting could develop just such powers as music possesses.

This passage throws light on why the basic concepts of Kandinsky's Munich writings are couched in a musical vocabulary, and why terms like "tonality" and "sonority" recur so frequently. It also helps explain why Kandinsky devoted such a large segment of his *Blaue Reiter Almanac* to the Russian composer Alexander Scriabin, who undertook experiments into the evocative power of colour when he played the piano. In May 1913, Kandinsky added an analysis of *Composition VI* to his memoirs in which he employs the words "fugue", "note" and "largo". And once again he refers to *Lohengrin* – the opera that, for Thomas Mann and Ernst Bloch, conjured up harmonies in blue, the colour seen by Kandinsky as the most fundamental. Discussing Rembrandt, the artist wrote, "The great divisions of light and dark, the blending of secondary tones into the larger areas, the way in which these tones melt together in these areas (which from a distance produced the effect of a mighty chord and reminded me immediately of Wagner's trumpets)."

"It Was the Same to Me as Making Music"

The oil paintings and watercolours produced by Arnold Schoenberg during the same period led Kandinsky to perceive a spiritual affinity between himself and the composer. In 1911, Schoenberg was asked to dispatch to Munich his contribution to the Blaue Reiter exhibition. He chose a *Self-portrait* showing him from the back and some imaginary "visions" that sparked Kandinsky's enthusiasm and approval, although Franz Marc and particularly August Macke were less positive in their judgement. There is no doubt, however, that Schoenberg's treatise on harmony, *Harmonielehre*, published in the same year, had a considerable influence on the Munich painters. Marc actually wrote:

> This is the idea that was constantly in my mind today as I painted, and that I draw upon in my work as a painter: it is absolutely unnecessary to display all the complementary colours next to one another as they appear in the spectrum; on the contrary, one can "dissociate" them and leave spaces between them as big as one likes. The partial dissonances that result are ultimately resolved in the painting as a whole, creating an impression of consonance (harmony) depending on their degree of complementarity as regards radiation and intensity.[14]

Schoenberg was also awarded a place in the *Blaue Reiter Almanac*, produced by Kandinsky and Marc; he is represented by a musical setting of a poem by Maeterlinck and an essay entitled "The Relationship to the Text", which deals with the composition of lieder and programme music. In it, he expresses his contempt for the attempt to attain an "external congruence of music and text". Schoenberg supports his thesis with arguments taken from painting: no one, he says, still expects a history painter to rival a historian in erudition or a portrait to "look like" its model, rather than having character and expression.

Schoenberg's painting is an almost primitive manifestation of the intuitive approach to art, which sees the artist's creative process as instinctive and imposes on the fully focussed composer the following requirement: "Genuine feeling should never hesitate to plunge ceaselessly into the darkest depths of the subconscious to reap the substance and form of the work, fused in a single entity."

Schoenberg painted both portraits and imaginative compositions. His portraits of the members of his circle in Vienna recall the works of Delaunay and the Fauves, while his "Impressions" and "Imaginations" have a superficial similarity to the work of Richard Gerstl and Oskar Kokoschka but are actually more closely related to Munch and the painter Strindberg. They consist of masks, visions of unreality, fixed "gazes", coloured mists with eyes floating on the surface – accounts of nightmares "found in the cave of an intelligent troglodyte", as Albert Paris Gütersloh put it in 1912, the year Schoenberg gave up painting. His pictures, bold forays into an area as yet unformulated, coincided with his first great compositional period – the period bounded by the Chamber Symphony No. 1 and *Pierrot Lunaire* – and share the same mood of liberated harmony and the same atonal technique.

The blossoming of Viennese modernism owed much to the Wagnerian concept of the *Gesamtkunstwerk*. It was present from the outset, for example, in the work of town planner Camillo Sitte. In his *City Planning according to Artistic Principles* (1889), he criticized the attitude that had led to the development of the Ringstrasse. According to Sitte, town planning should be guided by cultural considerations rather than the requirements of traffic. For him, urbanism meant successfully uniting society's various layers in an architectural context, as Richard Wagner had done at Bayreuth. Taking *Die Meistersinger* as a model, it was his aim to build upon a social myth, a myth that would be realized later, and under different circumstances, in the urban centres of "red Vienna". Sitte, who was Director of the Staatesgewerbeschule, had his official quarters decorated with scenes from *Der Ring des Nibelungen*, and his inaugural lecture was devoted to "Richard Wagner and German Art". For Sitte, the meeting of minds that marked the gathering in Bayreuth of so many different kinds of people was a foretaste of the organic town planning of the future.

Wagner was also considered a precursor by painters. When Gustav Klimt designed his famous ceiling for the University of Vienna's large festival hall – a project that was moreover refused in 1900 by the institution's scandalized teaching staff – he included in it an allusion to the *Ring*. The university authorities were particularly shocked at the representation of Philosophy by female nudes, floating aimlessly in space and clearly derived from Wagner's Rhine Maidens. The appearance towards the bottom of the mural of the figure representing Knowledge also recalls the prophetic appearance of Erda in *Das Rheingold*.

But Wagner's impact went far beyond the simple borrowing of themes. In 1902, when the influence of the Vienna Secession was at its height, the fourteenth exhibition focussed on Max Klinger's huge sculpture *Beethoven*, around which, in

14. August Macke and Franz Marc, *Korrespondenz 1910-1914* (Cologne: DuMont, 1964), p. 40.

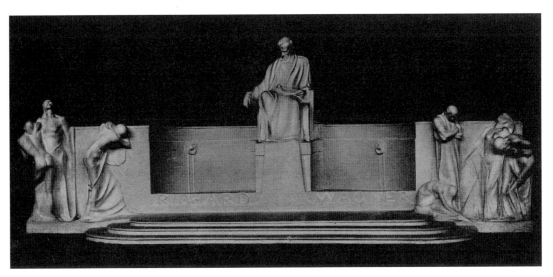

Franz METZNER
Project for a Monument to Richard Wagner, Berlin, 1901 (lost)

a building by Joseph Maria Olbrich, Josef Hoffman created a veritable *Gesamtkunstwerk*. The key piece was Klimt's *Beethoven Frieze*,[15] which depicts humanity's ascension towards fraternal love: it shows an embracing couple, inspired by the verse "Diesen Kuß der ganzen Welt" from Friedrich Schiller's "Ode to Joy", which Beethoven used for the final chorus of his Ninth Symphony.

For the concerts he conducted in Dresden in 1846, Wagner had produced a programme designed to facilitate compre-hension of this work. He had a particular fondness for the Ninth owing to its mood of liberation. For both Beethoven and Wagner, only art could soothe the sufferings of humanity, only art could vanquish the forces of adversity. The text of this musical narrative was, in fact, reproduced in the Secession catalogue, and Klimt recounts all its episodes in his compo-sition. It amounts to the proclamation of a new era, with Richard Wagner as source of energy and pioneer figure in the emanci-pation of mankind.

When the city of Berlin, capital of the German Reich, was preparing to erect a monument to Wagner in 1903, the only submission to the competition worthy of the composer's enor-mous influence in the intellectual realm came from an Austrian sculptor, Franz Metzner.[16] It was not selected.

G. M.

15. M. Bisanz-Prakken, "Der Beethoven-Fries von Gustav Klimt in der XIV. Aus-stellung der Weiner Sezession", *Traum und Wirklichkeit, Wien 1870-1930* (Vienna: Künstlerhaus, 1985).
16. Günter Metken, "Denkmale, wo keine sind. Richard Wagner und die plastische Erinnerung", *Walküre* programme booklet (Bayreuth Festival, 1983), pp. 33-34.

II. *The Self beyond Recovery*

JEAN CLAIR

Far from being the "detestable" thing it was for the Classical age, the Self was the cherished child of Romanticism. Elevated to the status of a cult in the work of Stendhal, egotism became an ethic as much as an aesthetics. Thus, the most enigmatic figure in the eyes of the Romantics themselves, one that keeps coming back like a fear deep within the supremacy of the subject, is perhaps that of Kaspar Hauser, the man who no longer remembers who he is. From E. T. A. Hoffmann to Guy de Maupassant, the figure of the vagabond amnesiac fascinated the nineteenth-century sensibility. Jules Verne's Captain Nemo is but a popular avatar of it.

In the economy of the Symbolist psyche, the Self and its celebration remain the kernel of the creative phenomenon. They bring the Western culture of the individual to what is perhaps an unparalleled degree of refinement. Huysmans's hero Des Esseintes cultivates the unity of his Self fervently and furiously. But his pursuit also leads to exhaustion and depletion, which are quintessential features of a vital principle. Unlike the flamboyant, extravagant Self of Romanticism, this is a threatened, besieged Self, one that is, in any case, elusive and maybe even *unrettbar*, to use the term Ernst Mach popularized around 1880.

Sovereignty of the inner world of the mind, like mastery of the world outside, was an aspiration of the Romantics. However, as soon as such an ambition is achieved, it comes up against its own limitations. If the Self exists, where are its boundaries? For they fade the moment we seem to grasp them, and we must wonder if they ever really existed. Romanticism thought it had achieved a balance between the inner world and the physical world – between the *Innenwelt* and the *Umwelt* – and it believed that this balance had reached such a degree of refinement that both worlds could be said to be equivalent. In *Naturphilosophie*, *physis* and *psyche* exchanged properties, were immersed in one and the same cosmos.

If Romantic painters looked upon landscape as a state of mind, a place where the gaze both rests and reposes, Symbolism invites us to invert this formula: the state of mind becomes the landscape. But it is an empty landscape, a deserted world without any centre or circumference – in Schnitzler's expression, *das weite Lande*, a distant land forever un-knowable and foreign. Thus, the search for an essential identity perceived as the Self's proximity with itself – this perilous and many-faceted game – soon comes to be experienced as a loss of self, as an illusion that the mind can never truly grasp.

This represents a revolution in the idea of the subject, a calling into question of the sovereignty of the inner world. The emergence of the emancipated individual and Romantic

hero at the beginning of the nineteenth century is transformed, by century's end, into the collapse of the underpinnings of self-possession. Released from subjugation to society, the Symbolic figure is one who, far from being intoxicated by his freedom, discovers that he is inwardly subjugated.[1] The Symbolist project – the very word *sym-bolon* conveys the idea – is nothing but a desperate attempt to re-establish links between fragmented representations of the subject, to recapture a unity threatened by the dislocating forces that the new psychology was only just beginning to define and remedy. Such forces, of course, included dreams, unconscious drives, and psychic automatisms and reflexes, as well as the newly discovered ills of the soul, the neuroses and various forms of hysteria.

We mentioned Ernst Mach above. Indeed, it is from the most entrenched kind of Positivism that the sharpest attack upon the Self comes. We are familiar with the scientist, but less so with the philosopher and the considerable influence he exerted on the Viennese intellectual milieux of the Symbolist and other eras. A friend of Hermann Bahr, he had Hofmannsthal and Peter Altenberg as fellow students at the University. At one point, he planned to collaborate on a libretto with Schnitzler. Robert Musil dedicated his doctoral thesis to him. Taking up the empiricism of Hume and Berkeley, with a nod in the direction of the Kantian transcendental subject, Mach advanced a sense-based, constructivist theory of the subject taken to its most extreme consequences. In his view, the subject is only the transitory result of the interrelationship between complexes of sensations – "times, spaces, pressures, colours, sounds", what he refers to as elements perpetuated by memory and habit, yet modified and altered, incessantly metamorphosed by experience. The thing-in-itself and the Self cannot exist independently of each other. Rather, they are reciprocally constituted on the basis of experience, in other words, on the basis of the perception of phenomena and events filtered through sensation. The logical consequence of this conception, by which "the Self cannot be rescued", is a relativist vision of what one might, with a certain degree of difficulty, still call "the subject".[2]

> When I say that the Self is beyond recovery, I mean that it resides in the human perception of all things and manifestations, that this Self dissolves in everything that is susceptible of being felt, heard, seen and touched. Everything is ephemeral, a world without substance made up only of colours, shapes and sounds. Reality is in perpetual flux, changes its colours like a chameleon. What we call the "Self" is crystallized in this play of phenomena. And from the day of our birth until the day of our death, this Self is in constant transformation.[3]

"Chameleon" reality, "ephemeral" world, "perpetual flux", and dissolution . . . In the light of this analysis, one can understand why a historian of the Jung Wien like Johnston was able to give the generic title of "Impressionism" to what we ordinarily refer to as "Symbolism".[4] The formal distinction that art historians have made between Impressionism and Symbolism no longer holds when one considers that their reaction to Naturalism operates through a common refusal of a subject and object posited as both independent and interdependent. In response to Munch's sinuous, swirling lines, the graphic maelstroms engulfing his characters, we have the flicker and shimmer, the luminous dust, that dissolve

1. See Marcel Gauchet and Gladys Swain, *La Pratique de l'esprit humain* (Paris: Gallimard, 1980).

2. Here we draw upon Yves Kobry's excellent analysis, "Ernst mach et le moi insaisissable", in *Vienne: L'Apocalypse joyeuse* (Paris: Centre Georges Pompidou, 1986), pp. 124ff.

3. Letter to Hermann Bahr, 1908. Quoted in Kobry, 1986, p. 126.

4. William M. Johnston, *The Austrian Mind: An Intellectual and Social History, 1848-1938* (Berkeley: University of California Press, 1972).

forms and shapes in the Post-Impressionist paintings of Segantini and Klimt. In countries like Austria and Italy, where the Impressionist revolution arrived late, Divisionism and Pointillism were ways of casting doubt on the sensory reality of the world of colour. In the same way, curved lines, arabesques and lines considered as transcriptions of forces were linear devices for dissolving outlines and abolishing the distinction between the inner world of the mind and the outer world of sense perception. On the one hand, we have the disappearance of localized colour, which is replaced by flecks of paint, by points and dabs that break down light – a "chameleon" world that replaces the once-durable colours of objects with evanescent veils. On the other hand, we have a line-by-line parsing and carving up of form, which deprives the object of weight, foundations and stability.

Once again, the evolution of ideas in psychology aptly echoes this revolution in plastic vocabulary. In 1896 in France, Bergson's *Matter and Memory* had already questioned the identity of the subject on behalf of the fertile mobility of duration. And more than a decade before him, Théodule Ribot, in his *Maladies de la personnalité*, advanced a sense-based conception of mental life that was not far different from the one proposed by Mach. Taking up the Romantic idea of synesthesia, the *Gemeingefühl* – in other words, the "general sensibility" by virtue of which the soul is informed of the state of the body – he affirmed that our personality, our Self, was nothing other than the set of continually fluctuating and partially unconscious messages that emanate, under a constant barrage of "intermittences",[5] from our corporal existence.

> The unity of the ego, in a psychological sense, is, therefore the cohesion, during a given time, of a certain number of clear states of consciousness accompanied by others less clear, and by a multitude of physiological states which without being accompanied by consciousness like the others, yet operate as much and even more than the former. Unity, in fact, means coordination . . . The problem of the unity of the ego is, in its ultimate form, a biological problem.[6]

Later, Pierre Janet was to correct any overly biological or mechanistic leanings in this theory by introducing the idea that the operation of the real implied, above all, attention, effort and voluntary action aimed at maintaining its presence. The term he employed was "presentification", in other words, the concentration of the mind on the present moment. The operations of the mind were not all of the same nature. Rather, they composed a hierarchy. Below the activities performed in an indifferent or reflexive manner were imaginative functions, memory, revery, affective reactions and motor discharges. Moving up the hierarchy, there were functions that demand presence of mind, will and attention. Each mental operation corresponded to a sort of coefficient of reality attributed to the psychological tension of the subject.

As enlightening as it may be for analyzing the themes and forms of Symbolism,[7] there is no point in continuing this account of the discovery of unconscious functions and of the gradual stripping away of the Self's privileges. Let us simply say that our few brief examples make it clear how profoundly in error Freud was when, in 1925, he stated that prior to psychoanalysis the identification of psychism and conscious mind was the norm.[8]

5. We already know the importance that Proust attributed to this function of sensibility.
6. Quoted in Jean Starobinski, "A Short History of Bodily Sensation", in *Fragments for a History of the Human Body* (New York: Zone Books, 1989), p. 358
7. Henri Ellenberger, "Pierre Janet et l'analyse psychologique", in *Histoire de la découverte de l'inconscient* (Paris, 1993), p. 399.
8. Sigmund Freud, *Ma vie et la psychanalyse* (Paris, 1968), p. 40.

The crisis of the subject and the collapse of the primacy of the conscious mind go back well before Freud and the turn of the century, before Mach, Bergson, Ribot and Janet. These developments began before the mid-century, with Romanticism's establishment of the origins and meaning of an unconscious that would eventually undermine the omnipotence of the Self. Schelling, who affirmed the identity of nature and mind in a common *Weltseele*, or world soul, and von Schubert, who studied the hieroglyphic nature of visual imagery (*Traumbildsprache*) in *The Symbolism of Dreams*,[9] did more than open the doors to the Romantic sensibility. They also opened the treasure chest of Symbolism.

But the first to recognize the importance of the unconscious was Carus, the painter and doctor who, in his book *Psyche* (1846), wrote:

The key to knowledge of the conscious life of the soul is to be sought in the domain of the unconscious. Hence the difficulty, if not the impossibility, of fully understanding the soul's secret. If an absolute impossibility prevented us from finding the unconscious within the conscious, man would have no other choice but to despair of ever arriving at an understanding of himself. But supposing such an impossibility to be merely apparent, then the first task of a science of the soul will be to establish how the mind of man can descend into the depths.[10]

Subsequently Schopenhauer, Hartmann and especially Nietzsche would infuse Symbolist ideology with the premonitions of these precursors from the first forty years of the nineteenth century, premonitions that had deprived people of their sense of self and of the mastery they ostensibly exercised in their own house.

We are generally familiar with the role Schopenhauer's philosophy played in propagating the teachings of Buddhism throughout Europe. The extinction of the will to live, the illusion of the subject and the world's lack of reality – these would become the topoi most familiar to fin-de-siècle minds that were not only yearning for religious syncretism and gnosis, but also fascinated by the idea of death.

We know less about the degree to which Nietzsche participated in this radical critique of the fetishism of the subject, or the full scope of his acute insights into the impersonality of subjective processes. At the beginning of *Beyond Good and Evil*, he writes:

I shall never tire of underlining a concise little fact which these superstitious people are loath to admit – namely, that a thought comes when "it" wants, not when "I" want; so that it is a *falsification* of the facts to say: the subject I is the condition of the predicate "think." *It* thinks: but that this "it" is precisely that famous old "I" is, to put it mildly, only an assumption, an assertion, above all not an "immediate certainty".[11]

A half century later (it was already 1936) Paul Valéry, that faithful heir of Symbolism, was to write: "There are, therefore, in this Self, in this *Ipséité*, parts and elements as foreign to yourself as if they belonged to other people; and you are quite surprised by the dreams in which you happen to have dealings with people you never think about and find yourself in strange situations. Instead of saying, 'I dreamed', you should say, '*He was dreamed*.'"[12]

9. *Die Symbolik des Traumes*, 1814.
10. Carl Gustav Carus, *Psyche. Zur Entwicklungs-geschichte der Seele*. Quoted in Ellenberger, 1993, p. 237.
11. Friedrich Nietzsche, *Beyond Good and Evil: Prelude to a Philosophy of the Future*, trans. Helen Zimmerman (London: Allen and Unwin, 1967).
12. Paul Valéry, *Cahiers*, vol. 2, p. 321. Quoted in Marcel Gauchet, *L'Inconscient cérébral* (Paris: Seuil, 1992) p. 159.

The Agony of the Self

As an object susceptible to an unlimited range of symbolic meaning, the mirror could be the symbol of Symbolism itself. It has been said that the mirror is, in any case, its emblem of choice.[13] In a world in the process of dissolution, in this "foreign land" that the Self has become, the *speculum* is the one object that can still focus attention, concentrate the flow of consciousness and halt the dissolution of appearances. For was it not, all the way down from Plato to Plotinus (both of whose teachings were rediscovered at the turn of the century), the image of the soul itself? And the painter's canvas, that mirror of the mirror, in which he depicts and represents himself, is its instrument.

Mirrors, like symbols, provide revelation and thereby partake of the magical. One uses a mirror to see what could not be seen without it – one's face, for example, or what lies beyond one's field of vision. Like the mirror, the symbol holds before us the reflection of what we cannot grasp, of what eludes us somewhere beyond our space and time. All symbolism is a form of catoptromancy that plunges us into what Baudelaire would call the "profound years".

It is no accident that Böcklin uses the canvas as a mirror when, drawing upon the medieval imagery of the *danse macabre*, he inscribes the background with the image not of the devil, but of Death playing the fiddle. Rethel had already used this iconography, which a new taste for the "gothic" had restored to popularity. This tale of the quick and the dead is also a meditation on vanity, the ephemeral and the fallacy of the senses; in it the aural faculty that picks up the sound of the instrument contends with the faculty of vision, which exalts the talent of the painter in a preposterous duel where the weapons are brush and palette on one side, and violin on the other.

Later, Munch takes up the dialogue between the skeleton and the body, but in a more original manner, by painting his own already-skeletonized arm as half living and half dead. And – coincidentally? – the date of the lithograph, 1895, is the year the X ray was invented and the first radiographs of the human skeleton were published. The Nordic imagery of the *danse macabre* and its cortege of bones exits one final time, dispelled by the penetrating light of Science.

While Böcklin remains tied to a traditional formula associated with a sombre form of Romanticism, Spilliaert treats the theme in a striking and original manner. The great mirror whose waters solidify in the gilded frame, the *abolis bibelots* on the mantelpiece and, particularly, the clock with its scintillations, make up a room that the author of *Igitur* could have lived in. But what emerges from Spilliaert's work is far from Mallarmé's quiet reflexivity. Here, one is closer to the horrors of Poe's "Berenice" and de Maupassant's "La Chevelure" and "Le Horla". The theme of obsessive fear is fiercely present. The dialogue is no longer with a personification of Death but with an invisible being that is all the more frightening in that it is one's own double. In certain passages of *The Notebooks of Malte Laurids Brigge*, Rilke speaks of the horror of the face suddenly transformed into a mask, as the unbearable transformation is revealed in the glare of a mirror. Spilliaert's treatment of the unre-

141

238

160

13. Guy Michaud, *Message poétique du symbolisme* (Paris: Nizet, 1949).

coverability of the Self is probably unequalled, particularly in the way it blends the myth of Narcissus with that of the Medusa.

Symbolist portraits have often explored the paroxysms of consciousness, those borderline states in which an individual who is abruptly torn from his status of "bourgeois" subject connected to a community, a milieu, a *socius*, realizes that he is alienated and disassociated from himself, and sees himself as *homo demens*. Witkiewicz systematically represents the dissolution of the personality ("the systematic disordering of all the senses")

161-163 under the influence of drugs, intoxicants and alcohol. Carlos Schwabe, among many others, exhibits the postures of hysteria he encountered in Albert Londe's photographs in the *Iconographie de la Salpêtrière* (the hospital Charcot was associated with). Shaken by a domestic crisis – his wife Mathilde ran off with the painter Richard Gerstl – Schoenberg

151 abandoned composition to paint a series of hallucinatory self-portraits that combine Symbolist and Expressionist means.

In the early years of this century, Paul Klee, a fellow countryman of Lavater, was the

154 last to revive the tradition of physiognomy. He accomplished this in a series of grotesque engravings, which were motivated by the ambition of classifying the humours and passions of an "elusive" Self.

Troubling Places

Never before has the "interior", that metaphor we use in speaking about houses, appeared a more appropriate evocation of the places so dear to Symbolist painters. The world of the home, of domesticity and the hearth, is first and foremost the world of the interior, of the *Innenwelt*, of quiet repose and inwardness.

However, through a reversal like that which transforms the known into the unknown and the familiar into the troubling, if the Self falls prey to dissolution, if (as Freud would say) it is no longer master in its own house, then it is the hearth and home, those places inhabited by human beings, that would seem to become the last witnesses to humanity, conserving whatever warmth it left behind. Filled up by this absent presence – dying footfalls, fading shadows, recently drawn curtains – they reflect, or better still exude, its moods, feelings, fears and anxieties. It is as if the walls, furniture and household objects were there, like communicating vessels, to collect the warmth and redolence, the most evanescent traces, of this Self that goes on fragmenting, changing, withering away. Interiors contaminated by people and their invisible presence, these are haunted spaces that exist at the frontiers of the familiar and the frightening.

187 The commanding intimacy of a Biedermeier interior as reworked by Walter Hampel, with its aura of serenity and peace issuing from a well-ordered, domesticated world that makes one think of Stifter, is supplanted by disquieting interiors. Perhaps it was Freud who gave us the best analysis of this sense of "the uncanny" (*Unheimlich*) that permeates those places, these houses and dwellings (*Heimat*) that, because they are the most familiar to us,

are also the most foreign. Here we have images of an intimacy that we once knew but cannot go back to, for if we do, we will, like Lot's wife, be changed into a pillar of salt. These interiors are at one and the same time projections of our selves and of all that is not us. Thus, what is infinitely close is also infinitely remote. Although usually deserted, these interiors are nonetheless haunted – not by beings from some world apart, but by our own selves, whom we no longer recognize.

Munch is perhaps the one who has taken this anthropomorphism of dwellings the furthest. More than once, he has transformed the façade of a house into a face, into an animate apparition that beckons to us through the darkness, staring at us, calling us, an anxiety-inducing and consoling presence that is at once a maternal refuge and a lethal trap. This tendency of Munch's to lend a face to inanimate objects has been referred to as a kind of "psychic Naturalism". It is as if the psyche, in the role of a medium, possessed the power to extend its forever-mobile features, like ectoplasm, to the inert world of the *physis*.

This realm of *petits châteaux de l'âme*, fit to set the stage for a play by Maeterlinck, also fascinated French painters. Nabi interiors, where many have seen no more than an image of bourgeois ease and comfort, are often permeated with uneasiness, sudden obsessions, apparitions that plunge us into the Other World.

We must not forget that, with this aesthetic that makes the outside world a phantasmagorical projection of the inner one, the artist's studio becomes the favoured site for the reconquest of the Self. Khnopff makes his own house into his masterpiece, his total work of art. In it, each object – walls, doorways, chairs – is assigned the task of protecting and comforting the genius of the creator in his inexplicable singularity.

Hypnos

The reader may recall the epigraph inscribed on a tablet at the Bellevue resort villa in Vienna: "Here revealed itself, on July 24, 1895, the secret of the dream to Dr. Sigm. Freud." Still, the publication of Freud's *The Interpretation of Dreams* had to wait until 1900. Despite the scientific cast of the book, the German-speaking public detected in its original title, *Traumdeutung*, echoes of *Sterndeutung*, the word for astrology. Was this, then, just another "Dream Guide" of the kind used by fortune tellers? Was the choice of title an unconscious provocation on Freud's part? The fact is that, by choosing this preposterous title, Freud placed himself within a burgeoning tradition, for not a week went by without the publication of some book on dreams or such related phenomena as hypnosis, somnambulism, catalepsy and even occultism, spiritism and the use of mediums.

We are aware of the importance that Romanticism attributed to somnambulistic states, in works ranging from the stories of E. T. A. Hoffmann to those of Jean Paul, and from Young's *Nights* to the poetry of Gérard de Nerval. This "dream surge", as the Surrealists called it, had dried up around 1860 under pressure from Positivism and scientism, for whom the dream was nothing more than a meaningless by-product of involuntary cerebral activity

occurring during sleep. However, 1860 also marked the beginning of a decade that saw the publication of the great pioneering works on the dream. In 1867, the remarkable Hervey de Saint Denis published *Les Rêves et les moyens de les diriger*. He was, along with Scherner and Maury, among those who set the stage for the profound fascination that people would come to feel for all that existed behind the dreamworld's ivory gates. This was a world that, following Nerval's *Aurélia* (1853), Symbolists would explore in greater depth.

In this connection, Janmot is undoubtedly a precursor, for in the context of the antirationalist crusade he was already conducting by the mid-century, he managed to give

197, 198 parts of his ***Poem of the Soul*** an unforgettable dreamlike flavour.

During this period, dreams were seen as more than an excess, as the products of a normal, calm sleep. In line with a Decadent aesthetics of the anti-*physis*, the Symbolist dream is first and foremost an artificial dream, one that is induced, stimulated and artificially maintained. The fin de siècle was not only the period that discovered the virtues of tranquillizers and anesthetics (chloroform began to be used in dental surgery towards 1880); there was also the eruption of *paradis artificiels*: hashish, opium, nicotine, absinthe, cocaine and morphine. Loved and feared in turn, pharmacology henceforth became the bedfellow of creative genius.

The new neurology studied other types of secondary states. It has been said that, in the 1880s and 1890s, the figure of hysteria replaced that of somnambulism, which had dominated the 1850s and 1860s. Charcot brought hysteria to centre stage at the Salpêtrière, conducting the show before a crowd that furnished both accomplices and astounded witnesses. At Bernheim's school in Nancy, however, it was hypnotism that drew questions from the audience. Were these merely fairground antics, or actual therapeutic techniques?

Even photography, as a new means of recording images, could not help being drawn into this craze for nocturnal states of consciousness. Much more than a new tool of Naturalism, it was in league with the occult and the forces of the subterranean world. In the form of solar script, negative or positive printing, proofs inscribed with rays from the invisible world, it had already been used to "prove" the case of spiritism and, following Schopenhauer, the existence of ghosts. It had also demonstrated the authenticity of the Shroud of Turin, just as the first X-ray photographs had revealed the interior of the body. Rejlander would use it to

215 confer a material presence upon the most impalpable element of cerebral activity, that is, dream imagery. Scandinavian cinema, with Sjöström's *Körkarlen* (*The Phantom Carriage*) in the lead, would remember these forerunners.

It can be said that with the publication of *The Interpretation of Dreams* at the turn of the century, the reign of Hypnos had come to an end. The book's rigorous analytical approach lowered the curtain on the preceding century's phantasmagorias, its magnetism, hypnotism and catalepsy, which had set out to explore the path to the unconscious.

The *Traumdeutung* could also be seen as theory's monument to Symbolism, as the masterpiece of a hermeneutics that, in order to function, postulated the existence of the symbol without ever really questioning its heuristic value. By interpreting what he believed to be sexual symbols, and by including under this umbrella everything from stairways and

houses to boxes and hats, Freud may simply have swallowed whole the old doctrine of empathy, of *Einfühlung* – that obscure impulse that causes us, apparently, to project our corporal sensations on things or other people so that, aided by such copious illusionism, we may see "symbols" in them. A theory such as this could never be anything more than a matter of faith, a sort of modernist version of ancient animism.

The most recent research on dreams[14] tends to prove that dreams do not "intend" any meaning whatsoever. Accordingly, we do not dream but are, instead, "dreamed". Like the Positivism of the 1860s, today's neuroscience views oneiric activity as meaningless and uncertain. So much for symbolism! Thus, there is no intention behind the chain of images or symbols we believe we apprehend in sleep. We are as much strangers to our own dream imagery as we are to meaningless script, so that dreams, those products of a psychism that we so profoundly believe to be our own, do not concern us at all.

Freud had brought to the fore the three major phases of humiliation inflicted upon human narcissism.[15] Was he concerned that a fourth, and perhaps the most acute, humiliation lay in store – the discovery that today we cannot even claim to possess our dreams, that we are estranged from the world of which they are composed, along with our central place in the universe, our divine origins and the mastery of our consciousness?

Thanatos

Because sleep is the brother of death, it is sometimes difficult, when looking at a Symbolist painting, to tell who is dreaming and who is dying, who is asleep and who is dead. The often emaciated figures of dream imagery are easily confused with cadavers.

We already noted how the revival of scholarship on the Middle Ages facilitated the return to Nordic iconography. Death and the Maiden, Death and the Knight, Death and the Youth – these motifs spring straight out of the *danse macabre* and the engravings of Dürer and Grien. It is no accident that Flanders, the bridge between the Teutonic and Latin worlds, should be so conducive to such grimacing vignettes. They range all the way from Ensor's fretful skeletons to the *chinoiseries* of Rops, who illustrated the French edition of "The Mask of the Red Death".

250
245

Much more original, more specific to the fin de siècle and, above all, more striking, is the theme of dying and the process of death. Never before had such acute attention been brought to bear on the stages immediately preceding the passing away of life. Operating within the very core of Symbolism, an almost clinical vision of the phases of dying attests to a Naturalist fascination not with death but with the dying, which recalls the descriptions of Zola, or Flaubert's sober precision in describing Emma Bovary's death by poisoning.

Never before was the approach of death, the recording of the process of decomposition, so well documented day by day, hour by hour, as in the series of sketch sheets Hodler devoted to the ravages of cancer on the body and face of his beloved. And never had the fact of death been stated with the rigour exemplified by Edvard Munch and Ejnar Nielsen.

234
241, 244

14. Here we have in mind the work of Michel Jouvet.
15. These are outlined in the introductory essay to this catalogue, *Lost Paradise*.

And it is above all the young who littered death's door. The fin de siècle knew a level of morbidity that is difficult to comprehend. Tuberculosis and syphilis, not to mention illnesses like cholera that already had a long career, were daily realities. They gave rise to innumerable crises, echoes of which are found in literary works ranging from Ibsen's *Ghosts* to Thomas Mann's *Death in Venice*. When Freud espoused the myth of a form of hereditary syphilis ostensibly transmitted from generation to generation and then went on to make this one of the basic causes of neuroses, he was merely restating an opinion commonly held in contemporary medical circles.

One can see why the fin de siècle was obsessed by the idea of decadence and degeneration. In 1892 in Berlin, Max Nordau published his *Entartung*, which, as we know, played such a key role in preparing the way for Nazism. In France, the psychiatrists Morel and Magnan developed the idea of "mental degeneration", and in Italy during the 1880s, Cesare Lombroso established his typology of the "born criminal", whom he saw as the product of an atavistic regression towards a kind of "archaic" man.

The gulf separating the triumphant attitude of an era that believed in unlimited scientific progress, and the fears of a society that foresaw the end of humanity and racial extinction, has often been singled out for notice. In this regard, Jules Romains underlined the striking contrast that existed between the Symbolist movement and the general direction in which civilization was headed:

> The world was awash in vitality. All around, political freedom and social justice were making great strides forward. The material conditions of life were continually improving . . . Modern science and technique had so far shown only their kindly features and seemed to promise that one's earthly journey could only get better . . . On the other hand, pure Symbolists considered that they were living in a period of decadence, of Byzantine corruption . . . This amounts to one of the greatest errors of interpretation every committed by literature . . . This attests to a kind of collective schizophrenia which probably had far-reaching implications.[16]

A Canadian historian, A. E. Carter, described the situation in similar terms:

> Nearly all authors of the time thought their age decadent. This was not the whim of a few eccentrics but the settled opinion of pathologists, philosophers and critics . . . Seen from the ruins of the present, the nineteenth century looks almost unbelievably massive, an accumulation of steam, cast-iron and self-confidence, rather like one of its own international expositions. It was the century which absorbed continents and conquered the world . . . Why such an age, which lived a vigorous life vigorously, should have spent so much time in sullen musing on its own "decadence", real or imagined, is a strange problem to which no real answer can be given.[17]

16. Jules Romains, *Souvenirs et confidences d'un écrivain* (Paris: Fayard, 1958), pp. 15-16.
17. A. E. Carter, *The Idea of Decadence in French Literature, 1830-1900* (Toronto: University of Toronto Press, 1958), pp. 144-151. Quoted in Ellenberger, 1993, p. 308.

Inner Voices

Once again it is Baudelaire who, in his poem "Recueillement", seems to have defined the features of a theme that Symbolism would exploit *ad nauseam*. The moment of the elusive, irredeemable Self, of the Self reduced to a flux of discontinuous sensations (the "intermittences du cœur") and soon taken apart by obscure forces that rise up from the unconscious, is also the moment of the recovery of this same Self. Quiet repose and inwardness thus become part of those psychological attitudes that define an era; they compose a topos whose features – the fixed or distracted gaze, clasped hands and other such standard equipment as the veil – attain such a degree of stability that they can be compared with certain topoi of sixteenth-century Mannerist femininity.

This recovery of the Self often requires some form of physical foundation or sensory base and, in this, music is the instrument of choice. Klimt painting Schubert at the piano and Khnopff's *Listening to Schumann* serve to fix a moment and a circumstance that one finds again in Malczewski (**The Unknown Note**), Burne-Jones (**The Love Song**) and Watts (**Hope**).

263, 270
271

Synesthesia, the cross-wiring of visual and auditory sensations, is, as the psychology of the day taught, also a means of achieving Pierre Janet's "presentification", of centering one's mind on the moment.

But such repose and inwardness also come dangerously close to sleep and the fascination of hypnosis. The small winged figure of Hypnos in Khnopff's *A Blue Wing*, at the British Museum, reminds us of how the mind can slide imperceptibly from the most alert attention to the deepest sleep. The theme of the mirror is also present here, attended by the contemplative speculation that derives from reflection and inwardness. It is not only the double who is revealed in this play of reflections. As in Khnopff's *Memories*, which recall a time released from time, a time not unlike the kind of temporality of the unconscious that Freud refers to as *zeitlos*, the same figure can go on duplicating itself endlessly like the expanding ripples of a wave. We have a striking example of this visual echo in Rossetti's **Rosa Triplex**.

264

The Flux of Appearances

In *The World as Will and Representation* of 1819, Schopenhauer, the philosopher of Symbolism *par excellence*, placed the sexual instinct at the core of the will to live, just as Freud would do with the concept of the *libido*. However, it was from the teachings of Buddhism that he drew the most pessimistic aspects of his worldview. According to Schopenhauer, the world consists merely of appearances, veils and illusions; it is an infinite succession of transitory phenomena that owe whatever semblance of continuity and meaning they may have exclusively to our erotic desires. Everything is in constant movement, like labile images upon a screen or the play of light upon water. Everything is transformed and gives way to the void that essentially forms the basis of all that we call reality.

It is indeed curious that studies of time should only confirm these religious intuitions, which tend more and more to see physical phenomena as the manifestations of one and the same continuum of energy. The concepts of uncertainty, quantum energy and waves are beginning to penetrate the laboratories.

296-302

307

Mobility, transitory reality, the discontinuous flux of phenomena, surges of one and the same energy – perhaps the finest concrete image we have of these ideas, which permeated the fin de siècle, is that of the dancer Loie Fuller.

She is, in any case, the model that painters, sculptors, decorative artists and photographers kept copying, modelling and sculpting. She is even one of the first to be recorded by the new process of cinematography (1895), in a few precious seconds of film where she can be seen twirling, pale and hesitant, like a butterfly against a black background. She contains within herself all the poetry of an era that was fascinated with liquid and aerial metaphors, and undoubtedly preserves a tradition. She is the last manifestation of a myth that became an obsession of the fin de siècle. In her, Salome is still very much present. But above and beyond all this, she opens the way to the future, heralds something totally new. The very image of that elusive, prismatic and scintillating Self that would remain forever unknowable, she is *anima* conversing with *animus*, just as, for the new painters, she represents the use of pure colour, the revelation of original tones of the spectrum that were soon to replace the thinners and browns on their palettes. Above all, however, she was movement, inexorably condemning the old immobility of painting. Futurism would be mindful of her example.

But how can one escape noticing that the progression of her twirls and leaps defines a series of volumes composed of commanding geometrical shapes and mobile solids reminiscent of those that Henri Poincaré was at that same time shaping from movable threads, in an attempt to define multidimensional geometrical shapes? The stripes and streaks and fitful appearance of these veils evoke the image of that dancer who was so dear to Richard Strauss; more important, they herald the coming of the strict system of measurement that would soon enable Science to imprison the data of our senses in the wire net of its co-ordinates. It is curious, however, that Maury never thought of taking time-lapse photographs of her.

J. C.

The Agony of the Self

141 to **163**

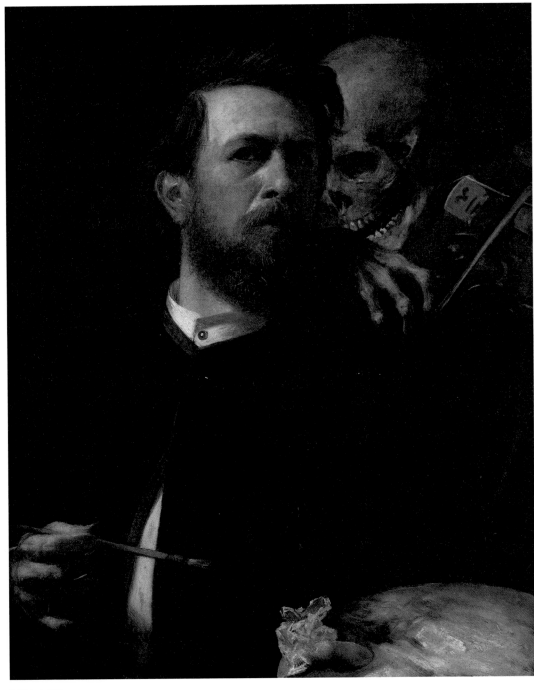

141 (cat. 26)
Arnold BÖCKLIN
Self-portrait with Death Playing the Fiddle, 1872
Berlin, Nationalgalerie

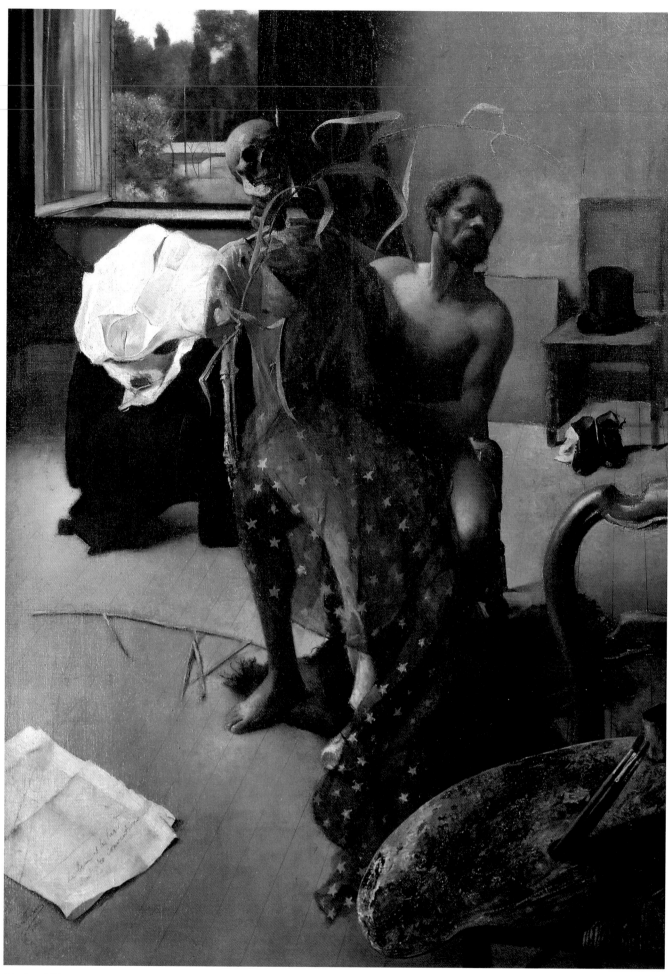

142 (cat. 117)
Léon FRÉDÉRIC
Studio Interior, 1882
Brussels, Musée d'Ixelles

144 (cat. 258)
Jacek MALCZEWSKI
Self-portrait with a Paintbrush, 1914
National Museum of Cracow

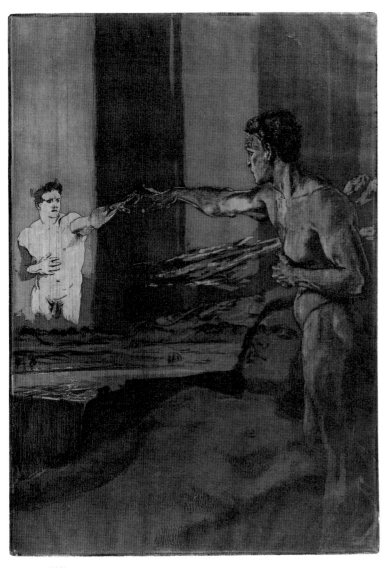

143 (cat. 212)
Max KLINGER
The Philosopher, 1910
Leipzig, Museum der bildenden Künste

145 (cat. 7)
Ivar AROSENIUS
Self-portrait with Floral Wreath, 1906
Stockholm, Nationalmuseum

146 (cat. 208)
Max KLINGER
Bust of Nietzsche, 1904
Toronto, Joey and Toby Tanenbaum collection

148 (cat. 411)
Edward J. STEICHEN
Richard Strauss, 1904
New York, The Metropolitan Museum of Art

147 (cat. 47)
Alvin Langdon COBURN
Portrait of F. Holland Day in the Darkroom, 1900
Bath, The Royal Photographic Society

149 (cat. 64)
F. Holland DAY
Portrait of Maurice Maeterlinck with Crystal Ball, 1901
Bath, The Royal Photographic Society

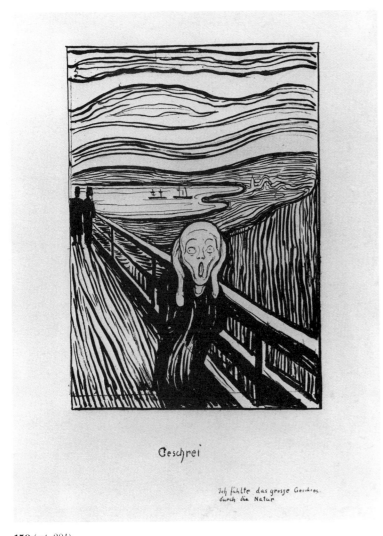

150 (cat. 304)
Edvard MUNCH
The Scream, 1895
Oslo, Munch-museet

151 (cat. 372)
Arnold SCHOENBERG
The Red Gaze, 1910
Munich, Städtische Galerie im Lenbachhaus

152 (cat. 479)
Stanisław Ignacy WITKIEWICZ
Self-portrait, 1912
Warsaw, Stefan Okolowicz collection

153 (cat. 44)
Jean CARRIÈS
Self-portrait, 1889
Museum für Kunst und Gewerbe Hamburg

154 (cat. 203)
Paul KLEE
Threatening Head, 1905
Kunsthalle Bern

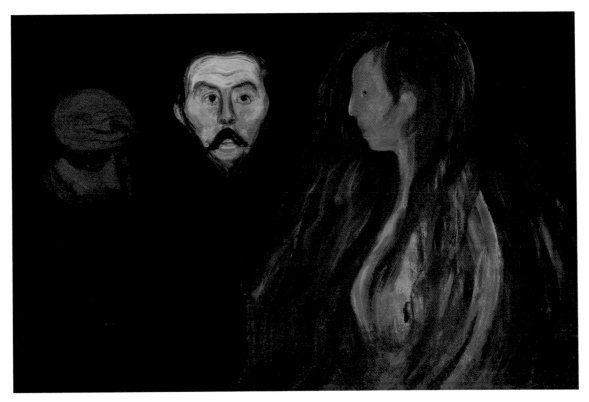

155 (cat. 298)
Edvard MUNCH
Jealousy, about 1897
Minneapolis Institute of Arts

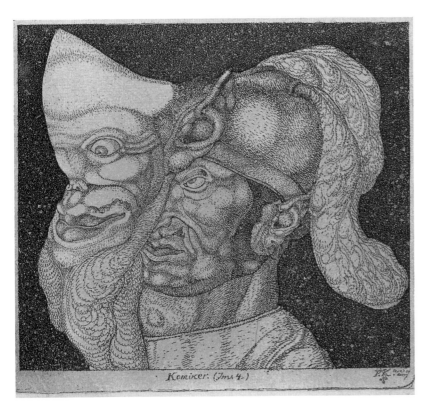

156 (cat. 200)
Paul KLEE
Comedian (Invention 4), 1904
New York, The Solomon R. Guggenheim Museum

157 (cat. 95)
Magnus ENCKELL
Head, 1894
Helsinki, Ateneum

158 (cat. 107)
Frederick EVANS
Portrait of Aubrey Beardsley: "A face like a silver hatchet", 1895
Bath, The Royal Photographic Society

159 (cat. 48)
Alvin Langdon COBURN
Self-portrait, about 1905
Rochester, New York, George Eastman House

160 (cat. 406)
Léon SPILLIAERT
Self-portrait in a Mirror
1908
Watercolour, gouache and pastel
48 x 67 cm
Ostend, Museum voor Schone Kunsten

This self-portrait, the most disturbing of the series painted by the artist between 1907 and 1908, may be based on Oscar Wilde's *Picture of Dorian Gray* (1890), the story of a debauched dandy who appears perpetually young while his portrait, hidden away in an attic, takes on the ravages of time. In the novel's dramatic ending, the hero severs this link between flesh and painting by stabbing the picture, which then reverts to its pristine beauty as Dorian Gray's face breaks out immediately into the scrofulous pustules hitherto accumulated on the painted surface. Spilliaert incorporates several archetypes of "noir" Symbolism: the clock, a sign of time's threat; the mirror, whose surface repels reflections; and the face in the process of becoming a death mask. It is significant that this is not, properly speaking, a mirror portrait. Rather, the painter depicts himself turning away in horror from looking at himself. Spilliaert is perhaps less appalled by this accelerated aging process than by his metamorphosis into nonhuman form – the glassy eye in the centre of the composition indicates that he is reverting to the reptile stage. The low-angle perspective also makes this icon of Symbolism a forerunner of fantasy and gothic films.

G.C.

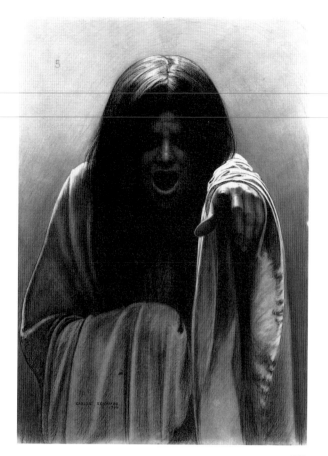

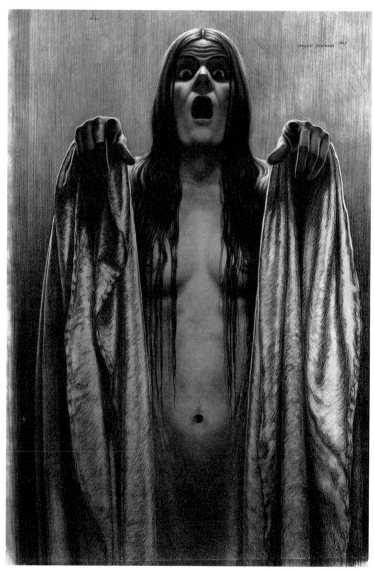

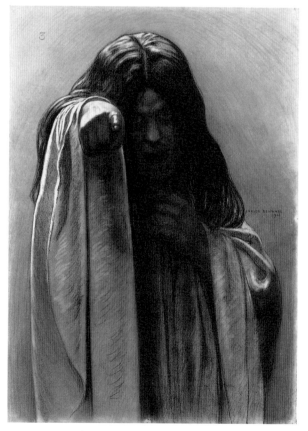

161 to **163** (cat. 373) **161**
Carlos SCHWABE
Three Studies of Female Figures for "The Wave", 1906-1907
Geneva, Musée d'Art et d'histoire

162

163

Troubling Places

164 to 195

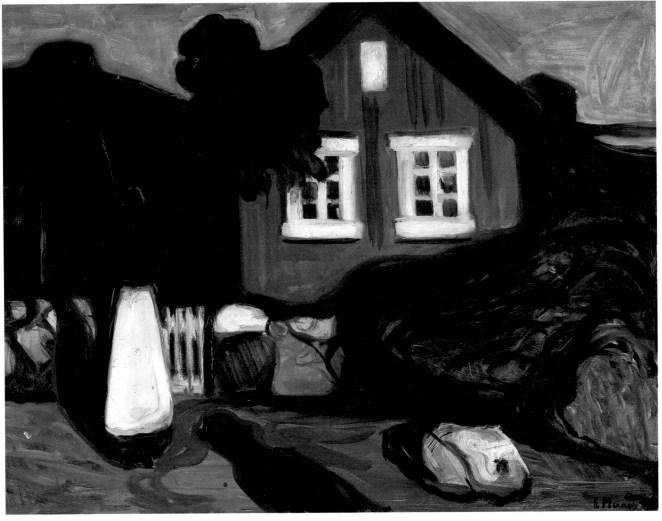

164 (cat. 297)
Edvard MUNCH
House in Moonlight, 1895
Bergen, Rasmus Meyer Collection

165 (cat. 164)
Theodor and Oskar HOFMEISTER
Night Walk (The Witch)
1900
Blue gum print
64.5 x 92.5
Museum für Kunst und Gewerbe Hamburg

This photograph belongs to a cycle taken in the north German landscape and near Hamburg. It was preceded by a study entitled *The Witch*, also in the Juhl collection at Hamburg's Museum für Kunst und Gewerbe, which shows the silhouette, by daylight, of an old woman supporting herself on a stick. With the help of multicoloured gum printing, which the Hofmeisters had been using since 1896 at the suggestion of Kühn, the daylight photograph was transformed into a threateningly sinister nighttime scene. The fairy tale atmosphere made contemporaries think of Nordic myths and sagas. Both the large-format enlargements from the original negatives and the motifs broke new ground in European photography and, according to Ernst Juhl, editor of the journal *Photographische Rundschau*, exercised a considerable influence on German photographers, many of whom were inspired by the Hofmeisters' style and themes. Through exhibitions and reproductions in *Camera Work*, their photographs also became known in North America.

U. P.

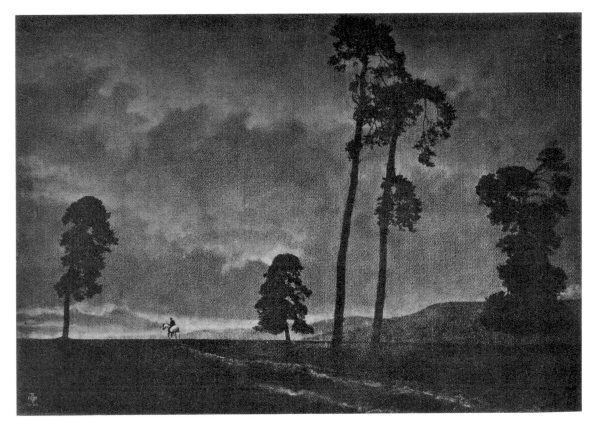

166 (cat. 165)
Theodor and Oskar HOFMEISTER
The Solitary Horseman, 1904
Munich, Dietmar Siegert collection

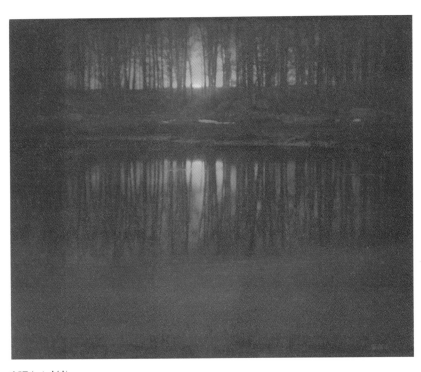

167 (cat. 414)
Edward J. STEICHEN
The Pond: Moonrise, 1903
New York, The Metropolitan Museum of Art

168 (cat. 415)
Edward J. STEICHEN
The Pool: Evening Milwaukee, 1899
Gilman Paper Company collection

169 (cat. 49)
Alvin Langdon COBURN
The Haunted House
1904
Gum platinum print
18.7 x 23.2 cm
Bath, The Royal Photographic Society

Through a thicket of bare, slender trees and undergrowth can be seen the front of a deserted house. Its bright façade, empty windows and door take on the form of a human face. This transformation into the abstracted shape of a face was made possible technically by the evenly fuzzy reproduction of the detail, by means of which the visual depth was dissolved into a surface effect turning the composition into a subtle interplay of light and shaded surfaces. Images from the uncanny fairy-tale world of such Edgar Allan Poe stories as "The Fall of the House of Usher" merge thematically with Coburn's representation of a haunted house. This little-known photograph, which was not considered in either the photographer's autobiography or any monograph, only appeared once in a publication, in 1905, in a special issue of the art journal *The Studio* entitled *Art in Photography*.

U. P.

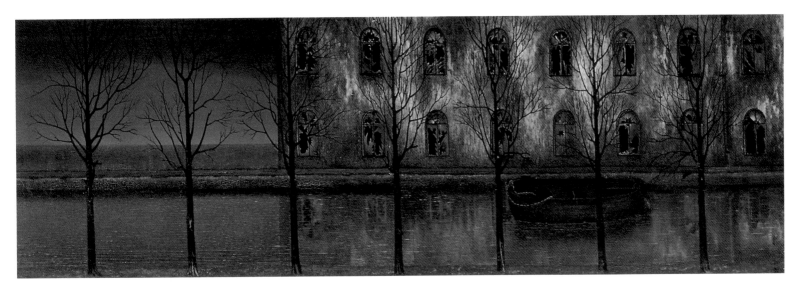

170 (cat. 73)
William DEGOUVE DE NUNCQUES
The Canal, 1894
Otterlo, The Netherlands, Kröller-Müller Museum

171 (cat. 318)
Giuseppe PELLIZZA da VOLPEDO
The Bush, 1900-1902
Piacenza, Galleria d'Arte Moderna Ricci Oddi

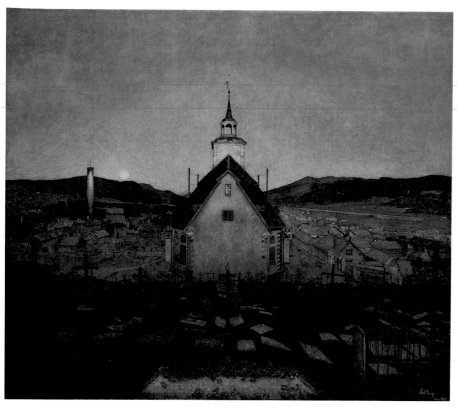

172 (cat. 399)
Harald SOHLBERG
Night, 1904
Trondheim, Trondhjems Kunstforening

173 (cat. 148)
Louis Welden HAWKINS
Le Foyer, about 1899
Nantes, Musée des Beaux-Arts

174 (cat. 244)
Ozias LEDUC
End of the Day, 1913
The Montreal Museum of Fine Arts

175 (cat. 196)
Fernand KHNOPFF
Souvenir of Bruges: The Entrance to the Béguinage, 1904
The Hearn Family Trust

176 (cat. 247)
Henri LE SIDANER
A Canal in Bruges at Dusk
Oxford, Ashmolean Museum

177 (cat. 125)
Akseli GALLEN-KALLELA
Autumn
1902
Oil on canvas
75 x 144 cm
Private collection

Like his compatriots, Gallen-Kallela was involved in the revival of mural painting that occurred in Scandinavia around the turn of the century. After painting the frescoes for the Finnish Pavilion at the Paris Exposition universelle of 1900, he undertook a new commission: the interior of the Sigrid Juselius Mausoleum in Pori (on the southwest coast of Finland), built in memory of the industrialist's daughter, who had died at the age of eleven. The possibility of transcending the inevitability of death by repeatedly recalling the spiritual dimension

of human existence was the basic theme proposed by Josef Stenbäck, the monument's architect. Gallen-Kallela's iconographical programme was incorporated in a series of large frescoes; three illustrated the Ages of Man and two others, landscapes entitled *Autumn* and *Winter*, symbolized death by suggesting the passage of the seasons. This monumental work was destroyed by fire but restored during the 1930s. Fortunately, the artist had also made identical versions of the murals on canvas. Painted in an extremely economical style,

Autumn presents a melancholy and austere image of Finland's windswept, ice-bound coast. Mysterious black crosses sombrely evoke the grief caused by death, which had haunted the artist since the loss of his own daughter seven years before.[1]

C. N.-R.

1. See the letter to Stenbäck quoted in Roald Nasgaard, *The Mystic North* (Toronto: University of Toronto Press, 1984).

178 (cat. 25)
Arnold BÖCKLIN
Ruins by the Sea, 1880
Gottfried Keller Foundation, on deposit at the Aargauer Kunsthaus, Aarau

179 (cat. 187)
Ferdinand KELLER
The Pool, 1911
Toronto, Joey and Toby Tanenbaum collection

180 (cat. 313)
Alphonse OSBERT
Moonlight, about 1896
New York, Stuart Pivar collection

181 (cat. 152)
Hugo HENNEBERG
Villa Adriana, 1901
Museum Folkwang Essen

182 (cat. 106)
Frederick EVANS
"A Sea of Steps" (Wells Cathedral: Stairs to Chapter House and Bridge to Vicar's Close), 1900
Bath, The Royal Photographic Society

183 (cat. 410)
Edward J. STEICHEN
Nocturne: Staircase of the Orangerie, about 1910
New York, The Museum of Modern Art

184 (cat. 378)
George SEELEY
Landscape, about 1907-1910
Bath, The Royal Photographic Society

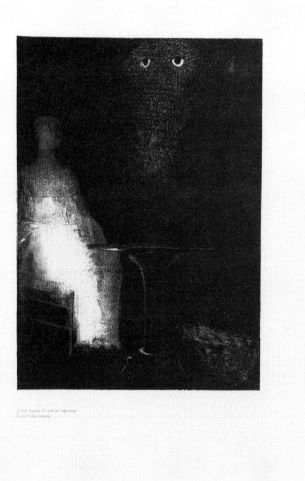

185 (cat. 339)
Odilon REDON
We Both Saw a Large Pale Light, 1896
Ottawa, National Gallery of Canada

186 (cat. 339)
Odilon REDON
And Fancied I Saw on It a Pale Blue Misty Outline of a Human Form, 1896
Ottawa, National Gallery of Canada

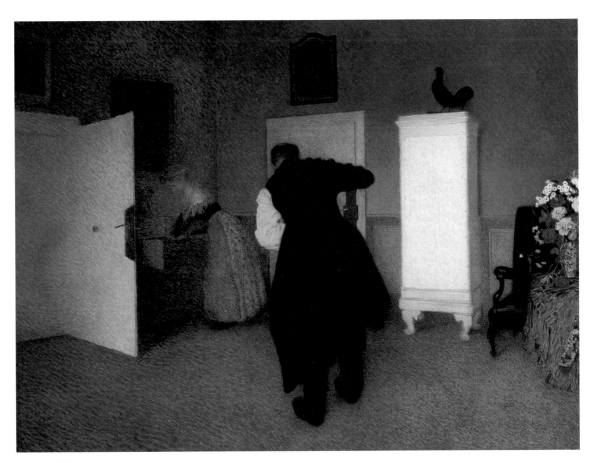

187 (cat. 143)
Walter HAMPEL
Biedermeier Interior, 1900
Vienna, Österreichische Galerie

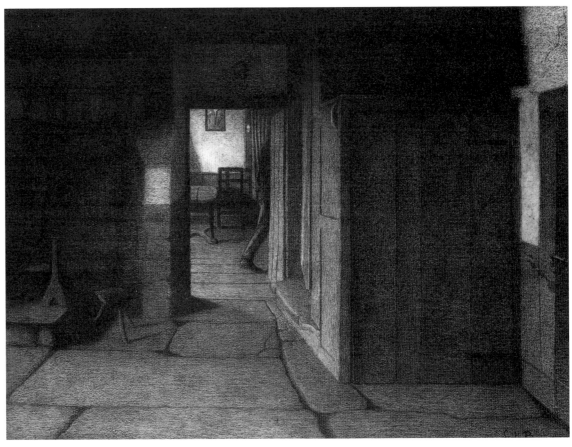

188 (cat. 242)
Georges LE BRUN
Interior: Man Passing Through, 1900
Verviers, Belgium, Musées Communaux

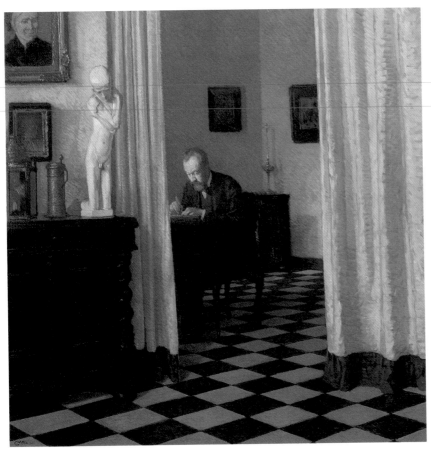

189 (cat. 278)
Carl MOLL
Studio Interior, about 1906
Vienna, Gemäldegalerie der Akademie der bildenden Künste

190 (cat. 141)
Vilhelm HAMMERSHØI
Dust Motes Dancing in the Sunlight, 1900
Copenhagen, Ordrupgaardsamlingen

191 (cat. 274)
Xavier MELLERY
Interior with Open Doors, undated
The Hearn Family Trust

192 (cat. 405)
Léon SPILLIAERT
Table d'Hôte, 1904
Brussels, Musées royaux des Beaux-Arts de Belgique

194 (cat. 404)
Léon SPILLIAERT
November 2, about 1907-1908
Ghent, Museum voor Schone Kunsten

193 (cat. 403)
Léon SPILLIAERT
The Bedroom, about 1908
Brussels, Musées royaux des Beaux-Arts de Belgique

195 (cat. 461)
Édouard VUILLARD
Mystery Interior (The Kerosene Lamp), about 1895
Geneva, Galerie Jan Krugier

Hypnos

196 to 223

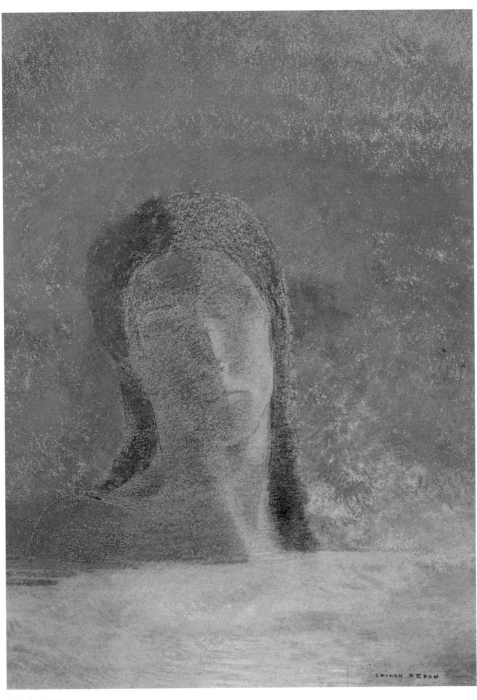

196 (cat. 347)
Odilon REDON
Closed Eyes, after 1890
Épinal, Musée départemental d'art ancien et contemporain

197 (cat. 170)
Louis JANMOT
The Poem of the Soul: The Wrong Path, about 1854
Lyons, Musée des Beaux-Arts

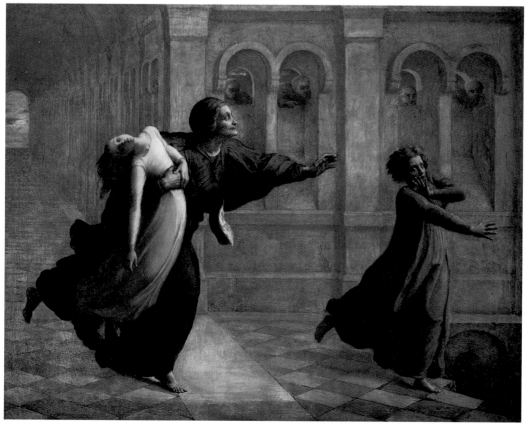

198 (cat. 171)
Louis JANMOT
The Poem of the Soul: Nightmare, about 1854
Lyons, Musée des Beaux-Arts

199 (cat. 36)
Edward BURNE-JONES
The Prince Enters the Wood (The "Briar Rose" Series)
1870-1873
Oil on canvas
61 x 129.5 cm
Ponce, Puerto Rico, Museo de Arte de Ponce

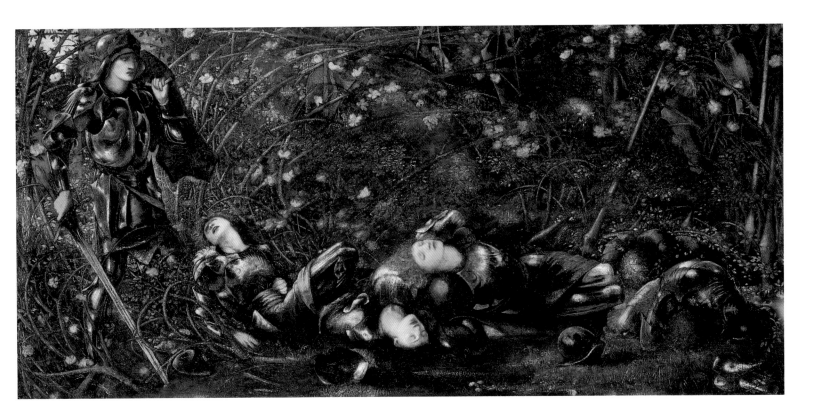

The subject of this elegant scene is taken from the tale "Sleeping Beauty", published by Charles Perrault in 1697. The picture illustrates the episode in which Prince Charming penetrates the protective tangle of brambles that surrounds the castle where the princess and her court have lain sleeping for a hundred years. We see the prince happening upon the officers of the Royal Guard, sound asleep among the sinuous arabesques traced by the branches of wild rose bushes. The brilliant shine of their armour shows that the effects of time have been suspended, but it also symbolizes a rejection, both moral and aesthetic, of modern civilization. The painting's horizontal format helps convey the prostration of sleep.

Burne-Jones first employed this theme in 1863, in a series of decorative tiles created for the house of the watercolourist Birket Foster. The legend was also the subject of a series of three small paintings executed by the artist between 1870 and 1873. A larger version, begun in 1870, was not completed until 1895, by which time close personal ties and even a certain aesthetic continuity linked the Pre-Raphaelites and the Symbolists. Burne-Jones died the same year as Gustave Moreau and, like him, was recognized by art critics of the period for his contribution to the revival of idealism. At the time, Burne-Jones's evocation of far-off enchanted worlds inspired by a nostalgia for the Middle Ages held widespread appeal, for it satisfied the escapist tendencies of a generation weary of Naturalism and eager to go beyond the world of appearances.

C. N.-R.

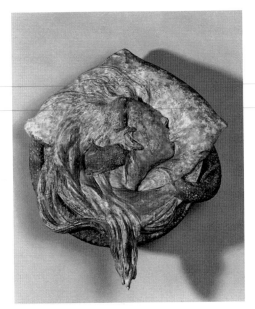

202 (cat. 3)
Jean-Barnabé AMY
Crime Asleep, about 1870-1880
Marseilles, Musée des Beaux-Arts

200 (cat. 408)
Léon SPILLIAERT
Vertigo: The Magic Staircase, 1908
Ostend, Museum voor Schone Kunsten

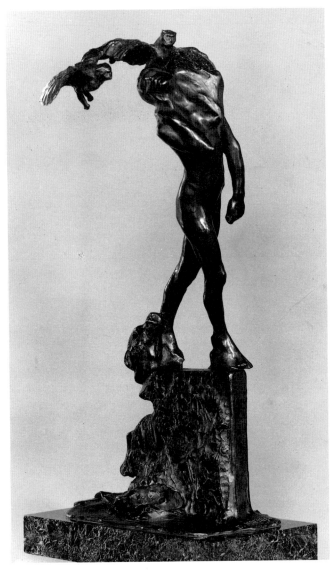

201 (cat. 195)
Fernand KHNOPFF
The Veil, about 1887
The Art Institute of Chicago

203 (cat. 174)
Bohumil KAFKA
The Sleepwalker, 1906
Prague, Národní galerie

204 (cat. 331)
Victor PROUVÉ
"La Nuit" Coupe
1894
Bronze
50.7 x 76 x 46.7 cm
Musée de l'École de Nancy

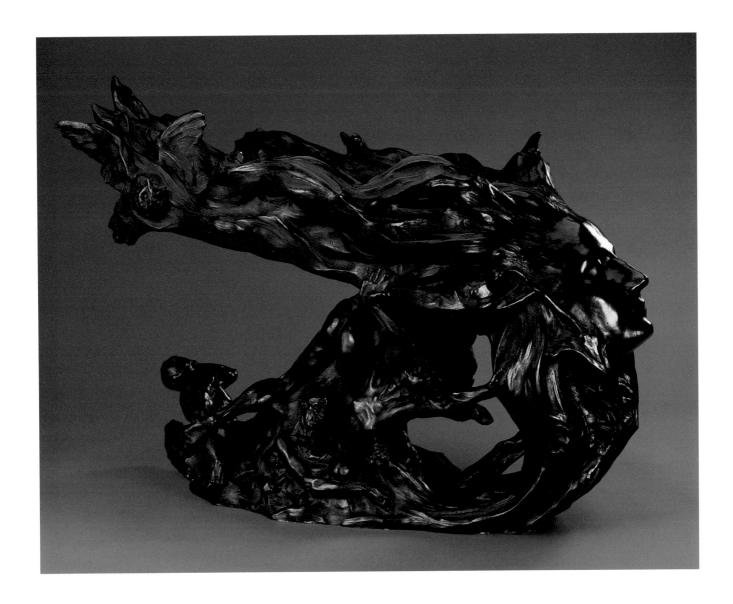

A native of Nancy, Prouvé studied and lived in Paris in the late 1880s and the 1890s and, like his friend Émile Gallé, absorbed Symbolist ideas through his Paris contacts and his interest in literature and poetry. The Nancy journal *La Lorraine artiste* of March 31, 1895, proudly announced that Prouvé's "La Nuit" had been given the place of honour in Brussels at the exhibition of La Libre Esthétique, the Belgian group that succeeded Les XX. The sculpture was exhibited again that year at the Salon du Champ-de-Mars in Paris.

A striking Symbolist image, "La Nuit" depicts the serene face of a woman, her eyes closed as if in sleep, facing full front like the figurehead on the prow of a ship. Her hair streams backward as if she were gliding into the wind, and in her flowing tresses, symbols of the night – owls, bats, poppies and stars – lie concealed. Crouching and writhing in the darkness under the shadow of this mass of hair are various figures in the throes of the night's miseries, passions and anxieties: a gaunt mother and hungry child, a pair of lovers, and tormented souls reaching out in their nightmarish agony. The scene recalls Rodin's *Gates of Hell* (1880-1917), which would have been in progress during Prouvé's period of residence in Paris.

R. P.

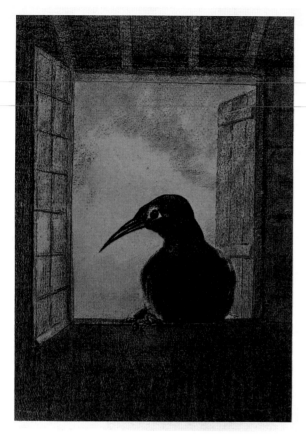

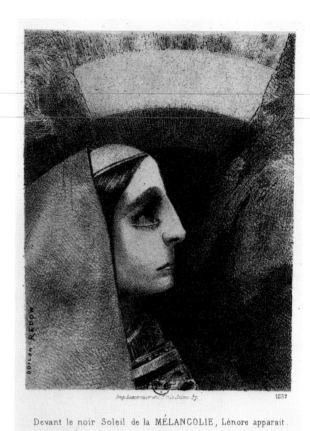

Devant le noir Soleil de la MÉLANCOLIE, Lénore apparait.

205 (cat. 344)
Odilon REDON
The Raven, 1882
Ottawa, National Gallery of Canada

206 (cat. 342)
Odilon REDON
Lithograph from "To Edgar Allan Poe", 1882
Before the black sun of MELANCHOLY, Lenore appears
Paris, Bibliothèque nationale de France

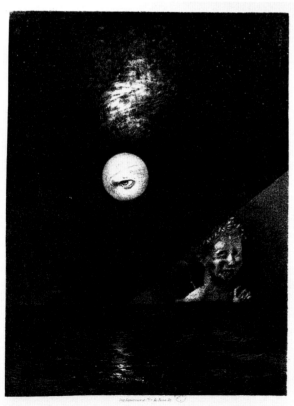

A l'horizon, l'Ange des CERTITUDES, et dans le ciel sombre un regard interrogateur.

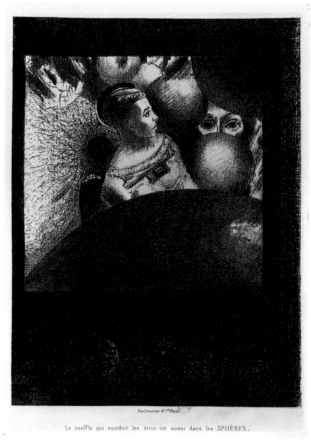

Le souffle qui conduit les êtres est aussi dans les SPHÈRES.

207 (cat. 342)
Odilon REDON
Lithograph from "To Edgar Allan Poe", 1882
On the horizon the angel of CERTITUDE, and in the somber heaven a questioning eye. Paris, Bibliothèque nationale de France

208 (cat. 342)
Odilon REDON
Lithograph from "To Edgar Allan Poe", 1882
The breath which leads living creatures is also in the SPHERES
Paris, Bibliothèque nationale de France

209 (cat. 160)
Ferdinand HODLER
The Dream
1897
Pencil, India ink, pastel and
watercolour on paper
95 x 65 cm
Private collection

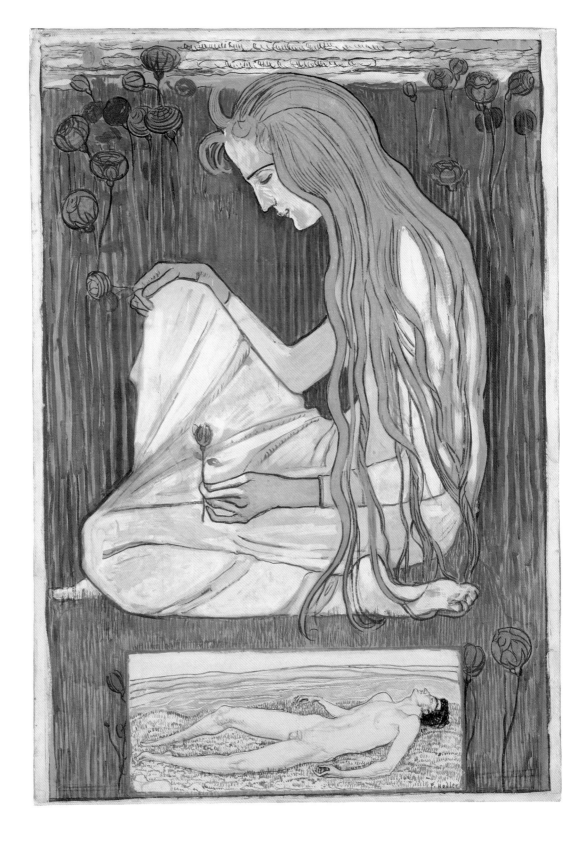

The Dream, originally created as the design for a poster for the Zurich Fine Arts Association, was to be the companion piece to *Poetry* (1897), in which a girl with her arms outstretched to the sky stares at the viewer. When the poster design was abandoned, Hodler modified both compositions: in *The Dream*, the space left for text was filled by the figure of a nude youth lying in the sun; in *Poetry*, the lower part of the painting was covered by a flowery hill. While the meaning of the latter painting was unaffected, the addition of the youth radically alters the subject of the dream.

The girl, dressed in a spotless gown and plucking a red poppy, is no longer an adolescent lost in a seraphic dream but finds the objective correlative to her heretofore unspecific dream in the male body a little way away. Like the field of poppies suggesting the realm of sleep, the red wash Hodler uses for the hair and the flower stems, all intertwined like creepers, symbolizes the movement of desire paradoxically rein-forced by the state of erotic trance in which the two figures are suspended. This melancholy, even pessimistic, work is a celebration of the power of Hypnos. It harks back to the spatial composition of Dante Gabriel Rossetti's *Blessed Damozel* (1871-1879), another figure from the beyond who carries on an impossible confabulation with her lover across "the golden barrier of Heaven".

G.C.

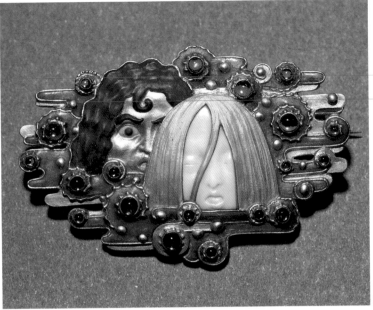

211 (cat. 135)
Eugène GRASSET and Maison Vever
"Apparitions" Brooch, 1900
Paris, Musée d'Orsay

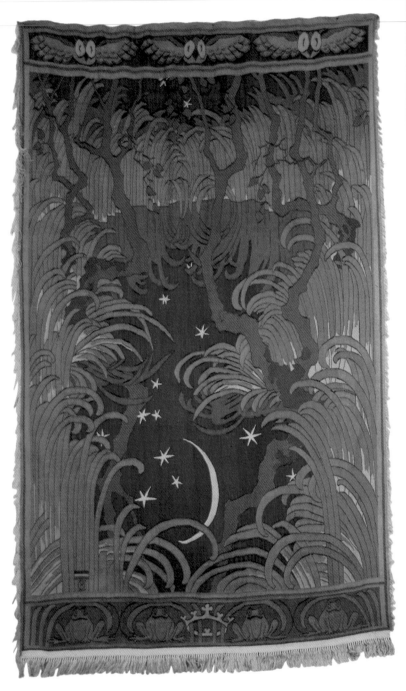

210 (cat. 91)
Otto ECKMANN
"Pond in Moonlight" Wall Hanging, 1896-1897
Museum für Kunst und Gewerbe Hamburg

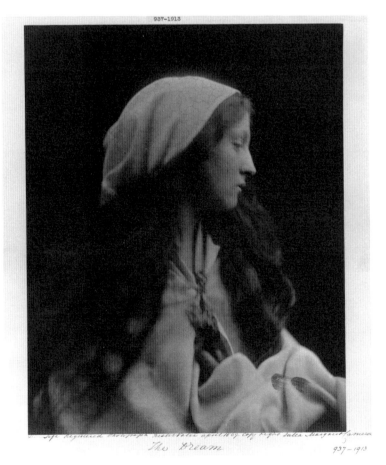

212 (cat. 40)
Julia Margaret CAMERON
The Dream, 1869
London, The Victoria and Albert Museum

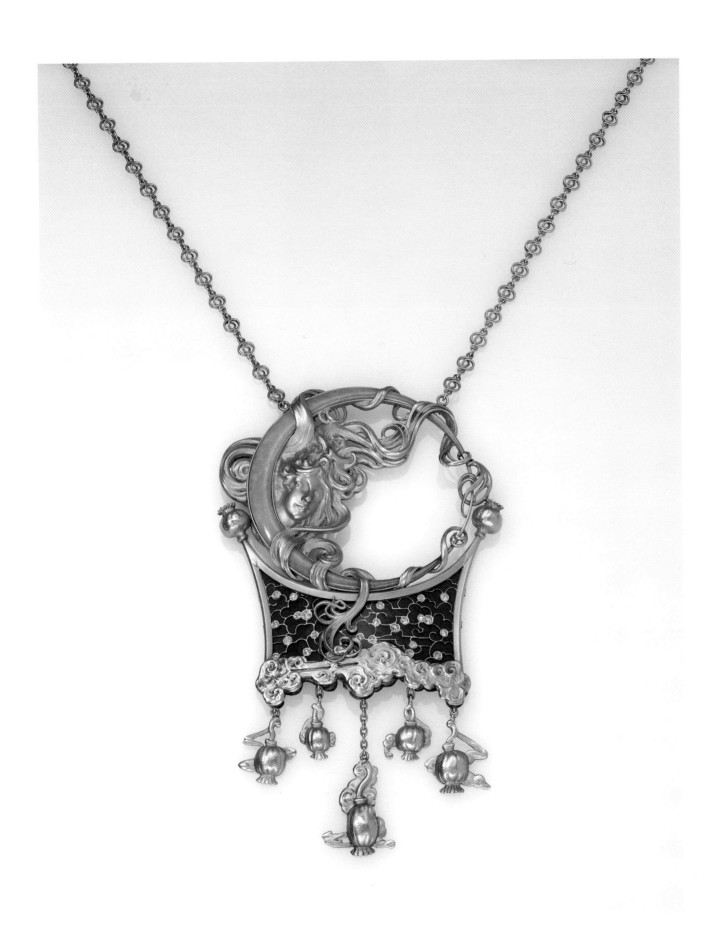

213 (cat. 292)
Alfons MUCHA
"La Nuit" Pendant, undated
Gingins, Switzerland, Neumann collection

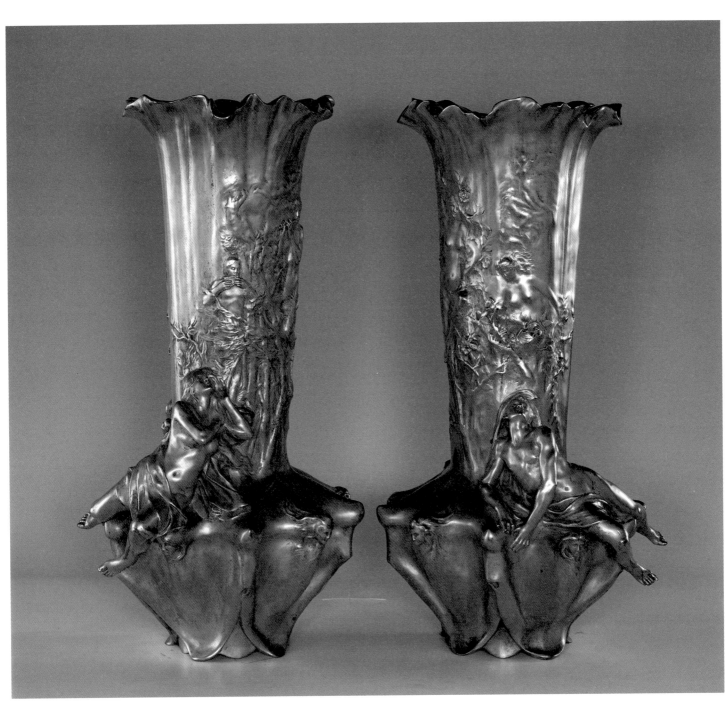

214 (cat. 241)
Raoul LARCHE
"Rêves" Pair of Vases, about 1900
Gingins, Switzerland, Neumann collection

215 (cat. 350)
Oscar Gustav REJLANDER
The Dream
About 1860
Albumen print
14 x 19.6 cm
Rochester, New York, George Eastman House

Oscar Gustav Rejlander achieved fame with his mounted allegory *The Two Paths of Life* (1857). *The Dream*, one of his most puzzling works, shows a male model sleeping on an ottoman. His bachelor's dream seems to manifest itself in the hooped crinoline petticoat apparently inhabited by numerous artist's models or mannequins. (Crinoline dresses were popular in England in the late 1850s. Their awkwardness was caustically ridiculed in the English press and caricatures of the time, for example in *Punch*). While the man lies passive, protecting his sexual organs with his hand, the models climb up the crinoline hoops and throw themselves off the top. Stephanie Spender has viewed this photograph as a cryptically ironic statement on the theme of marital relations.[1] The almost surreal dream-image thus links the fantasy of the bachelor and the threat of an impending marriage, against which the man has to protect himself even in his dreams.

U. P.

1. Stephanie Spender, *O. G. Rejlander: Photography as Art*, 1985.

216 (cat. 190)
Fernand KHNOPFF
White, Black and Gold, 1901
Brussels, Musées royaux des Beaux-Arts de Belgique

217 (cat. 192)
Fernand KHNOPFF
Dream Flowers, about 1895
Paris, Lucile Audouy collection

218 (cat. 60)
F. Holland DAY
Hypnos
About 1897
Platinum
16.1 x 11.3 cm
Bath, The Royal Photographic Society

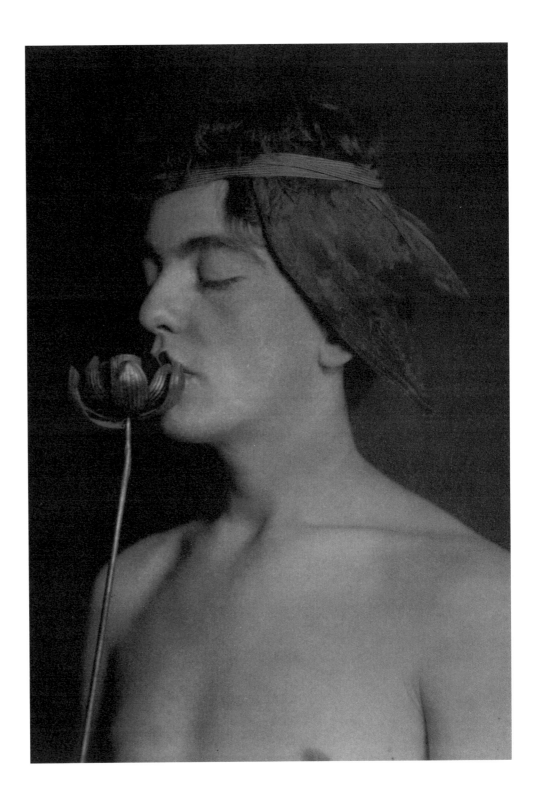

This image, which caused a sensation at the exhibition of Day's work at the New York Camera Club in 1898, shows a youth with eyes closed breathing in the intoxicating perfume of a poppy. The poppy and the bird's wings fixed to his head with a headband identify the model as Hypnos, the Greek god of sleep, brother of Thanatos (death) and son of Nyx (night). The photographer had used similar accessories for a series of nude photographs of black male models, including, for example, *An Ethiopian Chief* (1897).

In Symbolist art, representations of Hypnos are closely connected with Mnemosyne, the personification of memory. Through the use of narcotics in particular, it was possible to submerge oneself in the hallucinatory dream images of a diffuse unconscious and thus stimulate the process of internal awareness that leads to spiritual awakening. In the work of the Belgian Symbolist Fernand Khnopff, Hypnos and Hermes Trismegistus, the founder of the occult sciences, are constantly recurring elements. In his home, Khnopff even had an altar dedicated to the god of sleep, and a replica of a late Roman mask of Hypnos appears in several of his paintings.

U. P.

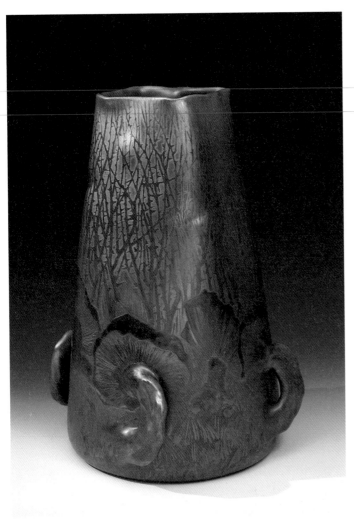

219 (cat. 269)
Clément MASSIER and Lucien LÉVY-DHURMER
Vase, about 1895
New York, Daniel Morris and Denis Gallion, Historical Design Collection, Inc.

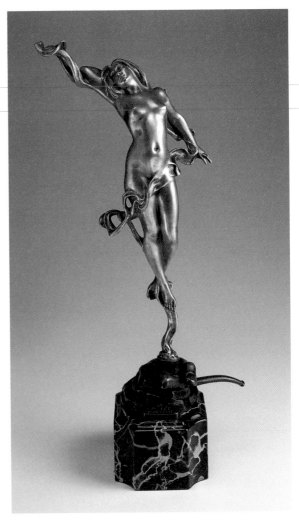

220 (cat. 149)
Louis-Philippe HÉBERT
The Nicotine Sprite, 1902
The Montreal Museum of Fine Arts

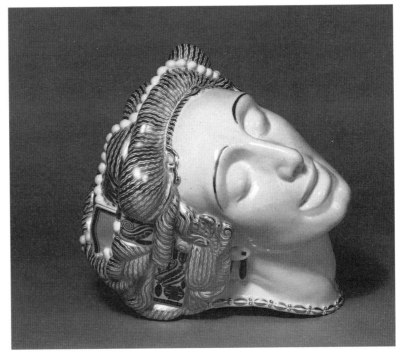

221 (cat. 28)
Paul BÖRNER, made by Meissen
Head of a Woman: Awakening, 1911-1912
Badisches Landesmuseum Karlsruhe

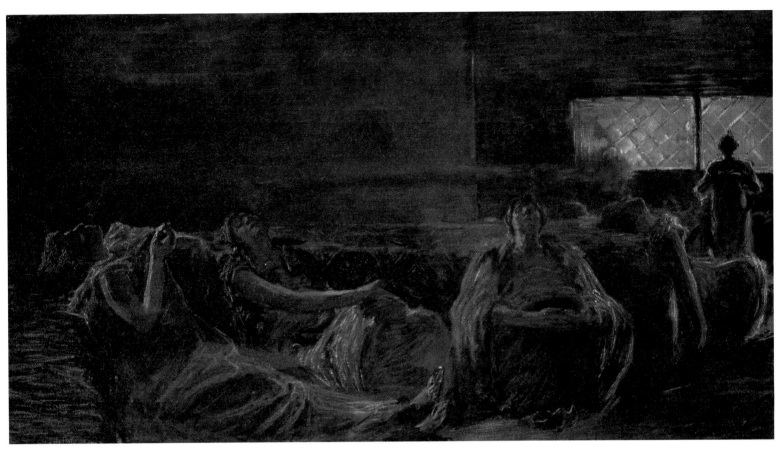

222 (cat. 327)
Gaetano PREVIATI
Women Smoking Hashish, 1887
Piacenza, Galleria d'Arte Moderna Ricci Oddi

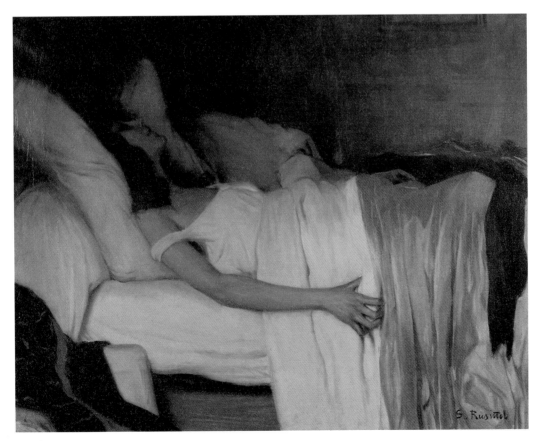

223 (cat. 365)
Santiago RUSIÑOL
The Morphine Addict, 1894
Sitges, Spain, Museo del Cau Ferrat

Thanatos

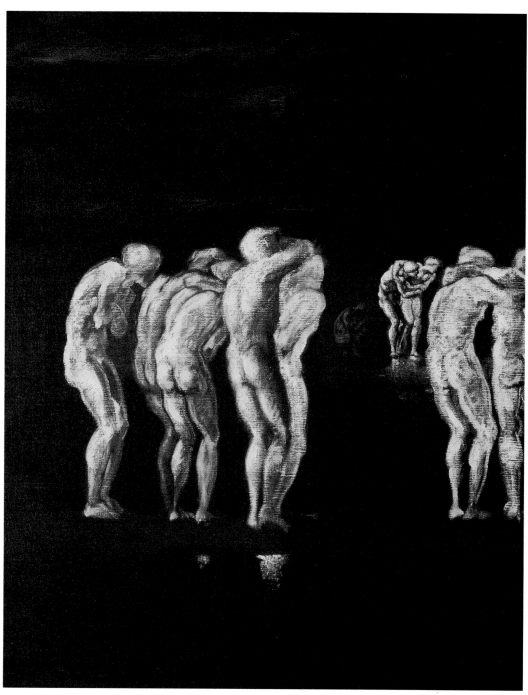

224 (cat. 35)
Edward BURNE-JONES
Souls on the Banks of the River Styx, about 1873
Peter Nahum at the Leicester Galleries

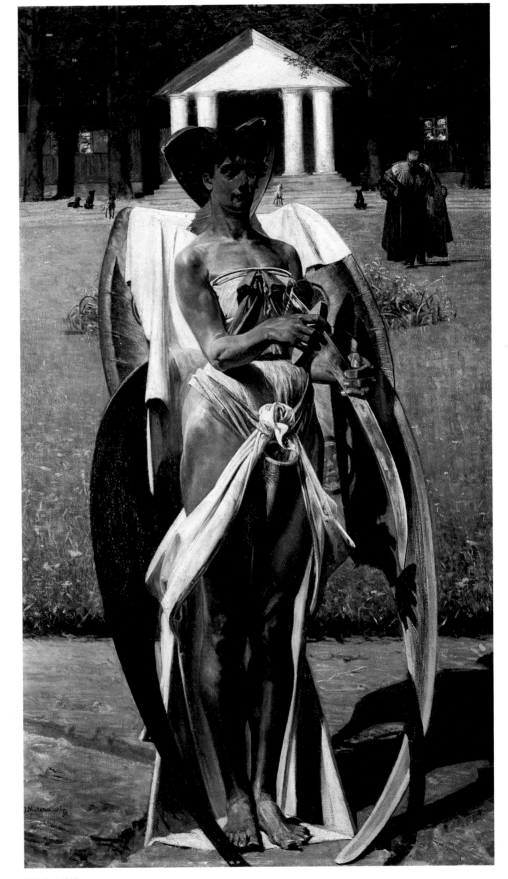

225 (cat. 284)
Gustave MOREAU
The Young Man and Death, about 1865
Paris, Alain Lesieutre collection

226 (cat. 263)
Jacek MALCZEWSKI
Thanatos, 1898
National Museum of Poznań

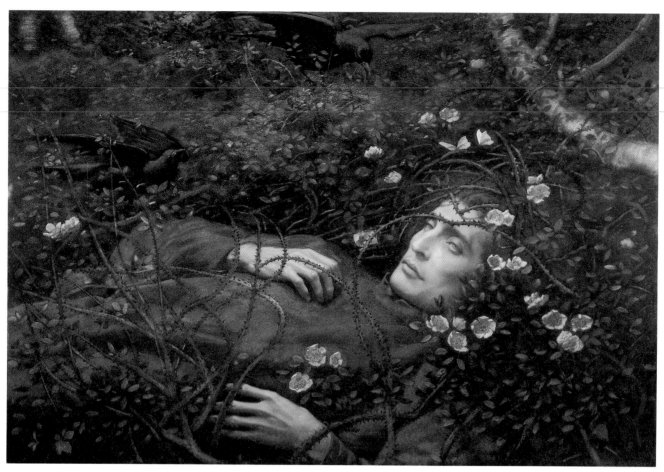

227 (cat. 166)
Edward Robert HUGHES
Oh, What's That in the Hollow?, about 1895
London, The Diploma Collection of the Royal Watercolour Society

228 (cat. 105)
Frank EUGENE (Smith)
The Lady of Shalott, about 1899
Munich, Fotomuseum im Münchner Stadtmuseum

229 (cat. 354)
Henry Peach ROBINSON
The Lady of Shalott
1860-1861
Gold-toned albumen print
31.9 x 52.5 cm
Bath, The Royal Photographic Society

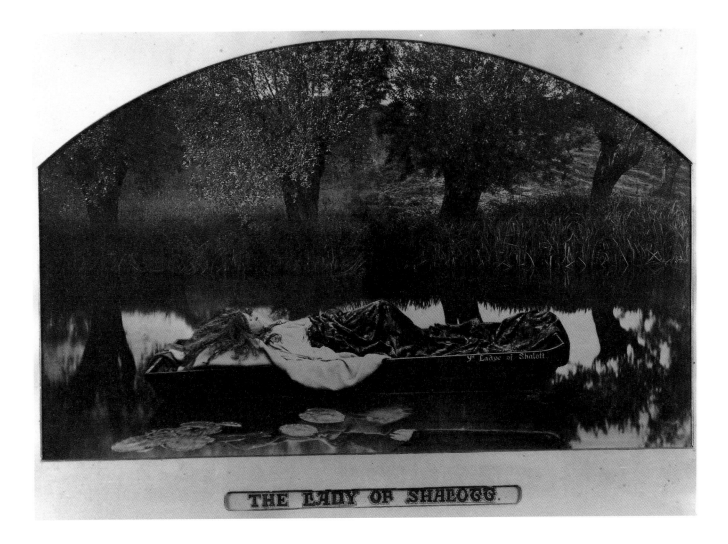

THE LADY OF SHALOTT.

Up to the turn of the century, Tennyson's poetry served numerous Pre-Raphaelite painters as well as photographers as a source. Not only Robinson, but also Cameron, Annan and Eugene took the poet as the point of departure for their own figurative inventions. The large-format *Lady of Shalott*, a montage of two negatives, is a transposition of the poem of the same name by Tennyson. The poem deals with the unrequited love of the Lady of Shalott for Sir Lancelot, hero and knight of King Arthur's Round Table. It ends with the tragic death of the Lady while travelling by boat to Camelot. Formally, Robinson's photograph seems to have been influenced less by William Holman Hunt's painting of the same name (1852) than by John Everett Millais's

well-known *Ophelia* (1852), which the photographer had seen at a Royal Academy exhibition.

Surrounding the photograph are lines from the poem it makes direct reference to: (centre): *Down she came and found a boat / Beneath a willow left afloat / And round about the prow she wrote / The Lady of Shalott;* (left): *And down the river's dim expanse / Like some bold seer in a trance / Seeing all his own mischance / With a glassy countenance / Did she look to Camelot. / And at the closing of the day / She loosed the chain and down she lay / The broad stream bore her far away / The Lady of Shalott;* (right): *Lying robed in snowy white / That loosely flew to left and right / Thro' the noises of the night / She floated*

down to Camelot. / And as the boat head wound along / The willowy hills and fields among / They heard her singing her last song / The Lady of Shalott.

Later, in 1892, Robinson was to distance himself from the subject of the photograph and its closeness to Pre-Raphaelite painting, describing it in the *Photographic Quarterly* as "a ghastly mistake".

U. P.

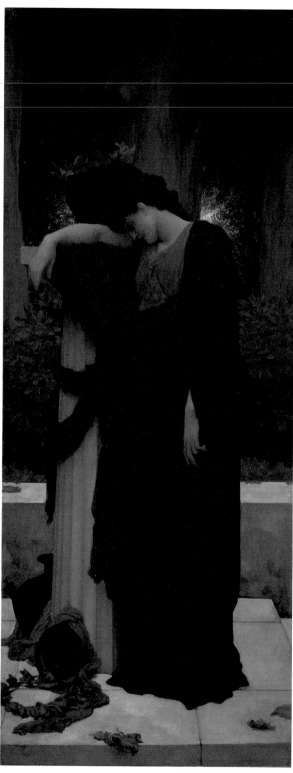

230 (cat. 245)
Frederic LEIGHTON
Lachrymae, about 1895
New York, The Metropolitan Museum of Art

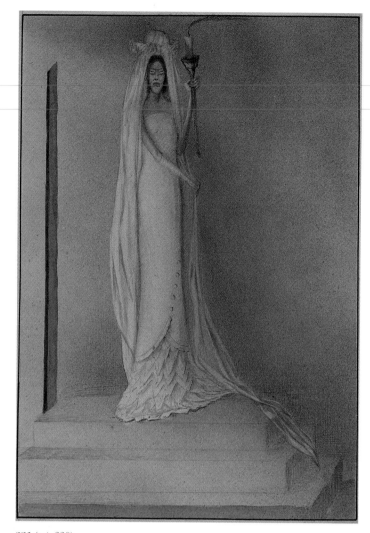

231 (cat. 220)
Alfred KUBIN
Death's Fiancée, about 1900
Vienna, Graphische Sammlung Albertina

232 (cat. 383)
George SEELEY
Untitled, 1906-1907
Ottawa, National Gallery of Canada

233 (cat. 374)
Carlos SCHWABE
Sorrow
1893
Oil on canvas
155 x 104 cm
Geneva, Musée d'Art et d'histoire

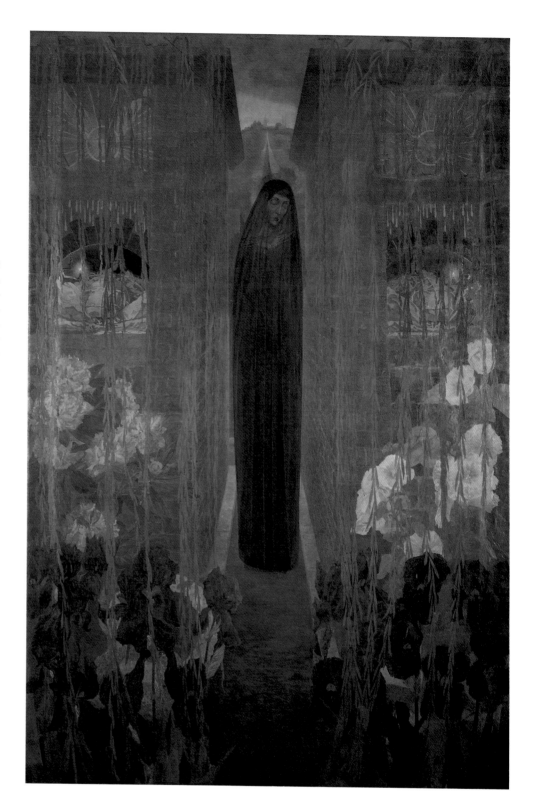

Schwabe, one of the Swiss artists who participated in the Salons de la Rose + Croix, designed the poster for the first exhibition organized by Sâr Péladan, held in Paris in 1892. At that time, Schwabe's production consisted mainly of watercolours and drawings intended as illustrations for books, such as Zola's *Le Rêve* (1891), or for one of the short-lived journals that fervently advocated the revival of idealism, such as *L'Art et l'Idée* and *L'Idée libre*. One of the very few paintings executed by the artist during the Symbolist decade, *Sorrow* expresses with admirable understatement the pain caused by the death of a loved one, and its suggestive power was much noted by critics at the time. An emaciated figure with closed eyes moves through a complex and subtle scene whose meaning is not immediately evident. It is a quintessentially Symbolist image: it arrests and perplexes the spectator, encouraging reflection. Roger Marx, one of the most influential critics of the time, described the work in the following terms: "Having come from beyond, beyond, symbol of all sorrows, veiled in mourning, she advances, hands crossed upon her breast, between the tombs where the night-lights dimly flicker, where the departed sleep their endless sleep; between the tombs that see the irises and hollyhocks spread, in sorrowful tears, the willows' grey leaves."[1]

Characteristically, Schwabe pays meticulous attention to detail in his depiction of the black irises, the tombs with doves on them and the shrouded corpses, hands clasped in eternal prayer. But such precision does nothing to elucidate the meaning of his highly original iconography, and the picture, like all genuinely Symbolist images, defies analysis.

C. N.-R.

1. *Revue encyclopédique*, February 15, 1894.

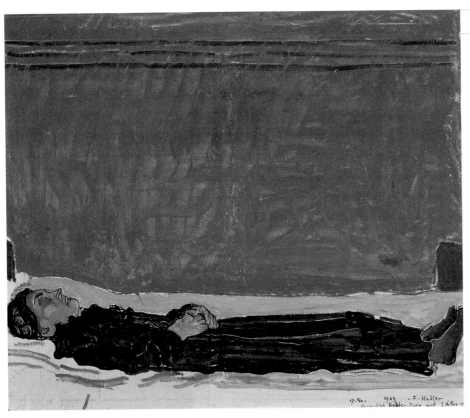

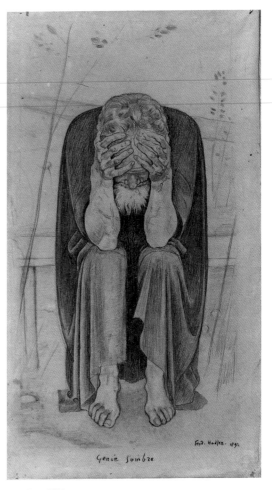

234 (cat. 156)
Ferdinand HODLER
Augustine Dupin on Her Deathbed, 1909
Kunstmuseum Solothurn, Dübi-Müller Foundation

235 (cat. 162)
Ferdinand HODLER
Dark Genius (study for "Disappointed Souls"), 1892
Montreal, Mr. and Mrs. Michal Hornstein

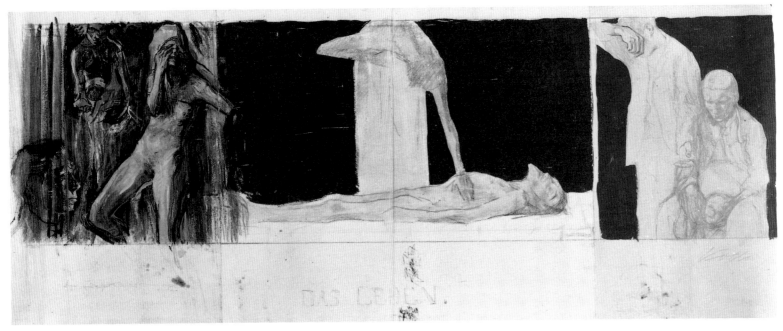

236 (cat. 217)
Kathe KOLLWITZ
Life, 1900
Staatsgalerie Stuttgart

237 (cat. 161)
Ferdinand HODLER
Tired of Life II
After 1892
Oil on canvas
110.5 x 221 cm
Winterthur, Switzerland, Stiftung für Kunst, Kultur und Geschichte

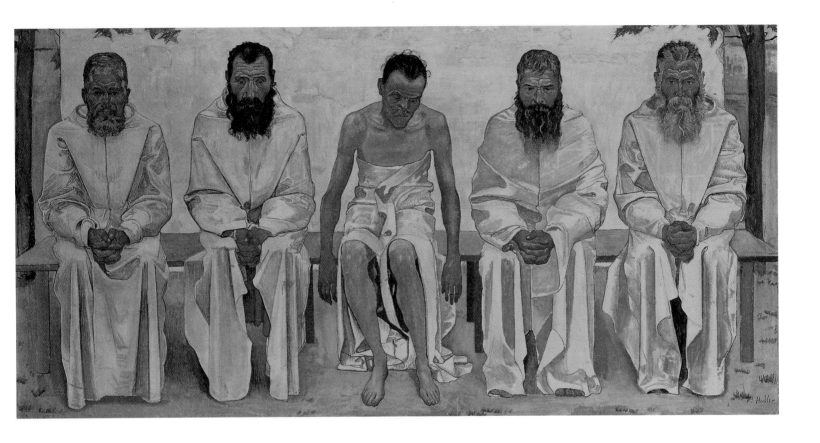

In 1891, Hodler, who had been excluded from the Geneva Municipal Exhibition, achieved his first major Parisian success with *Night* ("that great symbol of death"), which was shown at the Salon du Champ-de-Mars, presided over on that occasion by Puvis de Chavannes. Encouraged by the support of Symbolist writers Charles Morice and Joséphin Péladan, and the Genevan poet Louis Duchosal, Hodler undertook two monumental and very similar compositions: *Disappointed Souls*, exhibited in Paris at the first Salon de la Rose + Croix in March 1892, and *Tired of Life*, presented in May of the same year at the Salon du Champ-de-Mars. The latter, a typical example of Hodler's "parallelist aesthetic", which involved the creation of a rhythmic composition through the repetition of analogous forms across the pictorial surface, was a landmark work of the then-flourishing Symbolist movement.

The painting, executed in pale, fresco-like colours, shows five men – all dressed in long white tunics, eyes downcast – seated equidistant from one another on a bench, beneath autumn-coloured trees. The youngest, in the centre, who is beardless, has his head slightly bent and his arms wearily dangling. He is framed by the four others, bearded and obviously older, who sit facing the spectator, hands clasped upon their knees. All the figures express the moral and psychological exhaustion that results from life in an era of decadence and symbolize the pessimistic mood of Europe's collective unconscious at the turn of the century.

C. N.-R.

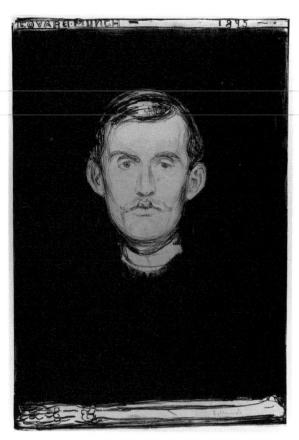

238 (cat. 302)
Edvard MUNCH
Self-portrait with Skeleton Arm, 1895
Oslo, Munch-museet

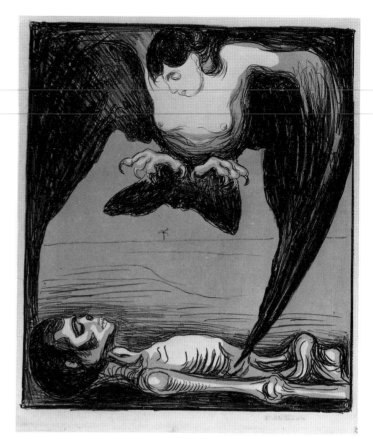

239 (cat. 296)
Edvard MUNCH
Harpy, 1899
Oslo, Munch-museet

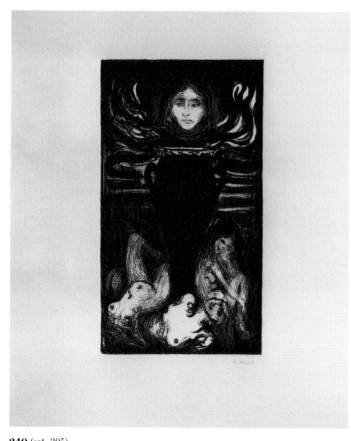

240 (cat. 305)
Edvard MUNCH
The Urn, 1896
Oslo, Munch-museet

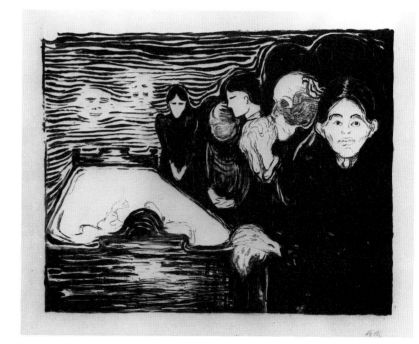

241 (cat. 293)
Edvard MUNCH
By the Deathbed, 1896
Oslo, Munch-museet

242 (cat. 303)

Edvard MUNCH
Death and the Maiden
1893
Casein on canvas
129 x 86 cm
Oslo, Munch-museet

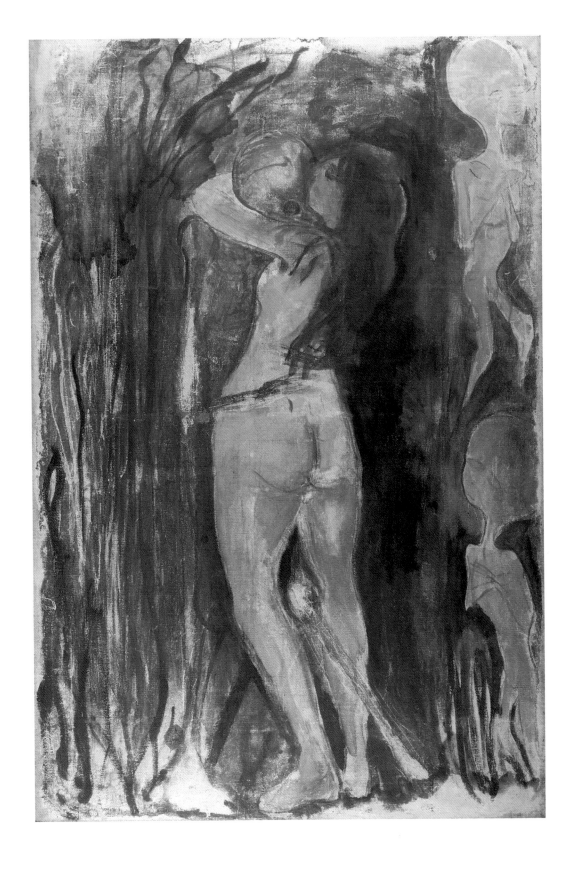

Between 1890 and 1900, the decade that marked the height of the Symbolist movement, Munch's pictorial production focussed on a cycle to which he gave the general title "The Frieze of Life". Conceived as an open series, these largely auto-biographical works can be grouped under three themes – love, anguish and death – each of which was the object of numerous variations. The anxieties of Munch and his contemporaries in the Norwegian avant-garde regarding sexuality gave rise to images rooted in a fear of women – quite prevalent in Scandinavian and German Symbolist circles – caused by the psychological and biological effects of "free love" (see *The Scream*, cat. 304; *Vampire*, cat. 306; *Madonna*, cat. 299; *Jealousy*, cat. 298). This unique and powerful image reflects one of the darkest sides of fin-de-siècle man, prisoner of his instincts, unable to attain salvation through either religion or Positivist science. By linking death to the act that produces life, Munch puts an end to all hope of regeneration. The picture, featuring an entwined couple in a vague setting filled with circulating sperm and the floating figures of syphilitic children, symbolizes not the cycles of life but the obsession and despair of a whole generation confronted by the hereditary effects of a dread, and alarmingly prevalent, disease.

C. N.-R.

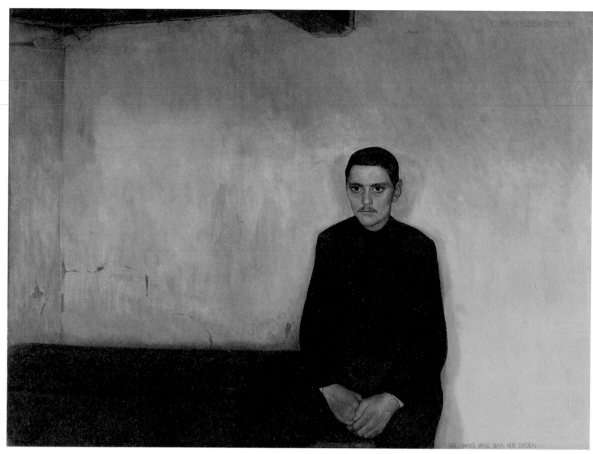

243 (cat. 310)
Ejnar NIELSEN
And in His Eyes I Saw Death, 1897
Copenhagen, Statens Museum for Kunst

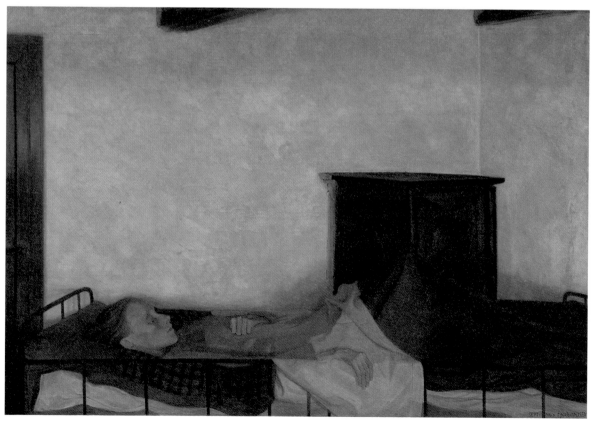

244 (cat. 309)
Ejnar NIELSEN
The Sick Girl, 1896
Copenhagen, Statens Museum for Kunst

245 (cat. 358)
Félicien ROPS
Death at the Ball
1865-1875
Oil on canvas
151 x 85 cm
Otterlo, The Netherlands,
Kröller-Müller Museum

Like other Northern European artists, Félicien Rops stood at the more macabre extreme of international Symbolism. As a young student at the Académie de Saint-Luc in Brussels, he was a friend of Henry De Groux, with whom he continued to share a taste for harsh realism, even while his literary tastes tended towards writers such as Barbey d'Aurevilly, Baudelaire and Joséphin Péladan, for whom he executed numerous frontispieces. *Death at the Ball* is obviously a reference to Poe's "Masque of the Red Death", a fantasy tale about a ball organized by Prince Prospero in an imaginary kingdom ravaged by the Red Death. In the midst of the reckless festivities and extravagant costumes, the Red Death appears on the last stroke of midnight to strike down all within the castle. Rops's depiction of the scene, very similar to the frontispiece he executed for Péladan's *Le Vice suprême* (1883), goes beyond the simple literary reference, aiming at presenting an archetype. The painting can be read as one of the many versions of the motif of the femme fatale, linked here to the obsessive fear of sickness and death – *mors syphilitica* – expressed in all its naked horror in a medieval *danse macabre*. All dolled up for the ball, the skeleton, breaking into an obscenely swaying walk, betrays the grotesquely comic aspect of this weighty symbol. In short, the penchant for a kind of exacerbated sexuality goes hand in hand with a fascinated revulsion to death, a syndrome soon to be broken down into its neurotic components by Freud.

G.C.

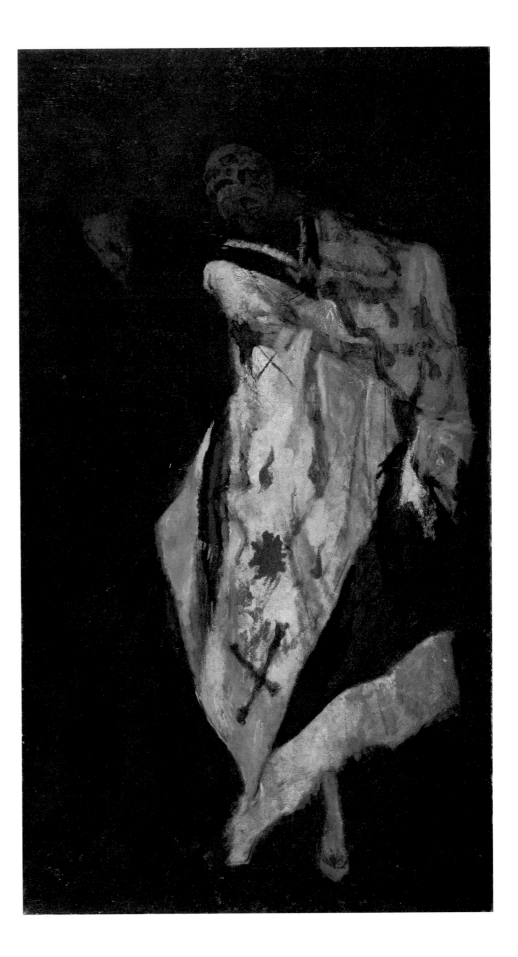

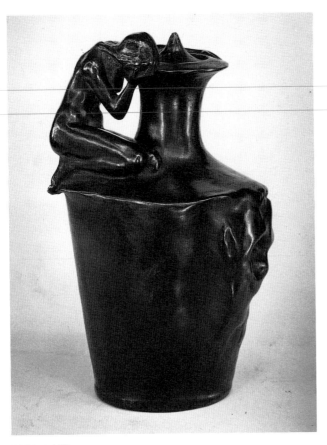

246 (cat. 439)
Ville VALLGREN
Tear Bottle, 1892
Helsinki, Ateneum, Antell collection

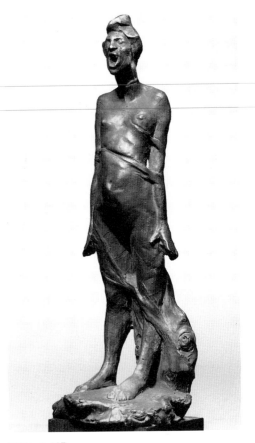

248 (cat. 447)
Gustav VIGELAND
Anxiety, 1892
Oslo, Nasjonalgalleriet

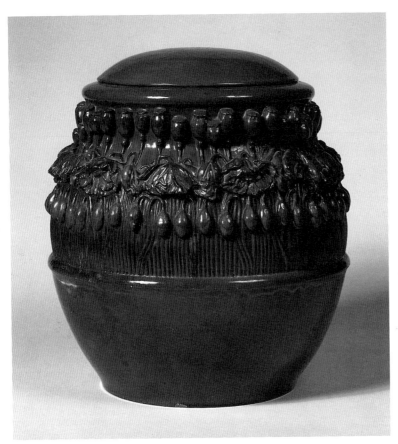

247 (cat. 476)
J.F. WILLUMSEN
Funerary Urn with Poppies, 1897
Frederikssund, Denmark, J.F. Willumsens Museum

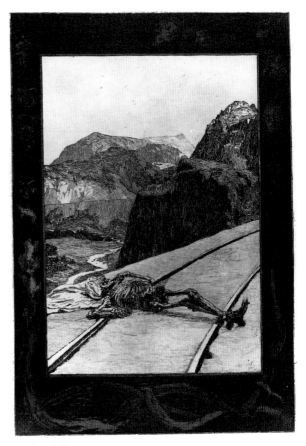

249 (cat. 212)
Max KLINGER
On the Rails, 1889
Leipzig, Museum der bildenden Künste

250 (cat. 99)
James ENSOR
Skeleton Looking at Chinoiseries, 1885
New York, The Solomon R. Guggenheim Museum

251 to **262** (cat. 199)
Theodor KITTELSEN
"The Black Death" (12 illustrations) 1894-1896
Oslo, Nasjonalgalleriet

251 *Autumn Night*

252 *Pesta's Coming*

253 *Mummy, There's an Old Woman Coming*

254 *The Pauper*

255 *She Covers the Whole Country*

256 *Sweeping Every Corner*

257 *Pesta on the Stairs*

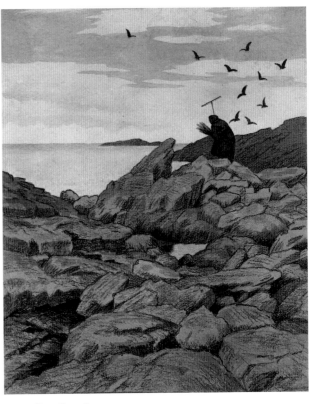

258 *Pesta Departs*

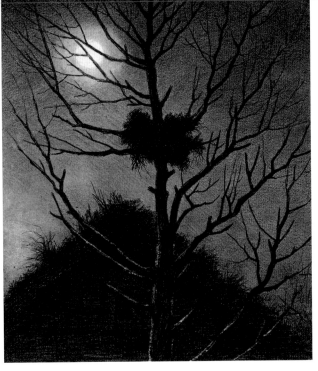

259 *Desolation*

260 *Musstad*

261 *The Old Church*

262 *The Capercaillie Playing*

Inner Voices

263 to 294

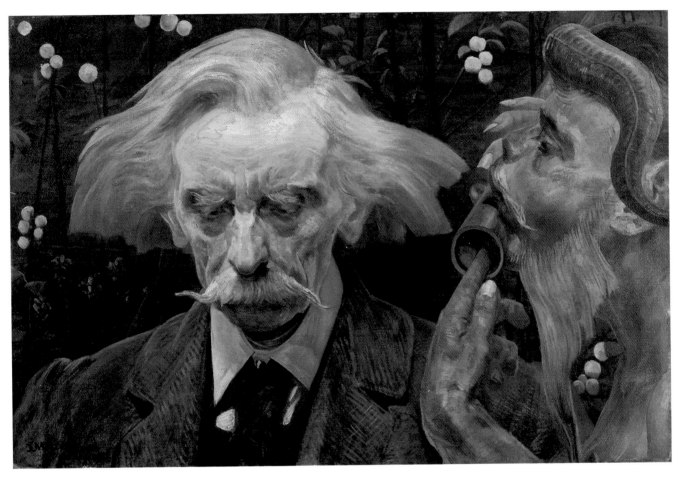

263 (cat. 259)
Jacek MALCZEWSKI
The Unknown Note, 1902
National Museum of Cracow

264 (cat. 363)
Dante Gabriel ROSSETTI
Rosa Triplex
1874
Red chalk
51 x 73.5 cm
The Hearn Family Trust

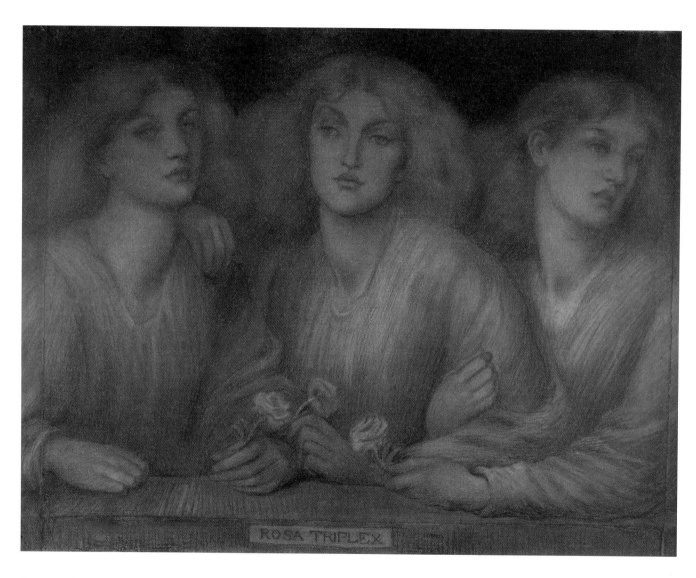

This second version of a triple portrait in watercolours of William Morris's daughter May, begun at Kelmscott Manor the previous year, bears witness to the close ties binding the artists of the Pre-Raphaelite Brotherhood. But whereas the first version had elements of the affectionate portrait, here Rossetti has turned to another sitter, Alexa Wilding, which gives the portrait a greater complexity of meaning, the multiplication of a single likeness providing a narrative element. In *Rosa Triplex*, the repetition no longer indicates, as it did in the 1855 *Paolo and Francesca da Rimini*, a separation in time. Instead, it becomes an iconization of several appearances of the same figure as it returns fitfully to the arena of memory, which the artist himself defined as "the only flower of consolation in the bitterest of hells". In Rossetti's paintings, the evocation of the beloved is always a reconquest of time linked to an underlying suggestion of death, as *Astarte Syriaca* (1877) so triumphantly demonstrates. His images of listless faces heavy with thought had a remarkable influence on the Symbolist generation from Khnopff to Segantini and Delville to Armand Point. Maurice Denis, who admired Rossetti and responded to this aesthetic of memory-distancing, used the same visual layout in his *Triple Portrait of the Fiancée Marthe* (1892) and *Yvonne Lerolle in Three Aspects* (1897).

G.C.

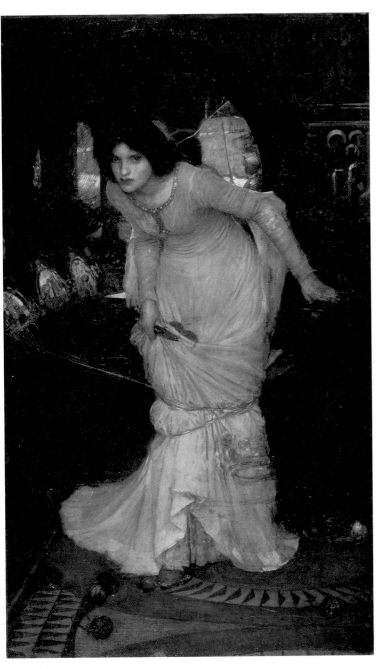

265 (cat. 463)
John William WATERHOUSE
The Lady of Shalott, 1894
Leeds City Art Galleries

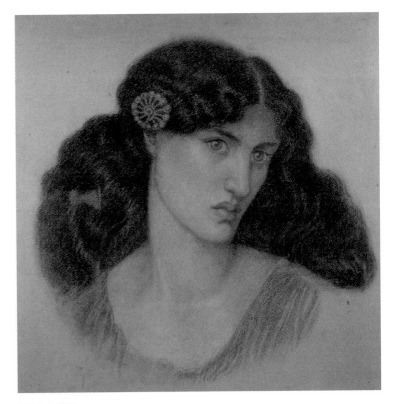

266 (cat. 362)
Dante Gabriel ROSSETTI
Study for Marianna, about 1895
New York, Stuart Pivar collection

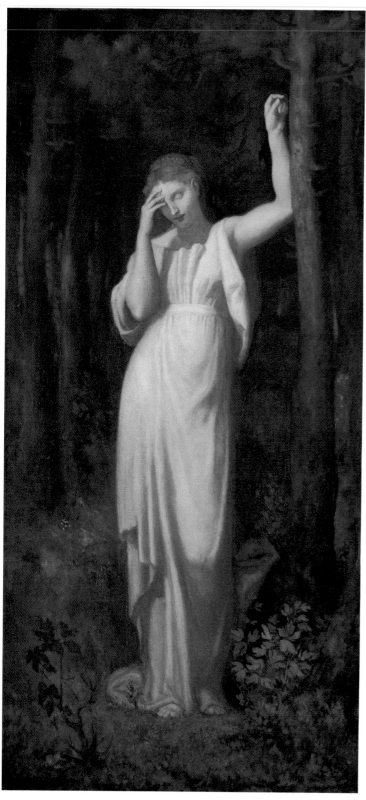

267 (cat. 334)
Pierre PUVIS DE CHAVANNES
Meditation, 1867
Private collection

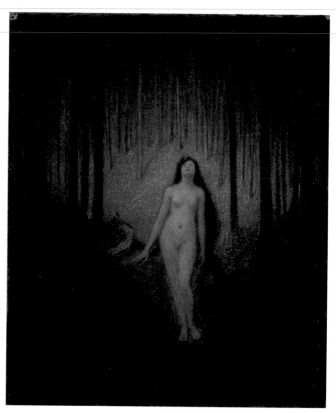

268 (cat. 243)
Ozias LEDUC
Erato (Muse in the Forest), about 1906
Ottawa, National Gallery of Canada

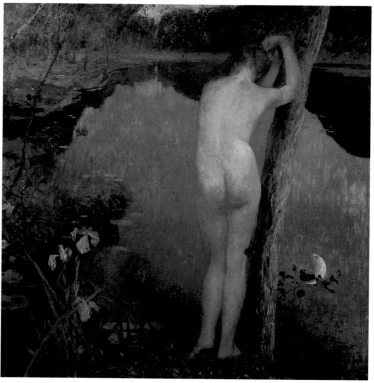

269 (cat. 320)
Eilif PETERSSEN
Nocturne, 1887
Oslo, Nasjonalgalleriet

270 (cat. 37)
Edward BURNE-JONES
The Love Song
1868-1877
Oil on canvas
114 x 155 cm
New York, The Metropolitan Museum of Art

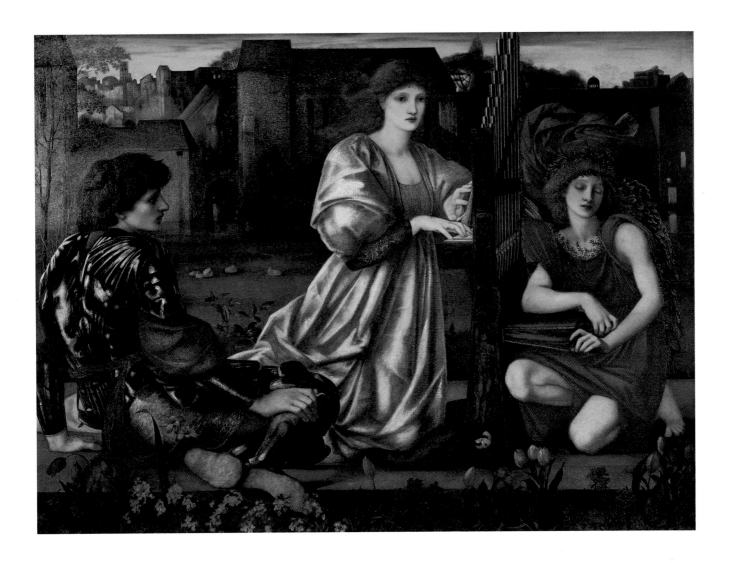

The subject of this painting appears to have been taken directly from a Breton song with the refrain "Alas! I know a song of love, / Sad and gay by turns". Burne-Jones often used musical references in his work, and his wife Georgiana was an accomplished musician. The canvas represents an oblique treatment of the subject: a young woman, seemingly lost in a strange dream, is playing the organ in the centre of the composition, while an androgynous figure with closed eyes (personifying Love) works the bellows. In front of these two rests a barefoot man in armour. The symbolism of the story unfurls in the border of medieval-style flowers: tulips, the sign of ardent love, and wallflowers for bitterness repeat the contrary emotions in the words of the song. However, this canvas harks back more to Renaissance paintings like Mantegna's *Madonna Trivulzio* and Titian's *Venus, Cupid and an Organist*, with its organ, than to medieval art.

The cityscape behind the figures is not descriptive in a realistic sense. To the left, the buildings are silhouetted against the first glimmer of dawn, while the right seems already plunged into dusk. The break in the narrative unity of time, the mutual indifference of the three figures and the juxtaposition of real and purely allegorical beings make this yet another gloss on the theme of seduction and absorption in love, indicated by the young warrior's bare feet, a sign of submission. *The Love Song* seems therefore to be one of the many versions of the *belle dame sans merci* topos, here treated in a wholly distanced manner.

G. C.

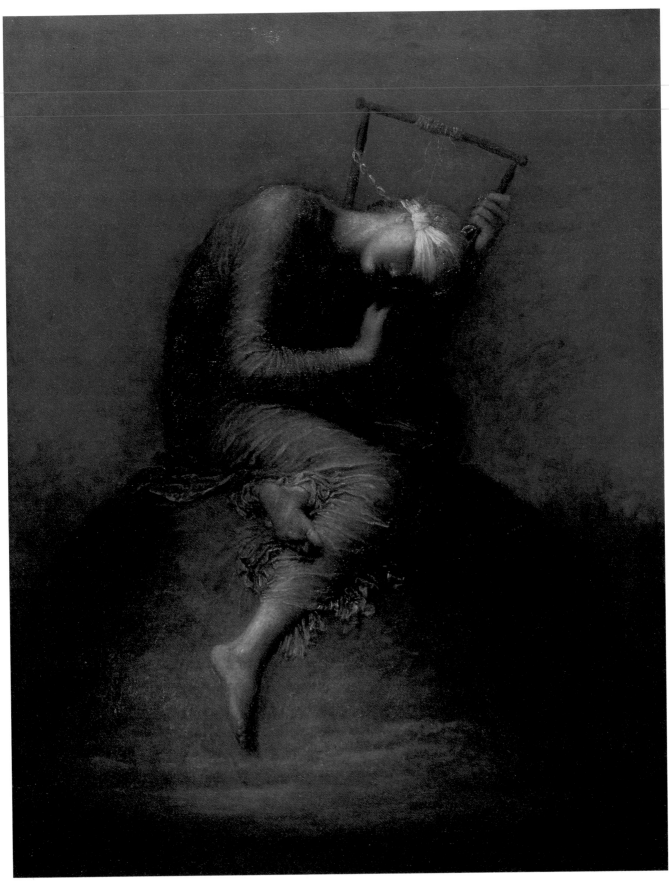

271 (cat. 466)
George Frederick WATTS, with assistants
Hope, 1886
London, Tate Gallery

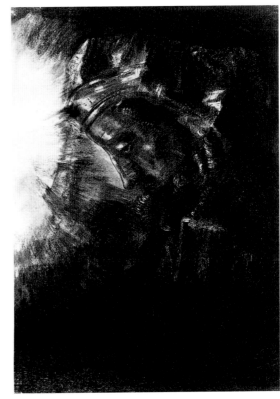

273 (cat. 345)
Odilon REDON
The Poet, about 1887
Antwerp, Museum Plantin-Moretus

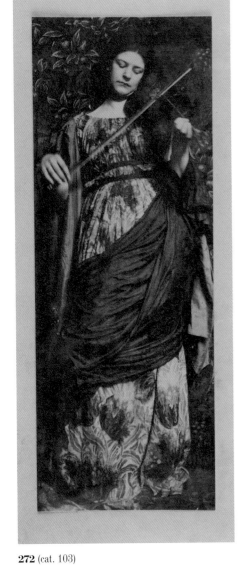

272 (cat. 103)
Frank EUGENE (Smith)
Music (Summer), 1899
Munich, Fotomuseum im Münchner Stadtmuseum

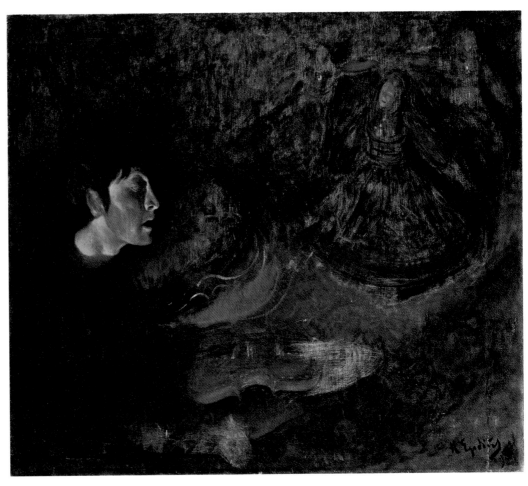

274 (cat. 92)
Halfdan EGEDIUS
Play and Dance, 1896
Oslo, Nasjonalgalleriet

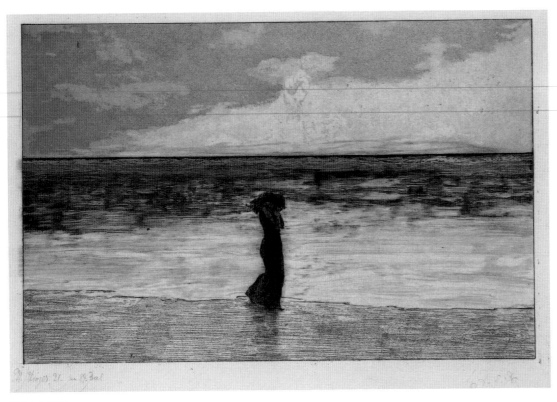

275 (cat. 207)
Max KLINGER
Abandoned, 1884
Ottawa, National Gallery of Canada

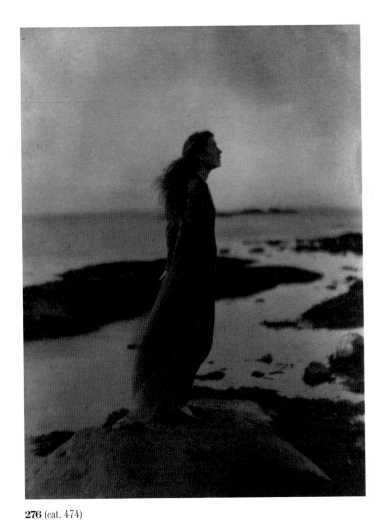

276 (cat. 474)
Clarence H. WHITE
The Sea, 1909
Princeton University, The Art Museum

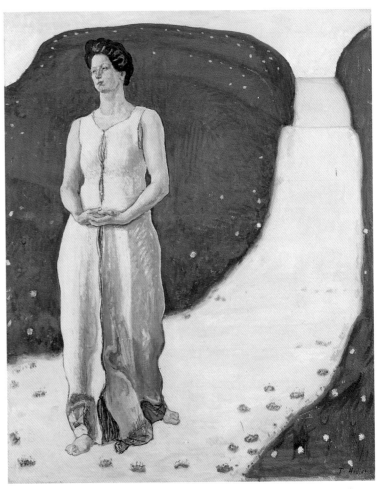

277 (cat. 159)
Ferdinand HODLER
Silence of the Evening, 1904-1905
Kunstmuseum Winterthur

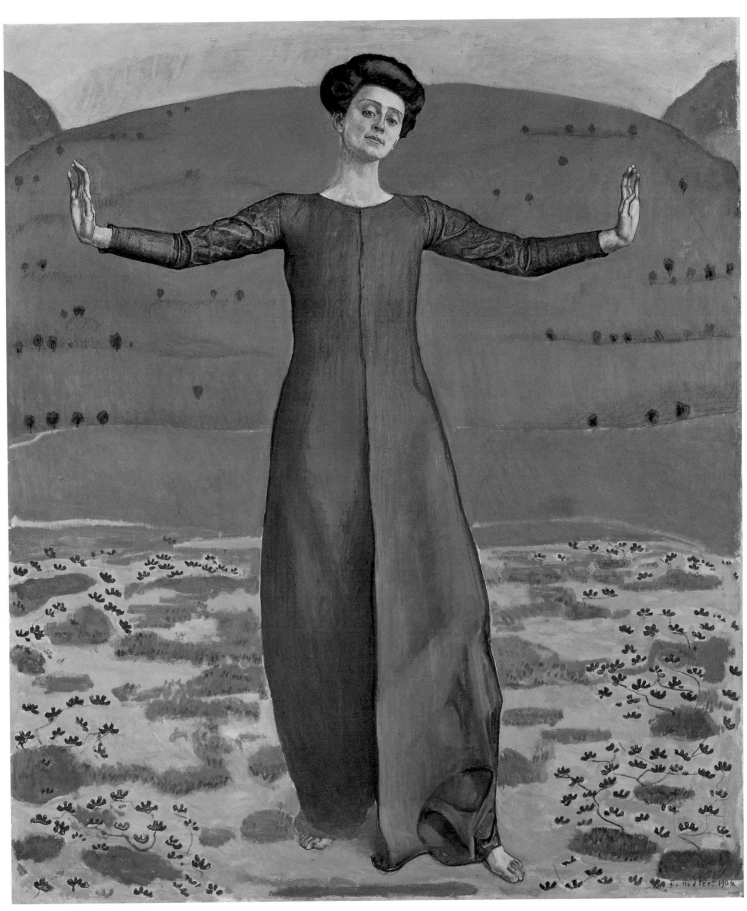

278 (cat. 158)
Ferdinand HODLER
Song from Afar, 1906
Kunstmuseum St. Gallen

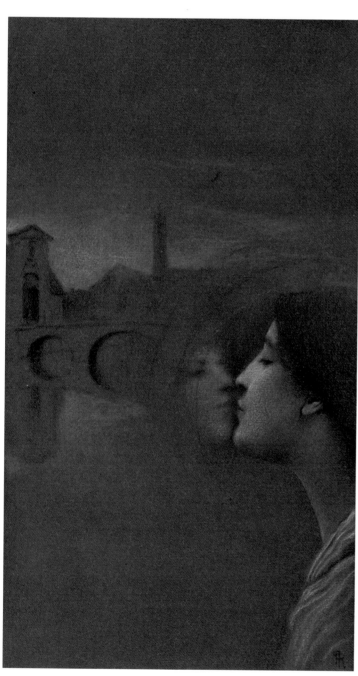

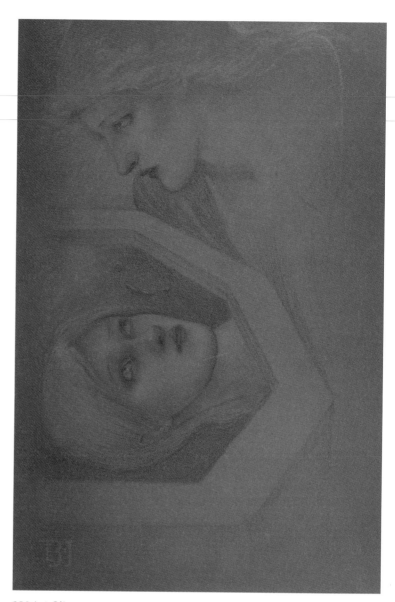

280 (cat. 34)
Edward BURNE-JONES
Sketch for "The Baleful Head", about 1872
New York, Stuart Pivar collection

279 (cat. 194)
Fernand KHNOPFF
With Grégoire Le Roy: My Heart Longs for Other Times, 1889
The Hearn Family Trust

281 (cat. 189)
Fernand KHNOPFF
With Georges Rodenbach: A Dead City
1889
Coloured crayon and ink on cream laid paper
26 x 16 cm
The Hearn Family Trust

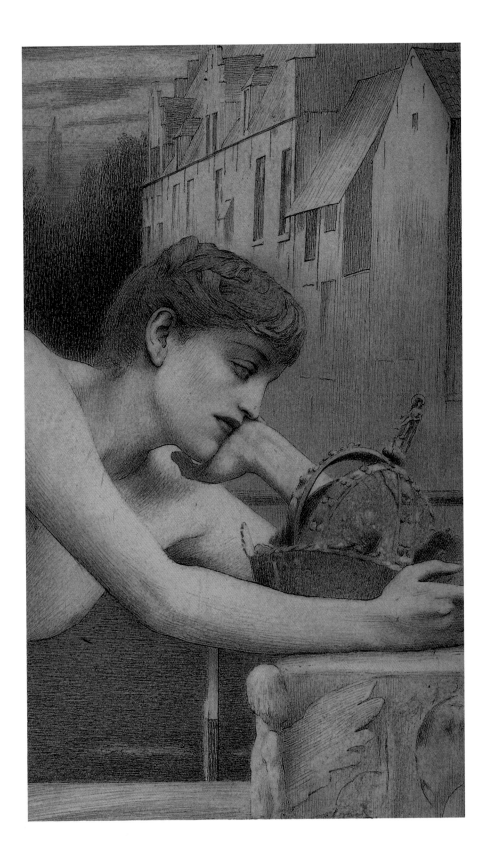

This work should be considered in relationship to Georges Rodenbach's novel *Bruges-la-Morte*, published in 1892. We see a coldly beautiful woman lost in contemplation of an imperial crown, like Maeterlinck's Mélisande peering into the fountain in search of her lost crown. However, this image has little to do with the subject of the book, which takes up the Poe-style theme of the new woman superimposed on the memory of the dead woman loved long ago. As in his later illustrations to Mallarmé's poetry, Khnopff is here concerned with perceptual equivalence, an image turned in on itself that captures the novel's various atmospheres and incidents in a synthesis outside of time. The artist uses to maximum effect two primary elements from his personal pantheon of symbols: the androgynous woman with the hard, thoughtful expression, and the water-girt city, symbol of oblivion and death, reflected in the depths of her eyes.

G.C.

282 (cat. 197)
Fernand KHNOPFF
Solitude
1890-1891
Pastel on canvas
150 x 44 cm
Gingins, Switzerland, Neumann collection

An androgynous female figure, haughty and resolute, sits stiffly beneath a medieval vault. She holds a spearlike sceptre, expressing the inviolable solitude of introspection. This painting encompasses virtually all the elements of Khnopff's personal mythology and private world, which had much in common with that of the Belgian Symbolist poets. Here, this obsessively taciturn painter deploys on a much smaller scale the principal elements of another work, executed the same year, with the significant title *I Lock My Door upon Myself* (Munich, Neue Pinakothek): a winged bust of Hypnos, god of sleep; a red-headed Pre-Raphaelite figure with folded arms, doubly cut off from the world – sleeping and enclosed inside a crystal ball; and a poppy, also protected from the ravages of time by its containment within a glass sphere. Privy to his own secret, the artist has inscribed side by side near the bottom of the panel, against a blue (his favourite colour) ground, a monogram of his own interwoven initials inside a rectangle and a peculiar rosette surmounted by a Chi-Rho, or Christogram, which consists of the first two letters of Christ's name in Greek. This may represent a discreet allusion to the artist's friendship with Joséphin Péladan, or simply a desire to remain abstruse.

The work was originally designed as the central panel of a triptych that has since been separated. At the inaugural exhibition of the Vienna Secession in 1898, two female figures drawn from Edmund Spenser's allegorical epic *The Faerie Queene* flanked the central image. To the left was a nude figure of the enchantress Acrasia, personifying Intemperance; to the right was an armoured Lady Britomart, representing Chastity. The triptych's title, *Isolation*, provides a vital clue to the hidden meaning behind this pictorial riddle. The intensely personal symbolism with which Khnopff imbued the central panel indicates that it is possibly the disguised self-portrait of an artist who had withdrawn into the temple of his own Self, supremely conscious of his sacred commitment.

C. N.-R.

283 (cat. 470)
Clarence H. WHITE
Still Life (Crystal Glass), 1907
Bath, The Royal Photographic Society

284 (cat. 185)
Gertrude KÄSEBIER
The Magic Crystal, about 1905
Bath, The Royal Photographic Society

285 (cat. 471)
Clarence H. WHITE
Symbolism of Light, 1907
Washington, Library of Congress

286 (cat. 379)
George SEELEY
The Black Bowl, 1907
Bath, The Royal Photographic Society

287 (cat. 290)
Gustav Adolf MOSSA
The Moon, about 1911
Paris, Lucile Audouy collection

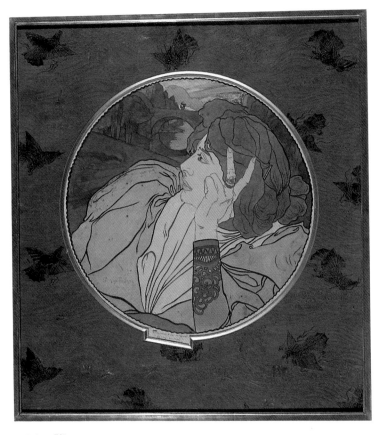

288 (cat. 72)
Georges DE FEURE
Melancholy, about 1895
Paris, Alain Lesieutre collection

289 (cat. 249)
Johann LÖETZ-WITWE
Lamp, 1901-1902
Kunstmuseum Düsseldorf im Ehrenhof

290 (cat. 188)
Fernand KHNOPFF
An Evening at Fosset, 1886
The Hearn Family Trust

291 (cat. 367)
Théo van RYSSELBERGHE
Marguerite van Mons, 1886
Ghent, Museum voor Schone Kunsten

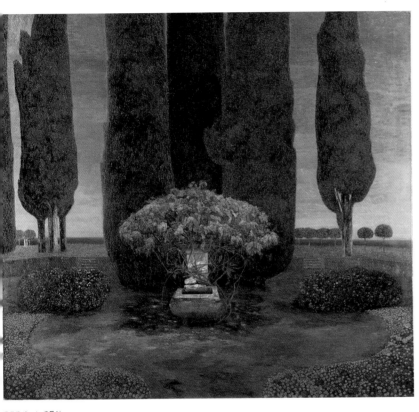

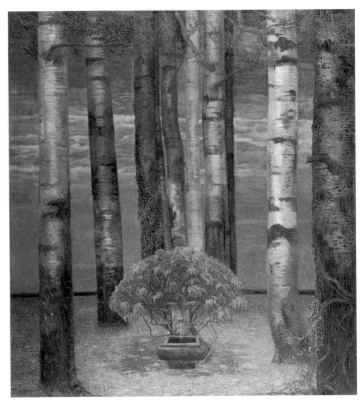

292 (cat. 271)
Karl MEDIZ
Wisteria Fountain with Cypresses, 1900
Private collection

293 (cat. 272)
Emilie MEDIZ-PELIKAN
Wisteria Fountain in a Birch Grove, 1900
Private collection

294 (cat. 462)
Édouard VUILLARD
The Dressmakers ("Desmarais" Screen)
1892
Tempera on linen glued to canvas
Four panels:
The Dressmaker: 95 x 38;
The Fitting: 120 x 38;
The Apprentices: 120 x 38;
The Lost Spool: 95 x 38 cm
Geneva, Galerie Jan Krugier

In the fall of 1892, Vuillard was commissioned by Paul Desmarais, a relation of the Natansons, to create a series of decorative panels to be enclosed in carved woodwork. After these were executed, Desmarais wanted to complete the ensemble with a folding screen. Vuillard's first suggestion was to present a continuous story unfolding panel by panel. Desmarais, however, preferred his second suggestion, whereby the figures would appear as though imprisoned in the space containing them. The scroll-like *kakemono* format of the screen, the lack of symmetry in the ensemble, which originally had a fifth panel now lost, and the narrow horizontal bands framing each panel at top and bottom indicate Japanese influence. Rejecting all spatial depth, Vuillard obtains his effects by flattening the planes, emphasizing this with a series of brightly coloured squares that give structure to the lower part of the composition. In the small Fauvist paintings he made between 1880 and 1890, Vuillard revealed his subjects (anonymous seamstresses from his mother's corset factory) through a progressive accumulation of pictorial material, through effects of overlay; in the absence of drawing, the women show through as if on unpainted canvas. The deliberate confusion of narration and pure decoration, together with the manner in which the figures seem to appear and disappear, has the effect of making the everyday seem sacred. These anonymous seamstresses might even be interpreted as quiet, latter-day Norns spinning out the web of fate.

G.C.

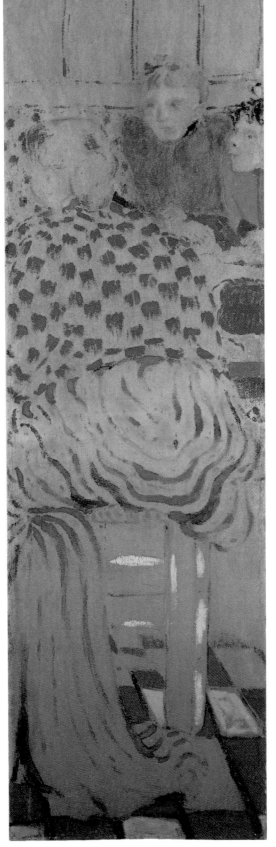
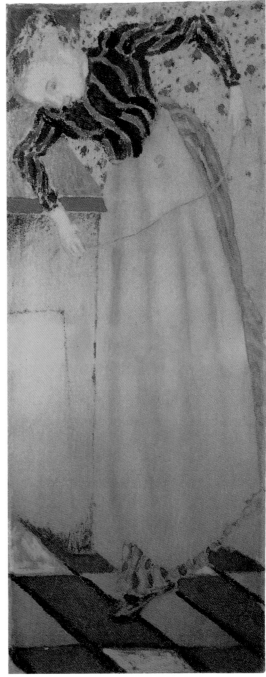

The Flux of Appearances

295 to 312

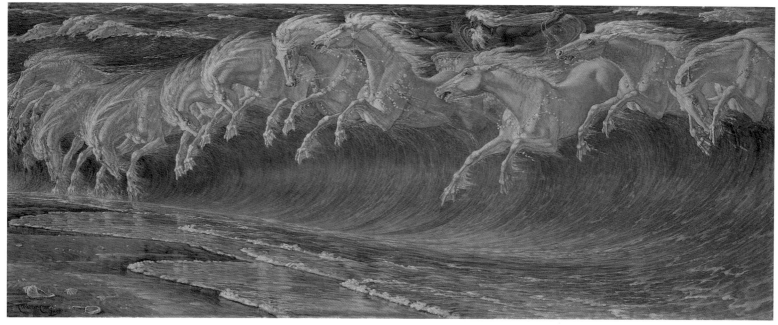

295 (cat. 53)
Walter CRANE
The Horses of Neptune, 1892
Munich, Bayersische Staatsgemäldesammlungen, Neue Pinakothek

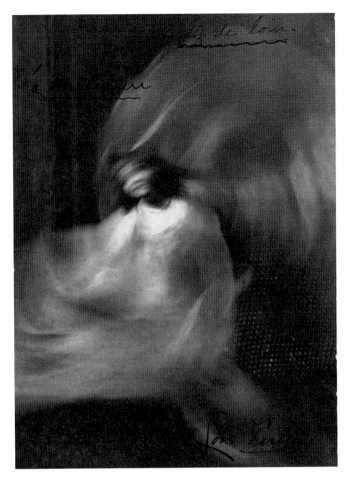

296 (cat. 5)
ANONYME
Loie Fuller Dancing, undated
Paris, Musée Rodin

297 (cat. 6)
ANONYME
Loie Fuller Dancing, before 1906
Paris, Musée Rodin

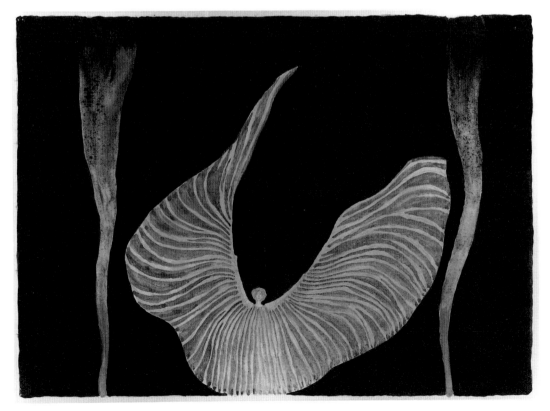

298 (cat. 288)
Koloman MOSER
The Dancer Loie Fuller, about 1900
Vienna, Graphische Sammlung Albertina

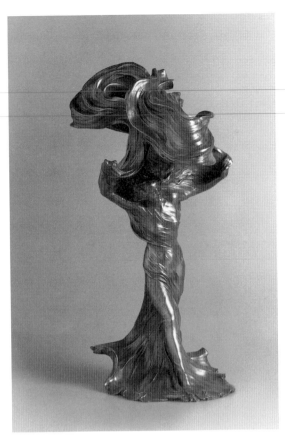

299 (cat. 240)
Raoul LARCHE
"Loie Fuller" Lamp, about 1900
Norfolk, The Chrysler Museum

301 (cat. 432)
Henri de TOULOUSE-LAUTREC
Mademoiselle Loie Fuller, 1893
Ottawa, National Gallery of Canada

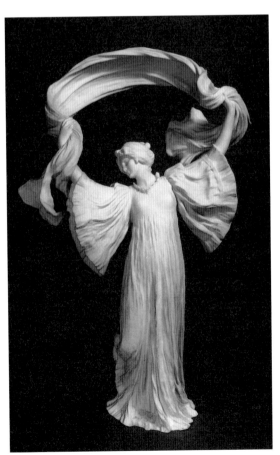

300 (cat. 246)
Agathon LÉONARD
and Sèvres National Porcelain Manufactory
Scarf Dance, 1900
Sèvres, Musée national de Céramique

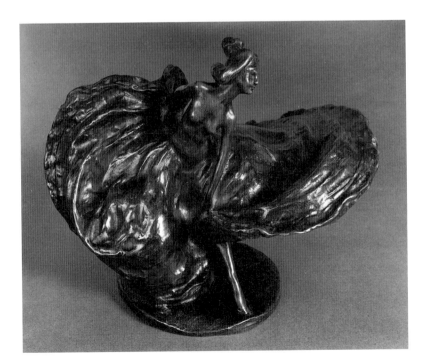

302 (cat. 163)
Bernhard HOETGER
Loie Fuller, about 1900
Städtische Kunstsammlung Darmstadt

303 (cat. 102)
Frank EUGENE (Smith)
Dance Study of Fritzi von Derra
About 1905
Platinum print
18.8 x 14 cm
Munich, Fotomuseum im Münchner Stadtmuseum

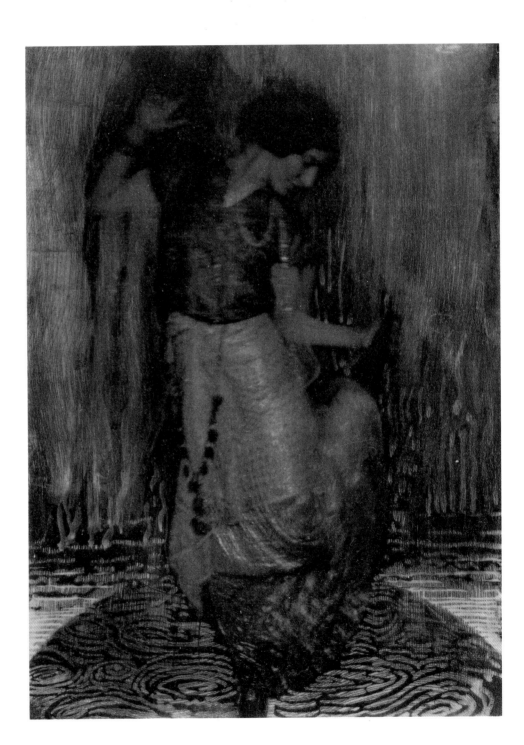

This *Dance Study* is based on the movement of the Portuguese dancer Friderica Derra de Moroda ("Fritzi von Derra") who, like Émile Jaques-Dalcroze and Isadora Duncan, tried to broaden the scope of classical dance by including free expressive dance in the Greek, Oriental and exotic modes. The composition, which has formal associations with representations of Salome dancing, acquires its dynamism not so much from the dance position itself as from the rich ornamentation of the picture's surface. Heart shapes in concentric, spiral and linear arrangement join to create dynamic lines whose the rhythmic structure recall the ornamental features in paintings by Klimt, Moreau, Stuck and Spilliaert (*Les Pieux*, 1910).

In this *Dance Study*, Eugene's radical and "unphotographic" method of "photo-etching" attained a maximum of expressiveness.

U. P.

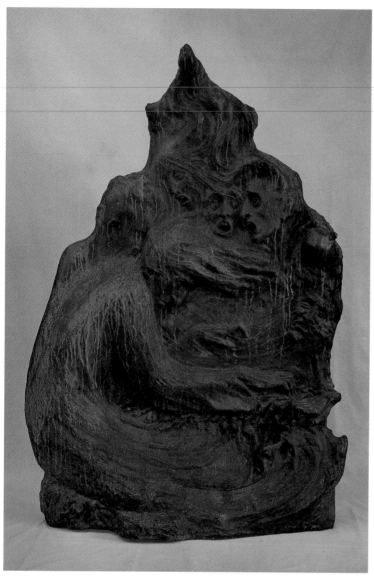

304 (cat. 18)
Boleslas BIÉGAS
Chopin, 1902
Paris, Galerie Elstir-Audouy

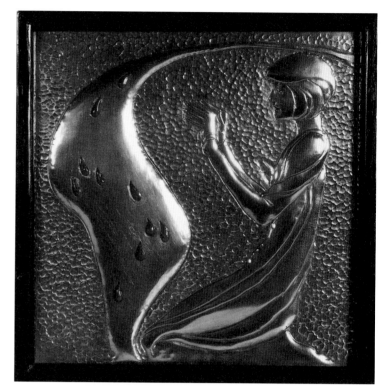

305 (cat. 289)
Koloman MOSER
Young Girl, 1903-1904
Historical Museum of the City of Vienna

306 (cat. 266)
Étienne Jules MAREY
Time-lapse Photograph of a Running Man Dressed in Black, 1883
Beaune, Musée Marey

307 (cat. 268)
Lucien LÉVY-DHURMER (design) and
Clément MASSIER (execution)
Charger
About 1895
Earthenware with metallic-lustre glaze
Diam.: 49.5 cm
New York, Daniel Morris and Denis Gallion,
Historical Design Collection Inc.

The female figure on this plate is modelled after the celebrated American dancer Loie Fuller, who was born just outside Chicago in 1862 and died in Paris in 1928. She caused a sensation at the Folies Bergères in Paris in 1892 and went on to great acclaim at the Exposition universelle in 1900, where she had her own theatre. In her famous "Serpentine Dance" or "Fire Dance", her only props were her flowing silk dresses and long, billowing silk scarves, which she would swirl while she danced under the glow of coloured electric lights. The image of this ethereal creature swaying and bending in a haze of drapery captured the Symbolist mood and captivated many artists, sculptors and illustrators who attempted to translate into their work the movement, line, colour and light of Fuller's performances.

The ceramist Clément Massier was known for the metallic lustre glazes he achieved in his works. In the plate, a figure with arms upraised in a dance movement is completely enveloped in drapery, her flowing hair merging with the lines of the silken folds. Engraved on the surface of the plate are aquatic plants that are tossed about as if in a whirlpool. The iridescent rainbow of colours produced by the lustre glaze and the golden highlights evoke the shimmering, luminous effects of Loie Fuller's dancing.

R. P.

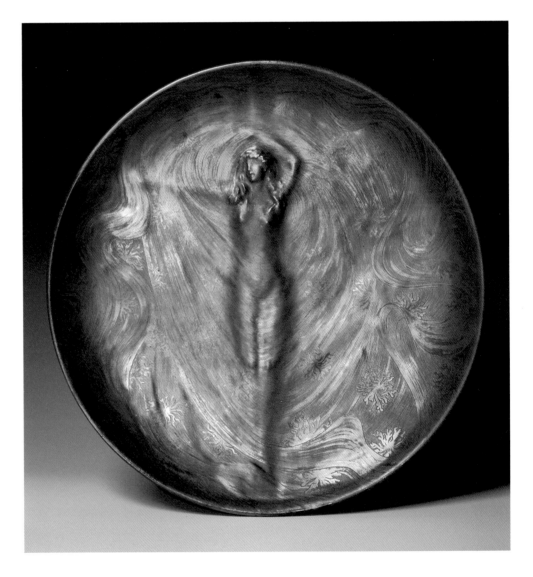

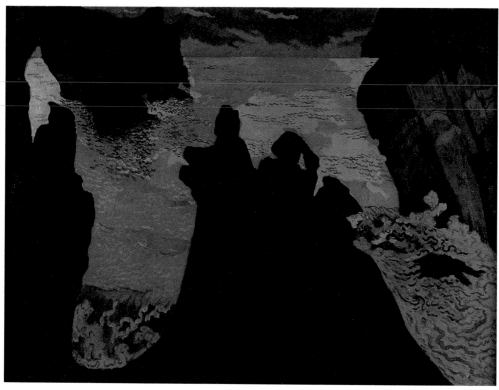

308 (cat. 235)
Georges LACOMBE
Yellow Sea, Camaret, about 1892
Musée de Brest

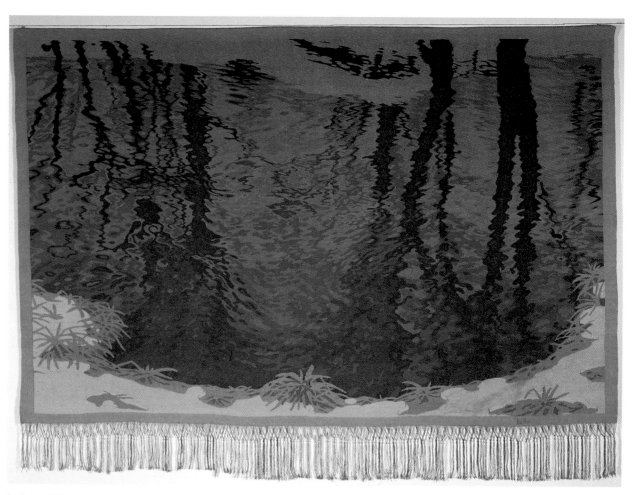

309 (cat. 115)
Gustaf FJAESTAD
Running Water, 1906
Göteborg, Sweden, Göteborgs Konstmuseum

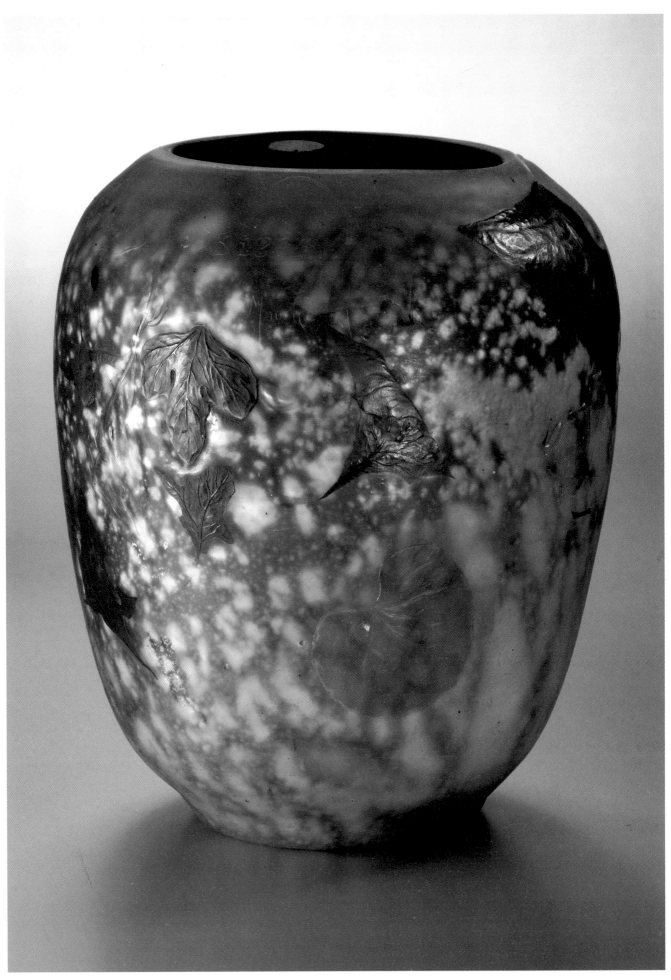

310 (cat. 123)
Émile GALLÉ
"Les feuilles des douleurs passées" Vase, 1900
Kunstmuseum Düsseldorf im Ehrenhof

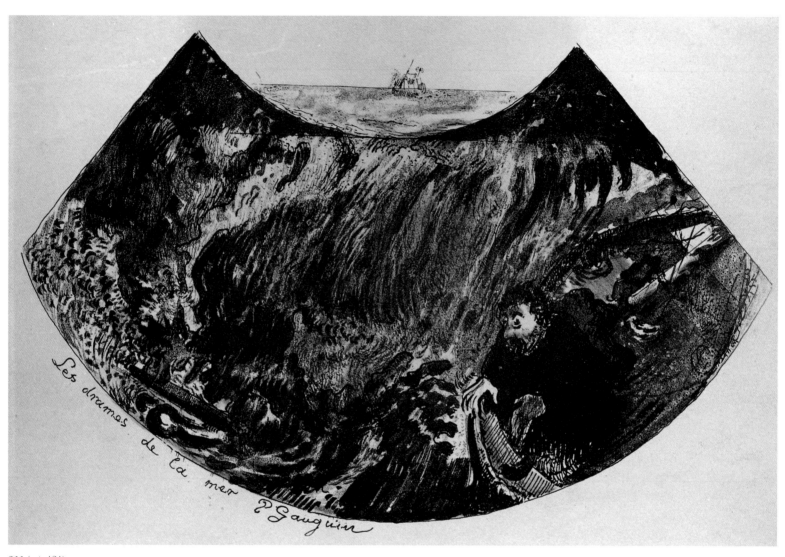

311 (cat. 131)
Paul GAUGUIN
The Drama of the Sea (Descent into the Maelstrom), 1889
Northampton, Massachusetts, Smith College Museum of Art

312 (cat. 262)
Jacek MALCZEWSKI
Vicious Circle
1895-1897
Oil on canvas
174 x 240 cm
National Museum of Poznań

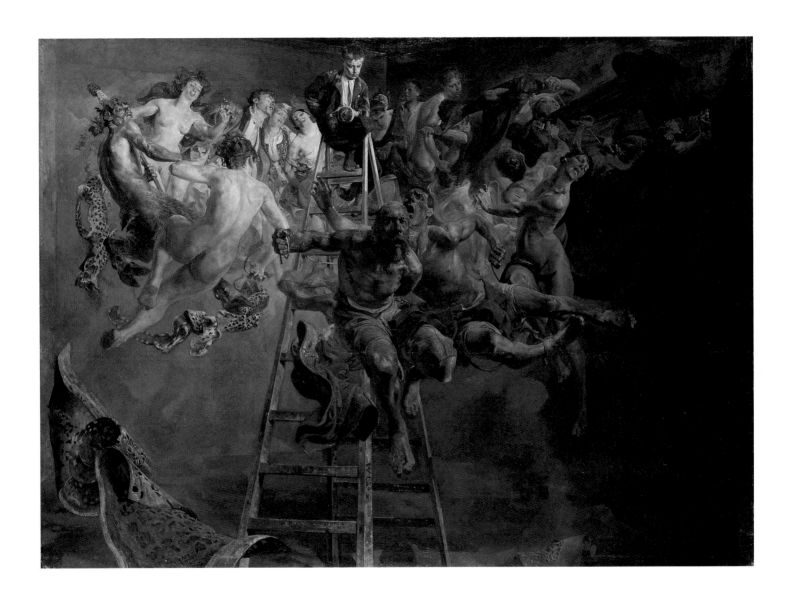

Vicious Circle was, after *Melancholia*, the artist's second attempt to portray his own life as an artist. The painter, once more a child, meditates perched on a ladder in the centre of the composition, while around him float a host of figures. On his right, fauns, nymphs and country people in traditional dress seem to incarnate old-fashioned pictorial models and a certain theatricality, while on his left, ill-lit figures in contorted poses express the artist's determination to find inspiration in the tragic sense of life.

This depiction of the painter's inspiration,

a hallucinatory reworking of Courbet's *The Studio* (1855), is the product of an unbridled sensibility typical of a narcissistic temperament like that of Malczewski. Rather than an orderly presentation of his various sources of inspiration, he preferred to show a frenzied round of images sprung from a dream, the antecedents of which are perhaps to be sought in depictions of the Last Judgement or the Fall of the Titans, or among more contemporary sources in Gustave Doré's *Fall of the Rebel Angels*. The "loose framing" at the top of the picture, too,

hints at the torment of being confined, emphasized by the unnerving detail of the hero being pressed towards the ceiling.

G. C.

From Anguish to Ecstasy
Symbolism and the Study of Hysteria

RODOLPHE RAPETTI

This mental hysteria or morose rapture inevitably
found expression in works of art and served to fix the images
it had created. In art it found its spiritual outlet,
the only one possible for it, since a physical outlet,
as I have already stated, is the surest destroyer of art.

J.-K. Huysmans[1]

The relationship between Symbolism and certain aspects of medical science belongs to what one might call the "underground" history of the art of the last century. The current body of research – it should be made clear at the outset – contains little indisputable evidence linking Symbolism with the study of hysteria. It may seem paradoxical, moreover, to apply a strictly scientific, typically Positivistic approach – a medical one in this instance – to art that answered the materialism of its time with allusion, irreality and dream. The way the study of nervous diseases developed in the last quarter of the nineteenth century is indicative of the era's confidence in scientific progress. But underlying the history of Charcot's medical research and experimentation involving hysteria were, from its inception, a number of ambiguous elements.

By 1882, the year he was appointed to the professorship in diseases of the nervous system, a position newly created for him, Charcot had already transformed the study of nervous-system pathology. In order to define the symptoms of hysteria, he added a photography laboratory to his department, placing it under the direction of Paul Régnard. The Salpêtrière Hospital thus possessed unequalled facilities for conducting clinical experiments. A first collection of photographs of hysteria appeared in 1875. Two years later, the first volume of the famous *Iconographie photographique de la Salpêtrière* appeared, with successive volumes published yearly until 1880; beginning in 1888, when Albert Londe replaced Régnard, it

became the *Nouvelle iconographie de la Salpêtrière*. These initiatives were in line with the development of medical photography in the late nineteenth century and, in particular, with the *Revue photographique des Hôpitaux de Paris*, which first appeared in 1869. The *Iconographie de la Salpêtrière* followed in the wake of older representations of mental patients,[2] but its penetrating photographic vision was rather shocking.

The methods used in studying hysteria at the Salpêtrière, particularly the on-site photography studio and the demonstrations given by Charcot in his open "Tuesday Lessons", brought this field of experimentation and its related medical documents (that is, photographs of hysterics) to many outside the field – to laymen, to the simply curious. At the same time, Charcot's demonstrational approach gave the illness a theatrical quality, as evidenced by Brouillet's well-known painting, exhibited at the Salon of 1887.

Charcot's interest in art has often been noted: the *Iconographie de la Salpêtrière* contained numerous articles by his direct associates dealing with the representation in art of the "possessed". According to Gilles de la Tourette,

1. Joris-Karl Huysmans, "Félicien Rops", in *Certains*, ed. Hubert Juin (Paris, 1975), p. 335.
2. See the atlas of twenty-seven engravings by Ambroise Tardieu in E. Esquirol's *Des Maladies mentales considérées sous le rapport médical, hygiénique et médico-légal* (Brussels, 1838).

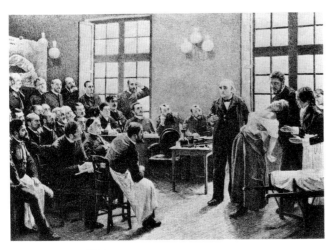

André BROUILLET
A Clinical Lesson at the Salpêtrière, 1887
Paris, Bibliothèque nationale de France

Charcot's artistic bent was inherited from his father, "a modest carriage-builder... more artist than artisan",[3] while Henry Meige describes how the young Charcot was torn between art and medicine.[4] Charcot sketched throughout his career, and one of his colleagues at the Salpêtrière, Paul Richer, who compiled a chart of line drawings illustrating the various positions of the body in "grand hysterical attack, complete and unremitting", was also a Professor of Creative Anatomy at the École des beaux-arts. As simplistic as it may appear, the hypothesis that Charcot transformed his artistic aspirations into a kind of theatricalization of experimental medicine would seem to have some basis.

This "dramatic" representation of torment is in keeping with a specific Symbolist tendency, perhaps best described as a new expressive approach towards the human body, an approach that led Huysmans to define the modern artist as "hysteric". It was hysteria that would bring on the "disruption of all the senses" sought by Rimbaud in *Lettre du voyant*.

These preliminary remarks provide a context for the field of our investigation: a host of examples in the corpus of

paintings now known as Symbolist attest to the emergence of new modes of representing the human body that broke with the traditional models, and even with the main artistic currents of the nineteenth century. Symbolism adopted, *mutatis mutandis*, an attitude similar to the one it was opposing, since artists like Degas and Caillebotte based their stylistic research on new modes of representing the modern world, photographic composition among them, which also placed the body in a new expressive situation.

With Symbolism came a marked propensity for capturing paralytic tension, nervous contraction and a certain ostentation with regard to sexual pleasure: the body frozen in a significant gesture. These images generally conveyed something of a feeling of terror towards women, the anatomical frenzy most often being limited to the female form; in Symbolist iconography, they were thus the counterpart of the saintly figures who symbolized chastity or meditative serenity. Set against these images of purity (mother, fiancée, wife) were images of feminine perversity and temptation, a pre-eminent theme in the art and literature of the time.

Numerous examples, representing neither a stylistic mode nor a feature of Symbolist iconography (in the sense that Symbolism has never taken hysteria as a *subject*), could serve to illustrate a tendency in Symbolist art to depict how the nervous system manifested, through the attitude of the body or facial expression, a mind on the edge of rational equilibrium and functionality. Bearing in mind the difficulties in determining the artists' sources, we will limit ourselves to a few eloquent examples. Most of the artists, certainly, would not have had direct access to the images we would consider crucial. Nonetheless, their approach in conveying the body's peculiar expressiveness coincided with what may be called the "invention of hysteria",[5] which shed new light on the human condition in the last quarter of the nineteenth century. This is not to say that any concerted or systematic investigation of the medical documents took place. There are only a few examples where this was most likely the case, among them Klinger's *Shipwreck*, part of the series "Ein Leben" [A Life] published by the artist in 1884. Klinger made regular visits to Paris in 1883, although his interest in this type of imagery likely began even earlier, from an encounter with Jules Laforgue in Berlin in 1882. Laforgue, in the second volume of his collection *Le Sanglot de la terre*, planned to combine "the Morgue, the Dupuytren Museum, the hospital, love, alcohol, melancholy, massacres, solitary retreats, madness, the Salpêtrière".[6] But

3. Gilles de la Tourette, "Jean Martin Charcot", *Nouvelle iconographie photographique de la Salpêtrière*, vol. 6 (1893), p. 241.
4. Henry Meige, *Charcot artiste* (Paris, 1925), p. 8.
5. The works of Georges Didi-Huberman are particularly valuable in this regard, especially his pioneering study *Invention de l'hystérie. Charcot et l'Iconographie photographique de la Salpêtrière* (Paris, 1982).
6. Jules Laforgue, "Pensées et paradoxes" (*Mélanges posthumes*). Quoted in Jules Laforgue, *Les Complaintes. L'Imitation de Notre-Dame la Lune. Derniers vers*, ed.

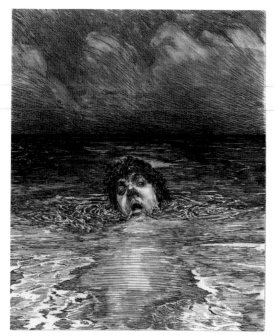

Max KLINGER
Shipwreck (Pl. 12 of *"Ein Leben"*), 1884
Leipzig, Museum der bildenden Künste

Paul RÉGNARD
Hystero-epilepsy. Hallucinations.
Anxiety. Photograph from the *Iconographie*
photographique de la Salpêtrière

examples of this kind are rare. Rather, the use of clinical evidence shows up as an echo that lets us sense how, loosely based on the sources in question, the characteristic imprint of this new way of looking at the human figure surfaced in the work of various artists. In its spread, this new way of perceiving most often eluded direct influences. Klimt, Munch, Spilliaert and the minor Symbolists who clustered around Sâr Péladan, including Eugène Grasset and Carlos Schwabe, are cases in point. The works of Schwabe, whose studies for **The Wave** evoke the world of hysteria through their hallucinatory tension, reflect the diffuse manner in which this sensibility of the early 1880s infiltrated a large portion of Symbolist art.[7] Whether the artist actually interpreted the documents or made imaginative transpositions (perhaps through theatrical models) is difficult to say. It is unlikely that Schwabe had direct knowledge of hysterical phenomena in the early 1890s, when he completed his illustrations for Zola's *Le Rêve*; if he had, they would have borne the traces. It is rather in his works after 1900 that the signs of this particular sensibility appeared, as they did in a number of artists who reflected the late developments of Symbolism in the early twentieth century.

The specific achievement of Symbolism, however, lies not in its representation of mental aberrations, but rather in the

161-163

status it gave them within the structure of the image. Earlier in the century, Romanticism provided a few celebrated examples of the depiction of madness. But whether they be the clinical observations of Géricault or the wild imagery of Wiertz,[8] the Romantic images were presented as *representations* of madness and were based on presuppositions rooted in the observation of reality, in the imagination of the artist or in literature (Delacroix, in particular).[9] An analogous situation, in the era that concerns us, existed in Naturalism, with obviously much different results. Jean Béraud's painting *The Madmen* is representative. Like the famous *Fascinés de la Charité*[10] by Georges Moreau de Tours painted five years later, it renders, with all the necessary precision, the exterior manifestations of madness and establishes a typology specific to painting. The following contemporary commentary bears this out:

6. . . . Claude Pichois (Paris, 1959), p. 302. *Le Sanglot de la terre* was never published, but Laforgue was working on it in 1882.
7. On Schwabe and *The Wave*, see Jean-David Jumeau-Lafond, *Carlos Schwabe. Symboliste et visionnaire* (Courbevoie, 1994), pp. 144ff.
8. *Faim, Folie, Crime*, oil on canvas, 155 x 164 cm. Brussels, Musée Wiertz.
9. *La mort d'Ophélie*, 1853, oil on canvas, 23 x 30.5 cm. Paris, Musée du Louvre.
10. *Les fascinés de la Charité (service du Dr Luys)*, 1890, oil on canvas, 121.5 x 158.5 cm. Reims, Musée des Beaux-Arts.

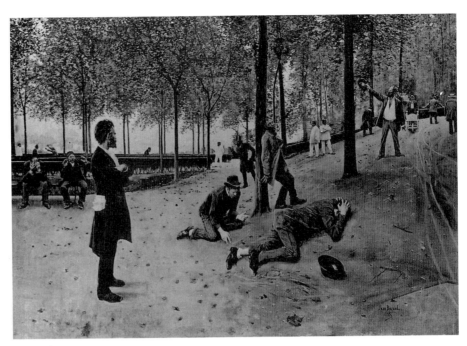

Jean BÉRAUD
The Madmen, about 1885
Location unknown

Jean Béraud, whose powers of observation are very acute, uses his brush like a scalpel, making clean and confident strokes in displaying all the innocuous forms of madness. Mercifully, he left the furious and the frenzied in their padded cells. But how many sad and peculiar types remain! The gay and the despondent; the ambitious and the disillusioned; the politician engrossed in oratory as if before the Chambre; the reflective philosopher, arms folded solemnly across his chest; the worker who spends his life determinedly wheeling a wheelbarrow over sandy pathways. Everything is seen with a clear vision and rendered with a skilled hand. Sad, but interesting to the highest degree.[11]

It is understandable that hysteria in the strict sense would cause problems for the Naturalist painters, whose policy of truth in representation would ultimately have to rely on clinical documents. There is also the difficulty of assimilating the most venturesome advances in science, of using data that was still fragmentary and uncertain, and in any case belonged to a field of investigation centred in the *psyche*, an area that even the Symbolists felt was neglected by the Positivists.

11. Louis Énault, *Paris-Salon* (Paris, 1885), p. 33.
12. Jules Claretie, *Les Amours d'un interne* (Paris, 1902, 2nd edition), preface, p. II.

In the novel *Les Amours d'un interne* (1881), Jules Claretie depicts the world of the Salpêtrière and the phenomena of hysteria. He also relates how these phenomena – which to him "seemed almost unbelievable"[12] – fascinated the artistic world. This work may thus be considered the essential "document" on hysteria, in the Naturalist sense of the word. Belgian author Camille Lemonnier's novel *L'Hystérique*, published in 1885 by Georges Charpentier in Paris, is an unambiguous work since the case of "possession" the book is about is presented as the equivalent of mental illness. Although the "demonic" character of hysteria was easily admitted, its relationship with mysticism was not, despite the fact that this relationship was demonstrated in a number of texts published under the aegis of Charcot. Zola was thus unable to define the psyche of Angélique, the heroine of *Le Rêve* (1888), with the kind of scientific rigour expected of the leader of the Naturalist movement. And yet the work, a study of the appearance and development of a religious sentiment of extraordinary intensity, would seem to lend itself to this. In fact, Zola evinced a certain prudence with regard to any aspect of his subject that might be considered provocative, as if the turmoil inevitably resulting from a look into these inner recesses of the mind was too dark and obscure for analysis. The final "resurrection" of the heroine can only be

tenuously related to the phenomenon of "hysterical sleep" observed in certain patients at the Salpêtrière.[13]

Hysteria, represented in and of itself, produced documents that were uncomfortably close to clinical studies and thus had a certain unpleasantness and brutality about them, which may explain why so few Naturalist works adopted this theme. One that did was *La Grande Névrose* [Great Neurosis], a marble statuette by Jacques Loysel exhibited at the Salon of 1896[14] and based directly on clinical studies of patients.[15] It elicited this comment from Jean Lorrain:

> Further on, a lovely marble piece by a certain Loisel [*sic*], a frost white, finely textured Paros; a nude woman reclining languorously, lips parted and eyelids half-closed, waiting for . . . the impossible, for this spasm in marble is entitled *Grande Névrose*. In the shaping of the torso and the contortions in the feet, there is much to recommend to art lovers.[16]

Despite the vague term "great neurosis", it is obvious that the work represents one of the phases of *grande hystérie*, as evidenced by Lorrain's description and its allusion to feminine sexuality. But this type of representation was no doubt a rarity, given its position midway between medical document and *curiosa*.

Whereas Naturalism, with its social itinerary, could only *relate* these "fringe areas" of the mind, Symbolism wholly immersed itself in the subject. The literary precursors of Symbolism repeatedly expressed their fascination with the phenomena of hysteria. As early as 1865, the symptoms of Calixte Sombreval, the heroine of Barbey d'Aurevilly's *Un prêtre marié*, were described with enough precision as to leave no doubt about their origin. There we find, among other things, the tension of the arching body, the dramatic culmination of what in Charcot's era would be called *l'attaque*.[17] The description of the heroine's face, moreover, anticipates certain typically Symbolist representations of the female form:

> Every hair on her beautiful blond head became a painful needle into the scalp. Deep quiverings shook this fragile body to the point of breaking. Her eyes, lined with dark circles, grew hollow under their eyebrow arches and rolled towards her brain. This frightening sign made Néel shudder, for it heralded attacks like those of epilepsy, ending in contractions and rigidity.[18]

Hysterical phenomena underpin the entire output of Barbey d'Aurevilly, and Félicien Rops's illustrations for ***Les Diaboliques*** convey a sense of nervous quaking that echoes the work's pulsating rhythm. In the plate ***At a Dinner of Atheists***, the heroine is indeed "insolent, ironical, laughing with the hysterical laughter of hate at the most acute paroxysm".[19] Her nude body is arched, the very image of the unrepentant sinner that would reappear for years, right up to Segantini's *Unnatural Mothers*.[20]

122-130

130

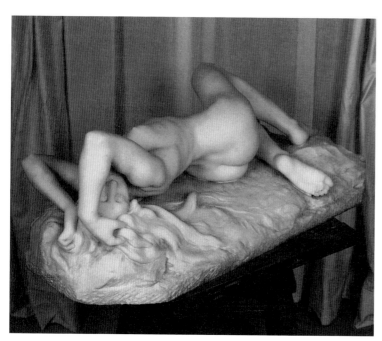

Jacques LOYSEL
La Grande Névrose, 1896
Neuilly-sur-Seine, private collection

13. On the relationship between hysteria and Naturalist literature, see Jacqueline Carroy-Thirard, "Hystérie, théâtre, littérature au dix-neuvième siècle", *Psychanalyse à l'université*, vol. 7, no. 26 (March 1982), p. 299.
14. Cat. 3625. This small-format sculpture was exhibited in the *objets d'art* section. The description "marble statuette" in the catalogue leads one to imagine it was a reduction made from the work illustrated here or from another version of the same subject (a bronzed terra-cotta study, 10.5 x 12 x 21.6 cm, Neuilly-sur-Seine, private collection).
15. Information conveyed by the artist's descendants. At the time this sculpture was created, Loysel stayed for several days in a psychiatric hospital in Paris, no doubt in order to witness a complete "attack".
16. Raitif de La Bretonne [Jean Lorrain], "Pall-Mall Semaine", *Le Journal*, May 21, 1896.
17. Jules Barbey d'Aureville, *Un prêtre marié*, ed. Jacques Petit (Paris, 1980), p. 406.
18. *Ibid.*, p. 391.
19. Jules Barbey d'Aurevilly, *Les Diaboliques* (Paris, 1960), p. 366. An English version by Ernest Boyd was published as *Les Diaboliques* (London: Paul Elek, 1947), and reissued as *The She-devils* (London: Dedalus, and New York: Hippocrene, 1986), from which the translated quotation is derived (p. 167 and p. 216, respectively).
20. Oil on canvas, 1894, 120 x 225 cm. Vienna, Kunsthistorisches Museum. See Jean Clair, "Une volée de bois mort. *Les mauvaises mères* de Segantini", *Nouvelle revue de psychanalyse*, vol. 45 (Spring 1992), p. 49.

In his novel *À rebours* (1884), Huysmans explicitly linked hysteria with the precursors of pictorial Symbolism, by describing the figure of Salome portrayed in Gustave Moreau's *The Apparition* as "the symbolic incarnation of undying Lust, the goddess of immortal Hysteria, accursed Beauty exalted above all other beauties by the catalepsy that hardens her flesh and steels her muscles".[21] This "between the lines" reading of Moreau's work is similar to Des Esseintes's reading of the Gospel of Saint Matthew.

It is on this same model that Symbolism initiated, in keeping with the intellectual tenor of the time, an acclimatizing process that fulfilled a need to subvert the image; its representation of mental disturbances was introduced surreptitiously, as it were, without the illustrative clarity of Naturalists like Brouillet. These representations of the dark areas of the mind were deviated by way of the fable, and thus the force of the photographic document, which was lost in Naturalism, regained its former intensity.

While the relationship between Symbolism and the study of hysteria cannot be demonstrated on the basis of solely factual evidence, it is fundamental in understanding the movement's expressive depiction of the body, its derivation and ramifications. In the imagery of Symbolism, the hysterical body or frenzy belonged to an unconscious subject, as it were, generally in depictions of spiritual communion with supernatural powers or of overpowering instincts (most notably in Munch).[22] When a traditional theme, be it religious or mythological, is infused with elements of modern neurosis, the work is divested of its previous meanings and given a new set of meanings. This overstepping of the traditional iconographic

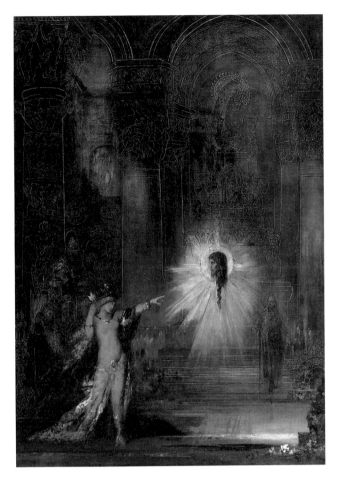

Gustave MOREAU
The Apparition, 1876
Paris, Musée du Louvre

boundaries is one of Symbolism's major contributions to twentieth-century art.

A significant example is the famous painting by Alphonse Osbert entitled *Vision*. Exhibited first at the 1892 Salon of the Société nationale des beaux-arts and the following year at the Rose + Croix Salon, this work exemplifies the new imagistic modalities that originated in Symbolism. Its elliptical title led to some confusion regarding its subject: Saint Geneviève or Joan of Arc? The celebrated *Joan of Arc* that Bastien-Lepage presented with great success at the Salon of 1880, and which invited parallels with the Charcot's research,[23] had no doubt not been forgotten. In 1899, Osbert himself settled the question by presenting the work as *The Vision of Saint Geneviève* at the Salon d'art religieux de Durendal in Brussels.[24] Although Osbert's daughter indicated in 1990 that her father did not intend to represent a saint, but simply "a state of mind",[25] the fact remains that the artist frequently related this figure to Saint Geneviève.[26] With good reason, the

21. Joris-Karl Huysmans, *À rebours*, ed. Pierre Waldner (Paris, 1978), p. 106. Quoted in English from *Against Nature*, trans. Robert Baldick (Harmondsworth, England: Penguin Books, 1959), p. 66.

22. See Rodolphe Rapetti, "Munch face à la critique française : 1893-1905", *Munch et la France*, exhib. cat. (Paris: Réunion des musées nationaux, 1991), p. 25.

23. Now at the Metropolitan Museum of Art, New York. See Marie-Madeleine Aubrun, *Jules Bastien-Lepage 1848-1884* (n.p. [Paris: Association Jules Bastien-Lepage redécouvert], 1985), p. 175

24. See Geneviève Lacambre, in *Le Symbolisme en Europe*, exhib. cat. (Paris: Réunion des musées nationaux, 1976), no. 159, p. 159.

25. Yolande Osbert to Geneviève Lacambre, oral communication of February 19, 1990.

26. One of the sketches for *Vision* was reproduced in 1909 under the title *Sainte Geneviève* (see Pierre Courtois, "Les Geneviève", *La Revue française politique et littéraire*, January 3, 1909, p. 119); Osbert presented this painting again at the Société Nationale des beaux-arts in 1934 under the title *Vision de sainte Geneviève* (cat. 1493). Representing Geneviève in a visionary state in no way corresponds to the usual iconography of the saint. See Louis Réau, *Iconographie de l'art chrétien*, vol. 2 (Paris, 1958), p. 563. Note that one of Osbert's drawings, a nude study for *Vision*, was reproduced in the catalogue of the 1893 Salon de la Rose + Croix, p. 94, where it was misattributed to George Morren.

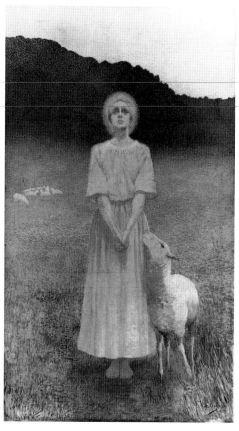

Alphonse OSBERT
Vision, 1892
Paris, Musée d'Orsay

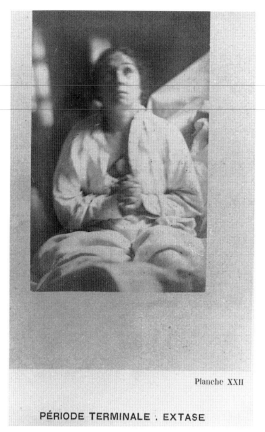

Planche XXII

PÉRIODE TERMINALE : EXTASE

Paul RÉGNARD
"Attitudes passionnelles". Ecstasy
Photograph from the *Iconographie photographique de la Salpêtrière*

artist always regarded this particular painting as one of his finest, and he kept it in his possession his entire life. When Lepage, the director of *Le Journal*, expressed a wish to acquire it in 1899, Osbert made a rigorously faithful replica.[27]

Although the title of the work is vague and reflects in some ways the climate of the time,[28] it is clear that this image was meant to be placed in a Christian context. The halo and the hands clasped in prayer would appear to confirm this. And yet the woman's rigid frontal pose is in sharp contrast with traditional hagiographic representations. The rendering of the face in particular, the protruding eyes with pupils set against the arch of the eyebrows,[29] has no real contemporary equivalent.

From a stylistic viewpoint, this work is a significant example of how certain irrealistic aspects of Neo-Impressionism found their way into Symbolism. The essentially dreamlike colour of this vast bluish monochrome, with faint shades of green and yellow, is quite telling in this regard. Although Osbert did not divide his tones into primary colours,

the major portion of the pictorial surface employs a fragmented brush stroke, like that of the Neo-Impressionists. Similarly, the curtain of trees that closes off the top of the composition provides contrast with the complementary shades of blue and orange.

Along with this incorporation of recent painting techniques came the influence of an entirely new source. In the first volume of the *Iconographie photographique de la Salpêtrière*, Bourneville and Régnard[30] studied the case of a hystero-epileptic presenting what may be called attacks of mystical delirium. Geneviève B., born in Loudun on January

27. This replica, now at the Musée d'Orsay, was bought back by Yolande Osbert at the end of World War II. According to the *Grand Dictionnaire encyclopédique Larousse*, after the death of its founder in 1899, *Le Journal* was directed by H. Letellier.
28. At the first Salon de la Rose + Croix in 1892, Henri Martin presented a work entitled *Vision* (cat. 95), as did Hubert de La Rochefoucauld (cat. 124). At the second Salon, in 1893, a work by Georges de Feure bore the same title (cat. 92).
29. This detail, scarcely discernable in the photograph, is clear in a viewing of the work itself.
30. Désiré Magliore Bourneville and Paul Régnard, *Iconographie photographique de la Salpêtrière*, vol. 1 (Paris, 1877), pp. 70ff.

2, 1843, of unknown parents, was described as a "succubus" in the second volume of the *Iconographie*[31] and as a "visionary" in the first. The same model, the namesake of Osbert's saint, thus embodied the feminine ambivalence that was to be a common theme in Symbolism:

> Over the course of the year we were witness to another variety of delirium in which the religious stamp was even more pronounced. Instead of a purely melancholic delirium, accompanied by ramblings and lamentations, it was of the nature of veritable *ecstasy*.
>
> G[eneviève] is seated: sometimes her head is in an almost natural position; her eyes are raised slightly upwards, her clasped hands rest on the bed; it is the *attitude of prayer*; – sometimes the head is tilted back; – other times its position evokes such visionaries as Saint Teresa, etc. In the latter case, her head is thrown back, her gaze heavenward; her physiognomy, imbued with great gentleness, expresses ultimate satisfaction; her neck is swollen, tense; her breathing seems to have stopped; the immobility of her entire body is, so to speak, absolute. Her clasped hands, resting high on her chest, complete this resemblance to the images of saints that the most perfect art has bestowed upon us.

This description of a hystero-epileptic attack in its terminal phase was accompanied by several photographs: one of them in particular is very close to the expression of the saint represented by Osbert, and likely served him as a source. It is worth noting the emphasis the text places on the conjunction of ecstatic abandon and tension. In drawing inspiration from the *Iconographie photographique de la Salpêtrière*, Osbert was simply following the precepts of Charcot and Richer as set down in their *Les Démoniaques dans l'art* (1887), a veritable catalogue of demonic possession in art from the fifth to the eighteenth century. With regard to ecstasy, in fact, the work stated:

> To render all these various expressions, artists discovered that hysterical subjects made inestimable models. This assertion will appear neither dubious nor exaggerated to anyone who, like us, has seen hysterics, even the most common women, in a specific phase of the grand attack, on whose faces a hallucinatory, quasi-religious expression suddenly appears. This look is so true and intense that the most consummate actors could scarcely have offered better; nor could the greatest artists ever have found more worthy models.[32]

This whole question was part of a larger movement whose challenge of society's religious and moral foundations was typical of one component of public opinion under the Third Republic. Scientific theories associating the exterior manifestations of religious mysticism with hysteria were vehemently contested by the Catholic world.[33] The scope of the ensuing debate is suggested in the following lines by Hungarian Symbolist poet Endre Ady (1877-1919), a correspondent for *Budapesti Napló* in Paris beginning in 1905, who was describing the teaching of history in France:

> It is not with raucous cheers, with singing or spitting or the bravado of drunks that they love their motherland here. And it is the future they love, not the past. Children learn that the glorious Louis XIV was a heartless pirate. *Joan of Arc was a hysterical, maniacal woman*, Napoleon was a latter-day Attila, and Pasteur was greater than a dozen conquering heroes.[34]

The interest that the phenomena of hysteria held for an artist like Osbert, as minor as he is, was certainly not an isolated case. In 1892, the same year Osbert presented his *Vision* at the Société nationale des beaux-arts, Alexandre Séon exhibited his *Joan of Arc*[35] at the first Salon de la Rose + Croix. Today, this work is known only through its catalogue reproduction. The pose, which in no way reflects the era's conventions of representation,[36] corresponds with one of the catalogued positions of catalepsy induced in hysterics "by an unexpected loud noise". In the Salpêtrière amphitheatre, Charcot held demonstrations of this type, and an engraving after a photograph by Régnard gives us an idea of what

31. *Ibid.*, vol. 2, pp. 202ff.

32. Jean Martin Charcot and Paul Richer, *Les Démoniaques dans l'art* (Paris, 1887), p. 109.

33. See, for example, J. de Bonniot, *Opposition entre l'hystérie et la sainteté, par le P. J. de Bonniot de la Compagnie de Jésus* (Paris, 1886), or Dr. H. Lavrand, *Hystérie et sainteté* (Paris, 1911). Conversely, Dr. Rouby's *L'Hystérie de sainte Thérèse* (Paris, 1902) contained the following lines: "The exact knowledge of the symptoms of hysteria should therefore lead to a revision of the history of Religions, and it is in this respect that this work may be particularly important."

34. Endre Ady, "A hazaszeretet reformja" [Reformed Love of Homeland], *Budapesti Napló*, September 6, 1906, p. 166 (emphasis added). Quoted in André Karatson, *Le Symbolisme en Hongrie* (Paris, 1969), p. 83.

35. Cat. 155.

36. See in this connection *Images de Jeanne d'Arc*, exhib. cat. (Paris: Hôtel de la Monnaie, 1979). Sarah Bernhardt's appearance in Jules Barbier's *Jeanne d'Arc* at the Théâtre de la Porte-Saint-Martin in 1890 may well have influenced Séon's choice of subject. We know, furthermore, that Bernhardt attended some of Charcot's demonstrations at the Salpêtrière.

Alexandre SÉON
Joan of Arc, about 1892
Location unknown

Catalepsy Induced by an Unexpected Loud Noise
Photograph from Paul Régnard, *Les Maladies épidémiques de l'esprit*

transpired there. It warrants a few remarks. First, the work shows the extent to which the gestures of hysteria were a cultural phenomenon: the majority of patients illustrated are in poses that traditionally appeared in the iconographic repertoire of "Visions" or "Ecstasies", in both painting and widely disseminated religious imagery. It is likely that a gestural mimetism was under way here, fostered by the "theatrical" conditions in which the experiments were conducted and by Charcot's interest in iconography. In the engraving, two of the women (third and fifth from the left) are extending their arms towards the ground, fists clenched. In his *Joan of Arc*, Séon reproduced this position with a systemization of the symmetry that is also entirely outside conventional modes of representation. This desire to go beyond the current iconographic repertoire was concomitant with a desire for authenticity based on the supposition that the pose, which clearly evoked a visual or auditory hallucination, was in itself too charged with cultural references to truly embody a second state of being.

Like Osbert, Séon was not far from Seurat and Neo-Impressionism.[37] Both artists, in fact, were among the principal figures of the Rose + Croix Salon, representing the new generation and the impetus of Puvis de Chavannes. The appearance of these two religious paintings, created around the same time and according to similar principles, thus belongs to a specific context. Although most of the works exhibited at the Rose + Croix Salon are now lost, it would appear that several Symbolists employed an iconography based on a study of hysteria. This is almost certainly true of Maurice Chabas and his painting *Celsa*, exhibited in 1894 and described in its catalogue entry as representing an "ecstatic phase".[38] Similarly, the Belgian artist Joseph Middeleer presented that same year a work entitled *Une démoniaque*.[39] There are thus indications that a new sensibility was emerging, the product of a certain curiosity about marginal states of mind on the one hand and the new scientific documents on the other.

The way this new consciousness led to a new imagery of the human body, the way these models and their successive variations spread throughout Symbolist art, is a subject that

37. Osbert, Séon and Seurat all studied under Lehmann. The three maintained rather close relationships, from their student days on.
38. Cat. 9.
39. Cat. 56.

remains to be studied – beyond the literal borrowing adumbrated above. One should not, however, see in the works of Osbert and Séon a desire to revitalize the religious art of their time, in the ultimately conservative way that certain artists of the era tried to maintain the traditions of historical painting. On the contrary, the image of religious faith at its apex of intensity here served as a pretext for conveying a troubled mental state not normally found in this type of painting. In this respect, the approach is entirely novel, even if precedents can be found in Rubens – as Charcot was bent on doing – or in a few rare examples drawn from the religious painting of the nineteenth century.[40]

However, the novelty of clinical documents is not enough to account for either the interest they aroused or the infiltration of patterns of this kind into Symbolist painting. Transforming the symptoms of hysteria into a work of art involved putting into practice a repertoire of fundamental physical attitudes. These images cannot be divorced from their rich meaning or from the idea of a search for the innermost secrets of the mind. From the beginning, Symbolism staked out its ground: the hidden recesses of the psyche, as opposed to what was a caricatural vision of Naturalism, oriented towards matter. The documents based on scientific observation, whose rareness could only confer upon them an added fascination, and the new modes of representing the body that resulted, were the catalysts that produced a new vocabulary sought by Symbolism.

That Charcot's study of hysteria was, in medical science's view, his only "error" – in that his approach proved inconclusive – is unimportant. His observation of the *crise*, on which a part of his methodology was based, had this benefit:

through the words of the patients (the spoken word, which was to become Freud's sole realm), it became clear that the trouble was rooted in a traumatic event buried deep in the memory. And although neither the cataloguing of hysterical gestures nor the tables and charts established by Richer shed much light on the illness itself, they did make more evident the codified aspect of the symptoms, their repetitive and impersonal nature leading to the institution of a language that transcends the individual. Hysteria set in motion a living metaphor. Through repetition, through the symbolic function of the gesture and the mysteriousness of the source from which it draws its meaning, hysterical chorea took on an expressive, liturgical character, which Symbolism would actively cultivate.

Symbolism shunned the rational; its interest in a state of mind and body in which the reason is momentarily suspended corresponded with its fundamentally idealist approach. Although the hysterical attack could be perceived as symbolic, given its repetitive, codified nature, the meaning of its symbolism remained relatively obscure. It was only with the studies of Freud, published in 1893-1895, that the notion of primary psychic trauma gained a foothold. The incoherence of hysterical behaviour vis-à-vis the outside world was tantamount to an objective negation of that world. In the words of Théodule Ribot, the ecstasy of the hysterical subject represented "a total violation of the laws of the mechanism of consciousness".[41]

Remy de Gourmont, in an article entitled "Dernière conséquence de l'idéalisme",[42] has also equated ecstasy (as well as sleep) with a negation of the subject's exterior world. Inherent in hallucinations – that world of false but powerful sensations appearing in the terminal phase of the crisis – is a relationship between the negating idealism of exterior reality, one of the intellectual cornerstones of Symbolism, and a second state implied by hysteria, in which the objective world ceases to have any referential value. Jules Claretie's *Amours d'un interne* contains an account of a hysteric under hypnosis: "The human being seemed to have been reduced to the state of a machine, to one of those wooden 'models' that sculptors bend the joints of all around as they please – a macabre caricature of man."[43]

Although the body of the hysteric was not as pliable as this model, his or her irrationality approached that of marionettes, whose powers of abstraction were evoked by

40. See in particular Pierre Claude François Delorme's *Saint Pierre, en prison, exorcise la fille de son geôlier*, 1855, mural painting, 610 x 220 cm. Paris, Church of Saint-Eustache, Chapel of Saint Peter the Exorcist. The figure of the young possessed woman is clearly inspired by a direct observation of hysteria. I would like to thank Georges Brunel, chief curator of art objects for the churches of Paris, as well as his department.

41. Quoted in Jacqueline Carroy-Thiraud, "Possession, extase, hystérie au XIXᵉ siècle", *Psychanalyse à l'université*, June 1980, vol. 5, no. 19, p. 499 (p. 511 for this quotation). See also Jacqueline Carroy-Thiraud, "L'hystérique, l'artiste et le savant" in Jean Clair, ed., *L'âme au corps. Arts et sciences 1793-1993*, exhib. cat. (Paris: Grand Palais, 1994), p. 446.

42. Remy de Gourmont, "Dernière conséquence de l'idéalisme", *La culture des idées*, ed. Hubert Juin (Paris, 1983), p. 267.

43. Jules Claretie, 1902, p. 174.

Heinreich von Kleist.[44] The same relationship between movement and signification inheres in both the body of the hysteric and the manipulation of the marionette, whose trajectory is "none other than *that defined by the soul of the dancer*".[45] What the marionette was to the actor – an *idea* of a character, bereft of psychological substance, the artificial materialization of a being ignorant of matter – the hysteric was to the rational being in his perception of the body. A sign of irrationality, the hysteric undergoing a "crisis" embodied both the rupture of an individual with the exterior world and the creation of a metaphorical microcosm. While this microcosm attracted the attention of others, it also kept them at a distance: it invited deciphering but remained obscure, sowing untold confusion.

R .R.

I would like to thank Brother Michel Albaric, librarian at Saulchoir, as well as my colleague Luce Abélès, who kindly allowed me to make use of her abundant and accurate notes on hysteria and Naturalist literature.

44. Heinrich von Kleist, "Über das Marionettentheater", *Berliner Abendblätter, Sämtliche Werke* (Munich and Zurich, 1962), p. 825.
45. Heinrich von Kleist, *Sur le théâtre de marionnettes* and *De l'élaboration progressive des pensées dans le discours*, trans. and with an introduction by Jean-Claude Schneider (Paris, 1991), p. 21.

Closed Eyes, Symbolism and the New Shapes of Suffering

PETR WITTLICH

The painting *Closed Eyes* (1890), perhaps Odilon Redon's best-known work, has come to symbolize the Symbolism that flourished in the late nineteenth century. This apparent tautology actually constitutes a two-pronged identity, setting out the features that enabled Symbolism, which was initially formulated as a programmatic declaration, to gain persuasive power and artistic strength as works were added to its fold. Because of its evocative nature, the painting breaks free of the superficial catchwords that had been promulgated by a cultural movement confined to a short period in time. And it raises issues that go much further.

Redon's wife was the model for the figure in *Closed Eyes*,[1] and some versions show evidence of the closeness that existed between subject and painter.[2] However, it is clear even from the preliminary sketches that the artist intended to invest the project with another level of meaning altogether. Proof of this may be found in the notes Redon kept on his creative development, where he speaks of being conscious of the spiritual energy flowing into him as he copied as accurately as possible the shape of a blade of grass, a hand or the profile of a face. The invisible can only be expressed through the visible. This continuum necessarily implies a dividing line, an extremely subtle but palpable boundary at which the miraculous metamorphosis from finite to infinite occurs.

In the final canvas of 1890, this boundary finds expression in two ways. The first is through the painting technique, in the luminous sfumato that seems to waver between line and a range of colours that scarcely strays from grey, giving the picture its general atmosphere and its impression of perceptible silence and spatial ambiguity. The second is through concrete symbols. The stark outline of a large nude figure of indeterminate sex rises out of a calm expanse of

Odilon REDON
Closed Eyes, 1890
Paris, Musée d'Orsay

water; the face, with eyes closed, is that of someone peacefully asleep. Moreover, the water's surface hints at two planes of existence: above, the realm of air, of the visible; below, the realm of water, of things unseen, whence this cosmic sleeper emerges bodily.

The theme of closed eyes that eventually provided the work with its title does not issue from the same spontaneous creativity that the work's other components are based on. Nor does it take an excessive imagination to see that, first and

1. Roseline Bacou, *Odilon Redon* (Geneva, 1956), vol. 1, p. 122.
2. Odilon Redon, *Les Yeux clos* [Closed Eyes], about 1890, oil and pastel, 53 x 48 cm, Switzerland, private collection.

foremost, this image refers to a symbol from the cultural past: Michelangelo's *Dying Slave*, one of the great treasures of the Louvre, almost certainly served Redon as a source of inspiration.

Gustave Moreau had already drawn upon the *Dying Slave* for his "new art", using the head as a model for Orpheus in the *Thracian Girl Carrying the Head of Orpheus on His Lyre*.[3] In this painting, highly acclaimed at the 1867 World's Fair in Paris, Moreau resuscitated the sovereign poet-artist, a type that was to become central to late nineteenth-century Symbolist theory, reigning through to Jean Delville's luminous blue *Orpheus*, painted in 1893.

Moreau, an avowed enemy of the pervading Naturalism, saw in the traditions of Italian art – primitive and classical – the foundations on which contemporary artists should base their creative approach. Through "line, arabesque and plastic means", he aimed to evoke "a world of ideas" and more specifically, "the dream of the soul most affected by the ideal".[4]

The concept of the ideal reappeared with the French idealist offensive of the 1880s. Joséphin Péladan, who was to become one of the most intelligible and coherent spokesmen for the antinaturalist forces, began his review of the Salon of 1883 with a declaration that reflects the movement's programme perfectly: "I believe in the Ideal, in Tradition, in Hierarchy."[5]

In classical aesthetics, the ideal was seen as the supreme sensory expression of the Idea; for Péladan, the ideal could not be confined to a particular type of idea, but was "the whole idea sublimated, at its highest degree of harmony, intensity and subtlety".[6] This sublimated definition of the Idea remained powerfully attractive and convincing for an entire conceptual branch of Symbolism. Émile Bernard was still advocating it in the early twentieth century when, in his letters to the Czech poet and essayist Miloš Marten, he argued for an aesthetics of the ideal anchored in tradition. This was actually to be the culmination of the principle of synthesis brandished by the Symbolists of the 1880s as a postnaturalist and Post-Impressionist rallying cry.[7]

Bernard was opposed at the time to all "deformers", by which he meant not only the young and rising avant-garde of Fauves and Cubists, but any creation resulting from a single idea, any situation where the creator is master of only a single imaginative approach, for such a narrow approach eliminates the effective use of artistic methods that, in going beyond representation, oblige the artist to render the Idea or else do violence to the beauty of the painting.[8] Bernard himself proved unable to translate this message into convincing art, and it was soon branded traditionalist and reactionary. Still, it contains an echo of the fascination exercised by the mysterious dream Gustave Moreau had glimpsed in the art of Michelangelo – the seduction of the "ideal somnambulism", the absorption of the individual in dream and the "beauty of inertia" that suffuses the statuesque poses in his works.

A view that demanded so strict a dichotomy be maintained between the materialistic interests of the ordinary man, bound by his own sexuality, and the subtle interests of the artist, who creates an illusion of divinity, was naturally an extremely narrowly held one, far removed from the concerns of "modern" man. In fact, it was a sublimated form of narcissism, derived from the reflection of previous sources, as Moreau's admiration for Michelangelo illustrates.

Redon's painting *Closed Eyes* pursues Michelangelo's theme, but from a different angle. The figure in the painting is not placed in a mythological setting, but looms like a colossus, mysteriously transcending all human proportions. Thus does Redon indicate that his desire to attain the sublime (a principle he and Moreau would have shared) derives from a different way of understanding this key Symbolist concept and consequently, from a different method of achieving desired artistic aims.

Redon's interpretation of the sublime is far closer to that found in pre-Romantic thought, which linked it to an aesthetics of astonishment and terror.[9] The opposition between the sublime and the beautiful implicit in this approach had a major influence on the subsequent development of modern art, for it treated the nonequivalence of the sensory and suprasensory worlds as a central issue, thus triggering a crisis in representation that would in turn generate the phenomenon of abstract art and the widely diverse modern forms of the fantastic.

Art in the late nineteenth century certainly did not lack in imaginative power. The illusionism of the period, Naturalist or otherwise, transformed the world into an infinite panorama of images that were beginning to move of their own accord. In

3. Odile Sébastiani-Picard, "L'influence de Michel-Ange sur Gustave Moreau", *La Revue du Louvre et des musées de France*, vol. 27, no. 3 (1977), pp. 140-152.

4. Quoted in *ibid.*, p. 140 no. 3 (1977).

5. Joséphin Péladan, *La Décadence esthétique, l'art ochlocratique: Salons de 1882 et de 1883* (Paris: C. Dalou, 1888), p. 45. Quoted in English from Edward Lucie-Smith, *Symbolist Art* (London: Thames and Hudson, 1972), p. 109.

6. Péladan, 1888, p. 156.

7. John A. Stuart, *L'art plus que nous . . . : correspondance d'Émile Bernard avec Miloš Marten (1908-1914)* (Arlington: University of Texas, 1974), pp. 98-102.

8. *Ibid.*, p. 99.

9. Edmund Burke, *Philosophical Enquiry into the Origin of Our Ideas of the Sublime and Beautiful* (London, 1757), p. 13.

such a situation – one that is recurring today on an even grander scale – artists had to find a new means of persuasion, to instil their images with a new power. Initially this meant negation, and the most important artists of the period, accused, often summarily, of "decadence", understood very clearly that the art of their time had to be subjective.

This new form of subjectivity embodied a paradox, for its results were to be fundamentally "suprapersonal". According to Albert Aurier, the mission of painting was to express Ideas whose symbols were emerging from the darkness and starting to live a life of their own, a true life.[10]

Redon's painting *Closed Eyes* meets this requirement: it juxtaposes a reference to Michelangelo and a limitless stretch of water. The motif of the watery depths evokes a symbolism of the unconscious and creates a spatial disorientation of the pictorial object. On the surface of the water, there is a blurred reflection of the face, which introduces a psychological dimension. Here again, the painter's narcissism must be recognized, and deciphered through the fantasticism of the apparition as a whole.

The painting's central image of closed eyes arises from Redon's need to internalize the pictorial object, and this interiorization of vision cannot be explained away as unmitigated but superficial antinaturalism, since it represents a conscious desire to subject pictorial objects to the artist's inner logic and psychological requirements. Redon is not concerned with the subject matter so much as with infusing it with his own creative, psychic energy. Nor should we allow ourselves to be misled by the many Symbolist statements on the mysterious nature of things. Any mystery here resides exclusively in the workings of the artist's psychological make-up, which obviously remains an enigma to him.

Paul Gauguin expressed the same idea in an evocative work executed in early 1889, a short time before Redon's painting: a ceramic vase portraying his own head, with eyes closed. In it, the theme of closed eyes brings a new depth to the self-portrait, and the work is placed in a cultural context by the invocation, through the use of a blood red glaze, of the head of John the Baptist. This is another archetypical figure that – like Orpheus, his head torn off by the Maenads – served in Symbolist iconography to herald a new art, a new era for humanity. Gauguin's vase should be seen as a highly significant attempt to integrate and synthesize Symbolist themes with the archetypical figures from the art of the past.

The impression of subjectivity created by this vase is not

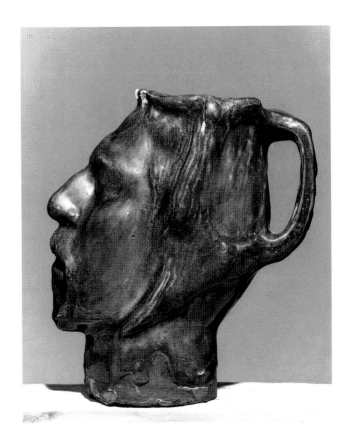

Paul GAUGUIN
Vase, 1887-1889
Copenhagen, Kunstindustrimuseet

rooted only in the expressive identification of the creative individual with a type, or in the idealization of the object. It is above all the result of the dark space created by the interior of the vase, or pot. Another 1889 work by Gauguin, moreover, *Still Life with Japanese Print* (Teheran, Museum of Modern Art) depicts this pot filled with flowers.

Redon's *Closed Eyes* and Gauguin's ceramic vase are evidence that when the Symbolist movement was in full flight, the closed eyes theme lay close to the heart of the Symbolist imagination. It occupied this privileged position not only because of its antinaturalist political content, but because it fostered an association with other themes and motifs that expanded and enriched the initial symbol.

Here, we stumble onto another of the paradoxes inherent to Symbolism: emotions were not just experienced, but deliberately worked up, and on occasion, even artificially stimulated. There is every reason to believe that this internal contradiction was a reflection of the modern era, an era marked by the clash between individual interests and the mechanistic logic of social processes.

Rodin's work offers obvious evidence of such connections. Recently, his assemblages with bodily fragments have been

10. Albert Aurier. *Œuvres posthumes* (Paris: Mercure de France, 1893), p. 211.

attracting increasing interest among commentators.[11] But this fascinating late period has its source in an earlier phase of the sculptor's career, a starting point that also incorporated the closed eyes theme. In *The Age of Bronze*, a statue unquestionably influenced by Michelangelo's *Dying Slave*,[12] the closed eyes and the "somnambulist" pose are paramount. When it was exhibited at the Salon, Rodin was accused (unjustly) of having moulded the work directly from life. The fact that *The Age of Bronze* had this effect on viewers perhaps foreshadows the sculptor's development towards techniques similar to montage.

Generally, we can accept the hypothesis that Rodin's sculpture was one of the most serious and comprehensive attempts to solve the riddle of the sphinx contained for the artistic imagination in the symbolic theme of closed eyes. This had an effect, moreover, on a whole branch of sculptural creation descending from Rodin, which adopted his themes and means of plastic expression and offered a frequently far less subtle but nevertheless valid interpretation of the same subject.

Modern sculpture's most consistent rendering of the closed eyes theme is the well-known series by Constantin Brancusi focussing on the plastic qualities of the materials employed, beginning with first *Sleeping Muse* in 1906 (Bucharest, Museul de Artā), which is related through the *non finito* effect of the stone to Michelangelo, Rodin and even Medardo Rosso, and ending with *The Beginning of the World* (1920-1924), which reduces the original form of the head to the elementary symbol of a cosmic egg.[13]

We begin to understand, then, something of the enormous import of the closed eyes theme, employed as a central motif. Even those interpretations that fail to achieve such cohesive results illustrate the extent to which the theme has been productive.

Works that link the motif of closed eyes to music, or more precisely to composers, form a special subgroup. The sculptor Antoine Bourdelle, who was Rodin's assistant for several years, worked from 1887 until his death in 1929 on a portrayal of Beethoven. The various versions give a good account of Bourdelle's stylistic development and show how certain approaches to the theme take form in a particular treatment of content. Bourdelle's representation of Beethoven's face was heavily influenced by a view of music derived from Schopenhauer and Wagner, a view that to some extent contradicted Beethoven's fundamentally moral attitude towards music. The motif of closed eyes, the theme of introspection or the "inner gaze", expressed a preoccupation with intuition and

the concentration of creative genius on the mystery of the universe. In this, it followed Schopenhauer, according to whom the composer manifests the most profoundly personal impulse of all, expressing the deepest wisdom in a language beyond his own understanding and, like the "mesmeric somnambulist", resolving issues he is unconscious of when awake. For Schopenhauer held music to be a thing quite apart from the others arts and independent of the phenomenal world. Music is not simply the reflection of Ideas; it is the immediate reflection of the will itself, which is why it is far more powerful than the other arts.

Schopenhauer's philosophy thus was more complex in its approach to the imaginative theme of introspection. The Idea, traditionally personified in a human figure, was gradually being perceived in a new way: in the different facets of the process of formal creation, in the search for new formal equivalents derived directly from the very wellsprings of creativity. In 1890, Bourdelle executed a second study for the head of Beethoven, notable for its broad effusions of material resembling hardened volcanic lava. This led, in 1901, to the great *Tragic Mask* of Beethoven, in which the sculptor mercilessly distorted the face to convey with immediacy the composer's inner turmoil, his tragic emotional upheavals. The effort of creation brought this musical genius to a pitch of Dionysian intoxication. This mask may have been a response on the part of Bourdelle to Nietzsche's celebrated polarity, for the year before, he had created a *Head of Apollo* that employed an entirely different sculptural approach, involving the arrangement of the material in well-structured planes. More interesting still, the polarity of Bourdelle's two works also corresponds to a polarity of spiritual states known to medieval mysticism, which even during the Middle Ages inspired works of art that combine the theme of introspection with the motif of closed eyes.[14]

In 1901, Bourdelle executed a study of the head of Beethoven (his fifth) in which he returned to the primacy of synthesis advocated in the earliest declarations of Symbolist theory. This "concentrated" counterbalancing of extremes, inclining towards sculptural monumentality, constituted a

11. Leo Steinberg, *Other Criteria: Confrontations with Twentieth Century Art* (New York: Oxford University Press, 1972), pp. 322-419.
12. Albert Elsen, *Rodin* (New York: The Museum of Modern Art, 1963), pp. 21-26.
13. Rosalind E. Krauss, *Passages in Modern Sculpture* (New York: Viking, 1977; reprinted Cambridge, Massachusetts: MIT Press, 1981), pp. 84-96.
14. In České Budějovice (Southern Bohemia), in the choir of a late thirteenth-century Benedictine church, there are two similar stone masks that express the polarity of the mystic state through the closed eyes motif.

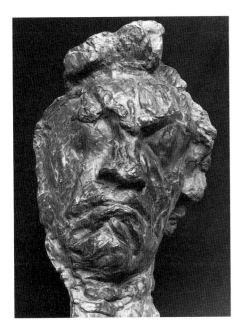

Antoine BOURDELLE
Beethoven: Tragic Mask, 1901
Paris, Musée Bourdelle

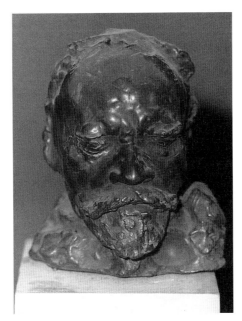

Josef MAŘATKA
Study for a Bust of Antonín Dvořák, 1905-1906
Prague, Národní galerie

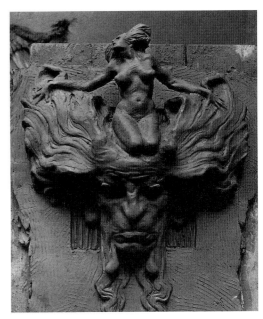

Ladislav ŠALOUN
Mascaron, about 1910 (destroyed)

mature artistic treatment of the originally Symbolist theme of introspection. Associated with the personality of a famous artist, it took on some of the prestige of official culture, and it also had a wide influence.

In 1904, on his return to Prague after four years in Rodin's studio, the Czech sculptor Josef Mařatka received a commission for the death mask of the composer Antonín Dvořák. Two years later, Mařatka made a sketch of the head of Dvořák as the spirit of Slavic music, in which he is pictured, eyes closed, listening to the melodies welling up within him. While Mařatka's work is more intimate and more impressionistic than Bourdelle's, both artists used a death mask as a starting point. Far more than simply a study aid, the mask represents an invitation to cross the boundary between the visible and the invisible, evidence of a process that transcends the limits of mortality.

Exhibited in Prague in 1909, Bourdelle's fifth study of Beethoven had a decisive influence on the Czech sculptor Ladislav Šaloun. Very soon after, Šaloun carved a mascaron (now destroyed) that formerly adorned the entrance to his Prague studio. True to its ornamental and decorative function, the mascaron consists of a symmetrically developed male mask that upon examination proves to be a crypto-portrait of Schopenhauer. However, it is the highly erotic female nude kneeling among the man's tangled hair that attracts most of the attention. And it is this element that provides evidence of Šaloun's second source of inspiration: the 1897 woodcut by Edvard Munch entitled *In Man's Brain*. Here again, a window is opened onto an iconographical sequence of extremely ancient origin, which fin-de-siècle art reactivated with a new emphasis on the predominance of the female principle.[15] The combination in Šaloun's work of the nude and the closed eyes motif throws light on the development of the theme of introspection, which can be described as vitalist (as opposed to an idealist development, which would have proved more respectful of tradition) and in the context of which the female nude personifies the libido.[16]

As regards the theme of introspection, it can be observed that towards the end of the century, the earlier idealist conceptions (which inspired Rossetti's *Beata Beatrix*) tended to give way to vitalist interpretations. These transformed the dualist spiritual vision, oneiric and related to beginnings, into a manifestation of psychic energy linked, this time, to the human body. It was a shift that apparently represented a move away from spiritism's attempts to communicate between the

15. Petr Wittlich, "Edvard Munch a české umění" [Edvard Munch and Czech Art], *Umění*, no. 30 (1982), pp. 422-446.
16. František Šmejkal, "Secesně-symbolistní tvorba Ladislava Šalouna" [The Symbolist Work of Ladislav Šaloun], *Umění*, no. 28 (1980), p. 469.

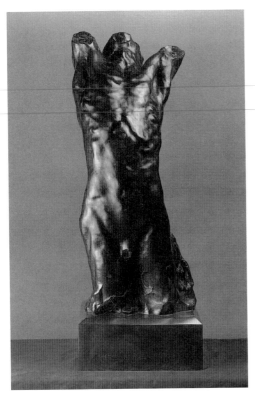

Auguste RODIN
Narcissus, about 1890
Paris, Musée Rodin

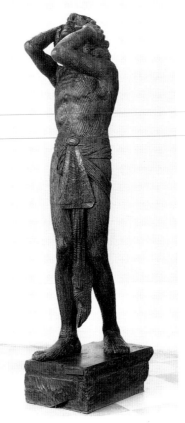

František BÍLEK
Wonder, 1907
Prague, Galerie hlavního města Prahy

distinct realms of the living and the dead, to far more comprehensive visions of spiritual life. But the more this new feeling – which introduced into art much more concrete notions, such as psychological suffering – gained in strength, the more complex the question of sublimation became. For the new suffering, whose source was outside art, it was in art that new expressive forms were to be discovered.

In this quest, sculpture took on a new significance – hence Rodin's extraordinary importance. The theme of closed eyes recurs many times in his sculpture, and we may observe how this originally idealist notion is gradually reinterpreted in the course of his career. The truncated body of the *Adolescent désespéré* [Young Boy in Despair] (about 1882), which later inspired the artist to create a whole series of variations, is a case in point. The contemplative atmosphere typical of the theme of introspection is brutally overshadowed by the tension of the armless adolescent torso; the expressive power of the incomplete body, symbol of despair, is enhanced by the violent cutting off of the vertical form. But something of the original psychological narcissism of the "inward gaze" still survives and is also evident in a larger version of the work, dating from 1890, which is actually entitled *Narcissus*.[17]

In so rendering the theme, Rodin delved deeper into the structure of the psyche. His intuition guided him beyond the secondary reflection of narcissism to its primary level; but this reversion, undertaken with the aim of bringing forth a new energy, also bore the traces of guilt-ridden trauma. Similar evidence appears in *The Prodigal Son* and *Fugit Amor*, and certain later groups, among them *Aurora*, can be seen as attempts to achieve a new mastery of the energy, at once creative and destructive, that arises at the point where man, for better or for worse, goes beyond himself.

This ambivalence of the physical and spiritual propulsion of man towards the Other constituted a new form of suffering that appeared elsewhere in the art of the period. A particularly trenchant formulation is Edvard Munch's lithograph ***The Scream***, which emphasizes the agony of the main figure by placing it diagonally against the cataclysmic deluge of a universal landscape.

In ***The Scream***, Munch achieved the most extreme expression of the anxiety of modern man. Moreover, it inspired

150

17. *Rodin sculpteur. Œuvres inconnues* (Paris: Musée Rodin, 1993).

exceptionally interesting reactions that attempted to regulate this wild energy. The theme of closed eyes also played a role here.

Let us take, for example, the works of Czech sculptor František Bílek, who himself employed a traumatic approach to the theme of introspection in his painting **Crucified** (1899) and in the preparatory sketch **Oh Mother!** (1899). A massive tree rises against a fantastic natural background; a glimmering swath that stands apart from the trunk takes on the appearance of a luminous human figure, like a sleepwalker with eyes closed. Above the figure, in the night sky shines a star, towards which the tree's soul seems to yearn. Bílek was a metaphysical painter with Neoplatonic sympathies, and fervently religious: Munch's "decadence" could not fail to provoke him into seeking an antidote. He apparently first reacted to **The Scream** in 1901 with a statue of the reformer Jan Hus, entitled *The Hundred-Year-Old Tree That Burned after Being Struck by Lightning*. He certainly responded in 1907, after the exhibition of Munch's work in Prague, when he sculpted *Wonder*, a statue over three metres high representing man the mystic, in ecstasy, glimpsing "the being of all things in true light". The backward-arched figure, dressed in an initiate's toga, contemplates the depth of the universe and wonders at its grandeur and beauty. Light bathes the figure from below and glances off the statue's broad surface, lessening the massiveness of the wooden block and creating an impression of swift upward movement towards the firmament.

However, in his correspondence with Miloš Marten, Émile Bernard was critical of these works by Bílek, for he saw a deforming ideal in Bílek's attempt to grasp the Idea in itself.[18] Such a criticism entailed a distinction that was a direct result of the initial Symbolist position and related to the development of the closed eyes theme. The generally accepted

renderings of this theme, such as the bust **Nature** Alfons Mucha presented at the Exposition universelle in Paris in 1900, combined two basic components: the deep and serene contemplation evoked by the symmetry of the face and the motif of closed eyes, which eliminates the expressiveness of the eyes themselves; and the emotional dimension of introspection, of the moving back towards the very sources of feeling – an element that, in Mucha's sculpture, is conjured up by the title and by the dynamic movement of the long hair.

In a letter to Marten, Bernard contrasts Bílek's feverish imagination with his own preoccupation with "silent perfection". This is the essence of an aesthetics centred on the "calm of the ideal", one that achieves a delicate balance between the contradictions of body and soul, and gives birth to a beauty that is not the expression of something, but expression itself, free and independent. This artistic vision may well have been one of the consequences of the narcissism embodied in the theme of introspection.

In Rodin's work, however, emotional reversion opened the way to the modern symbol, the subconscious symbol. In **The Scream**, the closed Cyclopean eye of Munch's image of suffering is highly evident in the lithographic lines of strident colour that form the sky and out of which emerge the violence of the landscape and the central figure. This "eye" becomes a chink in traditional space, an intuitive archetype of the dangerous fissure through which all the forces of the universe pass. The symbolic power of this metaphorical eye was, at the time, quite extraordinary.

At the very start of the twentieth century, Roger Gilbert-Lecomte wrote that in our accursed era it almost invariably takes pathological changes to open the dazzling rift through which the soul of the world penetrates little by little into the sluggish consciousness of the receptive. In his view, we must cultivate this attitude of receptivity if we are to drag humanity back from the brink of destruction: this "poetry" will save the world, or the world will perish.[19]

P. W.

18. Stuart, 1974, p. 100.
19. Roger Gilbert-Lecomte, *Testament* (Prague, 1975), pp. 98-113 (*Œuvres complètes*, vol. 1, *Proses* [Paris: Gallimard, 1974]).

"Of Oneself", "To Oneself"
Symbolism, Individualism and Communication

DARIO GAMBONI

Theory of Art and Image of the Artist

The theory of art and the image of the artist (that is, the identity, mental representation and visual representation of the artist) form a plane on which all the manifestations associated with Symbolism in the plastic arts can be seen to converge. The features that made up the popular image of the artist in the last two decades of the nineteenth century can be traced back to the Renaissance and even earlier,[1] but the tone of the image dates from the Romantic period.[2] The notion of art and the artist underlying this image lays primary emphasis on originality and individuality: the artist is fundamentally different from other people, and it is by working out this individual difference that he discovers his identity as an artist.

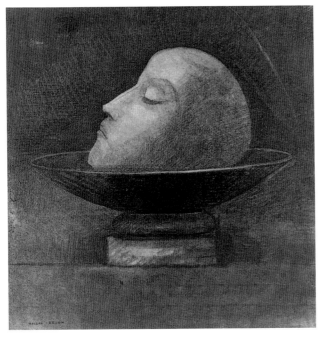

Odilon REDON
Head of a Martyr in a Bowl, 1877
Otterlo, The Netherlands, Kröller-Müller Museum

This construct is marked by a deep ambivalence. Artists as such may be regarded as members of an elite or as outcasts, as seers with remarkably acute senses or as abnormally excitable invalids, as prototypes of a new breed of humanity or as detritus from a bygone age.

The artists of the late nineteenth century tended, however, to depict themselves not as the marginal and "deviant" figures associated with Realism and Naturalism, but through metaphors that expressed – even if only ironically – the dignity to which they laid claim. This view of the domain of aesthetics as sacred resulted in a proliferation of religious allusions, and in self-portraits (more or less generic and explicit) as saints or martyrs, even as Christ; notable examples of this type of iconography can be seen in works by Paul Gauguin, Henry De Groux and James Ensor.[3] A martyr may be just a victim, but he can also use his suffering as an instrument of salvation for himself and others.[4] In his role as a redeemer, the artist approaches the status of prophet, an image reinforced not only by the sanctification of art and therefore of the artist, but also by the semideification of great men that was so much a part of

1. See Ernst Kris and Otto Kurz, *Legend, Myth and Magic in the Image of the Artist* (New Haven and London: Yale University Press, 1979).
2. See Philippe Junod, "(Auto)portrait de l'artiste en Christ", in *L'autoportrait à l'âge de la photographie : peintres et photographes en dialogue avec leur propre image*, exhib. cat. (Lausanne: Musée cantonal des Beaux-Arts, 1985), p. 63, and by the same author *Transparence et opacité. Réflexions autour de l'esthétique de Konrad Fiedler* (Lausanne: L'Âge d'Homme, 1976).
3. See Junod 1985; on De Groux, see Rodolphe Rapetti, "« Un chef-d'œuvre pour ces temps d'incertitude »: *Le Christ aux outrages* d'Henry De Groux", *Revue de l'art*, no. 96 (1992), pp. 40-50; on Ensor, see Gisèle Ollinger-Zinque, "Le Christ-Ensor ou l'identification au Christ dans l'œuvre d'Ensor", in *James Ensor*, exhib. cat. (Paris: Musée du Petit Palais, 1990), pp. 27-34; on the sanctification of aesthetics, see Renate Liebenwein-Krämer, "Säkularisierung und Sakralisierung. Studien zum Bedeutungs-wandel christlicher Bildformen in der Kunst des 19. Jahrhunderts", thesis, Frankfurt am Main, 1977.
4. See the apologia for the pain inflicted on the dreamer by his peers made by Odilon Redon in *À soi-même. Journal (1867-1915). Notes sur la vie, l'art et les artistes* (Paris: José Corti, 1961; originally published 1922), p. 60. The role of redemption, atonement, expiation in the cult of the artist has been stressed by Nathalie Heinich in *La Gloire de Van Gogh. Essai d'anthropologie de l'admiration* (Paris: Minuit, 1991).

nineteenth-century political life. According to the theory of correspondences, the artist, like the poet, was an interpreter of the language of the universe, a mediator between the macrocosm and the microcosm who could initiate into the mystery those of the laity not overtly philistine. In a painting by Georges Rochegrosse typical of the popularization of Symbolism, Orpheus, who is supposed to "charm monsters and wild beasts", seems to cater to and even excite their appetites with the blood streaming from his hands as he plays the lyre.[5]

The negative side of this ambivalence tended to prevail, as artists felt and expressed the "wanderer's lot" of "the soul exiled from its true home".[6] Icarus's flight becomes a downward spiral.[7] Fallen and imprisoned angels (as in Redon's works), ghostly or skeletal apparitions, as with Spilliaert and Munch, express in a more or less metaphorical way this otherness experienced as alienation. Even the psychological and physical manifestations of abnormality were brought into play: madness – neurosis, the new sickness that followed the Romantics' *mal du siècle* and Baudelaire's *spleen* – and monstrosities. J.-K. Huysmans, who in his preface to the 1904 second edition of *À rebours* was to describe the dilemma faced by the Naturalists because of their theoretical rejection of the exceptional, wrote and published his novel as a story of a nervous complaint[8] and in 1889 devoted a substantial essay in *Certains*, entitled "Le monstre", to the history of the monstrous in art. While Van Gogh remains an enduring and tragic reminder of artistic creativity linked to mental disorder,

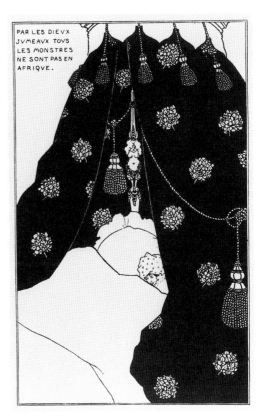

Aubrey BEARDSLEY
Portrait of Himself
From *The Yellow Book*

Aubrey Beardsley depicted himself as a Western monster and Gauguin portrayed himself as "Oviri", the monster who symbolized his break with the civilized world.[9] Alfred Jarry made the point with a significant inversion: "It is customary to call an unusual combination of dissonant elements a 'monster': the Centaur and the Chimera are defined as such by those who do not understand. For me a monster is any entirely original and inexhaustible beauty."[10]

The transition from the unusual to the pathological can be risky: many people gave credence to Cesare Lombroso's theory that genius was a form of madness and to his disciple Max Nordau, who denounced new movements in music, literature and the arts as symptoms of "degeneracy".[11] Men of letters also turned to science for support. Huysmans, Émile Hennequin and Jean-Marie Guyau invoked Lamarck and Darwin in claiming the artistic identity as a natural phenomenon, defining "the superior man, the artist, the man of letters" as "a monster, an artificial, fragile creature, incomplete in some ways and abnormally developed in others", but also as "the displaced person, the exemplary forerunner of future humankind".[12] This optimistic version, to culminate in

5. Georges Rochegrosse, *Orphée charmant les monstres et les fauves*, exhibited in Munich about 1890-1891, reproduced in the sale catalogue of the Rochegrosse studio (Drouot, June 14, 1993), no. 19.

6. Jean Starobinski, *Portrait de l'artiste en saltimbanque* (Paris: Flammarion, 1983; originally published Geneva: Skira, 1970), p. 104.

7. Philippe Junod, "Rodin et les métamorphoses d'Icare", *Revue de l'art*, no. 96 (1992), pp. 31-39.

8. See Jacques Lethève, "La névrose de Des Esseintes", *Les Cahiers de la tour Saint-Jacques*, vol. 8 (1963), pp. 69-73.

9. *Autoportrait "Oviri"*, 1894-1895, bronze, private collection (reproduced in *Gauguin*, exhib. cat. [Paris: Galeries nationales du Grand Palais, 1989], no. 214); *Oviri*, 1894, enamelled stoneware (reproduced *ibid.*, no. 211).

10. Alfred Jarry, "Les monstres", *L'Ymagier*, no. 2 (January 1895); reprinted in A. Jarry, *Œuvres complètes*, vol. 1, texts chosen, presented and annotated by Michel Arrivé (Paris: Gallimard, Bibliothèque de la Pléiade, 1972), p. 972.

11. Cesare Lombroso, *Genio e Follia* (1864); published in French as *L'homme de génie* (Paris, 1889); in German as *Der geniale Mensch* (Heidelberg, 1890); and in English as *The Man of Genius* (London, 1891). Max Nordau, *Entartung* (1892); published in French as *Dégénérescence* (Paris: Félix Alcan, 1895, 3rd edition); and in English as *Degeneration* (New York, 1895).

12. Émile Hennequin, "Le Pessimisme des écrivains", *La Revue indépendante*, October 1884, pp. 445-455, and November 1884, pp. 61-78; see Enzo Caramaschi, *Essai sur la critique française de la fin-de-siècle: Émile Hennequin* (Paris: Nizet, 1974).

Kandinsky's ascendant triangle in *Concerning the Spiritual in Art*, found its counterpart in the theme of engulfment and the "cultural pessimism" of those for whom artists represented the last barricade against the inexorable rise of materialism – or, for some, of democracy.[13]

In terms of behaviour, the dandyism imagined by Huysmans in *À rebours* and practised by people like Fernand Khnopff was another manifestation of this elitist claim to otherness. Following the example of Des Esseintes's planned journey to London rather than Gauguin's real departures, the flight anywhere out of the world came down in the end to an inward withdrawal, expressed by Khnopff in his motto: "We only have ourselves."[14] The solipsism of setting up the self as the sole source of values is related to the interest in Max Stirner and the sympathy for anarchism that were rife in independent art circles, even though the associated political stances were often diametrically opposed.[15] The deep-rooted but complex links between Belgian Symbolist circles and socialism should not be taken as proof of the often-postulated and overly simple equation of artistic with political progressivism,[16] as Camille Pissarro's violent dislike of Symbolist tendencies makes clear.[17] Most artists found in their calling and in the concept of art described here a way of projecting themselves above social struggle. Such was the case with Redon, who salved in this manner the guilty conscience of his youth and later on in life considered collecting together under the symbolic title "To Oneself" or "Of Oneself" some writings the most important of which begins with this declaration of self-sufficiency: "I have made my art on my own terms."[18]

Position of the Artist and Organization of the Artistic Life

The development of self-awareness and self-portraiture on the part of artists went hand in hand with the evolution of networks to display, promote and recognize artists and their work. The "dealer-critic system", which Harrison and Cynthia White describe as replacing the "academic system" in the mid to late nineteenth century, was based on a perception of artists and their work as individual, freed from societal standards of training and assessment.[19] Jean-Paul Bouillon suggests approaching this period of art history by recognizing a transitional period, the "era of societies", during which artists, among them the Impressionists, sought for ways of reaching the public themselves through groups and societies motivated

more by practical concerns than by a common aesthetic outlook.[20] Seen from this viewpoint, the late 1880s demonstrate a crisis in the artistic community out of which emerged new groups resting on the base of shared commercial and critical interests that were recognized as vital by artists born around 1870 – aesthetically oriented groups characterized by a certain tension between the urge to individualism and the collective interest.

In the field of literature, the year 1889 saw Charles Morice, one of the writers who claimed to speak for the new generation, asserting that there were no more schools of writers and that any attempt to found a new one would be betrayed by its own members, "who would all of them know how to play one part only – the lead".[21] Two years later,

13. See, for example, Teodor de Wyzewa, "Notes sur la peinture wagnérienne et le Salon de 1886", *La Révue wagnérienne*, May 1886, p. 113, and for the theme of engulfment, Edvard Munch's *Vision* (1892, Oslo, Munch-museet), reproduced with the preparatory sketches in *Munch et la France*, exhib. cat. (Paris: Musée d'Orsay and Oslo: Munch-museet, 1992), pp. 152-155.

14. Khnopff's device bearing this motto appeared in the December 1898 issue of *Ver Sacrum* devoted to him (reproduced in facsimile in *Fernand Khnopff 1858-1921*, exhib. cat. [Paris: Musée des Arts Décoratifs; Brussels: Musées royaux des Beaux-Arts de Belgique; and Hamburg: Kunsthalle, 1979-1980], p. 247); the well-known *I Lock My Door upon Myself* (1891, Munich, Neue Pinakothek) suggests a more complex expression of this theme.

15. On the reception of Stirner, see Dieter Lehner, *Individualanarchismus und Dadaismus. Stirnerrezeption und Dichterexistenz* (Bern: Lang, 1988); on the links between independentist art and anarchism, see among others Eugenia Herbert, *The Artist and Social Reform: France and Belgium, 1885-1898* (New Haven: Yale University Press, 1961) and Joan Ungersma Halperin, *Félix Fénéon: Aesthete and Anarchist in Fin-de-siècle Paris* (New Haven: Yale University Press, 1988).

16. See Herbert, 1961, and Paul Aron, *Les Écrivains belges et le Socialisme (1880-1913)* (Brussels: Labor, 1985); on reactionary elements in the criticism of Symbolist art, see Michael Marlais, *Conservative Echoes in Fin-de-siècle Parisian Art Criticism* (University Park, Pennsylvania: Pennsylvania State University Press, 1992).

17. See Françoise Cachin, "Some Notes on Pissarro and Symbolism", in Christopher Lloyd, ed., *Studies on Camille Pissarro* (London and New York: Routledge & Kegan Paul, 1986), pp. 95-98.

18. See André Mellerio, *Odilon Redon* (Paris: Société pour l'étude de la gravure française, 1913; reprinted New York: Da Capo Press, 1968), p. 48, and Dario Gamboni, *La Plume et le Pinceau. Odilon Redon et la littérature* (Paris: Minuit, 1989), pp. 28, 209-215; the analysis of Redon's social and political stance put forward in this study (especially pp. 22-30) is markedly different from the conclusions of Stephen F. Eisenman in *The Temptation of Saint Redon: Biography, Ideology and Style in the "Noirs" of Odilon Redon* (Chicago and London: University of Chicago Press, 1992). More recently on the same subject, see also *Odilon Redon: Prince of Dreams, 1840-1916*, exhib. cat. Art Institute of Chicago, Van Gogh Museum, Amsterdam, and Royal Academy of Arts, London (Chicago: 1994).

19. Harrison C. and Cynthia A. White, *Canvases and Careers: Institutional Change in the French Painting World* (New York, London and Sydney: Wiley & Sons, 1965); see also Pierre Bourdieu's analysis "L'institutionnalisation de l'anomie", *Les Cahiers du musée national d'Art moderne*, no. 19/20 (June 1987), pp. 6-19; Nicholas Green, "Circuits of Production, Circuits of Consumption: The Case of Mid-nineteenth Century French Art Dealing", *Art Journal*, vol. 48, no. 1 (Spring 1989), pp. 29-34; Patricia Mainardi, *The End of the Salon: Art and State in the Early Third Republic* (Cambridge: Cambridge University Press, 1993).

20. Jean-Paul Bouillon, "Sociétés d'artistes et institutions officielles dans la seconde moitié du XIXᵉ siècle", *Romantisme*, no. 54 (1986), pp. 89-113.

21. Charles Morice, *La littérature de tout à l'heure* (Paris: Perrin et Cie, 1889), p. V.

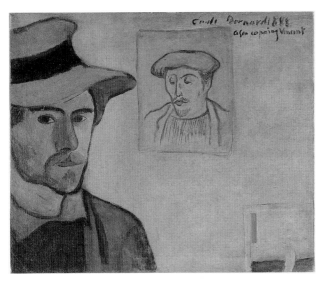

Émile BERNARD
Self-portrait: "À son copaing Vincent", 1888
Amsterdam, Van Gogh Museum

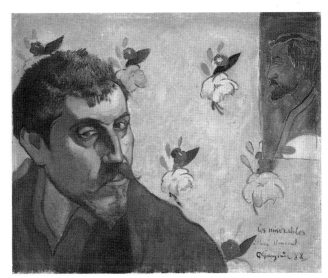

Paul GAUGUIN
Self-portrait: "Les Misérables", 1888
Amsterdam, Van Gogh Museum

Verlaine made fun of the "cymbalists' idiotic demonstrations and manifestos": "In 1830 we went to war under one banner only: it bore the word *Hernani*! These days, it's random sorties of louts, each with its own little flag screaming 'fame'!"[22] By 1898, Remy de Gourmont was speaking of Symbolism in the past tense when he said it was "even when excessive, outrageous, pretentious, the expression of individualism in art".[23]

This contradiction was equally apparent in the arts, where in 1890 the defining of a movement akin to the literary one that had gathered around Mallarmé was an aspect of the effort to organize the new generation of independent artists. Gauguin's ambition to be recognized as leader of the movement offended the self-esteem of the artists in his group and ran counter to their communal endeavours. This wish for collective action was also at the root of Van Gogh's tempestuous relationship with Gauguin, and goes some way towards

explaining the former's negative reaction to Aurier's article of January 1890, which called him "isolated" and focussed the spotlight on him.[24] When at the banquet in honour of Moréas on February 2, 1891, and then in a second article by Aurier, Gauguin was called the representative of "Symbolism in painting",[25] Émile Bernard suggested to Schuffenecker that

22. As reported by Jules Huret in *Enquête sur l'évolution littéraire* (Paris: Fasquelle, 1901; originally published 1891), p. 68.
23. Remy de Gourmont, *Le Livre des masques*, vol. 2 (Paris: Mercure de France, 1898), p. 13.
24. G.-Albert Aurier, "Les isolés. Vincent van Gogh", *Le Mercure de France*, January 1890, pp. 24-29; see Patricia Mathews, "Aurier and Van Gogh: Criticism and Response", *Art Bulletin*, vol. 48 (1986), pp. 94-104.
25. G.-Albert Aurier, "Le symbolisme en peinture. Paul Gauguin", *Le Mercure de France*, March 1891, pp. 155-165; for the context of this publication and the reactions it gave rise to, see James Kearns, *Symbolist Landscapes: The Place of Painting in the Poetry and Criticism of Mallarmé and His Circle* (London: The Modern Humanities Research Association, 1989), and Dario Gamboni, "Le «symbolisme en peinture» et la littérature", *Revue de l'art*, no. 96 (1992), pp. 13-23.

Vincent VAN GOGH
Self-portrait, 1888
Cambridge, Massachusetts, The Harvard University Art Museums

they form an "Association des Anonymes". Each member would remain "absolutely unknown" and would sign himself *anonymous*; the group would also stand for "the absence of individual literary criticism", and strive towards "combined communal efforts".[26] The self-portraits executed in 1888 by Bernard, Gauguin and Van Gogh at the Dutch painter's instigation express this dynamic, as well as the three artists' common involvement with the problems of self-portraiture and symbolization. Bernard confined himself to a Synthetist organization of the pictorial surface and the expression of his personal relations with Gauguin, whose picture, included in the composition, almost edges his own off the left side of the page. Gauguin and Van Gogh both proposed "enlarging their personalities" in order to depict "an Impressionist in general": the latter evokes a "bonze, a simple acolyte of the eternal Buddha"[27] through the shape of the head, the yellow background and the built-up paint strokes that create a sort of halo of light, while Gauguin uses a "complete abstraction" of drawing and colour with highly personal connotations[28] and a literary allusion in the inscription, *les misérables*, equating the painter with Jean Valjean.

Thus the sanctification of Gauguin and the proclamation of Symbolism in painting, which coincided with the sanctification and popular success of literary Symbolism,[29] did not bring about a movement, or even a Symbolist group; it merely sparked the much-disputed use of a new term and set a fashion within the context of aesthetic pluralism that was confirmed by the creation of the Société nationale des beaux-arts by secession within the Société des artistes français.[30] Despite its immense success as a curiosity, Joséphin Péladan failed to make the annual show of the Rose-Croix Esthétique a "third Salon". The second such exhibition featured only neo-idealist painters, most of mediocre talent, since the Nabis had declined to participate, as had the distinguished older artists invited by the Sâr.[31] The growing international network in modern art, of which the Brussels XX were a key element, made it possible to circumvent the obstacles posed by traditional institutions and provide footholds through the formation of small coteries.[32]

Ways of Communicating

Rejecting the subjection of "official" art to pre-existing standards and the determination of "commercial" art by identifiable expectations, the "avant-garde" artists preferred to be judged by their peers and also, ideally, sought

appreciation on a wider scale from an unprejudiced public. This goal corresponded with the theory of "suggestion", which grants the spectator's way of seeing equal status with that of the artist, thereby making the former part of the creative process. Charles Vignier had good reason for suggesting that it be recognized as a common objective for all the arts of the day.[33] The "ideal collaboration agreed to by ten superior persons scattered across the universe", Huysmans's definition of ideal literary communication, could also serve to describe the necessary ambiguity and endless interpretation that linked artists, critics and art lovers in Symbolist circles.[34] This collective usage of semantic indeterminacy also dictated the make-up of the groups that went in for it, as is apparent, together with the resulting political contradictions, in the announcement published in *L'Art moderne* by Edmond Picard, a Brussels lawyer committed to the social struggle, of the publication of a lithograph by Redon in "a run of only fifty prints, for you, Aesthetes, and you alone".[35]

And yet, in his article of 1890 Aurier praised Van Gogh's "notion of inventing a very simple, almost childlike kind of

26. Letter of January 19, 1891, from Émile Bernard to Émile Schuffenecker, quoted in Henri Dorra, "Extraits de la correspondance d'Émile Bernard des débuts à la Rose-Croix (1876-1892)", *Gazette des beaux-arts*, vol. 96 (December 1980), p. 238.

27. Undated letter (October 1888) from Vincent to Théo van Gogh, in V. van Gogh, *Lettres à son frère Théo* (Paris: Gallimard, 1988; originally published 1956), p. 426.

28. "The whole against a chrome background sprigged with childish posies. The bedroom of a pure young girl. The Impressionist is a pure soul, still uncontaminated by the poisonous kiss of the Beaux-Arts school" (letter of October 8, 1888, from Paul Gauguin to Émile Schuffenecker, in *Lettres de Gauguin à sa femme et à ses amis*, collected with a preface by Maurice Malingue [Paris: Grasset, 1946], pp. 140-141).

29. See Joseph Jurt, "Les mécanismes de constitution de groupes littéraires: l'exemple du symbolisme", *Neophilologus*, vol. 70 (1986), pp. 20-33.

30. See Pierre Vaisse, "Salons, expositions et sociétés d'artistes en France 1871-1914", in Francis Haskell, ed., *Atti del XXIV Congresso Internazionale di Storia dell'Arte*, vol. 7: *Saloni, Gallerie, Musei e loro influenza sullo sviluppo dell'arte dei secoli XIX e XX* (Bologna: Cooperativa libraria universitaria editrice, 1981), pp. 141-151.

31. See Jacques Lethève, "Les Salons de la Rose-Croix", *Gazette des beaux-arts*, December 1960, pp. 363-374; Robert Pincus-Witten, *Occult Symbolism in France: Joséphin Péladan and the Salons de la Rose + Croix* (New York and London: Garland, 1976); Jean Da Silva, *Le Salon de la Rose + Croix (1892-1897)* (Paris: Syros-Alternatives, 1991).

32. See Dario Gamboni, "Paris et l'internationalisme symboliste" in Thomas W. Gaehtgens, ed., *Künstlerischer Austausch/Artistic Exchange. Akten des XXVIII. Internationalen Kongresses für Kunstgeschichte Berlin, 15.-20. Juli 1992* (Berlin: Akademie Verlag, 1994), pp. 277-288.

33. Charles Vignier, "Notes d'esthétique. La suggestion en art", *Revue contemporaine littéraire, politique et philosophique*, vol. 3, no. 4 (December 25, 1885), pp. 464-476.

34. *Œuvres complètes de Joris-Karl Huysmans*, vol. 7: *À rebours* (Paris: Crès, 1929), p. 302; see Arthur George Lehmann, "Un aspect de la critique symboliste: signification et ambiguïté dans les beaux-arts", *Cahiers de l'Association internationale des études françaises*, no. 12 (June 1960), pp. 161-174, and Gamboni, 1989, pp. 146-150.

35. [Edmond Picard], "Yeux clos", *L'Art Moderne*, December 28, 1890, p. 412; for the identification of the author, see the collection *Lettres de Gauguin, Gide, Huysmans, Jammes, Mallarmé, Verhaeren... à Odilon Redon* (Paris: José Corti, 1960), p. 164.

painting, for the people, able to be understood by the least sophisticated or learned". In 1903, what Maurice Denis was to define as one of the "contradictions" in Gauguin arose from the fact that "He was fiercely individualistic, and yet attached to the most collective, most anonymous, folk traditions."[36] Thus two extremes – a penchant for the esoteric and a quest for immediate communication – were to be found in the art associated with Symbolism, poles often described by their adherents in terms of the difference between "allegory" and "symbol".[37] Aurier, who distinguished between "ideists" and "idealists" respectful of the conventions, therefore criticized Bernard's exclusive primitivism and his rejection of modern subjects. He asked,

> Why are you content to clothe your ideas in existing symbols, old symbolic forms that have become hackneyed, their impact dulled by overuse, by changes in our culture, our habits and our thinking, symbols that call your

sincerity into question? Pagan and Christian mythologies are not the only possible sources of symbols, or even the most interesting. Don't you believe in the possibility of finding, whether in nature, in the civilized life of our day or in the world of dreams, raw material that can be as beautifully and expressively symbolic as virgins and goddesses?

Nature is a temple where living columns
Sometimes speak in puzzling words,
Man walks through forests of symbols
That watch him with the eyes of kinship.[38]

The search for "plastic equivalents" and for direct expression by means of line and colour was not necessarily subject to Aurier's Platonism, just as the belief in "unconditional signs" could be adapted to individual notions of "correspondences".[39] The hegemony of literature, overtaken by the primacy of the "Idea" and by the metadiscursive status of aesthetic theories, found itself challenged not only by the ambiguous assertions of independence of Gauguin,[40] but also by the explicit claims to specificity of Denis. Like the connection with the allegorical tradition, the relationship to literature is a useful criterion in elucidating the various "symbolist" trends. Denis, who in 1890 regarded "a penchant for literature", together with "Naturalist negativity", as a sign of decadence in the plastic arts, in 1892 expressed astonishment that anyone could "confuse mystical and *allegorical* tendencies, that is, the attempt to express by means of the subject, and *symbolist* tendencies, that is, the attempt to express through the work of art itself". In 1895, he accused the "young men of letters" who "took it upon themselves to talk about painting" of having "contributed to drowning the remarkable undertaking of the Pont-Aven school ... in literature, in idealist trompe l'oeil (an outdated genre in any case)".[41]

This polarity between pictorial "symbolism" as understood by Denis and the symbolism of the "painters of the soul" and the Salons de la Rose + Croix has persisted in art history in the difference between modernist "Symbolism" as defined by Robert Goldwater – selective, based on French art of 1885-1895 and regarding formal innovation as of primary importance – and revisionist "Symbolism", which covers a number of styles, countries and decades and defines the movement mainly by a link with Symbolist literature and by the use of certain images.[42] These two points of view on the Symbolist "nebula" or Symbolist "moment"[43] could doubtless be linked, like the concentric circles suggested by René Wellek

36. Maurice Denis, "L'influence de Paul Gauguin", *L'Occident*, October 1903; reprinted in M. Denis, *Théories 1890-1910. Du Symbolisme et de Gauguin vers un nouvel ordre classique* (4th edition with new preface, Paris: Rouart et Watelin, 1920; originally published 1912), pp. 166-171.

37. See for example the following definition of "the recent pictorial symbolism" presented in an anonymous review: "It conceives of the forms and substances it portrays not as mere emblems, arbitrarily connected (according to the tradition of the allegorist) with the abstractions they represent, but as possessing inherent congruities with the intellectual images of which they are the autograph signature." ("Some Aspects of Modern Art, Art. III", *The Edinburgh Review or Critical Journal*, vol. 99 [July 1899], p. 64.)

38. Unpublished letter of June 23, 1890, from G.-Albert Aurier to Émile Bernard, Paris, Institut Néerlandais, Fondation Custodia, 1988-A.215.

39. See Georges Roque, "Les symbolistes et la couleur", *Revue de l'art*, no. 96 (1992), pp. 70-76, and Dario Gamboni, "L'impératif de nouveauté, le rejet de la convention et la recherche d'un langage universel dans les arts des années 1880 et 1890", *Sociologie de l'art* [Brussels], no. 5 (1992), pp. 49-54. Remy de Gourmont went as far as paraphrasing Baudelaire, apropos of Marcel Schwob, as follows: "The world is a forest of differences" (de Gourmont, 1898, p. 152).

40. See Charles Chassé, *Le mouvement symboliste dans l'art du XIXᵉ siècle* (Paris: Librairie Floury, 1947), pp. 67-70, and Vojtech Jirat-Wasiutynski, *Paul Gauguin in the Context of Symbolism* (New York and London: Garland, 1978), pp. 350-352.

41. Pierre Louis, "Définition du néo-traditionnisme", *Art et critique*, August 23 and 30, 1890 (reprinted in Denis, 1920, p. 9); Pierre L. Maud, "Le Salon du Champ-de-Mars. L'exposition de Renoir", *La Revue Blanche*, June 25, 1892 (reprinted in Denis, 1920, p. 17); M. Denis, "À propos de l'exposition d'A. Séguin", *La Plume*, March 1, 1895 (reprinted in Denis, 1920, p. 21).

42. Robert Goldwater, *Symbolism* (New York: Harper & Row, 1979), and Thérèse Burollet, "Symbolisme", in *Petit Larousse de la peinture* (Paris: Larousse, 1979), vol. 2, pp. 1777-1780.

43. The term "nebula" was used in reference to literary Symbolism by Louis Hautecœur ("It is all these nebulae which, fifty years on, form the constellation called Symbolism"), *Littérature et peinture en France du XVIIᵉ au XXᵉ siècle* (Paris: Librairie Armand Colin, 1963; originally published 1942, p. 211) and more recently in reference to the Nabis by François Fossier, *La Nébuleuse nabie. Les nabis et l'art graphique* (Paris: Éditions de la Réunion des musées nationaux and Bibliothèque nationale, 1993); the expression "the Symbolist moment" was coined by Jean-Paul Bouillon in his editorial to the issue of *Revue de l'art* devoted to Symbolism (no. 96 [1992], pp. 5-11).

to encompass the various meanings attributed to "Symbolism" in the field of literature,[44] but the homogeneity implied by a careless use of the term "symbolism" is liable to obscure the reality of late nineteenth-century painterly practice and the issues structuring it.

Criticism and Radicalization

The role played by individualism and intercommunication is again apparent when we look at the continuations of "Symbolism" proposed in the twentieth century by the French artists Maurice Denis and Marcel Duchamp. It should first be noted that even though independent art was succeeding in making its mark as the market for modern art grew stronger and the old institutions and official criteria of taste were becoming discredited, the overweening revolutionary ambitions of some of its practitioners found no more concrete expression than statements of principle. The desire for a more socially diverse public, expressed in the call to put Gauguin in charge of the decoration of public buildings that concluded Aurier's second article of 1891, became for Denis after his Nabi period a demand leading to concrete programmes, especially in the realm of church art. Although Denis was one of the few to go on using the term "Symbolism" and to predict it had a future in art, it was at the cost of a generalization – "All art worthy of the name is Symbolist, since the aim of all art is to mean something"[45] – and of a reappraisal that made the primacy of form a more relative matter and pitted individualism against the desire to communicate.[46] Certainly Denis continued to distinguish symbol from allegory – "An allegory speaks to the mind, a symbol to the eyes" – and he approved of the sorting process carried out by later generations: "Synthetism, a very rational and traditional theory, outlived literary Symbolism, which painters found suspicious and which was rather too classical in its metaphysics."[47] But he was horrified at his definition of neotraditionalism being invoked to support "the headlong rush to the abyss of abstraction"[48] and, in his diary for 1915, describes the Symbolism of 1890 and the concomitant "anarchic conditions of moral, social and political life" as follows:

> Defects of Symbolism (defined as "the art of expressing ideas, feelings and sensations through signs"): it is a communal, unanimous art, an art of the people, a language; but we had made of it an individualistic art, wishing to create signs rather than accepting them; a

language whose words were to be invented by each artist, who was then condemned to be misunderstood by the public.[49]

Running counter to this antimodernist attempt to return to the "classical" order (a movement whose adherents between the Wars should not be underestimated),[50] Marcel Duchamp pushed to its logical limits the avant-garde theory of individualism that was to prove so successful in the long run. Robert Lebel sees in Duchamp's invention of the ready-made a wish "to decry the commonly held, tacitly accepted notion of worth in order to glorify the strictly individual *sovereign* choice that owes nothing to anyone", a manifestation of his main concern "to set oneself up as unique".[51]

Seventeen years younger than Denis, Duchamp knew the "Symbolist moment" only indirectly, but his relationship with it was nonetheless significant. We know he read and reread Mallarmé, and the demonic head that surmounts his *Monte Carlo Bonds* of 1924 links this attempt to abolish the element of chance to the poet's "Un coup de dés jamais n'abolira le hasard" of 1897. The meaning of this inheritance of his has

44. René Wellek, "What Is Symbolism?", in Anna Balakian, ed., *The Symbolist Movement in the Literature of European Languages* (Budapest: Akadémiai Kiadó, 1984), pp. 17-28.
45. "Le sentiment religieux dans l'art du Moyen Âge", lecture given at the Société des amis des cathédrales, December 16, 1913; published in Maurice Denis, *Nouvelles théories sur l'art moderne, sur l'art sacré 1914-1921* (Paris: Rouart et Watelin, 1922), p. 149.
46. On Denis's progressive writing of the history of Symbolism, see Shigemi Inaga, "L'histoire saisie par l'artiste. Maurice Denis, historiographe du symbolisme", in *Des mots et des couleurs*, vol. 2 (Lille: Presses universitaires de Lille, 1986), pp. 197-236.
47. Maurice Denis, *Journal* (Paris: Vieux Colombier, La Colombe, 1957), vol. 2 (1905-1920), p. 140 ("Note sur l'allégorie et le symbole", 1911); "La réaction nationaliste", *L'Ermitage*, May 15, 1905; reprinted in Denis, 1920, p. 191.
48. Denis, 1957, vol. 2, p. 183 (1915).
49. *Ibid.*, p. 174 (February 1915, from letters to Sérusier); one is reminded of Mallarmé's lines from the "Tomb of Edgar Poe": "To give a purer sense to the words of the tribe". Denis came back to this question in 1918 in his "Le symbolisme et l'art religieux moderne": "I will not waste time pointing out what was wrong with a system that conceded far too much to the individual and the individual imagination; nor the obvious contradiction between the notion of *language* implicit in the theory of plastic signs, and the unlimited freedom of vocabulary permitted to the artist. Respect for nature should have been incorporated, leaving a role and a place for imitation" (reprinted in Denis, 1922, pp. 180-181); for his criticism of Symbolist and post-Symbolist individualism, see also Denis, 1957, vol. 1, p. 140 (1898) and vol. 2, pp. 180-181 (1915): "Introspection: I see myself thinking out the drawings for [Verlaine's] *Sagesse*. I leave college, I know that art is worth nothing unless it is the expression of an individual genius . . . Nature, rendered according to the rules of art, provides all the means of expression, all the language artists use. Objectivity is thus the link between the artist and the public."
50. See Jean-Paul Bouillon, *Maurice Denis* (Geneva: Skira, 1993).
51. Robert Lebel, *Sur Marcel Duchamp* (1959); reprinted in R. Lebel, *Marcel Duchamp* (Paris: Pierre Belfond, 1985), pp. 72-73. See also Dieter Daniels, *Duchamp und die anderen. Der Modellfall einer künstlerischen Wirkungsgeschichte in der Moderne* (Cologne: DuMont Buchverlag, 1992), p. 213.

been variously interpreted: John Golding feels that it was because more than anyone else, Duchamp kept alive the fruitful dialogue established in nineteenth-century France between literature and the visual arts that he became a leading artist of his generation,[52] while Jean Clair suggests that the irony with which his *Large Glass* mechanizes mankind shows Duchamp far from the climate of thought of his youth and expresses the collapse of that "twinness, the nature shared by the inner world of consciousness and the external world, celebrated by the Symbolists under the banner of 'correspondences'".[53] The break, however, seems not to have excluded all continuity, and Duchamp's major work incorporates both the extra-artistic conventions of "precision drawing" and the Neoplatonist theme of the "fourth dimension".[54] Even the criticism of art "for the retina" that gradually led him to give up painting, together with his claim to intellectual standing, comes very close to the early Symbolist critique of Impressionism, which Redon declared had "too low a ceiling".[55] Duchamp at various times expressed his indebtedness to Redon,[56] and his axiom "It's the 'spectators' who make pictures"[57] may be considered a logical

Marcel DUCHAMP
Monte Carlo Bonds, 1924
New York, The Museum of Modern Art

52. John Golding, *Marcel Duchamp: The Bride Stripped Bare by Her Bachelors, Even* (London: Penguin Press, Allen Lane, 1973), pp. 27, 85.

53. Jean Clair, *Marcel Duchamp ou le grand fictif* (Paris: Galilée, 1975), pp. 89-90. The notion of a break with Symbolism appears twice in the interviews with Pierre Cabanne. Recalling his youthful interest in Laforgue, Duchamp says, "It was like an exit from Symbolism"; of Raymond Roussel, he says: "That man had done something which really had Rimbaud's revolutionary aspect to it, a secession. It was no longer a question of Symbolism or even of Mallarmé – Roussel knew nothing of all that." (Marcel Duchamp, *Ingénieur du temps perdu. Entretiens avec Pierre Cabanne* [Paris: Pierre Belfond, 1977; originally published 1967]; quoted in English from Pierre Cabanne, *Dialogues with Marcel Duchamp*, trans. Ron Padgett [New York: Viking Press, 1971], pp. 30, 34.) Michel Sanouillet has pointed out that Duchamp had particularly close ties to the eccentric branch of Symbolism, that of the "Decadents" ("Marcel Duchamp and the French Intellectual Tradition", in Anne d'Harnoncourt and Kynaston McShine, eds., *Marcel Duchamp* (Munich: Prestel, 1980; originally published New York and Philadelphia, 1973), pp. 49-50; for the schism between Decadents and Symbolists, see Jurt, 1986.

54. See primarily Clair, 1975, and also Jean Clair, "La fortune critique de Marcel Duchamp", *Revue de l'art*, no. 34 (1976), pp. 92-100.

55. Marius-Ary Leblond, "Odilon Redon et l'Impressionnisme. Suite d'entretiens dans le jardin et l'atelier de Bièvres", *Le peintre. Guide du collectionneur*, October 1, 1957, pp. 6-11.

56. See Walter Pach, *Queer Thing Painting: Forty Years in the World of Art* (New York and London: Harper & Brothers, 1938), pp. 165-166, and the interview with Duchamp reported by James Johnson Sweeney, "Eleven Europeans in America", *Bulletin of the Museum of Modern Art* [New York], vol. 13, no. 4/5 (1946), p. 19.

57. See, for example, the remarks reported by Jean Schuster, "Marcel Duchamp, vite", *Le Surréalisme, même*, no. 2 (Spring 1957), pp. 143-145; reproduced in Marcel Duchamp, *Duchamp du signe. Écrits*, collected by Michel Sanouillet, new edition revised and enlarged with the collaboration of Elmer Peterson (Paris: Flammarion, 1975), p. 247.

58. Redon, 1961, p. 27 ("Confidences d'artiste", a text first published in 1909).

59. See Marcel Duchamp, *Notes*, edited and translated by Paul Matisse (Paris: Centre national d'art et de culture Georges Pompidou, 1980), nos. 7, 18, 35.

completion of the latter's aesthetics of suggestion. Redon wrote of his own drawings: "The reaction to them produced in the viewer's mind will inspire him to daydreams of greater or lesser significance, depending on whether his temperament and imaginative gifts lead him to dream large or small."[58] Duchamp's ready-mades, presented in accordance with a theory whereby there is always an "ultrathin" basic difference between two objects even when they are mass-produced from the same mould[59] (the best-known attempt to exhibit one of these – *Fountain* in 1917 – represented a libertarian continuation of the Société des artistes indépendants of 1884), were intended to imply that a work of art is as much a creation of the spectator's eye and verdict as of the artist's intentions. That this was the affirmation of an individualism that

extended and radicalized certain Symbolist postulates is demonstrated by an unusually explicit text of 1960 in which Duchamp defines the artist as "a curious reservoir of spiritual values in absolute opposition to the everyday 'functionalism' for which science is so blindly admired", and suggests that the artist must get a university degree to acquire "adequate tools to confront this materialist state of affairs by means of the cult of the self in a context of spiritual values". Harking back to Max Stirner's *The Ego and His Own*, Duchamp goes on to say, "Under the appearance of (I am tempted to say, in the disguise of) a member of the human race, each individual is in fact quite alone and unique, and the characteristics common to all individuals when in the mass have nothing to do with the solitary explosion of an individual left to his or her own devices."[60]

60. "L'Artiste doit-il aller à l'université?" (talk given in English during a colloquium at Hofstra College, Hempstead, New York, May 13, 1960), quoted from Duchamp, 1975, p. 238; on Duchamp's interest in Stirner, see Serge Stauffer, *Marcel Duchamp. Die Schriften* (Zurich, 1981), pp. 240, 290, 301; on "spiritual values", see other remarks quoted and commented on in William A. Camfield, *Marcel Duchamp, Fountain*, exhib. cat. The Menil Collection (Houston: Houston Fine Art Press, 1989), pp. 97-98.

III. *The Homeland Regained*

313 to 345

At the turn of the century, peace in Europe was guaranteed by the two great powers and by Russia. Queen Victoria could rightly be called "the grandmother of Europe", and dynastic considerations counted for more than the democratic system. Nationalist demands, however, were being heard expressed in much the same manner all across Europe. Hungary, which in 1867 gained an independent constitution, parliament and government, was the best off among these emerging nations, unlike the kingdon of Bohemia, which was nevertheless more prosperous than the Austrian Empire. Finland tried to resist the policy of Slavicization being implemented by Czar Alexander III. In many countries, the drive towards a renewal of national consciousness was a continuation of the apirations of the Romantics. Thus in Poland, parcelled out among three great powers, the failure of the 1863 uprising sparked a decades-long renewal of interest in the nation's history that was nurtured on the fervid patriotism of the early nineteenth-century poet Adam Mickiewicz. In their opposition to the campaign instigated by Bismarck in 1865 and pursued by Wilhelm II to stamp out Polish nationalism, Henryk Sienkiewicz, Stanisław Wyspiański and Stanisław Przybyszewski proposed a new look at their country's distant past, a rejection of materialism, and the primacy of reason. But Malczewski's self-portraits as Christ are as much the result of an introspective nature as of fierce opposition to the policy of Prussianization being imposed on Polish Catholicism and the national language. In Finland, the incorporation of ancient myths in great hymns to the nation by such creative geniuses as Gallen-Kallela, Jean Sibelius and Kittelsen amounted to open criticism of the Russian presence.

Symbolism seems to have been not just the artistic expression of a political stance but, more important, the actual stimulus for a reawakening of national consciousness. In Belgium, where the revolutions of 1830 and 1848 led to the organization of an independent state, it was the artistic and literary avant-garde who banded together to create a unifying vision. The dreamlike evocations of an immemorial, melancholy Flanders created by Maurice Maeterlinck, Émile Verhaeren and most hauntingly by Fernand Khnopff in **Memories of Flanders: A Canal** (1904) are echoed in the demands for Walloon independence made in a Symbolist periodical like Albert Mockel's *Jeune Belgique*, which had Socialist sympathies. In France, on the other hand, the adherents of Symbolism, and especially those who like Théodore de Wyzewa and Villiers de L'Isle-Adam proclaimed their admiration for Wagner, were seen as antinationalists, traitors to the common cause.

327

The Homeland Regained 251

The Symbolist generation succeeded in resolving the paradox of, on the one hand, objectively supporting nationalist ambitions while, on the other, sharing wholeheartedly in the exchange and dissemination of culture and ideas on an international scale.

G. G.

313 (cat. 218)
Nils KREUGER
Horse by the Shore, Summer Night, 1902
Stockholm, Prins Eugens Waldemarsudde collection

314 (cat. 317)
Giuseppe PELLIZZA da VOLPEDO
Ring a Ring O'Rosies, 1902-1903
Milan, Galleria d'Arte Moderna

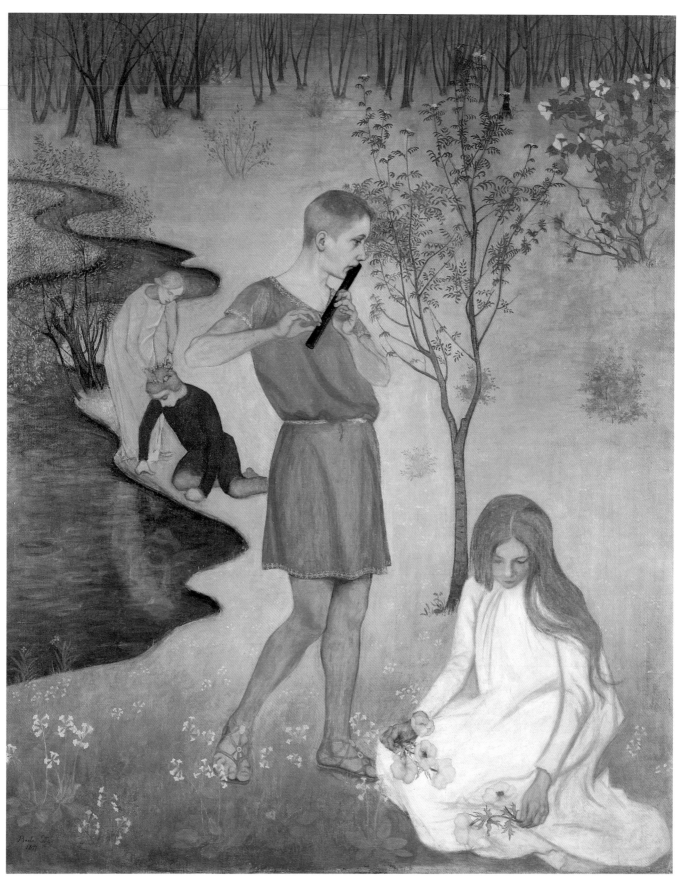

315 (cat. 418)
Beda STJERNSCHANTZ
Pastoral (Spring), 1897
Kokkola, Finland, K. H. Renlundin Museo

317 (cat. 387)
Giovanni SEGANTINI
The Angel of Life, 1894-1895
Saint-Moritz, Switzerland, Musée Segantini

316 (cat. 480)
Witold WOJTKIEWICZ
Parting (from the "Ceremonies" cycle), 1908
National Museum of Poznań

318 (cat. 257)
Jacek MALCZEWSKI
In the Dust Cloud, 1893-1894
National Museum of Poznań

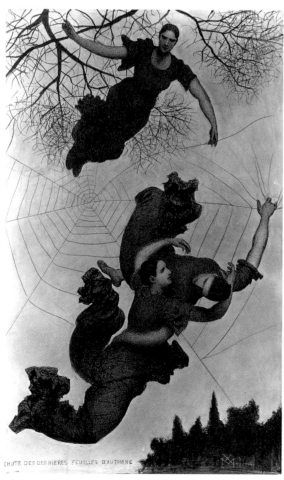

319 (cat. 275)
Xavier MELLERY
Autumn or *La Chute des dernières feuilles d'automne*
Brussels, Musées royaux des Beaux-Arts de Belgique

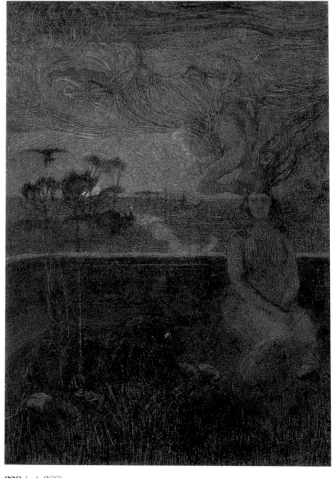

320 (cat. 388)
Giovanni SEGANTINI
The Annunciation of the New Word, 1896
Saint-Moritz, Switzerland, Musée Segantini

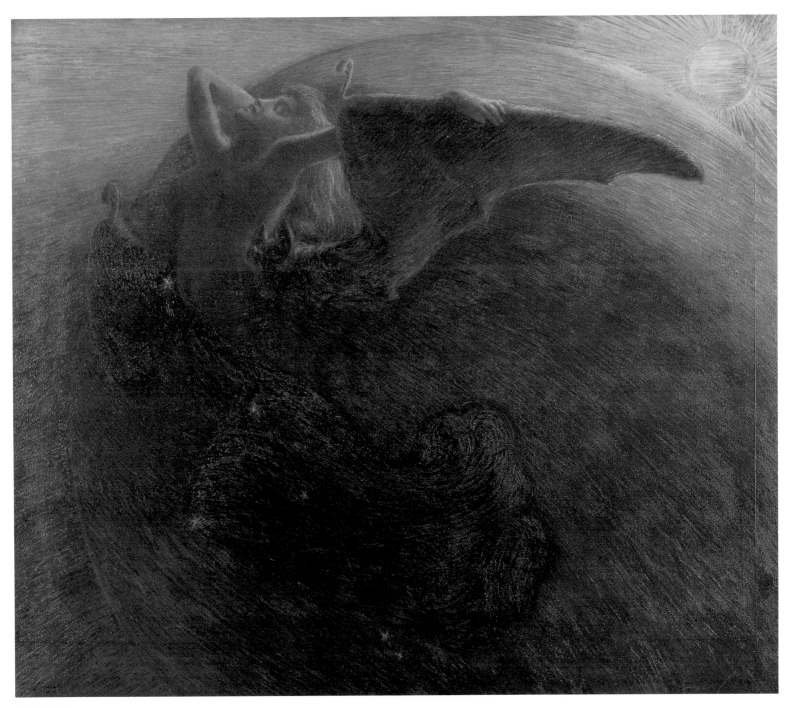

321 (cat. 329)
Gaetano PREVIATI
Day Awakens the Night, 1905
Trieste, Museo Civico Revoltella

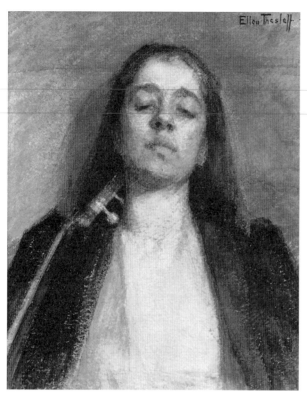

322 (cat. 423)
Ellen THESLEFF
Girl and Guitar, 1891
Helsinki, Ateneum

323 (cat. 398)
Léon de SMET
Interior, 1911
Ghent, Museum voor Schone Kunsten

324 (cat. 100)
Prins EUGEN
The Forest, 1892
Göteborg, Sweden, Göteborgs Konstmuseum

325 (cat. 400)
Léon SPILLIAERT
Boxes in front of a Mirror, 1904
Brussels, Musées royaux des Beaux-Arts de Belgique

326 (cat. 191)
Fernand KHNOPFF
Bruges: The Church of Our Lady, about 1904
Neuss, Germany, Clemens-Sels-Museum

327 (cat. 193)
Fernand KHNOPFF
Memories of Flanders: A Canal, 1904
The Hearn Family Trust

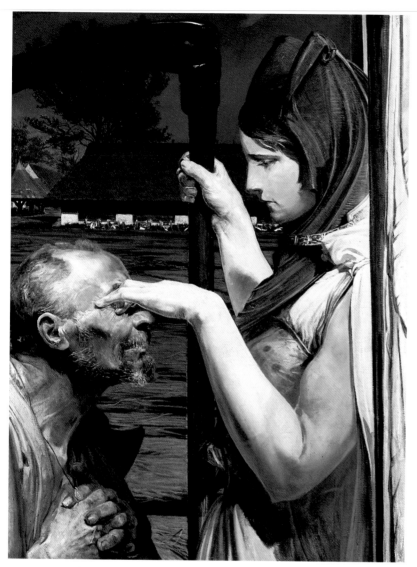

328 (cat. 264)
Jacek MALCZEWSKI
Thanatos: Death, 1902
National Museum of Warsaw

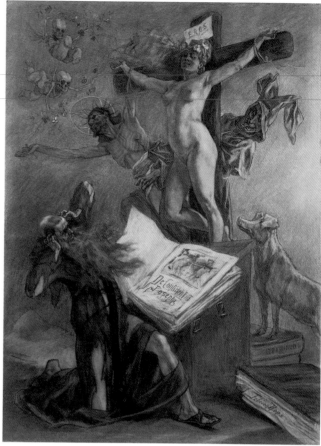

329 (cat. 359)
Félicien ROPS
The Temptation of Saint Anthony, 1878
Brussels, Bibliothèque royale Albert 1ᵉʳ, Cabinet des Estampes

330 (cat. 127)
Akseli GALLEN-KALLELA
The Defence of Sampo, 1895
Turku, Finland, Turku Art Museum

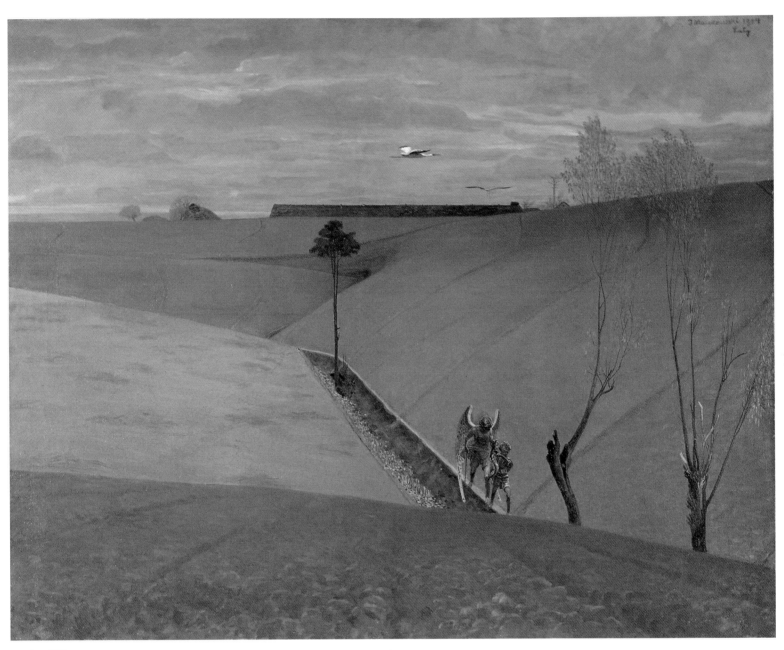

331 (cat. 260)
Jacek MALCZEWSKI
Spring: Landscape with Tobias, 1904
National Museum of Poznań

332 *Autumn II*, 1895

333 *The Farmer's Wife and the Poor Devil*, 1899

334 *Autumn I*, 1895

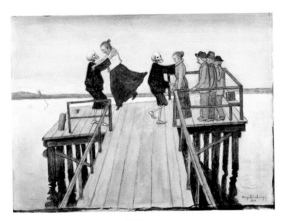

335 *Dance on a Bridge*, 1899

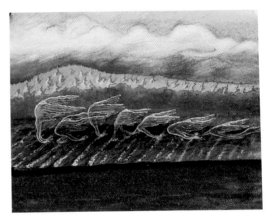

336 *Wind Blowing*, 1897

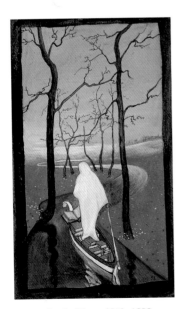

337 *By the River of Life*, 1896

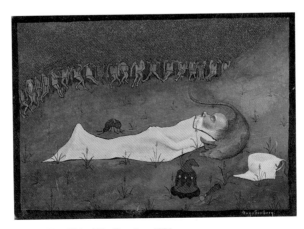

338 *King Hobgoblin Sleeping*, 1896

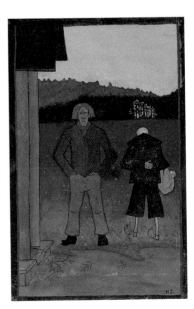

339 *Death and the Peasant*, 1896

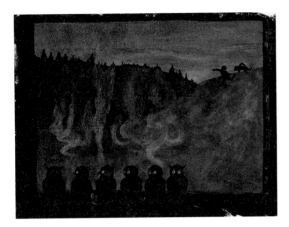

340 *Fantasy*, 1895

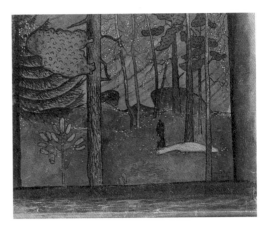

341 *Autumn in the Forest*, 1895

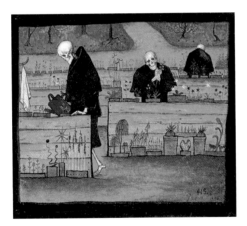

342 *The Garden of Death*, 1896

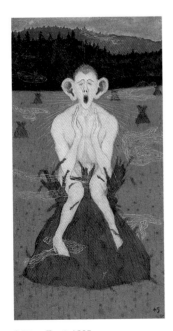

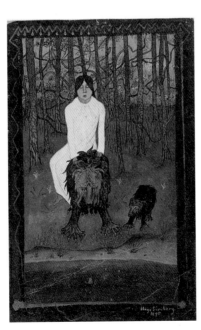

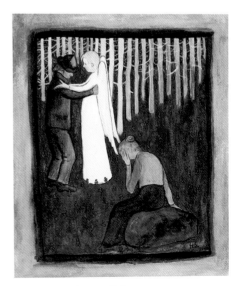

345 *Dream Regret*, 1900

343 *Frost*, 1895

344 *Fairy Tale I*, 1895

Belgium at the Turn of the Century
A Very International Nationalism

GISÈLE OLLINGER-ZINQUE

The Belgians are French people of brass. Peoples are shaped
by language, but although the Belgians speak our tongue,
they paint in their own idiom, and in a manner not devoid of style.

Joséphin Péladan

It is with these words that Joséphin Péladan, Grand Master of the Order of the Rosicrucians, marked the participation of Belgian lumininst Émile Claus in the Salon de Paris of 1884.[1] Although Péladan gave priority to the individual, even within his own order he was always concerned with internationalism. He never ceased trying to extend his influence beyond national borders, and Belgium was for him an ideal terrain. In 1895 he wrote, "A thing is true only when it is universally true for all the various eras, places and races."[2]

It was notably during Symbolism's period of greatness, at the turn of the century, that a major intellectual current arose in France and spread to the rest of Europe, immediately revealing points of comparison while evincing characteristics specific to each nation. Belgium played a leading role in this ferment of ideas and became one of Symbolism's most important centres, on a par with Paris. The ideas and precepts germinated in France found Belgian soil conducive to their blossoming; they intermingled with the tradition of Flemish painting, the national awareness cultivated by Belgian poets and human individuality to produce a powerful Symbolism, whose originality was recognized beyond the country's borders. As early as 1884, Brussels had become a cultural mecca, a roundtable for the exchange of ideas, welcoming to its artistic circles, journals and Salons even those who had not yet received recognition at home. In 1887, Seurat exhibited seven works at the Salon des XX, one of which was *Sunday Afternoon on the Island of La Grande Jatte*. Two years later, he returned with three drawings and nine paintings, including *The Models*. Gauguin, who first exhibited with Les XX, was represented by twelve key works that showed his transition from Impressionism towards Synthetism and Symbolism.

Cosmopolitanism combined with nationalism to produce wholly original trends attuned to Belgian sensibilities. The nationalistic feelings in the hearts of all Belgians were especially strong among poets. Although for the most part of Flemish origin, they wrote in French; yet, they asserted their difference and distinguished themselves from the poets of France. "Let us be ourselves!" proclaimed Max Waller and his friends at the influential magazine *La Jeune Belgique*, thereby expressing their wish to be independent and personal. Edmond Picard praised the "irrepressible and salutary need to be original; contempt for imitation; the strict obligation imposed on everyone to be himself or risk being disregarded", and concluded: "Relatively speaking, I do not believe there is an art movement anywhere as intense, sincere or independent as in our little Belgium."[3] Belgian literary Symbolism was a school of individualism that distanced itself very clearly from France: "We are not French! Our goal has always been to create in Belgium, with the Flemish and Walloon elements, an original art movement. Only then will we be able to put a stop to accusations of 'Belgian imitations'."[4]

1. Quoted in "Les Belges à l'Etranger", *La Fédération Artistique* [Antwerp], July 19, 1884, p. 319.
2. Joséphin Péladan, "Mandement de la quatrième geste sur l'Aristie, l'Humanisme et l'Exotérisation du Bulletin de l'Ordre", *Bulletin Mensuel de la Rose + Croix du Temple et du Graal* [Paris], no. 1 (April 1895), pp. 13-14.
3. Edmond Picard's response to J. Huret's questionnaire, quoted in "Enquête sur l'évolution littéraire", *L'Art moderne* [Brussels], June 14, 1891, pp. 188-189.
4. "Memento", *La Jeune Belgique* [Brussels], September 1890, pp. 352-353 (a statement issued by the management of *La Wallonie* in response to "Les Entretiens politiques et littéraires").

The case of Émile Verhaeren is revealing in this respect. In his writings, he acknowledged no rules but his own and, boldly disregarding conventions of syntax, grammar and vocabulary, developed a tortured style immediately recognizable as his even when unsigned. People decried the "barbarian" influences, referring to his Flemish origins and the close cultural ties Belgium maintained with Germany during the nineteenth century:

> It's an international congress of erroneous French, baroque turns of phrase, faulty images and incomprehensible metaphors. It's a mixture of Savoyard, Auvergnat, Apache, Malagasy, Huron, Comanche and Patagonian. It's a scalp dance whooping around grammar, logic and common sense. It's words running around in sacks.[5]

Because art is always closely linked to its time and social environment, it would be well to briefly describe the mood then prevailing in Belgium. A moral crisis confronted the generation of artists – painters and poets – active from 1880 on. Turn-of-the-century Belgium was dominated by the bourgeoisie. It was also a time of great industrial, commercial and economic growth, a period of prosperity for the young state that, under the enlightened rule of King Leopold II, witnessed a spectacular development due to the riches of the Congo. All the great scientific and technical discoveries were made in a very short period of time, and society became intellectualized. Consider for example the circles frequented by Fernand Khnopff, whose first champions and friends were the poet Émile Verhaeren and the jurists Edmond Picard and Octave Maus, both of whom achieved fame with the magazine *L'Art moderne*. Painting on commission, Khnopff became the official portrait painter of the bourgeoisie and the nobility. He frequented the great families who put their stamp on the era – the Philippsons, Brauns, Erreras, de Bauers and Nève de Mévergnies – as well as the English elite gathered in Brussels, whom he came to know and found to be a new source of inspiration. Khnopff first visited England in 1891. From then on, he went every year during the period of the great exhibitions, in which he participated. He met his friends Burne-Jones, Watts, Rossetti and Leighton, under whose influence he produced such works as *I Lock My Door upon Myself* and *Who Shall Deliver Me?*, inspired by the poetry of

5. Albert Giraud, "Les Moines", *La Jeune Belgique* [Brussels], May 1886, pp. 306-309.

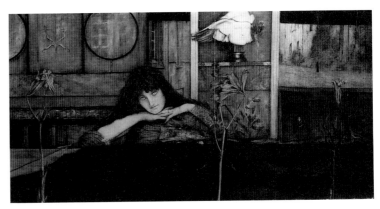

Fernand KHNOPFF
I Lock My Door upon Myself, 1891
Munich, Neue Pinakothek

Christina Georgina Rossetti. On his return to Belgium, no doubt in search of the English spirit that had charmed him, he became a friend of the Maquet family of Glasgow. The three daughters – Elsie, Lily and Nancy (born in 1868, 1872 and 1874) – provided the artist with models for his feminine ideal, gradually replacing his beloved sister Marguerite, who had married in April 1890 and whose absence, not to say abandonment and betrayal, had grievously affected him. From 1891 to 1900, several types of women appear in his work. The redhead is Elsie, the long-haired adolescent with slightly thick features is Nancy, and the slender young woman with delicate features is Lily. Khnopff also assiduously frequented the poetic avant-garde, to which his brother Georges belonged. He illustrated the works of a number of poets, including Péladan, Verhaeren, Grégoire Le Roy and Rodenbach. One should rather say that he accompanied them, as he was in the habit of giving his works directly connected with literature idiosyncratic titles beginning with the word "with", to emphasize the fact that artist and poet were fellow travellers and strove towards the same spirituality. Examples of this are *With Verhaeren: An Angel* (1889) and **With Grégoire Le Roy: My Heart Longs for Other Times** (1889).

The high society that Khnopff described so well for us in his portraits, and that he was proud to be associated with, did not resemble the Parisian elite. Brussels was not the gay Paris that comes to mind when one thinks of the fin de siècle. Brussels society was starchier, more austere. It was a "respectable society" that never lapsed into vulgarity and basically focussed its attention on the arts. This well-to-do and dominant class took scant interest in social issues and often showed unconcern for the conditions of the working class. The

279

too-rapid prosperity and industrialization caused an exodus from the countryside, which the peasants abandoned in search of work in the cities, thus creating a poor and easily exploited working class. It attracted the attention of artists and inspired Verhaeren's novels *Les Campagnes hallucinées* and *Les Villes tentaculaires*, which depict the anguish and loneliness of the people. The situation arising from an arts-oriented ruling class and an exploited proletariat gave birth to socialism, art concerned with social issues and, in Symbolism, distinctively Belgian characteristics. Poets and painters tried to solve this societal crisis, suffering and pessimism in different ways. Although they belonged to the bourgeoisie of Brussels, Ghent and Antwerp, poets felt a direct involvement with the country's economic situation and embraced the socialist ideal. In 1892, Verhaeren, along with Georges Eekhoud and Émile Vander-velde, established an art section at the Maison du Peuple in Brussels. Six years later, Jules Destrée wrote in *Art et Socialisme*: "As laws to protect the common people provide the masses with more leisure time and material comfort, intellectual needs will grow continuously. Everyone will be able to take an interest in the arts and sciences."

Symbolist painters were also greatly affected by this situation and rejected the world based on money, capitalism and industrialization in which they had to live. They sought the True, the Beautiful, the Ideal, and tried to escape from everyday reality by inventing a new world dominated, according to their personal inclinations, by mystery, dreams, occultism, refinement, mysticism, perversity and pessimism. They created a purely imaginary world that rediscovered and glorified the myths, legends and folklore of the past in the hope of finding salvation. We immediately observe that this new world was one of duality, where what we call Good and Evil, black and white, or the pure and the perverse coexisted. There were those who, like Jean Delville, George Minne, Émile Fabry, Charles Doudelet, Xavier Mellery and William Degouve de Nuncques, turned to supreme beauty, idealism, spirituality and religiosity and listened to the mystics or their own inner selves, rediscovering them in silence and contemplation. Others, on the contrary, sought a way out through pessimism, nurtured by reading Schopenhauer and through refined perversity and sadism. Félicien Rops was the leader of this trend, but other artists were drawn to it for a while. In 1885, Khnopff illustrated Péladan's **Vice suprême** and painted *Of Animality*, which Verhaeren described at length in the April 24, 1887, issue of *L'Art moderne*:

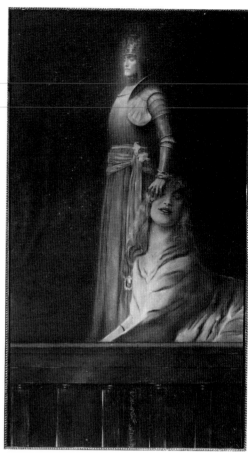

Fernand KHNOPFF
With Verhaeren: An Angel, 1889
Rome, Roberto Della Valle collection

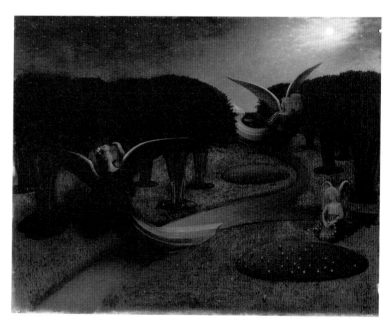

William DEGOUVE DE NUNCQUES
Angels in the Night, 1894
Otterlo, The Netherlands, Kröller-Müller Museum

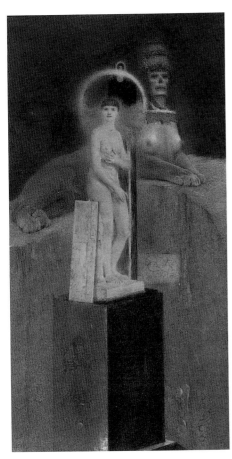

Fernand KHNOPFF
After Joséphin Péladan: The Supreme Vice,
1885
Private collection

would advocate depravity, suicide or death and, here again, Rops was considered the undisputed master. Death and damnation are favourite themes of Belgian Symbolist painting. Jean Delville, in *The Treasures of Satan* (1895), and Henry De Groux, in ***The Mocking of Christ*** and *Le Chambardement* (1893), pile up bodies in a manner reminiscent of mass graves. James Ensor, a highly original precursor of Symbolism, did not hesitate to include skeletons in his works, going so far as to portray himself skeletonized. But if he scoffs at death and plays with it, it is in order to forget how much he fears it. Ensor is at opposite poles from the true Symbolists, for his work shows no trace of mysticism, melancholy or idealism, but rather a taste for the macabre, for sarcasm, farce and black humour. He was an admirer of Poe, from whom he drew inspiration in works such as *King Pest*, *Hopfrog's Revenge* and *The Domain of Arnheim*. Ensor painted masks and depicted a fantastic world, perpetuating the great tradition of Belgian painting even as he renewed it. The Symbolists, who also cultivated the myth of the mask, did not limit it to hiding the face, but gave it a much deeper and more secret meaning. The mask is placed over the entire body, veiling and protecting it, making it inaccessible. It is the immaculate gown sheathing

80

250

Flaccid failure a woman, heavy under her golden hair, passive bosom, glances given . . . What results from contemplation of this work is the perception of boredom, satiety, slumped in heavy slumber. The body, crouched in wait on its fawn-coloured skin, has hands only for its own flesh, to be fingered, weighed, perfumed; it barely props itself up on one arm towards him who is to come; the nocturnal eyes, with violet rings around their lacklustre brightness, have tired themselves out in concupiscent glances; the redness of the hair and the gold of the stomach sound the flourish of nonsatisfaction and the rutting that follows upon lassitude.

Jean Delville showed interest in *The Idol of Perversity* (1891) before painting his *Angel of Splendour* (1894). Even Léon Frédéric, who, when he imagined his large-scale triptych *The Brook* (1890-1899) – a vast view of a forest paradise where putto-like children frolic – bordered on the perverse, despite the apparent theme of radiance and purity. Others

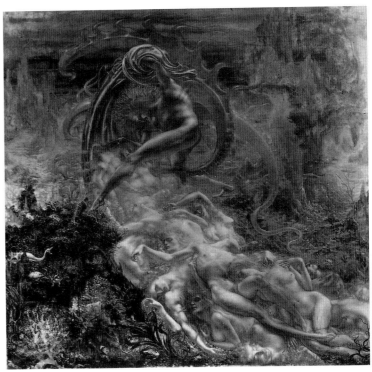

Jean DELVILLE
The Treasures of Satan, 1895
Brussels, Musées royaux des Beaux-Arts de Belgique

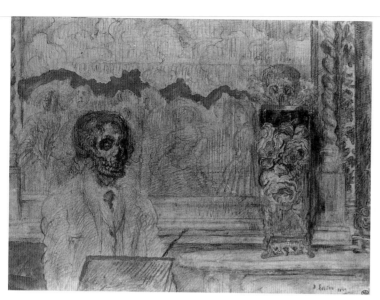

James ENSOR
Skeleton Making Nice Childish Drawings, 1889
Paris, Musée du Louvre

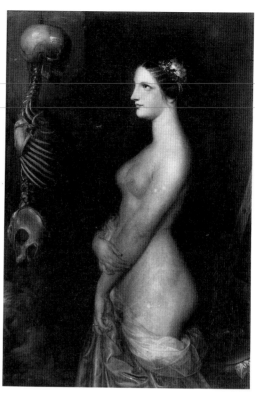

Antoine WIERTZ
The Fair Rosine, 1847
Brussels, Musée royaux des Beaux-Arts de Belgique

Marguerite Khnopff as she posed for her brother. It is also the long gloves the artist had the women wear in his paintings. The fantastic belongs to all periods, for it is man's refuge from his fear of the unknown. It creeps into the paintings of the precursors Wiertz and Ensor. It is present in Symbolists such as Henry De Groux and William Degouve de Nuncques, and a work like *The Pink House* (1892), inspired by Poe's "House of Usher" and strikingly similar to René Magritte's *Empire of Light* (1954), is marked by a strange, fascinating – and frightening – subtlety. Besides Poe (who was translated by Baudelaire), Lautréamont is another writer of the fantastic, and although publication of *Les Chants de Maldoror* in Brussels in 1869 by Lacroix and Verboeckhoven had remained a clandestine and semiconfidential affair, this was no longer the case in 1885 when Max Waller, the driving force behind *La Jeune Belgique*, rediscovered the work. When he had his friends Destrée, Iwan Gilkin, Verhaeren and Albert Mockel read it, they agreed it was "fiercely and startlingly original" and distributed it in turn not only in Belgium, but also in France, giving copies to those they admired, including J.-K. Huysmans, Péladan and Léon Bloy. The work met with great

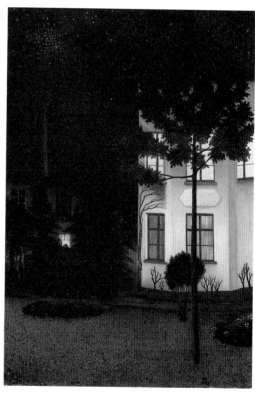

William DEGOUVE DE NUNCQUES
The Pink House, 1892
Otterlo, The Netherlands, Kröller-Müller Museum

Fernand KHNOPFF
Portrait of Marguerite Khnopff, 1887
Brussels, Musées royaux des Beaux-Arts de Belgique

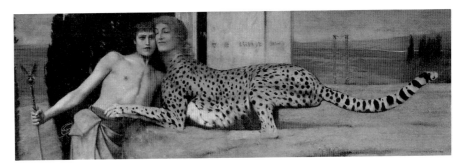

Fernand KHNOPFF
Caresses, 1896
Brussels, Musées royaux des Beaux-Arts de Belgique

success in Symbolist circles, and the importance the Surrealists would later attach to it is well known. It was but one of the numerous affinities that, throughout periods, unite painters of ideas.

The very embodiment of the world's duality and ambiguity, women play a major role in Symbolism. Among Belgian Symbolist painters, Khnopff and Rops best grasped and expressed the feminine mystique. In the works of Khnopff, whose biographers make a point of that unusual attachment he felt for his sister Marguerite, which may be what led him to remain celibate, women alternate as angel, muse and friend in time of need on one hand, and temptress, femme fatale and perverse – Péladan's *Vice suprême* incarnate – on the other. The inexhaustible theme of woman produced many variations among the Symbolists. Just as Khnopff did in his images, Baudelaire defined different types of women in his poems: "I am beautiful, oh mortals! like a dream of stone, and my bosom on which everyone has in turn been bruised, is made, as is matter, to inspire the poet with a mute and eternal love." In the *Portrait of Marguerite Khnopff* (1887), one of the most famous, along with *Caresses* (1896), Khnopff portrays this mysterious and inaccessible beauty, creating an ideal and imaginary woman. Delville said the women created by Khnopff were "at once Idol, Chimera, Sphinx and Saint". Angel or demon, the Khnopffian woman is always solitary, aloof and inaccessible. She communicates with no one, and love, the very symbol of human communion, is denied her. She is a prisoner of herself or of a rigid morality. This is expressed as much by the hieratic pose of the body as by the high, straight forehead and the strong and determined chin. Marguerite is no longer a woman of flesh and blood. Having succeeded in entombing her most secret desires in the very depths of her soul, she is a cold and virginal statue. In looking at *Memories* (1889), in which the sister's image appears seven times in different poses derived from photographic sessions to which she had patiently and lengthily submitted, one cannot help recalling the silent processions of women, goddesses or priestesses of an unknown religion that fill the canvases of Paul Delvaux. In the materialistic nineteenth century, woman could bring salvation to the artist, as Villiers de L'Isle-Adam suggests in *L'Ève future*: "I am, to you, the messenger from those limitless regions of which man can glimpse the pale

Fernand KHNOPFF
Memories, 1889
Brussels, Musées royaux des Beaux-Arts de Belgique

borders only amid certain dreams and certain slumbers." But alas, woman sells herself, and Satan becomes her master. That is what Félicien Rops remembers of her throughout his work: the devouring woman, and also death. "I am as beautiful as death and am public also like death," Verhaeren proclaimed in *La Dame en noir* (*Les Flambeaux Noirs*). J.-K. Huysmans depicted the unusual mood of the Symbolist period in *À rebours* and created in its main character, the Duc Jean Floressas des Esseintes, a man of uncommonly fine – and perverse – intellect, the last of a line that took refuge in solitude and the arts, a system that promoted eccentricity. Robert L. Delevoy called it the "manual of the complete neurotic" and denounced the work's immediate effect on Belgium's artists.[6]

Eighteen eighty-four, the year *À rebours* was published, the idea for which had germinated during Mallarmé's Tuesday soirées, was an important year for Belgium: the first Salon des XX opened on February 2. The movement known as Les XX was officially born on October 28, 1883.[7] Thirteen artists, nicknamed Les Vingtistes, among them James Ensor, Fernand Khnopff and Théo Van Rysselberghe, assembled at the Taverne Guillaume in Brussels to found a movement that, free of official ties, advocated an independent art and declared itself open to all, without constraint of borders or ideas. "What pleases me extraordinarily about Les XX is their lack of programme. A programme implies rules. Rules stress method. Method and doctrine are sisters: look where you're headed!"[8] This new-style association, whose annual exhibition always

created a stir, had no board of directors or president; there were a secretary and the founding members, and their number reached twenty only at the Salons of 1884, 1885, 1891, 1892 and 1893. Every year, the general meeting of Les XX decided which Belgian and foreign artists would be invited to exhibit along with the founders. A vote was taken and all the members expressed themselves freely, at times quite heatedly:

> You ask me my opinion concerning the election of Whistler. Here is my frank opinion: admitting Whistler to Les XX is to stride towards extinction. Having made this first blunder, we will not be able to stop there. We will then have to admit Rodin, Monet, Renoir or even Puvis de Chavannes, Moreau . . . and other artists worth as much as and more than Whistler. Why admit foreigners? Are there no longer any young people in Belgium? . . . Why admit Whistler? His painting already smells mouldy and stuffy. It is known and recognized. What new art and principle can it bring us? . . . I would be greatly distressed to see Les XX lose their virginity, their nationality and perhaps their personality by falling into the clutches of the newcomers.[9]

At the 1890 exhibition, Henry De Groux, outraged over Van Gogh's participation, withdrew his submission and tendered his resignation, "not wanting to find myself in the same room as Monsieur Vincent's indescribable pot of sunflowers or any other agent provocateur".[10]

The jurist Octave Maus (1856-1919), a great lover of art, poetry and music, and himself a pianist, was chosen as secretary of the new movement, but his actual duties were far more important. He was the driving force of Les XX from 1884 to 1893, and then of its successor La Libre Esthétique, which existed from 1894 to 1914. Maus sought help in his incessant search to discover young talent – Belgian and foreign – to be revealed in Brussels. He made no ideological or

6. Robert L. Delevoy, *Journal du Symbolisme* (Geneva, 1977), p. 52.
7. For further information about this movement, see M. O. Maus, *Trente Années de lutte pour l'art* (Brussels, 1926; reprinted 1980); Jane Block, *Les XX and Belgian Avant-gardism, 1868-1894* (Ann Arbor, 1984); as well as *Les XX and the Belgian Avant-garde*, exhib. cat. (Lawrence, Kansas: University of Kansas, Spencer Museum of Art, January 24-March 21, 1993); and *Les XX. La Libre Esthétique, cent ans après*, exhib. cat. (Brussels: Musées royaux des Beaux-Arts de Belgique, November 26, 1993-February 27, 1994).
8. Letter from Félicien Rops to Octave Maus, Paris, December 29, 1883. Brussels, Archives de l'Art contemporain, Musées royaux des Beaux-Arts de Belgique, inv. 4637.
9. Letter from James Ensor to Octave Maus, Ostend, November 1886. *Ibid.*, inv. 4784.
10. Letter from Henry De Groux to Octave Maus, January 16, 1889 [*sic*/1890]. *Ibid.*, inv. 5307.

geographical distinctions, giving priority to the value of the artist and the message that he wanted to convey through his art. Théo Van Rysselberghe was Maus's research associate, the man he relied on to make the artistic, literary and musical avant-garde known in Brussels.

I have heard from Émile Verhaeren that you were in Paris, where you succeeded in recruiting Claude Monet and Renoir... they are, it seems to me, very good acquisitions, and I thank you for having seen to it... Recently, Charlet, Schlobach, others and I were talking about the artists to invite; we were considering the landscape painter Pointelin, Besnard and Degas. We might even grovel to get Degas to exhibit! What do you think of these names? If it is Fernand Kh[nopff] who is with you in Paris, please speak to him about it.[11]

From the choices made for the exhibitions, it is apparent that Maus and his friends were interested chiefly in three schools: Impressionism, Pointillism and Symbolism. All the major names are there – Degouve de Nuncques, Rops, Mellery, Minne, Doudelet and Frédéric from Belgium; Besnard, Monet, Renoir, Redon, Pissarro, Seurat, Toulouse-Lautrec, Signac, Gauguin, Van Gogh and Denis from France; and from elsewhere, Sickert, Crane, Thorn Prikker, Segantini, Thaulow, Sargent and Whistler. All of which proves, if need be, that Brussels was the crossroads for ideas from all of Europe and even the United States. The Belgian art world was very receptive and made an extraordinary contact between these artists possible. Putting into practice the theories of total art advocated by that true master of Symbolism Richard Wagner, Maus organized lectures and musical performances featuring the most famous names during the annual Salons of Les XX and La Libre Esthétique. In 1884, Edmond Picard lectured on "L'Art jeune", Georges Rodenbach on "Les Jeunes-Belgique", and Catulle Mendès on Wagner. In 1888, Villiers de L'Isle-Adam gave a talk on, and a reading of, three of his *Histoires insolites*. Two years later, Villiers was dead and, as a

signal favour to Les XX, Mallarmé came to Brussels to recall his memory. In 1893, Verlaine defended "Contemporary Poetry"; in 1896, the Belgian poet Paul Gérardy spoke on "The Spirit of Germany Today"; and in 1899, Édouard Schuré on "Dream Theatre", to name only the principal figures. Music did not take a back seat, and contemporary Spanish, French, Belgian and Russian composers were performed at the Vingtiste soirées. Works by Tchaikovsky and Borodin had their world premiere in Belgium in 1891.

L'Art moderne supported and published the activities of Les XX. Founded on March 6, 1881, the magazine remained in existence until 1914 and was compulsory reading for anyone wishing to understand Belgium at the turn of the century. Edmond Picard (1836-1924), assisted by Octave Maus as editor in chief, was its driving force. A socialist militant, Picard wanted the magazine to be nationally oriented as well as politically and socially committed. This totally distinguished it from its main counterpart, *La Jeune Belgique*, founded in December 1881 by Max Waller.[12] For *La Jeune Belgique*, which considered itself the voice of the new classicism, social art was a negation of art. Verhaeren played a leading role in *L'Art moderne*, and from January 1, 1888, until 1900, his name appeared on the title page along with Maus and Picard. His regular contributions were regarded as authoritative, and although they were seldom signed, they were, as we have said, easily identifiable on the basis of Verhaeren's unmistakable style. On publication of its pro-

11. Letter from Théo Van Rysselberghe to Octave Maus, June 1, 1885. *Ibid.*, inv. 6328.
12. The role of magazines was decisive in the spread of Symbolist ideas. In addition to *L'Art moderne* and *La Jeune Belgique*, which remained in publication until 1897, one should mention *La Wallonie* (Liège, June 15, 1886-December 1892, founded by Albert Mockel); *Le Coq rouge* (Brussels, May 1895-June 1897, founded by Eugène Demolder, Georges Eekhoud, Maurice Maeterlinck and Émile Verhaeren); *Floréal* (Liège, January 15, 1892-December 1893, founded by Paul Gérardy and Charles Delchevalerie); and *Le Réveil* (Ghent, January 1892-December 1896, founded by Grégoire Le Roy).

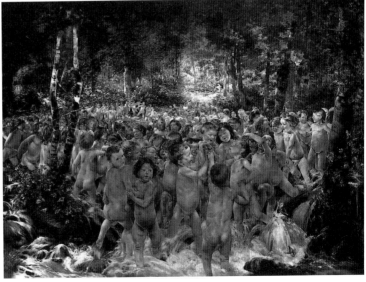

Léon FRÉDÉRIC
The Brook (centre panel), 1890-1899
Brussels, Musées royaux des Beaux-Arts de Belgique

gramme, *L'Art moderne* announced its receptiveness to the nascent Symbolism:

We are launching this magazine today without any bias in favour of a particular school, without any preoccupation with rule, code or symbol . . . Art is the eternally spontaneous and free action of man on his environment for the purpose of transforming and transfiguring it and modelling it on an idea that is always new. An artist is truly an artist only when, through a flash of inspiration, he suddenly sees in the world that surrounds him something that others have not seen . . . Every day, he invents a new form. Every day, he discovers an unexpected and striking aspect. He castigates stupid vulgarity, and a magical, astonishing, colourful and harmonious world appears and stands out against the dark chamber of thought. A true world, as real as the other, since it is made up only of the elements of the real world, but suffused with the luminous exhalations of feeling and idea.[13]

In 1886 and 1887, Verhaeren published articles in praise of Khnopff, in which he also first set out his personal vision of Symbolism:

Defining Symbolism, who could ever succeed in that? . . . First of all no confusion between Symbolism and Allegory, and even less so Synthesis . . . Present Symbolism unlike Greek symbolism, which was the concrete expression of the abstract, calls for the abstraction of the concrete . . . one speaks of the thing that is seen, heard, felt, touched and tasted in order, by means of the idea, to create from it an evocation and a totality . . . The Symbol is thus always refined, through an evocation, into an idea: a sublimate of perceptions and sensations. It is not demonstrative but suggestive. It demolishes all contingencies, facts and details; it is the highest expression of art as well as the most spiritualistic . . . Here, fact and the world become merely the pretext for an idea.[14]

After noting that being a Symbolist did not seem very easy for him and that up to then Redon and Moreau had succeeded, Verhaeren concluded his article by saying, "Monsieur Khnopff is marching, with some effort, towards the same conquests", and examining at length four works he considered proof of this: *After Flaubert: The Temptation of Saint Anthony; Of Animality; The Supreme Vice;* and *The Sphinx*.[15] Verhaeren was hardly mistaken: Khnopff was one Symbolism's most outstanding figures, embodying it as much in his physique,

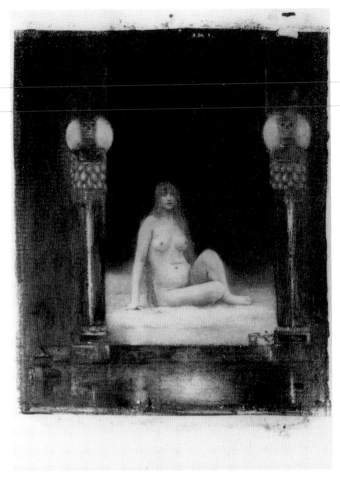

Fernand KHNOPFF
Of Animality, 1885
The Hearn Family Trust

dandyism, conduct and tastes as in his art – even in the house he had built in 1900, a veritable temple of the Self, where he lived until his death in 1921. Khnopff's work also enables us to discover the distinctive characteristics of Belgian Symbolism. A deep mysticism and memories from the past personified by a strange city where ghosts wander, the silence of which is disturbed only by the whispering of the Béguines – Bruges, "the Venice of the North", with its mysterious churches and façades staring at one another, seeking out the other's reflection in the cold waters of the canals. Many Symbolist artists took an interest in this city and visited it, to be won over by its unique atmosphere, at once mystical and

13. *L'Art moderne*, March 6, 1881, p. 2.
14. Émile Verhaeren, "Silhouettes d'artistes. Fernand Khnopff", *L'Art moderne*, September 5, 1886, pp. 281-282; September 12, 1886, pp. 289-290; October 10, 1886, pp. 321-323; and "Un peintre symboliste", *L'Art moderne*, April 24, 1887, pp. 129-131.
15. Verhaeren, 1887.

decadent – the symbol of its lost glory. Rossetti wrote poems in its honour. Ford Madox Brown studied at its Academy for a year. Baudelaire spoke of a "mummy city, a Venice in black", and Huysmans said it "smelled of both incense and sulphur".

Georges Rodenbach made its fame universal with *Bruges-la-Morte*, a Symbolist novel that relates the wanderings of an inconsolable widower, Hugues Viane, through the city whose atmosphere echoes his grief. In his foreword, Rodenbach writes that the novel is a "passionate study which invokes a city as an essential character associated with states of mind, counselling, dissuading and determining. Bruges that we were pleased to elect appears almost human." This Symbolist work of water and silence, night and death, is in perfect harmony with the doctrine of correspondences dear to Swedenborg and Baudelaire. In 1892, Khnopff drew the frontispiece for the

book, showing the face of an enigmatic female, with closed eyes, floating on the water, and the city's buildings standing out in the distance. The artist had resided for a few years in the City of the North, and it left a lasting impression. "I spent my childhood in Bruges (it was at that time truly a dead city – no one went there), of which I treasure distant but very distinct memories."[16] Around 1904, he produced from memory numerous works inspired by this city, *The Abandoned Town* in particular, a wonderfully precise and finely executed drawing. It never left his studio until it was donated by his heirs to the Musées royaux des Beaux-Arts in Brussels. Khnopff's drawings – in pencil, charcoal, crayon, pastel and chalk – are an integral part of his oeuvre, in which his artistic expression is at its peak. He mixed techniques to the point of confounding even a professional eye, and the alchemist in him went so far as to wax his drawings, giving them a new sense of materiality. Pastel, his favourite medium, offered him the fluidity and immateriality suited to evoking memories. His stroke is always extremely precise – thin, crisp and incisive. He used materials of extraordinary richness. The magnificence of his blacks never ceases to astonish. In 1886, Verhaeren commented on his extraordinary technique:

> Fernand Khnopff, quite to the contrary, almost never moves or gets carried away. Meticulous, with short little strokes, with a barely apprehensive slowness, his point, brush or pencil, scratches the panel or paper . . . The hand executes no movement that is not determined and controlled by thought . . . strokes that are slender, inquisitive, delicate, crisp and decisive – almost writing.

In Symbolism, Belgians found a form of expression that matched their sensibilities perfectly. Rejecting materialism, rationalism, Positivism and the excesses of Romanticism, they set out to reconquer their past, their Lost Paradises. In her book on Belgian Symbolism, Francine-Claire Legrand explains its distinctive characteristics in detail and at length. However, in my opinion, she sums up our uniqueness quite succinctly in these words: "Belgians' strengths are in their originality and their workmanship." This is in agreement with Péladan's contention that there are only two races – "the one that thinks and the other, separated by the frontier of ignorance".[17]

G. O.-Z.

16. Letter from Fernand Khnopff to Paul Schultze-Naumburg, February 1899. Private collection; facsimile reproduction in R. L. Delevoy, C. de Croes and G. Ollinger-Zinque, *Fernand Khnopff* (Brussels, 1987), pp. 26-27.
17. F.-C. Legrand, *Le Symbolisme en Belgique* (Brussels, 1971), p. 26, and Joséphin Péladan, *Le Coq rouge* [Brussels], no. 2 (June 1895).

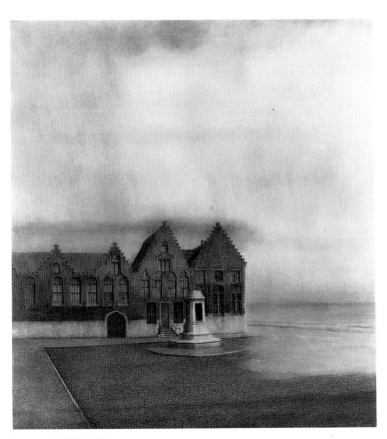

Fernand KHNOPFF
The Abandoned Town, 1904
Brussels, Musées royaux des Beaux-Arts de Belgique

Divisionist Painters in Italy Between Modern Chromatics and New Symbols

AURORA SCOTTI TOSINI

In the panorama of Italian painting during the last twenty years of the nineteenth century, the first conscious reaction to the triumph of Realism heralded at the national exhibitions in Turin in 1880 and Milan in 1881 occurred around the international exhibition in Rome in 1883. The Roman exhibition brought together artists determined to shun official art, with its tendency to glorify the events of past history and the Risorgimento – artists who sought to place the quest for beauty in the forefront.

For certain artists and literati living in Rome, the experience of Nino Costa seemed pivotal. Without rejecting reference to nature, Costa interpreted it not as a pictorial end product, but as a point of departure for an art that selected from the landscape specific luminous moments capable of suggesting moods, distilling them in compositional and chromatic harmonies somewhat akin to the English Pre-Raphaelites, especially Leighton, with whom he had been in contact for some time. In seeking to convey a mood, painting could vie with poetry in a reciprocal harmony of the arts, and it was upon this tenet that, in 1886, the refined and elitist project was conceived of publishing Gabriele D'Annunzio's *Isaotta Guttadauro* with illustrations by young artists like Giuseppe Cellini, Alfredo Ricci, Vincenzo Cabianca, Mario De Maria and Giulio Aristide Sartorio. The polished and ornate language of D'Annunzio's poetry, offering a persuasive escape into the world of fable, myth and nature's mysterious vitality, was given form through illustrations that celebrated pure beauty in highly studied compositions of fluid lines and intense chiaroscuro; elegant female figures – often in nocturnal settings with landscape elements animated by mysterious forces – revealed intimate, vital impulses, and plant life was metamorphosed into human elements. These were images apt to be understood and appreciated by *superior* beings who could interpret the secret language of things.[1] The artists' society "In arte libertas", which held its first exhibition in 1886, was founded on the same bases, but despite its continued existence, it never succeeded in spawning a true idealistic Symbolist art movement with a clearly established theoretical poetics.[2]

It was rather in Milan, towards the end of the eighties, that a number of voices were raised in a discussion of the possibility of creating a Symbolist art that, increasingly detaching itself from literature and the analogy between painting and poetry, would attempt to develop an intrinsically pictorial language, without, however, ignoring scientific advances in the analysis of light and the chemical composition of colours that might be of technical interest to artists. The Symbolist achievements of artists from Lombardy and the Piedmont were in fact closely tied to the affirmation and the development of the technique of Divisionism, starting with the necessity of surpassing the quest for *truth*, which remained accidental even if scientifically *exact* in the quality of its light. For this reason, there was no conflict between Symbolism and Divisionism, and the battle to defend the legitimacy of the new technique coincided in the end with the battle that won for

1. For further discussion of these subjects, see A. M. Damigella, *La pittura simbolista in Italia, 1885-1900* (Turin, 1981), Chapter 1; see also *Aspetti dell'arte a Roma dal 1870 al 1914* (Rome: Galleria d'arte moderna, 1972).
2. See M. Mimita Lamberti, "1870-1915: i mutamenti del mercato e le ricerche degli artisti", in *Storia dell'arte italiana*, part 2, vol. 3 (Turin, 1982), pp. 32ff.

painters the free choice of expressive content. Divisionism's scientific nature also seemed to impart a greater legitimacy to the ideal, universal content that artists sought, while upholding the desire to be modern and to make deliberate use of all that progress put at mankind's disposal.[3]

From the early seventies on, the experience of the Scapigliatura was characterized by direct contact with every aspect of contemporary life and growing ties to Milan's publishing business, which was greatly expanding in the last quarter of the nineteenth century. Dissolving the definition and contours of shapes in fringed brush strokes on the point of dissipating into the atmospheric light, the painters of the Scapigliatura, the iconoclast avant-garde, advocated a fusion of their art with music and poetry because of the shared ability to stir interior impulses.[4] The Scapigliatura, in its long, complicated development, which culminated in the notion of a democratic bohemia, was committed to an awareness of the social, collective, individual and psychological realities of modern life. Early on, this had stimulated the translation of important Realist writers, from Balzac to Zola, as well as of more psychological literature and *maudit* authors, like Baudelaire, E. T. A. Hoffmann and Poe, whom the *scapigliati*, from Carlo Dossi to Emilio Praga, had read and admired in Baudelaire's translations. At the national exhibition in Venice in 1887, Gaetano Previati – whose ties with the *scapigliati* through the painter Luigi Conconi[5] had led him from history painting to a painting of affect recalling Tranquillo Cremona – presented a large canvas called **Women Smoking Hashish**. This work was an evocative pictorial translation of the experimentation with "artificial paradises" that until then had been mainly the object of poetical and literary interpretations. Previati's image-world depicted the psychological state induced by opium and other drugs from the East – a serenity both paradisiac and perverse, an absolute beatitude linked not to the absence of physicality but to the absence of time and motion, "what the Orientals call 'kef'", as Baudelaire wrote in his *Paradis artificiels*, which Previati knew by way of Conconi and Praga.[6] An analogous literary influence would motivate Previati's illustrations for the Italian edition of a volume of Poe's short stories, *Racconti straordinari* (the Milan publisher Sonzogno had already published translations of Poe in 1883 and 1885). Between 1887 and 1890, Previati made some fourteen drawings in which, rather than illustrating individual episodes in detail, he tried to re-create the uncanny atmosphere of the stories by giving form to the visions that their tight-knit plots suggested to him. The result was what Vittore Grubicy de Dragon, adopting a term already used in France for the Wagnerian illustrations of Fantin-Latour, called "arte di immaginazione".[7] Instead of embellishing upon natural phenomena, seeking in them the mysterious soul of things (as was basically the case with *Isaotta Guttadauro*, so close in some respects to Redon and Rops), Previati projected the psychological tensions induced by his reading of the stories in drawings where large, dark masses of elongated, repeated linear strokes isolate, reiterate and deform an image, alluding to an evocative moment in the story. Through an almost hallucinatory overturning of time and space, Previati excited the observer's imagination and led him to identify himself in the situations evoked, as if in a gradually recovered memory.[8]

In their meaningful rhythmicality, the long, threadlike strokes of chalk suggest an infinitude that coincides not with a physical dimension but with an inward one. They serve as the equivalent of moods that are in turn symbolic of more general values. It is in the same context that Previati worked out his painting **Motherhood**, restoring an imaginative dimension to one of the most traditional themes in art.[9] The fascination awakened in him by the mystery of life's origins was transformed into psychological tension in the broadened emotive resonance springing from the infinite repetition, over almost the entirety of the vast canvas, of the undulating colour-light vibrations of the angels' wings. What emerges is not the portrayal of a particular instance of motherhood, but

3. The basic references are *Archivi del divisionismo*, collected and arranged by T. Fiori, Preface by F. Bellonzi, 2 vols. (Rome, 1968); *Mostra del divisionismo italiano*, exhib. cat. (Milan: Palazzo della Permanente, 1970); and *Divisionismo italiano*, exhib. cat. Palazzo delle Albere, Trento (Milan: Electa, 1990) and the related volume, *L'età del divisionismo* (Milan, 1990).

4. On the Scapigliatura, see G. Mariani, *Storia della Scapigliatura* (Caltanisetta-Roma, 1967). On the relationship between painting, music and poetry, see *Mostra della Scapigliatura: Pittura, Scultura, Letteratura, Musica, Architettura*, exhib. cat. (Milan: Palazzo della Permanente, 1966).

5. On Conconi, see most recently G. Ginex and M. Bianchi, eds., *Luigi Conconi, incisore*, exhib. cat. (Milan, 1994).

6. On these subjects, see A. Scotti Tosini, "Alla ricerca di una comunicazione col pubblico. Previati illustra Manzoni", in *Promessi Sposi di Gaetano Previati. Disegni dalle Civiche Raccolte d'arte di Milano* (Milan, 1993), pp. 11-29.

7. Vittore Grubicy, "Alla Famiglia Artistica. Arte di immaginazione", *Cronaca d'arte* [Milan], February 1, 1891.

8. See Scotti Tosini, 1993; see also *Gaetano Previati*, exhib. cat. (Ferrara: Palazzo dei diamanti, 1969).

9. See G. Piantoni, "Nota su Gaetano Previati e la cultura simbolista europea", in *Divisionismo italiano*, 1990, pp. 230-241.

an idealization of the mother figure, expunged of any of the satanic or demonic character frequently attributed to femininity in European literature. To achieve these effects, Previati replaced the broad masses of patterned impasto he had used previously with a new technique. This technique, based on the study of light synthesis, relies on how the viewer's eye perceives the chromatic reflections of pure colours applied to the canvas in long, regular, appropriately spaced filaments. This was the "division of colours" Grubicy[10] had begun to speak of among his Milan friends in 1886, when he suggested to Giovanni Segantini that he should rework his **Ave Maria in Transshipment** to achieve a more realistic lighting.[11] Grubicy's awareness of this phenomenon had ripened in previous travels to France, England and Holland, and he believed he could detect a foreshadowing of it in the painters of the Scapigliatura, especially Cremona and Daniele Ranzoni. The Divisionism Previati experimented with in **Motherhood** seemed to concur with Grubicy's thesis in that, rather than aiming for a limpid lighting that would imbue the scene with greater truth and reality, he re-created a diffuse atmospheric light and constructed an emotional space of iridescent vibrancy, producing a blaze of radiance in which the vital symbol of mother and child appears. Previati was moving towards a Symbolism that would affirm positive universal values, almost a triumph of Good over Evil, in idealized terms[12] whose very vagueness favoured a broader acceptance and as a result were socially more reassuring. When **Motherhood** was shown at the first triennial exhibition at the Brera Academy in Milan in 1891, Grubicy singled it out as an emblem of the new truly idea-oriented art. Previati seemed to him to be the artist who best embodied his own aspirations towards an art that, though evocative, had nonetheless a progressively expanding social basis. The opinion Grubicy expressed of Previati's work in 1891 underscores the breach that had opened between him and Segantini, the first and foremost of the artists Grubicy had supported from the early eighties through the art dealership he had undertaken in partnership with his brother Alberto. At the 1891 Brera exhibition, the contrast between Previati and Segantini was apparent in two paintings with analogous themes. Previati's **Motherhood** found its counterpart in Segantini's 1889 canvas *The Two Mothers*, where the lighting effects in the interior of a stable[13] give symbolic value to a double maternity – human and animal. The rhythms underlying the luminous vibrancy of the partially divided brush strokes are carefully executed to render the materiality of the figures and the transparency of the atmosphere; the composition gives a sense of absoluteness to the scene, raising the two mothers to the level of universal symbol, not in a spiritual sense but in a genuine, natural feeling of religious fervour. Thus, the two canvases differ in both content and technique: Segantini pursued an art centred on the examination of nature, with effects of light that exalt humanity, nonreligious feelings and existential situations; Previati, with the golden light of the optical cone formed by the angels' wings, in which the Virgin Mother appears, seemed to be opening the way to a newly spiritualist and visionary art with the power to rise above materiality. The contrast between Previati and Segantini would have been even more obvious if the latter had sent to the Brera all the paintings originally listed for inclusion, among which were *Aratura* [Plowing] and *Nirvana of the Lustful Women* (now known as *The Punishment of Luxury*).[14] Together, these would have demonstrated that Segantini was abandoning the Verist pastoral and peasant themes he had favoured until then, and devoting himself to setting down on canvas ideas suggested to him by literary influences tied to personal psychological motivations. The *Nirvana of the Lustful Women* was in fact inspired by a poem by Luigi Illica, who had passed it off in Milan's cultural milieu, which was fascinated by Oriental themes and Japonism, as a translation of the ancient Indian epic, the *Pāngiavāhli*.[15] It was

10. On Grubicy as a painter, critic and art dealer, see A.-P. Quinsac, *Le divisionnisme italien, 1880-1895 : origines et premiers développements* (Paris, 1972) and M. Valsecchi and F. Vercelotti, *Vittore Grubicy de Dragon* (Milan, 1976).

11. Grubicy refers to this in a letter to Benvenuto Benvenuti in 1910, adding, "I remember that at that time, I had a clear and firm vision of this process of painting; but I was equally convinced that – for its practical application – every artist must find his own means of expressing it" (*Archivi del divisionismo*, 1968, vol. 1, p. 109; see also A.-P. Quinsac, *Segantini. Catalogo generale* [Milan, 1982], vol. 2, no. 506, p. 412).

12. The theme of the triumph of good over evil in Previati's work from the early twentieth century has been pointed out by G. Piantoni, 1990, p. 238; however, his argument is based on the opposition of "maudit" and positive themes. For Grubicy's numerous contributions on *Motherhood*, see *Archivi del divisionismo*, 1968, vol. 1, pp. 463-465, and Damigella, 1981, Chapter 2. Previati's technique led him to theorize that a correct understanding of drawing lies not only in the outline, but also in proportion, modelling, relief, expression and movement (G. Previati, *Della pittura. Tecnica ed arte*, ed. A. P. Torresi [Ferrara, 1992]), p. 96. Previati was the only Divisionist to publish technical treatises.

13. Segantini reproduced the effect of the light from a lantern flame shielded from direct view by a smoke-blackened piece of paper glued to a pane of broken glass (see Quinsac, 1982, vol. 2, no. 557A, p. 457).

14. See A. Scotti, "Milano 1891. La prima Triennale di Brera", in *Ricerche di storia dell'arte*, no. 18 (1982), pp. 66-67.

15. On Segantini's works, see Quinsac, 1982, vol. 2, pp. 476-485, nos. 571-576, and pp. 462-475, nos. 561-570. Illica's poem, written in 1889, is reprinted in *Archivi del*

thus a question of legitimizing a purely subjective inspiration through artistic creation, in a process Segantini himself explained in reply to Grubicy's statements about the ideal and the symbolic in art. Even though inspired by an idea, the artist should look to nature for the image best suited to give this idea clear and distinct form, imbuing an easily intelligible symbol with his own inner vision: every "painting, in order to be called such, must contain within it a sense of colour, in its fineness and luminosity, and a sense of line, which renders form vivid and perceptible".[16] The opening of Illica's poem evokes a sort of Buddhist purgatory in which women, who had sought only sensual gratification from love, expiate this failing before attaining Nirvana. Segantini interpreted this in a broad alpine view with female figures condemned to hover above eternal ice and snow, suspended wingless in anguished resignation. In the mountainous span – which Segantini had studied from nature, selecting and compressing the elements to make the scene adhere more faithfully to his vision without sacrificing any of the truth of the natural image – the punishment of the lustful women, far from resembling a physical torment in the Christian tradition, embodied the idea of cosmic pain, with that total consonance between man and nature that is typical of the Oriental religions, Buddhism in particular. The white figures of the women, the fullness of their flesh rendered in fine lines of broken colour, rise in the shadowy zone that cuts across the snowy expanse reverberating in blue and red with silvery reflections, visually transcribing their aspirations to regain the whitest peaks of eternal Nirvana. The vision's truth of colour and light

highlights the symbol with the extraordinary power of an ineluctable, ongoing dialectic. Previati himself said:

> I don't know exactly what Nirvana means . . . and perhaps I never shall know whether there were lustful women condemned to flutter over the eternal ice and *metallic* vegetation there . . . But before these canvases, I feel emotion and admiration and return to look . . . to experience a fleeting moment of its noble existence and feel the pulsation of its lofty spirit.[17]

The material substance of Segantini's lustful women suspended in the void of an imposing, crystalline alpine panorama requires the viewer to seek the true meaning of the painting rather than being lulled by the mere contemplation of the vastness of the horizon. These were the indispensable ingredients of his Symbolism, which rediscovered in nature the unfailing wellspring in which the painter should seek, choose and reproduce in limpid, luminous colours the clear, distinct forms that would perfectly embody the ideas issuing from his mind and bestow upon them an absolute value. Previati, on the other hand, attempted in **Motherhood** to render reality evanescent, to give form to an indeterminate dream, interpreting it as a mystery that revealed itself to all who let themselves be captivated by its particular glow of vibrant light. He achieved this by applying the colour in threadlike parallel lines that, in their purely decorative undulations, cancelled out any exact or specific reference to material reality. Reopening the way to the possibility of the sacred and the religious in art, Previati seemed to approach the more mystical currents of European painting; but, as his participation in the 1892 Salon de la Rose+Croix in Paris makes clear, rather than seeking stylistic solutions like those of the Nabis, he turned to the misty atmosphere of Fantin-Latour and Carrière, and the great decorative expanses of Crane and Watts. Thus, in response to the apparent need to search for shining solar symbols, Previati turned to evoking other historical periods (*The Sun King*) and literary and religious subjects.[18]

With *The Punishment of Luxury*, Segantini had entered a new artistic phase. He begin to exhibit internationally more often and produced works that, standing apart from Realism and rustic sentimentality of the Millet stripe, were more comparable to the Pre-Raphaelite experiments of Rossetti and Burne-Jones: in short, he arrived at a redefinition of the female figure as epitomizing the eternal values of life and love.

divisionismo, 1968, vol. 1, p. 339. Segantini was aware of Illica's literary "fraud" (see A.-P. Quinsac, ed., *Segantini. Trent'anni di vita artistica europea nei carteggi inediti dell'artista e dei suoi mecenati* [Oggiono, 1985], pp. 346-348). Later but longer-lasting was the Buddhist fascination of Emilio Longoni, who, after the turn of the century, sublimated his vision of the landscape into cosmic immensity.

16. G. Segantini, "Sentimento e natura", *La Battaglia per l'arte* [Milan], vol. 1, no. 7 (January 26, 1893), (*Archivi del divisionismo*, 1968, vol. 1, p. 343). Regarding *La vanità*, Segantini wrote to his wife, "I'm out looking for the spring that will serve as a mirror" (quoted in Quinsac, 1982, p. 500, no. 587, who comments "The notion that a single spring might serve the purpose indicates clearly that now nature was for Segantini a reserve of images to use as elements of his symbolic compositions for projecting his interior reality onto the canvas.").

17. Letter to his brother Giuseppe of December 14, 1891, reproduced in *Archivi del divisionismo*, 1968, vol. 1, p. 267. The work was exhibited at the Galleria Grubicy.

18. It was Grubicy who approached Péladan about inviting Previati to the 1893 Salon (Piantoni, 1990, pp. 234-235, with bibliography). The analogy with Crane and Watts, pointed out in M. Rosci, "Simbolismo e divisionismo", in *Mostra del divisionismo*, 1970, pp. 51-59, surfaced clearly in the exhibition *Le Symbolisme en Europe* (Rotterdam, Brussels, Baden-Baden and Paris, 1975-1976). On *The Sun King*, see also Piantoni, 1990, pp. 244-245.

In so doing, he made an essential contribution to the creation of modern secular goddesses destined for long life in Central European Secessionist milieux. Segantini followed *The Punishment of Luxury* with *The Unnatural Mothers* (1894), also inspired by Illica's poem. In it, women who had rejected motherhood reconcile themselves with the children they never had, who take shape amid bare branches of trees growing from the eternal ice, to which the mothers are bound by their long hair. In this way, they attain Nirvana and peace in an uninterrupted continuity of figure and landscape.

At about the same time, the artist interpreted the relationship between woman and tree – both sources of life – in a considerably more peaceful and positive symbolic image than in the tormented *Unnatural Mothers*. **The Angel of Life**, from 1894, presents a fair-haired young woman sitting on the trunk of a gnarled tree and cradling a child in her arms, against an alpine panorama. Segantini recasts one of the oldest medieval Christian iconographic motifs, the Tree of Life, transforming the gothic tree into a sturdy trunk with realistically rendered bark, its convoluted branches wreathed around the young woman, who, in a penetrating reinterpretation of fifteenth-century motifs, is depicted with a light and almost transparent touch, highlighted with gold in the hair and clothing. Segantini's many works on the theme of motherhood are interconnected through a quite complex web of reciprocal references and continual reflections. The 1896 canvas **Love at the Fountain of Life** is another example. Segantini was an artist rigorous in the examination of colour and the use of Divisionist techniques when an exact, crystalline luminosity seemed to him the only means of giving form, in fragments of the natural world, to ideal content; as a painter, he was skilful in converting the driving movement of natural forms into abstract decorative rhythms that arranged themselves like graphic projections of an interior creative tension. In this case, he made explicit all the symbolic references of the composition: the large figure of an angel who protects – and thus renders more mysterious and precious – the pure mountain spring, and a couple in white advancing arm-in-arm through a dale of red rhododendrons and green shrubs.[19] This kind of specificity of symbols combined with tense lines of great decorative power is also present in the drawing **The Annunciation of the New Word**, done as a cover for an Italian edition of Nietzsche's *Also sprach Zarathustra* but never used. Between 1891 and 1899, Segantini's works

devoted to motherhood, love and the celebration of nature gave substance to a projected panoramic view of the Engadine, eventually reduced to the so-called **Triptych of Life (Life, Nature, Death)**, and enunciated a series of new symbols that seem to stem from the landscape of the Engadine. These imbue profoundly human and wholly contemporary content with spiritual value while reshaping the iconographic themes of the fifteenth-century Christian tradition that widespread interest in the primitives had begun to restate in a mystical, archaically spiritualist vein. As Segantini himself wrote in 1893: "To us, to you all, oh youth, who are strongly affected by the feeling of a complex art, belongs the task of embracing the entire past, of making a storehouse of the practical knowledge of the present, breaking the chains of material realism to grasp nature in the spirit of the lines, of form and colour, to be able to express our sensations, our feelings, our dreams."[20] It is not surprising that such a call was taken up by those who were intent upon renewing the various forms of art, such as Leonardo Bistolfi, who from 1892 on created the first authentically Symbolist images in sculpture. He transformed traditional female symbols of death into a new and more mysterious vision (the icon of the sphinx, for example), and the result was stylistically close to those of Segantini's works most influenced by the Pre-Raphaelites, from *The Agony of Comale* to the *Allegory of Music*.[21]

The artistic trajectory that Vittore Grubicy wished to pursue, however, went in an entirely different direction, for he aimed to blend scientific knowledge of the effects obtainable through painting in divided colours with the conviction, clearly expressed in 1891, that painting should transcend the description of nature to communicate powerfully evocative moods, analogous to those produced by music, in an

19. Writing to Tumiati, Segantini specified: "This represents the playful, carefree love of the woman, and the pensive love of the man, entwined together by the natural impulse of youth and spring. The narrow lane on which they advance is flanked by flowering rhododendrons, they are dressed in white (pictorial representation of the lily). Eternal love say the red rhododendrons, eternal hope replies the evergreen shrubbery. An angel – a mystic, suspicious angel – extends a large wing over the mysterious spring of life. The spring water gushes from the living rock, both symbols of eternity. Sun floods the scene, the sky is blue; with the white, the green, the red, I was in the habit of delighting my eye in gentle, harmonious cadence; in the greens, I aimed to signify this in a special way" (*Archivi del divisionismo*, 1968, vol. 1, p. 363; Quinsac, 1982, p. 505, no. 593, and all of Chapter 13).

20. Quoted from Segantini, 1893, in *Archivi del divisionismo*, 1968, vol. 1, p. 344.

21. See Damigella, 1981, pp. 178-184. A fundamental source is S. Berresford, "Gessi e bronzi di Leonardo Bistolfi", in *Scultura Marmo Lavoro* (exhibition in Carrara, Massa and Pietrasanta, 1981), (Milan, 1981), pp. 175-215, and S. Berresford and R. Bossaglia, *Bistolfi, 1859-1933*, exhib. cat. (Casale Monferrato, 1984).

equivalence among the arts that led him to desire the creation of musico-pictorial poems. Furthermore, in geometrically organized compositions like *La vela* [Sailing], the impressions aroused in him by nature, of which he declared himself an attentive and passionate observer, were transfigured into a vague atmosphere of motes that suggest the impalpable humidity of lakes and seas. It was his particular way of looking at the natural landscape, "sometimes harmonized in simple waves of melody, vague yet gentle, sometimes growing more intricate in close chordal harmony so detailed as to suggest actually hearing the sounds of specific musical instruments or even seeing scores of violin bows as I gaze upon the silvery shimmering birches".[22] During his long sojourns in Miazzina between 1894 and 1898, these polyphonic relationships were to be found not so much in individual pictures as in the cycle known as "Winter in the Mountains".[23] In looking at the natural landscape, Grubicy sought an evocative psychic emotion that would enable him to mute the material presence of the actual model so that all he perceived was his own pictorial vision. The nervous hypersensitivity in the artist's soul produced a disjointing of time and place, allowing him to rearrange a whole series of previously experienced psychological reactions and return to a picture at a distance of months or even years.[24] For this reason, he adopted a special technique that encompassed Divisionism. "My colour notations are slapdash, done in great haste: by that, I mean I am content to record the relationships of hue and chiaroscuro without

insisting on the vibrations of light, and hence I resort to a sketching of the old impasto."[25] Later divisionism, with its small brush strokes of pure colour skilfully disposed on this chromatic basis stepped in to create that luminous vibrancy which alone was capable of transforming into vividly colourful emotions the insights this psychological *disjointing* stirred in him, with ever more intangibly suggestive results. However, Grubicy was fascinated less by the theories of light placed at painters' disposal by modern colour science (O. N. Rood's *Modern Chromatics*), than by the way colour-light vibrations could give form to increasingly complex evocations, on a plane with the more acute nervous sensibility of modern artists in comparison with those of the past, owing to the greater refinement of their sensorial perceptions.[26]

Of the painters who considered Divisionism an appropriate means of expressing progressive and modern content, Giuseppe Pellizza da Volpedo, although of a very different education and socio-cultural background, is the only one to bear comparison with Segantini by clearly formulating his own poetics. Arriving self-taught at colour division as a means of achieving a greater realism of light, in 1891 he began deepening his knowledge of it by systematically reading treatises, like Rood's, which led him to illuminate the most pressing problems of his time through a secular Positivist Symbolism.[27] His earliest Symbolist works do not neglect the influence of literary stimuli – we need only think of the drawing for the cover of his friend Domenico Tumiati's volume of Florentine ballads entitled *Iris florentina* from 1895, and the almost neo-Botticellian rendering, also reminiscent of Segantini, of the *Danza Tebea* (or *The Three Graces*); yet, it is not by chance that his first important and conscious attempt to deal with a pictorial subject in a Symbolist vein was based on a contemporary political subject. The reworking of the studies for *Ambassadors of Hunger*, inspired by labour and peasant protests to obtain better salaries, led him to a more involved subject that draws attention, in the advancing mass of labourers, to the unstoppable force of social progress strongly supported by modern philosophy. For this canvas, Pellizza came up with the new title *Fiumana* [Swelling River of Humanity], which emphasizes the march's unremitting thrust in a Naturalist comparison with a raging river overflowing its banks. In working out *Fiumana*, he applied himself intensely, like Ruskin or some Renaissance painter, to preparatory drawings, executing detailed cartoons for each figure. In these

22. Letter from Grubicy to Benvenuti, February-March 1910, in *Archivi del divisionismo*, 1968, vol. 1, p. 111.

23. Grubicy grouped a number of works under the title *Winter in the Mountains*, among them the eight canvases that in 1911 were assembled along with the photos under the collective title *"Inverno a Miazzina". Poema panteista in otto quadri. 1894-1911* (see *Archivi del divisionismo*, 1968, vol. 2, p. 16, and fig. 111), presented again at the exhibition in Trento in 1990 (see G. Mascherpa, in *Divisionism italiano*, 1990, pp. 38-47).

24. See "La suggestione nelle arti figurative", in *La Triennale* (Turin, 1896), no. 13, pp. 102-104 (*Archivi del divisionismo*, 1968, vol. 1, p. 109).

25. Letter from Grubicy to Benvenuti of February 24, 1910 (*Archivi del divisionismo*, 1968, vol. 1, p. 109).

26. Grubicy referred to this superiority of modern perception in a letter to Luigi Torchi in 1897 (quoted in L. S. Gerardi, *Il divisionismo e Grubicy*, graduation thesis, Milan, Università Statale, academic year 1932-1933, advisor P. D'Ancona, on deposit at the Biblioteca d'arte del Castello Sforzesco, Milan, and pointed out to me by Sergio Rebora, who is preparing the catalogue raisonné on Grubicy).

27. Pellizza began reading the French edition of Rood's treatise, *Théorie scientifique des couleurs* (Paris, 1881), on January 18, 1896. In 1900, he purchased E. W. von Brücke and H. von Helmholtz, *Principes scientifiques des beaux-arts* (Paris, 1891). By 1894, he had also acquired V. G. Bellotti, *Luce e colori* (Milan, 1886), and in 1897, L. Guaita, *La scienza dei colori e la pittura* (Milan, 1893).

cartoons, elongated and tapered forms predominate, greatly attenuating the realism of the initial studies.[28] Therefore, *Fiumana* seemed to the artist a new product, a new symbol, and he spoke of it enthusiastically to his friends in Symbolist milieux: first in Florence, the "Marzocco" circle (with whom he had contact since 1893 through his close cultural ties with Tumiati, Occhini and Orvieto) and Augusto Conti, under whom he had studied aesthetics; and later in Turin, where things were picking up momentum about 1895-1896 and his most important contacts were the poet Giovanni Cena and Pio Viazzi.[29] Pellizza's literary interests became more specific between 1895 and 1898 with canvases like **The Mirror of Life** and *Spring Idyll*, which were fundamental stages in defining the course and values of his Symbolism.

In **The Mirror of Life**, a complex conceptual and compositional reworking transforms the subject, inspired by a flock of sheep passing through the Curone Valley, into a symbolic representation of human life, not in its physiological embodiment but in its ineluctable passing, its "fatale andare" so deeply consonant with all of nature. The flock's undulating, rhythmic progress sheds its descriptive properties to become a compositional paradigm of the natural landscape, clearly defined by the painter's judicious selection of elements. The serene, evocative broad green hollow delineated by the compact, gentle profile of hills in the background and the water's reflection of the riverbanks are both co-ordinated with and related to the sheep chromatically. The thorough study from life of groups of sheep, the choice of a wide-horizoned natural setting (recalling not only Segantini but also Hunt) are transformed into limpid, crystalline visions through the adroit use of a minute, and strict, web of thin brush strokes, lines and closely entwined notches with careful attention to how light is synthesized in the viewer's eye. The painting's tension and subtle movement derive from the interplay of undulating elements that correspond to the ever-changing arrangement of the material world caused by our perception of light. The inevitable advance of the sheep is given weight by a line from Dante added to the title: "e ciò che fa la prima, e le altre fanno" [what the first does, the rest do], expanding this inevitability to embrace the harmonious and rhythmic cycle of existence. Pellizza surrounded his sheep with a wide brown border like a large wooden frame, upon which a yellowish and reddish grain of regular wavy lines in bands of varying width and density is drawn. Whatever is connoted as nature in the presence of light is presented as pure, abstract decorative rhythm in the absence of light; Pellizza's skilful technique aimed to create scientifically exact chromatic effects, which Rood had studied even for colours like brown that, while existing in nature, do not appear in the spectrum.[30] Hence, Pellizza showed himself to be aware of the possibility of expressing content and value through simple juxtapositions of geometric forms and lines. In so doing, he claimed for the artist the role of the intellectual who, secure in his knowledge and confident of his powers, sought to give form to the great ideas that teemed in his head, directing his thoughts towards love, death and the origins of life in a desire to renew traditional iconographic figuration. He conceived a series of "Idylls" that were to be the fruit of an "ingenuous" gaze directed at nature. The first of them, *Spring Idyll*, was the result of complex research: compositional, playing throughout on recurring circular rhythms; expressive, in the opposition between the regular cadence of the dance, evoking universal harmony and beauty, and the twisted tree that relates immediately to the present in rhythms that convey a sense of gnawing pain; and chromatic, in the extraordinary airiness and transparency.[31] While honing his technical mastery, Pellizza endeavoured to broaden to the utmost the social base of his work (in this he was Segantini's opposite), having learned to mistrust the smugness of the conscious aesthete: this provoked a cooling off of relations with his Tuscan friends and a closer comradeship with those who had clearly grasped the import of **The Mirror of Life**, in particular Cena, Viazzi and Stratta in Turin, who, to elucidate Symbolism, were using scientific theories patterned after the model of Cesare Lombroso. These ran counter to the wave of spiritually and musically dominated Symbolism promoted by Grubicy, counter to the neo-Renaissance revival of ancient myths that fascinated the Roman milieu of the "In arte libertas" group of Sartorio

28. The phases of the theme's ten-year development (*Ambasciatori della fame, Fiumana, Il cammino dei lavoratori/Quarto Stato*) are illustrated and discussed in A. Scotti, *Pellizza da Volpedo. Catalogo generale* (Milan, 1986). See also A. Scotti, ed., *Giuseppe Pellizza da Volpedo, Il quarto Stato* (Milan 1976).
29. See Damigella, 1981, Chapter 3.
30. On *The Mirror of Life*, see also Scotti, 1986, no. 1002, and my catalogue entry in *Divisionismo italiano*, 1990, pp. 136-137. The reference to brown is in O. N. Rood, *Modern Chromatics* (New York: D. Appleton, 1879), p. 209 (beginning of Chapter 14).
31. On *Spring Idyll*, see Scotti, 1986, pp. 30-34, and F. Mazzocca, "'L'eterno idillio' della vita", in *"Idillio Primaverile" di Giuseppe Pellizza da Volpedo* [Milan], Finarte Asta 601 (June 9, 1987).

452

and Adolfo de Carolis, and counter to the natural and psychological symbolism of primitive myth that had begun to attract Plinio Nomellini.[32] Pellizza felt that Symbolism should not be thought of as the projection of emotions or a return to old values. It should rather capture the life in material things, in its continual concretization in forms and images at once, according to Schopenhauer, contingent and absolute. The many panels planned in 1900 as a series on the themes of love, motherhood, work and death hinted at a great cycle on the theme of life, worked out in formal harmonies and with particular polarizing effects of the chromatic range. Acknowledging that every form, group of forms and colour corresponds to an emotion, Pellizza hoped to devise a way of obtaining universal, scientifically exact results, going beyond Souriau's position to arrive at something more like that of Henry and Fénéon.[33] To Neera, who after Segantini's death had encouraged Pellizza to become Italy's Symbolist painter, he responded with pictures that, abandoning literary Symbolism, went back to viewing nature as a setting in which the continuity of life and death were renewed in an uninterrupted cycle: *Sunrise*, painted in 1903-1904, elevated a fact of everyday existence to the status of a symbol of life's continual regeneration in its most absolute form – the light of dawn breaking on earth. The natural occurrence becomes an event where the heavenly body shines out over the entire space, depicted by a confident and masterful handling of the brush in rigorous sequences of strokes of pure and divided colour appropriately meted out lengthwise, so as to cover the full range of the spectrum and, through backlighting, also create the airy semidarkness in the foreground. A dazzling vision, true both scientifically and spiritually, it accomplished what Cena had referred to as the sublime office of art, namely

Gaetano **PREVIATI**
Day Awakens the Night (detail), 1905
Trieste, Civico Museo Revoltella

"to represent ideas as material, and general principles as concrete symbols".[34] Pellizza had succeeding in finding a new form for the revelation of light and the dawning of life.

From the point of view of the choice of the ideas and feelings to be communicated and the choice of the appropriate language, the difference between Pellizza, the confirmed Divisionist, and Previati, the champion of Alberto Grubicy's stable of Divisionists, could not be clearer. In ***Day Awakens the Night***, Previati treated a similar theme, creating an image in which the star's cosmic value, while evident in its perfectly spherical shape, is expressed allegorically through the young woman symbolizing the eternal youth of creative genius; in *Triptych: Day*, he again felt the need to draw inspiration from a mythological, allegorical vision, as in Apollo's chariot standing out prominently in the central panel. For Previati, the exaltation of light merged with allegory, while for Pellizza, the symbol was intrinsic to the sun's chromo-luminous explosion and needed no further mediation. Even though his brush stroke had become more "scientific" by avoiding shimmery haziness, Previati cultivated the decorative potential of large surfaces coloured with a palette at times reduced to variations of two or three primary colours. The vast apparently monochromatic surfaces were actually built up of side-by-side brush strokes in varying hues according to what Rood described as the application of "colours which are distant from each other in the chromatic circle by only a *small interval*", to

321

32. A pivotal moment in this Symbolist confrontation was the Espozione di Venezia in 1899, at which Sartorio exhibited among other works his *Gorgone* and the *Diana d'Efeso*, which in his opinion symbolically represented the vanity of existence, but which showed signs of transforming Pre-Raphaelite rhythms into stuffy allegories. Nomellini inaugurated his mythic transfiguration of nature, recalling to some extent Böcklin and von Marées, in the political *La sinfonia della luna*, with refined chromatic harmonies (see G. Bruno, ed., *Plinio Nomellini*, exhib. cat. [Genoa, 1985] and G. Bruno's chapter on Nomellini in *Divisionismo italiano*, 1990). Also along lines somewhat akin to Nomellini was the work of De Maria, who had by then dropped his disquieting visions of the eighties.
33. In a manner far removed from Grubicy's emotional equivalences, in 1896 Pellizza began attempting to link compositional forms and colours to the expression of specific feelings and sought to anchor this in scientific laws derived from perception; he revised his theories about 1904-1905.
34. G. Cena, "Il vero nell'arte", in *Triennale*, 1896, no. 3, quoted in Damigella, 1981, p. 177.

obtain the impression of a single area illuminated more vividly in some places.[35] In works like ***Day Awakens the Night*** and the decorative cycle for the music room of Grubicy's house, Previati created figures in which the articulation and development of the shapes supported the articulation of the strokes of colour in a suggestion of motion that was above all interior motion, fixing it in allegorical and heroic forms with clearly Art Nouveau cadences. In the canvases Previati executed for the Milan Chamber of Commerce, his ability to cover vast surfaces with variations on a few essential ranges of colouration, without destroying the rhythm of the lines, transformed into decorative allegory some of the most hazardous undertakings of contemporary industrial technology, from the building of railways on the Pacific to the digging of the Suez Canal. And in his landscapes, too, his mood painting made way for the transposition of forms into broad ornamental backgrounds that allegorized the idea of the panorama without further indulging in contemplation enhanced by constantly shifting emotions.

A. S. T.

35. Rood, 1879, p. 273 (beginning of Chapter 16), which Previati was well acquainted with. In 1916, Boccioni explained Previati's technique: "In Previati's *Fall of the Angels*, the sun's rays are a brilliant yellow not because gradations of yellow are sustained and completed by gradations of violet, but because the overall yellow is made up of yellow A, which reinforces yellow B, which reinforces yellow C. Thus, we have a complementarism of colours in the creation of a single colour. A streak of bright yellow is placed near a streak of dark yellow, and so on to three or four gradations of yellow. This division of tones in the same colour, this streak-based construction that makes the painter's hand be felt in every square centimetre, brings the colour and the surface that supports it to an intense chromatic saturation" ("Gaetano Previati", in *Gli avvenimenti* (Milan) vol. 2, no. 14 [March-April 1916], quoted in *Archivi del divisionismo*, 1968, vol. 1, p. 57).

70

Eugène Jansson and the Swedish Symbolist School

ULF LINDE

When W. B. Yeats was in Stockholm in 1923 to receive the Nobel Prize for Literature, he saw paintings by Eugène Jansson. Writing about them later he said, "But much as the light pleased his imagination, one feels that he cared very much for the fact before him, that he was never able to forget for very long that he was painting a well-loved, familiar scene." Yeats saw clearly; his intuition accurately indicates what lay at the heart of Swedish painting at the turn of the century, in particular Eugène Jansson's.

The Swedish painters were well informed about developments in the literary life of Paris at the end of the nineteenth century. Not only had several lived there for long periods, but they also followed enthusiastically what their idol, August Strindberg, wrote about the new ideas – Zola's to begin with. One of them, Richard Bergh, had this memory of his youth: "In the 1880s, we were zealous scientists seeking only the truth." This was Zola's literary manifesto in a nutshell, and it set its stamp on their paintings.

In regard to what Yeats wrote about Jansson, it is worth noting that a scientist always deals with the generality of a phenomenon. If, for example, he is making a chemical analysis of a substance and discovers that it contains lead, he is dealing with the properties that lead has in every situation and on every occasion. How, when and where the lead in the substance analyzed has been produced is irrelevant. Painters had a similar approach. They wanted to represent nature as a collection of phenomena subject to the laws of optics – the sides of an object facing the strongest source of light are always brightest, for instance. The fact that their paintings actually did represent specific excerpts from nature is not what mattered.

But towards the end of the 1880s, faith in Naturalism waned, and this is what Yeats observed. Jansson did not depict nature as a general phenomenon – "He was painting a well-loved, familiar scene." In the years before and after 1900, his only subject matter was his own city of Stockholm. Even this states the case too broadly, for he painted only what could be seen in the narrowly defined southwest areas of the city.

Jansson always painted from memory. If an idea for a painting occurred to him, he would walk for weeks among the buildings he intended to depict without touching a brush. He got to know his subject by heart before finally choosing the point of view that best matched its *genius loci*. When he had made his choice, he painted his canvas in his studio, working quickly – he generally finished all in one night. In the 1890s he had, so to speak, deserted Naturalism and become a Symbolist in Mallarmé's sense of the term, "describing not the object but the effect it gives rise to".

During the 1880s, he had produced paintings of northern Stockholm that were so detailed and accurate in perspective that today you could use them to draw maps. However, his paintings from the 1890s would make such an enterprise completely futile.

This shift in how the depicted object presented itself had its counterpart in a shift in subject. Naturalism presupposed a form of standard subjectiveness with an impersonal relationship to the reality depicted. The ideal was science, and scientific findings were supposed to be valid for everyone. The compliance with the laws of optics that the naturalistic painter professed was not disavowed by the fact that his audience consisted of distinct individuals.

In the 1890s, Jansson reacted violently to such an approach. He wanted at all costs to avoid functioning as a standard subject. Instead, he systematically cultivated his otherness. The views he painted were *his* and did not need to be representative for other people. He had anarchistic leanings and disliked all forms of social conformity, which may well be related to his preference for blue twilight. Daytime is devoted to work, a socially conditioned way of life. But it is a way of life that is suspended when twilight falls. The individual is severed from his social context and left to his own devices. (Jansson was homosexual and never raised a family.) The streets in the blue paintings are empty. There is only one observer – the painter himself, untrammelled by the disciplines

of thought that collective activity entails, untrammelled by any culture. He himself is all that remains, one part of nature contemplating another, for the twilight deprives the buildings' façades of their attributes as utilities of civilization, and what distinguishes them from untouched nature evaporates. When this happens, the dividing line between the observing subject and the observed object is also erased; everything becomes nature – what Nietzsche called *das Ur-Eine*.

Jansson admired Nietzsche, who had also described the predicament well: "Resonance. – All strong impressions produce overtones of related sensations and impressions, as though they excavated something from memory. They bring to mind something inside us – similar states, and their causes reach the level of consciousness." This is how what is long past returns. The present resonates with echoes from the world of the uncivilized child and loses its character of being a point in time: the façades appear dreamlike and ageless.

This regression to *das Ur-Eine* allowed Jansson's earliest memories to permeate the twilit façades – "He was painting a well-loved, familiar scene." In this period, he was of course not alone in this endeavour. Edvard Munch, who influenced Jansson strongly, had said, "I do not paint what I see, but what I have seen."

One can speculate that Cézanne's late landscapes were a result of the same regressive point of view. He had returned to his childhood environment when he painted them. And Gauguin – when he went to Tahiti, was he travelling or coming home? He was born in the tropics. What Mount Sainte-Victoire meant to Cézanne is what southwest Stockholm meant to Eugène Jansson. Without any comparison in other respects.

U. L.

The Finnish View of Symbolist Painting
From Antinoüs Myth to *Kalevala* Mysticism

SALME SARAJAS-KORTE

Everything we encounter here blends into
a single harmony, an everlasting garland of beauty . . .
but our role is in time, the garland in eternity.

Magnus Enckell[1]

Finland is one of the European countries where intellectual life was totally revolutionized by the Symbolist ideas that flooded in during the early 1890s. Unlike Impressionism, Symbolism was swift to dominate Finnish art, especially towards the turn of the century. It displaced both its powerful predecessor, National Realism, and the burgeoning Impressionist-like painting. A main feature of Finnish Symbolism is that it was recognized from the very start as a humanist trend and the era's predominant form of modernism.

The first to introduce Symbolism were writers who had visited Paris, or then aesthetes who were broadly pondering the new image of man and the universe presented in Decadent and Symbolist poetry around the end of the previous decade.[2] The young painters who went off to study in Paris in 1891 thus had some notion of this new mystical trend. "All the young artists in Paris are Symbolists, and even those who don't want to be Symbolists have devoted themselves to mysticism," they could claim.[3] The self-evident leader of this first generation of Finnish Symbolists was Magnus Enckell.

The Finnish artists in Paris reacted most strongly to Symbolism's metaphysical message, to what was so different from the nationalistic ideology that held sway at the time, especially in Scandinavia. Although they may not have sought their inspiration in the works of any individual French contemporaries, like them they thrilled to the wellsprings from which the Symbolist movement arose, to the traditions of philosophy and poetry as well as painting on which the new movement was based.

The young Finnish artists who arrived in Paris in 1891 came at the perfect moment. This was the most intensive phase of Symbolism, "Symbolism's finest hour", as Ernest Raynaud called it.[4] Symbolism had come of age and dominated the bohemian life of the Latin Quarter as "the art of the future". Enckell found it particularly easy to blend into this international band of artists and intellectuals and did so with fewer reservations than, for instance, his friends Ellen Thesleff and Beda Stjernschantz. The whole group came from Finland's Swedish-speaking educated class, and they had a firm grounding in classical culture. Enckell was well versed in ancient mythology and mystical philosophy, the classics and a wide range of important contemporary foreign literature. He was acquainted with Ovid, Plato and Goethe as well as Baudelaire, Mallarmé, Verlaine and Rimbaud. The same is on the whole true of his closest artist friends, as Beda Stjernschantz's sketchbooks and notes show.[5] In Paris, a somewhat mixed array of the latest works filled the bookshops: V. E. Michelet, Édouard Schuré, Papus, Jules Huré's famous pamphlet, Sâr Péladan's eccentric mysticism.

The new offerings on the stage could only raise these young Scandinavians' self-esteem. Even the most prestigious

1. See Salme Sarajas-Korte, *Suomen varhaissymbolismi ja sen lähteet* [Early Finnish Symbolism and Its Sources], (Helsinki: Otava, 1966), p. 159, or its Swedish-language translation, *Vid symbolismens källor* (Jakobstad: Jakobstads förlag, 1981), p. 147. This essay is largely based on that work.
2. C. G. Estlander, "Den franska poesin i våra dagar" [French Poetry Today], *Finsk Tidskrift*, October 1889; Estlander, "Den franska poesin i våra dagar. Les décadents" [French Poetry Today: The Decadents], *Finsk Tidskrift*, January-February 1891; Richard Kaufmann, "Från den nyaste franska literaturen" [Recent French Literature], *Finsk Tidskrift*, vol. 1 (1891) pp. 159-166; and Kasimir Leino, "Uusia suuntia Ranskan kirjallisuudessa" [New Trends in French Literature], (Helsinki, 1892), pp. 25-41, which was presented as a lecture on November 9, 1891, in Helsinki.
3. Richard Kaufmann, "Symbolismen i den nya franska literaturen" [Symbolism in Modern French Literature], *Finsk Tidskrift*, vol. 2, pp. 205-213.
4. Ernest Raynaud, *La mêlée symboliste. Portraits et souvenirs*, vol. 2 (Paris, 1918-1922), p. 5.
5. Sketchbook belonging to the artist's estate in Helsinki.

of critics noted the "strange passion" of young Parisian intellectuals in admiring everything that came from the North: Wagner's Germanism was the object of tremendous admiration; Maeterlinck and Ibsen were the names of the hour. This new barbarism – "les cervelles brumeuses du Nord" – was not universally agreeable to lucid French intellects.[6] It interested all the more keenly Scandinavian artists visiting Paris. The young Finns, at least, seemed convinced that according to the "law of cycles", it was now Scandinavia's turn to assume the leadership of humanity's intellectual advance![7]

The Académie Julian, imbued with the ideas of Paul Sérusier, provided a fine place for male artists to monitor the phenomena of the age. The students at the Académie also hotly debated the manifesto of Symbolist art published by Albert Aurier in *Mercure de France*, in which he takes as his model Paul Gauguin's *Jacob Wrestling with the Angel*, basing his argument on Plato's allegorical myth of the cave.[8] But just as important as the Académie Julian was the Latin Quarter, with its atmosphere permeated by Symbolism and mysticism. The evenings at the Soleil d'Or made an important contribution here. Symbolism was regarded as more than simply another among many literary and artistic trends. In art, it marked a new view of life, a new understanding of the universe, which demanded a total change of feeling and thinking. According to Emmanuel Swedenborg, the human spirit was part of the spiritual *universum*, the microcosm corresponding to the macrocosm of the spirit, with a close analogy, or correspondence, between them. Direct contact with this spiritual state of being could be established only through the intuitive experience of the individual. After all, there were entire nations who instinctively understood the profundity of existence – "who feel everything all at the same time, *synthetically*" – and in one way or another, this became doctrine to these young opponents of Realism, which endlessly analyzed nature, and of what they saw as Realism's ultimate manifestation, Impressionism.

For most Finnish artists, adopting Symbolism also provoked a deep religious crisis. This often meant embracing a mysticism tinged with Theosophy or Catholicism. In some cases, there was also enthusiasm for the Rosicrucianism of Sâr Péladan. He, after all, proclaimed the artist's supreme standing as a visionary and creator of new beauty.

Just how these young Finns viewed modern Parisian art is recorded in a letter that one of them, Väinö Blomstedt (1871-1947), wrote home in the fall of 1891 (though he himself was not infected with Symbolism until spring 1894, when he was studying under Gauguin at the Collin studio).[9] Blomstedt, who had only just arrived in Paris and been briefed by his young colleagues, sent off two long letters, the main message being:

> As to painting itself, there is something new in the air right now in Paris. The art of ancient Assyria and Egypt has been elevated to an ideal. The Assyrian and Egyptian works are certainly the most interesting exhibits in the Louvre. Such power in the perception of the lines, such magnificent simplicity in the majestically decorative elements . . . Puvis de Chavannes is the first to have stepped forward to advocate the new style.

His equal, thought Blomstedt, was Manet: Puvis's *Poor Fisherman* and Manet's *Olympia* were the essential works that the young artist had to see first upon his arrival in Paris.[10]

It was obvious to Blomstedt that Enckell was far ahead of most others in terms of modernism. The simplicity of archaic art and its enhancement of the drawn form marked Enckell's early figures of boys. Drawing played an important role. "These days he says there's no colour at all in nature," Blomstedt wrote in amazement. To Enckell, only form was permanent and eternal, while colour was part of the sensory world and thus mutable and transient.

During his years in Paris, Enckell dreamed of an ancient pagan temple, its ruins still suffused with intense yet imprecise feelings and thoughts: "empty dreams and melancholy thoughts perhaps for those who step in from the outside, out of the sunlight; yet for those already inside, everything still appears as in the days when people gathered to worship in the temple." He felt himself to be the guardian of this dim temple, moving from room to room, penetrating ever farther into the building, suffering on every threshold for each thing he had to abandon. "But in me remains the certain hope that one day all will be regained. When we have reached the innermost sanctum, then surely the barriers will crumble. Everything will be revealed to our eyes and restored to our hearts. Time will no longer exist."

6. Léo Claretie, "Mouvement général : la saison 1892-1893", *Revue encyclopédique*, October 15, 1893.
7. Sarajas-Korte, 1966, p. 114 (1981, p. 113).
8. G.-Albert Aurier, "Le Symbolisme en peinture. Paul Gauguin", *Mercure de France*, March 1891, pp. 155-165.
9. Sarajas-Korte, 1966, pp. 66-67 (1981, pp. 63-65).
10. *Ibid.*, pp. 157-158 (p. 146).

This was the path of initiation taught by Schuré for instance, but it also describes Enckell's own angst and searching. The "innermost sanctum" is also a fin-de-siècle vision of a lost paradise that derives from Plato and Christian Neoplatonism, from Dante, Milton and Swedenborg, and in fact from the whole Romantic tradition.

A series of works depicting boys or youths forms a pivotal grouping in Enckell's Symbolist output. In Finland, they were still regarded mainly as drawing exercises, but as Blomstedt's letter reveals, Enckell had set his sights higher. As in archaic times, Enckell wanted them to spiritualize the flesh, to depict man from an eternal point of view, detached from time and place. The choice of subject tells us something about the androgyne ideal of the time, with which Enckell also identified his homosexuality. In those early Paris years, he wrote of his affinity with Antinoüs, the youth beloved of the Emperor Hadrian. Antinoüs sacrificed his young life by throwing himself into the Nile, but in the process became a god and was granted eternal youth. Antinoüs combined the sacred androgyne ideal proclaimed by Péladan with the mystical union of love and death. According to the Antinoüs scholar L. Dietrichson, the youth was worshipped first as Osiris and later merged into the Dionysus/Bacchus god revered in the Eleusinian mysteries.[11] The youths in Enckell's works are also linked with this tradition, in that he was trying to present an idealized image of man at his purest and most perfect. This idealization is also **157, 434** present in **Head** (1894) and **Awakening** (1894). In the former, the face is soft and spiritualized almost to the point of being immaterial. Enckell's personal inclinations are more to the fore in **Awakening**, where the youth is real and sensual. However, even here the artist wanted to express something deeper: the awakening of a young person to a higher state of being, more or less in the Swedenborgian sense, it would seem. The movement is arrested, and the boy seems rapt by an inner vision. We are told that the white background was meant to show that the youth was waking to "some brighter, better life", as the artist friend who served as model for **Head** wrote about

Magnus ENCKELL
Young Boy, 1892
Helsinki, Ane Gyllenberg collection

Awakening,[12] emphasizing its intimate character while also stressing the profundity and nobility of the ideas it expressed.[13]

In spring 1894, Enckell quitted the "decadent" atmosphere of Paris. He journeyed to Italy, attracted not only by mystical Antiquity but also by Early Renaissance frescoes and especially the work of Leonardo, whom Enckell, while still in Paris, had admired above all other artists, as had Péladan. "I study Leonardo more as a primitive artist of our time, or of a time to come, than as a symbol of the Renaissance. It seems to me that he possesses a quality that no one else possessed, but one that is now the very starting point for the modern style."

In Paris, he had particularly admired Leonardo's *John the Baptist*.[14] The Antinoüs/Dionysus/Bacchus dream also accompanied him to Italy.

Of the works produced in Italy, it is *Fantasy* (1895) that seems to distil everything that characterized Enckell's Symbolist period: admiration for mystical Antiquity, an extremely enigmatical quality and an almost musical harmony of form and colour, replacing his previous ascetic black. The main figure

11. L. Dietrichson, *Antinoo. Eine kunstarchäologische Untersuchung* (Christiania, 1884).
12. Kasimir Leino, "Suomen taiteilijain syysnäyttely II" [Autumn Exhibition of Finnish Painters], *Päivälehti* [Helsinki], October 24, 1894; Sarajas-Korte 1966, p. 190 (1981, p. 180).
13. Sarajas-Korte, 1966, p. 191 (1981, p. 181).
14. *Ibid.*, p. 162 (pp. 150-151).

in *Fantasy* is a youth that Enckell's letters initially refer to as a bacchant, though he later opted for the more masculine term "faun", and this, too, reflects the Antinoüs theme. The work's theme is clarified by a description Enckell sent to an aesthete friend: "A young bacchant, surrounded by black swans against a backdrop of dark waters – in the background, brown cypresses, a red temple of Bacchus and a dazzling blue sky. Between the cypresses, a flock of white swans glides towards the first group."[15] The youth, still referred to here by Enckell as a bacchant, is naked, with a golden lyre on his knee and the garland of eternal beauty around his head – the ideal of the poet. The artist obviously had difficulties achieving the expression of passionate exaltation that is a vital element in the figure.

Crucial to the whole composition are elements from the wild, sensuous and tragic Dionysus myth: the red temple of Bacchus, the dark cypresses and the swans swimming in dark water, which are part of the work's inner dynamism. In the centre, an Apollonian sea of light opens up, with white swans drawing near. These and the bright golden lyre form a contrast to the black swans swimming in deep water, expressing an undeniable sense of suffering. We are close to what was possibly the most familiar theme of Nietzsche, highly popular in Scandinavia at that time – the interaction described in "The Birth of Tragedy" between Dionysian and Apollonian elements in art, and their inevitable central role in all true artistic endeavour. They were realer to Enckell than to many other artists of the time, and their place in *Fantasy* is clear from the correspondence between the artist and his friend Yrjö Hirn, who was completing his doctoral thesis on the philosophy of art. Although Enckell never broke free of the basically tragic mood in his art, here he was clearly seeking not only release from suffering but also perfect expression in an Apollonian beautiful form. The sensuous tones of the watercolour seem to show the influence of Arnold Böcklin.[16]

One of Enckell's fellow students in Paris was the gifted Ellen Thesleff, whose relationship with Parisian Symbolism was more restrained and independent than Enckell's from the start. Her work, too, changed totally in Paris: she rejected the clear colours she had used in Finland and adopted a restrained harmony of black, grey and opal that, despite our lack of written evidence, inevitably points to Eugène Carrière's "colourism of black".[17] Thesleff must have felt a certain affinity with this artist, who was particularly admired by the international Symbolist circles of the Latin Quarter, along with Puvis

Ellen THESLEFF
Self-portrait, 1894-1895
Helsinki, Ateneum

de Chavannes and Rodin. What Thesleff and Carrière shared was a nonmaterial quality that spiritualized everything, with figures rising out of the mist like a breath of the hereafter. Carrière was proclaimed as a reformer of art – by Adrien Remacle to be exact, in *La Plume*, which was read by Finnish artists – in autumn 1891, when Thesleff had recently arrived in Paris. Remacle referred to Carrière's ability to grasp the link between man and absolute truth, which was the dynamic force behind all Symbolism: "This moving painter is highly innovative: he has invented something new and disturbing – a compassion intimately linked with a beauty."[18] With Puvis de Chavannes, Carrière was certainly most instrumental in banishing colour from Thesleff's work and in simplifying the forms she used.

15. Letter to Yrjö Hirn from Milan, November 21, 1894, HYK; Sarajas-Korte, 1966, p. 203 (1981, p. 194).
16. I have recently analyzed this interesting work in greater detail in an article in the Finnish National Gallery Bulletin, autumn 1994.
17. G.-Albert Aurier, "Eugène Carrière", *Mercure de France*, June 1891, pp. 332-335; Sarajas-Korte, 1966, p. 81 (1981, pp. 78-79).
18. Adrien Remacle, "Eugène Carrière", *La Plume*, October 15, 1891; Sarajas-Korte, 1966, p. 81 (1981, p. 79).

Of all the artists influenced by Symbolism, Thesleff was the first to abandon Paris, in early 1894, when she set off to seek the pure, primeval sources of the Symbolism that Paris had taught her to admire – the Early Italian Renaissance and Fra Angelico. Italy was to remain her spiritual home until the final years of her long artistic career.

Beda Stjernschantz was one of Enckell's close circle in Paris and subject to the same influences. Sickness and lack of funds, however, would make her stay in Paris shorter than the others': from autumn 1891 to the following summer, with a return in 1900 for the Exposition universelle. For the same reasons, her output was fragmentary. Thus, in addition to Parisian influences, her art was affected by the many publications available in Finland, perhaps especially the Danish magazine *Tårnet*, which appeared in 1893 and 1894 and from which she frequently copied excerpts into her notebook.

315 The work exhibited here, **Pastoral (Primavera)** from 1897, demonstrates how wholeheartedly she embraced painterly synthesis in her handling of both form and colour. The work also shows points of similarity to Enckell's favourite subjects in its mythical elements. We see the garlanded Antinoüs by a river, Pan with his pipes in the foreground and spring in full bloom. **Pastoral** involves us deeply in the melancholy problem of time. Once again, it is a dream of a lost paradise, of eternal youth and happiness, of an eternal flowering spring, where the sad and unsolved question of the meaning of life and its ultimate essence nonetheless presents itself. Perhaps the best interpretation of the painting is in the Swedish poet Viktor Rydberg's poem *Antinoüs*, from which the artist had copied the following lines into her notebook:

> We see him still, where he stood a thousand years / eyes gazing into the river of time / that still reflects the splendour of his graceful limbs, / his melancholy brow and lotus flower garland. / Forever blooms the shore where he stands, / around him smiles an everlasting Spring; / but the road goes on, leaving the Spring behind, / towards an unknown fate beyond an Autumn world.

In taking her own life in 1910, Beda Stjernschantz chose to move towards this unknown goal beyond autumn.[19]

As early as 1894 or so, some quite strong criticism of Parisian Decadence began to be expressed. Even so, Paris was to remain influential in the new phase of Finnish Symbolism that came some years later, differing greatly from the earlier manifestations. The most important representative of this Symbolism was Axel Gallén (later known as Akseli Gallen-Kallela), who had at first been highly critical of the movement. Gallén was a leading member of the Symposium, a circle that brought together the country's most talented nationalist-minded artists, poets and musicians, including Jean Sibelius (1865-1957). One of the youngest of the poets was Eino Leino (1878-1926).

What went wrong? The spirit of the times was to taint the group's clear nationalist line. As Leino wrote late in 1893, even this group was not immune to the pervasive trend towards mysticism.

> All the old religious ideas are coming back, and a new era of mysticism is sweeping through the most cultivated minds of the century... Once again, the human spirit feels the need to kneel before a great unknown world spirit. In vain do the heroes of the age of enlightenment, such as Georg Brandes, decry this reactionary new trend... It is coming willy-nilly, and leaves no one unaffected.[20]

This is particularly true of the pro-Finnish Symposium, which formerly swore allegiance to Realism. This time, it was the Swedish-born writer Adolf Paul (1863-1943), an early admirer and friend of Edvard Munch and Sibelius, who brought the message of Symbolism back with him from the Ferkel group in Berlin. Paul arrived in Finland and joined the Symposium at the end of 1893. For a while, he managed to lure the easily swayed Axel Gallén away from his nationalist themes, filling him with enthusiasm for ideas from Berlin, especially the Eros philosophy and Theosophy-imbued ponderings about the universe of the Pole Przybyszewski.[21] Paul painted a magnificent future for Gallén at Munch's side, as a leader of the most progressive circle in Berlin. Gallén developed a burning desire to free art from the old limits, to open a way to something higher and greater.

An important document that sheds light on this stage is Gallén's painting *Symposium* (originally called *The Problem*, 1894). It also conveys the mood of the endless discussions that often went on into the wee hours, ranging freely in time

19. Salme Sarajas-Korte, "Musiikin melankolia/Musikens melodi" [The Melancholy of Music], in *Målarinnor from Finland/Seitsemän suomalaista taiteilijaa* [Seven Finnish Painters], exhib. cat. (Stockholm: WASA-LITHO, 1981), pp. 56-63.
20. "Suomalaisia kirjailijoita" [Finnish Writers], Kootut teokset XIV I-XVI, tome XVI p. 259; Sarajas-Korte, 1966, p. 158 (1981, p. 244).
21. Sarajas-Korte, 1966, pp. 304-310 (1981, pp. 294-300).

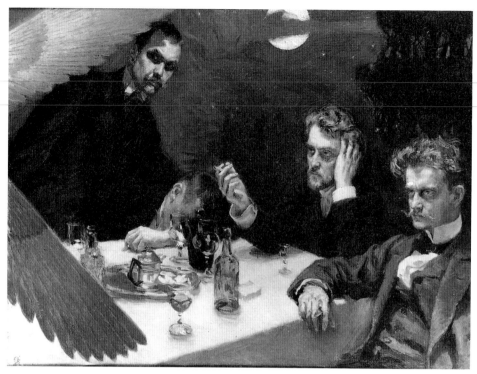

Akseli GALLEN-KALLELA
Symposium, or *The Problem*, 1894
Helsinki, Aivi Gallen-Kallela Sirén

and place over the sacred mysteries of ancient India, Egypt and Assyria. One key to the symbolic element in the finished work is an on-the-spot sketch made in 1893, in which the actual "problem" is presented as a female sphinx, and a man's astral body is drawn against the planet Jupiter visible in the sky. In the final painting, these symbols have been replaced by the swish of Osiris's wings. However, a sphinx as keeper of the secret of art and life is present in an 1894 work called *Conceptio artis*, which is close in theme to Enckell's *Fantasy*, though the results are not at all similar.[22]

The 1894 works are stylistically inconsistent transitional pieces, and Gallén did not find his real style as a Synthetist until his three-month stay in Berlin, which he visited towards the end of 1894 at the instigation of Adolf Paul. There, Gallén contributed illustrations to the magazine *Pan*, which was founded around this time, and arranged a joint exhibition with Munch, whom he felt was his rival.

Gallén soon returned home, distraught at the death of his daughter. As a result of this spiritual crisis, he went back to the *Kalevala* themes dear to him for so many years and, in the late 1890s and beginning of the new century, produced what is

considered his finest work. Stylistically, it is totally Synthetist, even tapestry-like, with ungraded colour surfaces and strong outlines. The *Kalevala* was to prove a splendid foundation for the Symbolist view of the world that Gallén now embraced.

In the 1890s, the *Kalevala* had come to be Holy Writ for Finnish artists and, in drawing upon it, Gallén had no need to cease pondering the "profound questions of human existence" that the Symbolist period had interested him in.[23] And in the background, we can detect the fascination felt elsewhere for the occultism of the *Kalevala*. Madame Blavatsky was familiar with the epic and borrowed the motto to her famous work *The Secret Doctrine* from it. Of particular interest here is her interpretation of Lemminkäinen as "the white seer".[24] The Swedish painter and mystic Ivan Aguéli (originally Gustaf Ageli) also sent his Finnish friend, the artist Werner von Hausen (1870-1951), a long and detailed letter dealing

22. *Ibid.*, pp. 289-293 (pp. 272-277).
23. *Ibid.*, p. 330 (p. 332); see also Sarajas-Korte, "Le Mysticisme de Kalevala dans l'œuvre de Gallen-Kallela", *Le Monde kalévaléen en France et en Finlande* (Paris: A.D.E.F.O., 1987), pp. 117-127.
24. Sarajas-Korte, 1966, p. 331 (1981, p. 323).

exhaustively with the *Kalevala*'s occultism. He compared it to many of the holy books of India and considered his artistic enjoyment of it unique.

> It reminds me of many things: of Indian epic tales about life and the life-force, although it is calmer, more harmonious; of Semitic traditions, of the pillars of the air, of tales from the *Arabian Nights*, with duels and magic spells; of Homer, yet it is far more beautiful than Homer. As an inspiration for art, the *Kalevala* ranks among the world's masterpieces. But it goes even beyond that: it is a book of initiation, and a cathedral, to Nordic nature.[25]

The main protagonist of the *Kalevala*, Väinämöinen, is a hero and seer, a sort of high priest of mankind, an Adam Gadmon. He is "the Old Man in primeval light".

However, it is the Lemminkäinen symbolism that is closest to my theme. Lemminkäinen is a poet and seer whose fate Gallén has made familiar through his painting ***Lemminkäinen's Mother*** (1897). As mythical images, the Mother figure and the Swan of Tuonela are heavier than Enckell's light-bathed Apollonian bird and, because of the direct link with the *Kalevala* legends, less mysterious. However, deep down, Gallén is pondering the same theme: the artist's and poet's desire to solve the eternal mystery of life and death.

Interpretation is aided by the practically contemporaneous dramatic poem *Swan of Tuonela* (1896), by Gallén's young friend Eino Leino, which Leino himself has interpreted as follows:

> Lemminkäinen has become a Titan, a *hero of faith*, who plunges through all dangers into the river of the underworld, torch in hand . . . The Swan has become the queen of death, *symbolizing the mystery of the hereafter*. Lemminkäinen wants to shoot the Swan with his bow of ideals and to win peace for himself and a message of joy for suffering humanity . . . He is just about to shoot when an arrow aimed by the Herdsman of Pohja, representing his own misdeeds, strikes him . . . The man who can shoot the Swan of Tuonela must be free from sin (Jesus).

One of Gallén's notebooks also contains a commentary on Lemminkäinen, "lying ghostly green by black waters where a swan swims away, its neck scornfully arched. Golden, vibrating rays of sunshine offer the kneeling mother hope, and she sends a bee to draw balm from that golden spring."[26] Lemminkäinen – Madame Blavatsky's white seer, Leino's hero of faith, Aguéli's hero and poet – wants to shoot the swan, symbol of the mystery of death, but it swims away without forfeiting so much as a feather. The symbolism of this work has links with the same problem as in Gallén's output in 1894: the artist is seeking something unattainable, a lost paradise from which he is separated, in this case by the cruel river of death.

Gallén embraced this *Kalevala* symbolism just as Enckell was abandoning his own Symbolist themes. Thus, it was Gallén who upheld the distinctive and unique tradition of Finnish Symbolism. He succeeded in remaining true to his old nationalist ideal while following the latest stylistic tendencies of his time.

However, Finland's most full-blooded Symbolist is probably Hugo Simberg (1873-1917), who flourished in thoroughly Finnish soil. As late as 1895, he was Gallén's student at the Ruovesi studio. His preference for Symbolism during these student years in Finland seemed the obvious choice in that context, especially as it apparently met the expressive needs of his own psyche. In the darkness of the Finnish late autumn, in primitive rural conditions, he absorbed his themes directly from simple country life, from its calm acceptance of the implacable passing of time, of birth and death. Gallén was unable to interest Simberg in *Kalevala* themes. Rather, Simberg was fascinated by subjects that he became familiar with in 1896, on his first trip abroad, which were typically of interest to the whole of turn-of-the-century art: the Egyptian art in the British Museum, old miniatures and Japanese woodcuts ("which surpass anything I could have imagined"), together with the Northern Renaissance (Dürer, Holbein and Memling), the English Pre-Raphaelites and Early Renaissance frescoes.[27]

The stylized quality and decorativeness of these models provided Simberg with suggestive ways of expressing the harmony between man and nature, life and death. This can be seen equally in his small watercolours and in a major work he carried out jointly with Enckell, the monumental ornamentation of Tampere Cathedral.

25. *Ibid.*, p. 332 (p. 324).
26. *Ibid.*, pp. 336-337 (pp. 328-329).
27. Salme Sarajas-Korte, "Hugo Simberg, täysverinen symbolisti" [Hugo Simberg, Full-blooded Symbolist], in *ARS – Suomen taide* [Finnish Art], vol. 4 (Helsinki: Weilin & Göös, 1989), pp. 272-274, 283-284.

But there is something in Simberg's work that eludes universal stylistic principles, a certain naïveté of form that he himself valued: in the search for technical perfection, he felt that art had failed to achieve the naïve, the childlike and pure, the main thing – the dedication and love that the artist gives to his work. The idea that a work of art is created out of and fertilized by love for the beautiful was one of Plato's ideas that found its way even into Simberg's remote and quiet work-room.[28]

S. S.-K.

28. Salme Sarajas-Korte, "Hugo Simberg", in *FINSKT 1900*, exhib. cat. (Helsinki: Frenckellska Tryckeri, 1971), p. 49.

The Image of Death and the Myth of Resurrection Romantic Sources of Polish Symbolism

AGNIESZKA ŁAWNICZAKOWA

Overstepping the limits of observable, scientifically verifiable reality, the Symbolist sensibility, if there can be said to be such a thing, and the kind of art it produced set out along the path towards metaphysics and transcendence. And although the Symbolist consciousness may not leave the world of the senses entirely behind to lodge in the realm of pure abstraction, it treats the real world as a Platonic reflection of Ideas or a veil concealing the elusive essence of things. It approaches reality as an encrypted message to be deciphered, as a piece of a larger cosmic puzzle, as a flickering mirror that sends back ever-shifting images of the observer.

And overstepping the limits of time and history, the Symbolist imagination never concentrated on the "here and now". When seen from the proper perspective, each moment is unique, since it is the focal point of the past's spiritual energy and the future's potential. The world is fraught with hidden connections whose forgotten or as yet undiscovered meanings must be revealed. The Symbolist imagination, which may be described as philosophical – epistemological, ontological, unfailingly metaphysical – seeks the truths, principles and purposes behind the whole of existence. In this, of course, it approximates the religious imagination; and like it, the Symbolist imagination – with its ahistoricism, mystical and mythological leanings, and propensity to ascend from the profane to the sacred in quest of the spiritual and eternal – attempts to comprehend the world in its entirety and re-establish man's position in the cosmic order. Caught up in the antinomy of Good and Evil, it plumbs the dark depths of hell and flies upward to bask in the celestial radiance.

However, Symbolism's most significant feature is its poetical nature, which imparts a potential that is not mimetic,

not reproductive, but creative. In the words of Gaston Bachelard, it creates an image of the thing "co-created", completed, by the imagination. "The rational consciousness [cogito] of the dreamer relates to the *thing itself*, on a level where the polarity of subject and object tends to dissolve, making way for the *thing that is dreamed*, close at hand and, so to speak, within man."[1]

In light of these preliminary remarks, which as the informed reader knows may be augmented by endless quotations, the Symbolist artist appears to enjoy almost unrestricted freedom. Even if not sovereign, as a creator, he is at least close to the power of God. And what gives the artist this godlike power is his attempt to delve down to the essence of things, to break the seal of the mystery.

In seeking to discover the eternal – the principle and not the accidentals – the Symbolist artist is freed from the constraints of time and history. Thus, the stuff of the Symbolist imagination may be not only ineluctable nature's contribution to human identity, but the whole of history and culture, with their myths and religions that constitute or reflect the cosmic order.

Early in 1896, Stanisław Wyspiański, writing to a friend about his extensive reading, spoke also of the incessant play of his imagination, which he called his "own theatre": "All of it goes on all over the world and nowhere, around and inside me, necessarily with me and independently, in a space that is difficult to locate, for once I am in Syria, then in Antwerp, then in Worms . . ." And in addition to that journey stimulated by reading, there is

> another one, parallel, directed by the undulation of my private thoughts (*ex capite*), so now you can imagine the whole itinerary of my fancy – episode after episode, I could write an interesting book without leaving my

1. Clémence Ramnoux, "Avec Gaston Bachelard, vers une phénoménologie de l'imaginaire", *Revue de métaphysique et de morale* [Paris], no. 1 (1965), p. 40.

room . . . Voyage de ma belle fantaisie à travers les pays imaginés pendant un jour de la verité.[2]

Thinking in symbols allowed late nineteenth-century artists to transgress the limits of space and local circumstance by feeling more strongly than under other epistemological conditions their generation's spiritual and ideological affinities and common enterprises. This seems to have been one of the most pronounced impulses behind the "internationalization" of all artistic activity at the fin de siècle and after. This mode of thinking tolerated, indeed encouraged, scouring the past for similar ideas, values and approaches to the world and focussed attention on the historical, mythological and literary figures who embodied them.

The belief that all of culture's rich heritage could serve as a field for unrestricted exploration was supported by new developments in the humanities and contact of unprecedented intensity between Europe and other parts of the world. The Far East, India and Africa, the primitive cultures of "savages" suddenly revealed a common denominator of basic problems and questions about existence. The poetic appeal and imagery of those other worlds often proved more suggestive than historically rationalized European systems of thought, but even these presented themselves in a new and unexpected light that fostered renewal.

Thus, the hidden core of light was sought in the heart of darkness, amid the most archaic myths and beliefs, where nature and mankind were still one, at the very inception of the world that had emerged from chaos. Discovering the secret of creation would at last explain the tragedy, and purpose, of being.

The Symbolists then turned their imagination-thought to the world's mythological history, passing in review the incomprehensible act of creation and subsequent Paradise and Golden Age – symbols of a Manichean split in the harmony of existence, of the antagonistic forces of Good and Evil, moments of destruction and death, and images of renewal and resurrection.

But the Symbolist imagination not only fed on the accumulated cultural heritage of concepts and images; in a new and original way, it meditated on nature and the surrounding world, reacted to the impulses of modern life and – perhaps most of all – sounded the depths, engaged in introspection. Artists analyzed the universe of their own impressions, emotions and instincts. Following the lead of the natural sciences and the ideas of Naturalism, they tried to descend to the "primal level" of the self, stalking the vestiges of primitive instincts that had not been totally repressed or erased by the centuries of civilization since man had lived closer to nature. It was an exploration of the inner microcosm, filled with trusting innocence and burning desire, the seeds of joy and sorrow, life's brutal impulses and a sense of death's inevitability. The artist projected this tangled knot onto the outside world in the hope of reconstructing the image of a complete being.

Consequently, the Symbolist artist's domain of exploration is total, as are his epistemological objectives. As never before, Symbolist art became the instrument of both cognition and revelation. Its space is as vast as the scope of the artist's thoughts and imaginings at a given moment and according to a given tradition; its revelations are persuasive to the extent that an individual pictorial poetics manages to conform to the accepted rules.

At this point, let us turn to the problem of Symbolist art's message, or as some prefer to think of it, the representation of transcendence in Symbolist art, especially at the turn of the century. It is the problem of the work that was "supposed to approach by means of an image perceptible to the senses the extrasensory, impenetrable essence of things". It was to be a persuasive, symbolic image of an idea in which "the roots of the concept are in darkness" – the poetic metaword, unspoken but generated by the startling encounter of two other words. . .[3]

Does Polish Symbolism have any characteristics that make it unique in the European context? Does Symbolist art admit of local or national schools at all? Or, because of its inherently individualistic nature, does it not rather favour the projection of tightly closed circles' views of the philosophical and aesthetic explorations within the European community of ideas? That it most certainly does, and yet, in order to round out the picture of turn-of-the-century European art and introduce artists who worked outside the main centres of culture, it seems imperative to investigate national traditions.

2. Stanisław Wyspiański, *Listy zebrane. II. Listy do Lucjana Rydla. Część 1 - Listy i notatnik z podróży* [Collected Letters. II], ed. Leon Płoszowski and Marta Rydlowa (Cracow: Wydawnictwo Literackie, 1979), letter of February 23, 1896, from Cracow, pp. 319-20.

3. See Zenon Przesmycki (Miriam), "Maurycy Maeterlinck", in *Wybór pism krytycznych* [Selected Criticism], ed. Ewa Korzeniowska (Cracow: Wydawnictwo Literackie, 1967), vol. 1, p. 306. The words in quotation marks paraphrase a longer passage from the first manifesto of Polish Symbolist art, 1891.

Otherwise, works by artists the global audience has only recently recognized and increasingly considers of importance to the period will forever remain a closed book.

This poses no problem with respect to Józef Mehoffer, who fits perfectly well into the international movements of Art Nouveau and Jugendstil. Nor is it the case with Władysław Ślewiński, a painter influenced by the Pont-Aven School and Gauguin's Synthetism; Józef Pankiewicz, the creator of pictures suffused with a poetic atmosphere; and Olga Boznańska, who painted intimate portraits bathed in a Symbolist-expressive aura.

But it may pose a problem in regard to Polish Symbolism's most original and outstanding artists: Jacek Malczewski and Stanisław Wyspiański (and to a lesser extent and in a different way, Witold Wojtkiewicz). The philosophical complexity of Malczewski's painting and Wyspiański's painting and dramatic works was largely determined by a moment in local history and the thrust of a vernacular tradition that introduced into their art a ceaseless dialogue with the realm of ideas, problems and values. Their significance in Poland reaches far beyond literary and art history. Their works had, and still have, the ability to arouse emotions, stimulate discussion and stir the public. And this is most certainly so because the creative imaginations of both artists always dwelled on grand archetypal images, instilling them with emotionally familiar meanings. Their symbolic imagination was "dynamically", to use Gilbert Durand's words, "a vital negation of the nothingness of death and time".[4]

Symbolism appeared in Poland as an element of a broader ideologically and artistically diverse movement referred to as Modernism or, more often, Young Poland, that lasted from 1890 to 1918. Although an analysis of its intellectual and artistic characteristics is beyond the scope of this essay, it must be stressed that, just as in Western Europe, the point of departure was a general crisis of culture: the rejection of Positivism, with its rationalist and materialist philosophy, social utilitarianism, scientism and Realist art. The determining features were the dominance of idealistic and irrationalist philosophical systems (together with a widespread acceptance of Schopenhauer's pessimism, the Promethean reflection of Nietzsche, and later, Bergson's intuitionism), the rise of interest in metaphysics and religion, the affirmation and primacy of individual over collective values, and in art, a fervent adoption of tendencies and styles corresponding to epistemological subjectivism and antinaturalism.

In Poland, the momentum of the contact with contemporary European art brought about the sudden emergence of artistic and literary phenomena that elsewhere had developed gradually. The early 1890s saw a brief but intense period of Polish Impressionism, with Symbolism as the other strong pole that, taken broadly, became one of the most important and lasting tendencies in the painting and poetry of Young Poland.

Three characteristic paintings by Cracow artists of three different generations heralded Symbolism's beginnings: Witold Pruszkowski's *A Vision* (1890), Jacek Malczewski's *Melancholia* (1890-1894) and Stanisław Wyspiański's *Polonia* (1892-1894). Each of them initiated a distinct Neo-romantic line of Polish Symbolism, directly referring to the poetry of the Romantic "prophets" Zygmunt Krasiński and Juliusz Słowacki.[5] And each took as its subject matter the national cause – the ideas of homeland and freedom that had been repressed in the era of Positivism but rediscovered by the late nineteenth-century Modernists for whom they enhanced the spiritual aura of the age. It was inevitable, in this matter, to refer to the example of Romantic poetry, which had already for some time been the unofficial inspiration for ideological reflection and artistic practice (mainly of Pruszkowski and Malczewski). After the 1830 insurrection was quashed, the question of the nation, considered historically, ethically and philosophically, became an important, perhaps even the most important, subject in the poetry of Mickiewicz, Słowacki and Krasiński.

Pruszkowski's *A Vision*, an avant-garde painting liberated from literature in its symbolistically abstract flow of light and colour, nonetheless directly refers to Krasiński's long poem *Przedświt* [The Dawn] (1843).[6] In a symbolic infinity of blue, it

4. Gilbert Durand, *L'imagination symbolique*, 2nd edition (Paris: Presses Universitaires de France, 1968), p. 112.

5. The period of early Modernism, or Young Poland, has occasionally also been referred to as "Neo-romanticism". Although the first two terms are preferable to designate the movement active between 1890 and 1918, Polish critics still analyze the ideological, literary and artistic affinities of Young Poland and Romanticism. See Tomasz Weiss, *Romantyczna genealogia polskiego modernizmu. Rekonesans* [The Romantic Genealogy of Polish Modernism. A Reconnaissance] (Warsaw: Państwowe Wydawnictwo Naukowe, 1974), and the remarks on art in Wiesław Juszczak and Maria Liczbińska, *Modernizm. Malarstwo polskie 1890-1918* [Modernism. Polish Painting 1890-1918], (Warsaw: Auriga, 1977). One of the first and most significant studies of turn-of-the-century art was published in Warsaw by Ignacy Matuszewski in 1902 under the title *Słowacki i nowa sztuka (Modernizm)* [Słowacki and the New Art (Modernism)].

6. Zygmunt Krasiński (1812-1859), Romantic writer, playwright and poet, author of literary letters and intellectual. As an amateur philosopher of history, he interpreted the problems of the future of Poland and the immortality of the individual soul. In the Modernist period, his most influential works, besides his plays, were *Psalmy przyszłości* [Psalms of the Future] (1845) and *Przedświt*.

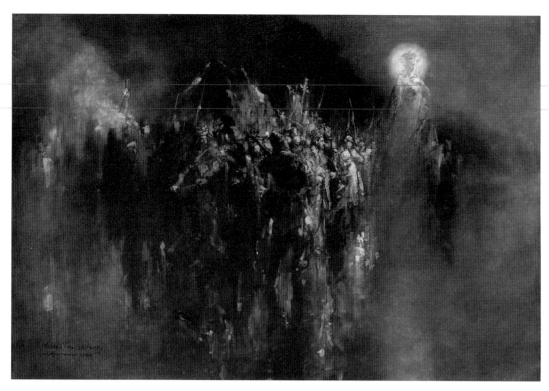

Witold PRUSZKOWSKI
A Vision, 1890
National Museum of Poznań

represents a remarkable procession of kings, knights and peasants to the shores of a dark sea; in the sky above reigns the Madonna, Queen of Poland. The picture alludes to the Messianic idea of the meaning of history and the experience of the Polish nation, interpreted in the religious and sacred terms of the poem, as the establishment of God's kingdom on earth through suffering and sacrifice.

Malczewski's *Melancholia*, one of the central programmatic works of Polish Symbolism, was painted under the sign of Słowacki,[7] to whose poetry the artist owes, along with the themes from *Anhelli* he had used earlier, the dual approach to melancholy, which, as the poet says, may be both "a stone around the neck of the small, and wings for the great". In Malczewski's painting, this duality encompasses not only the creative role of the artist and art, but also the revolutionary effort of the past in contrast to the inertia and apathy of the present. Though the painting is purely visionary, the vision is realized expressively and with technical clarity, the colour zones emphasizing the perspective and main linear-spatial axes of compositional tension. The vision transforms the interior of a painter's studio into the stage for the drama of history, mankind's destiny and artistic creation. The subject

underlying this synthesis is the centennial of the fall of Poland, a century of repeated abortive struggles for freedom (1794, 1830, 1848, 1863); this era of servitude is represented as an allegory of human life, from childhood through maturity and death. The action unfurls from a canvas on an easel at the far left. On the opposite side, a female figure in black, standing in the garden and leaning against the sill of an open window, embodies the painting's three-fold symbolic dimension: she is Melancholy, Polonia and Death. While the artist sits absorbed in reverie before the canvas he is painting on, she is positioned between the crowd pressing towards the window and the luminous view of the garden that symbolizes liberty and happiness.[8]

7. Juliusz Słowacki (1809-1849), Romantic poet and playwright, the founder of one of the most interesting systems of Polish Romantic thought. He expressed his philosophical ideas mostly in a number of mystical texts, such as the prose poem *Anhelli* (1836-1837), *Genezis z ducha* [Genesis from the Spirit] (1844), and the narrative rhapsody *Król-Duch* [King-Spirit] (1847-1849). Słowacki created a spiritualist system of genesis, the cosmic evolution of all beings, including also the concepts of national Messianism and Polish independence. Jacek Malczewski was the first (1877) to adopt the motifs from *Anhelli* in his painting – in fact, they contributed to the evolution of his originally realistic art towards Symbolism.

8. For a more detailed characterization of the symbolic meaning of *Melancholia*, see Agnieszka Ławniczakowa, "Das Gemälde 'Melancholie' von Jacek Malczewski", in

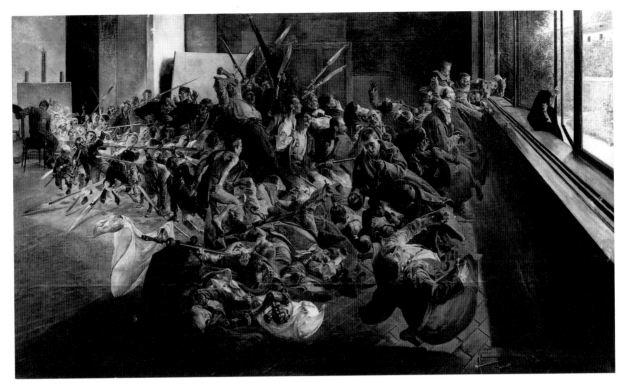

Jacek MALCZEWSKI
Melancholia, 1890-1894
National Museum of Poznań

Malczewski's painting, in some respects a depiction of the subjective imagination's causative powers, is saturated with pessimism; it is shaped by the era's characteristic view of itself as a time of spiritual decay and decline. The sense of destiny fulfilled in historical time and suffering also seems to refer to the Messianically interpreted future. The word *Prologue* that heads the inscription on the back of the canvas[9] raises the fundamentally millenarian aspect of the Messianic view of history, according to which the struggle, suffering and guilt of the Polish people are considered as the ordeal of purification and sacrifice that must precede resurrection. In the evolution of individual and collective history, death is not the end of existence but the threshold to its next phase. The course of history may be accelerated by a collective revolutionary undertaking, or by individual spiritual evolution, in which the artist has a vital role to play as priest of the new liturgy of art, the long-awaited era of the spirit.[10]

Wyspiański's *Polonia*, done when the artist was in Paris, is part of the second version of a competition design for a stained glass window in the Lvov Cathedral representing *The Vows of Jan Kazimierz*. The overall design shows the King's version of Poland's future; Mother Poland's swoon, into a state of nonbeing similar to the darkness of death, also hints at the future inscribed in the cosmic order of being and evolution. The evolution goes through the "bosom of the nation – the people, the mystical bosom of Polonia which is the organic cradle of the spirit and the personification . . . of the power that pulls the spiritual strength of the nation upward",[11] embodied in the Blessed Virgin Mary and Child, until its fiery power – represented by the Archangel Michael atop the

Polnische Malerei von 1830 bis 1914, ed. Jens Christian Jensen (Cologne: Du Mont Schauberg, 1978), pp. 96-102. See also Agnieszka Ławniczakowa, in *Symbolism in Polish Painting, 1890-1918*, exhib. cat. (Detroit: Detroit Institute of Arts, 1984), cat. 17, p. 57.

9. The inscription on the back of the canvas reads: *Prolog (Widzenie) Wiek ostatni w Polsce/Tout un siècle* [Prologue (A Vision) The Present Time in Poland/An Entire Century].

10. Compare the philosophical ideas of August Cieszkowski (1814-1894) as expressed in his *Ojcze Nasz* [Our Father]. See *Polska myśl filozoficzna i społeczna. Tom pierwszy: 1831-1863* [Polish Philosophical and Social Thought. Volume One: 1831-1863], ed. Andrzej Walicki (Warsaw: Książka i Wiedza, 1973), p. 421. In Poland, the modernist period was characterized by the renewed interest in Romantic Messianism. In the first place, it was a continuation of the tragically heroic effort of the poets Mickiewicz, Słowacki and Krasiński to root Poland in the world of ideas, as the nation could not rest on any other, real foundation. See "Adama Mickiewicza prelekcje paryskie" [Adam Mickiewicz's Paris Lectures], in *ibid.*, p. 271.

11. Zdzisław Kępiński, *Stanisław Wyspiański* (Warsaw: Krajowa Agencja Wydawnicza, 1984), p. 46.

Stanisław WYSPIAŃSKI
Polonia, 1892-1894
National Museum of Cracow

rainbow, drawing his sword – is unleashed. Like Pruszkowski and Malczewski, Wyspiański set the issue of nationhood in the wider context of "a purposeful evolution of the universe tending towards the coalescence of contrary elements in a synthesis so absolute that even the difference between matter and spirit disappears as they turn out to be One".[12]

These three examples clearly indicate that the Romantic tradition, important to late nineteenth-century Symbolism in general, was particularly significant in Poland, where it was more than merely coincident with the currently favoured worldview according to which spiritual dominated material, emotion and intuition dominated Positivism's reason and the scientific method, and the creative, rebellious individual dominated the egalitarian community. In that period in Poland, considered a time of stagnation outside history, Romantic poetry provided the young generation with models for approaching the issue of nationhood and its main goal, freedom. It offered various inspirations for rendering in art the notion of giving history a "push", either through blood-shed or through spiritual effort, a choice that became the central issue of Wyspiański's dramatic works. Polish Roman-tic poetry also represented an exemplary combination of extremely personal lyricism with the more general issues of patriotism, mysticism and metaphysics, a fusion that deter-mined the internal dynamics of Malczewski's Symbolism.

The poetry of the Romantic masters conveyed the message of art's moral and social obligations and the artist's role as a leader or prophet. Ascending the ladder of knowledge one rung at a time, the artist not only discovers hidden meanings and truths, but becomes a true son of God (understood in the context of both hermetic lore and Catholic modernism).

With Malczewski, particularly after 1909, these values were expressed most explicitly in a number of compositions on Old and New Testament subjects, where the central figure is a self-portrait, as Christ, the aged Tobias or the Prophet Ezekiel.[13] Moreover, they are present in a cycle dating from about 1900 that explores the symbolism of the well as the centre of the world, the mirror of the self and the source of the

12. *Ibid.*, ss. 45-46. The painter may have happened on this basic principle of hermetic lore, which is also fundamental to Romanticism – and of Polish Romanticism in particular – in the writings of both Mickiewicz and Słowacki, and in a concise form (as Kępiński indicates), in the widely read book by Édouard Schuré, *The Great Initiates* (1889).

13. In, for example, *Chrystus przed Piłatem* [Christ before Pilate] 1910; *Tobiasz i Parki* [Tobias and the Three Fates], 1912, Poznań, National Museum; and *Proroctwo* [Prophecy], 1919, Łódź, Museum of Art.

waters of "life" and "death".[14] This cycle conveys the ethical imperative of the quest for internal and external truth. In fact, this theme had already been introduced in *Melancholia* and the later ***Vicious Circle*** (1895-1897), and it was expostulated, after the fact, in a speech the artist delivered at the Cracow Academy of Fine Arts in 1912.[15]

Wyspiański turned his monumental painting projects and, after 1900, his poetry as well, into an arena for the conflicting forces of spirit and matter, life and death; he thus called for a Nietzschean intensification of the will in order to – in the words of Słowacki – let "the spirit like a pillar of fire" burn through the dead cover and, incarnated in other forms, create new life. He did not just revive the legendary and medieval Polish and Slavic motifs; he discovered in them a source of primeval strength and vital instinct, buried under the layers of culture, and yet still surviving in the contemporary common people (*Legenda* [Legend], *Skałka*). In his dramas based on episodes of nineteenth-century Polish history, Wyspiański referred to Greek myths to shed light on the cosmic sense of events and the deeds of local heroes (*Noc listopadowa* [November Night]) as well as the activities of his literary alter ego (*Wyzwolenie* [Liberation]).

Another aspect of Wyspiański's and Malczewski's common attitude towards reality is also worth dwelling on. Malczewski's ***In the Dust Cloud*** (1893-1894) and Wyspiański's *Capsheaves* (1899) both seem to have stemmed entirely from an individual yet universally comprehensible approach to landscape as corresponding to temperament and state of mind. The state of mind was to be transformed through the impulse to paint so as to suggest the Symbolists' ardently desired union of the human soul with the spirit of nature.

And so it was. An apparition floating in a cloud of dust and withered leaves in Malczewski's picture seems to be a last breath of pallid nature falling gradually asleep. The painting is an image of the vague fear, nostalgia and sense of loss we cannot avoid feeling when contemplating an autumnal landscape. Wyspiański's *Capsheaves*, a winter view of Cracow's Planty Park at night, with street lamps, even as they illuminate some features of the park, making the shaded nooks appear all the more spectral and fantastic. Bare branches and tree trunks seem to shudder convulsively, and the bushes bound in straw look like a circle of stooped human figures dancing through a puddle.

Because of compositional and representational similarities to certain works of Segantini,[16] Malczewski's ***In the Dust Cloud*** shares their symbolic reference to unwanted and rejected motherhood. But at the same time, the actual landscape that served as the painter's source of inspiration leads us to attach an extra meaning to the picture. The pale sky, dark mass of the forest bordering a meadow, and dirt road along side which nameless insurgents of 1848 were once buried struck the artist as a summing up of his homeland, where a captive mother must abandon her children. So the sensitivity to nature, together with the corresponding maternal sentiment, comes back to the idea of Polonia, to the concept of homeland tinged with sadness. The meaning of Wyspiański's *Capsheaves*, too, goes beyond vague suggestiveness and poetic feelings. Behind the trees in the background looms the silhouette of Wawel Castle. First the historic seat and then the burial place of Polish kings and national heroes, it was a permanent focus of Wyspiański's patriotic reflection.

Capsheaves presents in addition the motif of the beautiful bush protected in winter under a wrapping of straw. This motif recurs at least twice in the artist's plays as a symbol of life's power concealed beneath a lifeless shell. In *Noc listopadowa* (1900-1902), a verbal reconstruction of the earlier painting, except that it is set in Warsaw's Łazienki Park on the first night of the November 1830 insurrection, the motif accompanies the plot of the insurgents and the Eleusinian Mysteries – Demeter's farewell to Persephone – enacted in the same garden. The insurgents' sacrifice, as elucidated by the Greek myth, corresponds to the notion of death as a prelude to resurrection: "What will live, first must die."[17] Finally then, it is impossible not to hear in the sombre poetry of *Capsheaves* the quiet and clear strain of the mystical announcement of the return of all life, including the life of the nation. In the play *Wesele* [The Wedding] (1900), a scarcely disguised portrayal of members of the contemporary Polish intelligentsia, the hidden

14. For example, the well-known cycle of five paintings "Zatruta studnia" [Poisoned Well], 1905-1906, Poznań, National Museum.

15. Presidential speech of Jacek Malczewski delivered at commencement ceremonies, October 15, 1912, at the Academy of Fine Arts in Cracow. Printed in Michalina Janoszanka, *Wielki tercjarz. Moje wspomnienia o Jacku Malczewskim* [The Great Tertiary. My Recollections of Jacek Malczewski] (Poznań, after 1931), pp. 47-51.

16. I am referring to Segantini's *Punishment of Luxury*, 1891, Liverpool, Walker Art Gallery, and *The Unnatural Mothers*, 1894, Vienna, Kunsthistorisches Museum.

17. For an analysis of the Eleusinian myth in Wyspiański's drama, see Jan Nowakowski, "Persefona i Charon. Z młodopolskich dziejów motywów mitycznych" [Persephone and Charon. From the History of Mythic Motifs in the Times of Young Poland], in *Młodopolski świat wyobraźni. Studia i eseje* [The Imaginary World of Young Poland. Studies and Essays], ed. Maria Podraza-Kwiatkowska (Cracow: Wydawnictwo Literackie, 1977), pp. 338-345.

value remains dormant. The dreams of freedom awakened by the wedding night are overcome in the morning by the character Chochol, a "straw monster" who enters the hut and fiddles a tune to which the guests dance like sleepwalkers, in a ring that recalls Malczewski's *Melancholia* and **Vicious Circle**.

Malczewski's painting **Thanatos** (1898), another nocturne, depicts an autumn night when the sleep of a manor house is disturbed by an unexpected guest, Night's son Thanatos, who, standing ready to perform his sacred duty, reveals his power. The divine youth conveys a paralyzing inevitability and the double beauty of a boy and a woman, which is enhanced under the moonlight. From the manor house's white portico, a man bent with age approaches the graceful, statuesque androgyne. The moment seems full of promise, a "harvest when the full ear is ripe". Is this life's finale, its ultimate end? In many ways, Malczewski's painting seems to be saying that death is a threshold, a passage to the next phase of being, the frightening yet alluring promise of a state of spiritual harmony and fulfilment.

Malczewski and Wyspiański entered the new century having overcome the melancholy poetry of death that marked the beginnings of their artistic careers. They had gained a profound insight into the tradition of Romantic thought, especially the Romantic philosophy of history, with its temporal model stressing the coming "resurrection" of mankind and the Polish nation. Also of importance to Wyspiański was the belief in metempsychosis, as expressed by Juliusz Słowacki in *Król-Duch* [King-Spirit] and other mystical writings. Both painters found crucial inspiration in the light-dark dialectic of the Greek myths. Obviously, none of that diminished the importance of the question of death, the central problem of existential thought and the Symbolist imagination. Still, the result was that in the ubiquitous opposition of life and death, the accent began to fall with greater emphasis upon the former element. However, in the poetic philosophy of their symbolic art, life was not only, or at least not primarily, the rhythm of nature, the senses and instinct – not only emotion, but also will, intellect and, above all, spirit. And creation. Not re-creation, but creation, designing the world, putting together the bits scattered throughout the ages, dredging up forgotten truths from out of the darkness.

From about 1900 on, the works of both artists demonstrate a new, active dynamism, conveying more hope than doubt. Such was, in fact, the direction of the whole Young Poland movement. Wyspiański's series of unique stained glass designs for Wawel Cathedral, depicting kings and the Bishop-Martyr, with the accompanying rhapsodies, were an outburst of strength and the will to reject outworn concepts and forms, a dramatic, expressionistic effort to burn through fettering matter with the fire of the spirit. It was the smashing of decaying coffins and the breaking of the bonds of guilt and punishment; it was a Nietzschean appeal to raise a hammer and strike the chest of whoever barred the way to a new life in the world, an appeal that was much too daring at that time for the windows of the national Catholic Church, and in fact Wyspiański's designs were never adopted.[18]

In his drama *Akropolis* (1904), Wawel Cathedral becomes the symbolic centre of the world. In the darkness before the dawn of Easter morning, the figures from the altar and monuments, and the goblins surrounding the tomb of the bishop-martyr Saint Stanislaus in the nave, come to life. The anguish, truths and ideas of specific heroes recalled from the sleep of death and inscribed in the centuries-long discourse of culture that began in Antiquity, are ultimately expressed or transgressed in a great solar myth: in the light of the Resurrection, the dual figure of Christ-Apollo destroys the old temple with the wheels of his chariot and dispels the firmament of night with the "sun of salvation".[19]

After 1900, with the tellingly named *Nieśmiertelność* [Immortality], Malczewski's painting achieved the acme of expression and its unique style. Its colours became sonorous and clear, in lyrical and quiet, or contrasted and dynamic, tones. Line – confident and synthesizing – remained active in "co-creating" pictorial space, while composition took on a monumental quality. The usual arrangement included large figures in the foreground with a luminous background that constituted their spiritual environment. Malczewski's painting combined Realism with idealization, synthesis and expressiveness. The features of his style not only made the reality

18. Both the cartoon of the stained glass window design *Kazimierz Wielki* [Casimir the Great] (Cracow, National Museum) and the rhapsody by the same title were finished in the first half of 1900. The similarity of the motif of the hammer and "hammering" poetry to Nietzsche's rhetoric (Friedrich Nietzsche, *Der Wille zur Macht, oder wie man mit Hammer philosophiert*, 1888) was pointed out by Tadeusz Sinko in *Antyk Wyspiańskiego* [Wyspiański's Antiquity], 2nd edition (Warsaw: Instytut Wydawniczy Biblioteka Polska, 1922), p. 175.

19. For an analysis of the solar myth in Wyspiański's work, see Jerzy Kwiatkowski, "Od katastrofizmu solarnego do synów słońca" [From Solar Catastrophism to Sons of the Sun], in Maria Podraza-Kwiatkowska, 1977, pp. 302-304.

represented attract the viewer's attention, but also suggested truthfulness – the truth that connects our sensitivity and knowledge of the world with life's unforeseeable possibilities. It was the truth of poetic imagination that turned every place and every event into a potential focus of epiphany.

A household well turns out to be a cosmic centre of the world; the home becomes a mystical Arcadia, a vision of paradise that determines the direction of life. Amid familiar fields, we may come across a tempting chimera or a guardian angel. A lark is ready to fly up to the sky from the hands of a girl and scatter the notes of its airy song on the lines of the paths. On this native ground, glimmering with the waves of the Vistula, fauns' hooves clatter beside winged Pegasus, and at the window stands a beautiful Reaper-Death, summoned by Eros.

Here is the scene of a continual, eternal ritual. Nature falls asleep and then reawakens to live again. But the sign of the coming renewal is not really the stork flickering in the grey sky like an arrow of light; it is the young Tobias, carrying a fish in his hand as he makes his way across the pink fields. In the gloomy spectacle of autumn, a Polish aristocrat will have a double companion of Demeter – a pang of conscience for the dire fate of the homeland – and her daughter Persephone – a sign of hope, girded in the flame red of poppies.[20] Elsewhere, in the company of archangels, the young Tobias is leading a band of exiles from Siberia to Poland, in the group in the upper frieze of the artist's self-portraits framing the triptych *Grosz czynszowy* [The Tribute Money], whose centre is also occupied by Malczewski as Christ.[21]

It is indeed characteristic that Malczewski's self-portraits pervade all the ideological problems of his art. They are, as it were, a sign of the artist's continuous reflection on his work (again, this refers to Słowacki, author of "Beniowski"). But by various contexts and their corresponding imagery, they also attest to how the man-artist participates in life's pilgrimage to the "source of the water of life" and truth.

Obedient to the spirit of his times and Symbolist art, Malczewski continually indicates that the reality he creates is both a mirror of existence and the effect of the inner experience of the artist. To him, art is a never-ending process of "establishing the world" once more, of guiding it from darkness to light, from chaos to universal unity. That is what determines the true significance of the artist's role and vocation.

In 1914, at the threshold of regained independence, Malczewski painted two masterpieces in the form of self-portraits, his final idealizations of the Artist in the symbolic spectrum of his oeuvre: *Autoportret w białym stroju* [Self-portrait in a White Costume], pathetic and commanding, presents the figure of the artist as a sovereign-creator, a prophet and at the same time, inevitably, a jester; *Autoportret w zbroi* [Self-portrait in Armour] in a knight's armour, defines the artist's ethos and demonstrates that art is a quest, a struggle against the power of evil, in loyal service to the lofty values of the spirit.

A. L.

Translated from Polish by Marek Wilczyński

20. *Hamlet polski – Portret Aleksandra Wielopolskiego* [Polish Hamlet: Portrait of Alexander Wielopolski], 1903, Warsaw, National Museum; see Agnieszka Ławniczakowa, *Malczewski: A Vision of Poland*, exhib. cat. (London: Barbican Art Gallery, 1990), p. 66.
21. *Grosz czynszowy* [The Tribute Money], triptych, 1908, Poznań, National Museum; see Ławniczakowa, 1990, pp. 84-85.

IV. *The Cycles of Life*

GUY GOGEVAL

. . . et haec eadem usupare
Corpora prima, quod ex illis sunt omnia primis.
Lucretius, *De natura rerum*

Life Irrepressible

All historians of Art Nouveau have stressed the relationship between the movement's aesthetics, understood in terms of its formal criteria, and the dramatic upsurge in the scientific observation of nature. Startling advances in science shed new light on the origins of life and the evolution of the species. Drawing upon these developments, decorative art at the turn of the century created an array of animal and plant hybridizations: door handles, bedspreads and subway entrances adorned with floral motifs, combs decorated with dragonflies, lampshades resembling medusas, paper knives with mermaid-shaped handles.

The Symbolist generation was deeply sensitive to the pullulating force of creation, which humanity tried in vain to stifle: "What was decided among the prehistoric Protozoa cannot be annulled by an Act of Parliament."[1] The proliferation of life, accompanied by the imperceptible transformation of species over the ages, was seen as a relentless wave, an inescapable physical principle of universal history. This whole notion is strikingly embodied in Léon Frédéric's **Nature** (or *Fecundity*, 1897), in which a woman nurses her children 364 smothered among a wild profusion of plants, like a Flora of Stabiae being interviewed during a nightmare. The Belgian painter's predilection for depicting biological propagation is evident in other works, including *The Brook*, a triptych dedicated to Beethoven in which an accumulation of naked children are seen dallying by the water. Even more extraordinary is Mehoffer's **Strange Garden** (1903), a kind of enchanted horn of plenty disgorging a torrent 347 of multicoloured flora, in which the family of the artist symbolizes the generations of life. As if this were not enough, an antediluvian dragonfly with golden elytra hovers over the scene. More subdued is a sculpture by the Czech artist Alfons Mucha entitled **Nature** (1900), a gilt 363 bronze and silver allegory clearly related to the theme of the femme fatale.

Charles Darwin published *Origin of Species* in 1859 (a French translation appeared in 1862) and its logical extension, *The Descent of Man*, in 1871. One of his principal themes was sexual selection. Among the other scientific reference points of the Symbolist period, the

1. Patrick Geddes and J. Arthur Thomson, *The Evolution of Sex* (London, 1898), p. 267. Quoted in Shearer West, *Fin de Siècle: Art and Society in an Age of Uncertainty* (London: Bloomsbury, 1993), p. 70.

findings of Johann Mendel were perhaps pre-eminent. Through his experiments in the hybridization of plants, the Austrian biologist demonstrated the observable characteristics, dominant and recessive, of all biological life. Their unpredictable mathematical permutations led to a formal theory of heredity. A dominant theme in the Naturalism of Zola, heredity was also a preoccupation of the Symbolists – its fatalistic and flamboyant aspects in particular. The infinite ramifications of the processes of natural selection were the subject of intense and enduring fascination during this period of "Hot House Blooms".

In a series of lithographs entitled "The Origins" (1883), Odilon Redon rightly situated the birth of cellular life at the bottom of the ocean ("When life first stirred in the depths of darkest matter."); Wagner's four-part *Ring* cycle, composed around the same time, placed the origin of human conflicts at the bottom of the Rhine. The botanist Armand Claveau was a strong influence on the imagination of Redon,[2] as evidenced in the artist's monsters and larval organisms awakening on the surface of swamps, symbolizing the origin of all animal life, indeed the roots of all civilization. Redon, in this sense, had disciples in Kubin and Kupka, who saw in the figure of the monster the possibility of a reversal of the life cycle.

Redon's penchant for the monstrous encompasses the barbarous and the savage, which arouse in him a feeling of "nostalgia for a more primitive life".[3] The phantasmagorical creatures of Redon's imagination exist within the border zone between the newest discoveries of experimental science and a terrifying medieval bestiary. Des Esseintes's cabinet of curiosities included many such works: "Among the ubiquitous boulders and glacier mud-streams wandered bipeds whose apish features – the heavy jaws, the protruding brows, the receding forehead, the flattened top of the skull – recalled the head of our ancestors early in the Quaternary Period, when man was still fructivorous and speechless."[4] Redon's **Smiling Spider** (1881), one of his most widely known creatures, is also an animal-human hybrid; with its pointed teeth it "weaves its web in the depths of our brains". In Redon's work, the spider – a terrifying creature to begin with – evokes the recurrent theme of the severed head, the trickles of blood transforming into numerous legs or ineffectual cilia. Even more grotesque is Carriès's **Le Grenouillard** (about 1891), representing a hybrid phase somewhere between human and amphibian, and illustrating that the Symbolist mind was more interested in the metamorphosis, the moment of transfer, than in static states. **Le Grenouillard** also points to a well-established physiognomic tradition that, from Lavater to Grandville to Gustave Doré, pervaded the entire nineteenth century.

The "**Black Death**" series by the Norwegian painter Kittelsen, with its hordes of rats invading a village, was a striking symbol of the plague; in **The Monster of the Lake**, a frightening lacustrine creature emerges from the drab waters with only the top of its head and eyes visible – an amusing harbinger of the obsessions of contemporary science fiction. Even more modern are two watercolours by the Czech artist Josef Váchal, *The Elemental Plain* (1906) and *The Astral Plain* (1907), which depict a dense tangle of protozoan beings, larvae and plant forms, anticipating certain Surrealist visions (those of Tanguy and Matta, in particular).

The linking of natural selection with the laws of heredity accentuated even further

355

356

251-262

346

2. See Barbara Larson, "La Génération symboliste et la révolution darwinienne", in *L'Âme au Corps*, exhib. cat. Paris, Grand Palais (Paris: Réunion des musées nationaux, 1993), p.333.
3. Odilon Redon, *À soi-même* (Paris, 1979; originally published 1922), p.70.
4. Joris-Karl Huysmans, *À rebours*, chapter 5 (Paris: Folio/Gallimard, 1977), p.159; quoted in English from *Against Nature*, trans. Robert Baldick (Harmondsworth, England: Penguin Books, 1959), p.73.

the long-standing interest that Symbolism had for atavism, the dangerous distortions of which can be seen in Cesare Lombroso's theories of criminality. Edvard Munch dealt with the subject, most notably in his scandalous *Madonna*, with its dead fetus and dance of spermatazoa around a bare-bosomed woman. Even more explicit are his *Family Trees*, drawings from 1894-1895, in which the face of his father is entwined in the roots of a family tree, while the maternal body serves as its trunk. The notions of inherited characteristics and the gradual extinction of species provided grist to the mill for the theory of decadence, the catastrophic vision of evolution that was held in particular by Max Nordau (*Entartung*; *Degeneration*, 1895) and Oswald Spengler.

445

357-358

The Femme Fatale

The male at the end of the nineteenth century was terrorized by the female. This common-place certainly applies to Symbolist artists; it applies, in fact, to the entire Decadent era. Whereas the male hero of Byronic Romanticism was a willing Sadian actor, in late Romanticism he was considered a victim. In Sacher-Masoch's novel *Venus im Pelz* (1870), Wanda's declaration to Séverin may stand as the era's *petitio principii*: "I seek pleasure," she says,

> because I don't believe in happiness. Everything that men call happiness exists only in their imagination . . . and since there is no joy without the thorns of torment, instead of complaining of my lot, I take vengeance on hostile nature by playing the role of destiny with regard to others. If I cannot be happy, I can at least have the pleasure of seeing them suffer, and my pleasure is increased tenfold when I am the cause of their suffering.[5]

Owing to the prejudices inculcated by religion, the Catholic religion in particular, the female appeared as the vector of earthly evil, the objective ally of the devil. The apocalyptic visions in Flaubert's *Tentation de saint Antoine* gave rise to a satanic conception of women, embodied shortly thereafter by Rops and Redon: "Amidst the shadows Anthony glimpsed a sort of grotesque monster. It was a skull with a crown of roses. Under it was a woman's torso of nacreous white; below, a shroud spangled with gold in the shape of a tail. And the entire body undulated, like a gigantic worm trying to stand upright."[6] The woman's physical appearance may be diabolical, like Mendès's Méphistophéla: "And the Beloved, in fact, was no longer herself; filled with the Demon, she could feel herself being possessed."[7] Or, an apparent innocence may veil her true nature, as with Péladan's Princess d'Este: "A Botticelli or saint unclothed as a nymph will appear ill at ease in the perversity of a depraved form."[8] In either case, the femme fatale spread her black wings over this period, an emblematic creature, the idol-fixation of the castration complex that most of the artists of the period displayed. The so-called male resignation at the turn of the century may explain why Symbolist heroines adopted male characteristics. Wilde's Salomé, through her wilfully obsessive desire,[9] represents the appropriation of male authority to the detriment of the helpless and

329

5. Leopold von Sacher-Masoch, *Venus im Pelz* (1870), published in English as *Venus in Furs*, and quoted here in English from a French translation provided by the author, by way of the Italian edition, trans. G. De Angelis (Milan: Biblioteca dell'Eros, 1993), p. 89.

6. Gustave Flaubert, *La Tentation de saint Antoine*.

7. "Black, red, golden, she arose, diabolical and celestial, extraordinary. With her long thick hair, her mysterious gaze and fresh, blood red lips, she was woman; with golden hair on her arms and legs and her goat's feet, she was beast; and while her forehead shone with a diadem of black diamonds, like a constellation of accursed stars, she triumphantly displayed, under scarlet and gold, the wild splendour of the ostensorium! . . . The universal multitude of virgins, wives and widows made their way towards the altar; they sang, danced, rejoiced, kissed each other on the mouth; if men tried to restrain them, they would pounce on them, pierce them with their laughter, leaving them by the roadside, bloodied and dying." Catulle Mendès, *Méphistophéla* (Paris: Dentu, 1890), p. 409.

8. Joséphin Péladan, *Le Vice suprême* (Paris: Éditions des Autres, 1979), pp. 29-30.

9. In her "dialogue" with the dismembered head of Jokanaan, Salomé says, "Open your eyes! Raise your eyelids, Jokanaan. Why don't you look at me? Are you too afraid to look at me? . . . Well, Jokanaan, I am still alive while you are dead, and your head belongs to me. I can do with it what I may. I can throw it to the dogs or to the birds of the air."

dumbfounded man (just as it reveals the homosexuality of the author). This male weakness was at the same time confirmed by the study of the animal world. Following Jean Henri Fabre's ten-volume *Souvenirs entomologiques* (1879-1907) and concomitant with Maeterlinck's research on insect behaviour, Remy de Gourmont published an "essay on the sexual instinct" entitled *Physique de l'Amour* (1901-1903), where he lingers over the sexual cannibalism of the praying mantis, one of Symbolism's totemic creatures:

> The male has certain poses and eye movements that the female seems to regard with indifference or disdain. Weary of parading, however, the male makes his move: with wings spread, his entire body quivering, he jumps onto the ogress's back . . . While the male enlaces her and inseminates her, however, the female turns her head and calmly eats her sexual partner.[10]

This type of zoological observation, rife with allusions to human behaviour, was in keeping with the normative codes of Victorian society, a society more than ever defined by the principle of the sexual distribution of tasks. Adopting the Darwinian doctrine of natural selection and the liberal idea, developed by Milne-Edwards among others, of the psychological division of work, Herbert Spencer suggested that society was a living organism, dependent upon certain dynamic relationships ranging from homogeneity to heterogeneity and in which the differentiation of tasks, as a sign of progress, must result in a harmonious co-operation among all individuals.[11] At the end of the century, when women were fighting for emancipation and the right to vote, when they had to be accompanied by their husbands if they wanted to take a university course, the gradual imposition of these Darwinian laws – "Darwin and his followers asserted that men were katabolic (or energetic), while women were anabolic (or lazy)," etc.[12] – was tantamount to freezing the status quo and perpetuating the traditional reactionary perception of the male-female relationship as "aerial-terrestrial". The majority of Symbolist artists shared this view. In a famous article, August Strindberg inveighed against the lack of courage, the duplicity, the dependency on the man, all of which proved the "inferiority" of women.[13] And yet, few movements approached sexual themes as freely as Symbolism: the provocative inventions of the Decadent artists intentionally contrasted with the moralizing and the ponderous scientific observations of such as Max Nordau and Richard von Krafft-Ebing, whose inflated taxonomies often verged on the ludicrous.

Symbolist art approached these themes not through Positivist analysis but metaphorically: from a historical perspective, this was its great strength. The decidedly masculine faces of Rossetti's and Burne-Jones's ideal beauties, and their occasionally ghoulish stares, tell us much more about the masochistic tendencies of fin-de-siècle culture than the clinical nomenclature of Krafft-Ebing, where the *libido sexualis* becomes inventorial (sexual hyperesthesia, chronic nymphomania, myxoscopy, psychic necrophilia).[14] Seen in these terms, the Pre-Raphaelite master's *Beata Beatrix*, *Astarte Syriaca* and *Day Dream* were merely neurotic constructions, far afield of what their contemporaries described as the simple and wholesome natures of Elizabeth Siddal and Jane Morris.

The archetype of the femme fatale no doubt dates from the dawn of time; her image in Western painting, however, is fairly recent. Baroque painting was traditionally interested in

10. "The devouring of the male, then, would simply represent, partially or completely, the most primitive form of the union of cells, this blending of two units into one which precedes segmentation, which nourishes it, makes it possible for a limited period, after which a new union is necessary." Remy de Gourmont, *Physique de l'Amour* (Brussels: Les Libertés belges, 1944), pp. 114-115.

11. Herbert Spencer, *The Principles of Sociology* (1855); a 5-volume French edition appeared in 1878-1898.

12. West, 1993, p. 70. See also Harry Campbell, *Differences in the Nervous Organization of Man and Woman* (London, 1891), quoted *ibid*.

13. August Strindberg, "De l'infériorité de la femme", *La Revue blanche*, January 1895, pp. 1-10.

14. Richard von Krafft-Ebing, *Psychopathia Sexualis*, revised edition by Dr. Albert Moll, 1923, translated into French by R. Lobstein (Paris: Climats, 1990).

female victims, such as Sophonisba, Lucretia and Dido, who take their own lives rather than succumb to dishonour and disgrace. Guercino, Artemisia Gentileschi, Simon Vouet and Mattia Preti all rendered them as *exempla virtutis*, both moving and sexually troubling.

Böcklin's beautiful **Dying Cleopatra** (1872), with its reference to Guido Reni, belongs to this tradition. The Queen of Egypt's spasm after being bitten by the asp plunges her face into shadow, a tragic – and superbly theatrical – way of showing us that she is losing consciousness and that a fatal languor is pervading her body. The image contains a Sadian element of late Romanticism, and it is no exaggeration to say, if one is to believe Sainte-Beuve, Flaubert and Swinburne, that the shadow of de Sade extended over the entire Romantic era. More masochistic and more imbued with an imagination of conflict were those Symbolist works dealing with sexual or political themes. Thus Aristide Sartorio, in reviving the theme of the water nymph or mermaid, depicts in **The Green Abyss** (1895) a female water creature luring a young man in a boat towards the edge of an abyss.

It was Gustave Moreau, and he alone, who invented the ecstatic figure of Salome as she confronts the levitating head of John the Baptist. Obeying "her passionate and cruel female temperament", she breaks down the resistance of men with "the charms of a great venereal flower, grown in a bed of sacrilege, reared in a hot-house of impiety".[15] Edvard Munch developed the overtly masochistic implications of this theme with his watercolour **Salome Paraphrase** (1898). It shows his self-portrait against a red monochrome background, encircled by the straggling locks of a woman who hovers close, and whose head seems to take on the shape of a vulva.

An icier version is Klinger's **New Salome** (1893), in which a very young woman contemplates the magnitude of her act. In the marble version at Leipzig, amputated heads surround her like so many trophies. Another example is von Stuck's **Sin** (1899), wherein the master of the Munich Secession presents one of Symbolism's most beloved archetypes – the tempting and destructive woman. The seductive Eve-like figure here wrapped in the coils of an enormous black snake blithely observes the viewer. She is Lilith incarnate, the Talmudic demon resurrected by Remy de Gourmont in one of his unproduceable plays (1891-1892), where Satan addresses her, "Yes, Lilith, I will give you Man, I will place him under your power, so that you may debase him, so that his tears may be ridiculous, his joys shameful, his house a hospital and his bed a brothel!"[16]

On another level, women were seen as bearers of evil tidings, carriers of epidemics – as in Rops's "**Satanic Ones**" and Kubin's **Great Babylon**. The title of Munch's **Vampire** (1893), at first called *Love and Pain*, was suggested by the artist's friend, the writer Przybyszewski (whose livid face appears prominently in **Jealousy**). "Vampire" was more attuned to the two men's masochistic pessimism. What at first was "simply a woman kissing a man on the nape of the neck" became the witnessing of a man's destruction, a sign of "an immeasurable fatality of resignation".[17] Significantly, Munch linked the theme of the vampire with that of the femme fatale at a time when Bram Stoker was frightening Europe with *Dracula* (1897), the source of one of the most potent myths of the twentieth century.

Another example of zootropism, this time tinged with humour, is Malczewski's

15. Huysmans, 1977, p. 153; translation, p. 68.
16. Remy de Gourmont, *Lilith* (Paris: Mercure de France, 1921), p. 85.
17. Munch and Przybyszewski respectively, quoted in Reinhold Heller, *Munch: His Life and Work* (Chicago: University of Chicago Press, 1984), p. 129.

367

393

371

369

394

131-134, 399, 366

155

Harpy in a Dream (1907). It provides yet another striking self-portrait of the Polish painter, this time caught in a creative trance, projecting the powerful image of a ravenous she-monster – unless this dream image is reciprocal, as in Hodler's ***The Dream***, and the artist is the creation of the monster. Like Alfred Jarry's dreadful Mère Ubu, "She has claws everywhere, and you can't get hold of her."[18] The large clawed foot next to the delicate hand of a musing Malczewski is atrociously comic. The painter takes to ridiculous extremes the velvety figures of the Pre-Raphaelites and Fernand Khnopff (*Caresses*, for example, with its pensive Adonis and affectionate Sphinx), presenting masculinized ideals of beauty (Jane Morris, Marguerite Khnopff) whose timeless and asexual severity herald the end of history, as it were, an *ultima Thule* of the senses.

In an era when nudity was scandalous, it is not surprising that fetishism should prosper. Through a series of mnemonic associations such as "unhealthy" predispositions are liable to, articles of clothing and accessories can become the object of sexual fixations.[19] There is no better variation on this theme in Symbolist culture than Max Klinger's "***Glove Series***" (1881). The fate of a woman's glove is surrealistically depicted in a group of masterfully controlled images of frenzy and delirium. As the sole trace of a desired woman, the fetishistic glove is the eidolon substitution (the currency of exchange, in economic parlance) in an evolving fantasy: the glove rends the night sky, clenched in the jaws of a winged monster; magnified tenfold, it lies behind the bed of the artist in the throes of a nightmare; it rides triumphantly in a giant horse-drawn conch. These images of displacement, among the most oneiric of the period, prove (if proof were necessary) that Freud's ground had been well prepared by artists.

Adolescent Awakenings

Far removed from the excessive images of the castrating female vampire was the myth of the androgyne, towards which many Symbolist artists – often the very creators of these images – gravitated. This theme was especially popular among those attracted to the occult, including the circle who exhibited at the Salons de la Rose + Croix. Sâr Péladan himself described the androgyne as a "nightmare of decadence",[20] by turns the "supreme sex, a third mode", the "sex of Joan of Arc and the sex of the miracle", the "sex that denies sex, the sex of eternity".[21] His own disguise as a bearded man in the flowing garb of a woman went beyond the farcical figure portrayed by gossip columnists to embody a striving towards the ideal of a fusion of the sexes. The Rosicrucian androgyne in some manner superimposed the ancient Roman figure of Antinoüs and the Christian angel. Poised between Good and Evil, the androgyne's timeless beauty was regarded as the purest expression of artistic genius.

This is what Delville wanted to express in his ***Love of Souls*** (1900), an apotheosis of the mystical union, in turbulent ether, of a young man and woman whose features and form are of an androgynous cast. Equally beautiful, their bodies are an ideal match. In a final burst of Romanticism, they express a desire to escape the limitations of their sex, to minimize

18. Alfred Jarry, *Ubu Roi* (1896), Act V, scene 1.
19. "Observation 190, -X, age 33, manufacturer, American, happily married for eight years . . . When he was allowed to press the hand of a woman wearing glazed leather gloves, he was able to achieve erection and orgasm through the effects of 'warm and soft' leather. When he managed to obtain one of these gloves, he took it to the bathroom, wrapped it around his genitals, removed it and masturbated." Krafft-Ebing, 1923, p. 377.
20. Péladan, 1979, p. 126.
21. Joséphin Péladan, "L'Androgyne", *La Plume*, no. 45 (March 1, 1891), pp. 83-84. Quoted in Jean da Silva, *Le Salon de la Rose + Croix* (Paris: Syros-Alternatives, 1991), p. 42.

their differences, to meld into a perfect union of male and female. The Rosicrucians, and the Symbolist generation in general, cherished the Platonic notion that man and woman were the victims of the painful division of the original androgyne. The mystical and sensual quest for the ideal was thus a search for a primordial unity.

This nostalgia for a Platonic ideal, perfectly incarnated by the young man of Preisler's *Black Lake* (1904), was already present in the theories of Winckelmann and Neoclassical art.[22] A symbol of purity, the youthful and icy beauty of the androgyne had often symbolized the search, in line with the philosophy of the Enlightenment, for the immaculate being who preceded the corruption of history, an avatar of Republican virtue like David's *Bara* (1794), an ephebe put to death by the enemies of the Revolution.

425

Unlike Courbet, the Symbolists *saw* angels. They depicted that moment of equilibrium in the sexual indifferentiation of the adolescent, that moment of hesitation between femininity and masculinity, like the hesitation between youth and adulthood. This moment of vacillation was regarded by most authors of the fin de siècle as a state of absolute grace. Ferdinand Hodler's mysterious *Enchanted Boy* (1894) is a perfect example. Few images have so powerfully conveyed the hope embodied in nature's perpetual cycle of renewal. The boy, transported by an inner music, clutches a freshly plucked flower and holds it out to us enigmatically. For this work, and for the kneeling child in *Adoration III*, another variation on the theme of the Beloved, Hodler chose his own son Hector to model.

422

Frampton's *Flora of the Alps* (1918) works on the same level. A nude adolescent, wearing a crown of flowers on her head, turns away from the imposing mountain panorama and invites us into the "communion with infinity" that unites her with the landscape. The touching nostalgia of this *himmliche Leben* has parallels with the private mythology of Maurice Denis, wherein "figures of the soul", neither man nor woman, wander through sacred groves and along the byways of faith. Viennese culture at the beginning of the century added a new feeling of torment, of irresolution and anxiety with regard to the sexual mysteries besetting the young adolescent. Examples include Kokoschka's *Die träumenden Knaben* (1908), with its slender bodies in a fairy-tale setting; Robert Walser's *Jakob von Gunten* (1909), a novel in which the eponymous protagonist suffers the slings and arrows of the mysterious Benjamenta Institute, at once a prison and veiled paradise; and *Adolescence* by Elena Luksch-Makowsky (1903).

421

424

427

Paradoxically, at times this treatment of eternal youth cannot be separated from another phenomenon that grew more and more evident at the turn of the century: consciously or not, it became a metaphor of homosexuality, that scourge and terror of Victorian society. The adolescent symbolized Adam before the Fall. Here again we see a dual movement: psychiatry used the most normative and humiliating categories to define homosexuality, while its repression gave it the status of a curse or plague. In Wilhelmian Germany, Article 175 of the Penal Code severely punished any sexual relations between men. Literature and the visual arts, on the other hand, approached the question with increasing openness. In *À rebours* (1884), the scene where Des Esseintes is approached by a youth on the Esplanade des Invalides is explicit and eminently modern.[23] Similarly, Jean Lorrain's *Monsieur de Phocas*

22. "Ideal beauty, for the Gods, derived from the natural beauty of perfectly built boys." J. Winckelmann, *Histoire de l'Art chez les Anciens* (Geneva: Minkoff-Reprint, 1972), p. 267. (Originally published as *Geschichte der Kunst des Altertums* [Dresden, 1764].)

23. "They gazed at each other for a moment; then the young man dropped his eyes and came closer, brushing his companion's arm with his own. Des Esseintes slackened his pace, taking thoughtful note of the youth's mincing walk.

"And from this chance encounter there had sprung a mistrustful friendship that somehow lasted for months. Des Esseintes could not think of it without a shudder... Never had he known such satisfaction mingled with distress." Huysmans, 1977, p. 218; translation, p. 116.

(1901) does little to hide the sexual preferences of its author (which was not, at any rate, the intention). And one of the most important books of the Decadent age, *The Picture of Dorian Gray* (1890), revolves around a haunting obsession of the homosexual psyche: growing old. The plot of the dandy preserving his boyish beauty forever while his portrait reflects his true state of degeneracy is a quintessential homosexual fantasy, albeit with universal significance.[24]

434

It is against this subtly woven backdrop that one should view such paintings as Enckell's *Awakening* (1894), in which a nude boy rising from bed is caught in a state of numbness, of doubt and fear regarding life's mysteries. The works of American photographer F. Holland Day are further variations on the moving and troubling theme of the ephemeral beauty of youth. Even more explicit are the theatricalized photographs (sometimes sublime, 431, 517 sometimes unintentionally grotesque) of Baron von Gloeden, a self-imposed exile in Taormina, ensconced in an Arcadian dreamworld, an antiquified land of young Adonises. Underlying the often ambiguous appearance of these images is, once again, the aspiration towards an ideal purity, an unattainable earthly paradise.

Motherhood

"Love is an act of slight importance, since it can be made over and over again."[25] Alfred Jarry's provocative and mechanistic adage, amusing as it may be, did not meet with the approval of all Symbolists. From one end of Europe to the other, the majority of idealist painters and sculptors celebrated the cult of the mother. The theme of motherhood was no doubt linked to the revival of Catholicism and the major role the Church of Pius IX ascribed to Mary and the dogma of the Immaculate Conception. Paradoxically, this ancient theme, so decried by sixteenth-century Protestantism, not only flourished again but managed to associate itself with scientism and Darwinism, which took the principle of the regeneration of the species as a battle cry. It thus became, by design, a point of contact between Faith and Science.

The images of maternity were tangible evidence of a renewed form of Symbolism after 1900, a shift that showed more confidence in its aspirations and a gradual dispelling of its doubts. The search for the Ideal took on a more positive dimension at the turn of the century. In the words of Cardinal Newman, maternal fertility signified the "redeeming of decadence". The secular French Republic glorified motherhood, while its socialists were much attached to the theme's iconography, no doubt a new reaction against the Malthusianism that had reigned in France since the beginning of the century. The system of inheritance introduced by Napoleon I, which abolished primogeniture, resulted in a decline in the birth rate and a depletion of certain age groups, a situation that would become much worse with the Great War.

Many of the visual arts' celebrations of motherhood embraced a sort of angelic Catholicism. This was certainly the case with Maurice Denis, who was passionately in love with his wife Marthe and whose life, from 1894 on, was punctuated with the births of their numerous children. For Denis, the experience of conception and the long wait for birth were

24. "Yes, [Dorian] was certainly wonderfully handsome, with finely-curved scarlet lips, his frank blue eyes, his crisp golden hair. There was something in his face that made one trust him at once. All the candour of youth was there, as well as all youth's passionate purity. One felt that he had kept himself unspotted from the world. No wonder Basil Hallward worshipped him." Oscar Wilde, *The Picture of Dorian Gray*, in *Complete Works of Oscar Wilde* (London and Glasgow: Collins, 1975), p. 27.

25. Alfred Jarry, *Le Surmâle*, 1902 (Paris: Ramsay-Jean-Jacques Pauvert, 1990), p. 7.

articles of faith in the Marian cult. Another sire of a large family, Giovanni Segantini, despite being an anarchist and Nietzschean, elevated the mystery of conception above all else. His **Angel of Life** (1894) is a pantheistic exaltation of nature's inexhaustible burgeoning, of the direct link between the birth of Christ and the absolute goodness of Creation. Even more impressive is Gaetano Previati's **Motherhood** (1891), the first great Italian Symbolist painting. In it, the former illustrator of Edgar Allan Poe has adapted the theatricality of his earlier, very decadent **Women Smoking Hashish** (1887), thereby introducing an amusing soteriological mechanism. Around the mother of Christ, who is leaning against a Tree of Life, a host of angels seems to sway rhythmically like a field of rippling wheat. A sacred theme is thus associated with the celebration of natural renewal.

317

451

223

Giovanni Giacometti's 1900 canvas **Mother and Child under a Blossoming Tree** is rendered in a Divisionist style reminiscent of his friend and master Segantini. It too symbolizes the ever-changing cycle of seasons. Exceptionally, Van Dongen portrays his own family in **In Praise of Guss and Dolly** (1905): their monumental faces appear in the sky, in a kind of Pointillistic mosaic, below which a landscape is made minuscule by the effects of distance. American photographer Gertrude Käsebier was also interested in this exaltation of the mother, seen through the prism of personal experience. Her heartfelt Symbolism was decidedly close to reality.

450

444

449

Maternalism could also serve as a vehicle for moral catharsis, distilling profound feelings of pessimism. A number of Symbolists depicted the maladies of childbirth: Edvard Munch's frightening *Inheritance* for example, portrays a bleeding infant bewailed by her pallid mother, a carrier of syphilis. George Minne's **Mother Grieving for Her Two Children** (1888) expresses a despair that deforms the entire body. More complex is Gustave Klimt's **Hope I** (1903), in which threatening portents cluster around a nude red-haired woman with protruding abdomen. The expectancy of the period of gestation here is compromised by the apocalyptic evils – death, illness, madness – that are subtly sketched out. Within the complicated network of interlocking decorative themes (as if copied from a Japanese kimono) appears a hideous sea monster from the deep, with claws and a serpent's tail, a brilliant image of the *Ungeheuer* that infiltrates the mind of the mother and gnaws away at her confidence. Almost contemporaneous with Klimt's painting is Cuno Amiet's polyptych **Hope** (1902), which conveys a similar note of disquiet. The child in the predella above Anna, the artist's wife, sees its life threatened by the two skeletons adorning the side panels, who seem right out of some medieval millenarian imagination. Behind the mother is a large black curtain, a sign of mourning, which allows a glimpse of sky filled with clouds, a sign of hope.

440

438

439

Most of the artists of the era censured the abnegation of maternal duties. This "danger", according to Krafft-Ebing, was brought about by the rampant women's emancipation movement: "Whereas in former times a married woman considered reproduction her highest duty, and felt an instinctive need to have many children, the desire to give birth has now grown weaker."[26]

This threat to motherhood was also underscored by Segantini in his *Unnatural Mothers* (1896), one of the most unforgettable images of Symbolist culture. Inspired by a

26. "The veneration of virginity, which only a few years ago was a girl's most precious possession, is no longer so widespread . . . The female soul is now in a state of transformation. The maternal instinct is no longer as powerful as it once was." Krafft-Ebing, 1923, p. 127.

"translation" of a purported Indian epic, the Pāngiavāhli, the Italian painter deals with the theme of mothers who have refused their sacred duty and are destined to nurse their dead infants forever, their bodies bound to bare trees amidst vast expanses of snow and ice.

In Search of Innocence

470 On the gilded frame of his *Nuda Veritas* (1899), Gustav Klimt inscribed one of Schiller's maxims: "If you cannot please everyone through your actions and your art, please a small number of them. It is wrong to please a large number." Placed before the glorious body of an immaculate woman holding a mirror, this phrase encapsulates Symbolism's main facets: sincere commitment, honesty of language and intention, aptness of metaphor. For beyond the dissimulations of matter, beyond the stylistic mannerisms, the sex and perversion that Symbolism adopted, sometimes with great affectation, it was ultimately dedicated to a passionate pursuit of original purity, an unwavering quest to regain the primordial state of humanity. In many ways, it was a search for the naked truth.

469 The iconography of purity rested on proven imagistic ground: in Hawkins's *The Innocence* (about 1895), the young girl who personifies this virtue holds an olive branch in front of a row of lilies; a dishevelled woman, a sort of benign Medusa, warns her of the worldly temptations awaiting her, symbolized by a crowned globe. A wall hanging in the background alluding to the Apocalypse, combined with the golden monochrome of the whole, lends a deeply moralistic tone to the allegory. The Symbolist era is peopled with diaphanous young
453, 456 girls (Le Sidaner's *Sunday*, 1898), the unblemished betrothed (Matthijs Maris's *The Bride*)
458 and crystalline communicants (Carrière's *First Communion*). Maurice Denis was certainly in the vanguard of this theme. His entire existence was devoted to a clearly religious quest for purity: "Yes, it is our best hope that one of our works will spread and perpetuate a small amount of Truth from on high. Painters speak of God solely in terms of beauty, pristine whiteness, harmonious logic."[27]

316 The search for purity also involved a return (a regression?) to the innocence of childhood. In Wojtkiewicz's *Parting*, the sorrows of love unfold in a world of fairy tales, toy soldiers and rocking horses. One of the most perfect expressions of this striving towards
460 purity is unquestionably Segantini's *Love at the Fountain of Life* (1896). The white incandescence of the androgynously beautiful young couple, who seem clothed together in a pleated white veil, is echoed in the dazzling luminosity of the landscape. Joyous and carefree, the lovers confidently stroll along a path bordered by flowering rhododendrons. An angel unfolds its great wing above them, protecting the fountain towards they which they progress.

452 Finally, the work that perhaps best typifies the intimate pantheist interpretation of the cycle of existence is the magnificent *Mirror of Life* (1895-1898) by Pellizza da Volpedo. Possibly inspired by a reading of Dante, the silent procession of sheep against the light is assuredly one of the finest representations of the unending biological cycle. Together with its frame, in which the artist has sculpted undulating waves borrowed from Swedenborg, the

27. Maurice Denis, "Notes sur la peinture religieuse", in *Le Ciel et l'Arcadie*, ed. J.-P. Bouillon (Paris: Hermann, 1993), p. 34.

Mirror of Life is like a transliteration of Muybridge's *Animal Locomotion* (1887). Unintentionally reminiscent of liturgical texts (the *Dies irae*'s "Inter oves locum praesta" from the Requiem Mass) this procession calls to mind the flock of sheep seen by little Yniold in Maeterlinck's *Pelléas et Mélisande* ("The little sheep are coming; here they come. There are lots of them! Lots! They're afraid of the dark. They're huddling together . . . They'd all like to go to the right!").[28] As cogs of a perpetual motion machine, as abstract and unconscious victims of an unswerving design of nature, they signify the inexorable march of fate.

G. C.

28. Maurice Maeterlinck, *Pelléas et Mélisande*, Act IV, scene 3. Quoted in English from the translation by Paul Meyers.

Life Irrepressible

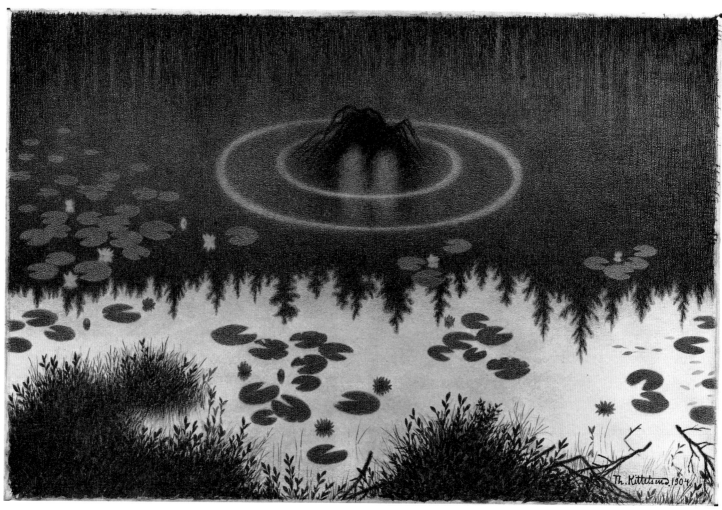

346 (cat. 198)
Theodor KITTELSEN
The Monster of the Lake, 1904
Oslo, Nasjonalgalleriet

347 (cat. 273)
Józef MEHOFFER
The Strange Garden
1903
Oil on canvas
222.5 x 208.5 cm
National Museum of Warsaw

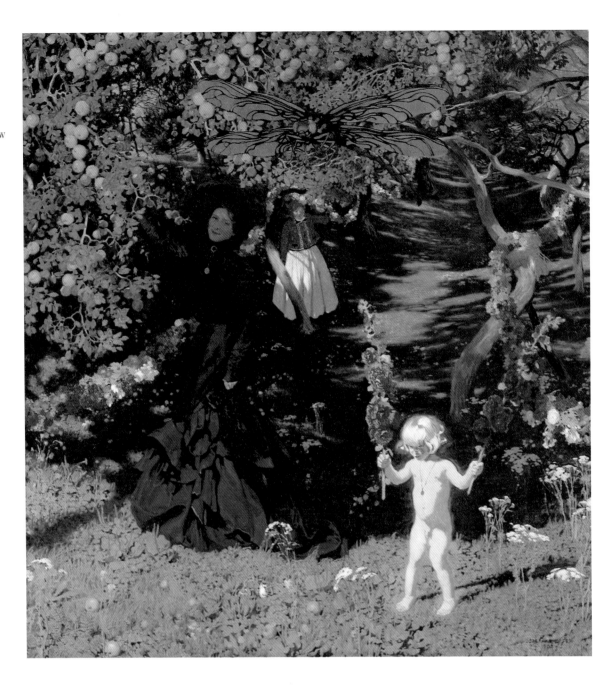

In a wild and overgrown garden, three figures wander, taking no notice of a huge golden dragonfly hovering above them. With its contrasts between dark and light areas and the detailed treatment of the fabric, the painting could well be a late Impressionist canvas. But there is a much more complex iconography in this afternoon garden, the ambiguities of which are apparent in its multiple alternative titles *Sun, In the Sun* and *A Strange Garden*. There is a calculated contrast between the brilliantly lit foreground, where a little boy (the artist's son) is carrying a stalk of flowers, and the shaded foliage behind him, where two women stand, one of them Mehoffer's wife. The movement towards the background of the composition, which corresponds to the progression in age of the figures, is emphasized by the winding path and the strange garlands of flowers echoing the flowering bough held by the child. His nakedness, signifying innocence, together with the luxuriance of flowers and the fruit-laden boughs, are allegories of plenty standing in counterpoint to the brevity of human life. Similarly, the figures portrayed, the painter's family, seem to be embodiments of the three ages of life, a concept also found in works by Puvis de Chavannes and Gustav Klimt. This garden flooded with sunlight, constructed like a horn of plenty from which mysterious beings might emerge, represents the irrepressible proliferation of biological life, as does the dragonfly in the foreground, yet another of Symbolism's most unforgettable motifs. In a format similar to that of a history painting, Mehoffer makes us see the continual growth of cellular life, at the very time when scientists were discovering long-lived forms of ancient life. The dragonfly with its uncoordinated outer wings was, after all, one of the first insects to appear on the earth.

G. C.

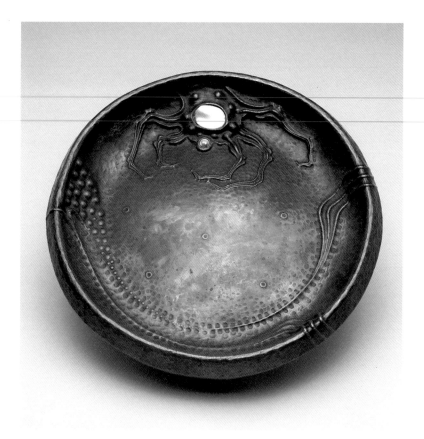

348 (cat. 446)
Ludwig VIERTHALER
Shallow Bowl, 1906
Minneapolis, Norwest Corporation

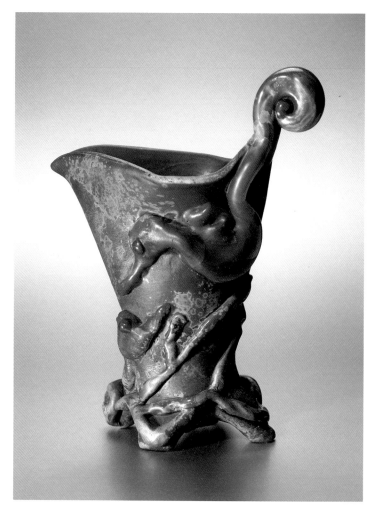

350 (cat. 122)
Émile GALLÉ
"Hypocampes" Vase, about 1901
Kunstmuseum Düsseldorf im Ehrenhof

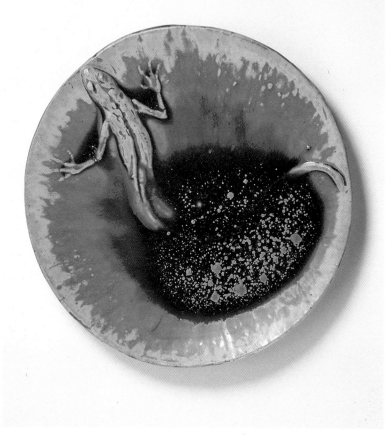

349 (cat. 355)
Pierre ROCHE and Alexandre BIGOT
Plate, 1897
Badisches Landesmuseum Karlsruhe

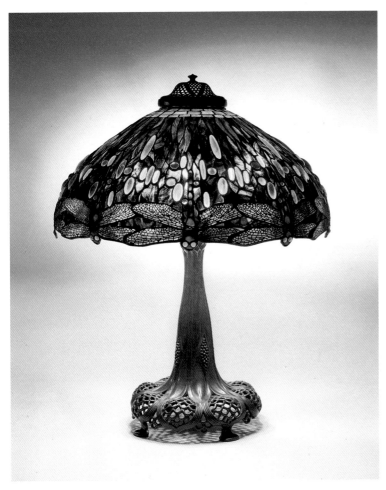

351 (cat. 427)
Tiffany Glass and Decorating Co.
"Dragonfly" Lamp, about 1900
Richmond, Virginia Museum of Fine Arts

353 (cat. 448)
Wilhelm Lukas VON CRANACH
"Octopus and Butterfly" Brooch, 1900
Schmuckmuseum Pforzheim

352 (cat. 120)
Émile GALLÉ
"Dragonfly" Coupe, 1903
Corning, New York, The Corning Museum of Glass

354 (cat. 219)
Alfred KUBIN
Fairy-tale Creature, 1903-1904
Linz, Oberösterreiches Landesmuseum

355 (cat. 349)
Odilon REDON
The Smiling Spider, 1887
Paris, Bibliothèque nationale de France

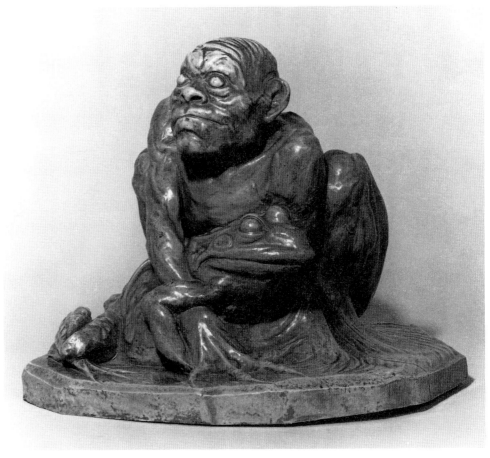

356 (cat. 45)
Jean CARRIÈS
Le Grenouillard, about 1891
Paris, Musée d'Orsay

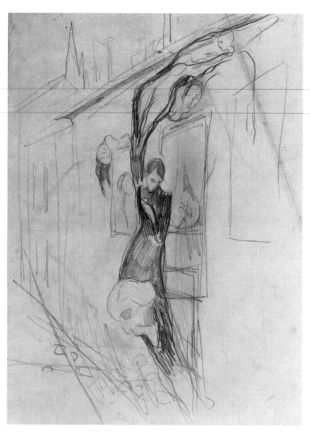

357 (cat. 294)
Edvard MUNCH
Family Tree, 1894-1895
Oslo, Munch-museet

359 recto (cat. 279)
Piet MONDRIAN
Chrysanthemum, about 1908-1909

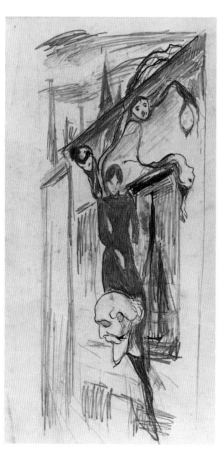

358 (cat. 295)
Edvard MUNCH
Family Tree, 1894-1895
Oslo, Munch-museet

359 verso (cat. 279)
Piet MONDRIAN
Young Woman, about 1908-1909
Northampton, Massachusetts, Smith College Museum of Art

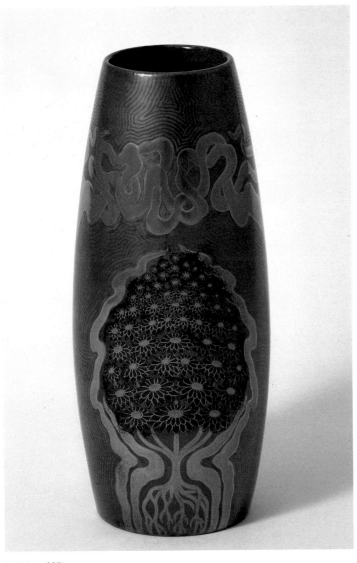

360 (cat. 485)
Vilmos ZSOLNAY and Lajos MACK
Vase, about 1900
Private collection

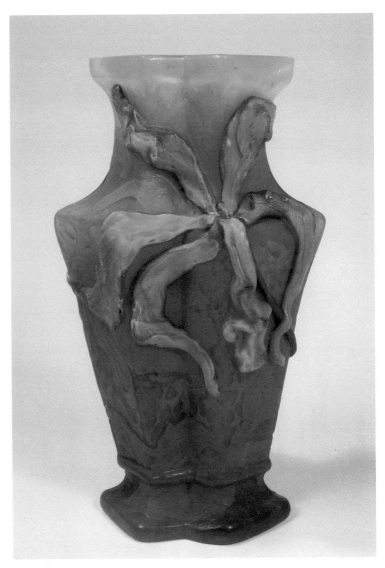

361 (cat. 124)
Émile GALLÉ
"Orchid" Vase, 1900
Château-musée de Boulogne-sur-Mer

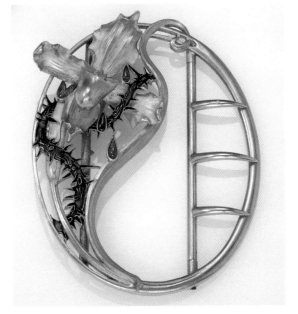

362 (cat. 236)
René LALIQUE
"Sabot de Vénus" Belt Buckle
Gingins, Switzerland, Neumann collection

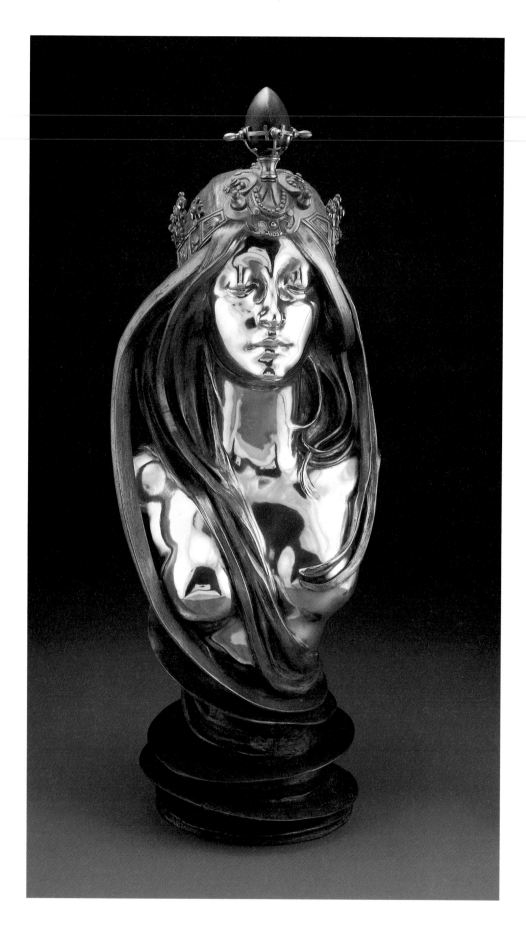

363 (cat. 291)
Alfons MUCHA
Bust: "Nature"
1899-1900
Gilt bronze, silver, marble
69.2 x 27.9 x 30.5 cm
Richmond, Virginia Museum of Fine Arts

Two years before Alfons Mucha created this bust, he had designed a page of a calendar with the signs of the zodiac encircling a similar woman's head wearing a jewelled crown surmounted by a large ovoid stone. From medieval times, Nature was allegorically represented as wearing a jewel-encrusted diadem symbolizing the stars and planets. For this bronze, Mucha turned his model into a stately, medieval Nature goddess, passive and beautiful beyond desire – an image that concurred with one aspect of the Symbolists' view of woman. The ample breasts of Mucha's goddess signify her fertility and at the same time her sensuality. The hair billows out and over her shoulders, flowing down her bosom to finally encircle her waist like a planetary ring. This treatment of the hair is characteristic of Mucha's graphic designs and jewellery, and it reflects the period's preoccupation with the dramatic power of women's hair. The swirling, luxuriant locks often entangled their prey like a living force, calling attention to woman's beauty in all its seductive power.

Three other versions of this sculpture are known, each varying slightly in the materials used and in surface treatment. Another model was exhibited in the Austrian Pavilion at the Exposition universelle of 1900 and again in Turin in 1902. Mucha had considered including a version of this bust in the interior of the shop he designed in 1900 for Parisian goldsmith Georges Fouquet. The artist's records include an early sketch of the fireplace wall, with the bust prominently displayed in the centre of the mantelpiece;[1] however, it was omitted from the final plan.
R. P.

1. Paris, Musée Carnavalet, inv. D.8078 (51).

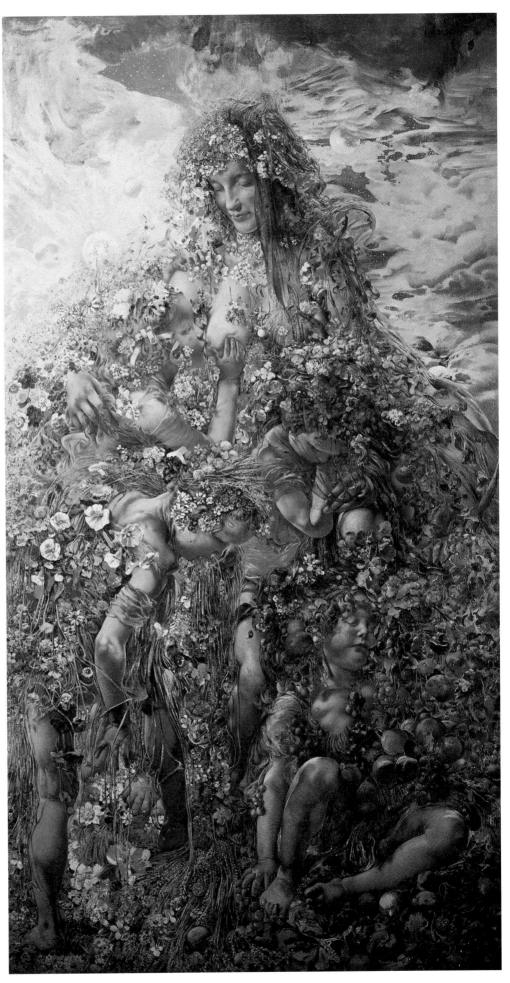

364 (cat. 118)
Léon FRÉDÉRIC
Nature, 1897
Private collection

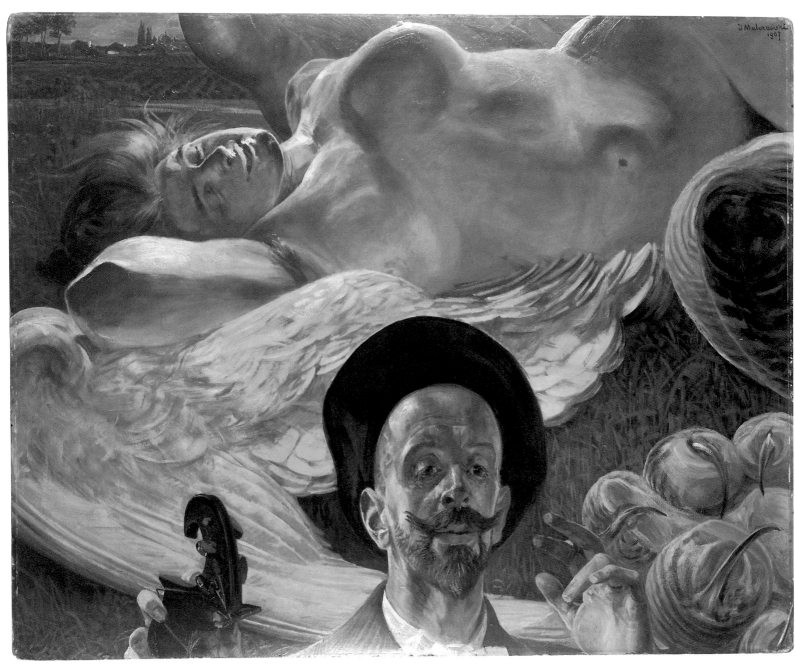

365 (cat. 261)
Jacek MALCZEWSKI
Moment of Creation: Harpy in a Dream, 1907
Poznań, Jerzy Nowakowski collection

366 (cat. 306)
Edvard MUNCH
Vampire
1893
Oil on canvas
80.5 x 100.5 cm
Göteborg, Sweden, Göteborgs Konstmuseum

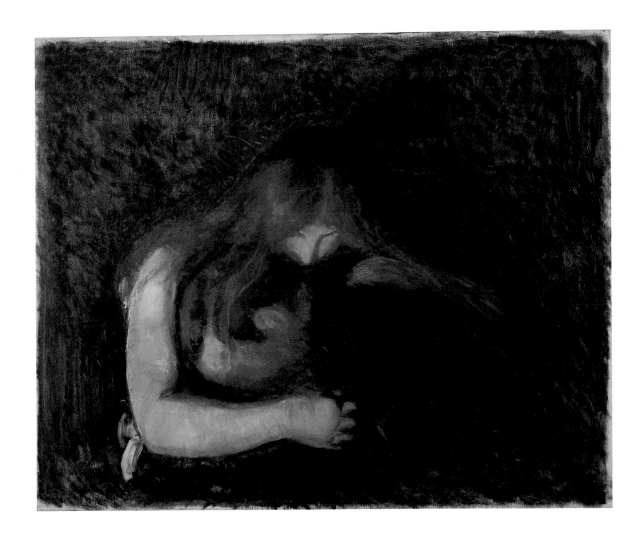

Confined within a darkness depicted in short, light brush strokes, a couple embrace; the man seems trapped, held as he is by the woman's hair that glimmers with red under a sinister light. The sado-masochistic game played by the two figures, disturbing in its contrasts of light and dark, takes on a terrifying connotation.

The murderous embrace was a common theme in the era of black Romanticism. Symbolism revived it, and there are innumerable images of lethal women in the writings of Barbey d'Aurevilly, Octave Mirbeau and D'Annunzio, just as there are throughout European painting from Gustave Moreau and Félicien Rops to Aubrey Beardsley. Munch's friendship with those two misogynist intellectuals, Strindberg the playwright and Przybyszewski the poet, probably had something to do with the appearance of this theme free of any dubious eroticism. Munch, whose early work often dealt with puberty and the ambivalence of desire and death, approaches the subject of the vampire woman with confidence. He did not share Rops's taste for macabre detail, preferring to convey meaning through his use of paint: the progressive dissolution of the outline of the man's body, absorbed into the darkness, becomes a metaphor for his slow enslavement, this psychological decomposition. Yielding to a violent need for destruction, he curls up into the vampire's body, that mocking phantom of his fickle memory.

G.C.

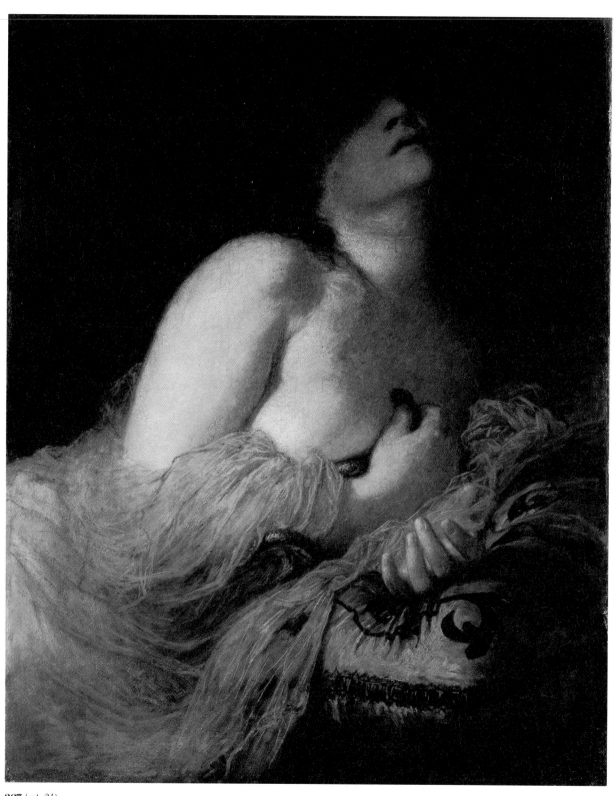

367 (cat. 24)
Arnold BÖCKLIN
Dying Cleopatra, 1872
Kunstmuseum Basel, Öffentliche Kunstsammlung

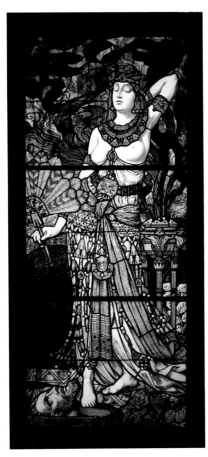

368 (cat. 119)
Jacques GALLAND
Stained Glass Window, 1900
Zurich, Bellerive Museum

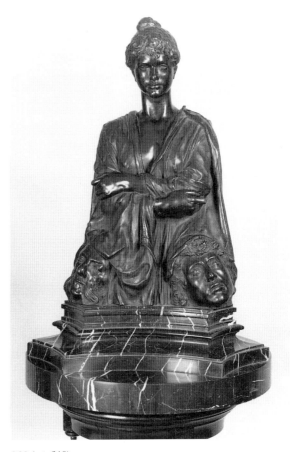

369 (cat. 210)
Max KLINGER
The New Salome, after 1893
Badisches Landesmuseum Karlsruhe

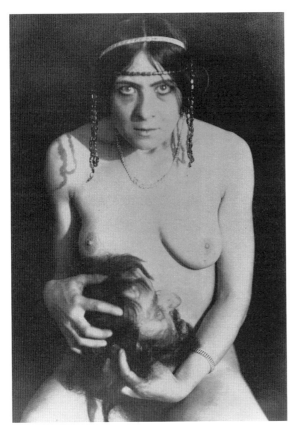

370 (cat. 86)
František DRTIKOL
Salome, 1912-1913
Museum of Decorative Arts in Prague

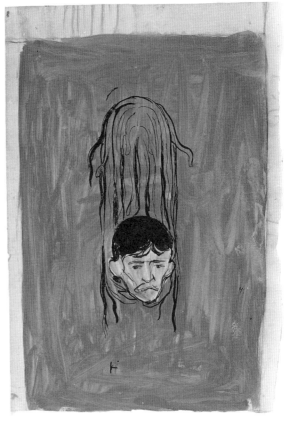

371 (cat. 301)
Edvard MUNCH
Self-portrait (Salome Paraphrase), 1894-1898
Oslo, Munch-museet

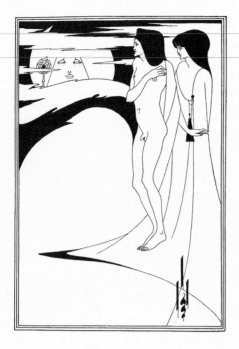

Plate I

372 *The Woman in the Moon*

Plate III

373 *Cover Design*

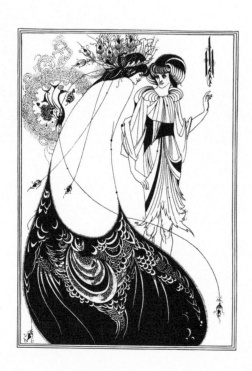

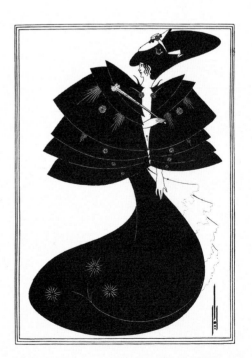

Plate V

374 *The Peacock Skirt*

Plate VI

375 *The Black Cape*

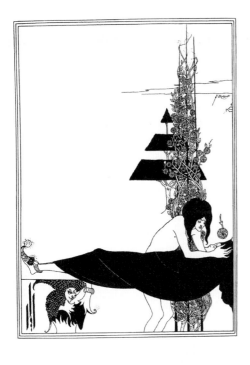

Plate VII

376 *A Platonic Lament*

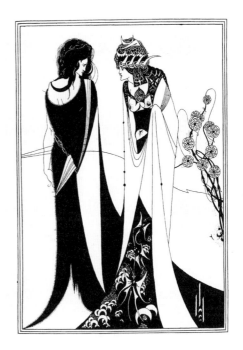

Plate VIII

377 *John and Salome*

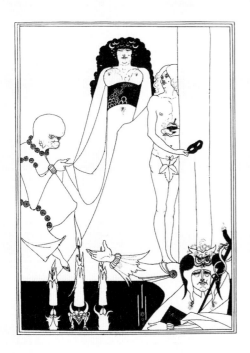

Plate IX

378 *Enter Herodias*

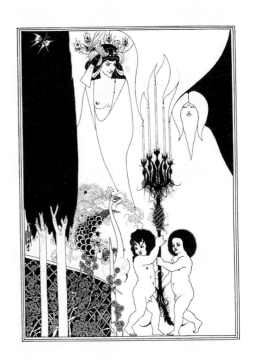

Plate X

379 *The Eyes of Herod*

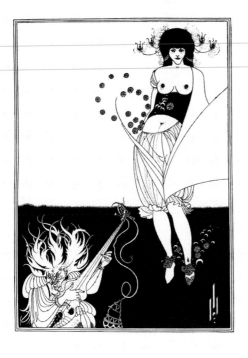

Plate XI

380 *The Stomach Dance*

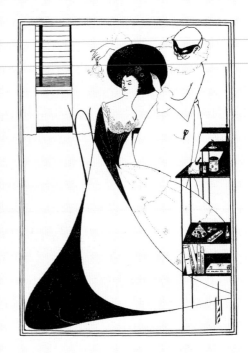

Plate XII

381 *The Toilette of Salome I*

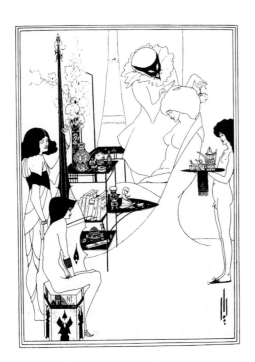

Plate XIII

382 *The Toilette of Salome II*

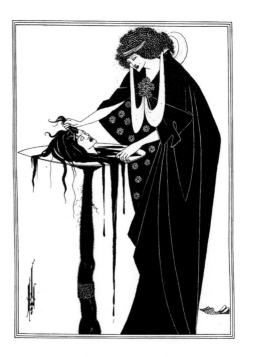

Plate XIV

383 *The Dancer's Reward*

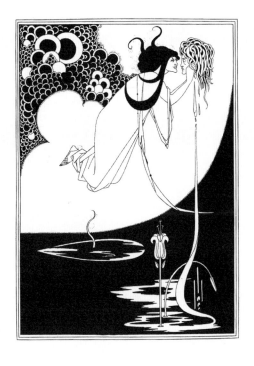

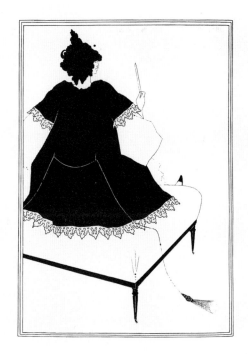

Plate XV

384 *The Climax*

Plate XVI

385 *Salome on Settle*

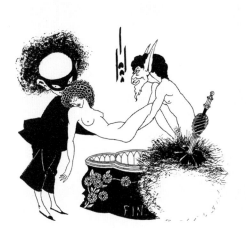

Plate XVII

386 *Cul de Lampe*

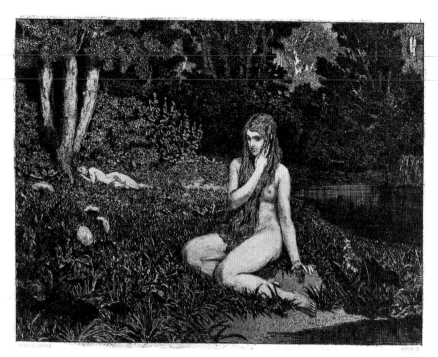

387 *Eve*

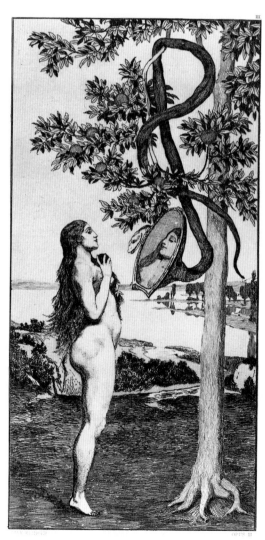

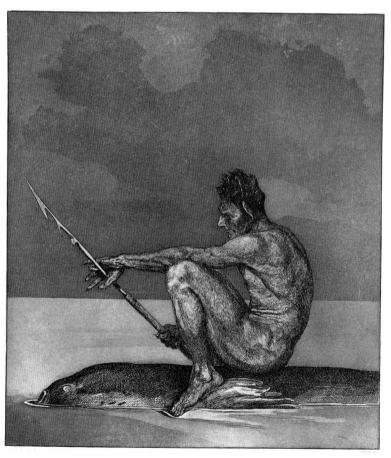

388 *The Serpent*, 1874-1877

389 *Second Future*

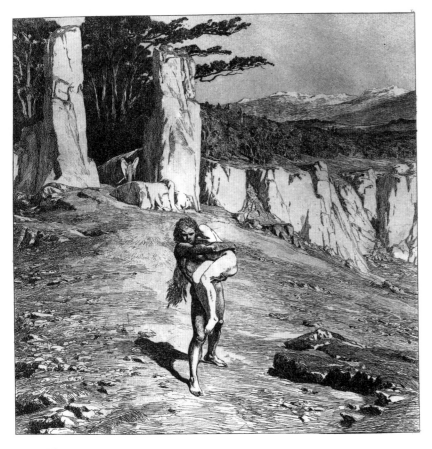

390 *Adam*

392 *First Future*

391 *Third Future*

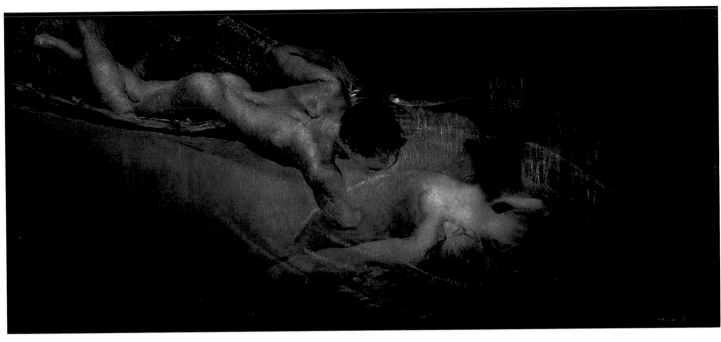

393 (cat. 368)
Aristide SARTORIO
The Green Abyss, 1895?
Piacenza, Galleria d'Arte Moderna Ricci Oddi

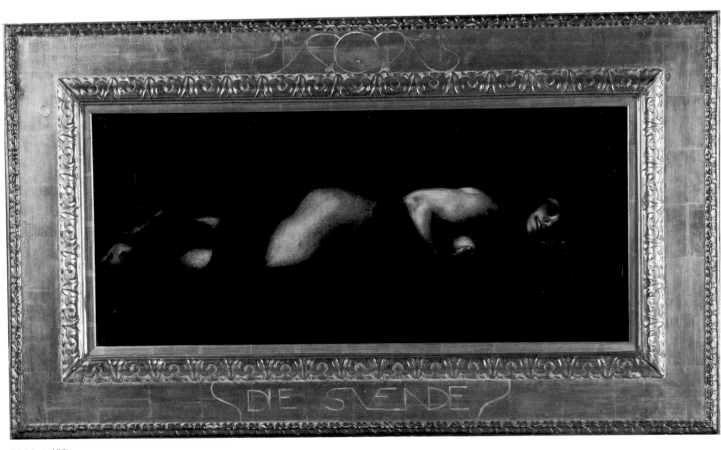

394 (cat. 458)
Franz VON STUCK
Sin, 1899
Cologne, Wallraf-Richartz-Museum

395 (cat. 321)
Armand POINT
"Serpent" Jewel Box, 1897-1899
Paris, Musée d'Orsay

396 (cat. 396)
Joakim SKOVGAARD
Large Plate (Eve and the Serpent), 1899
Copenhagen, Museum of Decorative Art

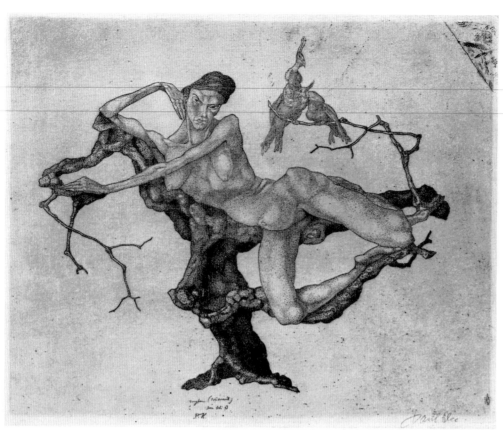

397 (cat. 204)
Paul KLEE
Virgin in a Tree (Invention 3), 1903
New York, The Solomon R. Guggenheim Museum

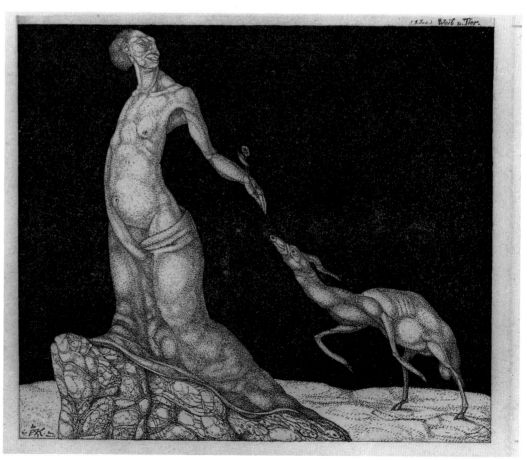

398 (cat. 203)
Paul KLEE
Woman and Animal, 1904
Kunstmuseum Bern, Paul Klee Foundation

336 *LOST PARADISE*

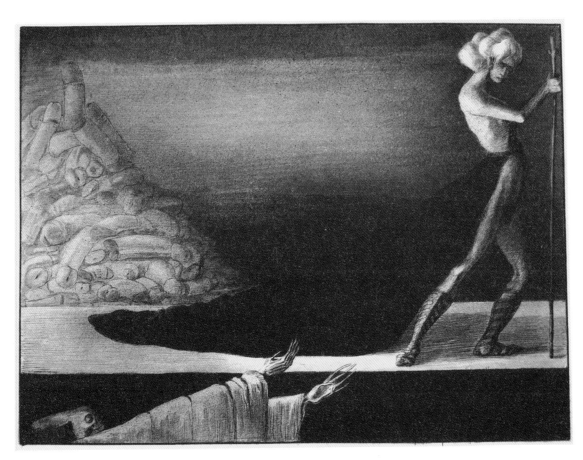

399 (cat. 223)
Alfred KUBIN
The Great Babylon
Vienna, Galerie Würthle

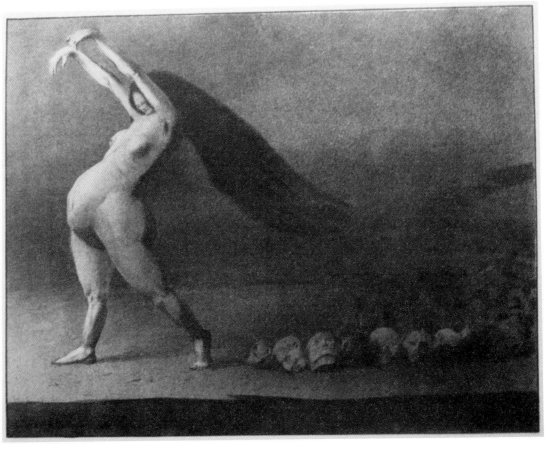

400 (cat. 226)
Alfred KUBIN
Earth, Mother of Us All, 1901-1902
Vienna, Galerie Würthle

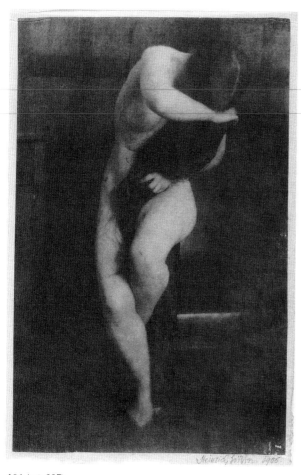

401 (cat. 227)
Heinrich KÜHN
Female Nude, 1906
Museum Folkwang Essen

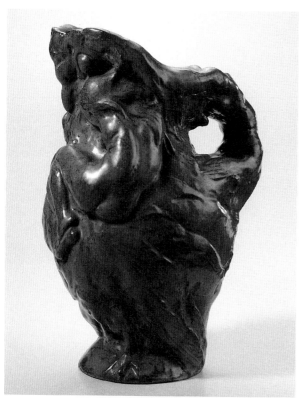

402 (cat. 55)
Pierre A. DALPAYRAT
"La Nuit" Jug, 1894
Württembergisches Landesmuseum Stuttgart

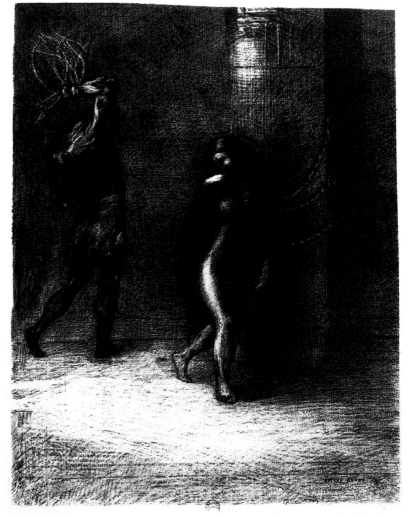

403 (cat. 341)
Odilon REDON
Frontispiece from the series of lithographs "À Gustave Flaubert", 1889
Paris, Bibliothèque nationale de France

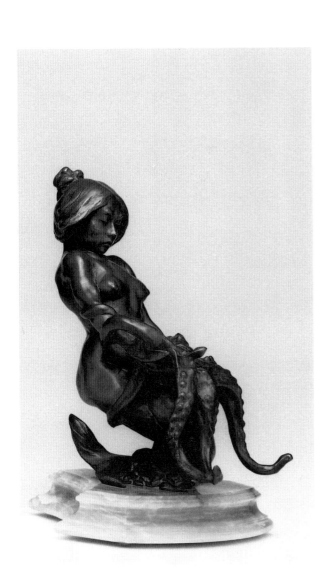

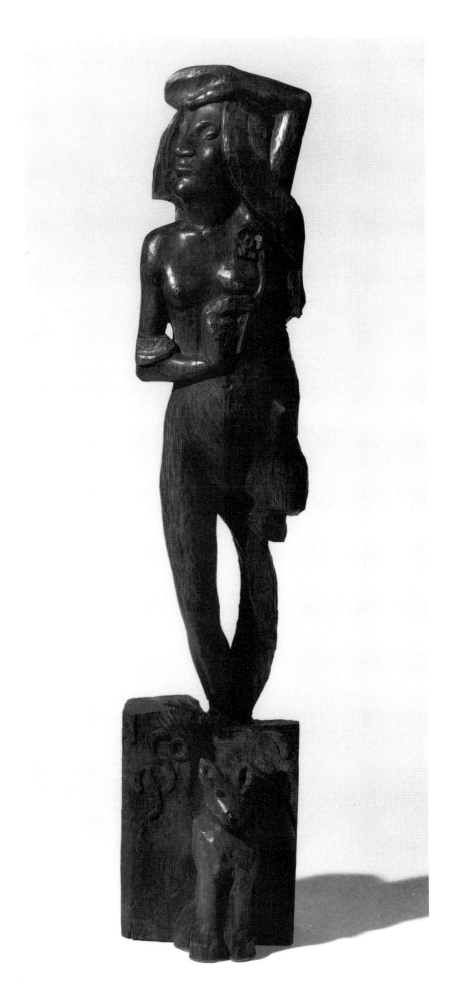

404 (cat. 42)
François Rupert CARABIN
Inkwell, 1900-1901
Richmond, Virginia Museum of Fine Arts

405 (cat. 130)
Paul GAUGUIN
Lust, 1890
Frederikssund, Denmark, J.F. Willumsens Museum

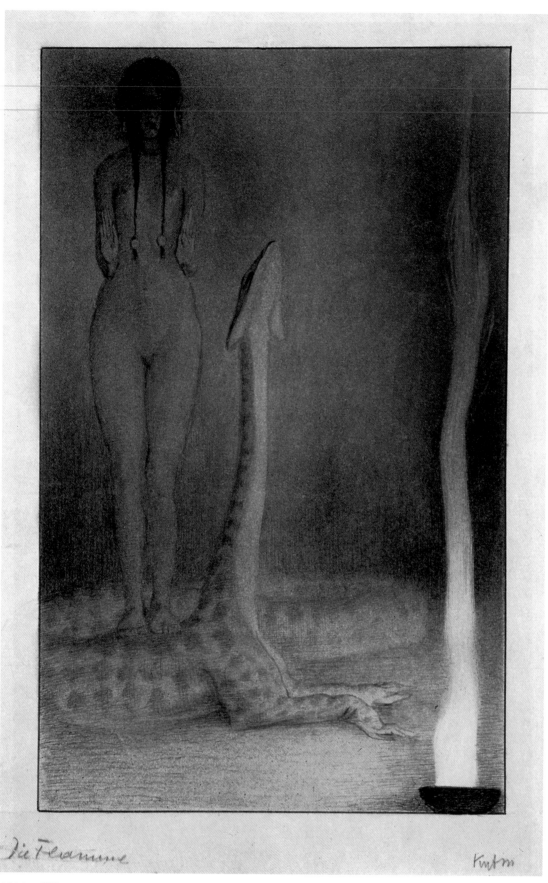

406 (cat. 222)
Alfred KUBIN
The Flame, about 1900
Vienna, Galerie Würthle

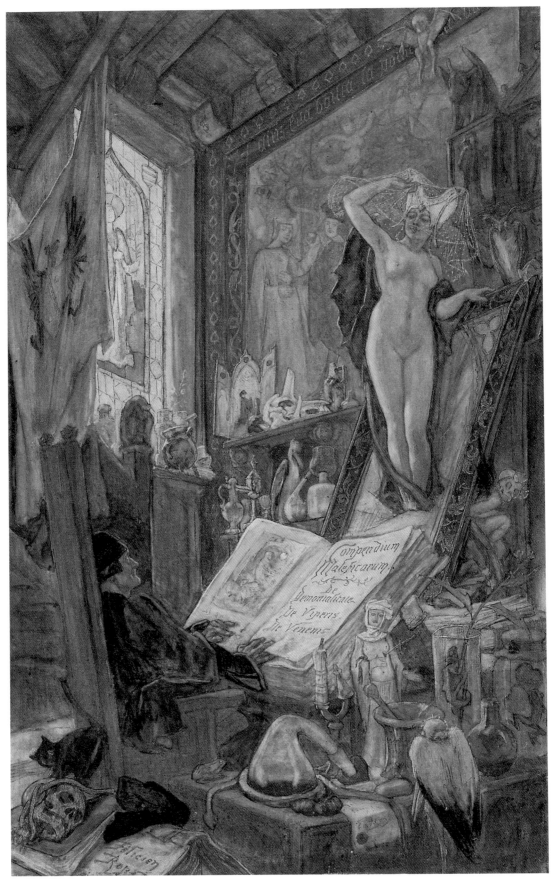

407 (cat. 357)
Félicien ROPS
The Incantation, about 1878
Babut du Marès collection

408 to **417** (cat. 213)
Max KLINGER
Ten engravings for "Paraphrase on the Finding of a Glove"
Fourth edition, about 1878-1880
Hamilton, Ontario, McMaster University

408 *Place*

409 *The Act*

410 *Desires*

411 *The Rescue*

In Brussels, where he made his earliest series of engravings, Klinger was very impressed by the compositions of Antoine Wiertz. He was absolute in his admiration for Wagner and Beethoven (his famous polychrome statue of the latter is now in the Leipzig Gewandhaus). Klinger's painting seems like a Germanic adaptation of the aesthetic principles of Puvis de Chavannes, but unlike Puvis's allegorical friezes, Klinger's compositions give concrete form to fantasy in a most original manner, as can be seen in this 1881 series, which is also

12 *Triumph*

413 *Homage*

414 *Fears*

415 *Tranquility*

416 *The Abduction*

417 *Cupid*

known as "Adventures of a Glove" and "Fantasies upon the Finding of a Glove". The trivial story of the loss of a glove, the fetishistic object par excellence, serves as a pretext for a descent into the winding ways of the subconscious. In the later drawings of the series, Klinger reworked iconographic constructs created by "visionary" artists such as Gustave Doré, William Blake and even John Flaxman. In one scene, a giant glove dominates a mysterious pullulation of indeterminate life forms, while in another, sea horses pull a sort of primal egg with obvious sexual connotations, from which a gloved hand protrudes. Fabulous prehistoric beasts like the pterosaur that flies away with the glove, become elements in a chain of linked images equivalent to those hidden areas of consciousness that scientists would soon claim as our heritage from a prehistoric stage of the brain. Although the persistence of a reptilian brain in the cerebral cortex had not yet been established, these antediluvian creatures looming up in his work inescapably suggest the upsurge of impulses, from sexual desire to the fetishism in varying states implied by the titles of the works: *Place, The Act, Desires, The Rescue, Triumph, Homage, Fears, Tranquillity, The Abduction* and *Cupid*.

G.C.

418 (cat. 239)
René LALIQUE
Necklace
About 1900
Gold, enamel, Australian opal, Siberian amethysts
Diam.: 24.1 cm
New York, The Metropolitan Museum of Art
owned jointly with Lillian Nassau

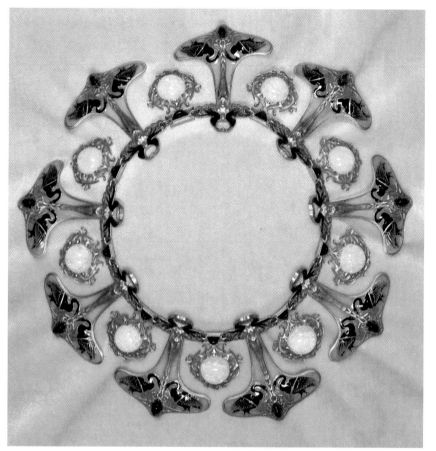

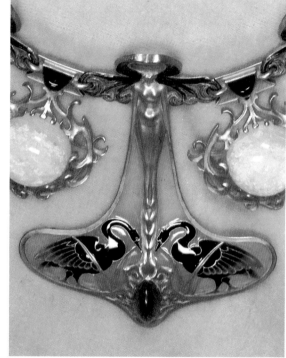

René Lalique's belief that jewellery need not simply be a setting for precious stones had a major influence on European jewellery design at the turn of the century. Lalique created works of great beauty by taking advantage of the varied hues, luminosity and texture of nonprecious stones and materials as ordinary as glass, enamel or ivory, setting them off against the richness of gold and the sparkle of the occasional diamond or topaz. Because of his interest in Symbolist themes, Lalique chose his materials for their symbolic value as well.

The necklace is made up of nine pendants, each one depicting the form of a woman in gold, her hair splaying out on the sides to resemble insect wings and rising above her head in the form of pincers. At her feet are two black enamel swans on either side of an amethyst beetle. Lalique used a similar hybrid of female and insect in other works of this period, and one of his chef-d'oeuvres is a large brooch of a dragonfly-woman with golden claws in a metamorphic state. In this necklace, the black swans, which could be interpreted as symbols of death, and the black pincerlike headdress of the women lend a sinister, unsettling tone to the image.

Between the pendants are medallions composed of circular opal cabochons set in interlaced leaf scrolls of gold. Lalique was known to favour the mystical, prismatic effects of the opal. The many fissures running through this stone are filled with air and moisture that reflect a spectrum of changing colour. In the nineteenth century, the opal came to be regarded as unlucky, and the Symbolists were attracted to its magical iridescence and cloudy semitransparency.

R. P.

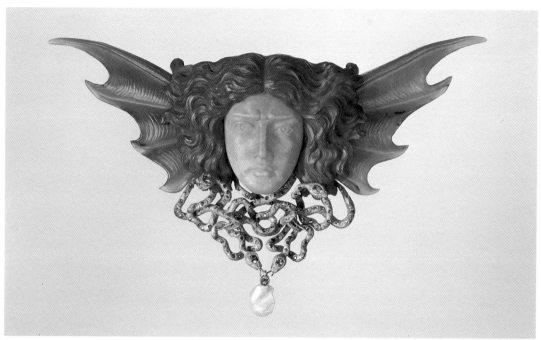

419 (cat. 449)
Wilhelm Lukas VON CRANACH
Medusa Head Brooch, 1902
Staatliche Museen zu Berlin, Kunstgewerbemuseum

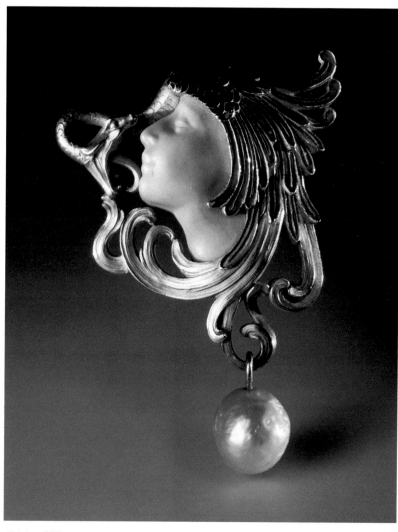

420 (cat. 237)
René LALIQUE
Brooch (Woman's Head with Peacock Wing and Serpent), about 1898-1899
Paris, Musée des Arts décoratifs

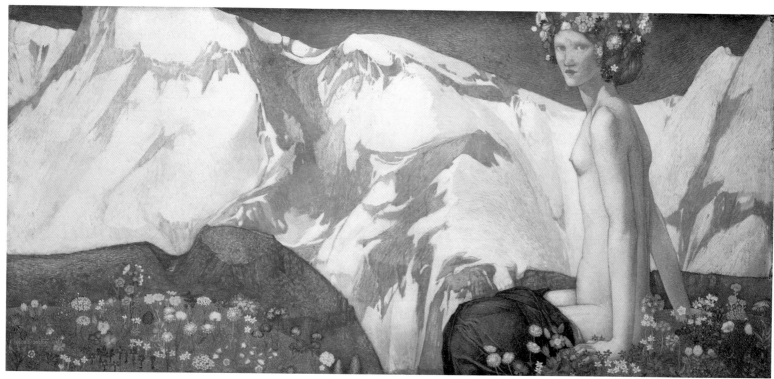

421 (cat. 116)
E. Reginald FRAMPTON
Flora of the Alps, before 1918
Birmingham Museums and Art Gallery

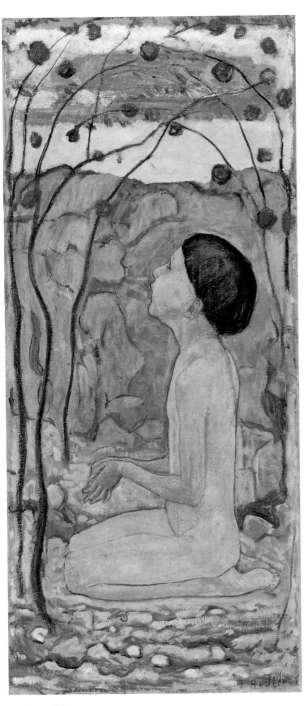

422 (cat. 155)
Ferdinand HODLER
Adoration III, 1895-1896
Gottfried Keller Foundation, on loan to the Kunsthaus Zürich

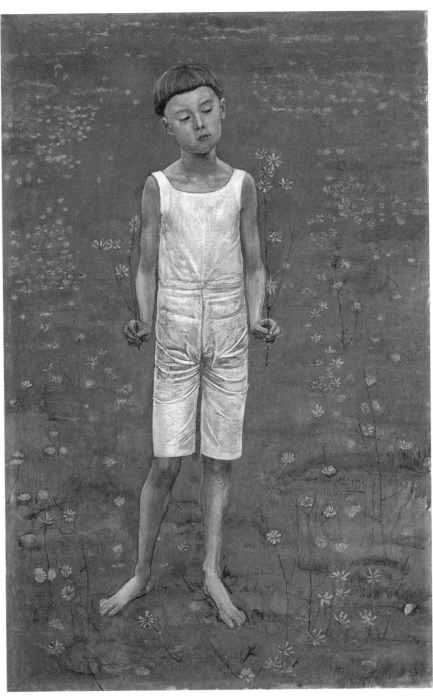

423 (cat. 154)
Ferdinand HODLER
Adoration I, 1893
Gottfried Keller Foundation, on loan to the Kunsthaus Zürich

424
Oskar KOKOSCHKA
Die träumenden Knaben
1908
Title page
19.3 x 17 cm
Historical Museum of the
City of Vienna

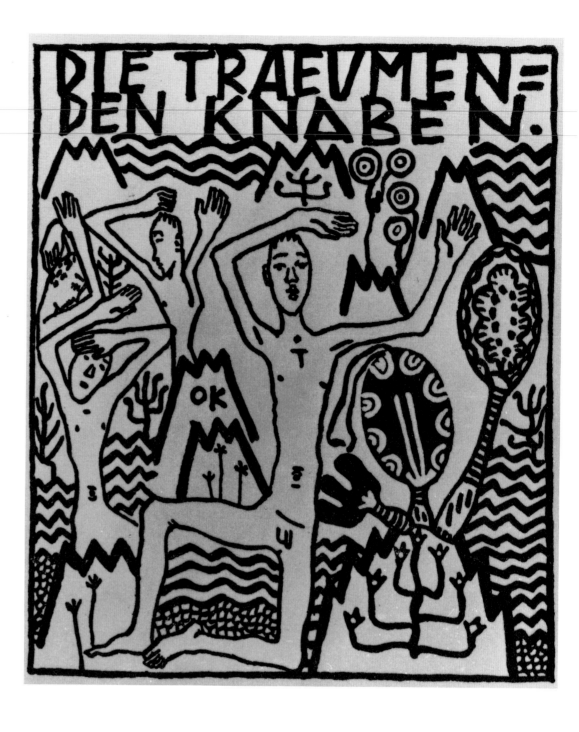

The fin-de-siècle sensibility of the artists of Vienna seemed determined to objectivize sexuality, as Kokoschka's *Träumenden Knaben* shows clearly: "And you, beloved women, why do you long, now and forever, under your red coverings, within your bodies, for the member sheathed in you? Do you feel the shudder of troubling warmth that invests the languid air? I am the Werewolf prowling . . . My unbridled body, my body alight with colours and blood, is slipping into your arbours, wandering in your hamlets, creeping into your souls, overrunning your bodies." Kokoschka is in fact describing a personal experience – his adolescent love affair with young Li, during which both young people described the gradual arousal of their desire. The use of visual devices inspired by the Middle Ages, in which the lack of spatial depth is counterbalanced by a series of planes rising upwards, emphasizes the essential loneliness of the players in this private drama; in a symbolic style, the artist keeps them inside circumscribed areas defined by networks of snaking lines. The overlapping of spaces, a metaphor for the psychic imprisonment of these adolescents, acts as a counterpoint to an irrepressible blossoming of impulses. The purity of the colours, thrown into relief by the lithographic technique handled like a woodcut, expresses an outpouring out of the soul in which the artist brings together the scattered fragments of moments of consciousness. "And I was suddenly intoxicated by the discovery of my flesh, and seized by a love of the whole world when I spoke to a girl."

G.G.

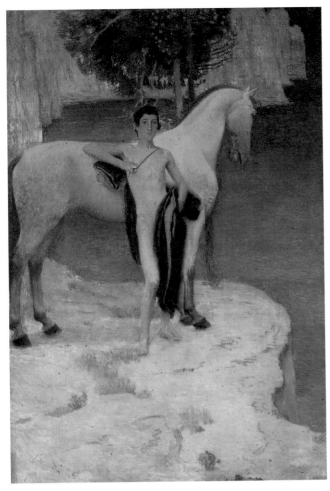

425 (cat. 323)
Jan PREISLER
Black Lake, 1904
Prague, Národní galerie

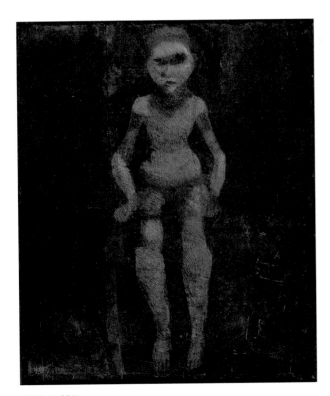

426 (cat. 201)
Paul KLEE
Nude Girl, 1910
Bern, Felix Klee estate

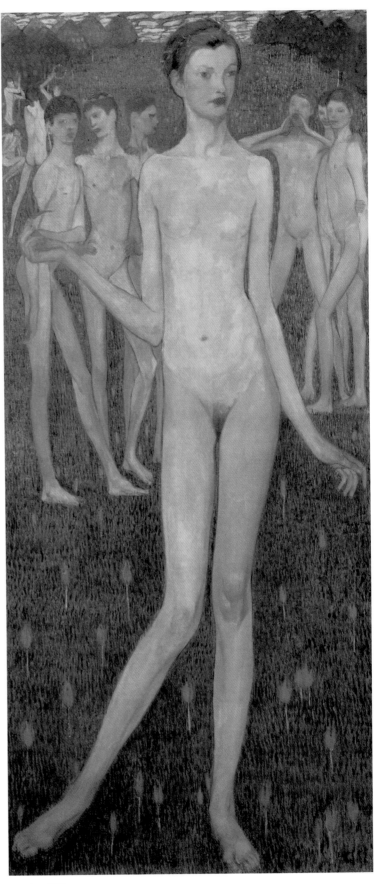

427 (cat. 251)
Elena LUKSCH-MAKOWSKY
Adolescence, 1903
Vienna, Österreichische Galerie

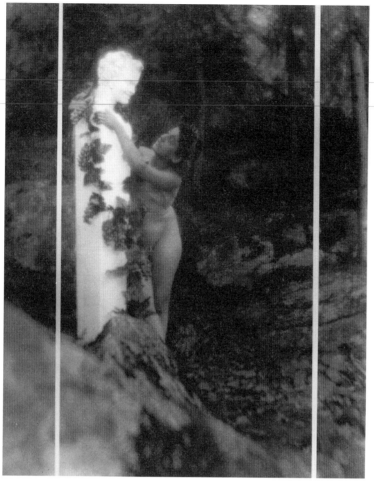

428 (cat. 57)
F. Holland DAY
Boy Embracing the Herm of Pan, 1905 or later
Washington, Library of Congress

429 (cat. 61)
F. Holland DAY
Male Nude in Shadow, 1910
Bath, The Royal Photographic Society

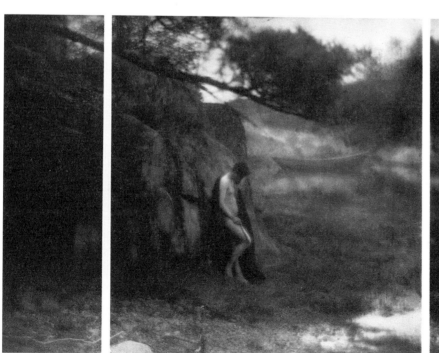

431 (cat. 451)
Wilhelm VON GLOEDEN
Young Sicilian (Hypnos), 1904
Bath, The Royal Photographic Society

430 (cat. 67)
F. Holland DAY
The Prodigal, 1909
Washington, Library of Congress

432 (cat. 450)
Wilhelm VON GLOEDEN
Boy with Palm Branch
About 1900
Albumen print
11.5 x 20 cm
Christoph Niess collection

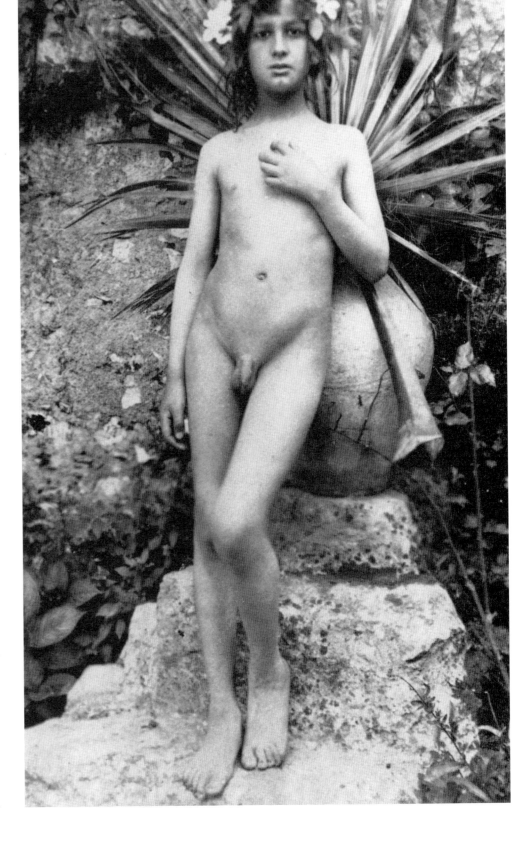

Among the over eight thousand nude, portrait and landscape photographs taken by the German Baron Wilhelm von Gloeden, in Taormina, Sicily, between 1880 and 1918, are numerous ones with religious motifs. Inspired by the tableaux vivants of the theatre, Gloeden staged religious scenes as living images, with protagonists chosen from among the village population. For this representation of a Christian martyr, for example, he got a young man to pose naked, his "innocence" being affirmed in the gesture of his left hand and the attribute of the palm branch. In contrast to the works of Day, only seldom can concrete iconographic links be identified in Gloeden's photographs. Thus, the fascination of his motifs, which celebrate the cult of the androgynous youth and were frequently used by artists as models, often lies in the unresolved tension between the intended idealization and the reality of the features and physical presence of the models.

U. P.

433 (cat. 391)
Alexandre SÉON
Portrait of Sâr Péladan
1891
Oil on canvas
132 x 80 cm
Lyons, Musée des Beaux-Arts

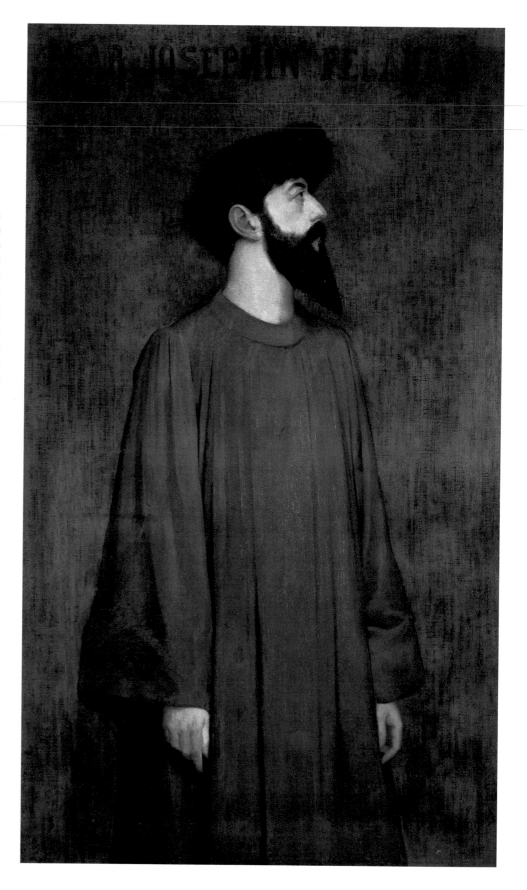

Séon was born in Chazelle-sur-Lyon and studied first in Lyons under the Prix de Rome laureate Danguin before moving to Paris. Here he enrolled in the studio of Henri Lehmann, one of Ingres's pupils, where he met Alphonse Osbert, Ernest Laurent, Edmond Aman-Jean and Georges Seurat. Disappointed in Lehmann's rigidly classical approach, Séon succeeded in speaking to Puvis de Chavannes, whose great decorative compositions he had long admired. Soon he became the muralist's assistant, working with him on the frescoes in the Panthéon. Séon found inspiration not only in the classics but also in the esoteric speculations of Joséphin Péladan, called the Sâr, whom he probably met about 1890. Péladan, also from Lyons, had arrived in Paris in 1882 and was close to writers like Barbey d'Aurevilly, J.-K. Huysmans and Villiers de L'Isle-Adam, as well as to the more esoteric circles including the Kabbalistic groups led by Stanislas de Guaïta, with whom Péladan was to revive Rosicrucianism by founding the Ordre de la Rose + Croix (Péladan later split off to establish the Ordre de la Rose + Croix du Temple et du Graal).

Together with Osbert, Séon regularly attended the Rosicrucian Salons organized by the Sâr, who imposed extremely strict pictorial rules. Séon's portrait of Péladan, with its hieratic, almost Byzantine quality, makes a clear distinction between the literary concepts and the artistic activity of the Rose + Croix Salons. Séon also created frontispieces for some of the Sâr's books, notably the series "La Décadence latine".

G. C.

434 (cat. 94)
Magnus ENCKELL
Awakening
1894
Oil on canvas
113 x 86 cm
Helsinki, Ateneum, Antell collection

The stark nakedness of this adolescent boy with a vacant expression, poised to leave his bed as if he were dragging himself out of some painful dream, gives a sad and sombre tone to this version of the purity of childhood. Three years earlier, in 1891, Frank Wedekind had published his tragedy *Frühlings Erwachen* (*The Awakening of Spring*), in which a young girl gradually becomes aware of her budding sexuality. But this canvas by Enckell could well be the perfect complement to Edvard Munch's *Puberty* (1893), where an adolescent girl seems to be frozen in a moment of terrifying revelation. The lack of depth in the pictorial space, which is enclosed by a monochrome wall (a feature of Nordic painting, when one thinks of Munch), accentuates the girl's introspective loneliness. The sleepy pose of this male nude, and Enckell's obstinate devotion to adolescence as a miraculous moment, seem to indicate a homosexual aesthetic shared by a number of contemporary photographers, starting with F. Holland Day. The touching minimalism Enckell brings to this fragment of Paradise lost is an indication of the global awareness of beauty and how time corrupts it.

The youth's distracted look, as if he were absorbed in unanswered questions, crushed by the bitter realization that all flesh is grass and doomed to die, also sets the spectator wondering about what our physical existence becomes, as do the many "vanities" painted by the artist. His interest in metaphysical and esoteric speculation, and in particular in the theories of Joséphin Péladan, which he encountered during his time in Paris between 1891 and 1894, enriches his objectivization of a broad-based sensuality.

G.C.

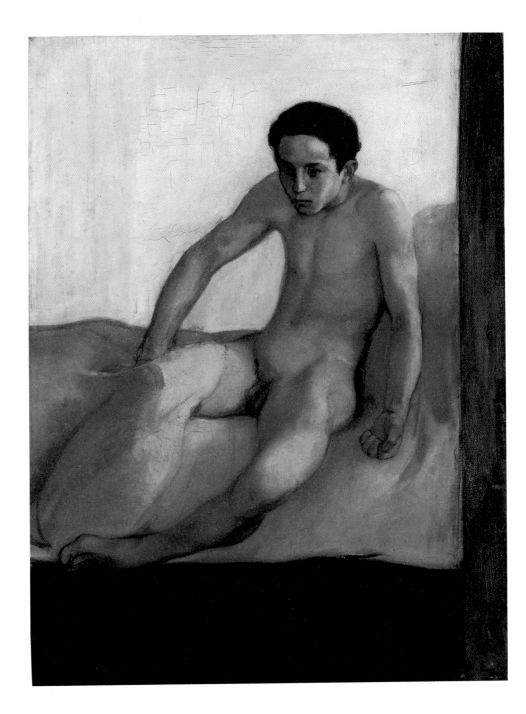

435 (cat. 277)
George MINNE
Standing Youth, 1900
Neuss, Germany, Clemens-Sels-Museum

436 (cat. 438)
Ville VALLGREN
"Lotus Leaf" Vase, 1893
Helsinki, Ateneum

437 (cat. 77)
Jean DELVILLE
The Love of Souls
1900
Egg tempera on canvas
238 x 150 cm
Brussels, Musée d'Ixelles

Jean Delville, who was acquainted with the
Kabbalah and exhibited at the Salons of the
Rose + Croix, started his career as an artist
with drawings based on Wagner's operas,
especially *Parsifal* (1890). He was a devoted
Platonist, and *The Love of Souls* demon-
strates a fierce belief in the fusion of male
and female by means of an absolute love. The
figures of his vision are, as it were, trans-
figured by their Wagnerian setting; like
Tristan and Isolde lost in their nocturnal
love duet, the lovers are borne up in the air,
as unaware of material things around them
as they are of time passing. The ethereal
swirls rising from some primeval sink turn
to flame above their heads in torrents of fire,
giving this study of primal androgyny a hint
of Pentecost as evoked in *Parsifal*.

G.C.

Motherhood

438 to 451

438 (cat. 205)
Gustav KLIMT
Hope I
1903
Oil on canvas
181 x 67 cm
Ottawa, National Gallery of Canada

Klimt, who served in 1897 as the first President of the Vienna Secession, defended modern art against conservatism and repression. His provocative nature came to the fore in his designs for the ceiling of the Festival Hall of the University of Vienna (now destroyed), which aroused a storm of protest when they were presented in 1900 (*Philosophy*) and 1901 (*Medicine*). *Hope I* employs some of the same elements as these allegories, including the figure of a pregnant woman, considered highly offensive at the time. Klimt disregarded the usual stereotypes and idealized views of maternity. The work's symbolism, which encompasses several levels of meaning, depends on the skilful superimposition of a number of elements in the same plane: a female nude, in a frank profile view that leaves no doubt as to the imminence of a birth; the serpentine form of a sea monster that curls around the woman and overlaps with various purely decorative motifs (an astute reference to Viennese stylization); and several evil-looking figures in the upper register. Despite the disturbing allusions to death, to man's inevitable biological fate and the subjection of eroticism to procreation, the assurance with which the young woman looks the spectator straight in the eye and the pride with which she displays her shimmering body shift the meaning of the painting towards the contemporary social, psychoanalytical and metaphysical issues that were at the heart of the Symbolist outlook: freedom from the taboos of a hypocritical bourgeoisie, revelation of the dark zones as yet only briefly explored by Freud and site of an intimate and ambiguous relationship between Eros and Thanatos, and faith in the advent of the new man announced by Nietzsche – this last, perhaps, as the title would suggest, representing the painting's deepest meaning.

C. N.- R.

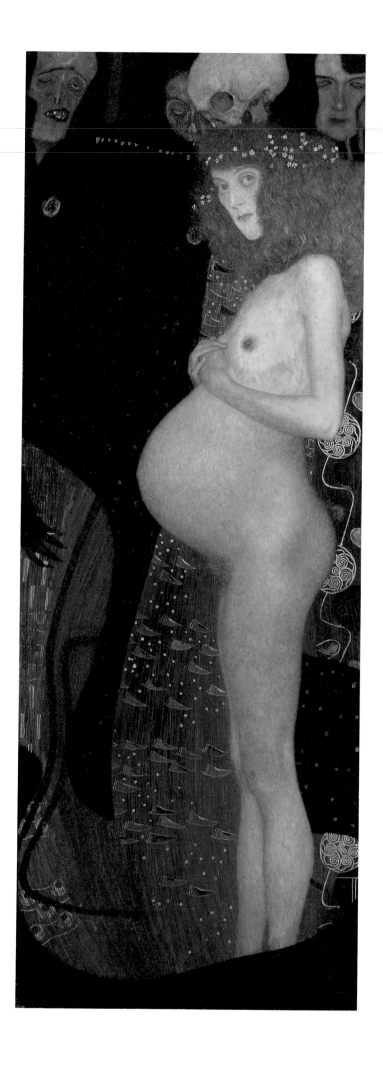

439 (cat. 2)
Cuno AMIET
Hope (or *The Ephemeral*)
1902
Polyptych:
(centre panel) tempera on cardboard, 64.5 x 47 cm;
(upper panel) tempera on cardboard, 11.5 x 47 cm;
(side panels) tempera on wood, 79.5 x 19.5 cm (each)
Olten, Switzerland, Kunstmuseum

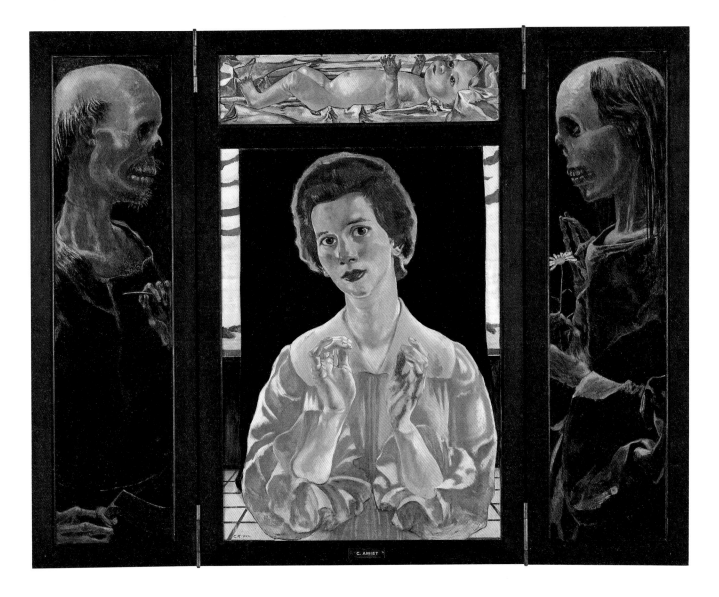

Amiet was born in Solothurn but eventually settled in Oschwand, in the canton of Bern. In 1892, he spent some time in Pont-Aven among the group that had gathered around Gauguin. In 1898, he met Ferdinand Hodler and was greatly impressed by him, even adopting his style for a while. Among the many portraits Amiet executed of his wife Anna, the one included in this extraordinary polyptych makes the greatest claim to universality, through language that is eminently Symbolist. According to George Mauner,[1] a small drawing appearing in a 1901 letter to Giovanni Giacometti indicates that the painting originally consisted of only the central section, which portrays Anna as a haloed Madonna, arms open in a gesture of presentation, with above her a newborn infant resembling the Christ Child.

What started out as an intimist painting, on which he worked throughout Anna's pregnancy in 1901, was transformed into a polyptych as the result of a personal tragedy: Anna's baby was stillborn. The side panels, added in 1902, embody easily recognizable traditional symbols that recall those of the *danse macabre*. But by adding odd masculine hair to the skeleton with the scythe and female hair to the one plucking the petals from a daisy, Amiet has altered the meaning to suggest a parental couple. Thus, as well as symbolizing the ephemerality and fragility of life, the work is given further meaning through the identification of the parents with the symbol of death. The polyptych was exhibited in 1904 at the Vienna Secession, and its funereal character was emphasized by flowers placed at the foot of the stand on which it was shown.

C. N.-R.

1. See *Amiet. Hoffnung und Vergänglichkeit*, exhib. cat. (Aarau Switzerland: Aargauer Kunsthaus, April 28 - June 16, 1991).

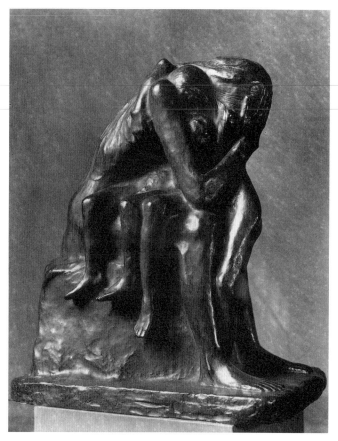

440 (cat. 276)
George MINNE
Mother Grieving for Her Two Children or *Sorrow*, 1888
Brussels, Musées royaux des Beaux-Arts de Belgique

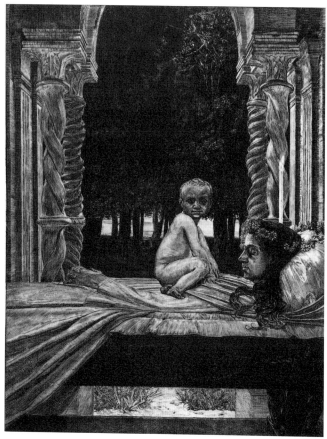

441 (cat. 212)
Max KLINGER
The Mother's Deathbed, 1889
Leipzig, Museum der bildenden Künste

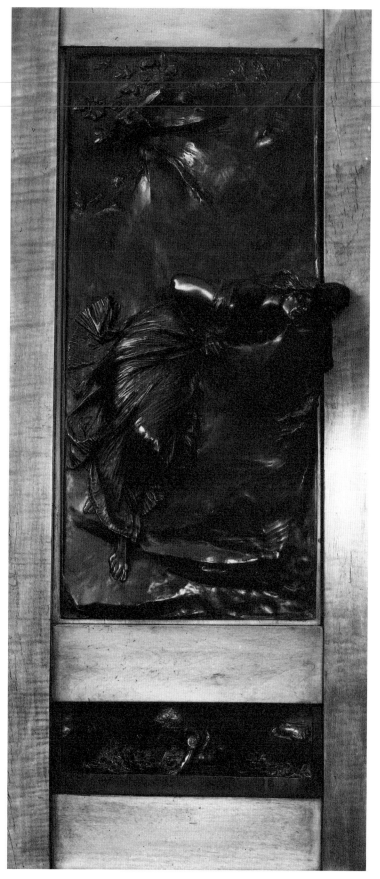

442 (cat. 422)
Stanislav SUCHARDA
Treasure, 1897
Hradec Králové, Czech Republic, Galerie moderního umění

443 (cat. 376)
George SEELEY
Golden October
1909
Coated pigment print
44 x 53.8 cm
New York, The Metropolitan Museum of Art

Independently of the metropolises of art photography, George Seeley, who only came into closer contact with the Photo-Secession in 1904, developed his own Symbolist work in Stockbridge, Massachusetts. The large-format print *Golden October* is an allegorical representation of the season, the iconography of which is presumably inspired by the medieval tradition of religious representations of the months or by the Demeter cult of antiquity. The composition has the atmosphere of a religious festival, and the iconlike effect is strongly emphasized by the nimbus around the head of the female figure and by the symbols of fertility, such as the grapes and corncobs. The halo, which occurs frequently in portraits by Seeley, for example in *The Firefly* (cat. 381, 1907), was achieved either by back lighting or by marking it in on the print.

U. P.

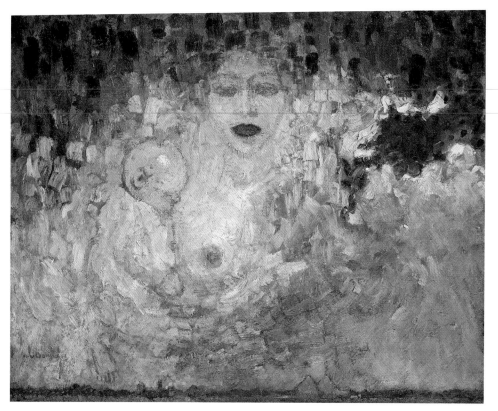

444 (cat. 443)
Kees VAN DONGEN
In Praise of Guus and Dolly, 1905
Private collection

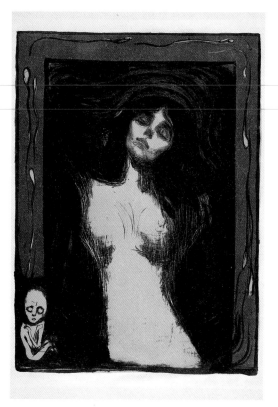

445 (cat. 299)
Edvard MUNCH
Madonna (Conception), 1895
Oslo, Munch-museet

446 (cat. 468)
Clarence H. WHITE
Nude with Baby, 1912
Washington, Library of Congress

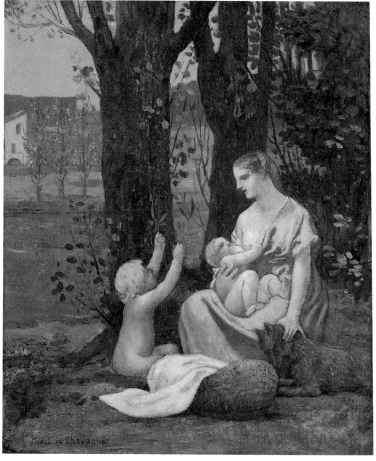

447 (cat. 335)
Pierre PUVIS DE CHAVANNES
Maternity, 1887
Private collection

448 (cat. 32)
Ford Madox BROWN
Take Your Son, Sir
1867
Oil on canvas
70.5 x 38 cm
London, Tate Gallery

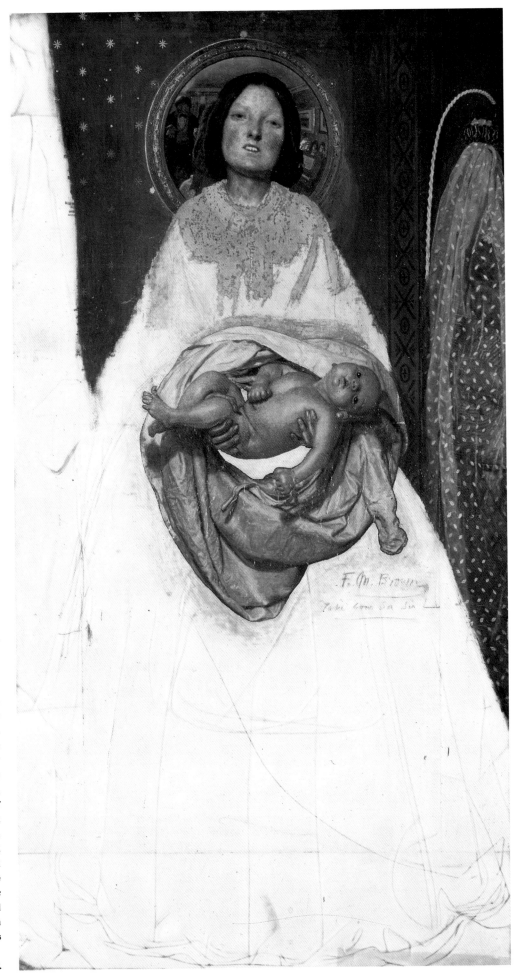

Paradoxically, the iconography of this canvas is easily read and yet difficult to decipher. In a domestic setting, a woman holds out a baby towards a man invisible to the spectator except for his diminished reflection in the convex mirror where the rest of the room can also be seen. A series of carefully arranged details gives even more ambivalence to the scene. The title of the work, inscribed by the artist below his signature, might suggest that what we have here is a kept woman asking her lover for compensation and help. But if the scene is really set in a middle class residence, how to explain the stars above the mother's head? And the mirror, whose refraction reveals to us the space otherwise hidden from view, functions perhaps even more as a sort of sacred halo than as a technical trick or a juggling with juxtaposed perspectives. When the work was first exhibited in 1897, the critic H. Wilson, in an article published in *The Artist*, saw it as a portrait of the artist's family. The privacy of this domestic scene, then, takes on a more universal meaning and presents us with a glorification of motherhood, of which the Virgin Mary is the archetype.

G.C.

449 (cat. 184)
Gertrude KÄSEBIER
The Heritage of Motherhood
1904
Gum bichromate on platinum
23.5 x 31.6 cm
Washington, Library of Congress, Prints and Photographs Division

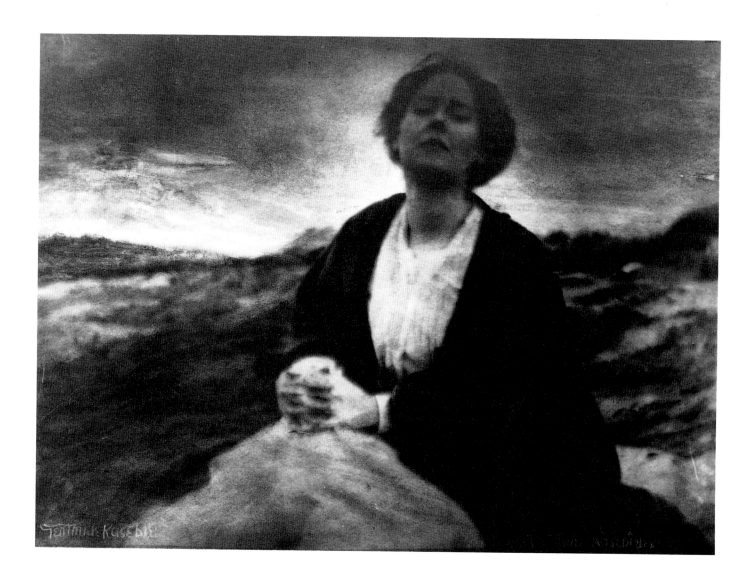

Käsebier's composition deals with the burdens and worries of motherhood and with the high rate of infant mortality around 1900. In the tradition of romantic landscape painting, she portrays a lonely woman in a bleak landscape, the oppressive sky allowing a bright light to break through only around the woman's head and on the horizon. According to Barbara Michaels,[1] the woman in the portrait is Agnes Rand Lee, author of children's books, who had already sat with her daughter Peggy for Käsebier's photograph *Blessed Art Thou among Woman*, the theme of which is the loving relationship between mother and child. *The Heritage of Motherhood* was taken after the sudden death of her daughter and records the mother in a deep personal crisis, in a state of sadness and religious meditation. A symbolic transposition of an individual fate into a scene from Christ's Passion is evident in another version of the photograph, where Käsebier transforms the setting into Golgotha by drawing in three crosses.

U. P

1. Barbara L. Michaels, *Gertrude Käsebier: The Photographer and Her Photographs* (New York: Harry N. Abrams, 1992).

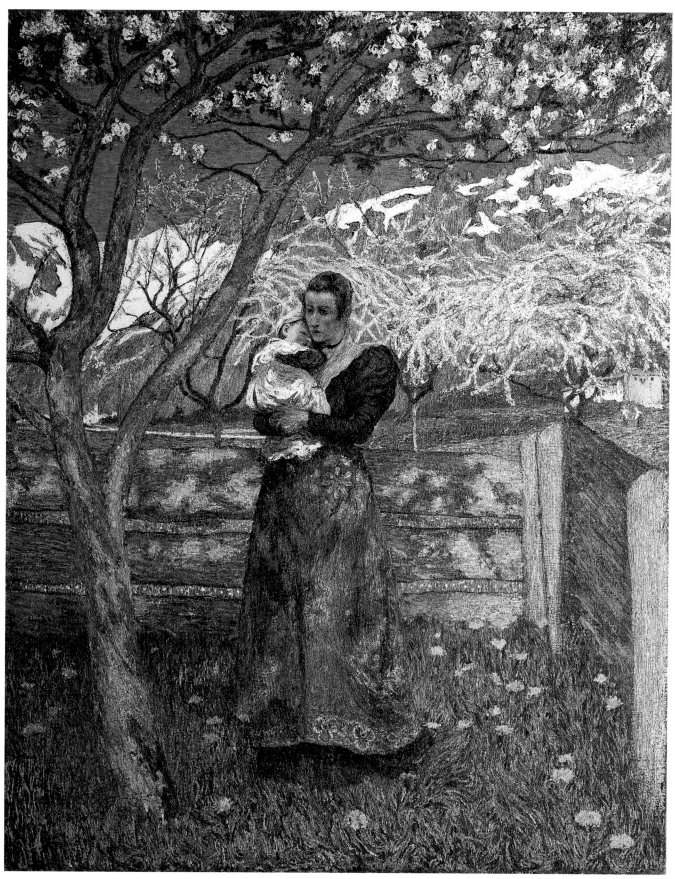

450 (cat. 133)
Giovanni GIACOMETTI
Mother and Child under a Blossoming Tree, 1900
Chur, Switzerland, Bündner Kunstmuseum

451 (cat. 330)
Gaetano PREVIATI
Motherhood
1890-1891
Oil on canvas
174 x 411 cm
Novara, Italy, Banca Popolare di Novara

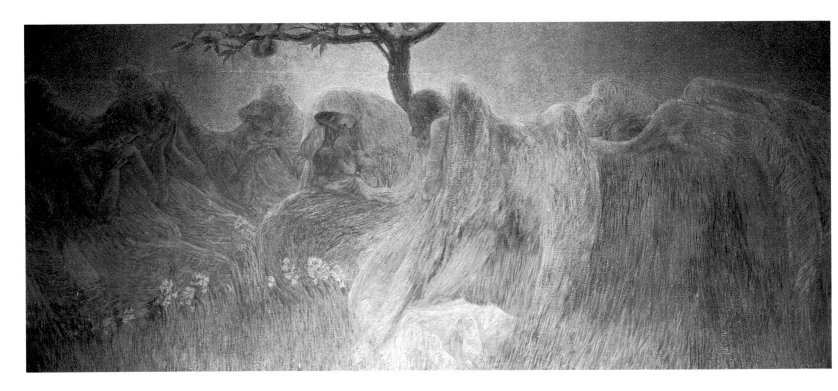

Previati's *Motherhood*, which was shown in the Brera Triennale in Milan in 1891 along with Morbelli's *Dawn* and Segantini's *Two Mothers*, gave rise to furious debate. Even more than his fellow students' output, treated by the critics as manifestos of the official birth of the Italian Divisionist movement, Previati's paintings aroused academic wrath. He was accused of inadequate drawing, unfinished contours, incomprehensibility and foggy mysticism. In Previati's work, which in this respect resembles that of the poet Giovanni Pascoli, the theme of motherhood occurs frequently. The band of angels surrounding the young mother gives a Christian slant to the scene, while the tree with fruit-laden branches recalls the Tree of Life in Genesis. Vittore Grubicy, another harbinger of the Divisionist movement, gave a thorough account of this interplay of symbols in an article published in the *Cronaca di Brera* on June 27, 1891: "Previati attaches no objective importance to shapes and colours; rather he uses them as signs within the minimum parameters required to express the overall idea. That is why he turns to this arbitrary, almost abstract simplification that even drastically changes shapes and colours, a habit for which he was widely criticized." This painting was exhibited in the first Salon de la Rose + Croix in 1892.

G.C.

In Search of Innocence

452 to 470

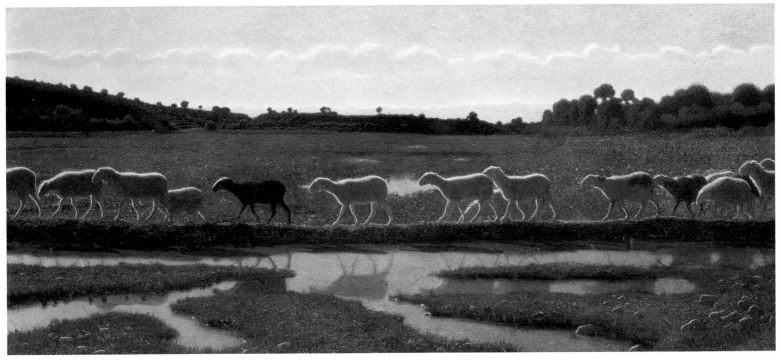

452 (cat. 319)
Giuseppe PELLIZZA DA VOLPEDO
The Mirror of Life, 1895-1898
Turin, Galleria Civica d'Arte Moderna e Contemporanea

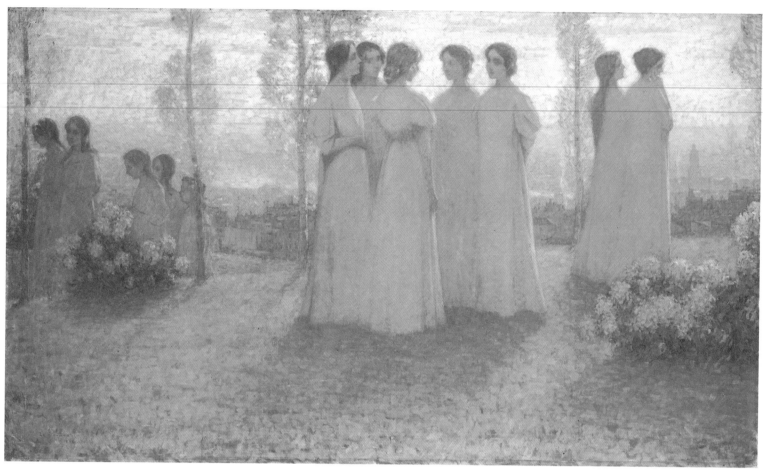

453 (cat. 248)
Henri LE SIDANER
Sunday, 1898
Douai, Musée de la Chartreuse

454 (cat. 228)
Heinrich KÜHN
On the Hillside (A Study in Values), before 1910
Gilman Paper Company Collection

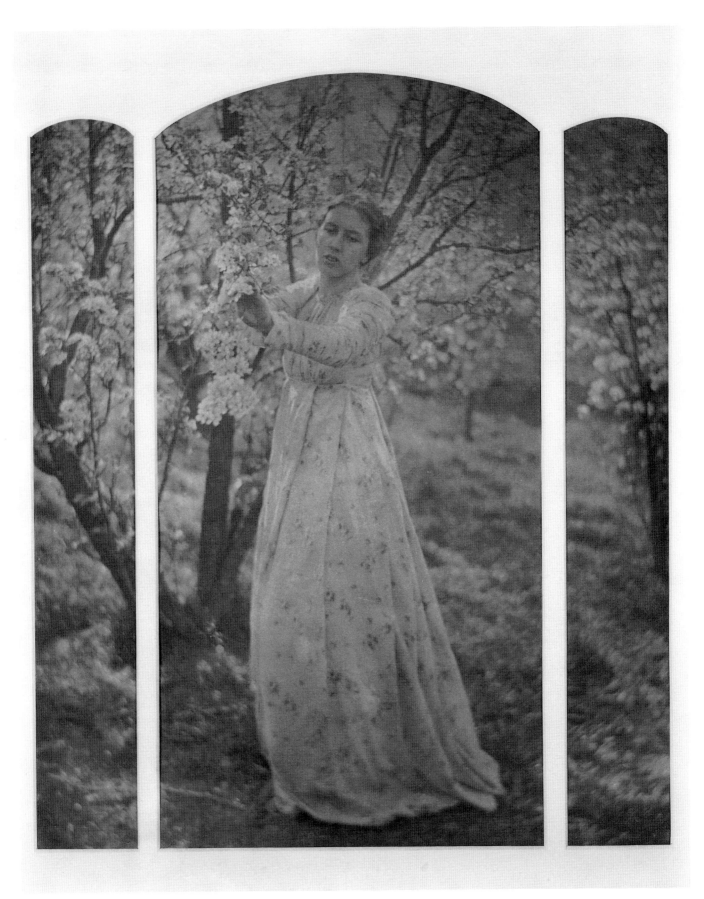

455 (cat. 469)
Clarence H. WHITE
Spring, a Triptych, 1898
New York, The Museum of Modern Art

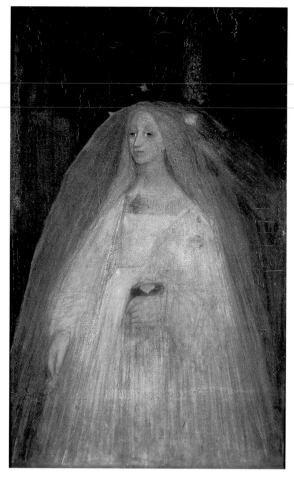

456 (cat. 267)
Matthijs MARIS
The Bride, about 1865-1869
The Hague, Museum Mesdag

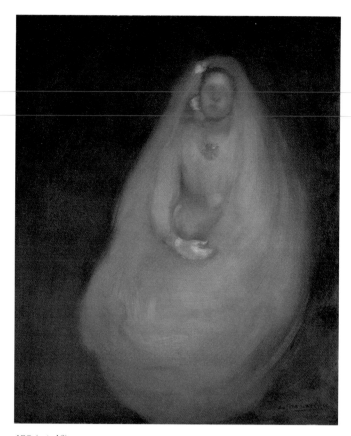

458 (cat. 43)
Eugène CARRIÈRE
The First Communion, about 1896
New York, The Metropolitan Museum of Art

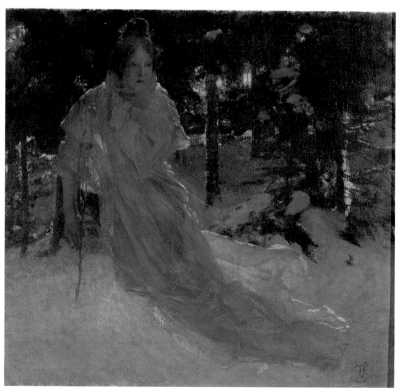

457 (cat. 169)
Vojtěch HYNAIS
Winter (Study for the Decoration of the National Theatre, 1901
Prague, Národní galerie

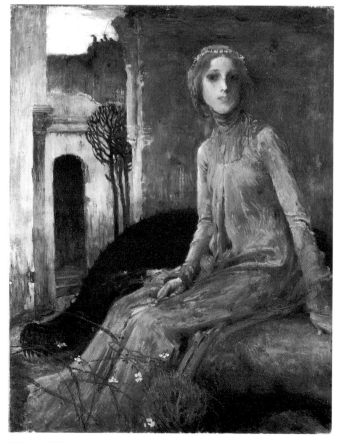

459 (cat. 325)
Jan PREISLER
Fable, 1902
Ostrava, Czech Republic, Galerie vytvarného umění

460 (cat. 386)
Giovanni SEGANTINI
Love at the Fountain of Life
1896
Oil on canvas
72 x 100 cm
Milan, Galleria d'Arte Moderna

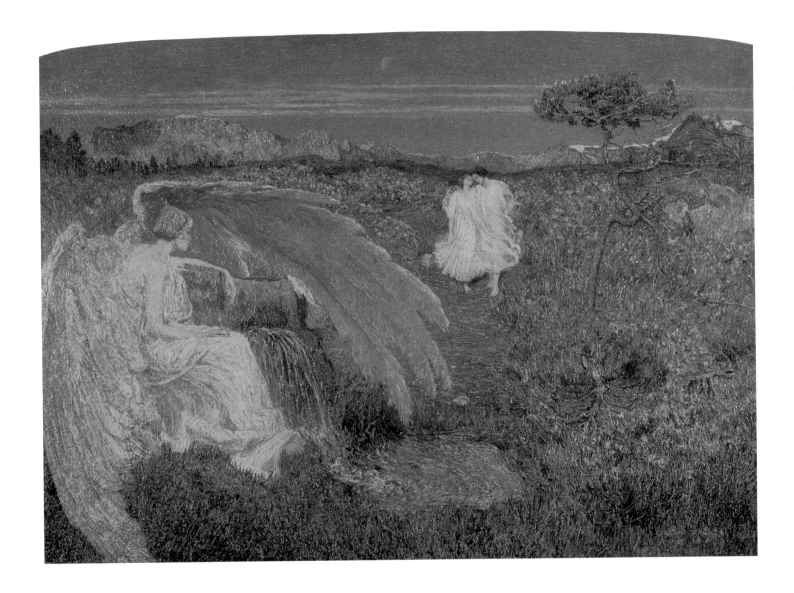

A letter from Segantini to his friend, the writer Domenico Tumiati, explains the meaning of this scene: "This represents the playful, carefree love of the woman, and the pensive love of the man, entwined together by the natural impulse of youth and spring. The narrow lane on which they advance is flanked by flowering rhododendrons, they are dressed in white (pictorial representation of the lily). Eternal love say the red rhododendrons, eternal hope replies the evergreen shrubbery. An angel – a mystic, suspicious angel – extends a large wing over the mysterious spring of life. The spring water gushes from the living rock, both symbols of eternity. Sun floods the scene, the sky is blue; with the white, the green, the red, I was in the habit of delighting my eye in gentle, harmonious cadence; in the greens, I aimed to signify this in a special way."[1]

G.C.

1. November 11, 1896, published in *Archivi del divisionismo*, collected and arranged by T. Fiori, 2 vols. (Rome, 1968), vol. 1, p. 363.

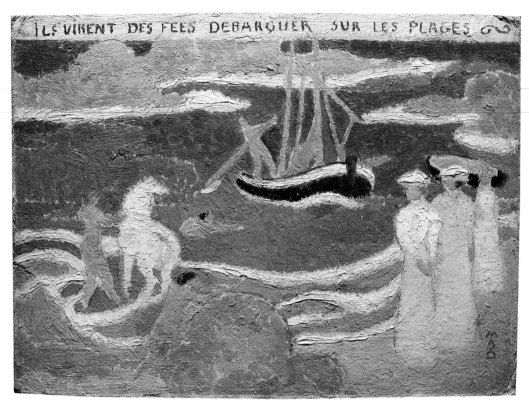

461 (cat. 82)
Maurice DENIS
They Saw Fairies Landing on the Beaches, about 1893
Private collection

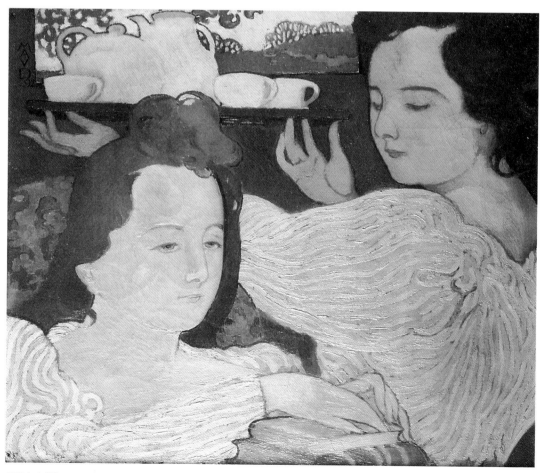

462 (cat. 80)
Maurice DENIS
Mystical Allegory or *The Cup of Tea*, 1892
Private collection

463 (cat. 85)
Maurice DENIS
"Dove" Screen
About 1896
Four panels, oil on canvas
164 x 54 cm (each)
Private collection

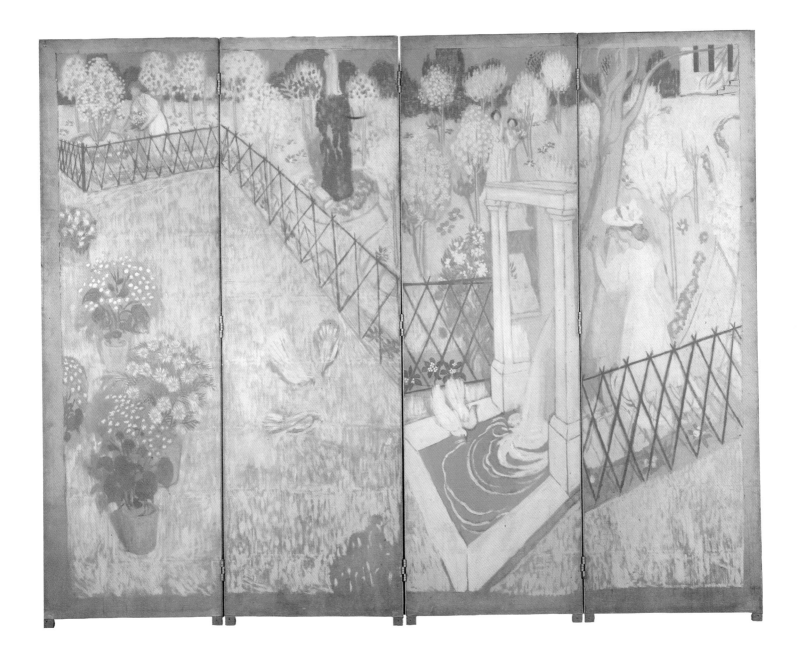

This masterpiece of decorative art by Maurice Denis was not commissioned. The delicacy of its composition seems to show the influence of the arts and crafts movement, while the sloping plane of the garden seen from below links this folding screen to Japanese models. Denis's personal mythology, however, is still apparent. The *hortus conclusus*, the pristine walled garden, a translucent lost Paradise, is bisected by an elegant stepped fence that separates it from the other Garden of Eden, forbidden to humans; pure young girls walk mysteriously across the garden, while a young woman, almost certainly Marthe, the painter's wife, carves a name on a tree (perhaps Denis's monogram). The motif of the purifying fountain, a partial reference to the Heavenly Jerusalem, was to reappear in his stained glass windows for the deambulatory of the Church of Sainte-Marguerite du Vésinet (1901), with its joyful affirmation of eternal youth.

G. C.

465 (cat. 473)
Clarence H. WHITE
The Fountain, 1907
Bath, The Royal Photographic Society

464 (cat. 29)
Anne W. BRIGMAN
The Heart of the Storm, about 1915
New York, The Metropolitan Museum of Art

466 (cat. 380)
George SEELEY
The Burning of Rome, 1906
New York, The Metropolitan Museum of Art

467 (cat. 467)
Clarence H. WHITE
Morning
1905
Gum bichromate print
24.5 x 19.5 cm
Princeton University,
The Art Museum

The photograph *Morning*, first published in 1905 under the title *Landscape with Figure*, illustrates the creative principle of pictorialist landscape representation. The dissolution of solid structures into abstract, low-contrast bright and dark surfaces, along with the limitation of pictorial depth, causes the figure, for which the photographer's wife Jane Felix posed, to meld into a unity with the landscape. At the same time, the subtle use of light and/or brightness corresponds to the symbolic expression of the composition. The figure dressed in white, a symbol of purity and innocence, conjures up representations of the Madonna in which the crystal ball becomes an image of the universe and heavenly perfection. In White's *paysages intimes*, which are as idyllic as they are hermetic, the influences of Japanese ukiyo-e prints and Whistler's painting are clearly recognizable.

U. P.

468 (cat. 181)
Wassily KANDINSKY
The Night, about 1906-1907
Munich, Städtische Galerie im Lenbachhaus

469 (cat. 147)
Louis Welden HAWKINS
The Innocence, about 1895
Amsterdam, Van Gogh Museum

470 (cat. 206)
Gustav KLIMT
Nuda Veritas, 1899
Vienne, Österreichisches Theater Museum im Palais Lobkowitz

Arabesques

JEAN-PAUL BOUILLON

The blue arabesques of the ground – a marvellous accompaniment
to the engulfing and persuasive rhythm of the orange motif,
like the seduction of the violins in the Overture to Tannhäuser!

Maurice Denis, 1890[1]

Although the arabesque can hardly be seen initially as a major component of Symbolist painting, it does recur frequently, coiling through it like a thread, linking Gauguin to Munch, and Denis to the candle depicted by Marcus Behmer in 1903 – the year of Gauguin's death – which seems to have represented the final flare, after some ten years, of the movement's sensual, blazing, equivocal flame.

This presence, admittedly nonexclusive, and apparently more evident in the work of Symbolism's "formalists" than that of its "image-makers",[2] seems at first view easy to explain; for is not the arabesque, which wrings the neck of Realist eloquence, precisely that line where "the Undefined and Exact combine"? A pure and quintessentially expressive means of expression, perhaps more immediate and more perfect even than the music of Verlaine's poem, of the "quick-wing'd thing and light– / such as one feels when a new love's fervor / to other skies wings the soul in flight".[3]

"Music, again and forever!": in their obvious lyrical effusiveness and their choppy rhythm, the final lines of the founding article of the Nabi movement, published in 1890 by Maurice Denis – a reader of Verlaine since at least 1889[4] – and quoted epigraphically above, are, as is often the case with Denis, a nodal point, the centre of a network of particularly close-knit vibrations that link the 1861 Baudelaire of "Richard Wagner et *Tannhäuser* à Paris" (in which the sonnet "Correspondances", it will be recalled, was once again quoted) with the Verlaine of *Art poétique*, that link musical references to their visual equivalent in something more than simple pastiche or literary device. In *La Joconde* (Redon's *Joconde*, that is, not Péladan's), which Denis describes and eventually proposes as an important reference for young artists repelled by the "sin" of Naturalism, the persuasive "seduction" – the

visual delight – comes not from the element of nature portrayed but from the purely pictorial "harmony" of the complementary colours: the blue of the background and the orange of the central figure. At first surprising, this conclusion is in fact perfectly in tune with the text's well-known initial definition, according to which the division into arabesques (with the colours "assembled in a certain order") is the only possible foundation for an authentic pictorialism.[5] This crucial notion reappears several times in the article (together with the more discreet but also revealing term "accompaniment", which must be examined later), notably in the passage devoted

1. "Définition du néo-traditionnisme", section 25, *Art et Critique*, vol. 2, no. 66 (August 30, 1890), p. 558. Recently reproduced in Maurice Denis, *Le Ciel et l'Arcadie*, texts selected and presented by Jean-Paul Bouillon (Paris: Hermann, 1993), p. 21. This edition restores the original punctuation, which was still respected by Denis in the 4th edition of his book *Théories* (1920). However, like Baudelaire in the early days, Denis always wrote "Tannhäuser" with the umlaut on the "u".

2. Jean-Paul Bouillon, "Le moment symboliste", editorial, *Revue de l'art*, special issue on Symbolism, no. 96 (1992), p. 6.

3. Verlaine, *Art poétique* (1882), dedicated to Charles Morice, reprinted in *Jadis et Naguère* (1884 and 1891). This English version from Paul Verlaine, *Selected Works*, trans. C. F. MacIntyre (Berkeley and Los Angeles: University of California Press, 1961), p. 183.

4. As his diary indicates (Maurice Denis, *Journal* [Paris: La Colombe, 1957], vol. 1, p. 78), the nineteen-year-old Denis began reading Verlaine's *Sagesse* in November 1889 (see Jean-Paul Bouillon, *Maurice Denis* [Geneva: Skira, 1993], p. 21).

5. Often quoted – but perhaps less known today outside France – the opening sentence of the vitally important 1890 article provides a backdrop to any exploration of Symbolism in painting: "It should be remembered that a painting – before being a warhorse, a nude woman, or some anecdote or other – is essentially a flat surface covered with colours assembled in a certain order" (Denis, 1993, p. 5, with my comment, note 3). Although arabesques are not mentioned immediately, the suggestion of "assembling" strongly implies their presence, and indeed they do appear some pages further on (see note 35 below). Moreover, Denis expressed the idea quite clearly in 1933 in the final chapter of *Charmes et leçons de l'Italie*, after having referred once again to the 1890 sentence and quoted Debussy on "the divine arabesque" in order, this time, to emphasize the limits of "this ornamental conception, this arabesque, this surface coloured according to certain relations and rhythms" (p. 178).

Marcus BEHMER
Illustration for Oscar Wilde's "Salomé", 1903
Staatliche Museen Berlin, Kunstbibliothek

with extraordinary density the best of Liszt's comments ("He draws the personalities of his characters and their principal passions melodically, and his melodies emerge, *in the singing or the accompaniment*, each time the passions and feelings they express come into play") and of Wagner's own when he analyzes the poetic effect at the point where it stops and allows the music to take over – "The rhythmic arrangement and the ornament (almost musical) of the rhyme are for the poet ways of imbuing the verse, the sentence, with a power that captivates by its charm and controls feeling at will."[7]

These definitions lead directly, via Denis, to the famous declarations made by Gauguin in 1895 about the musicality of painting:

> It's music, if you like! I borrow some subject or other from life or from nature, and, using it as a pretext, I arrange lines and colors so as to obtain symphonies, harmonies that do not represent a thing that is real in the vulgar sense of the word, and do not directly express any idea, but are supposed to make you think the way music is supposed to make you think, unaided by ideas or images, simply through the mysterious affinities that exist between our brains and such arrangements of colors and lines.[8]

And this after, of course, the remarks the painter made in 1892-1893 about what he called the "musical part" of *Manao tupapau* ("Musical part – undulating horizontal lines – harmonies in orange and blue linked by yellows and violets,

to the book's illustration, which similarly bases the authenticity of decoration on its autonomy in relation to the text it is purportedly designed to "illustrate": "rather an embroidery of arabesques on the pages, an accompaniment of expressive lines".[6] In fact, these three passages provide all the essential features of the arabesque: love and seduction (that of the Wagnerian Venus), but also well-founded harmony, rooted in reason, and indissoluble union (the "complementary colours"), decoration (of the book) and music (of the surface of the painting).

The Musical Arabesque

The arabesque is nevertheless first and foremost musical. In Baudelaire's essay it is used to actually define the dramatic ideal of the creator of *Tannhäuser* – "a veritable arabesque of sounds sketched by passion" – a definition that concentrates

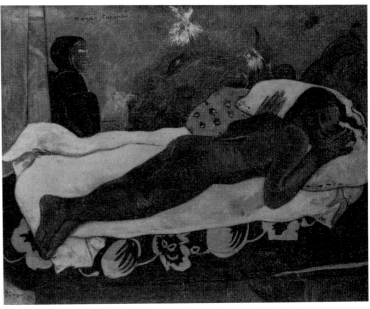

Paul GAUGUIN
Manao tupapau (Spirit of the Dead Watching), 1892
Buffalo, Albright-Knox Art Gallery

6. Denis, 1993, p. 18.
7. The quotations from Liszt (original emphasis) and Wagner are given by Baudelaire in his article, which was first published in *Revue européenne*, April 1, 1861, and reprinted in *L'Art romantique* in 1868 (*Paris: Gallimard*/La Pléiade, 1968, pp. 1219, 1231, 1220).
8. Paul Gauguin, "Interview with Paul Gauguin" by Eugène Tardieu, in *The Writings of a Savage*, ed. Daniel Guérin, trans. Eleanor Levieux (New York: Viking Press, 1978), p. 109. Originally published in French in *L'Echo de Paris*, June 13, 1895.

from which they derive")[9] – a work that indeed presents (making the seduction of the Tahitian Olympia – or Venus – still more complete) the same major harmony of complementary colours as *La Joconde* and its necessary alliance with the "undulating" line.

In a beautiful text dating from November 1890, which has not been anthologized, Denis describes the arabesque as one of the criteria of pure pictoriality, of the "non-literature" referred to by Puvis de Chavannes – by whom he, like Gauguin, was obsessed: "These are only two themes from colossal symphonies, barely emerged from the imagination of the Prophet and already sumptuous in the few arabesques that express them; already symbolic, on the barely brushed canvas, in rhythmic undulations."[10] The "colossal symphony" was first, for Denis, chamber music played by his fiancée Marthe, the pianist: in the 1891 painting *Marthe at the Piano*, "The dear hands, delicate and fine, / hands now lost to me forever", while recalling this time the music of *Sagesse*[11] ("the tender hands which bring me dreams"), are also specifically charged with linking the keys of the instrument to the arabesque of the arms, the apron and the symbolic image of the fictitious music resting on the piano, with its Titianesque combination of the

nude/clothed female couple and the arabesque of the "path or stream of life"[12] – in short, with converting into visual facts the intangibility of sounds, which nevertheless can hardly fail to evoke particular models: Schumann's Opus 18, conceived for the fingers of that other fiancée par excellence, Clara Wieck, or the recent *Arabesques* (1888) – that also paid her tribute – by the young Debussy, whom Denis saw then as the creator of her who was still very much a "Damoiselle élue".[13] This way of listening to Schumann – so different from Khnopff's, since it shows everything in detail, and "in the beauty of the work, all is contained", whereas the Belgian painter dissimulates and multiplies references to the "invisible": with sound, but, in 1883, with neither flat tint nor arabesque[14] – is that of Lerolle and his circle, including Debussy and especially Chausson. Denis's decorative arabesque rose to the ceilings – in imitation of Wagner again perhaps, this time the "tiered" voices in *Parsifal* ("And, O these children's voices, singing out beneath the dome!" runs the 1888 poem by Verlaine, reprinted in *Amour* in 1892)[15] – in an astonishing series continued with Chausson but opened by the marvellous ceiling for Lerolle, of which the original title, happily reinstated, is actually *Poetic Arabesques for the Decoration of a Ceiling*.[16]

In this pivotal work from 1892, which also carries echoes of the article published two years earlier, the harmonics are many-layered: there is the "harmony" of two scales of cool and warm colours, of nature and the human figure, emphasized by the dense framing of the arabesques, which is the only decorative element – picked up again in the effulgence of the frame's leaflike motif; a *da sotto* view, which ends by raising the ceiling up to heaven's breach, but one that also wrests away the earthly weight of the bodies of these angel-women, poised themselves on another Jacob's Ladder ("Angels are

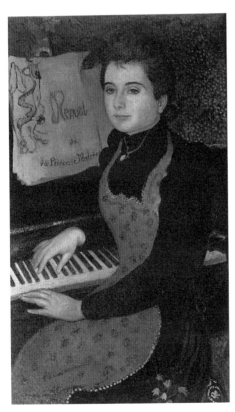

Maurice DENIS
Marthe at the Piano
(Princess Maleine's Minuet), 1891
Private collection

9. In the *Cahier pour Aline*, quoted in English from *Gauguin*, exhib. cat. Washington, Chicago and Paris, 1988-1989 (Washington: National Gallery of Art, 1988), cat. 154, p. 281.

10. "À Blanc et noir", *Art et Critique*, vol. 2, no. 76 (November 8, 1890), p. 717.

11. Poem XVII from the first part of *Sagesse*, "Les chères mains...". This English version from the MacIntyre translation (see note 3 above), p. 153.

12. For analysis of this complex work, see Bouillon, 1993, p. 27.

13. *Ibid.*, p. 43.

14. Fernand Khnopff, *En écoutant du Schumann* [Listening to Schumann], 1883, Brussels, Musées royaux des Beaux-Arts de Belgique (cat. C. de Croës and G. Ollinger-Zinque, no. 52). See, most recently, Philippe Junod's analysis in *La Musique vue par les peintres* (Lausanne: Edita, 1988), p. 110.

15. See Bouillon, 1993, pp. 69 and 62 for the work cited below.

16. The three Chausson ceilings are reproduced respectively in Bouillon 1993, pp. 69 and 78, and Claire Frèches-Terrasse and Antoine Terrasse, *Les Nabis* (Paris: Flammarion, 1990), p. 113; see Thérèse Barruel's catalogue of works by Denis that belonged to Chausson, in *Revue de l'art*, no. 98 (1992), pp. 66-76, nos. 2, 7, 15.

women who take me by the hand," Denis wrote in his diary in October 1890.[17] With these women, strung out on the series of rungs like notes on a staff (are not the bass and treble clefs actually arabesques?), never (unless naturally in Gauguin's work) has the decorative dimension of Symbolist painting more effectively manifested its essentially "spiritual" – and therefore musical – meaning, captured in the initial title of what was later so prosaically labelled *Ladder among Foliage*.

The Positivist Arabesque

Despite a widespread cliché, however, these variously "elevating" models have nothing of mystical effusions or evanescent emanations – neither Behmer's candle nor the bouquets of perverse perfumes that, for example, Huysmans strove to inhale from Moreau's *Salomes*.[18] In fact, the arabesque has extremely clear rational foundations, which can be discovered – again with Denis's help – in the Positivist origins, definite but largely unrecognized, of the Nabi movement.[19]

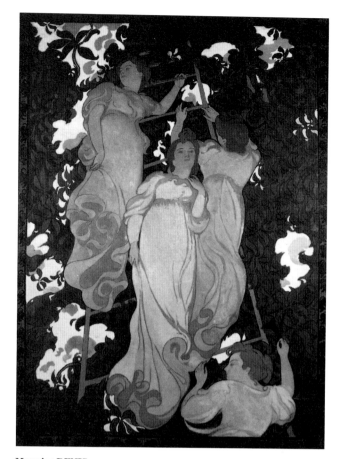

Maurice DENIS
Poetic Arabesques for the Decoration of a Ceiling, 1892
Saint-Germain-en-Laye, Musée départemental Maurice Denis « Le Prieuré »

In the last chapter of the eighth and final section of his *Principles of Psychology* (1855, second revised edition 1870) – whose French translation (1873-1875) was the young Denis's basic philosophical source, summarized extensively in his "Cahier de philosophie" during 1887 and 1888 – Herbert Spencer outlines, in his final conclusion, his views regarding "Aesthetic Sentiments". In line with his general theory of evolution, he proposes a graduated qualitative scale of aesthetic feelings at the pinnacle of which are located those states of consciousness "that are reached *through* sensations and perceptions", since "the aesthetic character of a feeling is habitually associated with separateness from life-serving function".[20] The superior levels, as he says when discussing music, are thus located in "the higher region of aesthetic feeling, where the states of consciousness are exclusively re-representative".[21] All these notions and terms were familiar to Denis and had been completely assimilated by him by 1887-1888, as a very detailed passage from a retrospective piece written in 1924 goes to show.[22]

The fact that Denis was able, in 1924, to recall so accurately Spencer's fundamental analysis of this question –

17. Denis, 1957, vol. 1, p. 82.

18. "Incense was burning, sending up clouds of vapour . . . The clouds rose higher and higher, swirling under the arches of the roof, where the blue smoke mingled with the gold dust of the great beams of sunlight slanting down from the domes". J.-K. Huysmans, *À rebours* (1884); quoted in English from *Against Nature*, trans. Robert Baldick (Harmondsworth, England: Penguin Books, 1959), p. 64.

19. On this important question, see my paper for the conference on the Nabis held at the Musée d'Orsay in November 1993, "Maurice Denis, Hippolyte Taine, Herbert Spencer : les origines positivistes du mouvement nabis" (forthcoming), which is based largely on detailed statements by Denis published during his lifetime and on notes in his unpublished "Cahier de philosophie" dating from 1887-1888 (and quoted below). As far as the statements go, I remind readers only of this important passage from "Notes sur la peinture religieuse" (1896) concerning the "Symbolist idea", which stresses the "little-known nature of a well-known movement": "It was not, of course, an idealist theory. The direct result of the then-fashionable Positivist philosophies and the inductive methods we admired so greatly, it was actually the most thoroughly scientific artistic endeavour. Those who initiated it . . . were deeply concerned with the truth . . . From the structure of the eye and its physiology, the mechanism of associations and the laws of perception . . . they derived the laws of the work of art and, by adhering to them, immediately obtained the most intense expressions. Henceforth, instead of struggling vainly to reconstruct their actual sensations, they strove to substitute equivalents" (Denis, 1993, pp. 36-37). This last idea, so important to Denis, the Nabis and all the Symbolists linked to Gauguin, is derived directly from Spencer's psychology, which excludes the possibility of a direct knowledge of the reality of things and substitutes instead a study of associational mechanisms, states of consciousness and the relations between the two.

20. Herbert Spencer, *The Principles of Psychology* (New York: D. Appleton and Company, 1898), vol. 2, part 2, pp. 642, 632.

21. *Ibid.*, pp. 642.

22. "Herbert Spencer, having defined the sensorial conditions of aesthetic pleasure, the small initial shock, stresses the consecutive sensations that he calls representative (representation of the object) and re-representative (those that invoke the whole

the transcending of the simple pleasure of sensation (presentative) and of perception (presentative and representative) to the highest quality of re-representation, which activates the emotions (especially altruistic ones) and the intelligence – is proof of the major impact of this theory during the 1890s on the development of a form of painting that rejected Impressionist sensation. For Spencer, this highest quality is located above music, in "the literature of imagination". But it is easy to understand how Denis (and later Gauguin) saw in it the justification for a "musical" form of painting, one that (to quote Spencer again) evoked "aesthetic sentiments dissociated much more decidedly from the lower modes of consciousness". The Positivist analysis of aesthetic feeling offered yet another reason to invent and legitimize a kind of painting that was both antirealist and antimaterialist.

As far as painting was concerned, Spencer was naturally able to think solely in terms of figurative paintings on traditional themes, and the only examples he mentions, both in 1855 and the revised edition of 1870 (and then only to criticize them for the inferior quality of the emotions they arouse), are Horace Vernet and Gérôme.[23] His remarks, however, lend themselves easily to extrapolation – when he writes, for example,

> Beyond the aesthetic pleasures derivable from a picture considered simply under its technical character, as giving the direct and indirect gratifications of sensation and perception harmoniously co-operating, there is the aesthetic pleasure derivable from a re-representative consciousness of the feelings implied by the action,

adding that it is essential that "these feelings shall have in them as much as may be of the moderate, mingled with as little as may be of the violent".[24]

This is the essence of the somewhat less elegant analysis that appears in the young Denis's "Notes d'esthétique", dating from June 1888, where he writes that "A pleasant sensation is one that leads to a moderate interplay of the physical and mental faculties, without fatigue, and without any negative effects on the organism."[25]

This moderation, invested with a high moral and even philosophical value, was a central notion for Spencer, and he gives examples of its application in the realm of pure forms, in a passage that could be the "technical manifesto", scientific and Positivist, of the Symbolist arabesque – at least as it was later developed theoretically by Denis:

> Turning to forms, we observe that the delight in flowing outlines rather than in ["à l'exclusion de", in the French

translation read by Denis] outlines which are angular, is partly due to that more harmonious unstrained action of the ocular muscles, implied by perception of such outlines: there is no jar from sudden stoppage of motion and change of direction, such as results on carrying the eye along a zig-zag line. Here again, then, we have a feeling accompanying an activity that is full, but contains no element of pain from excess.[26]

That a "delight in flowing outlines" is a common feature of the painting of both the Nabis and Gauguin is an obvious although apparently relatively unexplored fact, no doubt partially rooted in the ideas just quoted. Spencer's observation that no painting had yet achieved "the most perfect form of aesthetic excitement" by linking the "three orders of sensational, perceptional and emotional gratification"[27] can only have served to encourage these artists in their approach.

It is easy to see how this analysis could underpin, justify, legitimize the use – *exclusive*, as Spencer implies – of the arabesque, especially in Denis's work, which founded in reason something that existed in the art of Gauguin and other lesser artists in a more or less natural state: the "pleasure of the senses" Denis again notes in 1924, Spencer's "three orders of gratification" – sensation, perception, emotion – do not arise solely from the delights of Venus – Des Esseintes's Salome, or the character from the Wagnerian drama – but rather from a psychology that is also a morality and, in its way, a metaphysics, although one that rejects such a title. The arabesque epitomizes the function of *understanding* in Symbolist painting, the very function attributed to it by Leonardo.

22. ...
psychological structure, the feelings, the intelligence). Despite the extreme materialism of his system, Spencer did not go so far as to admit that his *association machine* failed to function for aesthetic pleasure, and that it did not contribute in all its resonances towards sensual pleasure" (Denis, 1993, p. 202). The example used by Spencer to illustrate the notion of "re-representative" is that of the *memory* (re-representative) we have that a vice was actually the cause (representative) of the pain we experienced the day before (presentative).
23. Spencer, 1898, p. 646.
24. *Ibid.*, p. 643.
25. Page 10 of the unpublished notes appended to the "Cahier de philosophie" (see Bouillon, forthcoming). All these pages by Denis are also full of references to Spencer's last chapter (not quoted): "These sensations contribute in various ways towards the well-being and hence the preservation of the organism, whose need for moderate action they satisfy" (p. 9) and "The conclusions of this psycho-physiological study are in perfect accordance with generally accepted ideas concerning the Beautiful" (p. 11).
26. Spencer, 1898, p. 639.
27. *Ibid.*, p. 645.

Maurice DENIS
"Pink Boats", 1893
Saint-Germain-en-Laye, Musée départemental
Maurice Denis « Le Prieuré »

The Decorative Arabesque

At the end of his book, Spencer offers a humanitarian and social vision that fully accords with the theories of evolutionism. In the future, a growing liberation from directly utilitarian adaptation and the gradual disappearance of egoistic feelings will result in the development of the aesthetic sentiment and its corresponding sphere of activity:

> The aesthetic activities in general may be expected to play an increasing part in human life as evolution advances . . . A growing surplus of energy will bring a growing proportion of the aesthetic activities and gratifications; and while the forms of art will be such as yield pleasurable exercise to the simpler faculties, they will in a greater degree than now appeal to the higher emotions.[28]

These lines, which appear at the very end of the volume

28. *Ibid.*, p. 648.
29. "For the wallpaper – meanders and reflections on the water, green and white, like the sea surrounding the dinghy" (Denis, 1957, vol. 1, p. 102).
30. For a more extensive analysis of this work see Bouillon, 1993, pp. 64-65, and for an example of a symbolic boat – a closely related model, created at the same period – see Denis's *They Saw Fairies Landing on the Beaches* (ill. 461).

translated in 1875, indicate perhaps another source – an entirely different source, anyway, than the one dear to the chroniclers of the languid prettinesses of fin-de-siècle art – for the "total" ambitions, particularly social, expressed through the decorative arts, of the Nabi movement and, more generally, of Art Nouveau, of which it was one of the founding components: it was here that the "moderate arabesque", the highest form of visual language, assumed its true meaning, found the ultimate goal of its mission.

In "Pink Boats", probably his best-known wallpaper design, created in 1893, Denis extracts the quintessence from an element of nature (watery meanders and reflections) and arrives at the arabesque. Simply the result of the Nabis' interest in interior decoration, it is usually said. But far more, in fact, and far closer to the essence of things: Denis's diary[29] indicates that the natural motif was inspired by his honeymoon in Perros, which took place that same year, and the boat that produces the meanders is – as in Gauguin's work – quite naturally imbued with a number of symbolic meanings.[30] When it reappears in the background of the conjugal painting par excellence, the *Family Portrait* of 1902, where it is breached by the irruption, in the heart of its flatness, of the volumetric and entirely Raphaelesque reality of wife and children (no longer the fictional Pre-Raphaelite flatness of the works from the early 1890s, the time of the "engagement"), the arabesque recalls its amorous origins and, in its swaying, in its form and colour, unveils its heart's desire: the rocking of a cradle. An interest in the decorative arts,

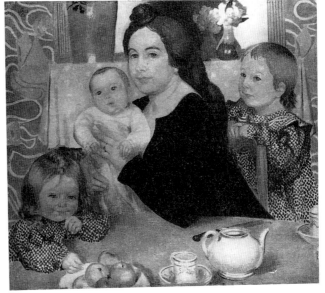

Maurice DENIS
Family Portrait, 1902
Private collection

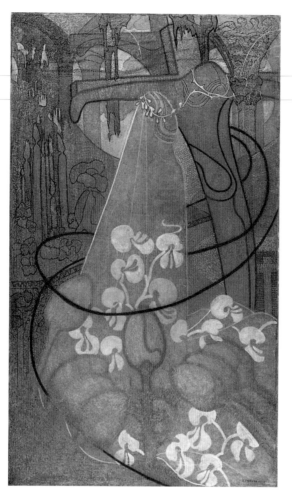

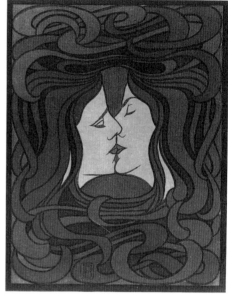

Hector GUIMARD
Wallpaper Design for the Castel
Béranger, 1896-1897
Paris, Bibliothèque Forney

Johan THORN PRIKKER
The Bride, 1892
Otterlo, The Netherlands, Kröller-Müller Museum

Peter BEHRENS
The Kiss, 1898
Cologne, Wallraf-Richartz Museum

certainly, but one informed by the moral significance of the arabesque, which implies the creation of a home, a home where the walls would actually be adorned with "Pink Boats": "the dream will become reality" Denis wrote in his diary, in November 1892.

It is well known that the decorative "expansion" of the great architects of Art Nouveau owes much to the rationalist theories of Viollet-le-Duc, expounded in his *Entretiens sur l'architecture*; but this expansion had, in fact, no other meaning or any other source, particularly Positivist. The remarkable wallpapers designed by Guimard for the Castel Béranger were perhaps his particular version of Horta's sinuous line, itself derived – along with the decorative creations of the English – from the medieval or medievalist ornamentations drawn by Viollet-le-Duc, but what they expressed, on walls and panels, was very like what Denis

applied in 1892 to ceilings, in the arabesques created for Lerolle.[31] Indeed, it might be said that the only real difference between the two works focusses on this question of location: Denis's *painting*, which was generally hostile to Art Nouveau and kept its distance from architecture even when associated with it,[32] had a "higher" goal. For the architect, according to the famous dictum, ornamentation "adheres" to the structure like flesh adheres to a skeleton; for the painter, and especially

31. This link has not been made before as far as I know: Denis's name, excluded a priori by the methods of Positivist analysis, does not appear in the excellent catalogue of the large *Guimard* exhibition held at the Musée d'Orsay in 1992 or in the monograph by Philippe Thiébaut published at the same time – *Guimard. L'Art nouveau* (Paris: Gallimard, 1992).
32. On Denis's relation to Art Nouveau – concerning which mention is usually only made of his participation (albeit unfortunate) in the early stages of the Bing undertaking – see Bouillon, 1993, pp. 70, 119.

the Christian painter, our short-lived earthly existence cannot represent the ultimate reality: between the arabesques on the ceiling are glimpses of heaven.

The Arabesque of Love

The line of the arabesque is a line of love: this fact, subtly evident in Denis's work, becomes strikingly so in the extraordinary *Bride* by Thorn Prikker, who at about the same time (1892) was exploring remarkably similar themes and may actually have been directly influenced: the rising double spiral, which unites only to descend and form a disappointing (after the promise of the lower part) bud on Christ's chest, at odds with his dramatically yearning form, not only encloses and enlaces the bride and her "mystical" spouse, but offers a "visual equivalent" in the ultimately convergent sinuosity of the lines, of the goal and the progression of the act of love. The "decorative" counterpoint created by the flat decoupage of the background, and its mosaic-like stippling, through an undulation of comparable lines that here, however, refute depth, inscribes in the surfaces – and thus "makes visible" – the underlying significance of this flight of creation, this flight of love. Behrens's famous 1898 engraving *The Kiss* (another echo, via Van de Velde, of Denis's *Poetic Arabesques*) offers a rendering that in the embrace of its interlaced forms, and of the faces themselves, is more coherent but ultimately less bold.

The arabesques of *Manao tupapau*, which encircle the encounter between night and day, the "spirit of Death" and wakefulness, life and death, eventually took on in the similarly named woodcuts made for *Noa Noa* (1893-1894) the ovoid form that is the logical extension of their meaning. Like the polar opposites, the arabesques are equally logically summarized in the extremes of black and white: at the frontiers of being and nothingness, where the body, enclosed in an egglike form, seems to be simultaneously fetus and corpse curled in upon itself (that of the 1888 "Breton Eve" as it appears, among other places, in the painting entitled *La Vie et la Mort* [Life and Death]).[33] In yet another derivation, an extraordinary print bearing the same title, the egg and the fetal form, enveloped in the gloom of night, nevertheless finally give birth to a luminous world where the arabesque once again takes flight, more decorative than ever, on a large scale, strongly horizontal, in a symmetrical and frieze-like composition. This work, also, provided the architect-decorators of Art Nouveau with a precise programme – a philosophical programme, initially, of which Van de Velde, in his theory of line, showed more understanding than many, or of which, perhaps, he took most effective advantage.[34] Necessarily an arabesque in the "nativity" of Art Nouveau, the "organic and living line" (according to one of its much-used formulas) was so because it *is* essentially birth, beginning ("At the beginning, the pure arabesque," wrote Denis significantly in the 1890 article, in a mythical but extremely revealing archeology of pictorial

Paul GAUGUIN
Manao tupapau (The Spectre Watches over Her), 1893-1894
The Art Institute of Chicago

Paul GAUGUIN
Manao tupapau, 1894
The Art Institute of Chicago

33. *Gauguin*, exhib. cat. 1988, cat. 79, p. 145.
34. I drew this parallel in *Journal de l'Art nouveau* (Geneva: Skira, 1985), p. 89. As regards the symmetry, which may at first seem surprising, Gauguin's print should be compared to the passage in Denis's 1890 article cited in the next note. Van de Velde, in the essays on line he began publishing in 1902, does not refer to Spencer, but to the aesthetic theory of Theodor Lipps (*Formules de la beauté architechtonique moderne* [Brussels: Archives d'architecture moderne, 1978, new edition], p. 61), nevertheless saying that his famous definition coined in 1902 ("Line is power") had been preceded by a "conviction ... acquired in 1891, the period when we were producing our first abstract and purely linear decorations" (*ibid.*, pp. 63-75). Here, again, we see the gulf that separates him from Denis, who was fundamentally hostile, despite his admiration and numerous interventions, to Van de Velde's Nietzschean paganism (see Bouillon, 1993, p. 13).

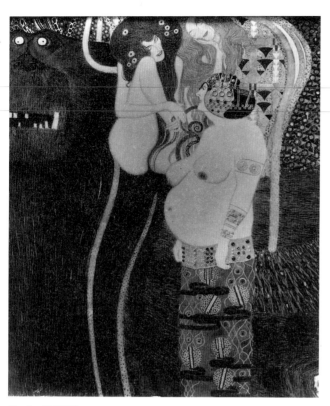

Gustav KLIMT
"Lewdness" (Beethoven Frieze), 1902
Vienna, Österreichische Galerie, Belvedere

Scream translate, finally, the anguish and profound terror.[36] For Denis, the "accompaniment" of the "embroidery of arabesques" could only be that provided by the companion, the wife, but the "line of love" is undoubtedly the one that leads back to the beginning, to the female body, as Klimt intimated in 1902 (perhaps even more clearly than Munch in his **Madonna**) in the centre of the *Beethoven Frieze* with the figure of Lewdness, which divides the composition while simultaneously begetting it. One year before Gauguin's death and the final extinguishing of Behmer's candle, the very year of the Turin exhibition, occurred the double demise of Symbolism and Art Nouveau – the double demise of the arabesque. While the depreciation of the female body became henceforth a sign of modernity,[37] the abortive ambition of Art Nouveau had been to return to a feminization – a *profound* feminization – of an art of which the arabesque, in the hands of its true masters, would ultimately have been the secret and magnificent expression.

<div style="text-align:right">J.-P. B.</div>

knowledge),[35] and because it derives this quality from the curled female body, or the ultimate curling of this body, of which the "veils" that covered that of Loie Fuller – as seen by Bradley or Toulouse-Lautrec – are simply a metaphorical expression, and of which the Munchian arabesques of *The*

35. What follows is also illuminating: "At the beginning, the pure arabesque, as little trompe l'oeil as possible; a wall is blank: fill it with symmetrical arrangements of shapes, harmonious with colours . . . " (Denis, 1993, p. 13).
36. Baudelaire's two notes in *Fusées* IV and V (quoted again by Jean Clair, p. 168 of the book cited in note 37 below) – "The arabesque design is the most spiritual of designs" and "The arabesque design is the most ideal of all" – should be understood, *a contrario*, as the expression of this sublime terror.
37. Jean Clair, *Méduse. Contribution à une anthropologie des arts du visuel* (Paris: Gallimard, 1989), p. 203 and *passim*: if Medusa appeared above the *entrance* of the Palace of the Secession (p. 55), it was perhaps not strange that, especially for Klimt, what she represented in Freud's brilliant 1922 analysis, the obvious transposition, should be featured explicitly *inside*.

Microbes and Maladies
Bacteriology and Health at the Fin de Siècle

BARBARA LARSON

Developments in the natural sciences in the second half of the nineteenth century provided fertile territory in the Symbolists' search for underlying truths – a deeper level of meaning in the world around them and an understanding of the hidden forces of life. Like the Naturalists before them, fin-de-siècle artists were influenced by new currents in evolutionary theory, the workings of the mind and medicine.

Louis Pasteur's germ theory of disease had been initiated as early as 1857 in his work on micro-organisms and fermentation, but its application to higher animals and man was not firmly established until twenty years later. By the early 1880s, an international revolution in bacteriology had taken place that laid the groundwork for the practice of modern medicine in the Western world. Pasteur had revealed an infinitely small yet infinitely powerful enemy to human survival: the microbe.[1] By 1880, advances in the high-resolution oil-immersion microscope allowed a detailed study of the organic world hidden to the naked eye, and international teams of microbiologists competed to isolate and classify the tiny bacteria, protozoa and viruses that caused human disease.[2] In Germany, Robert Koch, who rivalled Pasteur himself in important new discoveries, was particularly instrumental in linking specific germs with resulting pathologies. By the turn of the century, the micro-organisms that caused some of the leading illnesses of the period, such as tuberculosis, typhoid fever, cholera, diphtheria and pneumonia, had been identified.

Discovering the relationship between germs and disease, however, did not necessarily lead to a cure. Despite the

Albert EDELFELT
Portrait of Louis Pasteur (detail), 1885-1886
Paris, Musée d'Orsay

sensational updates in the press that kept the public informed on newly identified bacteria, the medical community seemed oddly impotent before this complex, unfolding world of rapidly multiplying organisms. In Gustav Klimt's mural *Medicine* (1901) for the University of Vienna, the powerlessness of curative science is suggested: Hygieia, goddess of health, holds forth a venomous-looking cup, while behind her, huddled humanity is united in suffering and grief under the surveillance of the skeleton Death.

Tuberculosis and syphilis were at all-time highs throughout Europe in the last decades of the century. In Michel Corday's *Venus* (1901), a story of syphilitic death, a medical doctor

1. The term "microbe", for micro-organism, was coined in 1878 by the surgeon Charles Sédillot. Pasteur's work, examined in this essay for its contribution to germ theory, was also central to the debate on origins. His classic paper "Mémoire sur les corpuscules organisés qui existent dans l'atmosphère" (1861) overturned the prevailing belief that life could emerge from nonlife in a process known as "spontaneous generation". From Pasteur, it was understood that micro-organisms could not arise independently of a living parent.
2. Micro-organisms were observed as early as 1674 by Antoni van Leeuwenhoek. Called "animalcules", they remained largely curiosities until the nineteenth century.

searches in vain for a curative serum at the Pasteur Institute. Drawing upon pre-existing medical notions, many, including some physicians, thought that diseases like syphilis and tuberculosis had an essential hereditary nature, and these beliefs became entangled with the newly revealed pathogenic germ.[3] High infant death rates were of grave international concern, and plagues continued their relentless sweep across the continent. Des Esseintes, the central character of J.-K. Huysmans's *À rebours* (1884) and mentor to the Symbolist generation, gloomily meditated on the constancy of disease: "After all, what did their lives amount to but impetigo, colic, fevers, measles in childhood; foul diseases, and unfaithful wives in manhood; and then, in old age, infirmities and death-agonies in workhouses or hospitals?"[4]

Popularized at a time when degeneration theories spelled doom to ageing European races,[5] and industrialization and the tensions of the urban environment were linked to nervous deterioration, germ theory of disease suggested a virulent external force ready to attack the weak and contributed to the late nineteenth-century obsession with morbid biology.

Borrowing from Romanticism's fascination with disease and Realism's sordid, tragic tales of modern civilization, the Symbolists explored the fears of their generation. Germs, morbid bodily processes and preoccupation with being ill went along with personal and social anxieties. In Symbolist art and literature, the spectre of early death often haunts the artist. The fin-de-siècle exploration of disease and decay was tied to the theme of social disintegration. Europe itself was sick and awaiting collapse, and the artist, with his finger on the invalid's pulse, charted the relentless progress of its decline.

Coming of age by the mid-1880s, a phalanx of Pasteurian hygienists countered the ever-present, invisible microbe with the defence of prevention. Late nineteenth-century hygiene was an attempt at rational control in the face of nature, which was deceptive. The European public learned that microbes could be transported in a drop of water or mote of dust, on one's skin or in folds of clothing. That germs could invade all public and private spaces, crossing social strata and political borders, gripped the public imagination; the threatening, horrific aspects of micro-organisms were popularized and, indeed, often sensationalized. The microbe was the late nineteenth century's scientific version of a nightmare.

Campaigns by Pasteurians to effect major changes in personal cleanliness, social relationships, housing and sanitation called continued attention to dangerous hidden forces.[6] Germs lurking in air and water seemed to have originally come from "elsewhere". When germ theory was established, class

Cover illustration for "Le Grelot" showing "the cholera microbe 125 thousand times larger than life", 1884
Paris, Bibliothèque nationale de France

boundaries seemed somewhat threatened, and congested cities brought people from various stations in life into closer contact with one another. At the same time, new railway lines and progress in modes of transportation made travel easier. As physical and social distances collapsed, fear of contamination spread. Shared objects and spaces were considered a risk.

3. The concept that illness can be hereditary and insinuate itself in family lines has a neo-Lamarckian basis. Originating in France, this idea had wide appeal in the immediate pre-Pasteurian period and continued to be referred to in the late nineteenth century. For an introduction to the confusion of infectious and hereditary disease, see Stephan Kern, "Germs, Genes and Ideas", in *Anatomy and Destiny: A Cultural History of the Human Body* (Indianapolis: Bobbs-Merrill, 1975), pp. 112-124.

4. J.-K. Huysmans, *À rebours* (Paris: Sans Pareil, 1924); quoted in English from *Against Nature*, trans. Robert Baldick (Harmondsworth, England: Penguin, 1959), p. 170.

5. The medical model of biological degeneration, which draws from the continued interest in heredity with ties to alcoholism, insanity and crime, is examined in Robert A. Nye, *Crime, Madness and Politics in Modern France* (Princeton: Princeton University Press, 1984), and Daniel Pick, *Faces of Degeneration: A European Disorder, c. 1848 - c. 1918* (Cambridge: Cambridge University Press, 1989). See also Ruth Harris, *Murders and Madness: Medicine, Law and Society in the Fin de Siècle* (Oxford: Clarendon Press; Toronto: Oxford University Press, 1989), and J. Edward Chamberlin and Sander L. Gilman, *Degeneration: The Dark Side of Progress* (New York: Columbia University Press, 1985).

6. The Pasteurian revolution had its political dimensions as well, most notably in France, where it was associated with ideas of fighting the enemy within, the

Crowds, foreigners and travellers were suspect. People on the fringes of society – the lower classes and prostitutes – were especially thought of as microbe-infested and liable to leave their germs behind.[7]

The city, with its compressed populations, was implicated as a true enemy to health. Between 1880 and 1913, the number of cities in Europe with a population over a hundred thousand rose from fourteen to forty-eight. Émile Verhaeren's *Villes tentaculaires* (1895) depicts the late nineteenth-century image of the crowded, suffocating city, where death stalks the streets. Its antithesis is found in Jules Verne's *Les cinq cents millions de Bégum* (1879), which envisions a healthful, microbe-free city with gleaming white walls. Thomas Mann, who came of age in Munich of the nineties, sets his *Death in Venice* in a city of stagnant waterways, where the overstrained novelist Aschenbach gradually succumbs to cholera as it creeps over the city.[8] As an agent of communicable illness, the unsanitary city could suggest the diseased state of culture as a whole.

With the rise in urban population, the potential effect of crowd diseases grew more alarming. The Pasteurians published disaster statistics on the number of microbes per city street, and manufacturers capitalized on fin-de-siècle anxiety by promoting new devices to safeguard health. The Mallie water filter, for example, on view at the 1889 Exposition universelle in Paris, promised buyers that the microbes in household water would be reduced from 2,100 per cubic centimetre to zero, thereby preventing epidemic diseases.[9]

Crowd diseases are a result of germs quickly crossing populations and moving from one place to another, and epidemics were a major focus in the medical community. Plagues, a theme revived by Symbolism, are treated in the work of James Ensor, Arnold Böcklin, Félicien Rops and Max Klinger. Alfred Kubin's *Cholera* gives visual form to the power of the mighty microbe, which gathers force as it travels.

Typhoid and cholera, both water-borne, were a serious form of contagion during the Symbolist period. Koch had isolated the cholera bacillus in 1883, when an outbreak in Egypt threatened Western Europe. Despite the social precautions taken, the disease began its insidious move once again and reached Europe by 1892. Two years earlier, echoing the lack of faith in medical science, Pierre Veber expressed the anxiety of his period in a short story in the Symbolist journal *La Revue blanche*.[10] Having read about the outbreak of cholera that year in Asia Minor, his character consults up-to-date scientific literature – Bouillaud's *Traité du choléra morbus*, Blondel, de Gendrin and the *Bulletin de la conférence sanitaire de Vienne* – and describes the stages of the disease in gruesome detail. Obsessed with the unstoppable progress of the "germs of destruction", he implicates "the nomads who carry death in the folds of their garments". Convinced of the disease's ultimate advance, he tracks its

regeneration of the country in the aftermath of the Franco-Prussian War and, by the nineties, interdependency and social solidarity. See Léon Bourgeois, *La politique de la prévoyance sociale* (Paris: E. Fasquelle, 1914); Jacques Léonard, *Médecins, malades et société dans la France du XIXᵉ siècle* (Paris: Sciences en situation, 1992); Georges Vigarello, *Le sain et le malsain : santé et mieux-être depuis le Moyen-Âge* (Paris: Seuil, 1993); Bruno Latour, *The Pasteurization of France*, trans. Alan Sheridan and John Law (Cambridge, Massachusetts: Harvard University Press, 1980; originally published as *Microbes : guerre et paix*); and Pierre Rosanvallon, *L'État en France* (Paris: Seuil, 1990). On the complex politics of health, national unification and a medical concept of race in Germany, see Paul Weindling, *Health, Race and German Politics between National Unification and Nazism, 1870-1945* (Cambridge: Cambridge University Press, 1989).

7. On the working class as an agent of contamination in France before germ theory, see Louis Chevalier, *Classes laborieuses et classes dangereuses à Paris pendant la première moitié du XIXᵉ siècle* (Paris: Hachette, 1984), and Alain Corbin, *Le miasme et la jonquille : l'odorat et l'imaginaire social, XVIIIᵉ-XIXᵉ siècles* (Paris: Flammarion, 1986), which looks at the belief that odour carries disease.

8. Hygienists had advocated cleaning up towns, digging drains, and increasing running water and the circulation of air even before the Pasteurian period, and significant advances had been made by mid-century in urban sanitation and water management. But it was in the concern for pure water, new housing regulations and the methods of disinfection gradually instituted towards the turn of the century that the move to apply bacteriology to hygiene was revealed.

9. Beginning with the 1874 congress in Vienna, international issues of public hygiene took on importance in Europe, with leadership gradually shifting to France. The language grew increasingly Pasteurian, with an emphasis on bacteriology. By 1912, thirteen more international congresses had taken place. The quality of water and necessity of better sewer systems were always an issue. Laboratories to test water and food were gradually set up in major cities.

10. Pierre Veber, "Choléra", *La Revue blanche*, June 1890, pp. 65-74.

Alfred KUBIN
Cholera, about 1898-1899
Linz, Landesgalerie

westward journey from Afghanistan through Russia, and scoffs at the commission set up by the French government to halt the epidemic: "What foolishness! They are trying to stop the invisible, rein in the intangible. It is everywhere – in the water we drink, the air we breathe. I know that it is coming." Hypochondria gives way to the inevitable as he is choked on the streets of Paris by "the blue demon".[11]

Germ theory confirmed the Symbolist thinking that visible reality was an illusion and greater truth lay in hidden realms. The shadowy and blurred effects in the works of some Symbolists, such as Eugène Carrière and Odilon Redon, suggest a matter that is neither solid nor impermeable. Invisible microbes also implied insidious, malevolent forces in the world. In his satanic *Là-bas*, Huysmans wrote, "Space is peopled by microbes. Is it more surprising that space should also be crammed with spirits and larvae? Water and vinegar are alive with animalcules. Now why should not the air, inaccessible to the sight . . . swarm, like the other elements, with beings more or less corporeal, embryos more or less mature?"[12]

Crowd disease, with its micro-organisms multiplying in the bodies of sick individuals, spreading its symptoms to others, has its analogy in the interest taken in crowd psychology during this period. The popularization of germ theory and the study of mobs both arose in the last quarter of the nineteenth century. The crowd as morbid, oppressive, anonymous or persecuting plays an important role in the work of Henry De Groux, Munch and Ensor, as in the latter's *Entry of Christ into Brussels* (1888, J. Paul Getty Museum). Crowds were thought of by theorists in terms of a kind of collective pathology. The growing presence of socialism and anarchism had an analogy in crowd disease's threat to undermine the bourgeoisie. Crowds were like a spreading fever, a kind of plague. Hippolyte Taine, an early crowd theorist, would refer to crowds as bacterial infections. The discipline drew upon a number of popular scientific models, including anthropology and hypnosis, but the similarity of the language used to describe crowd behaviour with that used by the new wave of Pasteurian scientists to describe infectious disease is unmistakable. In a classic statement in the book that summarized his ideas on collective psychology, *La psychologie des foules* (1895), Gustave Le Bon, the most important contributor to this field, wrote, "Ideas, sentiments, emotions and beliefs possess in crowds a contagious power as intense as that of microbes . . . Cerebral disorders like madness are contagious."[13] Crowd theory was popular in France, Belgium, Italy and other countries as well.[14]

Microbes also invaded private space. They could easily be transported on the skin, and the careful washing of the entire body was strongly promoted by hygienists. In art, the theme of bathing became increasingly important by the last two decades of the century.[15] In 1886, Degas exhibited a set of bathers whose catalogue description read: "Series of nude women bathing, washing, drying and towelling themselves, or having their hair combed".[16] In certain of Degas's works, plump matrons step from bathtubs, a luxury item in this period, to white towels held for them by their maids. Their poorer counterparts squat in shallow metal washtubs, twisting awkwardly to reach all areas of the body. Women were considered more germ-infested than men, and lower class women especially so. In *Certains*, Huysmans wrote that Degas's bathers conveyed the "moist horror of a body that no lotion can cleanse".[17] Gauguin, Félix Vallotton, Renoir and Carrière all took up the subject of bathers. In Carrière's *After the Bath*, one woman carefully inspects the skin of another.

The importance of personal hygiene influenced the public bath movement. The idea of regeneration and health through the purity of water also contributed to a boom in health spas from 1880 to 1914. Seabathing, too, with its savage, everrenewed waters, increased in popularity.

The domestic interior, with its dusty tabletops, drapes and dark corners, was considered an ominous breeding ground for microbes. There was a virtual horror of dust during this period. Dust carried with it smallpox, diphtheria, measles,

11. Many of those who persisted in doubting that tiny micro-organisms could bring about such utter devastation were silenced by the experience of Hamburg in 1892, where residents from one side of town who drew water from an antiquated system fell victim to cholera while the other side, benefiting from improvements, was spared.

12. J.-K. Huysmans, *Là-bas* (Paris: Librairie Plon, n.d.); quoted in English from *Down There*, trans. Keene Wallis (New York: Albert & Charles Boni, 1924), p. 142. The idea of the horrific microbe that controls man had currency in science fiction during this period as well. As early as 1863, Flaubert had envisioned writing a story about a microbe that outgrows the scientist who studies it and devours him. André Couvreur's occultist mad-scientist Dr. Tornada, in *Invasion of the Macrobes* (1908), develops the "micrococcus aspirator", which grows to enormous proportions and heads for Paris decimating villages as it goes.

13. Gustave Le Bon, *La psychologie des foules*, 2nd edition (Paris: Alcan, 1896), pp. 112-113. Le Bon was trained in medicine and assumed the position of a pathologist in his analysis. In 1881, he began publishing in *La revue scientifique*, one of the major organs of the Pasteurians.

14. Edmond Picard, editor of *L'Art moderne* and supporter of Les XX, was one of the popularizers of crowd psychology in Belgium. The crowd figures prominently in his play *Le Juré* (1887). A great admirer of Le Bon, he wrote his biography in 1909.

15. On the increasing attention paid to bathing by the end of the century, see Georges Vigarello, *Concepts of Cleanliness: Changing Attitudes in France since the Middle Ages*, trans. Jean Birrell (Cambridge: Cambridge University Press, 1985; originally published as *Le propre et le sale*), and Julia Csergo, *Liberté, Égalité, Propreté : la morale de l'hygiène au XIX^e siècle* (Paris: Albin Michel, 1988).

16. Quoted in J.-K. Huysmans, *Certains* (Paris: Tresse & Stock, 1889; reprinted Westmead, England: Gregg International publishers, 1970), p. 23.

17. *Ibid.*, p. 27.

of tuberculosis, would blame his poor health on "pulmonary weakness" and often treats this illness in his work. Young female invalids, as in Ejnar Nielsen's *The Sick Girl*, are a common theme in Scandinavian Naturalism and Symbolism.

As tragic as the protacted death of frail young women was another phenomenon common to the period: the high infant mortality rate. Especially critical in France, where it was tied to fears of infertility and national decline, it was a major problem throughout all of Europe, and at least one in ten children died in infancy. In 1886, eighteen hundred babies died in Paris alone. Some of the major causes of infant death were diphtheria, diarrhea and bronchopneumonia. The infant mortality rate was a top priority at international hygiene conferences, and many studies were devoted to infant disease at the end of the century.

By the mid-1880s, infant death was a prevalent theme in literature and art. In Zola's *L'œuvre* (The Masterpiece, 1886), Claude Lantier obsessively paints his dead child. In 1885, the year his four-year-old son died of diphtheria, Carrière exhibited his first *Sick Child*. This may well have been an inspiration for Munch's *Sick Child* begun the same year, which the Norwegian artist would call his most important painting.[19] Sick or dead children are a recurrent theme in the sculpture of George Minne. Charles Maurin's *Serum Treatment* (1895), celebrates the discovery of an anti-diphtheria serum in 1894 by Pasteur's follower Dr. Émile

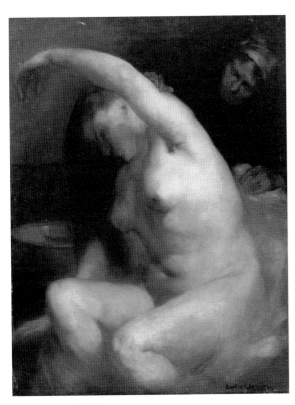

Eugène CARRIERE
After the Bath, undated
Paris, Musée d'Orsay

scarlatina and tuberculosis. Redon's *On the Backdrop of Our Nights, God with His Knowing Finger Traces a Multiform Implacable Nightmare* suggests dust's potential horrors as one sleeps. The images of Redon, a great admirer of Pasteur, are full of references to terrifying micro-organisms that could be transported by water or air.[18] In Ensor's *Woman in Distress* (1882, Musée d'Orsay), the small figure of a woman sunk in bedding lies in a dark room with thick carpeting and heavy drapes – the well-appointed bourgeois bedroom was now known to be a potential death chamber.

One of the most common and deadly diseases of the period, tuberculosis seemed to strike infants and young women most often. It was linked to as many as one in seven deaths by Koch, who isolated its bacillus early in 1882. Despite its bacterial origins, many persisted in believing it to be hereditary in nature. Munch for example, whose mother and sister died

18. Redon's original biographer noted that Redon sent Pasteur a fan letter along with a set of his lithographs, *Les origines* (1883). Pasteur's remark that it took the hand of Redon to give life to monstrosities would be treasured by the artist. See André Mellerio, *Odilon Redon : peintre, dessinateur et graveur* (Paris: Henri Flour, 1923), p. 155, footnote 3.
19. Reinhold Heller, *Munch: His Life and Work* (Chicago: University of Chicago Press, 1984), p. 21.

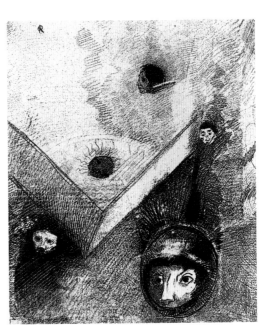

Odilon REDON
On the Backdrop of Our Nights
(No. 6 of "Les Fleurs du Mal"), 1890
London, British Museum

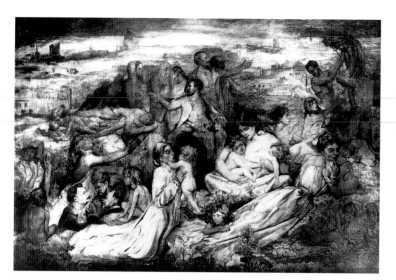

Charles MAURIN
The Serum Treatment, 1895
Lyons, Musée des Hospices civils

Roux, who appears like an Olympian god surrounded by mothers and infants.

Many of the micro-organisms that led to the rapid deterioration of young children were believed to be transported through diet. By 1890, infant consultations based on Pasteurian ideas were being instituted in France. The related "goutte de lait" movement, launched in 1892, encouraged mothers to breast-feed their own babies or use sterilized milk made available at low cost. "Goutte de lait" was part of the developing science of puericulture, which educated mothers and encouraged repeated office visits for young children. This movement had an enormous impact outside France. In 1905, the first international "goutte de lait" conference took place at the Pasteur Institute. In Jean Geoffroy's *"Goutte de lait" Movement at the Dispensary in Belleville*, the founders Doctors Variot, Budin and Pinard are shown at centre, as infants are weighed and mothers breast-feed or buy pasteurized milk.[20] The public attention called to infant care and survival, purity of diet and "mother's own milk" no doubt influenced the Symbolist maternity theme, which was popular by the nineties and can be found in the work of Maurice Denis, Giovanni Segantini and Léon Frédéric, among others.

Developments in the sciences, from Darwinism to an interest in hysteria, had provided a discourse on the role of the female in the late nineteenth century. Tied to her own biology, she was at her best as procreator, embodying nature's cycles of fertility. Physically weak or ignorant women, however, could be sources of contagion.

Less innocent than the homebound female invalid or the mother who needs tutoring in the care of her child is the venal female who transported the most dreaded viruses. In a prose poem in reference to Munch's *The Kiss*, August Strindberg wrote: "*Kiss* – The merging of two beings, of whom the lesser, like a carp, seems ready to engulf the larger, in the manner of vermin, microbes, vampires and women".[21]

The female, especially the prostitute, could be a tempting trap of contamination. The untrustworthy femme fatale, a common Symbolist theme, found inspiration in the high anxiety associated with the possibility of contracting a venereal disease. Syphilis found numerous victims in the bohemian community, from Baudelaire to the young Picasso, whose lurid prostitutes in *Les demoiselles d'Avignon* (1907) have been interpreted as carriers of the disease. Although syphilis had haunted generations of Europeans, its golden age was the period from 1885 to 1914.[22] Confused medical theories implicated drinking glasses, towels and kissing. The fear of syphilis was so intense acute that it gave rise to the international phenomenon of "syphilophobia". Although by 1900 only three percent of actual deaths were attributed to syphilis – compared with tuberculosis, which sometimes claimed as much as twenty percent of the population – no disease was more dreaded. In 1899 and again in 1902, international congresses on syphilis and other venereal diseases were held in Brussels, with most European nations represented.

The prostitute, implicated as the foremost source of veneral contagion, was a growing presence on the streets of major European cities.[23] Attempts to regulate prostitution in supervised brothels where regular medical inspections were conducted met with limited success, for many prostitutes worked clandestinely. The prostitute seemed to be increasingly contaminating the upper classes as she circulated in society.[24]

20. Pierre Budin was a major force behind the child welfare movement. By the time of his death in 1907, there were 497 puericulture clinics in France alone.

21. August[e] Strindberg, "L'exposition Edward Munch", *La Revue blanche*, vol. 10, no. 72 (1896), p. 525.

22. Although long suspected to be bacterial in nature, the spirochete of syphilis was isolated as late as 1905. Four years later, the highly toxic Salvarsan was developed by the German bacteriologist Paul Ehrlich and began to replace the uncertain mercury treatment. The latter involved a four-year regimen that included careful attention to diet and hygiene. By the 1940s, syphilis was treated with antibiotics.

23. The literature on prostitution in the fin de siècle is vast. See Alain Corbin, *Le temps, le désir et l'horreur* (Paris: Aubier, 1991) and his *Filles de noce : misère sexuelle et prostitution (19ᵉ et 20ᵉ siècles)* (Paris: Flammarion, 1982; published in English as *Women for Hire: Prostitution and Sexuality in France after 1850*, trans. Alan Sheridan [Cambridge, Massachusetts: Harvard University Press, 1990]). See also Charles Bernheimer, *Figures of Ill Repute: Representing Prostitution in Nineteenth-Century France* (Cambridge, Massachusetts: Harvard University Press, 1989), and Judith Walkowitz, *City of Dreadful Delight: Narratives of Sexual Danger in Late-Victorian London* (Chicago: University of Chicago Press, 1992).

24. Parent-Duchatelet's study of prostitutes in Paris in 1836 still had credibility in the late nineteenth century and was referred to outside of France. His famous analogy

364

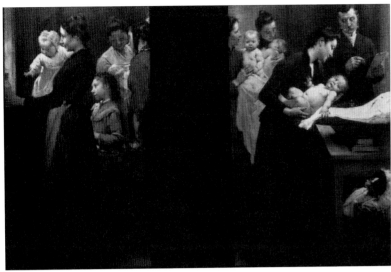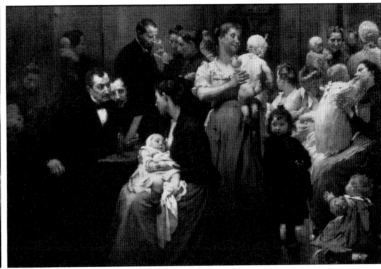

Jean GEOFFROY
The "Goutte de Lait" Movement at the Dispensary in Belleville, 1903
Paris, Musée de l'Assistance publique

Categories of prostitution also became hazy, for some working class women supplemented their income through occasional prostitution. As germ theory gained ground and people came to fear shared objects, all women whose jobs brought them into repeated contact with the public became a highly suspect source of infection. The fear of venereal disease also brought about a shift in groups of women who were sexually exploited and might carry syphilis. An example of this is the Viennese "süßes Mädel", memorialized in the plays of Arthur Schnitzler. Considered sexually safer than a streetwalker, these naïve working class women, tempted by the flattery of bourgeois gentlemen, were lured into an endless cycle of abandonment.

Because of the reality that untreated syphilis could affect the unborn child, as this disease began to assume a middle class identity, it became increasingly bound up with the fear of a hereditary legacy. Ibsen's *Ghosts* (1881) is a play about hereditary syphilis. Oswald Alving, riddled with the illness he inherited from his father, eventually loses his mind. Obsessed with its deadly horrors, there were many who came to believe syphilis could even skip generations and suddenly reappear in

yet a more virulent form. Tainted family lines and the contamination of innocents is a recurrent fin-de-siècle theme. Dread over the effects of syphilis contributed to the late nineteenth-century interest in biological monstrosities and progressive decomposition of the body – the microbe was also the agent of putrefaction.

Félicien ROPS
Mors syphilitica (Death on the Pavement), 1905
Paris, Bibliothèque nationale de France

is that controlled prostitution was akin to city sewers, keeping the social body clean. The increased visibility of prostitution later in the century suggested that these "sperm sewers" were infecting society. In 1857, a study of other major cities was added. See A. Parent-Duchatelet, *De la prostitution dans la ville de Paris : considérée sous le rapport de l'hygiène publique, de la morale et de l'administration... Suivie d'un précis... sur la prostitution dans les principales villes de l'Europe*, 3rd edition, amplified and annotated by A. Trebuchet (Paris: J.-B. Bailliere, 1857), 2 vols.

The hereditary aspect of syphilis was tied to the very notion of racial degeneration. In Eugène Brieux's controversial play *Les avariés* (1901), a doctor warns a young syphilitic man against marrying and having children: "It is in the name of these innocents that I implore you; it is the future, the race that I am defending."[25] Huysmans's Des Esseintes, himself obsessed with this disease, implicates all of humanity:

"It all comes down to syphilis . . . in the end" . . .

And he had a sudden vision of unceasing torments inflicted on humanity by the virus of distant ages. Ever since the beginning of the world, from generation to generation, all living creatures had handed down the inexhaustible heritage, the everlasting disease that ravaged the ancestors of man and even ate into the bones of the old fossils that were being dug up at the present time.

Without ever abating, it had travelled down the ages, still raging to this day. [26]

After pleading for his health, Oswald's final words in *Ghosts* are, "Mother, give me the sun . . . the sun." No longer just a romantic symbol of life and power, the sun was strongly promoted by Pasteurian hygienists from the last two decades of the century on as nature's great prophylactic in killing infectious agents. Public buildings, from schools to hospitals, were to have more and larger windows. Vilhelm Hammershøi's **Dust Motes Dancing in the Sunlight**, potentially harmful in a dark interior, are rendered innocuous by the flood of light that streams through the window. The sun was not only a destroyer of bacteria in the environment; in the mind of the public, it became associated with a vague understanding of the use of heat in sterilization processes, seemingly confirming a scientific basis for the action of sunlight on the body. In part, it was the healing power of the sun, a favourite motif in his work, that drew Van Gogh from polluted Paris to Arles in the south of France. Munch would call the sunlight that bathed his tubercular female in *Springtime* (1889) "Oswald's sun" and traced a direct correspondence from this image to the powerfully radiating solar disk of his Oslo murals (1909-1912), which illuminates, among other things, the robust figure of a nursing woman.[27] The vital force of the sun was an inspiration for Nietzsche and an important motif in his influential *Thus Spake Zarathustra* (1885). The significance of sunshine to health assumed a near-religious character for some. Nature cults and nude sun bathing were popular by the turn of the century. Sun-soaked nudes were one of the first subjects depicted by German Expressionists. Healthy-bodied neo-classical nudes in the out-of-doors can be found in the work of

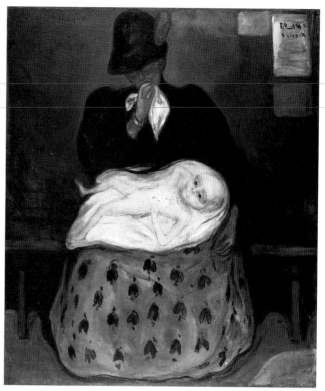

Edvard MUNCH
Inheritance, 1897-1899
Oslo, Munch-museet

Picasso and Matisse, among others, in the first decade of the new century. Sunlight and the solar spectrum also drew the attention of artists like František Kupka, who began to leave Symbolism for experimental abstraction in the early twentieth century.

The quest for sunshine and microbe-free air fostered the fast-growing practice of taking an alpine cure. Pasteur himself had ascertained the low number of germs at high altitudes by climbing mountains to measure the number of microbes. The desire for regeneration of the body taxed by civilization and racial and family heredity, and constantly menaced by the silent, secret microbe, encouraged the escape into nature, with its light, open spaces and seaside. Science was reinforcing the idea that the great antidote for civilization and its ills was the healing power of nature itself.

Health and survival meant freedom from gloom and claustrophobic spaces. The rejection of the contaminated urban environment resulted in a series of reforms in workers' living quarters as well as utopian housing schemes, such as

25. Eugène Brieux, *Les avariés* (Paris: P.V. Stock, 1901), p. 20.
26. Huysmans, *Against Nature*, pp. 101-102.
27. Heller, 1984, p. 209.

the garden city movement, that were influenced by bacteriology. By the early years of the twentieth century, there was a dramatic decline in deaths from some infectious diseases. Improvements in sanitary engineering, public health laws and housing regulations, the protection of water through purification and milk through pasteurization, and programmes of vaccination and bacteriological diagnosis all contributed to well-being, and the morbid fin-de-siècle fear of a world overwhelmed by contagion began to subside.

B. L.

I would like to thank the following people for their assistance in the preparation of this essay: Robert Rosenblum, Linda Nochlin, Richard Shryock, Thomas Kirchner, Stefan Germer, Joshua Cole, Karen Carter, Marina Neri and especially Laura Morowitz.

V. *New Territories*

471 to 515

The flight "anywhere out of the world" advocated by Baudelaire and Mallarmé, the desire for self-sufficiency, and a deliberate emotional investment in aspects of the inner life led to a turning in on the self, an approach for which the Parisian apartment, a supremely private place, became the concrete equivalent. The turn-of-the-century dandy, his consciousness painfully at grips with an existential horror of living, seems to have dreamed of a secluded interior within which he could create an ideal, autonomous world. Des Esseintes's residence as Huysmans described it in *À rebours* (1884) is a perfect example of this, and its re-creation of the sensations of the natural world through elaborate artificial means testifies to an oblique relationship with that world. Like the easel paintings scattered over the walls, the wallpaper, art objects and illustrated books were defining components of the contemplative sensibility whose everyday surroundings they constituted; the Japanese-style arabesques of an Émile Gallé vase, like *"Les feuilles des douleurs passées"* (1900), fulfil their decorative function in plastic effects echoing the melancholy aphorisms inscribed on their sides. The profusion of art objects produced by Symbolist artists and craftsmen speaks eloquently of the need to reduce the range of quotidian backgrounds to a single ornamental function.

311

Far from providing exotic vistas for spectators seeking only to lose themselves in private meditation, the photographs turned out by American and European illustrators evoked the same kind of contemplative approach, removed from the everyday world; tinted in pastel, they have the effect of hand-produced work. Fernand Khnopff's photographs and Clarence H. White's *Symbolism of Light* (1907) become a kind of mirror in which the viewer's eye loses itself.

285

G. G.

471 (cat. 144)
Frida HANSEN
The Dance of Salome
1900
Wool tapestry
193 x 682 cm
Zurich, Museum Bellerive

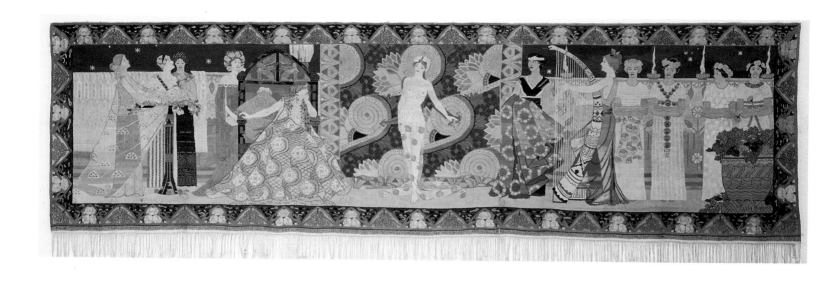

A recurrent theme in Symbolist art is the story of Salome, who danced for King Herod and, encouraged by her mother Herodias, asked for the head of John the Baptist in exchange. The biblical account was popularized in the nineteenth century by writers such as Gustave Flaubert and Oscar Wilde; artists like Max Klinger, Lovis Corinth, Gustave Moreau and Aubrey Beardsley contributed their versions of the story. The subject was not usually treated by women artists of the period, but the Norwegian tapestry designer Frida Hansen may have been drawn to this Symbolist theme after her stay in Paris in 1894-1895.

In the tapestry, only the women of the story are represented. Salome is the central figure, dressed in strands of pearls and a diaphanous skirt decorated with tiny coiled snakes. Coiled forms are repeated in the background as seven large spirals, which may refer to the seven veils Salome used in her dance. Her mother Herodias, wife (and former sister-in-law) of Herod and herself a great seductress, is given a prominent position at the left, where she sits on a throne decorated with two sphinxes. Her attendants appear to be more worldly wise than the virginal figures dressed in white at the right who attend Salome, as she is transformed from a chaste beauty to the "the symbolic incarnation of dying lust", as the image from Gustave Moreau's painting is described in J.-K. Huysmans's *À rebours*.

The tapestry is woven in a contrast of rich, vivid colours and lighter tones, highlighted with overall geometric and floral patterns, some with decidedly Nordic references. Hansen was one of the outstanding textile artists in Norway at the turn of the century. She was at the centre of the revival of handwoven tapestries crafted from handspun wool coloured with vegetable dyes. Hansen won international recognition for her work in both Europe and America, and *The Dance of Salome* was shown at the Exposition universelle of 1900.

R. P.

472 (back view)

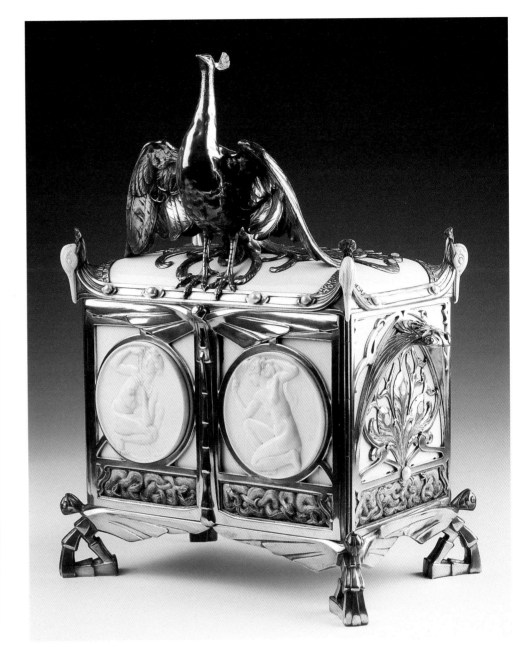

472 (cat. 482)
Philippe WOLFERS
"La Parure" Jewellery Box, 1905
Brussels, Musées royaux d'Art et d'Histoire

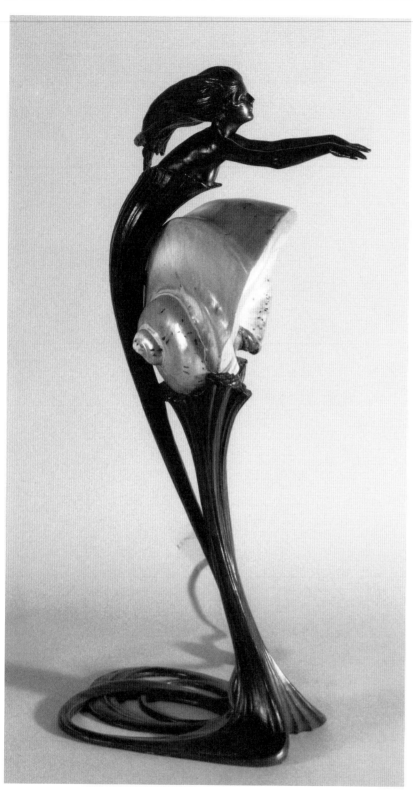

473 (cat. 140)
Gustav GURSCHNER
Table Lamp, undated
New York, Barbara and Lloyd Macklowe collection

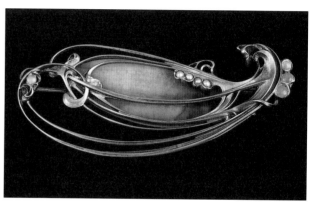

474 (cat. 137)
Hector GUIMARD
Brooch, about 1909
New York, The Museum of Modern Art

475 (cat. 50)
Edward COLONNA
Sugar Spoon, about 1900
Paris, Musée des Arts décoratifs

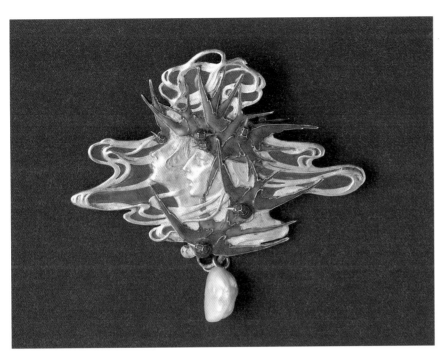

476 (cat. 238)
René LALIQUE
Brooch-Pendant, 1898-1900
Schmuckmuseum Pforzheim

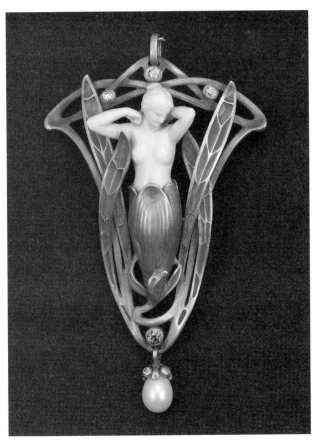

477 (cat. 370)
Hugo SCHAPER
"Erwachen" Brooch, 1902
Württembergisches Landesmuseum Stuttgart

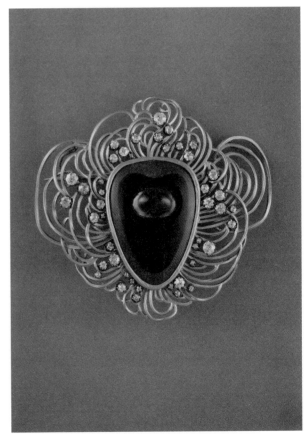

478 (cat. 46)
Hans CHRISTIANSEN
Brooch, about 1901
Württembergisches Landesmuseum Stuttgart

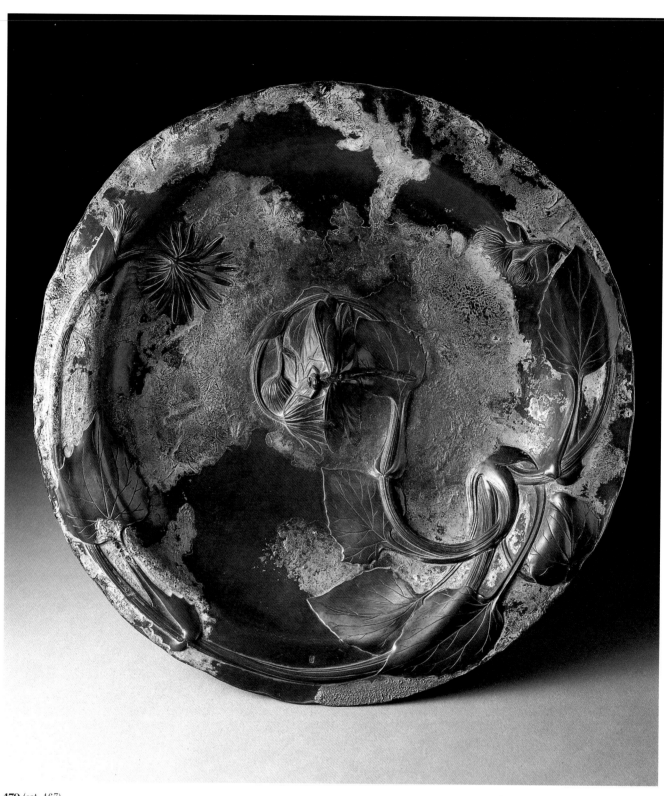

479 (cat. 167)
Henri HUSSON
Bowl, 1909
Paris, Musée d'Orsay

480 (cat. 440)
Henry VAN DE VELDE
Abstract Plant Composition, 1893
Otterlo, The Netherlands, Kröller-Müller Museum

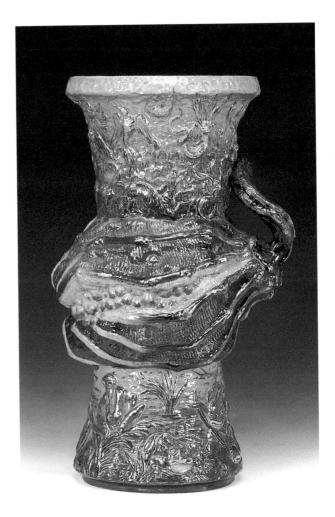

481 (cat. 121)
Émile GALLÉ
Large Vase with Bursting Fruit, 1884-1889
Musée de l'École de Nancy

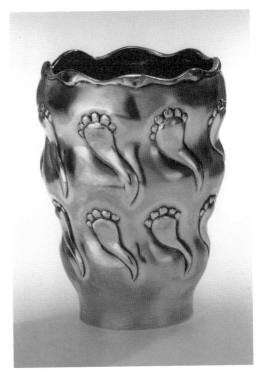

482 (cat. 21)
Thorvald BINDESBØLL
Beaker, about 1900
Copenhagen, Museum of Decorative Art

483 (cat. 436)
Phoebe TRAQUAIR
The Progress of the Soul
1893-1902
Four embroidered panels:
"The Entrance" and "The Stress", 180.7 x 71.1 (each);
"Despair", 184.8 x 74.9; "Victory", 188.3 x 74.3 cm
Silk and gold thread on linen
Edinburgh, National Gallery of Scotland

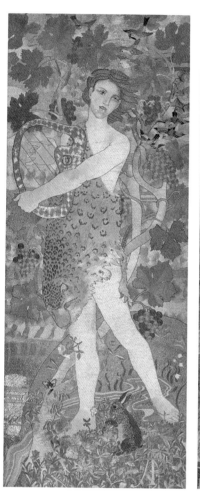 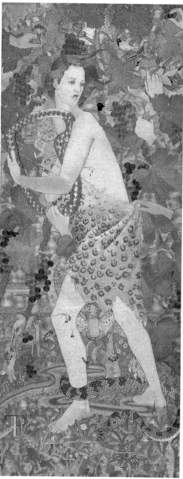 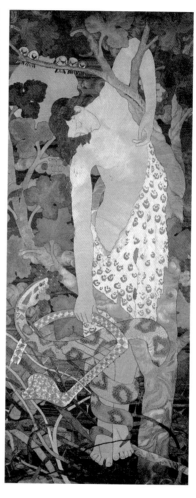 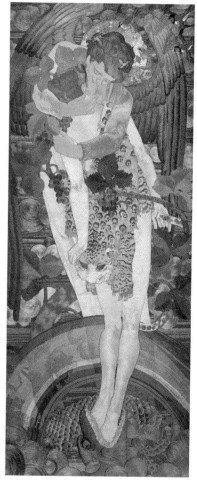

In keeping with her arts and crafts philosophy, Phoebe Traquair executed works in a variety of media during her career. Noted especially for mural decoration, she also created enamelled jewellery, objets d'art, book illuminations and embroidery. These four panels, intricately stitched in coloured silks and gold thread, are her masterpiece in this form.

Traquair was drawn to Symbolist themes through her admiration for the art and poetry of William Blake and Dante Gabriel Rossetti. The redemption of mankind and the spiritual states of the soul were frequent subjects in her work. The four states of

mankind depicted in *The Progress of the Soul* were loosely modelled on the myth of Orpheus. However, Orpheus's appearance is inspired by that of Denys l'Auxerrois, a figure from a thirteenth-century tapestry described in Walter Pater's *Imaginary Portraits* as a "flaxen and flowery creature, sometimes wellnigh naked among the vine-leaves", "with all the regular beauty of a pagan god".[1]

In the first panel, "The Entrance", a young Orpheus charms the birds and animals with the music from his lyre. In the second panel, "The Stress", the youth is troubled by threatening images of death and evil. In the third scene of the soul's journey, "Despair",

the youth hangs limp and lifeless from the vine against a darkened sky. His lyre is broken; his feet, pricked by thorns, are bound by a large, malevolent serpent. The final panel, "The Victory", depicts mankind's salvation as an angel pulls Orpheus from the gaping mouth of a serpent symbolizing hell.

R. P

1. Noted in Elizabeth Cumming, *Phoebe Anna Traquair*, exhib. cat. (Edinburgh: Scottish National Portrait Gallery, 1993), p. 65.

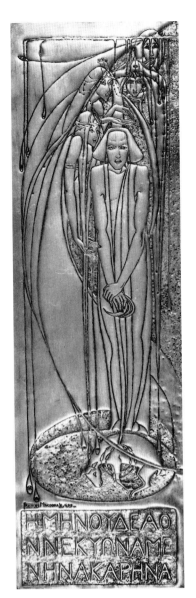
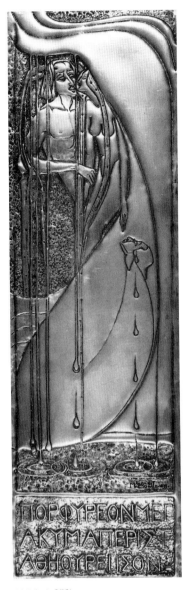

484 (cat. 252)
Margaret and Frances MACDONALD
The Odyssey (Scene from Book XI),
1899
Private collection

485 (cat. 252)
Margaret and Frances MACDONALD
The Odyssey (Scene from Book XI),
1899
Private collection

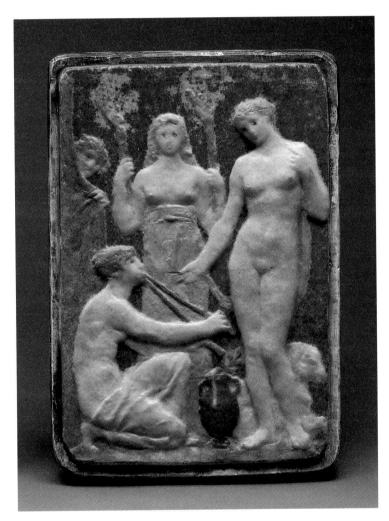

487 (cat. 54)
Henry CROS
Incantation, 1892
The Cleveland Museum of Art

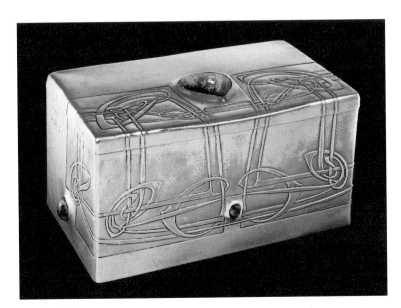

486 (cat. 215)
Archibald KNOX
Box, 1903-1904
London, The Victoria and Albert Museum

488 (cat. 168)
Henri HUSSON
Vase, about 1910
Paris, Musée du Petit Palais

489 (cat. 136)
Hector GUIMARD
Balcony Railing, 1905-1907
New York, The Museum of Modern Art

490 (cat. 96)
August ENDELL
Chest, 1899
Munich, Münchner Stadtmuseum

491 (cat. 138)
Hector GUIMARD
Three-legged Side Table, about 1904-1907
New York, The Museum of Modern Art

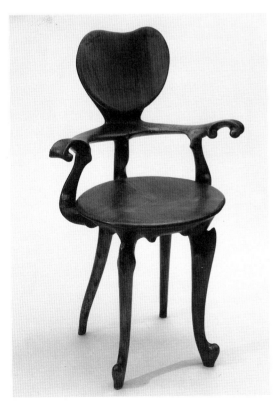

492 (cat. 128)
Antonio GAUDÍ
Armchair, 1902-1904
New York, The Metropolitan Museum of Art

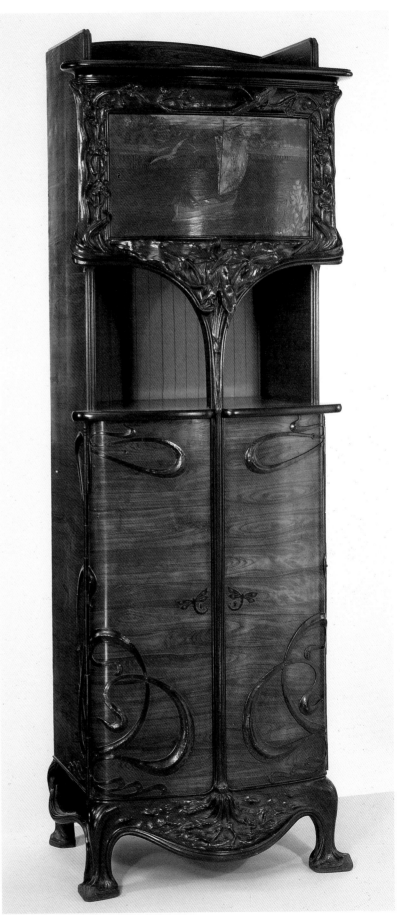

493 (cat. 256)
Louis MAJORELLE
Cabinet, 1900
London, The Victoria and Albert Museum

"Cette enchanteresse matière"
Symbolism and the Decorative Arts

ROSALIND PEPALL

Of course, like most painters from his country, he is very conscious of his material, of its importance and beauty, but most of the time he only looks upon the material – this enchantress – as a wondrous language for translating the idea.

Albert Aurier[1]

The Symbolist movement embraced all forms of art, including the decorative arts. As many writers have commented, Symbolism was less a style than an attitude or an approach to art shared by groups of artists who were searching for new directions as the century came to a close and they were faced with a new, uncertain age. The themes favoured by Symbolist artists and writers were evident in the works of designers and creators of glass, jewellery, furniture, metalwork, ceramics and textiles. Decorative art designers assimilated Symbolist views through literature, poetry and articles in art journals and newspapers of the period. Some of these artists had close ties with other artists or writers. For example, Jean Carriès exhibited with the Belgian Symbolist artists who formed the group Les XX; the sculptor and furniture designer Rupert Carabin exhibited at the Salon de la Rose + Croix in 1892; Henry Cros associated with Paul Verlaine and other Symbolists through his brother Charles, who was a poet; and both Émile Gallé and René Lalique were advised by their friend and patron Robert de Montesquiou, the quintessential Symbolist aesthete.[2]

The main aim of these decorative art designers was to break with the accepted aesthetics of late nineteenth-century design, which drew its inspiration from an eclectic array of historical styles and emphasized excessive ornamentation, often machine-made and of poor quality. Designers who can be linked with Symbolism shared this goal with Art Nouveau artists. The two movements intersected and overlapped, so

that certain decorative art works have characteristics of both movements. However, work defined as Art Nouveau lacked the emotional tension and evocative quality of a Symbolist work, which was intended to express an idea in tangible form. In his discussion of the ideals of the two movements and their similar stylistic elements, Robert Goldwater looked at the use of line in Symbolism: "Symbolist line reveals the impulse of its creator; its curves retain a weight and awkwardness which are evidence of a struggle to give shape to an impelling idea, of a conflict between control and expression, between awareness of form and an awareness of emotion." He contrasts this use of line with the "light and graceful, seemingly self-generated" line of Art Nouveau, "responsive only to its own character . . . a line of care and reassurance, expressive of nothing but itself."[3]

The interdisciplinary approach of Symbolist artists also allied them with the movement to give the decorative arts more prominence and importance in relation to the major arts, so that by the turn of the century painters such as Paul Gauguin found expression in the ceramic medium; the Belgian

1. G.-Albert Aurier, writing about the painting of Vincent van Gogh, in "Les isolés : Vincent van Gogh", published in Pierre-Louis Mathieu, ed. "*Le Symbolisme en peinture*" by G. Albert Aurier (Caen: L'Échoppe, 1991), p. 38.
2. See Françoise-Thérèse Charpentier, "Régionalisme, Littérature et Art Nouveau. Quelques remarques à propos de deux amitiés littéraires de Gallé", *Gazette des Beaux-Arts*, April 1974, pp. 235-236. See also Philippe Thiébaut, "À propos de deux amitiés littéraires de René Lalique", in Yvonne Brunhammer *et al.*, *René Lalique*, exhib. cat. (Paris: Musée des Arts décoratifs/Réunion des musées nationaux, 1991), pp. 38-46.
3. Robert Goldwater, *Symbolism* (New York: Harper & Row, 1979), pp. 24-25.

sculptor Philippe Wolfers earned a reputation for his jewellery and silverwork; and the Scottish architect Charles Rennie Mackintosh designed the furniture and painted decorations for his buildings, in order to create a visual and expressive unity in his architectural work.

Decorative artists at the turn of the century were inspired by Symbolist themes and depicted subjects that were current in Symbolist paintings and sculpture. For example, at the Paris Exhibition of 1900, one of Norway's finest textile designers, Frida Hansen, exhibited her seven-metre tapestry, **The Dance of Salome**, which illustrates a central theme of the Symbolists' preoccupation with the image of woman as an alluring seductress. The ceramic plate by painter Hans Thoma is another example of this Symbolist view of the female as a threatening predator. The recurring Symbolist theme of the struggle between the forces of good and evil was depicted in jewellery, metalwork and earthenware.

The Symbolist aesthetic was expressed not only through the actual subject depicted, but also through the artists' treatment of their medium, whether clay, glass, wood or metal. Decorative artists recognized the expressive power of the textures, colours, variations of light and abstract forms they were able to create through their material. Rather than representing a subject realistically, they sought to evoke feelings and sensations by means of their medium. According to the art critic Albert Aurier, who helped to define Symbolist thought, their aim was to render ideas visible through form:

> You understand that in the art so construed, the purpose is no longer the direct and immediate reproduction of the object; rather all the elements of pictorial language – line, plane, shadow, colour – become abstract elements that may be combined, attenuated, exaggerated, distorted in

their own expressive mode to achieve the work's main goal: the expression of a dream, an idea or a thought.[4]

Émile Gallé: À rêver pour le cristal des rôles tendres ou terribles

Émile Gallé was one of the artist-designers most obviously influenced by Symbolist views. He began his career in his father's porcelain and crystal company in Nancy and afterwards turned his attention to glass. He attempted to create a language out of this fragile, unpredictable medium, exploiting its captivating, evocative power. Gallé was a master in the techniques of glassmaking. He experimented continually with the effects he could elicit from the material by superimposing layers of glass in what he called his "verres doublés" or "triplés", streaking or marbling it by the addition of coloured oxides, decorating it with translucent or opaque enamels, inserting paper-thin leaves of metal into or onto the vitreous mass, creating fissures and air bubbles, or simply allowing the fluid material to react in unpredictable ways to form shapes or colours that suggested certain moods or feelings. When he exhibited his works, he would include extensive detailed comments on their chemical composition and how he had created certain special effects.[5]

Not only was Gallé an expert in the technical properties of his medium, but he was clearly enthralled by its suggestive possibilities: "I have sought to make crystal yield forth all the tender or fierce expression it can summon when guided by a hand that delights in it."[6] The importance of medium to Gallé is evident throughout his public pronouncements and descriptions of his work. In an homage to Edmond de Goncourt published in 1896, for example, Gallé wrote rapturously of de Goncourt's sensitivity to the nuances of the white porcelain body.[7] Gallé had an almost mystical rapport with the glass medium through which he sought to express his innermost thoughts. He spoke frequently of translating his dreams into glass. "My own work consists above all in the execution of personal dreams: to dress crystal in tender and terrible roles."[8]

In analyzing the portrait of Gallé painted by his friend Victor Prouvé, Debora Silverman has commented on how Prouvé depicted Gallé gazing as if in a trance at one of his vases.[9] In her discussion of art in fin-de-siècle France,

4. G.-Albert Aurier, "Les Peintres Symbolistes", 1892, in Mathieu, 1991, pp. 57-58.
5. See "Notice sur la production du verre", which Gallé submitted to the Union Centrale des Arts Décoratifs when he exhibited with them in 1884. Published in Émile Gallé, *Écrits pour l'Art. Floriculture – Art décoratif – Notices d'exposition (1884-1889)*, Preface by Françoise-Thérèse Charpentier (Marseilles, 1980; originally published Paris, 1908) pp. 302-314.
6. Émile Gallé, "Exposition Universelle de 1889. Notices sur la production de verre de cristaux de luxe d'Émile Gallé", 1889, published in Gallé, 1980/1908, p. 352; quoted in English from *Émile Gallé: Dreams into Glass*, exhib. cat. (Corning, New York: The Corning Museum of Glass, 1984), p. 189.
7. Gallé, "Goncourt et les métiers d'arts", *La Lorraine artiste*, July 26, 1896; published in Gallé, 1980/1908, p. 174.
8. Gallé, 1980/1908, p. 350; quoted in English from Corning Museum, 1984, p. 188.
9. Debora L. Silverman, *Art Nouveau in Fin-de-Siècle France* (Berkeley: University of California Press, 1989), p. 237.

Silverman chooses Gallé as a model of an artist who was infused with ideas emanating from the current scientific studies on the power of the subconscious and the inner psyche by French doctors like Jean-Martin Charcot in Paris and Hippolyte Bernheim in Nancy. She examines how Gallé's psychological vision found expression through his medium. The writer Roger Marx, a fellow native of Nancy, confirms the evocative intention of his friend's work:

> Let it be said that Émile Gallé is not just the shaper of his material, and the one who infuses it with infinite seductive properties; he wants it to speak to the spirit, to excite long reveries, and under his hand, it becomes supremely suggestive and evocative. The alchemy of this "lapidary forger" transforms vitreous matter into precious stones.[10]

Well acquainted with Symbolist poetry, Gallé would sometimes inscribe lines from a poem into his work to emphasize the evocative role of the visual effects he created. These quotations he took from Baudelaire, Verlaine, de Montesquiou and Maeterlinck, among others.[11] The meaning of these inscriptions in Gallé's "verreries parlantes" went beyond a simple association with the subject to a freer translation of the sensations suggested by the colour, light or forms in the glass.[12] These poetic lines then played an incantatory rather than a descriptive role. For example, in a covered glass vase entitled "Eaux dormantes", Gallé created an atmosphere of pond life at dusk with the flutterings of insects, water creatures and leaves floating within a mass of dark blue, flecked with green and metallic flashes. Engraved on the glass of the vase are the lines: *La frissonnante libellule / Mire le globe de ses yeux / Dans l'étang splendide où pullule / Tout un monde mystérieux V. Hugo*.[13] Another vase by Gallé, depicting the image of a glassblower, is inscribed: *La matière pour nous est matière à poésie. Emile Hinzelin*.[14] In a vase from the Düsseldorf Kunstmuseum's collection, Gallé incorporated a line of poetry from Maurice Maeterlinck's *Serres Chaudes: Les feuilles des douleurs passées*. Even though the vase is composed of autumn-coloured leaves being tossed about against a mottled sky of blue, grey and white forms, the poetic line was intended not simply to illustrate the image on the surface of the glass, but to evoke a deeper meaning suggested by the material itself.[15]

Gallé was a studious observer and lover of nature and drew upon it for his subjects. Inspired as a child by the books of Jules Michelet, he was attracted to the mystery and aesthetic beauty of the insect world, which Michelet encouraged his readers to explore. Among Gallé's most famous works are the series of glass bowls or vases in which the dragonfly is the central motif. One of the finest examples is represented in the exhibition. Its focus is the magnified form of a dragonfly, held frozen in flight within the glass. By building up the layers of glass to render certain areas more translucent than others, by varying the intensity of the coloured areas and by engraving certain very fine outlines, Gallé created a delicate, shimmering vision of the insect, floating in a hazy dreamworld, its double image or shadow barely visible nearby. The enlarged size of the dragonfly and its prominent, luminous eyes give it a threatening appearance. The dragonfly is no longer just an insect but a creature of prey, closer to Józef Mehoffer's version of the insect in his painting *The Strange Garden* than to reality.

To depict the globular orbs of the insect's eyes, Gallé used a technique he called "émaux-bijoux", which involved superimposing translucent enamels on metallic foil.[16] The process required a difficult balancing of temperatures so as not to ruin the work. Gallé's invention of this process is typical of his wish to take full advantage of the properties of the glass and its power of suggestion. In the dragonfly coupe, he also resorted to engraving, an art he had revived in new and original ways. As he stated, "I have found in engraving above all a means of expression, a means to bring forth out of warm and living material all the elements that have been consolidated within it."[17]

In another work by Gallé, the artist seems to have transformed his material into a living substance. The vase from the collection of the Musée de Boulogne-sur-Mer depicts an exotic member of the orchid family, the cattleya. Its bright mauve-pink petals spread out over the form of the vase and seem to be pulsating with life. It is a sensual, erotic and

10. Roger Marx, "Émile Gallé : psychologie de l'artiste et synthèse de l'œuvre", *Art et Décoration*, August 1911, p. 243.
11. See Françoise-Thérèse Charpentier, "Mythes et modes dans l'art de Gallé", in F.-T. Charpentier and P. Thiébaut, *Gallé*, exhib. cat. (Paris: Musée du Luxembourg, 1985), pp. 38-40. See also F.-T. Charpentier, "L'art de Gallé a-t-il été influencé par Baudelaire?", *Gazette des Beaux-Arts*, May-June 1963, pp. 367-374.
12. "Verrerie parlante" was the heading Gallé gave to a section in his *Écrits pour l'art*, p. 316.
13. Charpentier and Thiébaut, 1985, cat. 100, p. 186.
14. *Ibid.*, cat. 118, p. 205.
15. *Ibid.*, entry for cat. 127 (by P. Thiébaut), p. 214.
16. He explains his technique of "émaux-bijoux" in Gallé, 1980/1908, pp. 343-344.
17. *Ibid.*, pp. 347-348; quoted in English from Corning Museum, 1984, p. 19.

perhaps disquieting image of the orchid, which was a favourite subject of the Symbolists for reasons Gallé noted himself: "the orchid, with a richness, an inconceivable strangeness of forms, species, odours, colourations, whims, voluptuousness and unsettling mysteries".[18]

Even though glass lent itself more easily than other mediums to the expression of dreams and abstract visions, Gallé incorporated Symbolist themes into some of his ceramic works. For example, in a vase in the collection of the École de Nancy, the focus of the work is a very ordinary vegetable, the squash. Gallé has turned it into a strange, troubling vision in vivid tones of yellow and red. The centre of the vegetable has burst open, displaying its seeds like a giant, fleshy mouth full of teeth. This form divides the vase into two parts: the world of frogs and pond life at the bottom, and a teeming world of fantastical reptilian and winged creatures in a murky atmosphere in the upper portion.

Gallé also designed some of his furniture in a Symbolist mood, for example in his "Aube et crépuscule" bed symbolizing the cycles of the day as well as the cycles of life, and his "Fleurs du Mal" corner cupboard with poisonous mushrooms and other noxious, spiky plants represented in wood marquetry.[19]

It was, however, Gallé's mastery of the glass medium that made him stand out among the artists of the period, as his work is summed up by his contemporary Jules Henrivaux: "An artist like Gallé makes one think of an extractor of essences who attempts to materialize the impalpable, to vitrify a dream. His example stands to demonstrate the suppleness, power, diversity and extent of the resources of a material like glass."[20]

Henry Cros is another artist of the period who was drawn to the medium of glass. He was trained as a sculptor in Paris, but early in his career, he became interested in ancient encaustic painting, which may have inspired him to create his

sculptures in polychromed wax. In 1872, Edmond de Goncourt visited Cros's atelier with a friend who had commissioned the artist to make a wax bust of his daughter. De Goncourt described the visit in his *Journal* and suggests to the reader an image of Cros as a mysterious sorcerer, conjuring up his visions created out of strips of wax:

> He's a lean young fellow, dark and bearded, with an unnerving fixity in his deep-set eyes. And in the lamp light, these bits of wax on a pane of blackened glass, gradually taking on a mysterious reality in the half-light, at last cast over me a vague fear of the magical life this wan fellow concocts in his basement.[21]

From a family of philosophers, scientists and poets, Henry Cros was well acquainted with ancient myths and legends from which he drew the subjects of many of his works, for example **Incantation**. His knowledge of Greek and Latin and his interest in ancient techniques of art led him finally to explore the possibilities of *pâte-de-verre* glass, a forgotten medium used in Antiquity. The artist carried out endless trials to perfect his own *pâte-de-verre* technique, which in brief terms consisted of compressing a cold paste of coloured glass particles in a mould and then firing it to fuse the glass in such a way that the colours would not run and so that each form was defined by its mass of fused colour. The whole process, even in ancient times, was shrouded in secrecy, and Cros himself refused to reveal the precise methods he used.[22] It was his work in this medium that best reflects his links with Symbolist thought of the period.

Cros is noted especially for his bas-reliefs in *pâte-de-verre*, for example the large-scale allegorical works *L'Histoire de l'Eau* and *L'Histoire de Feu*, for which he won a gold medal at the Paris Exhibition of 1900.[23] The forms in these reliefs are defined by masses of vivid colour that in some areas have been deeply absorbed into the glass, while in others the colour appears to have been lightly applied over the rough surface as if with a pastel stick, allowing uncoloured areas to show through. This treatment, together with the blurred outlines of the moulded forms, imparts a hazy, otherworldly feeling to the scenes Cros created in this medium. The pitted and rough surface of the glass reliefs, with their imperfections, hairline cracks and striations, gives the material the appearance of stone. The transparency, translucence and reflective qualities normally associated with glass were no longer apparent in this opaque, textural material resembling some lost archeological

18. *Ibid.*, p. 224.

19. The bed is illustrated in Charpentier and Thiébaut, 1985, cat. 168, pp. 287-290. The cupboard is illustrated in Marx, 1911, p. 250.

20. Jules Henrivaux, "Au Musée Galliéra – Les Verreries de Gallé", *Le Verre*, August 1910, not paginated.

21. Quoted in Victor Barrucand, "Les Pâtes de Verre et Henry Cros", *L'Art dans les deux mondes*, 1890, p. 49.

22. Léandre Vaillat, "La Pâte de Verre : Henry Cros", *L'Art et les Artistes*, 1908, pp. 27-28, relates his difficulty in obtaining precise details of the *pâte-de-verre* process from the artist or his assistants.

23. *L'Histoire de l'Eau* is in the collection of the Musée d'Orsay and *L'Histoire de Feu* now belongs to the Musée des Arts décoratifs, Paris, and has lately been restored.

treasure. Cros's reliefs often had irregular edges, which made them appear even more to be fragments of larger works or parts of a larger wall decoration. The cool, pastel tones Cros used and the way the matt colour seems to have been absorbed into the material itself call to mind ancient frescoes. This quality of his work and his preference for classically draped figures, which bear a close resemblance to figures in Puvis de Chavannes's paintings and murals, have caused many writers to refer to Chavannes's work in discussing Henry Cros's *pâte-de-verre* reliefs.

Le culte de la matière

In the same way that glass could be blown and melded into evocative shapes and colour formations, the malleability and coloured glazes of the ceramic medium could suggest a mood or feeling. In the 1880s, Gauguin realized the plastic qualities of earthenware and admired this most basic of materials, which could be transformed with firing: "God made man from a little mud. And with a little mud, we can make metal or precious stones – with a little mud and a touch of genius!"[24]

Ernest Chaplet was in the forefront of French ceramic artists who experimented with the effects of glazes, inspired by the Japanese tradition of simple forms and an emphasis on the inherent beauty of the ceramic material. Other ceramic artists moulded the material into forms which seemed to emerge from the mass of the ceramic body itself; for example, in the plate by Alexandre Bigot, the form of a salamander crawls slowly out from the mysterious depths of a glistening pool of green glaze.[25]

In a jug entitled *"La Nuit"*, by Pierre Adrien Dalpayrat, two female figures appear to be one with the mass of the stoneware body. They are hunched below the form of an owl's head. A green and brown glaze covers the jug overall so that the outlines of the forms blend together and become indistinguishable from each other, like shadows under the cover of night. A writer in 1898 commented on the mysterious quality of Dalpayrat's stonewares, some characterized by the red tones he achieved in his "grès flammé", others featuring the pale, unearthly tones of ancient artifacts.

The work of Dalpayrat viewed as a whole forms a strange and curious world in the multiplicity of its facets; an obviated, tormented, flame-licked world, bursting and

349

402

languishing by turns…All manner of gentleness mingles with all manner of brashness, and therein one senses the soaring of his vibrant and moving imagination, whose every impression is transmitted by a dazzling transformation of the material.[26]

Few artists of the Symbolist period, however, could handle the ceramic medium with the expression, feeling and imagination of the sculptor Jean Carriès. He turned his attention to stoneware in the middle of his career and developed what has been described as a "culte de la matière" in his ability to express himself through this basic material.[27] Carriès's **Le Grenouillard** is one of his most arresting sculptural works in stoneware, which he created in about 1891. It depicts a frog-man in the crouched position of a frog, his long arms with webbed hands, clutching a frog. The sculpture is covered overall with a brown-coloured lead glaze, blotched and uneven in tone, as if the creature had just emerged from a swamp. Although human, this frog-man has the thin epidermis of the reptile family, barely covering the distinctive muscles and well-defined spinal cord and ribs of the body. The artist regarded the glaze as a living skin covering the porous stoneware, stretched tightly in some areas and in others deposited thickly and darkly within the contours of the form. The glaze gives similar expressive power to the numerous series of grotesque masks that Carriès created throughout his preoccupation with stoneware.

Various influences may have inspired his work, notably Japanese ceramics and perhaps gothic creatures from medieval art, but he was a solitary, introspective artist whose disturbing, strange forms of monstrous frogs, contorted faces and frog-men: were the creation of his inner reflections and probably the result of troubled nights and haunting dreams, brought about by illness and possibly drugs.[28] Carriès's unique personality, his sensitivity to his art, his melancholia, ill health and early death exemplify the Symbolist temperament.

350

154

24. Paul Gauguin, "Notes sur l'art. L'exposition universelle", *Le Moderniste illustré*, July 11, 1889, and reprinted in Paul Gauguin, *Oviri – écrits d'un sauvage* (Paris: Gallimard, 1974), p. 50.
25. Described as "passionné pour l'art de grès et de terre" (Louis de Fourcaud, "Salon de Champ de Mars", *Revue des Arts Décoratifs*, July 1894, p. 6), Bigot carried out many commissions for architectural ceramics in addition to the creation of smaller wares.
26. Ch. Pierre-Géringer, "Les Grès de Dalpayrat", *Revue des Beaux-Arts et des Lettres*, June 1, 1898, p. 30.
27. "L'Œuvre de Jean Carriès", *La Nouvelle Revue*, December 1904, p. 308.
28. See Philippe Thiébaut, "À propos d'un groupe céramique de Jean Carriès: «Le Grenouillard»", *La Revue du Louvre*, no. 2 (April 1982), p. 125.

Hermann OBRIST
Coverlet (detail), 1897
Munich, Stadtmuseum München

Published research on psychological disorders and the inner states of the mind was a subject of discussion among fin-de-siècle artists and writers, who attempted to translate their subconscious thoughts into their work. The tension and nervous energy exhibited in the work of Symbolist artists could be interpreted as a reflection of the anguished state of urban man suffering from doubt and a general malaise as the century died. Des Esseintes, the epitome of the Symbolist hero in J.-K. Huysmans's novel *À rebours*, was affected by a "nervous hypersensitivity".[29] He sealed himself off from society and the outside world and created his own artificial interior environment, which for him replaced the external world.

In the decorative arts of the period, this nervous energy and feverish excitement could be expressed in the way the artist manipulated the material with which he worked. An embroidered motif on a coverlet designed by Hermann Obrist reflects the internal psychological intensity associated with the Symbolists' state of mind. The motif in the form of undulating vines or plants expresses dramatically the tense, excitable movement of organic growth and could even suggest the restless motion of human nerve endings and filaments responding to a stimulus and sending out sensorial messages like electricity in waves of energy.

This energy was translated into the medium of wood by the French architect and designer Hector Guimard. In

Guimard's furniture, the wood curves, bends, pulls, stretches and whips around corners like the tendrils of a plant. The forms evoke a feeling of restless motion. At focal points, the wood has been carved into tiny, tight, abstract swirls, as if the forces of growth had turned in upon themselves.

These same stretching, attenuated lines seem more appropriate to the pliable medium of wrought iron, which Guimard used for decorative grilles and railings in his architectural work. Here again are the frenzied lashings of organic lines representing the push and pull of nature with all its intensity and force. In his three-dimensional works in ceramic and metal, Guimard moves beyond natural representation of plant forms to abstract, fluid shapes, which appear as outgrowths of the medium itself.

Other artists of the period also created nonrepresentational forms that were abstract expressions of nature's flow of lines and masses. In Germany, the artist August Endell, while he acknowledged finding inspiration in nature, opposed design that imitated too closely nature's models. Because of his early studies in psychology and philosophy, he preferred to explore the effects of colour and abstract forms upon the senses and the emotions. Along with Hermann Obrist and Bernhard Pankok, Endell was at the centre of the Jugendstil movement in Germany and encouraged new directions in art by moving away from the traditional reliance on historic models. In response to the pessimists who saw no hope in breaking away from past traditions, he wrote in his essay on "The Beauty of Form and Decorative Art", in 1898:

491

489

536

29. Silverman, 1989, p. 77.

To those with understanding, this despondency is simply laughable. For they can clearly see, that we are not only at the beginning of a new stylistic phase, but at the same time on the threshold of the development of a completely new Art. An Art with forms which signify nothing, represent nothing and remind us of nothing, which arouse our souls as deeply and as strongly as music has always been able to do.[30]

Endell's controversial decorations of bizarre organic shapes in vivid green and violet on the façade of the Elvira photography studio in Munich (1896-1897) boldly represented his belief in the power of form, colour and medium to evoke sensations. The wood and iron chest Endell designed as part of a bookcase for the poet Henry von Heiseler is another example of his unconventional approach to decoration. The steely grey metal ornament on the front seems to spread like a hideous growth over the wood. The smooth, planar surface of the chest, its rectilinear form and blond tone contrast sharply with the rough texture and irregular shape of the metal form flowing like a pestilent liquid over the wood, its movement accentuated by small streaks incised in the iron.

August Endell's development of abstraction in ornament had its counterpart in the work of Thorvald Bindesbøll, a Danish architect and designer. He was at the centre of a small arts and crafts group of artists and designers in Denmark who were interested in the applied arts, notably ceramics. Bindesbøll created a series of large earthenware plates decorated with freely expressed abstract forms in bold colours. Rather than experimenting with the chemistry of glazes and their sometimes accidental effects, as did many of the French ceramicists of the period, Bindesbøll concerned himself with creating expression in pattern, form and surface texture.[31] He also executed handcrafted silver works that display odd, unidentifiable embossed motifs.

Another artist who emphasized the expressive power of his medium and at the same time relied on a traditional artisanal approach to the applied arts was the metal craftsman Henri Husson. For many years he worked for the head of a bronze foundry, A. A. Hébrard, who encouraged Husson's independent work by showing the artist's pieces at his gallery.[32] Husson is not known to have had direct links with Symbolist artists or writers, and the Symbolist subjects he favoured – insects, bats and sea nymphs, for example – were part of Art Nouveau imagery as well. Yet, Husson may be placed within the Symbolist sphere because of the way he crafted his medium, perhaps unconsciously, into expressive, evocative forms. A vase in the collection of the Petit Palais, Paris, displays as the central motif a frond of seaweed that spreads over the body of the vase against a background of textured and burnished areas edged with undulating engraved lines, as if the plant were agitating the sea around it. Strange natural forms reminiscent of the fantastic motifs devised by August Endell make up the handles above two bulging shell shapes applied to the lower part of the vase.

Husson experimented with the textures, tones and patinas of various metals, combining them in an original way. To create his visions in metal, Husson would hammer the copper or silver base into the repoussé forms he wanted and then pour streams of silver onto the surface, allowing the metal to settle in varying degrees of thickness. He would add further particles of metal to form incrustations and to give the surface a grainy texture.

In a large coupe by Husson now in the Musée d'Orsay, the artist created abstract clouds of textured silver on a copper ground. In some areas, the nebulous forms are outlined with an incised line; in other areas, the silver mass is left to float and dissipate like thin clouds against the rust orange tones of the copper. A large plant, chased and embossed, rises out from these undefined, vaporous mists of metal and stretches around the rim of the coupe, finally curving into the centre and around a dragonfly poised as if on the surface of a shimmering pool.

Orfèvres-poètes

Artists, designers and writers of the Symbolist period were intrigued by the expressive and symbolic power of precious stones and gems.[33] Gallé used numerous techniques in his

30. Originally published in the periodical *Dekorative Kunst*, vol. 1 (1898), p. 75; cited in Hans Ottomeyer, "August Endell oder die Erfindung der abstrakten Kunst", *Kunst und Antiquitäten*, no. 1/2 (1992), p. 28. Quoted in English from Tim Benton, Charlotte Benton and Dennis Sharp, eds., *Architecture and Design, 1890-1939* (New York: Whitney Library of Design, 1975), p. 21.

31. See Jennifer Opie, "A Dish by Thorvald Bindesbøll" (Victoria and Albert Museum, London), *Burlington Magazine*, May 1990, pp. 356-358; see also Marianne Ertberg, *Thorvald Bindesbøll: Arkitektur-Keramik-Formgivning* (Copenhagen,1982).

32. Hébrard also organized an exhibition of the work of Henry Cros in his gallery on Rue Royale (Vaillat, 1908, p. 26).

33. For a discussion of the importance of gems, see Jean Pierrot, "Rêverie ...

glassmaking to suggest the striations, mottling and iridescence of gems and minerals. Louis Comfort Tiffany, another designer working in glass at the turn of the century, created lamps with shades of luminous glass cabochons that sparkled like gems when light shone through them.

Jewellery also played a major symbolic role in Symbolist painting and literature's depiction of the fin-de-siècle woman, whether seen as the sensually enticing and wicked Salome, or as a remote goddess, her status defined by her adornment. Sarah Bernhardt, one of Europe's most famous actresses in the 1890s, enhanced her presence on stage in such roles as Cleopatra and Théodora through a dazzling display of jewellery, often created by such designers as René Lalique and Alfons Mucha.[34] In her elaborate headdresses, she could have been a figure from one of Gustave Moreau's paintings, which glow with the brilliance of richly coloured gems. The impression given by the jewels with which Moreau dressed the figure of Salome as she began her dance is described by J.-K. Huysmans in *À rebours*:

> The strings of diamonds glitter against her moist flesh; her bracelets, her belts, her rings all spit fiery sparks; and across her triumphal robe, sewn with pearls, patterned with silver spangled with gold, the jewelled cuirass, of which every chain is a precious stone, seems to be ablaze with little snakes of fire, swarming over the mat flesh, over the tea-rose skin, like gorgeous insects with dazzling shards, mottled with carmine, spotted with pale yellow, speckled with steel blue, striped with peacock green.[35]

Moreau was referred to as an "orfèvre-poète" by Edmond de Goncourt because of the artist's ability to create emotional sensations through the brilliance and richness of his colours.[36]

Sarah Bernhardt in the Role of Théodora (detail), 1902
Paris, Musée des Arts décoratifs

Other contemporary writers, too, commented on the jewel-like effects in the work of this artist who was known to have been interested in the decorative arts, especially enamel work.[37] In an 1881 review of Moreau's watercolours illustrating La Fontaine's fables, Charles Blanc, a contributor to *Le Temps*, wrote:

> One would think oneself in the presence of an illustrious artist that, before becoming a painter, had been a jeweller who, having let himself get drunk on colour, ground up rubies, sapphires, emeralds, topazes, opals, pearls and mother-of-pearl from which to create his palette.[38]

Another artist who was called an "orfèvre-poète" was the goldsmith and glass designer René Lalique,[39] whose jewellery creations caught the Symbolist mood and appealed to the fin-de-siècle interest in the visual effects of stones and gems. Lalique was the most important jeweller in France at the turn of the century, and his art very much reflected the Symbolist period, as his contemporary, author Gustave Geffroy, wrote:

> If one were to draw up a chart of our mores, tastes, desires, weaknesses and strengths, of all that at present

élémentaire", in *L'Imaginaire décadent (1880-1900)*, (Paris: Presses universitaires de France, 1977), chapter 4, pp. 265-271.

34. See Evelyne Possémé and Anne Vanlatum, "Mirage de scène", in *René Lalique: Bijoux, Verre*, exhib. cat. (Paris: Musée des Arts décoratifs/Réunion des musées nationaux, 1991), pp. 70-81. See also Jane Abdy, "Sarah Bernhardt and Lalique: A Confusion of Evidence", *Apollo*, vol. 125 (May 1987), pp. 325-330.

35. Joris-Karl Huysmans, *À rebours* (1884); quoted in English from *Against Nature*, trans. Robert Baldick (Harmondsworth, England: Penguin Books, 1959), p. 64.

36. Edmond de Goncourt, *Journal*, vol. 3, entry for May 15, 1881, p. 112 (1956 edition); cited in Pierre-Louis Mathieu, *Gustave Moreau, sa vie, son œuvre* (Freiburg, Switzerland: Office du Livre, 1976), p. 155.

37. Rae Beth Gordon, "Aboli Bibelot? The Influence of the Decorative Arts on Stéphane Mallarmé and Gustave Moreau", *Art Journal*, Summer 1985, p. 106.

38. Cited in Mathieu, 1976, p. 148.

39. Roger Marx, "René Lalique", *Art et Décoration*, vol. 6 (July-December 1899), p. 22.

animates the nervous system of existence, the gems of Monsieur René Lalique certainly ought not be omitted, for they express a certain kind of life – fine and subtle, disturbed and sickly. It is an art that seeks out sensations, an art of pale colours and shuddering nerves.[40]

Hailed as a genius, Lalique was admired not only for his original subject matter, but also for the way he brought together different materials in a striking composition. He had many followers and imitators, especially after his presentation at the Paris Exhibition of 1900 and the subsequent praise from the critics in numerous published articles.

Lalique was noted for his use of nonprecious materials such as glass, horn, ivory and quartz, which he chose for their expressive properties of colour, transparency, plasticity and texture. For example, a hair comb depicting the "sabot de Vénus" (lady's-slipper), a species of orchid, is crafted of ivory and horn in tones of white, beige and cream, which emphasize its uniqueness and purity. A brilliant topaz drop is the focal point and only bright highlight as it dazzles from within the flower's petals. The grain and sheen of the ivory medium together with the exquisite craftsmanship of the carving give the flower the appearance of a seductive, animate material.

Many writers commented on Lalique's close observation of nature, and like Gallé, he translated images of nature into his own poetic visions.

> Monsieur René Lalique chooses what will serve his purposes from the infinite world of existing forms . . . but in doing so – and it is here that the individuality of his talent comes into play – he does not make "still lifes" of these birds, insects, reptiles and flowers that he has looked at and surprised in the freedom of nature. He retains in them that life which is properly theirs; he suffuses the material with the *frisson* of reality.[41]

In another work, Lalique took advantage of the glossy, rich colour effects of enamel to represent a coiled knot of angry snakes, their glistening scales composed of green and blue enamelled patterns. Their intensity of colour matches Huysmans's description of the steel blues and peacock greens of Salome's jewels in Moreau's painting, and this frightening apparition calls to mind the Hydra of Lerna that confronts Hercules in another of the artist's paintings of 1876.

Working at the same time as Lalique was the Belgian sculptor Philippe Wolfers, who also created silverwork,

René LALIQUE
"Sabot de Vénus" Hair Comb, about 1903-1904
Lisbon, Calouste Gulbenkian Museum

jewellery and glass. Drawn to Symbolist subjects like his French contemporary, Wolfers chose his materials for their symbolical significance and not for their value as precious stones. A writer of the period, S. Pierron, called Wolfers a "psychologue des gemmes" who selected stones that would best set off the beauty of the women who wore his jewellery.[42] Like many Symbolist artists and writers, Wolfers especially favoured the opal, because of its iridescence, its variation of colour, its changing reflections and its historical association with evil. In one of Wolfers's most striking and Symbolist pieces of jewellery, a necklace with the head of Medusa in ivory, her eyes consist of two large opals, symbols of ill fortune, and convey the terrible gaze of the snake-haired Gorgon who could turn men into stone with her stare.

Wolfers worked frequently with ivory, which was readily available because of Belgium's links with the state of the

40. Gustave Geffroy, "Les Salons de 1901: René Lalique", *L'Art Décoratif*, no. 33 (June 1901), p. 89.
41. *Ibid.*, p. 90.
42. Sander Pierron, "Philippe Wolfers", *Revue des Arts Décoratifs*, May 1900, p. 156.

Congo in Africa. Wolfers sometimes even incorporated complete ivory tusks into his sculptures. This smooth, cream-coloured, naturally lustrous material was favoured by Symbolist artists for its associations with purity, virginity and the sheen of the female body, as well as for its texture in comparison with harder, more brittle and more colourful metals and stones.

472 One of Wolfers's chef-d'oeuvres in ivory and silver, a jewel box he created in 1905 entitled "*La Parure*", reflects the Symbolist theme of women's vanity and self-adornment. The ivory bas-relief medallions around the sides of the case depict women putting on jewels and looking into a mirror while combing their hair, scenes repeated in fin-de-siècle images of Lilith, Salome and other legendary seductresses. Surmounting the case is a majestic silver peacock, its outspread tail studded with stones. Around the bottom of the case are writhing green enamel serpents, messengers of evil, tensely coiled and tightly enframed within narrow panels.

Another outstanding jewellery designer of the period was the German artist Wilhelm von Cranach, who was a friend of Wolfers.[43] Von Cranach was similarly drawn to Symbolist themes in his designs, as is evident in two of his brooches,
419, 353 one with a Medusa head, the other entitled "*Octopus and Butterfly*". In the latter work, the focus is the extraordinary irregular pearl at the centre. The glossy, white sheen of the stone and its rippling texture suggest the fluid, glutinous membrane of an octopus that has spread its golden tentacles over the butterfly's wings of multicoloured enamels edged with diamonds. This disturbing image of a repulsive sea creature swarming with its interlaced tentacles over the fragile, decorative butterfly is in keeping with familiar fin-de-siècle Symbolist imagery. Also, by recognizing and bringing out the expressive power of the textures and tones of his medium, von Cranach, like Lalique and Wolfers, was able to go beyond appearances to the "*frisson* of reality".

43. Wolfers had made contacts with German goldsmiths through his family's silver business, which had connections in Germany. See *Philippe & Marcel Wolfers: de l'Art Nouveau à l'Art Déco*, exhib. cat. (Brussels: Musées royaux d'Art et d'Histoire, 1992), p. 35.
44. Léonce Bénédite, "La Bijouterie et la joaillerie à l'Exposition Universelle de 1900: René Lalique", *Revue des Arts Décoratifs*, August 1900, p. 244; and Henri Vever, "Les Bijoux aux Salons de 1898", *Art et Décoration*, vol. 3 (1898), p. 171.
45. Rodolphe Darzens, "Notes sur les ouvriers d'art: Rupert Carabin", *L'Art moderne*, 1895, p. 261.
46. Rupert Carabin, "Le Bois", *Art et Industrie*, March 1910, not paginated. Also cited in Nadine Lehni and Étienne Martin, *François-Rupert Carabin 1862-1932*, exhib. cat. (Strasbourg: Musée d'Art Moderne de Strasbourg, 1993), p. 22.

On veut... explorer le ciel des idées

A contemporary criticism of Lalique's jewellery was that the works were made more as "objets de vitrine" or as museum pieces rather than as wearable jewellery.[44] The works of decorative artists linked with the Symbolist movement were not produced with function as the main priority. Even though they were creating applied art objects, their aim was to reach beyond the practical purpose of an object and provoke thoughts and associations in the viewer. They wished to turn their ideas into poetry and express themselves through the evocative qualities of their medium. In reference to the Symbolist-inspired furniture of Rupert Carabin in the review *L'Art moderne*, Rodolphe Darzens stated: "In the manner of Baudelaire, endowing the Firmament of the Arts with a new kind of sensation . . . Rupert Carabin evokes with his wood sculptures, which must nonetheless fill an everyday function, rare aesthetic sensations, and this makes him the equal of the most marvellous poets."[45] Carabin's unique furniture is characterized by his use of naked women as the supports for tables, desks and chairs. They bend and crouch, crushed under the weight of their load. These furniture-sculptures are imbued with the artist's misogynist views, which reflect a recurrent Symbolist attitude of the fin-de-siècle period. Carabin's work was made all the more impressive by his devotion to his material and his emphasis on bringing out the inherent natural qualities of the wood to further the symbolical value of his work. As he stated in an article on the subject of wood, "Wood is the most admirable material that nature gave to man. And to keep the cult of this material, there must be priests."[46] In his encouragement of the use of wood, Carabin urged adherence to traditional artisanal methods of cabinetmaking. Like other decorative art designers working in a Symbolist mood, he created one-of-a-kind objects.

Faced with the arrival of the Industrial Age, these artist-designers took refuge in handcraftsmanship. They had a thorough knowledge of the properties of their medium, and they frequently revived forgotten techniques of their craft. Through the handling of their material, the "enchanteresse matière", decorative artists aspired to Symbolist aims of translating ideas through their art. These works were exclusive and far removed from the concerns of mass production and industrial design of the new century. The approach of such

artists as Gallé, Carriès and Endell to the techniques of their art was traditional and artisanal. But at the same time, they realized the expressive power of colour, line, texture and abstract form – concerns of the approaching age. Placed within the Symbolist context, these artists wished to go beyond reality, to explore their inner consciousness and, in the words of Albert Aurier once again, to soar into the unknown like Icarus:

> One finds oneself regretting the absence of the dreams of the true artists of former times and, to put it plainly, their wings. Even though like Icarus we may only break our necks, we want to rise up out of the mire in which the presumption of this century wallows, to bask in the ethereal, to explore the celestial realm of ideas, the sphere of Symbols.[47]

R. P.

47. Aurier, 1892, reprinted in Mathieu, 1991, p. 49.

Rupert CARABIN
Armchair, 1893
Musée de la Ville de Strasbourg

494 (cat. 59)
F. Holland DAY
Ebony and Ivory
1897
Platinum print
18.3 x 20 cm
New York, The Metropolitan Museum of Art

Ebony and Ivory represents a high point in the "Nubian Series", the first ever nude photographs of a black model in North America. Day's chauffeur and servant Alfred Tanneyhill posed for the photograph on a leopard's skin. In his right hand, he is holding a brightly coloured marble replica of a miniature ancient statue representing a god with a spear, probably Tyrsos. Contemporaries regarded the composition as being from a "purely Greek point of view" (1899), and the nuances in the print's different shades were regarded as masterly. Day achieved this through a complicated system of lighting and a meticulous printing technique.

Besides the formal criteria, the composition acquires a certain tension from the dualist interplay of black and white, which may be interpreted as the juxtaposition of black nature and white culture for the purpose of ennobling the former. The idea for the photograph possibly came from the paintings of Flandrin or Caravaggio, from whom Day repeatedly drew his inspiration.

U. P.

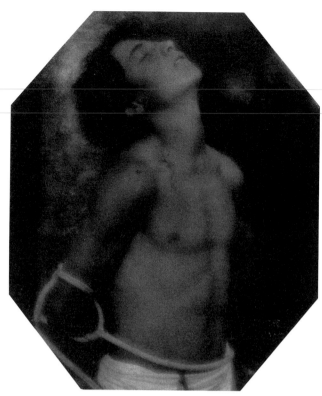

496 (cat. 66)
F. Holland DAY
Saint Sebastian, 1906
Bath, The Royal Photographic Society

495 (cat. 68)
F. Holland DAY
The Storm God, 1905
Bath, The Royal Photographic Society

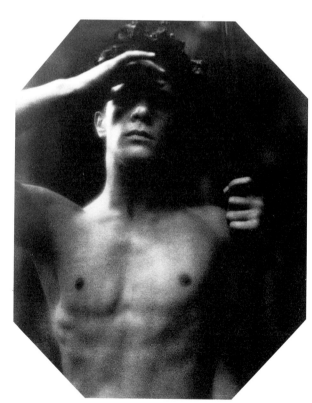

497 (cat. 70)
F. Holland DAY
Youth with Staff Shading His Eyes, 1906
Washington, Library of Congress

498 (cat. 65)
F. Holland DAY
Reclining Youth on Boulder with Tortoises
About 1905
Platinum print
24.5 x 19.2 cm
Washington, Library of Congress

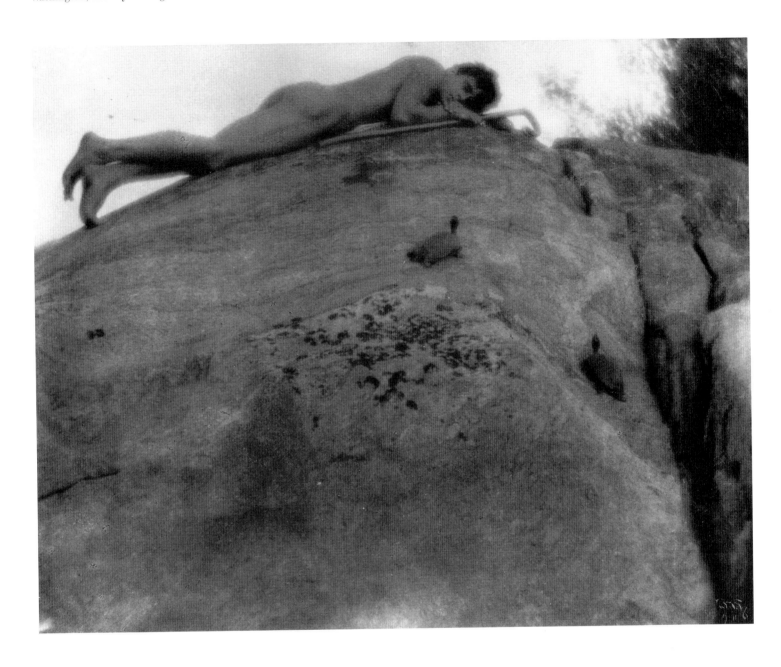

This untitled photograph was taken in the woods surrounding the photographer's summer residence near Five Islands, Maine. Estelle Jussim has classified it in the "Pagan" series. The image would seem to convey several levels of symbolic meaning. The suggestive position of the young model, the shepherd's crook or herald's staff, and the tortoises – symbols of fertility, immortality and vitality – may refer to Apollo or Hermes. The lyre is an attribute of Apollo, god of prophecy, music and flocks; Hermes is traditionally considered to be the instrument's inventor, having fashioned a seven-string lyre with a tortoise's shell for a soundbox. The photograph may represent the moment the instrument was built and its musical capacities discovered. Day repeatedly used the lyre, which was also Keats's emblem, with the aim of reviving ancient myths; another instance is in representations of the Orpheus legend, itself an expression of the longing for harmony between man and nature.

U. P.

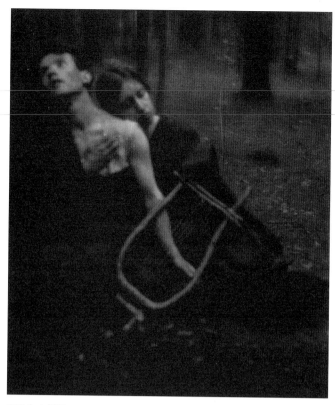

499 (cat. 382)
George SEELEY
The Pines Whisper, 1904
New York, The Metropolitan Museum of Art

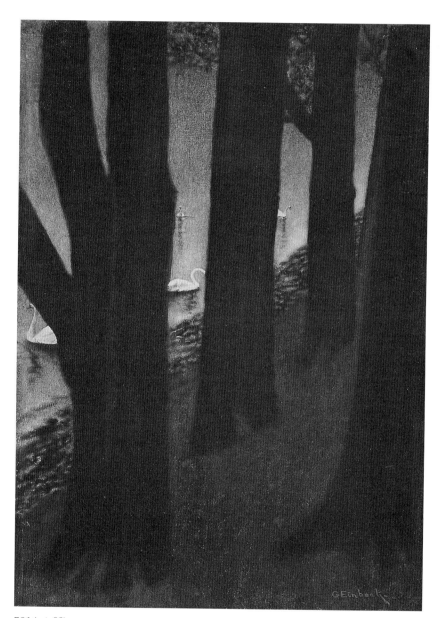

501 (cat. 93)
Georg EINBECK
Silence, 1898
Museum für Kunst und Gewerbe Hamburg

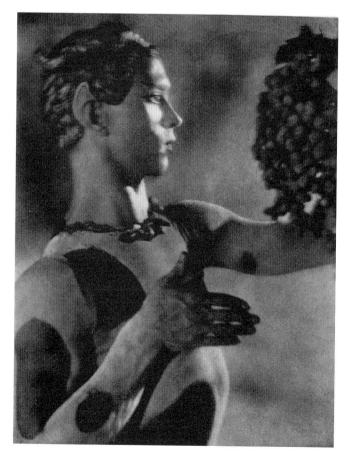

500 (cat. 78)
Adolphe DE MEYER
Nijinsky in "L'Après-midi d'un faune", 1910s
New York, The Metropolitan Museum of Art

502 (cat. 416)
Edward J. STEICHEN
The Silhouette (4 O'clock in the Morning: Rodin's "Balzac", Meudon)
1908
Gum-bichromate print
45.9 x 37.8 cm
Paris, Musée Rodin

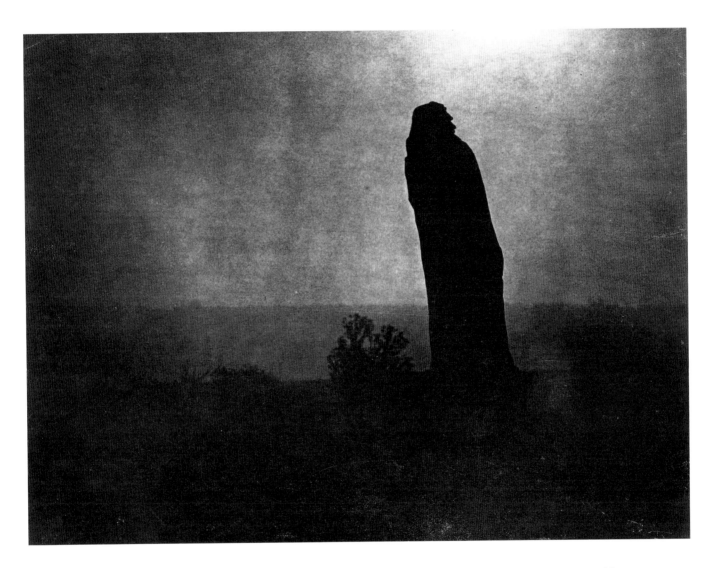

In the 1870s, Rodin began having his sculptures photographed at various stages in their development, according to precise guidelines that he provided. In the summer of 1908, he commissioned the American pictorialist Steichen to photograph the plaster of Paris model of his *Balzac* statue (1897) by moonlight, for a fee of 2,000 francs. As opposed to classical nineteenth-century photographic reproductions of artworks, which favoured a frontal view, Steichen photographed the statue in various positions and from slightly below. Instead of showing the moulded structure of the surface in detail, Steichen achieves an alienating effect by transforming it into a silhouette through the technique of gum printing. As if placed dramatically on stage, the figure takes on an aura of living and powerful monumentality.

Besides the sculptor himself, other contemporaries had high praise for Steichen's photographic interpretation of the *Balzac*. Sadakichi Hartmann contributed a striking description for this symbolic representation of the poet and genius: "It is not the glorification of classic form, but of an abstract idea, of a feeling of awe and wonder akin to that we feel in the presence of a great mind; face to face with the desert, the mountains, night or the sea. It produces instantaneously a tangled mass of sensations . . . We repeat the same process of soul activity which the statue represents; an ideal struggling through matter, some endless wrong or injustice, some deep flamboyant grace, some bold prophecy or triumphant conquest, struggling to the surface, to light and space."[1]

U. P.

1. Sadakichi Hartmann, "Rodin's Balzac", *Camera Work*, no. 35 (1911), p. 21.

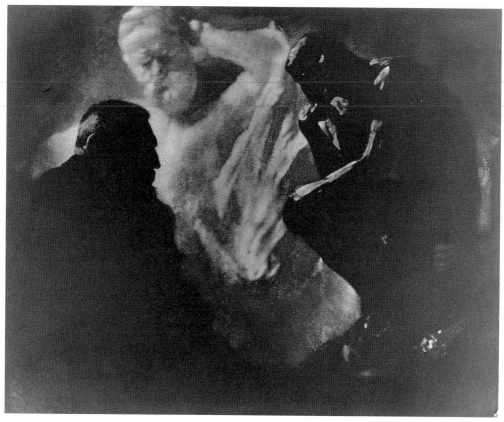

503 (cat. 412)
Edward J. STEICHEN
Profile of Rodin with "The Thinker", Victor Hugo Monument in the Background, 1902
Paris, Musée Rodin

504 (cat. 4)
James Craig ANNAN
The Church or the World, 1893
New York, The Metropolitan Museum of Art

505 (cat. 475)
Clarence H. WHITE et F. Holland DAY
Portrait of Holland Day, about 1897
Gilman Paper Company Collection

506 (cat. 413)
Edward J. STEICHEN
Sadakichi Hartmann
1903
Direct carbon print
24.6 x 30.5 cm
New York, The Metropolitan Museum of Art

The writer and restless bohemian Sadakichi Hartmann (1867-1944) was one of the most important critics and promoters of pictorialist photography in North America, alongside Charles H. Caffin and Roland Rood. Under a number of pseudonyms – Chrysanthemum, Hogarth, Juvenal, Caliban and Sidney Allan – he published hundreds of articles on all aspects of art photography. Hartmann wrote not only handbooks on photographic portrait and landscape composition, but also works like *Shakespeare in Art* (1901), *A History of American Art* (1902), *Japanese Art* (1903) and *The Whistler Book* (1910). Generally speaking, his reviews for *Camera Work* and other magazines were characterized less by a methodical approach than by subjective irony and spontaneous judgement, which served to polarize the contemporary debate.

In this portrait by Steichen, the writer's profile and the Buddha on the left side are highlighted, while the upper part of his body recedes in the photograph's even shading. Steichen presents Hartmann as a visionary, with the Buddha referring symbolically to his German-Japanese origins and, possibly, to his play *Buddha: A Drama in Twelve Scenes* (New York, 1897).

U. P.

507 (cat. 456)
Albert Freiherr
VON SCHRENCK-NOTZING
Eva C. and a Phantom Face
1911
Photoprint
24 x 18 cm
Freiburg im Breisgau, Institut für
Grenzgebiete der Psychologie und
Psychohygiene

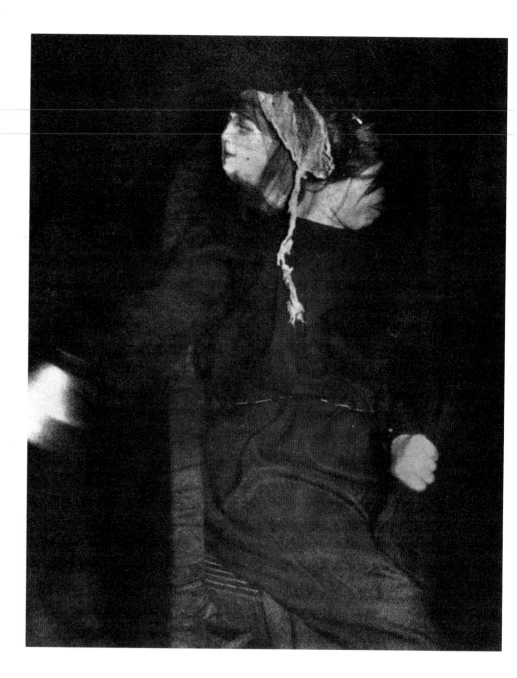

The Munich doctor and parapsychologist
Albert Freiherr von Schrenck-Notzing was
concerned with acquiring objective proof of
the supernatural. He continued the type of
experiments initiated by John Beattie in the
attempt to fix optically – by means of pho-
tography and film – ectoplasmic substances
and their transformation into physical
entities. Schrenck-Notzing published the
results of his findings in *Materialisations-
Phänomene, ein Beitrag zur Erforschung
der mediumistischen Teleplastie* (1914), his
most important work, which was illustrated
with over a hundred photographs.

This representation of the medium Eva C.
dates from a session held on December 30,
1911. Under the name Marthe Beraud and
supervised by the physiologist Charles
Richet, Eva C. had already produced various
ectoplasmic materializations in 1905 in
Algiers. The photograph shows an uniden-
tified female face growing like a Janus head
out of the medium's head. Schrenck-

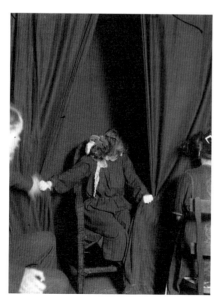

507 bis
*Eva C. at the Same Séance, a Few
Seconds Later*
Print from original stereoscopic negative
Freiburg im Breisgau, Institut für Grenzgebiete
der Psychologie und Psychohygiene

Notzing's experiments took place in a spe-
cially furnished office with numerous
neutral observers in attendance and were
strictly monitored. Using magnesium
flash-light, the teleplasmic emanations were
photographed by five different cameras, two
of which were stereoscopic instruments.
Later, cinematographic techniques were
also used. The phantoms appeared two-
dimensional even in the stereoscopic
photographs. Despite his scientific approach,
Schrenck-Notzing could never fully rid
himself of his doubts about the plausi-
bility of a "transcendental" or "psychic"
photography.

U. P.

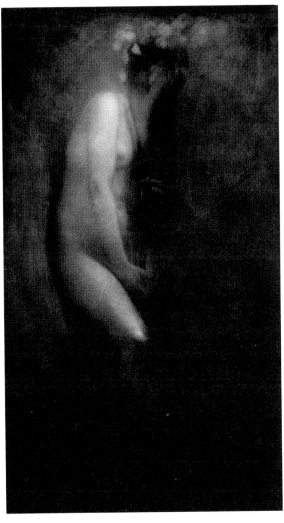

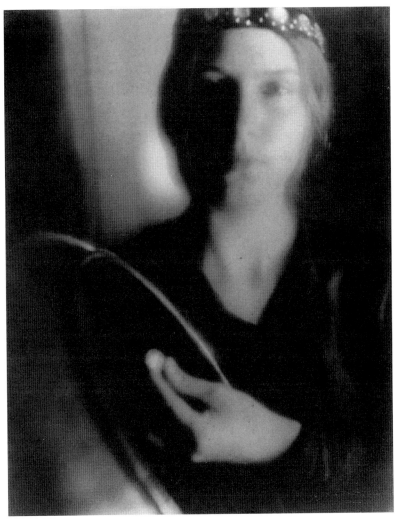

508 (cat. 409)
Edward J. STEICHEN
Figure with Iris, 1902
New York, The Metropolitan Museum of Art

509 (cat. 381)
George SEELEY
The Firefly or The Glow-worm, about 1907
Gilman Paper Company Collection

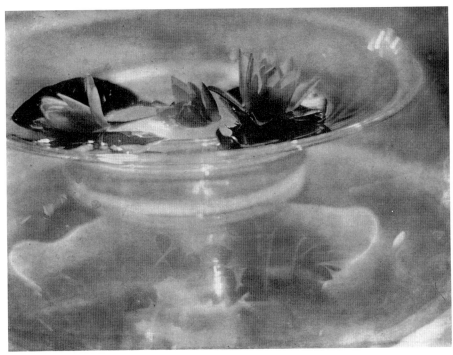

510 (cat. 79)
Adolphe DE MEYER
Waterlilies, 1908
Bath, The Royal Photographic Society

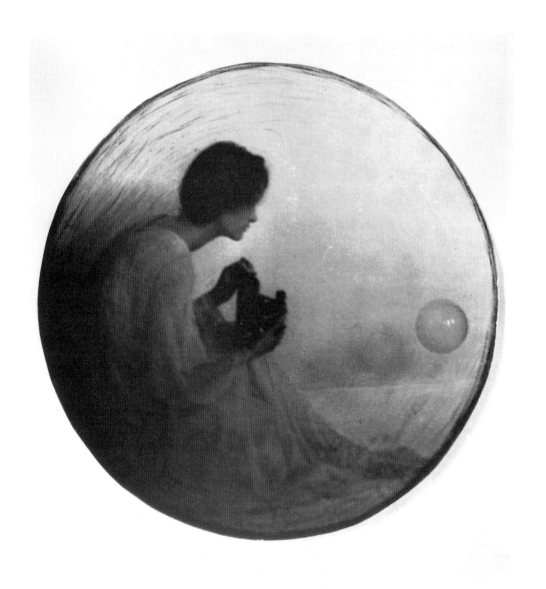

511 (cat. 31)
Anne W. BRIGMAN
The Spirit of Photography, 1907
Bath, The Royal Photographic Society

512 (cat. 311)
Karel NOVAK
Woman with Little Vase, about 1910
Museum of Decorative Arts in Prague

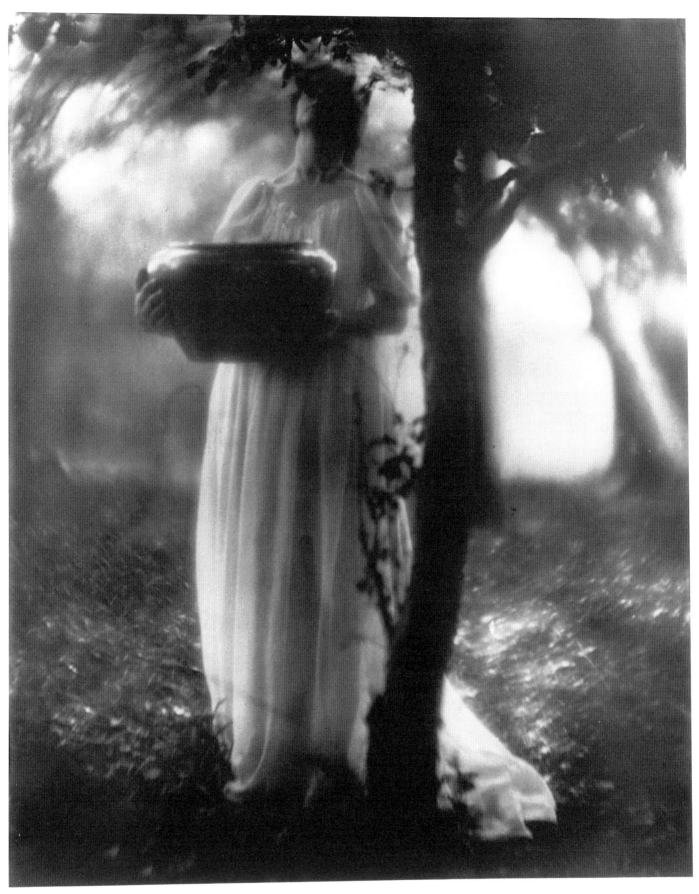

513 (cat. 377)
George SEELEY
The Tribute, about 1907
Paris, Musée d'Orsay

The Dream of Beauty, or
Truth Is Beauty, Beauty Truth
Photography and Symbolism, 1890-1914

Picture-making is the symbolical use of objects,
form and color, to express ideas.

Eva Watson-Schütze*

All visible things are emblems; what thou seest is not there
on its own account; strictly taken, is not there at all;
Matter exists only spiritually, and to represent some idea,
and body it forth.

Thomas Carlyle**

The pursuit of pure beauty is the aim of the soul of the world

Joseph T. Keiley***

Freed of prejudices concerning the so-called inferiority of works of art from the close of the nineteenth century, today we approach the culture of the fin de siècle with a keener awareness of the specific socio-political and intellectual history of that time. Analyzing works of art, among which in the meantime photography is also included, is above all a phenomenon of reception history and thus raises questions about the cognitive theories of a specific era and the identity of the interpreter. This also applies in the case of art photography around 1900, which has traditionally been looked upon by recognized historians as a decadent development and even a "dreadful aberration",[1] as opposed to the photography of the New Objectivity and the "New Vision" of the 1920s and 1930s. Art photographers at the turn of the century were repeatedly reproached for having merely reacted imitatively to the pictorial tradition of contemporary painting and graphics, a reproach primarily determined by the dictates of the history of the development of the medium itself, evolutionary and progress-oriented as it was. This observation may at first seem justified, especially if one considers the time lag with which photography adopted specific iconographic and formal artistic patterns. At the same time, it is somewhat surprising that general studies of the history of Symbolism have practically ignored the interrelationships between Symbolist art and pictorialist photography.[2] The literature on the history of

* "Signatures", *Camera Work*, no. 1 (1903), p. 35.
** *Sartor Resartus*, quoted in Jeffery Howe, *The Symbolist Art of Fernand Khnopff* (Ann Arbor: UMI Reasearch Press, 1982), p. 101.
*** "The Buffalo Exhibition", *Camera Work*, no. 33 (1911), p. 25.
1. See Helmut Gernsheim, *Geschichte der Photographie. Die ersten Hundert Jahre* (Frankfurt am Main: Propyläen, 1983), p. 725. Gernsheim's phrase, "ungeheure Geschmacksverirrung", refers to F. Holland Day's photographic cycle on the Passion of Christ.
2. See Hans Hofstätter, *Symbolismus und die Kunst der Jahrhundertwende* (Cologne: DuMont, 1965); Philippe Jullian, *Les Symbolistes* (Neuchâtel: Ides et calendes, 1973; published in English as *The Symbolists* [London: Phaidon Press, 1973]); Michael Gibson, *Les Symbolistes* (Paris: Nouvelle éditions françaises, 1984; published in English as *The Symbolists* [Harry N. Abrams, 1988]); Roger Bauer, ed., *Fin de Siècle. Zu Literatur und Kunst der Jahrhundertwende* (Frankfurt am Main: Klostermann, 1977); Werner Hofmann, *Von der Nachahmung zur Wirklichkeit. Die schöpferische Befreiung der Kunst 1890-1917* (Cologne: DuMont, 1970); *Le Symbolisme en Europe*, exhib. cat. (Paris: Grand Palais, 1976); José Pierre, *L'univers symboliste : Décadence, Symbolisme et Art Nouveau* (Paris: Éditions Aimery Somogy, 1991); *Simbolismo en*

428 *LOST PARADISE*

photography does make reference to thematic parallels, but without a closer historical delineation of the phenomenon of Symbolist photography.[3]

The orientation towards the canon of painting does not seem unusual at first, given the fact that photographers in the nineteenth century scarcely had access to training workshops or teaching institutes of their own similar to art academies, which might have acquainted them with the wealth of forms in the visual arts and thus provided the basis for a critical debate with the art tradition. This absence of tradition, however, often led to a more experimental appropriation of artistic modes of expression and, as we shall see, even helped the photographers' inventive spirit and individual capacity for expression in achieving autonomous results that go well beyond a mere fashionable imitation of established genres of painting.

Pictorialism as Art Agenda and as Revolt

What is to be understood by the term "art photography/ pictorialism" around 1900? The term "art photography" itself pointed to an agenda ambitiously aimed at emancipating photography from the traditional arts and establishing it as an artistic mode of representation in its own right. This striving for emancipation consciously targeted nineteenth-century

Europa, exhib. cat. (Las Palmas de Gran Canaria: Centro Atlántico de Arte Moderno, 1990-1991); and Jeannine Paque, *Le Symbolisme belge* (Brussels: Labor, 1989).
3. See *Pictorial Photography in Britain, 1900-1920* (London: Arts Council of Great Britain, 1978); *Fotografía Pittorica 1889/1911* (Milan and Florence: Electa and Alinari, 1979); Margery Mann, *California Pictorialism* (San Francisco: San Francisco Museum of Modern Art, 1977); Peter C. Bunnell, ed., *A Photographic Vision: Pictorial Photography, 1889-1923* (Salt Lake City: Peregrine Smith, 1980); *La Photographie d'art vers 1900* (Brussels: Crédit Communal, 1983); Janet E. Buerger, *The Last Decade: The Emergence of Art Photography in the 1890s* (Rochester, New York: International Museum of Photography at George Eastman House, 1984); Enno Kaufhold, *Bilder des Übergangs. Zur Mediengeschichte von Fotografie und Malerei in Deutschland um 1900* (Marburg: Jonas, 1986); Erika Kempe, Fritz Kempe and Heinz Spielmann, *Die Kunst der Camera im Jugendstil* (Frankfurt am Main: Umschau, 1986); Michel Poivert, *Le Pictorialisme en France* (Paris: Hoebeke, Bibliothèque Nationale, 1992); *Le Salon de Photographie. Les écoles pictorialistes en Europe et aux États-Unis vers 1900* (Paris: Musée Rodin, 1993). Among the few discussions of the relation between photography and Symbolism are Mike Weaver, *Alvin Langdon Coburn: Symbolist Photographer, 1882-1966* (New York: Aperture, 1986); Colleen Denney, "The Role of Subject and Symbol in American Pictorialism", *History of Photography*, vol. 13, no. 2 (April-June 1989), pp. 109-128; and Pierre Abraxine, "Turn of the Century: Chrysalis of the Modern", in *The Waking Dream: Photography's First Century, Selections from the Gilman Paper Company Collection* (New York: The Metropolitan Museum of Art and Harry N. Abrams, 1993), pp. 172-178.
4. See Joseph T. Keiley, "The Linked Ring", *Camera Notes*, vol. 5 (1901/1902), pp. 111-120; Margaret F. Harker, *The Linked Ring: The Secession Movement in*

habits of professional photography that were considered to be stereotyped, preferring to be looked upon as a reform movement opposed to certain formal and aesthetic conventions of studio photography. In its commercial orientation, the latter employed illusionist decor such as painted landscape backdrops, paper flowers, plaster columns and atelier poses, not so much in order to produce individual portraits of its mainly bourgeois clients, but rather to give expression to their respective social status.

Art photography was an international movement with supporters in North America, Europe and Russia. The majority of its representatives came from the wealthy upper middle class, the civil servant class and the aristocracy. Often the art photographers had undergone no regular vocational training, taking up photography as so-called dilettantes. Only a few of them, such as Eugene, Käsebier and Steichen, belonged to that rare group of "painter-photographers" who had completed courses of study in art.

Taking their lead from the Secessionist movements in painting, art photographers in the late nineteenth century founded their own associations, at first in Europe (Vienna, Hamburg, Paris, London, Brussels) and later in North America (New York, Boston, Philadelphia). By organizing exhibitions, these associations helped to propagate and promote photography as a purely artistic representational form. Of major importance for Symbolist photography were the groups known as the Linked Ring and the Photo-Secession. The Brotherhood of the Linked Ring, modelled after the Pre-Raphaelite Brotherhood around Rossetti, Millais and Watts, was founded in 1893 in London, when its members split from the traditional Royal Photographic Society. The Linked Ring's emblem was three linked rings, which stood for "beauty, truth and nature", and its members were given pseudonyms related to their psychological ambitions. The emblem of the Photo-Secession – an elitist community of American pictorialists from the former Camera Club, formed in 1902 in New York around Alfred Stieglitz – was a gleaming golden disk, a symbol of light. Although both the Linked Ring and the Photo-Secession were loosely connected groupings without any fully fledged or specifically defined theoretical programme, they were decisive in the process of achieving the aims and publicizing the works of the pictorialists.[4]

The most important representatives of Symbolist-inspired photography came from these two associations, and North

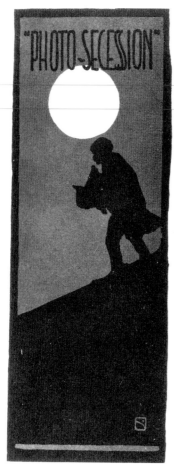

Edward STEICHEN
Photo-Secession Poster, about 1905
Munich, Fotomuseum im Münchner
Stadtmuseum

American photographers developed a language more marked
by Symbolist influence than the Europeans. Photographers
who cultivated this style included Fred Holland Day,[5] Edward
Steichen,[6] Gertrude Käsebier,[7] Clarence White,[8] Anne
Brigman,[9] Alvin Langdon Coburn,[10] Frank Eugene[11] and George
Seeley[12] in North America; Theodor and Oscar Hofmeister[13] in
Germany; Heinrich Kühn,[14] Hans Watzek, Hugo Henneberg
("Trifolium") and Paul Pichier in Austria; Vladimir Bufka,
František Drtikol, Karel Novák and Josef Anton Trčka[15] in
Czechoslovakia; Robert Demachy[16] and Constant Puyo in
France; and James Craig Annan,[17] Frederick H. Evans[18] and
Adolphe de Meyer[19] in England. *Camera Work*, a quarterly
edited by Alfred Stieglitz, represented the central journalistic
organ of Symbolist photography. It appeared in New York from
1903 until 1917 and constituted a forum for Photo-Secession
members. The journal carried articles by George Bernard
Shaw, Maurice Maeterlinck, Benjamin De Casseres, Charles
Caffin and Sadakichi Hartmann, who were all concerned with

the phenomenon of Symbolism and photography and with
intellectual connections between the philosophy, art, literature
and photography of the fin de siècle.[20]

Characteristic of the pictorialists was the elitist nature of
their community and their tendency towards exclusiveness, to
say nothing of their dandyish attitude, so impressively
portrayed in the decadent figure of Des Esseintes, the protag-
onist in J.-K. Huysmans's novel *À rebours*. For the art

4. . . .
Photography in Britain, 1892-1910 (London: William Heinemann, 1979); Robert
Doty, *Photo-Secession: Stieglitz and the Fine-Art Movement in Photography* (New
York: Dover, 1960); Weston Naef, ed., *The Collection of Alfred Stieglitz: Fifty Pioneers
of Modern Photography* (New York: The Metropolitan Museum of Art and Viking Press,
1978); William Innes Homer, *Alfred Stieglitz and the Photo-Secession* (Boston: Little,
Brown and Co., 1983).
5. Estelle Jussim, *Slave to Beauty: The Eccentric Life and Controversial Career of
F. Holland Day, Photographer, Publisher, Aesthete* (Boston: David R. Godine, 1981).
6. Dennis Longwell, *Steichen: The Master Prints, 1895-1914. The Symbolist Period*
(New York: The Museum of Modern Art and The New York Graphic Society, Boston,
1978).
7. Barbara L. Michaels, *Gertrude Käsebier: The Photographer and Her Photographs*
(New York: New York, 1992); William Innes Homer, *A Pictorial Heritage: The
Photographs of Gertrude Käsebier* (Wilmington: Delaware Art Museum, 1979).
8. *Symbolism of Light: The Photographs of Clarence H. White* (Wilmington: Delaware
Art Museum, 1977); *Clarence H. White* (Millerton, New York: Aperture, 1979).
9. Terese Thou Heyman, *Anne Brigman: Pictorial Photographer, Pagan, Member of
the Photo-Secession* (Oakland, California: Oakland Museum, 1974); *Anne Brigman:
Songs of a Pagan* (Caldwell, Idaho, 1949).
10. Helmut and Alison Gernsheim, eds., *Alvin Langdon Coburn, Photographer: An
Autobiography* (New York: Dover, 1978); Mike Weaver, 1986 (reference in note 3).
11. Ulrich Pohlmann, ed., *The Dream of Beauty: Frank Eugene* (Munich: Nazraeli
Press, 1995).
12. George Dimock and Joanne Hardy, *Intimations and Imaginings: The Photographs
of George H. Seeley* (Pittsfield, Massachusetts: Berkshire Museum, 1986).
13. Ernst Juhl, "Theodor und Oskar Hofmeister, Hamburg", *Photographische
Rundschau* [Halle an der Saale] vol. 16 (1902), pp. 65-70; Margret Kruse, "Theodor
und Oscar Hofmeister. Von der Ideenskizze zum Gummidruck", in *Kunstphotographie
um 1900. Die Sammlung Ernst Juhl* (Hamburg: Museum für Kunst und Gewerbe,
1989), pp. 39-46.
14. Ulrich Knapp, *Der Kunstphotograph Heinrich Kühn 1866-1944*, dissertation,
Leopold-Franzens-Universität, Innsbruck, 1984.
15. Monika Faber and Josef Kroutvor, *Photographie der Moderne in Prag 1900-1925*
(Schaffhausen: Edition Stemmle, 1991); Anna Fárová, *Frantisek Drtikol Photograph
des Art Deco*, ed. Manfred Heiting, translated from the French (Munich: Schirmer/
Mosel, 1986).
16. Bill Jay, *Robert Demachy, 1859-1936: Photographs and Essays* (London and New
York: Academy Editions and St Martin's Press, 1974).
17. William Buchanan, ed., *J. Craig Annan: Selected Texts and Bibliography*, "World
Photographers Reference Series", vol. 6 (Oxford: Clio Press, 1994).
18. Anne Hammond, ed., *Frederick H. Evans: Selected Texts and Bibliography*,
"World Photographers Reference Series", vol. 1 (Oxford: Clio Press, 1992).
19. Robert Brandau, ed., *De Meyer* (New York: Alfred Knopf, 1976).
20. See the following articles on Symbolism and photography in *Camera Work*:
Leonard van Noppen, "The Sphinx", no. 29 (1910), pp. 29-34; Charles H. Caffin, "Of
Verities and Illusions", no. 12 (1905), pp. 25-29; Charles H. Caffin, "Symbolism and
Allegory", no. 18 (1907), pp. 17-22; Benjamin De Casseres, "The Unconscious in Art",
no. 36 (1911), p. 17; Benjamin De Casseres, "The Brain and the World", no. 31
(1910), pp. 27-28; Benjamin De Casseres, "Art: Life's Prismatic Glass", no. 32 (1910),
pp. 33-34.

photographers, dandyism was not only an expression of spirituality and refined connoisseurship, but also of a revolt against the bourgeois lifestyle, which they felt to be mediocre. Benjamin de Casseres described the "decadent" and the "revolté" as "the man with a new vision, a new way, a finer perception", who is "always a danger to the community of dullards, to the stratified hierarchy of saintly academicians and embalmed mediocrities. Originality wears the mien of Catalina and brings not peace, but a sword."[21]

This intellectual position managed to link such diverse characters as Day, Coburn, Steichen and Eugene, who saw themselves as misunderstood and forlorn pioneers with a common idea. *The Solitary Horseman*, a work by Theodor and Oscar Hofmeister, may be regarded as illustrative of their artistic agenda and of their vision of themselves as restless searchers. Sadakichi Hartmann saw in this work a symbol for the striving of the pictorialist movement:

> They are also solitary horsemen, treated with indifference as they are for the present by the profession and denounced by the majority of artists . . .
>
> The artist, whose gaze is at all times turned inward, seems to be the true personification of the solitary horseman. He is always ready to saddle his horse and leave behind him the great, curious city with its many superstitions, its grotesque rivalries of castes and classes and set out on another journey along highways swept by wintry rains or burned by the summer sun.[22]

The manifold involvements and personal contacts between the representatives of the Symbolist literary, art and photographic worlds of the fin de siècle can only be briefly hinted at within the framework of this essay. Alfred Stieglitz repeatedly exhibited works by the American Symbolist painter Pamela Smith in the gallery of the Photo-Secession. Sadakichi Hartmann, the most important critic and theoretician of art photography, was an ardent admirer of Maeterlinck and Mallarmé. The English bookseller and photographer Frederick H. Evans, a follower of the teachings of the Swedish nature mystic Emanuel Swedenborg, collected drawings by his friend Aubrey Beardsley and lithographs by Odilon Redon, among them illustrations of Flaubert's *La Tentation de saint Antoine* and Baudelaire's *Les Fleurs du Mal*. The most colourful and renowned figure among the art photographers at the turn of the century was Fred Holland Day, who came from a wealthy Boston family and had already gained a reputation as a collector of manuscripts and memorabilia of the poet John Keats. With Herbert Copeland, he founded the publishing house Copeland & Day in Boston in 1893. Aided by the book designer Bertram Grosvenor Goodhue, this publishing house carried on the style of William Morris's Kelmscott Press. Under the motto *Sicut lilium inter spinas* [like a lily among the thorns], they published not only two hundred books but were also responsible for the first North American edition of *The Yellow Book* and Oscar Wilde's *Salomé* (1894), illustrated by Aubrey Beardsley, as well as poems by Dante Gabriel Rossetti. Day, who was closely involved with the Decadent movement through his friendships with Wilde and Beardsley, belonged to the Bostonian Visionists, a group of aesthetes that included Ralph Adams Cram, Bertram Goodhue and Francis Watts Lee. It was Day who from 1901 onwards brought Coburn, Käsebier, Steichen and Seeley into closer contact with Symbolist ideas, in particular with the writings and the person of Maeterlinck. By their own accounts, Coburn and especially Steichen were strongly influenced by Maeterlinck's *Treasure of the Humble* (1896) and *Wisdom and Destiny* (1898), which, like the works of Mallarmé, had appeared in translation in North America around 1900. Thus it comes as no surprise that Hartmann was able to discover similar artistic conformities and creative principles in the poetry of Maeterlinck and the photography of Steichen.[23] In 1903, in an article on photography written for *Camera Work* and reprinted in the special Steichen supplement of 1906, Maeterlinck credits the photographer and the medium of photography both with going beyond any mere reproduction of reality and with the capacity for an "idéiste" representation as defined by Albert Aurier. And Coburn illustrated works by Maeterlinck using the photogravure process, as in the American edition of *The Intelligence of the Flowers* (1913).

Distinctly Symbolist influences can be detected in pictorialist photography from approximately 1893 onwards – that is, seven years after the publication of Jean Moréas's literary Symbolist manifesto and two years after Aurier's essay

21. Benjamin De Casseres, "Decadence and Mediocrity", *Camera Work*, no. 32 (1910), p.39.

22. Sadakichi Hartmann, "The Solitary Horseman", *Camera Work*, no. 7 (1904), p.17.

23. Sidney Allan [pseudonym of Sadakichi Hartmann], "A Visit to Steichen's Studio", *Camera Work*, no. 2 (1903), p. 26; for a discussion of Maeterlinck's influence on Steichen, see Lucy Bowditch, "Eduard Steichen and Maurice Maeterlinck: The Symbolist Connection", *History of Photography*, vol. 17, no. 4 (Winter 1993), pp. 334-342.

372-386

on the essence of Symbolist art, "Le Symbolisme en peinture. Paul Gauguin", appeared in *Mercure de France*.

Works like James Craig Annan's *Eleanore* (1893-1894) and *The Dark Mountains* (1890) and Fred Holland Day's "sacred photographs" (as of 1896) constitute the beginning of this development. In 1898, photographs by the elite of international art photography were already exhibited jointly with posters, lithographs, watercolours and drawings by Félicien Rops, Aubrey Beardsley, Eugène Carrière, Alfons Mucha, Henri de Toulouse-Lautrec and Édouard Vuillard in the galleries of the Munich Secession.[24] The international exhibition *The New School of American Photography*, organized by Fred Holland Day, provided an impressive first demonstration of Symbolist influences on the pictorial aesthetics of photography. This exhibition at the Royal Photographic Society in London, with more than four hundred works by Steichen, Coburn, Käsebier, Eugene, Day and others, and later shown in Paris, was greeted with mixed feelings by the relevant specialist publications in England. Professional photographers reacted to it with a total lack of understanding, deriding it as a "cult of the spoilt print", "fuzzyography" and the "Oscar Wilde School". In and around the Linked Ring, however, its visionary character received great praise, with Steichen acknowledging it as "a bombshell exploding in the photographic world of London".[25] In the following years, and under the direction of Stieglitz, it was essentially the New York gallery known as "291" – and from 1905 onwards its successor the Little Galleries of the Photo-Secession – that established itself as the most important exhibition forum for the American pictorialists. Alongside the latest Photo-Secession works by Steichen, Coburn, De Meyer, Eugene, Brigman, White and Seeley, contemporary European painting was also on view here for the first time in North America in exhibitions of the works of Picasso, Matisse and Rodin. In Europe, the works of the American pictorialists were publicized in Photo-Secession group exhibitions in Dresden, Turin, Paris, Brussels, Glasgow, London and The Hague, under Stieglitz's curatorship. Detailed reports on these exhibitions and on the status of developments in art photography in general were published in specialist international journals and art magazines such as *Art et Décoration*, *Dekorative Kunst*, *Ver Sacrum* – the organ of the Viennese Secession, and the widely read art publication *The Studio*, which brought out special issues on art in photography in 1905 and colour photography in 1908.

From Imitation to the Invention of Reality

But what is to be understood by "Symbolist photography"? What themes preoccupied the photographers, and what pictorial means did they employ in order to give their ideas form?

First and foremost, the relationship between photography and Symbolism seems to have been marred by the same contradiction which also fed the conflict, omnipresent in the nineteenth century, between photography and art, that is, the relationship between the real and the ideal, imitation and invention. Due to its documentary stringency, its naturalistic faithfulness and supposed objectivity, photography was regarded as unable to idealize reality or translate it into an abstract symbolic language. The diffuse, the indeterminate, the ambiguous – those external features of Symbolist art – were essentially opposed to the photographic principle of a minutely exact, mechanical transcription from nature.

The task photographers set themselves in order to erase that stigma of reality and give shape to the tension that existed between visible reality and their own pictorial ideas was defined in 1891 by the French writer Albert Aurier who, taking Gauguin's painting as an example, demanded that art be "idéiste". As for the world of literature, J.-K. Huysmans was to aptly formulate the respective maxim in his roman à clef *Là-bas*:

> "We must," he thought, "retain the documentary veracity, the precision of detail, the compact and sinewy language of realism, but we must also dig down into the soul and cease trying to explain mysteries in terms of our sick senses. If possible the novel ought to be composed of two elements, that of the soul and that of the body, and these ought to be inextricably bound together as in life. Their inter-reactions, their conflicts, their reconciliation ought to furnish the dramatic interest. In a word, we must follow the road laid out once and for all by Zola, but at the same time we must trace a parallel route in the air by which we may go above and beyond . . . A spiritual naturalism!"[26]

24. *Offizieller Katalog der I. Internationalen Elite-Ausstellung künstlerischer Photographien ... des Vereins bildender Künstler Münchens "Secession"* (Munich: Secession, 1898).

25. For details of the exhibition, see Jussim, 1981, pp. 137-152.

26. J.-K. Huysmans, *Là-bas*, quoted in English from *Down There*, trans. Keene Wallis (New York: Albert & Charles Boni), pp. 4-5. Werner Hofmann, *Das irdische Paradies*.

This artistic conflict was also reflected in the technical discussions about the sharpness of the photographic image which had raged since the mid-1850s and which flared up again at the end of the nineteenth century. The point of departure for this theoretical debate in the field of art was the aesthetic maxims coined by John Ruskin – "Truth to nature . . . rejecting nothing, selecting nothing, scorning nothing" – and the controversial theory of naturalistic photography put forward by Peter Henry Emerson.[27] Whereas Ruskin had seen the real strength of photography in its exactness of detail and its ability to make nature visible in hyperreal fashion, Emerson pleaded for a slight lack of sharpness in the reproduction of pictorial details, making reference in 1889 in his book *Naturalistic Photography* to the Impressionist and Naturalist theories of perception, and to Hermann von Helmholtz's physiology of perception. The German physicist's theory claimed that the human eye only sees clearly at the so-called yellow spot, or focal centre, on the retina, while the surroundings always remain more or less out of focus. The illusion of a complete and exact visual image only comes about through a gradual scanning of objects with the help of this spot in the sharpness zone.[28] Although Emerson soon withdrew his thesis, it nevertheless exercised a great influence on the development of art photography and led to a veritable boom in out-of-focus photographs. This argument in favour of a lack of sharpness based on the physiology of human perception was to give way at the end of the 1890s to an argument with a more philosophical-psychological basis. From now on, vision was understood as the result of a spiritual

process. Reflecting and intensifying the discovery of personal emotional worlds of sensation, two terms largely unknown until then – "empathy" and "subjectivity" – became key words in photographic theory at the fin de siècle, paralleling psychology's scientific research on the soul.

Technically, photographers laid claim to a lack of sharpness as an indicator of their spiritual power of guidance and selection. Statements to this effect were made by various theoreticians such as Max Allihn, Willi Warstat, Hans Merian and Robert de la Sizeranne. In 1895 Allihn noted, "The overall image is a composite one, not merely a physical product but a spiritual product. The artist holds this spiritual product in his mind's eye; his task is to reproduce an object as we have seen it and in the same way as our memory maintains it as an overall image."[29] From Allihn's "memorized image", it was only a small step to an "imagined image". The popular French writer Robert de la Sizeranne also exercised a great influence, in particular with the theories he published in the magazine *La Revue des Deux Mondes* in 1897. Sizeranne saw in art photographs "mirror images of the soul" and the power of imagination of the photographer. He took a decisive stand "against the truth of science, the truth of the details", and against the "mania for stock-taking".[30] In connection with the image, much reference was made to the aesthetic tradition of the early years of photography, to the picturesque blurred effect of the calotypes by D. O. Hill and R. Adamson, and the Pre-Raphaelite photography of J. M. Cameron, whose portraits, blurred close-ups and transposition of literary themes, as in her illustration of Alfred Tennyson's *The Idylls of the King*, were lauded enthusiastically as exemplary pioneering achievements. Influences of Pre-Raphaelite photography are clearly recognizable in the works of Clarence White (*The Kiss*, 1904) in particular, and in Frank Eugene's ethereal presentations of women (***The Lady of Shalott***, about 1899).

228

Against this theoretical background, the pictorialists developed unusual technical means to achieve blurring effects in both the negative and positive process, and thus to do justice to their imagined images. The relationship between these "primitive" techniques[31] and the contemporary advances in optics and camera technology was indeed an anachronistic one. Oriented as it was towards progress, technology was producing faster and more precise lenses, like the Anastigmat (1890), with which it was possible to represent phenomena that were not visible to the eye. Among the most important

Motive und Ideen des 19. Jahrhunderts (Munich: Prestel, 1974; 3rd edition, 1991), pp. 18-19, erroneously ascribes the passage to Huysmans's *À rebours*. See also G.-Albert Aurier, "Le Symbolisme en peinture. Paul Gauguin", *Mercure de France*, March 1891, pp. 155-165.

27. Peter Henry Emerson, *Naturalistic Photography for Students of the Art* (London: Sampson Low, Marston, Searle and Rivington, 1889); Nancy Newhall, *P. H. Emerson: The Fight for Photography as a Fine Art* (Millerton, New York: Aperture, 1975).

28. See Thilo Koenig, "'Feine Platinbilder'. Die internationale Kunstphotographie und der Beitrag Amerikas zu den Hamburger Ausstellungen", in *Kunstphotographie um 1900. Die Sammlung Ernst Juhl* (Hamburg: Museum für Kunst und Gewerbe, 1989), pp. 47-55.

29. Max Allihn, "Über unscharfe Photographien", *Süddeutsche Photographen-Zeitung*, vol. 1 (1895), p. 338.

30. Robert de la Sizeranne, "La Photographie, est-elle un art?", *Revue des deux mondes*, vol. 144 (1897), pp. 565-595; published in German as "Ist die Photographie eine Kunst?", *Photographisches Wochenblatt*, vol. 24 (1898), pp. 41+.

31. See Willi Warstat, "Der künstlerische Wert primitiver Techniken", *Photographische Rundschau und Mitteilungen* [Halle an der Saale], vol. 50 (1913), pp. 5-8; see also Willi Warstat, *Allgemeine Ästhetik der photographischen Kunst auf psychologischer Grundlage* (Halle an der Saale: Knapp, 1909).

methods and techniques used for achieving soft-focus photographs were placing gauze in front of the lens, thus effecting a "veiling" of the image through longer exposures; moistening the lens or using a special lens for soft-focussing; telephoto lenses (Pinkham & Smith lenses, Imagon, Dallmeyer) and simple monocle lenses that converted depth perspectives into surface perspectives; making the camera vibrate by stroking a violin string stretched between the tripod and the lens; using pinhole cameras (camera obscura) and paper negatives.

The selection and combination of experimental interventions knew no bounds. The photographer Benedikt Herzog mounted complex allegorical tableaux using several negatives; the German-American Frank Eugene resorted to the unconventional technique of reworking the negative with an etching needle and colours, a process described by contemporaries as "unphotographic photography". Professional photographers looked upon Eugene as an experiment-loving eccentric who achieved the artistic effects in his "light etchings" with little regard for normal photographic practice. His method, however, was taken up by Demachy and Brigman.

Modern positive processes offered further possibilities for refining the effect of the photograph and giving form to the photographer's artistic intentions, while providing the image with its personal signature and definitive form. Metaphorically speaking, work in the dark room resembled the occult practices of a pictorial magician who, as illustrated in Coburn's portrait of Day, created mysterious pictorial worlds with the help of "black art".

In place of the usual albumen and bromide developing papers and collodion and gelatin printing papers, the so-called high-grade printing processes, such as gum bichromate, oil pigment, gelatin carbon, glycerine-developed platinum and hand-printed photogravure, were gaining acceptance. Contrary to developing papers, these processes allowed manual interventions and alterations.[32] The majority of these reproduction processes were not discovered by art photographers. They had been developed some decades earlier but had not been commonly used. What was in widespread use was glycerine-developed platinum, because of the subtle reproduction of tone values it enabled, and photogravure, which was particularly suited to the reproduction of half tones. In appearance, photogravures or heliogravures are similar to etchings. They could be produced by the photographer himself from the original negative without too much technical effort, and they also offered possibilities for manipulating the printing plate during the etching and inking process. With their help, more than a hundred copies of a motif could be reproduced on thin japan paper. A highly developed version of this technique was used by Emerson, Annan and Stieglitz. The majority of the top-quality illustrations in *Camera Work* were produced by means of photogravure.[33]

Gum-bichromate printing also enjoyed great popularity. This versatile and manipulable process became widespread around 1895, at first in Europe (Paris and London) and later in North America. After Demachy and Hinton experimented with the technique, the Austrian photographers Henneberg, Watzek and Kühn adopted it and produced polychrome gum-bichromate prints. In Germany, it was the Hamburg photographers Theodor and Oscar Hofmeister and Georg Einbeck who experimented with large-format gum-bichromate prints, while in the United States, Stieglitz, White, Käsebier, Coburn and Steichen gradually began to use this technique from 1898 onwards. Steichen was the one who mastered the use of polychrome gum-bichromate printing to perfection, with pictorial results so convincing as to win both admiration for their artistic quality and respect for their technical skill. Particularly important are Steichen's gum-bichromate prints of Rodin's *Balzac* and *The Thinker*, to mention but two. Gum-bichromate printing made possible not just the selection of "artistic" coarse-grained (watercolour) paper media, but also technical interventions such as isolation, drawing in and/or accentuating details for decorative surface effect, reduction of the tone scale, interpretative introduction of moods not present in the negative, and greater plasticity and alienation arising out of the multistage colour printing process. As opposed to this, the autochrome process, which in 1907 was welcomed enthusiastically by the pictorialists Steichen, Eugene, Stieglitz and Kühn as the first practicable colour process, was only partially suited to manipulatory inter-

502-503

32. On printing techniques, see Robert Knodt and Klaus Pollmeier, *Die Verfahren der Fotografie* (Essen: Museum Folkwang, 1989); Marjen Schmidt, *Fotografien in Museen, Archiven und Sammlungen* (Munich: Weltkunst, 1994).

33. See Jonathan Green, ed., *Camera Work: A Critical Anthology* (Millerton, New York: Aperture, 1973); Marianne Fulton Margolis, ed., *Alfred Stieglitz: Camera Work, A Pictorial Guide* (New York: Dover, 1978); Christian A. Peterson, *Camera Work: Process and Image* (Minneapolis: The Minneapolis Institute of Arts, 1985); Christian A. Peterson, *Alfred Stieglitz's Camera Notes* (New York and London: Minneapolis Institute of Arts in association with W.W. Norton, 1993).

147

ventions, so that in practice this technique was only used for a short while.[34]

Although between 1898 and 1908 large-format gumbichromate prints were particularly important in promoting the recognition of photography as an independent mode of artistic expression, the technique also gave rise to great controversy. In 1902, Steichen had made a plea for the complete artistic freedom of the photographer in an article entitled "Grenzen" [Borders].[35] In 1904, on the occasion of the Photo-Secession exhibition in Pittsburgh, Sadakichi Hartmann became the leading spokesman for the critics of the subjectivism of the "Whistlers of photography" (Coburn, Eugene, Steichen, Demachy), when he in turn put forward his "plea for straight photography": "It is only a general tendency towards the mysterious and bizarre which these workers have in common; they like to suppress all outlines and details and lose them in delicate shadows, so that their meaning and intention become hard to discover."[36] Both Hartmann and Charles Caffin, an American art historian and co-editor of *The Studio*, came out in favour of a purist, unmanipulated medium and characterized Steichen's and Coburn's works as "freak photography" and "brilliant aberrations".[37]

In art circles, the spread of these new photographic techniques was met with mixed feelings. Until then, photog-

Franz VON STUCK
Photographic Study for "The Guardian of Paradise", before 1889
Munich, Fotomuseum im Münchner Stadtmuseum

34. See Dixon Scott, "Colour Photography", in *Colour Photography and Other Recent Developments of the Art of the Camera*, Charles Holme, ed. (London: The Studio, 1908), pp. 1-10; John Wood, *The Art of the Autochrome: The Birth of Color Photography* (Iowa City: University of Iowa Press, 1993).

35. Edward J. Steichen, "Grenzen", *Camera-Kunst*, ed. Ernst Juhl (Berlin, 1903), pp. 12-15.

36. Sadakichi Hartmann, "Plea for Straight Photography", 1904, in Harry W. Lawton and George Knox, eds., *The Valiant Knights of Daguerre: Selected Critical Essays on Photography and Profiles of Photographic Pioneers by Sadakichi Hartmann* (Berkeley: University of California Press, 1978), pp. 108-114. Similar opinions about the appearance of Symbolist photography were expressed in Germany by Fritz Knapp. See Fritz Knapp, "Der Symbolismus und die Grenzen der Photographie", in Fritz Matthies-Masuren, ed., *Die photographische Kunst im Jahre 1905*, vol. 4 (Halle an der Saale: Knapp, 1905), pp. 127-134.

37. Charles H. Caffin, "The Development of Photography in the United States", in *Art in Photography*, special summer issue of *The Studio* (London, Paris and New York, 1905), p. US7.

38. Between 1889 and 1925, Stuck used photographs for mythological and allegorical compositions, for example **The Guardian of Paradise** (1889), *Wounded Amazon* (1905) and *Salome* (1906). See J. A. Schmoll gen. Eisenwerth, "Lenbach, Stuck und die Rolle der photographischen Bildnisstudie", in *Vom Sinn der Photographie. Texte aus den Jahren 1952-1980* (Munich: Prestel, 1980), pp. 114-135; Eva Mendgen, *Franz von Stuck 1863-1928 "Ein Fürst im Reiche der Kunst"* (Cologne: Benedikt Taschen, 1994).

39. Arne Eggum, *Munch und die Photographie* (Wabern-Bern: Benteli, 1991).

40. Jiri Mucha, ed., *Alphonse Mucha: Posters and Photographs* (London: Academy Editions, 1971); Graham Ovenden, *Alphonse Mucha Photographs* (London: Academy Editions, 1974).

raphy had been looked upon and used by some artists as a welcome support in their work process. Photographic studies of movement in particular, such as those by Eadweard Muybridge (from 1878), Jules-Étienne Marey (from 1883), Albert Londe (from 1883) and Ottomar Anschuetz (from 1884), which had made access to the structure of successive phases of movements possible through the use of series of photographs and chronophotography, were to exercise a lasting influence on artists such as Meissonier, Puvis de Chavannes, Rodin, Kupka, Duchamp, Villon, Bragaglia and Balla. Photographs were occasionally used for memorizing purposes or as models by painters such as Félix Vallotton, Pierre-Bonnard, Édouard Vuillard, Maurice Denis, Paul Gauguin, Ferdinand Hodler, Vincent van Gogh, Fernand Khnopff, Alfons Mucha, Edvard Munch and Franz von Stuck. The latter[38] also took photographs, as did Munch,[39] Mucha[40]

Alfons MUCHA
Photographic Study of a Model Holding a Wreath,
about 1900
The Mucha Trust

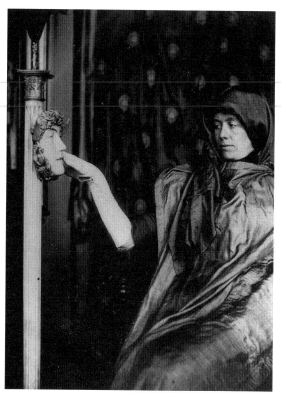

Fernand KHNOPFF
The Artist's Sister Marguerite Posing for "Secret-reflet",
about 1902
Brussels, Musées royaux des Beaux-Arts de Belgique

and Khnopff.[41] Just how much concrete importance Symbolist artists attributed to the medium of photography becomes clear from different surveys that appeared between 1893 and 1908 in various art and photography periodicals. Thus, in 1893 under the heading "Is the Camera the Friend or Foe of Art?", the English art magazine *The Studio* published the results of a survey carried out among nineteen sculptors, painters and graphic artists, including Frederick Leighton, Lawrence Alma-Tadema, John Everett Millais, Walter Crane, Walter Sickert and Joseph Pennell. While Leighton, Alma-Tadema, Millais and Crane conceded a positive influence on painting to the camera, Sickert, in a categorical rejection, wrote that in the future, in order to disclose the artist's work process "It would be well if the fact that a painting was done from or on a photograph were always stated in the catalogue."[42] A second survey of artists published in 1894, in the German-language periodical *Gut Licht!*, in which Hans Thoma, Walter Leistikow and Franz Stuck participated, among others, centred around the issues of the artistic value of photography and the "independence of artistic means". Here Leistikow made

positive claims for photography as a means of artistic expression, while Stuck and the majority of the others were negative and condescending in their statements.[43] In the United States, the surveys in *Camera Notes* in 1901[44] and *Camera Work* in 1908[45] contained mainly favourable judge-

41. Khnopff made use of photographic studies between 1889 and 1902 for many paintings, drawings and etchings, for example *Memories* (1889), *Du Silence* (1890) and *Le Secret* (1902). See Robert L. Delevoy, Catherine de Croes and Gisèle Ollinger-Zinque, *Fernand Khnopff: catalogue de l'œuvre* (Lausanne: La Bibliothèque des arts, 1979), pp. 117-140; *Fernand Khnopff 1858-1921 "Im Lebenstraum gefangen"* (Hamburg, 1980), pp. 44-47; Jeffery Howe, *The Symbolist Art of Fernand Khnopff* (Ann Arbor: UMI Research Press, 1982), pp. 36-37; Charles de Maeyer, "Fernand Khnopff et ses modèles", *Bulletin (Musées Royaux des Beaux-Arts de Belgique)*, vol. 13, no. 1/2 (1964), pp. 43-56; Fernand Khnopff, "À propos de la photographie dite d'art", *Bulletins de la Classe des Beaux-Arts*, Académie Royale de Belgique [Brussels], June 8, 1916, pp. 224-226; Fritz Matthies-Masuren and Fernand Khnopff, "Zählt die Photographie zu den schönen Künsten?", *Photographisches Centralblatt*, vol. 5 (1899), pp. 203-208.
42. "Is the Camera the Friend or Foe of Art?", *The Studio*, vol. 1, no. 3 (June 1893), pp. 96-102. Sickert's reply is on p. 102.
43. Hermann Schnauss, ed., *Gut Licht! Jahrbuch und Almanach für Photographen und Kunstliebhaber*, vol. 1 (Dresden, 1894), pp. 113-136.
44. Sadakichi Hartmann, "A Photographic Enquete", *Camera Notes*, vol. 5 (1901/1902), pp. 233-238.
45. George Besson, "Pictorial Photography – A Series of Interviews", *Camera Work*, no. 24 (1908), pp. 13-23.

ments on the expressive qualities of art photography put forward by such artists and writers as Albert Pinkham Ryder, Rodin, Gustave Geffroy, Steinlen, Alexandre Charpentier, Bartholomé, Camille Mauclair, Gabriel Mourey and Matisse. In France, a wide-ranging debate on photography and the illustration of literature was carried on in the *Mercure de France*, the literary organ of the Symbolists.[46] It can be assumed that the discussion was triggered by the illustrations in Georges Rodenbach's Symbolist novel *Bruges-la-Morte* [Bruges the Dead City], the original French edition of which (1892) contained thirty-two photogravures based on views of the city of Bruges by the photographer Neurdin. The statements by the twenty-four French authors and artists, among them René Ghil, Comte de Larmandie, Stéphane Mallarmé, George de Lys, Pierre Louÿs, Zola, Rodenbach and Paul Sérusier, dealt with the relationship between reality and imagination, with particular reference to photography. Whereas de Larmandie, de Lys, Sérusier and Zola expressed certain reservations regarding the utility of photography due to its proximity to reality, Rodenbach and Ghil conceded that instantaneous photographs enhanced the ability to illustrate the "written thought". Mallarmé's rejection of illustrative photography is brusque, ironic and ambiguous: "I am in favour of – no illustrations, as everything evoked by a book should happen in the reader's mind; but if you replace photographs, then why not go straight to the movie camera, whose development will replace – text and image – many a volume, and to good advantage."[47]

A Subjective Symbolic Language

The artistic ideals and goals of the pictorialists can be understood as a reaction to the general, fundamental crisis in humanist thinking and the social conditions around 1900, not to mention the crisis in the specific history of the development of the medium of photography in the nineteenth century. Until the turn of the century, the practices of commercial studio

photography and future-oriented scientific photography had clearly dominated the scene, their diverse manifestations determining the image we have of the world. Around 1900, it had become possible to represent practically everything photographically. Exploration of the visible and the invisible included the exact depiction of humans and animals in motion. Microphotography, X-ray photography and photography used in criminal identification and classification meant that humans could now be completely surveyed, measured and recorded. New discoveries in the sphere of photographic technology brought ever greater technical perfection, with the result that it was now possible to see and to photograph even under the most extreme conditions. This is illustrated by such areas of application as travel photography in the tropics, high in the mountains and in winter, astrophotography, balloon photography, and meteorological photography. These pictorial achievements could be marvelled at among the innumerable items on display at the international industrial expositions and world's fairs that had been taking place since 1851 in Europe and North America, those "parades of capitalism" (F. Naumann) that in their symbiosis of national self-presentation and encyclopedically inspired manifestations of the latest developments in science, technology, handicrafts and art, were bound above all to utilitarian ideals of progress.[48] A similarly cosmic feeling was mediated by the "instantaneous snapshots" of illustration photography, which had become popular in the 1890s. These were disseminated by the million in weekly journals and enabled the spread of news and pictures of topical events to the remotest regions of the globe. In addition to the public world of images, the popularization of amateur photography (snapshot photography) – the Kodak company's motto was "You press the button – we do the rest" – meant that the private sector, as defined until 1900, had now also become accessible to photography.

The pictorialists vehemently abjured such modern uses of photography. Free from any desire to apprehend the topicality and dynamism of everyday life, and thus also free from the physical threat of the obliteration of the individual which they associated with it, their photographs mediated a world of contemplation, seclusion and standstill. In their conscious retreat from the outer world of events, they felt that they were more bound to a process of self-discovery – in the sense of a "voyage intérieur". Their representation of subjective emotions and their observation of the inner life were supported by

46. André Ibels, "Enquête sur le roman illustré par la photographie", *Mercure de France*, January 1898, pp. 97-115.
47. *Ibid.*, p. 110.
48. Ulrich Pohlmann, "'Harmonie zwischen Kunst und Industrie' — Zur Geschichte der ersten Photoausstellungen", in Bodo von Dewitz and Reinhard Matz, eds., *Silber und Salz. Zur Frühzeit der Photographie im deutschen Sprachraum 1839-1860* (Heidelberg: Braus, 1989), pp. 496-513.

the conviction that their photographic work provided invariably only a symbolic representation of reality and not just a mere reproduction of it. One critic reviewing an exhibition of Day's at the New York Camera Club in 1898 characterized this change in paradigms in his description of the photographs not as "representations of external nature" but rather as "the embodiment of mental creations in which the imagination of the spectator is called upon to do its part in the rendering of the ideal".[49] In this sense, simply by re-identifying the subject, the photographs represented for the viewer an incentive to an individual vision, because they provided access to the concealed world of universal knowledge and constituted an event for the "spiritual eye".

As a type of counter-world to unrestricted technical progress and industrialization, as a sceptical negation of Positivism and the pragmatic materialism that was especially prevalent in North America, the pictorialists sought an introspective symbolic language that was to be dominated by the power of the imagination and the intellect, and which existed beyond normal reality. In this sense, pictorial photography raises the question of the identity of modern man and of fundamental cultural renewal. The photographs, which were created in accordance with the principle of pure beauty, represent an attempt to synthesize by means of harmonious images the contradictions arising out of an atomized presence, to re-create the entity our image of the world has forfeited.

Nature as the Landscape of the Soul

As Ulrich Keller claims in his article "The Myth of Art Photography",[50] the artistic world of the pictorialists was restricted to just a few themes: landscapes, architecture, portraits, genre scenes, interiors and nudes. Compared with conventional representations of nature, which were realistic and often heroic reproductions of a concrete topography, the pictorialists strove towards an artistic re-interpretation and transformation of the landscape, seeing in it a mirror and mediator of individual spiritual moods. Approaching landscapes on the basis of exact studies of nature, the art photographers – like Des Esseintes in *À rebours* – nevertheless preferred the twilight, the hours of dusk and nightfall, when "both soul and consciousness are awakened":

It is in the penumbra, between the clear visibility of things and their total extinction in darkness, when the concreteness of appearances becomes merged in half-realized, half-baffled vision, that spirit seems to disengage itself from matter and to envelope it with a mystery of soul-suggestion.[51]

This wild profusion of reality's bewildering detail allowed itself to be tamed in large decorative masses and abstract expanses of brightness and darkness. Pictorialist landscapes make the world appear as if in an extensive, somewhat blurred mirror without any perspective. This depiction suggests endless space, which, drawing upon the Romantic tradition of landscape painting, functions as an expression of longing and other moods of the soul. Thus for example, walking through a forest and visiting a medieval cathedral unleashed similar emotions, and a shadowy landscape was seen as the animated refuge of elves and fauns.

Taking photographs at night involved certain technical complications, as it often required exposures of up to several hours. Thus, daylight photographs were occasionally turned into night-light photographs at the printing stage or altered by means of manual additions. In both their lighting effects and process of abstraction from nature, the hermetic landscapes of Steichen and Coburn in particular, show obvious influences of Whistler's aesthetics, as in his "Nocturnes" of the 1870s, and similarities with the "sacred groves" of the Nabis and the landscapes of Stuck and Klimt. Whistler, the American painter Arthur Wesley Dow and the writings of Sadakichi Hartmann had taught the pictorialists to appreciate the principles of Japanese painting and woodcuts, whose influence can be seen in the conscious neglect of, or emphasis on, certain details and the choice of expansive, seemingly empty backgrounds where nature takes on the character of a stage set.[52]

A characteristic feature of pictorialist landscapes is a preference for mystic-melancholic moods, betraying a fascination for the enigmatic, concealed and mysterious. Just as

49. W.M.M., "F. H. Day's Exhibition of Prints", *Camera Notes*, vol. 2 (1898), p. 21.
50. Ulrich F. Keller, "The Myth of Art Photography: An Iconographic Analysis", *History of Photography*, vol. 9, no. 1 (January-March 1985), pp. 1-38.
51. Charles H. Caffin, "The Art of Eduard J. Steichen", *Camera Work*, no. 30 (1910), p. 34.
52. On the influence of Japanese art, see Sidney Allan, "Repetition, with Slight Variation", *Camera Work*, no. 1 (1903), pp. 30-34; Sidney Allan, "The Influence of Artistic Photography on Interior Decoration", *Camera Work*, no. 2 (1903), pp. 31-33; see also *Le Japonisme*, exhib. cat. (Paris: Grand Palais, 1988), pp. 240-253; Charles H. Caffin, *Photography as a Fine Art* (New York: Morgan & Morgan, 1978; reprint of 1901 edition).

Rodin, in conversation with Paul Gsell, had emphasized the importance of "mystery" for the efficacy of art, referring to the manifold concealed meanings contained in certain phenomena in the visual arts, so too did Dallett Fuguet underline the omnipresent existence of "mystery" in the graphic world of the pictorialists:

> The sea breathes mystery; the woods and mountains are full of it; so is the dusk, starlight, the dawn – all vague or vast spaces, all ever-recurring, basic things. Materially and scientifically has man banished the unknown to the farthest confines of his physical world . . .
>
> Begotten of man's spiritual needs and melancholy possibilities, suggestion is its handmaid. Death is its brother. And its essence is as its name – mystery![53]

Gertrude KÄSEBIER
Bungalows, about 1907
New York, The Museum of Modern Art

Occasionally too, the landscape becomes an uncanny, threatening place, as in Coburn's **Haunted House** and Käsebier's *Bungalows*, which as a landscape of the soul represents an almost oppressive hallucination. A melancholic, gloomy mood also marks James Craig's photograph *Dark Mountains* (1890), the dramatic atmosphere of which led his contemporaries to associate it with "imaginations of Walpurgian nightmares or Dantesque dreams, ideas of massive, awful grandeur, unknown, threatening dangers, the unexplored countries beyond".[54]

The modern urban world, with its skyscrapers, factories, and transport systems, and the general vitality of big city life were only rarely considered by the pictorialists to be worthy themes, especially as they often regarded city life itself as a threat to the creative powers of the individual. Stieglitz, Coburn, Steichen, Pierre Dubreuil and Pichier are the exceptions. Most likely at the instigation of Arthur Symons, Coburn conceived the cycle of photographs "The Adventures of Cities", of which two portfolios, on London (1907) and New York (1910), provide evidence. As Mike Weaver outlined in his detailed study, Coburn's cityscapes are full of metaphorical significance, and many of the motifs in the London series – such as steps and staircases, corridors and portals, wells and rivers, groves and gardens, natural and artificial temples – are also to be found in the emblem books of Freemasonry, to which the photographer was drawn.[55] A comparable emblematic significance also suggests itself in Pierre Dubreuil's depiction of the abstract silhouette of an illuminated Ferris wheel, which awakens associations with a sun disk or a wheel of life.

Portraits as Mirrors of the Soul

In contrast to traditional nineteenth-century portrait photography, the pictorialists were less interested in an idealized presentation of social status than in a psychologically intuitive grasp of the individual. Liberating themselves from the conventions of studio photography, art photographers preferred to set their portraits in a landscape or a living-room interior. Referring to the pictorial tradition of painters such as Rembrandt, Velázquez, Watts and Millais, they intended the results of their efforts to be mirrors of the soul. Subsequently, visual attention was concentrated on the head and the hands, which were considered to be the main expressive media of a person's intellect and character, while the body faded into the

53. Dallett Fuguet, "Mystery", *Camera Work*, no. 14 (1906), p. 49.
54. Caffin, 1910, p. 34. On the Symbolism of the landscape, see Joseph T. Keiley, "Landscape – A Reverie", *Camera Work*, no. 4 (1903), pp. 45-46.
55. See Weaver, 1986 (reference in note 3), p. 54.

Edvard Munch "à la Marat" at Dr. Jacobson's Clinic, 1908-1909
Oslo, Munch-museet

Stanisław Ignacy WITKIEWICZ
Kolaps (Self-portrait with a Lamp), about 1913
Zakopane, Muzeum Tatrzańskiego

background as a mere decorative silhouette. Often the photographers had a close friendship or were on familiar terms with the sitter, or else were bound to the artists, writers and "muses" they photographed by a spiritual affinity.

159

As for staged self-portraits – such as Coburn's – the physiognomic approach often resulted in a narcissistically invested dream image, a cult of the self. Day's self-portrait, however, offers a specifically psychological variation: it shows Day as a dandy, together with a naked model, his chauffeur. Reminiscent iconographically of Böcklin's self-portrait, Day's version represents a remarkable document and personal avowal of the artist's homosexual tendencies.

238

The search for the true self, nature and identity of the individual is also an essential motive behind the self-portraits of August Strindberg and Edvard Munch, which hold a unique position in the history of photography due to their intense subjectivity. The Norwegian painter Munch employed photography as a tool in a cognitive process of self-analysis, which to a certain extent also had a cathartic effect. Thus, between 1902 and 1910, the artist took numerous photographs of himself, which have come to be regarded as an expression of a deep-rooted crisis, an existential predicament. Through these photographs, Munch in a way redefined the task and boundaries of photography, independently of existing

traditions and iconographies: "The camera cannot compete with painting as long as it cannot be utilized in heaven or in hell."[56] The Swedish writer August Strindberg practised a similar form of psychological self-observation, fixing his various spiritual states with the help of photography. In Gersau, Switzerland, he took several self-portraits that, in their deliberately artificial poses and serious mimicry, illustrate the extent of his psychological agitation and irritation.[57] For the Polish writer and painter Stanisław Ignacy Witkiewicz, on the other hand, photographic self-portraits represented a means of self-exploration, without the masklike self-representations ever being able to reveal the "true" self.[58]

56. Edvard Munch (1904), quoted in Eggum, 1991 (reference in note 39), p. 137.
57. Strindberg's photographic portraits were likely inspired by Paul Nadar's famous series of the chemist Eugène Chevreul, published September 5, 1886, in the *Journal Illustré*. Strindberg also experimented with colour photography and published the results in an article "On Photography in Direct Colours" in the occultist journal *L'Initiation (Revue philosophique des Hautes Études)* in Paris in 1896. On Strindberg and photography, see *Immagini dal pianeta Strindberg* (Venice: Electa, Biennale di Venezia, 1981); Angelika Gundlach, ed., *Der andere Strindberg Materialien zu Malerei, Photographie und Theaterpraxis* (Frankfurt am Main: Insel, 1981), pp. 247-289.
58. *Stanisław Ignacy Witkiewicz 1885-1939* (Berlin: Neue Gesellschaft für Bildende Kunst, 1990), pp. 21-27; Anna Micinska, *Stanisław Ignacy Witkiewicz: Life and Work* (Warsaw: Interpress Publishers, 1990).

The Battle of the Sexes

The separate worlds of the sexes at the fin de siècle also find figurative expression by the pictorialists: men are portrayed as creatively shaping human culture; women are depicted in the exercise of their "sacred" duties or assigned to the home and family sphere.

Steichen's portraits of Rodin and Bartholomé, where the artist is glorified as a contemporary celebrity or a solitary genius among his works, have to be seen against this background. In these portraits, which the French writer Camille Mauclair described as "visible pages of psychology",[59] the artists often seem to emerge like luminous figures from out of a Rembrandt-like darkness, or else they are photographed against the light as silhouettes. Steichen portrays Rodin, among his sculptures of Victor Hugo and *The Thinker*, as if dwarfed by his creations. This photograph is the complex result of a montage of several positives printed in combination. In an exemplary way, it embodies Rodin's artistic temperament and his dualist principle of work and life, of a *vita contemplativa* and a *vita activa*.[60]

Equally complicated as regards the production process were Steichen's photographs of Rodin's statue of Balzac. These came about in October 1908 in Meudon in compliance with Rodin's instructions. Once the huge sculpture had been dragged up a hill, Steichen photographed it by moonlight so as to lend its silhouette that mysterious aura which has been interpreted as the symbolic representation of the genius of the writer. In view of this congenial co-operation, it is not surprising that Rodin – the most famous artist in the world – praised the young American photographer as "a very great artist and the leading, the greatest photographer of his time".[61]

Pictorialist representations of women oscillate between two symbolic figures of womanhood, the "femme fragile" and the "femme fatale". What dominates in the figurative world of the pictorialists is the introspective pictorial worlds of "white" Symbolism, which knows no perversions or challenging sexuality such as are evoked and embodied in Stuck's painting *Sin*. There are exceptions, however, as in Gertrude Käsebier's *The Bat* and Annie Brigman's *The Spider's Web*, where the women are given sphinxlike, seductive and demonic features. The depiction of a woman's long flowing hair by Kühn and Steichen still symbolizes female sexual vitality.

One central theme recurring in Symbolist painting is motherhood. The pictorialists also took up this theme, glorifying motherhood as representative of woman's natural biological destiny. Portrayals of female models with vases or round and swelling receptacles refer symbolically to motherhood, to "women's role as millennial vessels" (Melinda Parsons). Gertrude Käsebier turns to this theme repeatedly and, in *The Heritage of Motherhood*, even presents the strains and dark sides of the biological process of pregnancy, birth and child-rearing, alongside the tenderness of the mother-child relationship. One fascinating point is that Käsebier, and Clarence White as well, developed an interest in the psychological situation of the small child, above and beyond the classical Madonna-and-Child type of depiction. White's photograph *Nude with Baby* (1912), in which the child strives towards the surge of light, is evidence of this. The American photographer George Seeley sees the woman as a symbol of earthbound fertility, or else in the passive role of mysterious muse and priestess, the depictions of which conjure up associations with *The Virgin of the Lilies* (1898) by Carlos Schwabe. In their static pose, their somnambulist passivity, Seeley's figures are reminiscent of the statuesque, sometimes anemic compositions of Fernand Khnopff, whose work presumably influenced the photographer. Only seldom do women appear as creatively active. More frequently they are depicted, for example by Paul Haviland, as caught up in melancholy contemplation that has at least formal links with the pictorial tradition of Dürer's *Melancholia I*.

Another image that became widespread was that of a woman wrapped in long white robes and holding a lily or iris in her hand. By analogy with Christian iconography, as in the depictions of Mary and the martyrs, this figure was raised and transfigured into a symbol of purity and chastity and thus received the nimbus of a saint, as for example in White's *Spring, a Triptych* and Heinrich Kühn's *On the Hillside*.

503
502
394
114, 115
401
449
446
232
94
455, 454

59. Quoted in Besson, 1908 (reference in note 45), p. 20.
60. See Melinda Boyd Parsons, "Edward Steichen's Socialism: 'Millennial Girls' and the Construction of Genius", *History of Photography*, vol. 17, no. 4 (Winter 1993), pp. 317-333.
61. Quoted in Besson, 1908 (reference in note 45), p. 14. On Rodin and photography, see Albert Edward Elsen, *In Rodin's Studio: A Photographic Record of Sculpture in the Making* (Oxford: Phaidon, 1980); Hélène Pinet, ed., *Les Photographes de Rodin. Jacques-Ernest Bulloz. Eugène Druet. Stephen Haweis et Henry Coles. Jean-François Limet. Edward Steichen* (Paris: Musée Rodin, 1986); Hélène Pinet, ed., *Rodin. Sculpteur et les photographes de son temps* (Paris: Musée Rodin, 1986).

The combination of a female model and a crystal ball, however, represents a particular iconographic variation.[62] This pictorial element, which also crops up in connection with portraits of artists, was used by Brigman, Alice Boughton, Day, Steichen and in particular Seeley and White in more than twenty compositions. The inclusion of the crystal ball more than likely refers to a poem by the Belgian writer Maeterlinck, in which he describes the glass ball symbolically as the vessel of his inner soul. "Maeterlinck saw his very soul as a bell-jar, crystal globe, or hot-house – sheltered from the outside world and separate from it physically and spiritually."[63] Since the 1890s, Redon and Khnopff had introduced the crystal ball repeatedly in allegorical portraits of women to express spirituality, as in Khnopff's *Solitude* (1890-1891).[64] At the beginning of a series of photographs containing a crystal ball is a portrait of Maeterlinck taken by Day in Paris in 1901. Whereas the accessory functions as a symbol of spiritual inspiration in this portrait of Maeterlinck, in the portrayals of women by White and Brigman the transparent ball becomes a symbol not only of fragility, purity and immaculate conception but of meditative concentration on the inner voice. Steichen's somewhat staged portrait of Richard Strauss, on the other hand, makes reference more to prophetic visions, the combination of the composer's hypnotic gaze and the crystal ball constituting an almost magic-demonic entreaty to the viewer.

The nude also became a popular subject of photography at the end of the nineteenth century. The omnipresent articles and discussions in the professional journals on the "educational" value of nude photography demanded that the photographer chose "natural" open-air surroundings, carefully select his or her model, and strive for an idealized representation.[65] As opposed to the academic nude photographs artists had sometimes used in place of live models since the middle of the nineteenth century because the photographs reproduced physical appearance with such precision, the pictorialists experienced their representation of female and male nudes both as a liberation from puritanical moral precepts and as a return to a more archaic, natural way of life. At first sight, however, what dominates in the allegorical nudes of Eugene and Steichen is not so much a liberation of female Eros but more an almost noncorporeal, asexual, ephemeral depiction of the models whose diffuse physique awakens the suspicion that they were influenced by the painting of

Carrière. One is tempted to interpret the photographs of the slightly turned faces of the female models taken in Steichen's studio, in contrast to the widespread outdoor nude photographs, as a concession by the photographer to the pervasive prudish taste of the time. Yet there is another meaning concealed behind this gesture, as Sadakichi Hartmann explains. Hartmann compares the naked body to a shrine in whose "clair-obscur" are concealed the various modes of appearance of the human soul, in all its mysteriousness: "The mystic, psychological note alone can save us from animalism in the representation of a nude. It will enable us to wrest from it the sentiment and deeper significance which reigns beneath the external. The nude body reveals its highest beauty only in fugitive visions and fragments."[66]

The romanticized depiction of woman as the incarnation of ideal timeless beauty is typical of Steichen. While in the course of the reform movement and the women's rights movement around 1900 concepts of womanhood and, with them, the fixed roles of the sexes were caught up in a process of disintegration, in the figurative world of the pictorialists the woman was granted at best the function of an inspiring if passive muse, in contrast to the active creative protagonists of the male art world.

The Androgynous Ideal of Beauty and Social Utopia

In the photographic representation of the male nude, on the other hand, a fundamental redefinition of the relationship between man and woman is evident. Here one can observe the photographers' fascination with the ideal of beauty embodied in the androgynous. The mythological accounts of Pan and Orpheus are prominent in impressive photographic works by Day, Eugene, Seeley and White. In White's *Pipes of Pan* and Day's "Orpheus" series, taken at his summer residence at Five Islands, Maine, the youthful models remain in a state of

62. Denney, 1989 (reference in note 3), pp. 109-128.
63. *Ibid.*, p. 124.
64. In Redon's work, the crystal ball appears for example in *The Metal Ball* (1878) and the pastel *The Priest of the Kabbala* (later *The Sphere*, 1895).
65. See for instance the articles "The Nude in Photography", *The Studio*, vol. 1 (1893), pp. 103-109; Gleeson White, "The Nude in Photography" (1897), in Bunnell, 1980 (reference in note 3), pp. 78-84.
66. S[adakichi] H[artmann], "Visions of the Nude", *Camera Work*, no. 31 (1910), p. 30.

passive indecision and dreamy rapture, sexually indifferent yet at the same time posing seductively. The mythological Greek bard Orpheus exercised a great fascination on Theosophers like Schuré and painters like Stuck, Séon and Moreau, especially since Orpheus seemed to personify both a harmonious symbiosis between man and nature, and an unfulfilled longing and grief at the vanity of human striving. While paintings by Redon and Stuck, for example, conceived of the singer mainly as a "charmer of animals", taking up motifs such as the death of Orpheus, the photographs of Day and White seldom offer a concrete iconographic or narrative situation from the Orpheus myth, except for the depiction of Orpheus's lament. Day's photographs provide evidence of this and have formal analogies with Alexander Séon's two painted versions of *The Lamentation of Orpheus* (1883 and 1896), which show the mourning poet in a barren rocky landscape.[67]

At a time of widespread social turmoil, the androgynous figure was destined to become a symbol of utopia and protest.[68] As the embodiment in painting and photography of an ideal human condition, the youthful androgynous being remained an artificial construct, the expression of a longing for the origins of human nature, or for an ideal sexual transformation. With reference to the late Romantic period, the androgynous ideal of beauty as an aesthetic work of art was propagated at the turn of the century mainly in elite circles, and yet its revival gave expression to wider social concerns. The veneration of a sexless being, free of sexual desires and eternally young, symbolized for many an apparent overcoming of the battle between the sexes and a redefinition of their relationship. Removed from "profane" reality, the androgynous figure embodied a perfect primordial state of being with an aura of innocence and indecision, the fascination of which is vividly described by Thomas Mann in *Death in Venice* and is also manifest in the work of the painter Elisàr von Kupffer.[69]

This longing for a utopian conception of man and for an earthly paradise coincided with social developments at the end of the nineteenth century that were to lead to the emergence of escapist tendencies among the bourgeoisie in the face of changes in the conditions of life in the large cities. While the flight from the land was overcrowding cities, industrialization was leaving large expanses of destroyed natural and agrarian landscape in its wake. One consequence of this fast-moving industrialization was a trend towards the commercialization of all areas of life, which in turn led to an alteration in the political power structures. As a political force, the bourgeoisie increased its power but at the same time was constantly confronted with the "social question", the term used to describe the concerns of the working population, the proletariat and the "left-wing" parties.

The factors at the root of the new socio-critical tendencies, which often found expression in the concept of "another world", encompassed the erosion of meaning in everyday life determined by mechanization and hectic speed, the decline of religious belief with its expectation of salvation, and living conditions in the large cities which were viewed as a threat to individuality. "Hope in an earthly paradise is coupled with a fear of the meaninglessness of existence. This hope radiates in different directions. History and life, the antipodes of the nineteenth century, also imposed two diametrically opposed focal points on that century's notions of an earthly paradise."[70] The movement for social reform proclaimed a classless society as the model for the future, whereas conservative circles opted for a concept of paradise based on the past. At the turn of the century, the desire for liberation from the constraints of civilization led to the construction of aesthetic counter-worlds for which models were willingly sought in ancient or exotic cultures. The German photographer Wilhelm von Gloeden, who lived in Taormina, Sicily, between 1880 and 1930, was encouraged by similar motives to capture that landscape and its inhabitants in compelling atmospheric photographs in which the cultural landscape has been so stylized through human "invigoration" as to represent an event, an idyllic habitat of the blissful.[71] Gloeden's nude photographs in particular, whose popularity was in no way restricted to homophile circles, conjured up among his contemporaries reminiscences of the Golden Age of Antiquity. Iconographically, this revitalization of ancient myths by Gloeden and Day comes close to Böcklin's paintings. The Austrian art photographers Henneberg and Pichier were also inspired by Böcklin's work.

431

432

67. See Dorothy M. Kosinski, *Orpheus in Nineteenth-century Symbolism* (Ann Arbor and London: UMI Research Press, 1989), pp. 158, 201. See also Patricia G. Berman, "F. Holland Day and His 'Classical' Models Summer Camp", *History of Photography*, vol. 18, no. 4 (Winter, 1994), pp. 348-367.

68. *Androgyn. Sehnsucht nach Vollkommenheit* (Berlin: Neuer Berliner Kunstverein, Dietrich Reimer, 1986).

69. *Elisàr von Kupffer* (Basel: Kunsthalle Basel, 1979).

70. Werner Hofmann, *Das irdische Paradies. Motive und Ideen des 19. Jahrhunderts* (Munich: Prestel, 1974), p. 230.

71. See Ulrich Pohlmann, *Wilhelm von Gloeden – Sehnsucht nach Arkadien* (Berlin: Dirk Nishen, 1987).

For the American photographers Imogen Cunningham and Anne W. Brigman, an idealized refuge comparable to the Mediterranean south was to be found on the relatively untouched West Coast of California with its large tracts of forest. Brigman's photographs in particular celebrate the beauty of nature as a pantheistic idyll inhabited by "natural spirits" and unclothed humans in forests of pine and oak trees, which as trees of life were intended to symbolize immortality. During Brigman's lifetime, her nature photographs, which were close to the tradition of American Transcendentalism as embodied in Ralph Waldo Emerson, Henry David Thoreau and Walt Whitman, were often compared to Ovid's *Metamorphoses* and Shakespeare's *A Midsummer Night's Dream*. Brigman's idyllic landscapes portray a magical world in which man and nature still exist in positive harmony.[72]

464

500

The cycle of photographs entitled "*L'Après-midi d'un faune*", by Adolph de Meyer,[73] created in a studio and therefore considerably more artificial in their effect, also evokes a hymn to paganism. The ballet of the same name – to music by the French composer Claude Debussy (first performed in 1894) that was inspired by a poem of Mallarmé (1876) – was premiered in Paris in 1912 by the Ballets Russes. Nijinsky, who danced with six ballerinas, was also the choreographer. In accordance with the Greek myth, the ballet tells the story of Pan, who lives in Arcadia, pursues nymphs and naiads, and is particularly interested in the Arcadian nymph Syrinx. She spurns his love, however, and in fleeing him arrives at the River Ladon, where she is transformed into a reed, from which Pan then fashions a panpipe. With great sensitivity, de Meyer captured the dancers in minimalist angular movements, positions formally reminiscent of bas-reliefs, Greek vase painting or Egyptian murals. De Meyer, who at the time had already photographed Nijinsky in performances of *Le Carnaval* and *Le Spectre de la Rose*, makes a unique, synesthetic attempt to represent simultaneously the three elements of music, dance and poetry. Nijinsky was so enthusiastic about the photographs, which are the only visual documents of the performance, that he contributed financially to their duplication for a special edition of which unfortunately only a few copies have survived.

After 1900, de Meyer and other photographers such as Hugo Erfurth, Eugene and Drtikol became preoccupied with the depiction of dance and, in particular, with the figure of Salome, who was mainly regarded as the female expression of

erotic, sensual vitality. The dualism of this figure, oscillating between "negative female elementary forces" and captivating "inhuman" beauty, is characteristic.[74] The Czech photographer František Drtikol's transposition of the Salome theme seems almost grotesque and ironic: during the "meloplastic evenings" in Prague in 1912, he captured the Russian dancer Olga Vladimirovna Gzovska on film in the role of Salome.[75]

370

In contrast to these depictions, the photographs taken of the American expressive dancer Loie Fuller as the "femme voilée", possessed an ethereal, almost angelic aura. The silent performance of the veil dance, also known as the "serpentine dance", without any scenery and in darkness illuminated only by projected abstract colour patterns, seems to have had a magical effect upon contemporary viewers. In 1893, in an article in the magazine *L'Illustration* about the dancer and the transitory circumstances of her performance, Rastignac wrote: "She is not a woman of flesh and bone and brown hair. She is an apparition equal to those ideal creatures that one perceives, restless, seductive and unreal, in the paintings of Mantegna."[76]

296, 297

Christian Religion, Occultism and Spiritism

Increasingly, and in reaction to a pervasive spiritual vacuum, religious themes became the subject of complex photographic productions, which illustrated a Christian counter-world intended to overcome the loss of traditional beliefs and an apparently meaningless state of existence, an existence whose

72. See Joseph T. Keiley, "The Buffalo Exhibition", *Camera Work*, no. 33 (1911), p. 27; Emily J. Hamilton, "Some Symbolic Nature Studies from the Camera of Annie W. Brigman", *The Craftsman*, vol. 12, no. 6 (1907), cited in Christian A. Peterson, "American Arts and Crafts: The Photograph Beautiful, 1895-1915", *History of Photography*, vol. 16, no. 3 (Autumn 1992), p. 198 and note 42.
73. *L'Après-midi d'un Faune: Nijinsky 1912, 33 Photographs by Baron Adolphe de Meyer* (new palladium prints by Richard Benson), (Eakins, New York: The Eakins Press Foundation, n.d. [about 1978]). See also William Ewing, *Dance and Photography* (New York: Henry Holt, 1987), pp. 20-21; Monika Faber, ed., *Tanz: Foto Annäherungen und Experimente 1880-1940* (Vienna: Österreichisches Fotoarchiv im Museum moderner Kunst, 1990), pp. 36-45; Michele Penhall, "Adolf de Meyer: L'Après-midi d'un Faune", in Mike Weaver, ed., *British Photography in the Nineteenth Century: The Fine Art Tradition* (Cambridge: Cambridge University Press, 1989), pp. 273-280.
74. Hans H. Hofstätter, 1965 (reference in note 2), p. 198.
75. Josef Kroutvor, "Der Tanz als Inspiration bei František Drtikol", in Monika Faber, 1990 (reference in note 73), pp. 38-39.
76. Quoted in *Loie Fuller: The Magician of Light* (Richmond: Virginia Museum, 1979), p. 18; see also Hélène Pinet, ed., *Ornement de la Durée. Loie Fuller. Isadora Duncan. Ruth St.Denis. Adorée Villany* (Paris: Musée Rodin, 1987).

notion of progress was manifest mainly in material values. Spiritual experience was sought in Neo-Catholicism and in Oriental religions such as Buddhism or Hinduism, which entered into syncretic symbioses with the traditional Western religions or with occult doctrines. Although since the 1840s religious themes had already preoccupied photographers such as John Mayall, Oscar Rejlander and especially Julia Margaret Cameron, the series entitled "Sacred Photographs" by the American pictorialist Fred Holland Day nevertheless attracted particular attention. In 1896, Day had already begun to photograph the Stations of the Cross.[77] In 1897, his *Entombment* was shown at the Vienna Camera Club, and in Boston in 1898, Day presented a selection of Christian themes "embracing the Baptism, Raising of Lazarus, the Betrayal, the Crucifixion, the Descent from the Cross, the **Entombment**, the Resurrection and others". A characteristic feature of the individual scenes, which were all taken close to Boston, is Day's striving for the greatest possible authenticity in his reconstruction and staging of the Passion cycle. At the same time, the photographs led to great controversy in the photography world when they were presented in the Salons and in the exhibition *The New School of American Photography*. They were judged to be either a total lapse of faith, mere blasphemy or the expression of extreme spirituality. Day himself claimed that he was inspired by the tableaux vivants of the Passion play in Oberammergau, Bavaria, but throughout his lifetime, he concealed the fact that he himself had portrayed the figure of Christ. In the final analysis, this serious and at the same time narcissistic identification with the Saviour reveals Day's conception of himself as an artist who must have understood the experience of the world as a symbol "of all the suffering in this world" (Max Klinger).

Wilhelm von Gloeden and Belgian photographer Pierre Dubreuil also took up religious themes, as for example in Gloeden's self-portrait as Christ. In addition, the choice of clothing and the whole outward appearance suggest a link with the Rosicrucian movement, whose initiator Joséphin Péladan had a predilection for presenting himself as a long-haired,

88

87

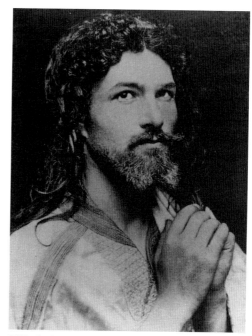

Wilhelm VON GLOEDEN
Self-portrait as Christ, about 1895
Munich, Fotomuseum im Münchner Stadtmuseum

bearded Messiah. A connection between Gloeden and the cult of the Rosicrucians seems possible, especially as his photographs were much appreciated as models by artists such as Alexandre Séon.

In contrast, the works of the Czech photographer František Drtikol seem to refer more to satanic rituals such as black masses. Drtikol staged a crucifixion cycle using a female model. The portrayal, which was not made public in the photographer's lifetime, conjures up associations with the occult practices in Huysmans's *Là-bas* (1891) or with Félicien Rops's **Temptation of Saint Anthony** (1878), in which a female nude on the cross, a personification of Satan and Eros, attempts to seduce the Saviour. In comparison, the photographs of the interiors of Gothic cathedrals in England taken by Frederick Evans represent an invocation of Christian ideals. In his architectural photographs, which were preceded by several weeks' studying the lighting conditions and spatial features, Evans was concerned with grasping the pure spiritual essence of the construction and its sacred function, or, in Evans's own words, of making "a record of emotion rather than a piece of topography".[78]

In the course of the spiritualization of the arts at the fin de siècle, an interest also emerged in the paranormal psychic phenomena of mediums and spiritists. Here, photography had

120

329

182

77. See discussion in Jussim, 1981 (reference in note 5), pp. 121-135; F. Holland Day, "Sacred Art and the Camera", *The Photogram* [London], vol. 8, no. 88 (1901), pp. 91-92.
78. Frederick H. Evans (1904), quoted in Beaumont Newhall, *Frederick H. Evans* (Millerton, New York: Aperture, 1973), p. 11.

Albert VON SCHRENCK-NOTZING
The Medium Eva C., Nude, with Phantom, 1913
Freiburg im Breisgau, Institut für Grenzgebiete der
Psychologie und Psychohygiene

Darget and Baraduc were to capture the "movements of the living spirit" and inner emotional states by means of camera-less photography, in so-called thought photographs. The beginnings of ghost photography can even be traced back to the late 1850s. All these attempts were raised to an empirico-scientific level by Doctor Albert Freiherr von Schrenck-Notzing, who between 1909 and 1911 fixed materializations of the phantoms of a female medium with the help of photography.

The End of Symbolist Photography?
"Towards a New Photographic Vision"

The last important international exhibitions of art photography took place in Dresden in 1909 and in Buffalo in 1910, although these were primarily retrospective in character. At about the same time, the influential associations Linked Ring and Photo-Secession began to disintegrate, and leading representatives such as Day, Käsebier, Seeley and Demachy were to more or less give up photography by 1914, while others such as Kühn and Eugene made no recognizable progress as regards their themes and their pictorial aesthetics. When compared to the vitality of technical advances and of modern city life, the hermeticism of Symbolist art photographers seemed to their contemporaries to be escapist. The photographs by Alvin Langdon Coburn taken in co-operation with Ezra Pound in 1917 represent perhaps a last attempt to give unity to an atomized present, an inherently shattered modernity, using the photographic means of a Cubist-inspired pictorialism.

From then on, the abstract formal vocabulary of Paul Strand was to dominate, the photographer to whom the last issues of the American *Camera Work* were dedicated. The introduction presenting eleven of Strand's photogravures that Stieglitz wrote in 1917 indicates an abrupt turning away from

the task and quality of an objective document, bearing witness to the existence of the supernatural, the beyond.[79] The public need for this kind of photograph was enormous and can only be understood against the background of the international spread of spiritism. At the end of the nineteenth century, in North America alone there were over twelve million followers of spiritism and thirty-five thousand mediums. England had several million practising spiritists, while there were an estimated one hundred and fifty thousand in Paris and forty thousand in Lyons.

In the photography of psychic phenomena, two essentially distinct forms can be recognized: the photographic depiction of rays from the human body as emanations of the spirit, and so-called ghost photography, that is, the visual representation of the ghosts or souls of the dead. Approximately at the same time as the discovery of X rays by the German physicist Konrad Wilhelm von Röntgen in 1895, researchers such as

79. See Rolf H. Krauss, *Jenseits von Licht und Schatten. Die Rolle der Photographie bei bestimmten paranormalen Phänomenen – ein historischer Abriß* (Marburg: Jonas, 1992). Alfons Mucha and Edvard Munch occasionally referred to "spirit photographs" as preparatory studies, as Munch did for the painting *The Sick Child* (1886). See Eggum (reference in note 39), 1991, pp. 32-40. Mucha was initiated into the experiments of occultism and spiritism, as can be seen in the photographic series of the Parisian medium Madame de Ferkel, who was photographed by Mucha and Colonel de Rochas in Mucha's Paris studio on Rue Val-de-Grace. See Petr Wittlich, "Die Botschaft von Mucha", in Mucha Foundation, ed., *Alfons Mucha Pastelle, Plakate, Skizzen und Photographien* (Prague: Prager Burg, 1994), pp. 12-20.

the Symbolism of the graphic vocabulary of the pictorialists. "The work is brutally direct. Devoid of all flim-flam; devoid of trickery and any 'ism;' devoid of any attempt to mystify an ignorant public, including the photographers themselves. These photographs are the direct expression of today."[80]

The photography of the New Objectivity and new vision represents a return to the world of objects and to topical events captured in dynamic camera perspectives. Even though the figurative world underwent a change after 1918, picto-

rialism, and especially Symbolist photography, had provided the pictorial aesthetics of the new vision with decisive impulses and had been able to make a particular contribution towards accustoming our eye to abstract images – one has only to call to mind the works of Seeley, Coburn or Malcom Arthbutnot. For the first time in the history of photography, the experimental possibilities of the medium had been thoroughly explored and a breakthrough achieved for a subjective symbolic language in which photography was perceived as a spatial, graphic medium and as an international style.

U. P

80. [Alfred Stieglitz], "Our Illustrations", *Camera Work*, no. 49/50 (1917), p. 36.

Translated from German by Pauline Cumbers

514
Edward BURNE-JONES
and William MORRIS
The Works of Geoffrey Chaucer
1896
Illustrated book
Kingston, Ontario, Queen's University

This illustrated folio edition of Chaucer, which W. B. Yeats described as the most beautiful book ever printed, is typical of the output of the Kelmscott Press. Having discovered Chaucer as undergraduates at Oxford, William Morris and Edward Burne-Jones conceived in 1891 the idea of publishing a new edition of his works. Morris embarked on a programme of meticulous research based largely on the critical reappraisal being carried out in Oxford at the time by Ellis. The task was to take five years. Careful attention was paid to every last detail: a new font of type, named "Chaucer", was cast (but only after "Troy", another typeface designed by Morris, had been tried), based on fifteenth-century German gothic type, and the Kelmscott printers chose paper appropriate for the folio format, to be designed by Morris with ornamental borders.

During the years of preparation, the number of illustrations to be contributed by Burne-Jones grew from forty to sixty and finally to eighty-seven. Within the almost stiflingly dense foliage of the borders, Burne-Jones's illustrations seem like spaces where the soul can breathe, opening up vistas of endless space. Knights palely loitering in enchanted gardens, strange tomes that come down from the heavens, female figures wild with loneliness in a waste of oceans: the iconography evokes themes linked not only to the Pre-Raphaelite movement but to international Symbolism. The reader wanders alone in an enclosed garden, ideally set within a pre-existing framework whose impenetrable leafiness creates a boundary and becomes imperceptibly a metaphor for a contemplative and detached view of the world.

G. G.

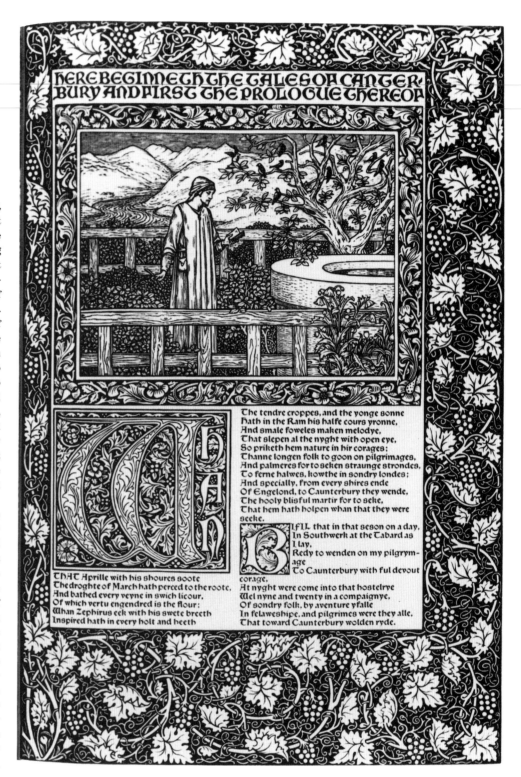

515
Paul VERLAINE
Sagesse
Illustrated by Maurice DENIS
1910
Private collection

After reading *Sagesse* in November of 1889, Denis seems to have decided at once to illustrate it. It was the right moment in the artist's life – the passionate religious feelings of his youth, the chaste love he felt for Madame Portelette and his ambition to revive the art of book illustration found the ideal subject in these moving poems, in which a return to more orthodox Christianity and a gradual detachment from the temptations of the flesh go hand in hand with a rediscovery of the Middle Ages. *Le Journal* arranged the meeting, and it was probably Lugné-Poe who, through the agency of Adolphe Retté, enabled young Denis to meet the poet.

The illustrations, produced in white-hot haste, were soon shown to Verlaine, then already seriously ill. Looking at the drawings with their medieval style, the poet sighed, "That's me, all right, poor beggar", to the delight of the budding artist. Plans were made for publication (especially with the firm of Vanier, which had republished *Sagesse* in 1881), but came to naught. The drawings, which Denis had begun as a student, were polished and took their final form over a number of years, and they were to be widely exhibited. The images vary between intense sensuality, sometimes incorporating an almost Expressionist eroticism, and chaster moods, where ethereal feminine forms stand out against a space that gradually fades away into a cloud of tiny Japanese-style commas.

For the frontispiece, Denis turned to one of his earliest lithographs, *La Voie étroite* [The Narrow Way] (1889), of which only a few prints had been made, some highlighted in gouache for colour. The motif of the path winding across a clearing before losing itself in the depths of the forest is to be taken as an ideal symbol of the young artist's spiritual quest. It is found again in the *Éventail des fiançailles* presented by Denis to his wife-to-be Marthe Meurier. The four "figures of souls" (only the outstretched hands of one of them can be seen) represent, therefore, in an ellipse typical of Denis, four moments in the evolution of one person, four stages of an internal psychological journey. The recurrence of iconographic motifs, the intentionally tenuous boundary between the sacred and the profane (here given added metaphorical resonance by what the artist himself called an "embroidery of arabesques"), thus constitute the limits of a sentient universe in which his quotidian mythology finds places of anchorage.

G.G.

Illustrated Symbolist Books

GILLES GENTY

Overture

Aside from a few artists' monographs and some big retrospectives like the *Cinquantenaire du symbolisme* at the Bibliothèque nationale in Paris in 1936, illustrated Symbolist books have rarely featured in major exhibitions of fine arts. Indeed, even though the relationship between painting and literature was clearly one of the sources of the Symbolist aesthetic, artists' books attract less attention in retrospectives than works of art did. Although the applied arts of turn-of-the-century Hungary and Russia are fairly well known nowadays, we are still regrettably ill informed about the production runs of illustrated books published in Prague and Budapest. The definition of what constitutes an illustrated Symbolist book is not altogether obvious, beginning with the subject itself, which is elusive. What are, then, its basic attributes? Is it the capacity of the text to embody themes dear to international Symbolism – Mallarmé's *L'Après-midi d'un faune* (1876), illustrated by Manet, is one of the masterpieces of the genre – or is it rather the quality of the illustrations that adorn it? It would be useful to define a "Symbolist style", which is just what seems impossible to pinpoint in the realm of painting. It also seems difficult to assign the production of Symbolist books to an exact time period or to specific places. In England and France, the movement sprang up in 1865-1870; in Italy, Russia and across Eastern Europe, Symbolist books continued to be published until World War I.

The reservations artists felt about book illustration seem to have proved insurmountable for some of them. Gauguin, in his manuscript *Noa Noa*, declares it is impossible to render a text in images, while Rachilde and especially Mallarmé wrote of their dream of ideal illustrations, the perfection of which could only be a *cosa mentale*, a figment of the imagination. As in stage productions (soon to be the subject of much theoretical discussion), the manuscript itself must strive towards the "total work of art". But although Mallarmé, in "Quant au livre. Le livre comme instrument spirituel" (*Divagations*, 1897), defined the page as a "miniature tomb for the soul", he went on immediately to say,

> The paper intervenes every time an image, of itself, ends or retreats, giving way to others, and since, as always, it is not a question of regularly sounding lines or verses but rather of prismatic subdivisions of the *Idea*, of the instant in which they appear and the duration of their effect, in whatever conceptual scenario, the text must, for reasons of verisimilitude, appear in varying places in relation to the implicit thread of the discourse.[1]

Aside from any visual paraphrasing, it is primarily the scansion of the printed phrase that, in its alternating presence and absence, opens the gateway to the dream. Seen from this viewpoint, Mallarmé's "Un Coup de dés", with its typographical experiments heralding both Apollinaire's *Calligrammes* and simultaneous poetry, seems a work complete in its kind. The poet nevertheless agreed to Odilon Redon's illustrating the collection with a few lithographs to echo the soul's breathing. Despite meticulous preparations (attested to by the correspondence between poet and painter as to the choice and tint of paper), Mallarmé's death in 1898 put an end to the plans of the publisher Ambroise Vollard. This was the second such cancellation: in 1888, a collection of Mallarmé's *Poésies* was to have been published by Deman with illustrations by Degas, Manet, Renoir, Berthe Morisot and John Lewis Brown. It was becoming apparent that any renewal of art books would have to come from practitioners rather than theoreticians.

1. "Letter to André Gide", *Mallarmé. Œuvres complètes* (Paris: Gallimard/La Pléiade, 1945), p. 1582. On this point, see also Jean-Pierre Bobillot, "Du visual au littéral : quelques propositions", *Poésure et peintrie*, exhib. cat. Marseilles, Centre de la Vieille Charité, February 12-May 23, 1993 (Paris: Réunion des musées nationaux, 1993).

Towards a Renewal of the Art Book

The discussions about technique that began in about 1875 to 1880 were only the tip of the iceberg: what lay beneath was a more serious reappraisal of how to renew the means of expression. The in-text images of illustrators such as Lhermitte, Loir, Lalauze and Flameng, with their long visual paraphrases that rarely rise above the purely descriptive, are tedious.[2] Although there were those who rejected everything but woodcuts, an increasing number of book lovers, soon with the support of innumerable bibliophilist associations, were prepared to countenance other techniques.[3] While Félix Bracquemond, prime mover in the Society of Etchers, and Lesclide, director of *Paris à l'eau-forte*, defended the etching, and Édouard Pelletan, author of the famous essay "Le Livre", advocated xylography, others looked to the lithograph. The same passionate partisanship was displayed in the many flourishing publications devoted to the arts and literature. Some, like *Le Livre* (1880-1889) and *Le Livre et l'Image* (1893-1894), were the forum for the main theoretical debates, while others, such as *La Plume*, *La Revue blanche*, *Le Mercure de France* and *L'Ymagier*, established their own publishing companies where they employed avant-garde artists.[4]

There was a clear need for artists to change the old, too formal relationship between text and image. *L'Après-midi d'un faune*, a work not unconnected with the Symbolist movement, served here too as a manifesto. Published by Alphonse Derenne after being turned down in a rude and almost insulting manner by Alphonse Lemerre, the Parnassians' publisher, this book, in an unprecedented manner, makes the image independent of the text. Like Mallarmé's verses, which flit about the wide-margined page, Manet's illustrations interrupt the justification of the text and seem like annotations. The fauns and butterflies, sketched in swift lines, seem to be lifted by a continual wind and to glow with joy in a rosy mist.

At about the same time, Henri Fantin-Latour's illustrations for *Richard Wagner, sa vie et ses œuvres* (1886) use the same method of gradually "de-realizing" the image. The fourteen original lithographs on the main themes of Wagner's operas present figures looming out of an undefined, endless space that seems carved out of some murkily smouldering material. To achieve an effect something like his paintings, executed in a series of delicate interlaced strokes, Fantin-Latour's lithographs are incised with a drypoint at the end of the process, thereby accentuating their dreamlike dimension. It was at much the same time that the series of plates created by the German painter Max Klinger to illustrate an edition of Apuleius's *Cupid and Psyche* published in Munich in 1881 might have been taken for late-Romantic in style were it not for the strange heads peeping out of the flower-strewn frames. One of Symbolism's most original traits undoubtedly lay in this adherence to a traditional iconography, which artists attempted rather to use for different purposes than to impoverish it.

The Pre-Raphaelites and the Art Book

The earliest large-scale ventures in this area were initiated in the English-speaking countries. In England, the bond between the writers and the painters of the Pre-Raphaelite Brotherhood provided fertile ground. The subjects tackled by Dante Gabriel Rossetti, Holman Hunt and Burne-Jones, chosen from Gaelic legend and Greek mythology and handled with a commitment to suggestion and symbolism in art, were ideal material for unbridled imaginations. The illustration became almost naturally the place where concepts could be ideally incarnated in images, while the literary connotations

2. For a global view of the illustrated book, the best sources are François Chapon, *Le Peintre et le Livre. L'âge d'or du livre illustrée en France 1870-1970* (Paris: Flammarion, 1987); Gordon N. Ray, *The Art of the French Illustrated Book, 1700 to 1914* (New York: The Pierpont Morgan Library/Dover Publications, 1982, reissued 1986); and Gordon N. Ray, *From Manet to Hockney: Modern Artists' Illustrated Books* (London: Victoria and Albert Museum, 1985), 379 pp. More recently Giovanni Fanelli and Ezio Godoli, *Dizionario degli illustratori simbolisti e Art nouveau* (Florence: Cantini, 1990), 2 vols. in quarto, each 302 pp., undoubtedly one of the most important collections of images we have to date.

3. The publication and distribution of works of art were partly guaranteed by the innumerable associations of bibliophiles, including Les Bibliophiles contemporains (1889), Les Cent Bibliophiles (1895) and Les XX (1897). See, among others, Ray 1982, p. 373.

4. Édouard Pelletan, *Le Livre*, followed by the *Catalogue des éditions É. Pelletan* (Paris: É. Pelletan, 1896), in which he advocates a return to the technique of the woodcut, made easier at the time by the use of longitudinal-cut pearwood instead of transverse-cut box. Pelletan's literary and artistic tastes were highly eclectic; among the books he published in 1902 was *Five Poems* by Victor Hugo with illustrations and ornamentation by Eugène Carrière, Willette, Rodin and Steinlen engraved on wood by Frédéric Florian. A monthly magazine that appeared in one hundred and twenty issues between 1880 and 1889, *Le Livre* contained articles on both early and modern bibliography, along with many lithographs. Octave Uzanne, *L'Art dans la décoration externe des livres en France et à l'étranger...* (Paris: Société française d'édition d'art/L.-Henry May, 1898).

in the titles of most easel paintings show how ill defined was the boundary between the visual domain and that of literature. In the illustrations to Tennyson's *Poems* in 1857, executed by Mulready, Creswick, Rossetti, Millais and Hunt, we find figures imprisoned in magic circles and imaginary views seen through improbable oculi, further indications that this is a world ruled over by dreams. The early experimentation had ended, and numerous programmes for reviving the art of book illustration were now ripe. *The Germ*, a periodical published after 1850 by the Pre-Raphaelite Brotherhood, reiterated their wish to link painting and writing, and in 1884, Arthur H. Mackmurdo (1851-1942) launched *The Hobby Horse*, a magazine whose medieval revival typography heralded William Morris's innovations in that field. Mackmurdo even casually reuses a flower motif from the back of one of his chairs for the cover illustration of *Wren's City Churches*.

Morris had indeed been interested in old books for many years. In 1850, he began to copy out Gothic manuscripts and also Renaissance books, captivated by their calligraphy. His meeting the Covent Garden publisher and bookseller Frederick Startridge Ellis (1830-1901) in about 1864 was fundamental in this respect. From Ellis, who was to become manager of the Kelmscott Press, Morris acquired many illustrated manuscripts and incunabula.[5] Similarly, it was after attending a lecture on the history of books given in November 1888 by the self-taught printer Emery Walker that he decided to invite the latter to be his partner in founding a new publishing house, the Kelmscott Press. They began with fifteen employees in a house in Hammersmith. As a leader of the arts and crafts movement, Morris was inspired by his knowledge of old books to use traditional techniques. The typefaces he chose were directly inspired by his collection of incunabula, while Emery Walker helped him use photographic enlargements to copy the fonts and typography of the Renaissance (one of these, "Chaucer", became the Kelmscott Press's best-known font).[6] In October of 1890, Walker introduced Morris to Joseph Batchelor, a paper manufacturer, who provided him with stock modelled on fifteenth-century Italian watermarked paper. While the paper and typography for each book were selected with extraordinary care, the Kelmscott craftsmen were apparently less concerned about bindings. These, made by the London company of J. & J. Leighton, were either half-cloth or full vellum held shut by silk cords rather like the style used for *L'Après-midi d'un faune*. The activities of the publishing house and the expansion of Morris's own collection became increasingly inseparable.

The task of creating these editions, however, often proved too onerous because of Morris's perfectionist tendencies. The planned edition of *Jason*, which was to contain almost five hundred woodcuts, was finally cancelled after he had completed only about forty plates. Similarly, the projected edition of the *Aeneid* had to be abandoned in 1875 after Morris and Burne-Jones had worked on it for over two years. Both men were less concerned with imitating the styles of the past or aping times gone by than with re-creating the rhythmic sequences of early books. Thus, for ***The Works of Geoffrey Chaucer*** (1896), Burne-Jones's illustrations are set inside bowers of foliage that seem to hold in their depths the meaning of the scene. As Delevoy explains, this is a deliberate strategy of the image in situ.[7] Burne-Jones's compositions, bounded by an impenetrable border of flowers, were not intended to present any particular episode from the text they accompany: the knights who slip quietly into walled gardens, or seem transfixed by the huge, unreal architecture around them, become ideal embodiments of an existential anguish for which the medieval legends furnish simply the motivating events. The Pre-Raphaelites' output, widely disseminated by magazines (see Édouard Rod's long article in *La Gazette des beaux-arts* in 1887), soon brought about a full-fledged medieval revival. In France, Alfred Jarry and Remy de Gourmont (who worked at the Bibliothèque nationale) published in the magazine *L'Ymagier* between October 1894 and December 1896 a mélange of prints by Émile Bernard and fifteenth-century woodcuts and, to illustrate Rutebeuf's

514

5. William Morris's library, which in 1876 contained almost three hundred early books together with thirteen incunabula and six manuscripts, grew to eight hundred ancient works and about a hundred manuscripts, as the various sales catalogues of his collection show. He had on occasion to get rid of part of his library, either to keep his company solvent or to fund the cause of socialism. Morris spent considerable sums to build up his collection: for example, in 1894 he spent £800 on the Huntingfield Psalter and £900 on the Tiptoft Missal. On his death in 1896 his library was purchased for £18,000 by a collector who promptly resold part of it to Sotheby's. The collection was finally acquired by the Pierpont Morgan Library.

6. It was at this time that the fourteen-point "Golden" was created, based on Nicolas Jensen's Italian edition of Pliny (1476) and also on the *Historia Fiorentina Populi* printed by Jacobus Rubens, of which Morris owned copies (see *The Earthly Paradise: The Art and Craftsmanship of William Morris and His Followers in Canadian Collections* [Toronto: Art Gallery of Ontario, 1993], p. 254). The other type designed by Morris, "Troy", more Gothic in inspiration and generally used as an eighteen point, became "Chaucer" when reduced to twelve points.

7. Robert L. Delevoy, *Journal du symbolisme* (Geneva: Skira, 1977).

Miracle de Théophile in 1896, reworked occult medieval woodcuts. When in 1898 the Kelmscott Press suspended operations after the death of its founder, the writer and architect Charles Robert Ashbee (1863-1942), who in about 1890 had set up an association of craftsmen called the Guild of Handicraft, bought the firm's assets from Morris's heirs. Bringing together some of Morris's old colleagues, he established the Essex House Press and continued publication for a while. However, the real successors to the Kelmscott Press turned out unexpectedly to be Lucien Pissarro at the Eragny Press and Belgian artists such as Charles Doudelet and George Minne.

The Space of Dreams

Fernand Khnopff's illustrations, less well-known than the Kelmscott Press's images, offer a gentler version of the Pre-Raphaelite heritage. The silent girls, seemingly prone to fits of abstraction, who appear in his frontispieces to works by Villiers de L'Isle-Adam and to Grégoire Le Roy's ***Mon cœur pleure d'autrefois*** (1889) look much more like sisters of Botticelli's models than like Beardsley's castrating women. But Khnopff's deliberately hieratic, distant female figures are still evocations of a painful awareness of the world, like the mirror that repeats the face in the frontispiece for Le Roy's book and especially the surging, disturbed sensuality, strongly sexual in connotation, of the lithographs for Joséphin Péladan. It is noteworthy that these gusts of violent emotion appeared only in his work as an illustrator, as though, parallel with his search for *l'azur*, for a translucent sensuality, seen in works like his *Du silence* (1890), only the written word could provide a motive for such intimate outbursts. Thus, his frontispiece for Péladan's *Istar* (1888) shows lascivious women offering themselves to a corpse-like Gorgon's head, heralding the shameless male nude in the pastel *Déchéance* (about 1914).

8. Jean-Paul Bouillon, ed., *Le Ciel et l'Arcadie* (Paris: Hermann, 1993), p. 18. For further information on Denis and the illustrated book, see also *Maurice Denis*, exhib. cat. (Lyons, Cologne, Liverpool and Amsterdam, September 1994-September 1995), cats. 282-300; *Maurice Denis illustrateur*, exhib. cat. (Granville: Musée Richard Anacréon, June-September 1994); and *Maurice Denis illustrateur* exhib. cat. (Tours: Musée des Beaux-Arts, June 25-October 1, 1966).
9. Vollard reports having met Denis about 1893 when the latter, attracted by an exhibition of Manet's drawings Vollard was mounting, invited his Nabi friends to come and meet the art dealer. See Ambroise Vollard, *Souvenirs d'un marchand de tableaux* (Paris: Albin Michel, 1937), p. 236.

Meanwhile, Maurice Denis had set about formulating a theory for this renewal of the arts. In his *Définition du néo-traditionnisme* (August 30, 1890), published under the pseudonym Pierre Louis, the "Nabi of the beautiful icons" declared, a few pages after his famous aphorism on painting:

When the plastic arts come to grips with literature, monstrous things appear in books. I dream of old missals with their harmonious borders, of the sumptuous lettering in graduals, of the earliest woodcuts – which echo the complexity of our literature in their mannered style and refinements. But illustration is decorating a book! Instead, one finds: 1. Black squares looking like photographs placed either in the spaces or over the print; 2. Naturalist cutouts sprinkled at random throughout the text; and 3. More cutouts, insufficiently researched, mere sleight of hand, sometimes (aha!) presented as a Japanese influence. The aim should be decoration that does not slavishly adhere to the text, that does not oblige the image to correspond exactly to the written word, but rather creates a web of arabesques on the page, an accompaniment of expressive lines. In Maurice Denis's illustrations for Verlaine's *Sagesse*, we see how intensely expressive is the drawing of shapes and marks – and also how ineffectual are the images in which the literary element creates disharmony.[8]

The quest for purity that lay behind all Denis's work since his early years as a Nabi found ideal fulfilment in book illustration. While in his paintings it showed itself in an accumulation of pictorial material, formed by progressive layers, pools of bubbling pigment, on the printed page this yearning after purity is fulfilled in the paper left blank. What in his easel painting renders space opaque and plays on texture becomes in his prints and book plates an interaction with the site of the image, which seems, in his elegant use of the white space, to lie both on this side of the paper's surface and beyond it. Thus, in *La Demoiselle élue* (1893) and in the ornamentation Denis produced for Mallarmé's poem "Petit Air", the female figures when engraved rise up like silhouettes in a setting that allows them no spatial depth. Denis's young women, escapees from voiceless processions, seem, like those created by the Hungarian Nabi József Rippl-Rónai for Georges Rodenbach's *Les Vierges* (1895), as though clinging to a space with no substance, like the incarnations of a dream. In Verlaine's ***Sagesse*** (1889), published later by Ambroise Vollard,[9] his tightly orchestrated friezes with their almost

aggressive gestural quality alternate with small illustrations in which appear pale figures, left blank, with vague eyes. The illustrations engraved by the Beltrand brothers for this edition were coloured some in cool tones and others in warmer hues to correspond with the poet's changing moods.

The William Morris Influence in Belgium

The publication of illustrated books in Belgium was closely linked to the influence of publications like *La Jeune Belgique* and also to friendships between poets and publishers who believed in the new aesthetics. The firm of Paul Lacomblez in Brussels employed Albert Giraud, Fernand Séverin, Max Elskamp, Émile Verhaeren, Max Waller and Valère Gille, while Edmond Deman brought to his bookshop (as did his wife in her reading room at *La Lecture universelle*), his old comrades from the University of Louvain. Works by Giraud, Verhaeren and Iwan Gilkin soon amounted to a reading room full of publications of deluxe quality by any standards. Verhaeren's first small volumes, printed in limited editions, *Les Soirs* (1887), *Les Débâcles* (1888) and *Les Flambeaux noirs* (1889), opened with a frontispiece by Odilon Redon followed by pages decorated with Fernand Khnopff's arabesques, full of nervous energy.[10] The influence of Morris's work was associated with a very clear social commitment that was shared by the owner of the Kelmscott Press. Charles Doudelet (1861-1938), from Ghent, was at the time, along with George Minne (1866-1941), the artist most closely identified with this kind of work. To illustrate Maeterlinck's *Douze Chansons* (1896), he used woodcuts, the medium so dear to the Pre-Raphaelites, which offers strong contrasts of light and dark. The binary rhythm of the book (the poems appear opposite the plates) suggests an interplay of visual echoes between text and illustrations. But the energy in Doudelet's medievalist scenes is basically centripetal, with the images turned in upon themselves. The figures are prisoners of the settings they wander in, while those settings, etched in small directional grooves, of themselves embody the psychological imprisonment of the protagonists. The tiled floor, used later by Bilibine in his opera sets, provides a way of accelerating perspective and disorienting convergences of lines.

At times, the mere interplay of arabesques is sufficient to give the text a symbolic dimension, as Mallarmé noted in regard to Max Elskamp's *En symbole vers l'apostolat* (1895): "Dear poet, yours is the most transparent soul I know, and on this clear glass is found, in the plates for *En symbole vers l'apostolat*, something other than excuses for colour or a superficial shimmer . . . Few illustrations have so impressed me with their vigour and simplicity."[11] This was an application to art of the phenomenon of the "symbolic sympathy" of line, found in Van de Velde's decorative work for Max Elskamp's *Dominical* (1892) and also in Théo Van Rysselberghe's abstract arabesques for Villiers de L'Isle-Adam's *Histoires souveraines* (1899).

Odilon Redon and Félicien Rops

Odilon Redon's approach to illustrating texts was typical of Symbolist storytelling. When in 1886 the publisher-writer Edmond Picard (1836-1924) sent him, via Octave Maus, the manuscript of *Le Juré*, the painter began by selecting passages or even just words of which a visual paraphrase could be made.[12] Redon's images, which sprang from "an attraction to the indeterminate", went entirely beyond anecdotal illustration to become condensed forms of an imagination that can burgeon from a single word. It is as though these drawings represented the final metamorphosis in a whole series of visual and semantic shifts. The author also supported the painter's freedom of interpretation and included him in the work's destiny. When in February 1887 the monodrama was read aloud at the Cercle des XX, Redon's sketches were hung for the audience to see. This occasion soon brought the artist more commissions, notably one in 1888 from the publisher Edmond Deman (1857-1918) to illustrate the poems by Verhaeren and Gilkin already mentioned. Here, too, Redon's approach is indirect, the appearance and disappearance of his phantom figures becoming metaphors for gentle

10. For an overall view, see the fully researched article by Jane Block, "Book Design among the Vingtistes: The Work of Lemmen, Van de Velde and Van Rysselberghe at the Fin-de-siècle", in *Les XX and the Belgian Avant-garde: Prints, Drawings and Books, ca. 1890*, exhib. cat. (Lawrence, Kansas: Spencer Museum of Art, 1993), pp. 98-125.
11. Quoted in *Les Peintres de l'imaginaire*, exhib. cat. (Paris: Grand Palais, 1972), p. 191.
12. On these questions, see the remarkable work of Dario Gamboni, *La Plume et le Pinceau. Odilon Redon et la littérature* (Paris: Minuit, 1989), especially the chapter entitled "Illustrations, «interprétations» et avatars de la référence littéraire", pp. 178-189.

frissons of the senses. Hence the need for these images to be confined to the paper's surface in very specific places; they are independent worlds, unsoundable chasms that impose a limit, a concrete finality within which the meaning is found.

Félicien Rops's claim to paint like Redon seems in retrospect ingenuous. When he learned that Deman had commissioned Redon to illustrate Baudelaire, he wrote to the publisher,

> Ah! And the Baudelaire. I read in *La Jeune Belgique* that it's Odilon Redon who's doing it. Enlighten me in this respect, if you please. I have no wish to take the task away from a good man. I will do my own illustrations of Baudelaire for myself, that's all, and it may be suitable for your edition. I like our good Redon's spatter-work enough to want him for a neighbour.[13]

Although Rops took as many liberties with the texts he illustrated as Redon did – as is apparent from the many plates he executed for scandalous eighteenth-century novels – he nevertheless continued to be primarily a literal illustrator. Beyond any ambiguity of meaning, his sulphurous compositions, of a macabre eroticism, are still closely linked to the narrative, hence perhaps their capacity to stand alone, to be easily moved among texts whose survival they frequently guaranteed.

Existential Terror and Exuberant Writing: The Ambivalence of Eros and Thanatos

In Maurice Denis's illustrations to André Gide's *Voyage d'Urien* (1893) (the artist suggested to Bailly, the publisher, that it should be entitled "Voyage to the Malevolent Isles"), the line is looser, the silhouettes less defined, while the outlines of the figures seem to be corroding, irredeemably crumbling as if beneath the weight of an unbearable revelation, an irresistible surge of desire. The suggestive sensuality of Gide's prose is rendered by Denis in figures dropping with weariness, obliterating themselves against the lower edge of the frame, like the people in Edvard Munch's *Melancholies*, which were later reworked in unexpected

13. Quoted by Francine-Claire Legrand, "Rops et Baudelaire", *La Gazette des beaux-arts*, no. 2 (1986), pp. 191-200.

manner by Picasso in his frontispiece to Paul Eluard's *Balcon*. Denis's numerous sketches for *Urien*, almost all different, like so many psychological variations, show how little distance the artist wanted to allow between apprehending the feeling and capturing the image. He had to work fast so as to follow more closely the soul's impulses.

Unlike Denis's always rather restrained illustrations, Aubrey Beardsley's creations were the deliberate product of the more extreme forms of the Symbolist sensibility. While his illustrations for the **Morte d'Arthur** follow the Kelmscott Press house style, the drawings he submitted for Wilde's *Salomé* have a whiff of brimstone about them. The dandyism of his page layouts for the periodicals *The Yellow Book* (1894) and *The Savoy* (1895) has developed into an insistence on the decadent. His drawings, transferred on to japan paper by a photomechanical process to imitate woodcuts, avoid the merely decorative. Salomé's gown ends in an elegant swirl of Japanese inspiration, and this arabesque is echoed a few pages further on in the blood streaming from the martyr's head on the upraised platter. The exquisitely serpentine lines here hint at a hyper-stimulated sexuality, as do the intricate networks of arabesques in the work of the Dutch painter Jan Toorop (1858-1928).

Henri Caruchet, Carlos Schwabe, Georges de Feure: The Arabesque of Delight, the Tangle of Hysteria

The penchant of fin-de-siècle illustrators for the aesthetic experimentation of Art Nouveau is understandable given the expressive power of the Japanese-style arabesques that proliferated in turn-of-the-century Europe. In Henri Caruchet's illustrations to Octave Uzanne's *Voyage autour de sa chambre* (1896) and Jean Richepin's *Litanies de la mer* (1903), the etched Symbolist motifs end in elegant serpentine lines highlighted in watercolour and gouache. Where Huysmans's inner sanctuaries had the tragic dimension of an exile essential to continued existence, the kind of sanctum depicted by Caruchet is elegant and refined, like a priceless gem-encrusted coffer. From the work of Alexandre Lunois, Eugène Courboin and Léon Rudnicki, illustrators for Edmond Haraucourt's *L'Effort* (1894), to that of Eastern European artists, many new books contained texts inspired by Symbolism and illustrations taken from the formal language

46

372-386

of European Art Nouveau. Hungarian art books, especially *Elek Költemenyei* (1903) illustrated by Aladar Körösföi and Sandor Nagy, as well as the many ex libris designs of Béla Uitz, bring to the delight in detail and the Japanese-style motifs of Caruchet, Gaston Bussière and particularly Eugène Grasset their own folk traditions.[14]

When we look at the work of Maurice Denis and Fernand Khnopff, it is apparent that it was rather the influence of European Art Nouveau that marked the Swiss painter Carlos Schwabe (1866-1926) and the Flemish painter Georges de Feure (1869-1943). Schwabe's illustration for *The Gospel of the Childhood of Our Lord Jesus Christ* (1894) is a good example. After having this work published in instalments between 1891 and 1894 in Ludovic Baschet's *Revue illustrée*, Schwabe undertook along with Armand Colin to put out a luxury edition for collectors. The illustrations, meticulously realistic, are surrounded by an ornamental border of flower motifs alternating with geometric shapes repeated to infinity. These compositions, of remarkable graphic delicacy and detail, can only be deciphered gradually by the spectator. The historical references adduced by Octave Uzanne to explain Schwabe's style suggest the same reading:

> Thus it is that the frontispiece of this book bears a strange etching by Paul Avril, after an orchidlike stained glass creation by an artist of rare originality, Carloz [*sic*] Schwabe; – there will be great debate over the significance of these ten-headed women and the Byzantine mysticity of this symbolic production, but no sensitive person could in good faith say that this is commonplace, unimaginative work.[15]

The reasons for Schwabe's success at the 1892 Salon de la Rose + Croix had to do with more than just the esoteric content of his work. In his insistence on enclosing his hieratically posed figures within networks of interlacing lines, the artist achieved an almost ideal example of a codified art, basically literary in inspiration, of the sort advocated by Sâr Péladan in his mystifying little publications. This ambiguity of a highly ornamental art with a deliberately mystical content is found again in his plates for Zola's *Le Rêve* (1892).[16] With the help of the illustrator Lucien Métivet,[17] Schwabe produced for this book many illustrations, borders and tailpieces that at times display a certain morbidity of theme. Schwabe's female

figures, distant cousins of the Pre-Raphaelite ladies and depicted in exquisite detail, are clearly the expression of an eroticism both restrained and explosive, a controlled hysteria. Interestingly, the same visual schemas occur in the early work of Frances Macdonald-MacNair of the Glasgow Four, disciples of Charles Rennie Mackintosh. But while in Munch's work, the surge of desire is expressed in overwhelming terms, here it shows itself in an aesthetics of retreat, where the delight in detail is almost neurotic. Even more complex in their ambivalence are the illustrations executed by de Feure for books and periodicals.

Art Nouveau's use of endlessly multiplied arabesques, as in the architecture of Jules Lavirotte, is then of its very nature erotic. For the triptych he created as the frontispiece to *La Porte des Rêves* (1899), de Feure experimented with massing figures together, with tangled lines that interweave almost so as to obscure the subject itself. This style, with its overloaded graphics – even more pronounced when transferred into a mosaic of bright colours – is close to that of Mucha, with its pompous forms; but although the turgidity of ornament is the same, de Feure's arabesques are still well to the Symbolist side of Art Nouveau. The absence of empty space, the use of sometimes acid harmonies of colour, pertain to a truly Mannerist *horror vacui*, a hysterical need for filling in, for piling up line and detail, a characteristic found at about the same time in the grand educational compositions of the painter Charles Maurin. De Feure's interlacing lines stand midway between expressive outpouring and ornamental distancing.

G. G.

14. Aladar Körösföi began as a historical painter, and in 1901 with Sandor Nagy founded an artists' colony at Gödöllö in which the Pre-Raphaelite influence combined with that of Hungarian folk art; on this point, see *L'Art 1900 en Hongrie*, exhib. cat. Paris, Petit Palais, December 1976-February 1977 (Paris: Réunion des musées nationaux, 1976).

15. Octave Uzanne, *L'Art et l'Idée* (1892), vol. 1, p. 10. Carlos Schwabe, the subject of several articles in the magazine, contributed, besides a frontispiece etching highlighted in watercolour, an illustration for the title page. The magazine used as illustrators at various times Félix Vallotton, Carlos Schwabe, Louis Morin, Félicien Rops, Alexandre Séon and Albert Robida; its subtitle was "Literary dilettantism and curiosity".

16. On this point, see Jean-David Jumeau-Lafond, "Carloz Schwabe, illustrateur symboliste du *Rêve* de Zola", *Revue du Louvre*, no. 5/6 (1987), pp. 410-419.

17. Painter, draftsman and cartoonist, Lucien-Marie-François Métivet (1863-1930) is famous for having beaten Toulouse-Lautrec in the 1895 competition to design the poster for the launching of Sloane's *Napoleon*.

VI. *Towards Regeneration*

CONSTANCE NAUBERT-RISER

Here we reach the final stage in a presentation whose main goal has been to explore the various components of the Symbolist episteme. In spite of an obvious lack of any stylistic or formal unity and the frequent use of a traditional iconography dating back centuries, the works in this exhibition offer, as a whole, a clear picture of the scale of the crisis assailing Western culture at the close of the last century. With image after image, a fundamentally philosophical question seems to recur, implicit but insistent, forming the core of a widely propounded discourse that was haunted by the spectre of fin-de-siècle decadence. In 1898, in a crisis of despair, Gauguin asked this question openly in the title of his great Tahitian painting *Where Do We Come From? What Are We? Where Are We Going?* It is a question that reflects the pessimism and deep anxiety sparked by the spread of Darwin's theories of natural selection.[1] Could it be that man, seen within Christian doctrine as lord of all created things, was actually an inferior and entirely determined being, subject to the mindless laws of evolution in the same way the natural world (over which he had hitherto imagined himself sovereign) was?

In light of the destabilizing effects of this new uncertainty, which prompted an extraordinarily broad range of introspections, searches for true identity and escapes into a

1. Charles Darwin, *On the Origin of Species by Means of Natural Selection*, 1859, and *The Descent of Man and Selection in Relation to Sex*, 1871.

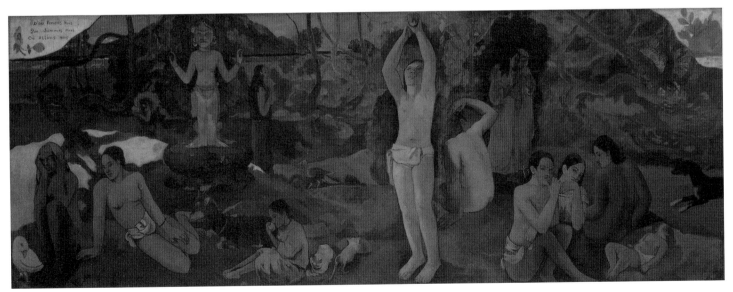

Paul GAUGUIN
Where Do We Come From? What Are We? Where Are We Going?, 1897-1898
Museum of Fine Arts, Boston

reinstated iconography of dreams – the impulse to find a way out of disillusionment was felt with increasing acuteness. Man was once again in need of salvation, and the artistic realm, under the impact of the spread of Nietzsche's writings, was selected as the ideal field for the redirection of the individual. The artist, able to convey in images the proclamation of a major spiritual shift, was henceforth required to provide ways of avoiding the inevitable "degeneration" of the peoples of Europe predicted in a much-read piece of pseudo-science published by Max Nordau in 1892.[2] But not until the posthumous publication of Nietzsche's *Will to Power*, in 1901, did it really become clear that the best alternative to decline was "the overcoming of man": "If man has turned out a failure . . . Well! Let's move on!" Zarathustra exclaims. There was a definite swing, in other words, towards optimism.[3]

Arcady and Paradise

Retrospective study reveals signs of this return to optimism in the art produced during the last decade of the nineteenth century. Drawing upon an allegorical repertoire well known to the intellectual elite, a number of artists, although previously recognized for the modernity of their formal investigations, turned back to the ancient pagan myth of peaceful harmony between man and nature in an attempt to counter the destructive effects of the Industrial Age and the disequilibrium it provoked. They reminded man that the history of the world began in Arcadia, ideal country of a Golden Age. The horizontally thematic approach of this exhibition enables a comparison of some of the more successful examples of this recourse to classical humanism as an antidote to the prevailing pessimism.

The mature work of the German painter Hans von Marées (1837-1887), who settled in Rome in 1875, was an attempt to present the classical view of happiness in a new way by reinvoking the significance of themes like the Golden Age and the Hesperides. The latter are the subject of a large triptych exhibited in a posthumous retrospective of this artist's work in Munich in 1891. Using an extremely inventive approach that fused classical detachment with an almost Mannerist elongation of the figures, Marées infused his works with a highly personal vision of an idyllic bygone era, whose lost unity had to be recovered at all costs. The image he often used of figures grouped beneath orange trees is a reference to the golden apples protected by the Hesperides in the garden of the gods. An idealized picture of eternal youth, abundance, peace and serenity was thus evoked in denunciation of an industrial society that had forfeited the vital link with nature.

Because of his figures' measured gestures and the contemplative mood created by his decorative compositions, Marées is often compared to Pierre Puvis de Chavannes (1824-1898). Puvis, who made frequent allusion to the Sacred Grove and the Land of Tenderness, was clearly perceived by the younger generation of his day as the artist who best succeeded in promoting the classical Arcadian vision in an innovative way. In an idyllic landscape

521

522

2. The book, influenced by Darwin's theories, appeared initially in German (*Entartung*); it was translated into French in 1894 and into English the following year. Its title, *Degeneration*, evokes the notion of irreversible decline.

3. The impact of Nietzschean thought, the source of the developing ideology of the New Man, started to make itself felt during the 1890s. The range of its influence is worth noting, for it went far beyond the boundaries of the Germanic countries. In France – to mention this country alone – it is significant that the philosophy was disseminated by the new Symbolist journals. In 1892, excerpts from *Zarathustra* appeared in translation in *La Revue blanche*. At the start of 1893, Henri Mazel, editor of *L'Ermitage*, summed up its importance: "If philosophical products contain, like organic ones, an active principle, Nietzschean philosophy may be one of the most powerful agents of social therapy, simultaneously dangerous and beneficial. Our era has need of it, and in drastic doses." Henri Mazel, "Nietzsche et le présent", *L'Ermitage*, no. 2 (February 1893), p. 81. This view was echoed in publications of wider circulation like *Le Mercure de France* and *La Revue des Deux Mondes*.

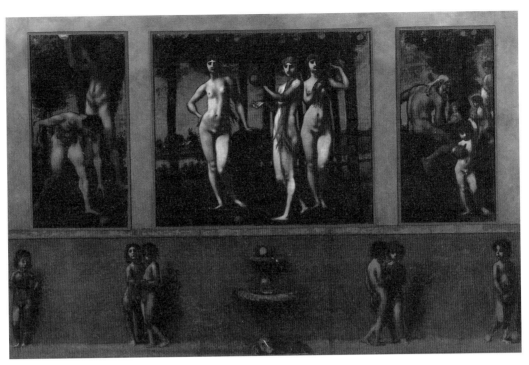

Hans VON MARÉES
The Hesperides (triptych, centre panel), 1884-1885
Munich, Neue Pinakothek

punctuated by clumps of fruit trees whose tops interweave to form a bower, he uses allegory to present an original and enigmatic meditation on the complex relations that exist ***Inter artes et naturam***. Exhibited at the Salon du Champ-de-Mars in 1890, in the atmosphere of instability and confrontation that reigned following the Salon's split into two rival associations, this central panel of an ensemble designed for the Musée de Rouen skilfully groups classically draped female figures and several sketchers wearing modern country costume. Aside from embodying specific references to the building for which it was intended, this monumental composition shows evidence of the need – seen by this artist as more relevant than ever – for the elaboration of an idealized vision of nature. 516

Symbolist painting, which encouraged a turning away from the world of sensory appearance in favour of a contemplation of the meaning of life, also drew part of its message from Christian iconography. As the painting by Franz von Stuck (1863-1928) entitled ***The Lost Paradise*** recalls, Original Sin caused man to fall from grace and forfeit the noble state of primeval innocence celebrated in ancient Greece. A first-level reading shows us Adam and Eve "leaving" the painting, banished from a Garden of Eden now guarded by an angel bearing a flaming sword, who bars the way to the Tree of Life. As a direct result of this expulsion from Paradise, an idyllic place where he was spared harsh agricultural labour, man was now forced to win back his initial state of perfection by tilling the soil. Here, the Symbolist painter makes a direct reference to Old Testament imagery. And from the eternal springtime of paradise on earth, it is a short remove to a characteristically Christian meditation on the passage of time. 523
525

Among works aimed at prompting a meditation on human destiny are those that focus on the expiration of time, such as the different stages of life or the cycle of the seasons, and this theme was explored by various members of the Symbolist generation, from Pont-Aven (Émile Bernard's 1891 *The Four Seasons*) to Milan. The preparatory drawings for the triptych *Life, Nature, Death* by Giovanni Segantini (1858-1899) – executed the same year that Gauguin, having fled European civilization, posed his three-pronged question – are a masterful illustration of how a seemingly realistic landscape, like this one of the upper Engadine, where the artist had settled, can embody a hidden message played out on two registers linked by a carved wooden frame. The scenes in the lower section symbolize the perfect harmony of man and nature that can only be achieved through a peasant existence, far from teeming cities. While Gauguin drew upon Tahitian mysteries to imbue his painting with a primitive religiosity, Segantini made use of more classical allegories, which he depicted in the lunulae above the main panels. This upper register loops the iconographical loop: among the allegorical figures representing the elements, the wind, fire and water that preside at birth, can already be seen the personage representing death. The image of a soul being carried skyward by two angels rising above a cold and snowy landscape represents Segantini's answer to Gauguin's question: souls go to Heaven.

In spite of the recurrence of such themes, however, the aim is not to establish links between a series of geographical points, but rather to reveal the configuration of a veritable constellation of artists, all of whom created images that bore the stamp of their native culture. The extraordinary *Day of Judgement* by Gerhard Munthe (1849-1929), theoretician of the decorative arts revival in Norway, presents an original view of Heaven inspired by the medieval sagas of the artist's homeland. Munthe was one of those who, from Paris to Warsaw, advocated a return to spiritualism, borrowing decorative elements from religion to create a picturesque atmosphere that corresponded to the wave of mysticism then rolling across Europe. In the generalized search for new sources of hope, there was a move to transcend the superficial and overly explicit language of Naturalism.

Such sources sometimes took an enigmatic form, as in the linear *Apocalypse* by the Dutch artist Jan Toorop (1858-1928). The drawing's precise meaning remains a mystery in spite of the explanations the artist carefully inscribed near the bottom. This work, whose symbolism is highly personal, was executed in 1892, the same year Toorop exhibited at the first Salon de la Rose + Croix catholique in Paris.[4] Two contorted figures, enclosed in medallions positioned symmetrically at either end of a recumbent body, symbolize the suffering caused by the insurmountable difficulties of life on earth. Death, represented by a tall, lanky figure with closed eyes, delivers souls from their bondage. As these liberated mortals rise up, they gradually dematerialize and blend with the rocky landscape of the background. Undulating sinuously around a valley, the souls create a mysterious and poetic vision of the Beyond, eloquently expressing the religious anxieties experienced by this generation.

4. Organized by the torchbearer of Catholic occultism, Joséphin Péladan, known as the Sâr, and held at the Galerie Durand-Ruel in March 1892, this Salon was in effect the first international Symbolist exhibition.

The Cosmos

Among the wide range of idealist responses to the triumph of Positivism was an extremely important trend rooted in a revival of interest in occultism, which made its appearance in painting towards the end of the last century. The aim of this new spiritualist approach, on a scale quite unsuspected initially, was to push back the narrow boundaries imposed by the sectarian and rigid attitudes of various belief structures. It was an attempt to explore possibilities that might result in a new synthesis, one that would reconstruct the lost unity between man and universe and permit the recentering of the Self. In order to accomplish the huge task of reconciling the opposing forces that science and religion had become, classical iconography had to be rejuvenated and artistic images drawn from areas as yet uncharted, located on the border between objective truth and faith. By the turn of the century, this renewal had become the prerequisite for the development of a modern view of the Cosmos. This exploration of the imaginary was the source of unprecedented combinations of elements capable of translating events occurring in the *Zwischenreich* – the "twilight zone" – and of capturing the mysterious unity between the traditionally divergent realms of earth and sky (Mackintosh's 1892 ***Harvest Moon***, Bílek's 1899 ***Oh Mother!***, Trachsel's 1901 ***Lightning***). In some cases (Kandinsky, Kupka, Mondrian), the new approach became truly iconoclastic and brought painting to the threshold of abstraction.

535

533, 544
547

The pictorial investigations of a number of artists began to converge on the creation of images inspired by a contemplation of the extraordinary unity of the laws governing the internal organization of the universe. Although there were many different routes leading to abstraction, in a number of cases, Theosophy played an important role.[5] In spite of its obscurity, from 1880 on this syncretic doctrine became the object of widespread fascination in Europe, even among those with reservations about its precepts.[6] It resonates through many creative works, moreover, often in unexpected and mysterious ways – as in the late painting by George F. Watts (1817-1904) entitled ***The Sower of the Systems***. The formal methods employed here to render the unity of Creator and Cosmos result in a dissolution of the forms, which fuse together into a dark blue. Nebulous stars and planets stretch out through space, flung by the ellipse-shaped gesture of a whirling figure. This image, which shows the Creator encircled by rings of gold dust, is actually inspired by Madame Blavatsky's "astral man".[7]

541

The influence of Watts's cosmic theme and the aesthetic theories of Ruskin[8] together formed the basis for the work of Gaetano Previati (1852-1920), one of Symbolism's most important Italian representatives. ***The Dance of the Hours*** (about 1899) uses circular forms – the gyratory movement of its flying figures, combined with the circle and the sphere – and an undefined cosmic space to create an allegory on time and space that emphasizes their infinite nature. Previati's highly personal symbolism is expressed here in his use of colour and of the light that gives the painting its golden glow.

66

Explorations into the internal laws of the universe were following a number of paths.

5. Inspired by occultism and various forms of Far Eastern mysticism, this "secret doctrine" owes its spread to Helena Petrovna Blavatsky, who took the major capitals of Europe by storm, setting up branches of the Theosophical Society she had founded in New York in 1875. From Paris to Prague to Amsterdam, she lectured tirelessly until her death in London in 1891. Her ideas, which were taken up by Annie Besant and Charles W. Leadbeater, continued to influence para-religious groups until the 1930s. On the question of the influence of Theosophy and occultism, see *The Spiritual in Art, 1890-1985*, exhib. cat. Los Angeles County Museum of Art (New York: Abbeville Press, 1986).

6. Kupka, Mondrian, Váchal and Van Doesburg were all members of the Society. But various other artists, including Filiger, Sérusier, Toorop, Watts, Trachsel and Munch, were interested in it as a branch of occultism.

7. This has been shown in David Stewart, "Theosophy and Abstraction in the Victorian Era", *Apollo*, vol. 139 (November 1993), pp. 298-302. Stewart found proof in the diary of the artist's wife, Mary Watts, held in the archives of the Watts Gallery in Compton, near Guildford. According to her, Watts became interested in Madame Blavatsky in 1889. And his later work, which deals with great cosmic themes, shows clear evidence of a renewed creative vision.

8. See Gianna Piantoni, "Nota su Gaetano Previati e la cultura simbolista europea", in *Divisionismo italiano*, exhib. cat. (Milan: Electa, 1990), pp. 230-240.

The sacred nature of geometric forms, so long neglected, was rejuvenated in 1910 by Paul Sérusier (1864-1927), a former member of the Nabis. While he was teaching at the Académie Ranson in Paris, his personal investigations led him increasingly towards an expression of that universal harmony rooted in the secret mathematics outlined some years earlier in Édouard Schuré's *Great Initiates*.[9] Although the precise significance of the two landscapes entitled ***The Golden Cylinder*** and ***Tetrahedrons*** may escape us today, the works stand as examples – virtually unique at the time – of an inquiry into the possibilities of using geometric forms as symbols of the universal.[10]

552, 551

Elsewhere, the need to bring the multiplicity of appearances together into one fundamental and united whole found perfect expression in a renewed approach to landscape painting. At the turn of the century, a number of Scandinavian artists, perhaps more open to pantheism, were quick to see nature, permeated with spirituality, as the ideal medium for communicating with the Invisible. They possessed, moreover, another great asset: "The self-confidence of these artists was enhanced by the Theosophical notion that, in the scheme of universal spiritual evolution, it was the Northern countries' turn to show the way: 'Das Licht kommt jetzt vom Norden'."[11]

While retaining references to the natural landscape – whether a Norwegian fjord (Munch, ***Moonlight*** [1895]), a Stockholm night (Jansson, ***Nocturne*** [1901]), a panoramic view of Lake Geneva (Hodler, ***Lake Geneva Seen from Chexbres*** [1908]), or the North Sea[12] – these artists transformed the scene into a Symbolist landscape, imposing an abstract pictorial structure onto the concrete object of their perception. The recurring presence in these works of a flattened oval shape, which accentuates the frontality of the canvas, seems to offer glimpses of the secret order of the universe, situated somewhere beyond the world of

549, 550

548

9. Édouard Schuré, *Les Grands initiés. Esquisse de l'histoire secrète des religions* (Paris: Perrin, 1889).

10. According to Caroline Boyle-Turner, *Paul Sérusier* (Ann Arbor: UMI Research Press, 1983), pp. 135-168, these two paintings may have been executed to illustrate his lectures at the Académie Ranson, where he taught from 1908 to 1912. These lectures, published in 1921 as *A B C de la peinture*, include a section devoted to number and proportion that reeks strongly of Theosophy.

11. Salme Sarajas-Korte, "Divers aspects du Symbolisme scandinave", in *Lumières du Nord*, exhib. cat. (Paris: Musée du Petit Palais, 1987), p. 45.

12. The concurrent presentation of the Mondrian retrospective in The Hague and Washington accounts for the absence from *Lost Paradise* of the 1909 and 1914 seascapes illustrated here.

Piet MONDRIAN
Sea at Sunset, 1909
The Hague, Gemeentemuseum

Piet MONDRIAN
Sea (Pier and Ocean), 1914
The Hague, Gemeentemuseum

appearances. With the gradual suppression of anecdotal detail, the overall organization of the surface began to predominate over any reference to a specific place. The motif was subordinated to the need to construct a flatter space, and the "hollowing out" of perspective was abandoned in favour of the "push-and-pull" created by the orchestration of coloured planes.

These abstract explorations could easily be wedded to a poetic approach, as in the 1913 work **Dream Landscape** by Albert Trachsel (1863-1924). Through a total blending into the ground of the semicircles of the rainbow and the horizontal parallels of the water, the artist succeeds in transforming one of the favoured elements of Romantic iconography,[13] used to symbolize the reconciliation of the two worlds, into a new image of the Cosmos that meets all the requirements of modernism. Paul Klee (1879-1940), in a small watercolour entitled **With the Rainbow**, presents us with an even more successful composition on the same theme. By introducing the silhouette of a church, which stands out against a planetary form topped by a rainbow, he situates the quest for spiritual renewal in a dynamic, modern and highly mobile space derived from the explorations of Cubism and Futurism. The unity of the painting – symbol of cosmic unity – depends in Klee's work on the analogy between the Cosmos and the canvas, as he continued to tell his Bauhaus students well into the twentieth century: "From the cosmic point of view, movement is the primary datum, an infinite power that needs no extra push. In the terrestrial sphere matter obstructs this basic movement; that is why we find things in a state of rest. It is a delusion to take this earthbound state as the norm."[14]

It is now evident that by the turn of the century a belief in the inherent oneness of the Cosmos had replaced the decadent anxiety of the preceding decade. This belief was manifested in a renewed interest in the theory of "correspondences" beloved of the Romantics;[15] considerable faith was now placed in nonrational forms of knowledge, in intuition,[16] for in their capacity to render perceptible correspondences between the spiritual (in the broadest sense) and perceptual worlds, they were seen as the only means of guaranteeing a return to cosmic unity and primal harmony.

Perfumes, Sounds, Colours

At the dawn of the twentieth century, the first signs began to appear of a decisive shift whose seeds were embedded in the Symbolist episteme. Linked to the rejection of Naturalism advocated by the Symbolist generation was an increasingly widespread use of the expressive properties of colour. The effect on spectators was shocking but could lead unexpectedly to a semimystical experience of art as the path to salvation. This feeling was powerfully captured by the poet Hugo von Hofmannsthal after his discovery of Van Gogh's work in 1907:

Have I not said that the colours of things, at special moments, have a power over me?
But is it not rather I who gain power over them, the full and total capacity, for a

554

555

13. See C. D. Friedrich, *Paysage avec arc-en-ciel* [Landscape with Rainbow], 1810, Museum Folkwang Essen.

14. Paul Klee, Lecture notes for Monday, February 27, 1922, in *Paul Klee: The Thinking Eye – The Notebooks of Paul Klee*, ed. Jürg Spiller, trans. Ralph Manheim (New York: George Wittenborn, 1961), p. 357.

15. For the Swedish scholar and philosopher Emanuel Swedenborg (1688-1772), who was also a grand master of occultism, this theory was the key to understanding the profound unity that exists between the two worlds. His work, which had an enormous influence on the Symbolists, was already familiar to Baudelaire, who summarized thus the mysteries of the universal analogy: "Everything, form, movement, number, colour, perfume, in the *spiritual* as in the *natural*, is significant, reciprocal, converse, *correspondent*." Baudelaire, *Art romantique* (Paris: Julliard, 1964), p. 231.

16. This concept was central to the arguments put forward by the French philosopher Henri Bergson in *Essais sur les données immédiates de la conscience*, published in 1889, in which he criticizes the "scientism" that killed spirituality during the nineteenth century.

certain length of time, to grasp their unfathomable mystery, transcending all language – is not this power within me, is it not this that I feel in my breast as a swelling, a fullness, a sublime and exalting presence, near me, in me, at the spot where the blood comes and goes?[17]

This sudden recognition of an unsuspected power was of vital importance to a whole generation of painters influenced by Symbolism: not only does colour act directly on the artist's soul – like music, Kandinsky would add – but through colour, the artist sees opening before him a whole new realm that had been left unexplored owing to a lack of means. In other words, freed from the obligation to make references to the external world, painters could now devote themselves to resolving the moral crisis using only the "language of form and colour".[18]

Foreshadowings of the radical innovation that would mark the early twentieth century can be seen in a strange figurative painting executed in about 1890 by the Swedish artist Ernst Josephson, as well as in the more classical work of Maurice Denis, in the small abstract sketches found in Gustave Moreau's studio after his death in 1898, and in the highly personal explorations of Charles Filiger (1863-1928), which recall the Synthetist style of Pont-Aven. In his **Chromatic Notations**, Filiger continued the process of simplification undertaken by Gauguin, enclosing highly synthesized profiles in a network of simple geometric shapes. These works are an expression of religious feeling and symbolize union between the soul, represented by the central figure, and the universe, which appears like a many-sided, multicoloured mosaic. Apparently inspired by a preoccupation with things cosmic, but actually, as Filiger wrote in 1904, more musical than pictorial,[19] these compositions are evidence of an interest shared by the pioneers of abstraction, Kandinsky, Kupka and Delaunay.

At the turn of the century, investigations into the relationship between music and painting were a subject of passionate interest in Symbolist circles. A keen debate was kindled on the possibility of simultaneous perception, or synesthesia, with arguments focussing especially on one particular form – the "coloured audition" mentioned in Rimbaud's well-known sonnet, where a sound evokes a specific colour.[20] Various aspects of the phenomenon were explored, including its physiological basis, its frequency and its exclusivity (that is, its restriction to particularly gifted individuals). Numerous artists accepted this pseudo-scientific idea, for they saw it as a tool that would reinforce the artwork's power to transmit its message of regeneration. It was thought that the regeneration of man, which should make no appeal to rational logic, was possible only if the frontiers of sensory perception could be pushed back. Thus, a work that combined perceptions of diverse origin in an original way should enable a receptive spectator to enter entirely uncharted areas of experience. Such a work would, in fact, coincide with Wagner's aims in his earlier conception of the *Gesamtkunstwerk*, the synthesis of all the arts.

After a long journey that led from his native Russia to Munich, it was Wassily Kandinsky (1866-1944) who ushered the urge to regenerate man into the twentieth century.

558

575, 576

578, 579

17. Hugo von Hofmannsthal, "Lettre du voyageur à son retour", in *Lettre de Lord Chandos et autres essais* (Paris: Gallimard, 1980), p. 201.
18. Wassily Kandinsky, *Concerning the Spiritual in Art*, trans. M.T.H. Sadler (1914), (New York: Dover, 1977), pp. 27ff.
19. See the essay by Marie Amélie Anquetil in *Filiger. Dessins, gouaches, aquarelles*, exhib. cat. (Saint-Germain-en-Laye: Musée du Prieuré, 1981).
20. Close attention had already been paid to correspondences between visual, auditory and even olfactory perceptions in Baudelaire's *Paradis artificiels*. They had inspired considerable interest among the German Romantics and were carefully examined by Diderot, who was particularly impressed by Louis Bertrand Castel's "clavecin oculaire" (1734).

In an essay significantly entitled *On the Spiritual in Art and in Painting in Particular*,[21] completed in 1910 and published in December of the following year, the artist embarked on an antimaterialism campaign whose source can be traced back to the militant anti-Positivism of Russian intellectual and literary Symbolist circles twenty years earlier.[22] To glimpse the prospect of a better world is to be acutely aware of the approach of change, of a "spiritual revolution". Deriving most of his iconography from Russian popular art, Kandinsky depicted the Apocalypse towards which European civilization was inexorably moving. Combining a spiritual theme with an innovative approach to form and colour, his painting **Study for "Improvisation 8"** was a pivotal work of the time. Turning his back on imitation, Kandinsky began to concentrate on a form of inner experience that, as his theoretical writings indicate again and again, he saw as being the artist's unavoidable, "necessary" destiny.

For Kandinsky, a painting actually "rang", and this inner resonance was rooted in the "sonority" peculiar to each colour. In the 1910 **Study for "Composition II"**, he approached pictorial techniques in a new way designed to introduce the spectator to a vaguely religious realm evocative of the Flood, the Apocalypse and the Second Coming. Traces of ghostlike figures fill a space structured primarily by colour. Kandinsky's pictorial explorations often corresponded to his less-known theatrical work.[23] These creations, considered revolutionary, pursued the same line as the Symbolist theatre of Maeterlinck, for example, but resulted in stage compositions that involved virtually no action. Jessica Boissel writes:

> These voices belong to actors with no role, who have lost all individuality. They are executors of simple movements – they enter, form groups, collapse, withdraw. But first and foremost, they are vehicles of colour . . . These colours inhabited by human voices (colours *are* beings for the painter, which is why he speaks of their inner sonority, even their soul) move in the changing light in time to sounds, against a set made up of carefully composed coloured planes.[24]

The sketches Kandinsky and his friend Thomas von Hartmann executed for these complex stage projects are all that remains to give any indication of their scope.[25]

The idea of aesthetic synthesis was in the air. Kandinsky, who travelled frequently between Munich, Moscow and Saint Petersburg during this period, was well acquainted with the work of two musicians who shared his ideas on the equivalence of colour and sound: Alexander Scriabin and Nicholas Kulbin. And in 1911, Kandinsky began corresponding regularly with Arnold Schoenberg, for he perceived numerous affinities between his painting and the music of the Viennese composer, himself a part-time artist.[26] All these related aspirations led Kandinsky to seek means of expression for painting as autonomous as those used in music, for he saw sound as the paradigm of immateriality. By thus freeing painting from its strictly representational function, he opened the way to abstract art.

This discovery of analogies between music and painting, although grounded in different approaches, occurred almost simultaneously in Paris, in the work of Robert Delaunay (1885-1941) and František Kupka (1871-1957). Kupka, who settled in Paris in

566, 567

564

565

559-563

151

577

21. This pivotal work, first published by Piper in Munich, was reissued twice in German during 1912 and appeared in an English translation in 1914. Exceprts from the essay also appeared in Russian as early as January 1912.

22. This triumph of spiritualism over Positivism was achieved through the combined efforts of Leo Tolstoy and Vladimir Solovyov, whose works had a profound impact on an elite hungry for spiritual sustenance. For both the novelist and the philosopher-mystic, art played a prophetic role in the transformation of the world. See Pierre Pascal, *Les grands courants de la pensée russe contemporaine* (Lausanne: L'Âge d'Homme, 1971). As it has not been possible to include the work of Russia's Symbolist painters, apart from Kandinsky, in the exhibition, they are not discussed here.

23. In 1908, Kandinsky became interested in stage composition, working both alone and with the musical collaboration of the young composer Thomas von Hartmann. He worked on compositions entitled *Jardin du Paradis*, *Daphnis et Cloé*, *Sonorité verte*, *Sonorité jaune* (the only one to be published, appearing in 1912) and *Composition scénique III (Noir et blanc)*.

24. Jessica Boissel, "Compositions scéniques, théâtre", in Christian Derouet and Jessica Boissel, eds., *Kandinsky*, exhib. cat. (Paris: Centre Georges-Pompidou, 1984), p. 68; see especially J. Hahl-Fontaine, *Kandinsky* (Stuttgart: Mark Vokar, 1993), pp. 143-156.

25. These projects were never realized owing to the advent of World War I. It was not until 1972 that one of the compositions, *Le Son jaune*, was performed at New York's Guggenheim Museum during a Kandinsky retrospective.

26. See Jelena Hahl-Koch, ed., *Wassily Kandinsky und Arnold Schönberg. Der Briefwechsel* (Stuttgart: Gerd Hatje, 1993).

1896, was a Czech artist who had been a member of Vienna's Symbolist group and possessed a sensibility honed by his activities as a medium at spiritualist seances. After executing a major series of Symbolist paintings, he came to realize the impossibility of "translating" an idea in painting using allegory. He drew his inspiration from music, which he saw as unique in its capacity to express cosmic harmony. It was his aim to create a "new reality", a "different reality", by executing "fugues" of colour. *The Study for Amphora, Fugue in Two Colours*, from 1911, is among the results of his investigations. Curves and countercurves, rendered in a palette of warm colours within an entirely abstract space, are employed as equivalents of the sounds of the voice or the movements of a dance. If we place this study alongside Van Dongen's *Souvenir of the Russian Opera Season*, from 1909, we realize that the two works are more than just investigations into the relations between colour and sound – they are evidence of a truly historical moment, when the effects of Symbolism were opening the door to modern art. One current, through the renunciation of representation, led to abstract art, while the other, without abandoning the figure, led the way via a new pictorial approach to another form of expression through colour.

By 1900, there was a feeling in literary Symbolist circles that an era had ended and that this sudden decline was due to the death of the movement's greatest representatives – Verlaine in 1896, and in 1898, almost simultaneously, Mallarmé, Rops, Rodenbach, Moreau, Puvis de Chavannes, Beardsley and Burne-Jones. As we look back on the period today, we get a clearer picture of Symbolism's true fate: through the tireless efforts of some of its later protagonists, it evolved from a literary movement into a purely pictorial one. As such, it became for many artists the fountainhead of modern art.

C. N.-R.

Arcady and Paradise

516 to 532

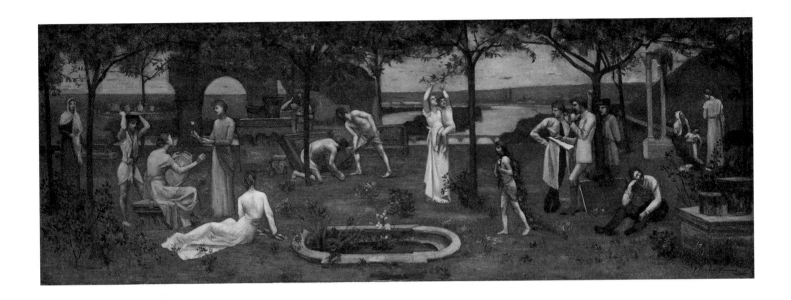

516 (cat. 332)
Pierre PUVIS DE CHAVANNES
Inter artes et naturam
1890
Oil on canvas
40.3 x 113.7 cm
New York, The Metropolitan Museum of Art

When in February 1888 Puvis de Chavannes obtained the commission from the Comité des musées in Rouen to execute a series of wall paintings for the city's new fine arts museum, he was already famous for the frescoes he had painted for the stairways of the fine arts museums of Marseilles, Amiens and Lyons, although only occasionally an exhibitor at the Salons. Rejecting the notion of a historical series depicting the city's past glories, Puvis preferred to find his subject in the future of the building, which was to house a collection of ceramics and antiques. As he had done in Marseilles, the artist chose to evoke the city's history indirectly rather than focus on specific episodes.

Two years after the eighth (and last) Impressionist exhibition, which heralded the breakup of the group, Puvis de Chavannes seems to have wanted to re-examine the question of the links between art and nature, rather than subscribing to Wilde's teasing adage, "Nature imitates Art." For Puvis, nature was not captured in the moment but rather reconstructed in the studio from memory, by means of initial sketches made from life. His is an ideal Arcadia, peopled by his own creations (mothers, potters, painters, poets and so on) dressed for the first time in contemporary garb. Van Gogh greatly admired this painting: "One has the impression of witnessing a complete and reassuring rebirth of all those things one might have believed or wanted, a strange and happy alliance of remote antiquity and raw modernity."

G.C.

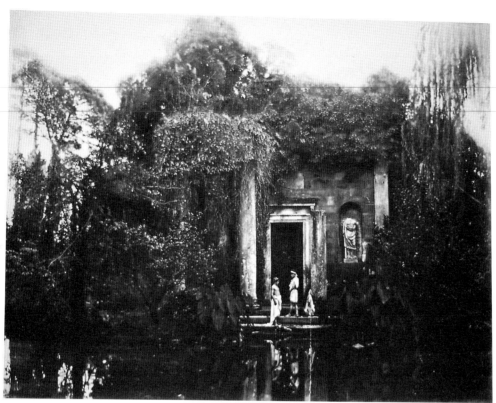

517 (cat. 452)
Wilhelm VON GLOEDEN
Ruins with Pond and Two Youths Dressed in the Antique Style, about 1900
Frankfurt, Uta and Wilfried Wiegand collection

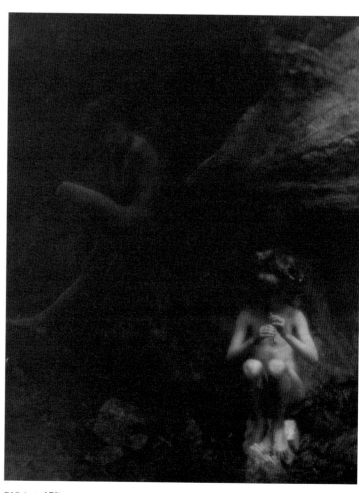

518 (cat. 472)
Clarence H. WHITE
The Faun, 1907
Bath, The Royal Photographic Society

519 (cat. 104)
Frank EUGENE (Smith)
Song of the Lily
1897
Platinum print
17 x 12.1 cm
New York, The Metropolitan Museum of Art

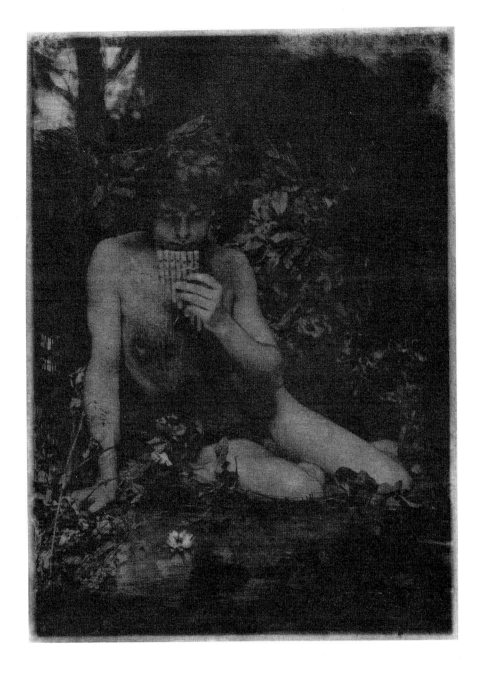

Like Day, White and Gloeden, Frank Eugene had a penchant for the photographic rendering of myths involving such nature deities as Pan and satyrs. He returned to this motif repeatedly in his photographs; another example is *Mopsus*, the self-portrait as a satyr he took on the occasion of an art festival organized by architect Emanuel von Seidl. The influence of the pictorial worlds of Franz von Stuck and Arnold Böcklin had a lasting effect on Eugene. He was probably introduced to the works of Böcklin in particular through the Schack gallery in Munich. What linked him with Stuck was a similar inclination for the representation of a sensual, animal exuberance, as well as a "strong tendency towards the decorative" (Otto Julius Bierbaum). An interest in the cult of Pan as the expression of a bucolic joie de vivre was particularly widespread in art circles in Munich at the turn of the century, not least in artists' festivals like "In Arcady" (1898). Yet, the main concern was less with Pan as the embodiment of a love-crazed fertility cult given to excess than with an idyllic fusion of nature with human life, a fusion in which Pan was occasionally allotted the role of the *figura buffa*.

U. P.

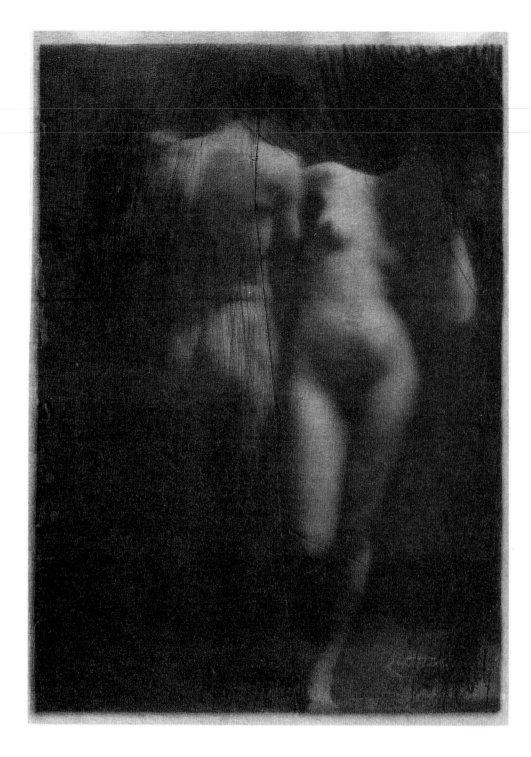

520 (cat. 101)
Frank EUGENE (Smith)
Adam and Eve
1898
Platinum print
16.9 x 11.9 cm
New York, The Metropolitan Museum of Art

The photograph *Adam and Eve*, exhibited between 1899 and 1910 in New York, Glasgow, Munich, Dresden, London and Buffalo, is one of the German-American pictorialist Frank Eugene's most famous works. The torso treatment, with its formal analogies to representations by Rodin and Stuck, is usually interpreted as an attempt to circumvent the period's restrictive moral attitude towards the reproduction of male and female nudes. However, this interpretation ignores the photograph's actual theme – the representation of the first couple. The modest turning away of the female model, whose head has been etched over, is a reference to the Fall of Man. Viewed in this way, the photograph can be understood as a symbolic expression of the irretrievable loss of Paradise and, at the same time, the fateful point of departure for the sexual entanglements of human nature.

U. P.

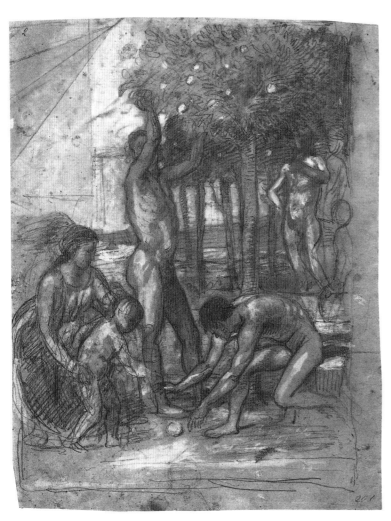

521 (cat. 454)
Hans VON MARÉES
Woman, Child and Men in an Orange Grove, about 1876
Munich, Staatliche Graphische Sammlung München

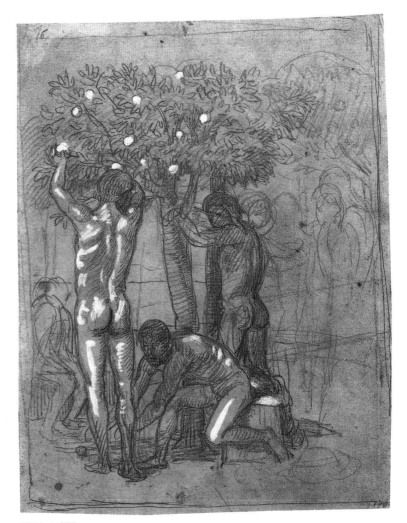

522 (cat. 455)
Hans VON MARÉES
Men with Orange Trees, about 1876
Munich, Staatliche Graphische Sammlung München

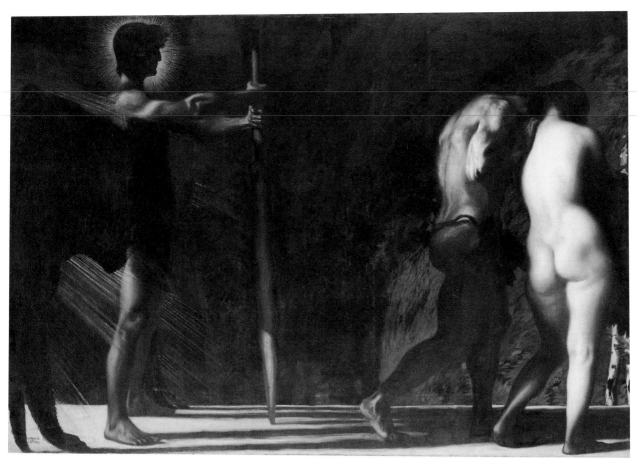

523 (cat. 460)
Franz VON STUCK
The Lost Paradise, 1897
Dresden, Staatliche Kunstsammlungen

524 (cat. 384)
George SEELEY
The Guardian (Woman with Spear), about 1905-1907
Bath, The Royal Photographic Society

525 (cat. 457)
Franz VON STUCK
The Guardian of Paradise
1889
Oil on canvas
250 x 167 cm
Munich, Villa Stuck

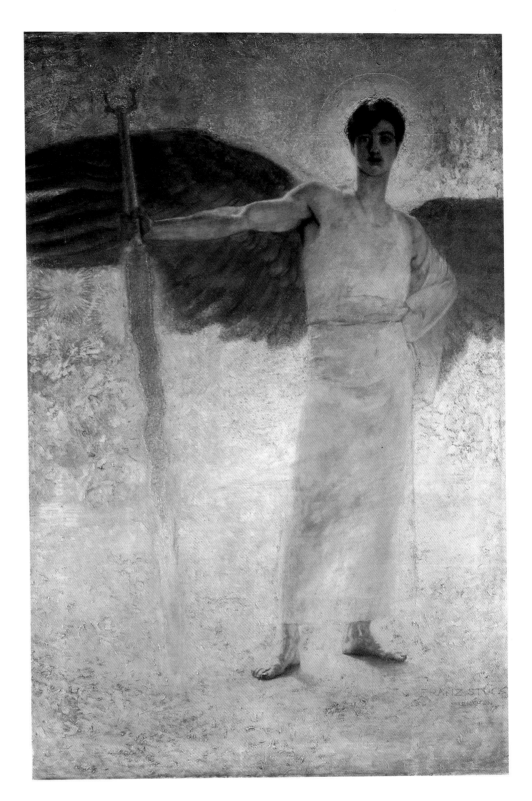

Although he derived some of his subjects
from Christian iconography, Franz von
Stuck was not a religious artist. He was best
known for his many erotic images of
nymphs and satyrs, and the few biblical
subjects he painted early in his career in
Munich made secular use of their various
Christian elements. Stuck's work is full of
images with multiple meanings. Presented
in 1889 at the first annual exhibition of
the Society of Munich Artists, the large,
luminous *Guardian of Paradise* was
awarded a gold medal. Against a sparkling,
star-filled background – consisting of a mass
of small brush strokes in yellow, purple,
orange and green, carefully applied side by
side – stands an angel with huge wings.
Despite the presence of the flaming sword,
traditional attribute of the guardian of
Paradise, the filmy garment, burning eyes
and sensual mouth of this well-muscled
hermaphrodite imbue the Christian image
with a barely concealed erotic significance.

C. N.-R.

526 (cat. 389)
Giovanni SEGANTINI
Triptych of Life: Life, 1898
Winterthur, Switzerland, Stiftung für Kunst, Kultur und Geschichte, on deposit at the Musée
Segantini, Saint-Moritz

527 (cat. 389)
Giovanni SEGANTINI
Triptych of Life: Nature, 1898
Winterthur, Switzerland, Stiftung für Kunst, Kultur und Geschichte, on deposit at the Musée
Segantini, Saint-Moritz

528 (cat. 389)
Giovanni SEGANTINI
Triptych of Life: Death, 1898
Winterthur, Switzerland, Stiftung für Kunst, Kultur und Geschichte, on deposit at the Musée
Segantini, Saint-Moritz

529 (cat. 15)
Émile BERNARD
"Les Quatre Saisons" Screen
1891
Tempera on canvas
Four panels, 171 x 62 cm (each)
Private collection

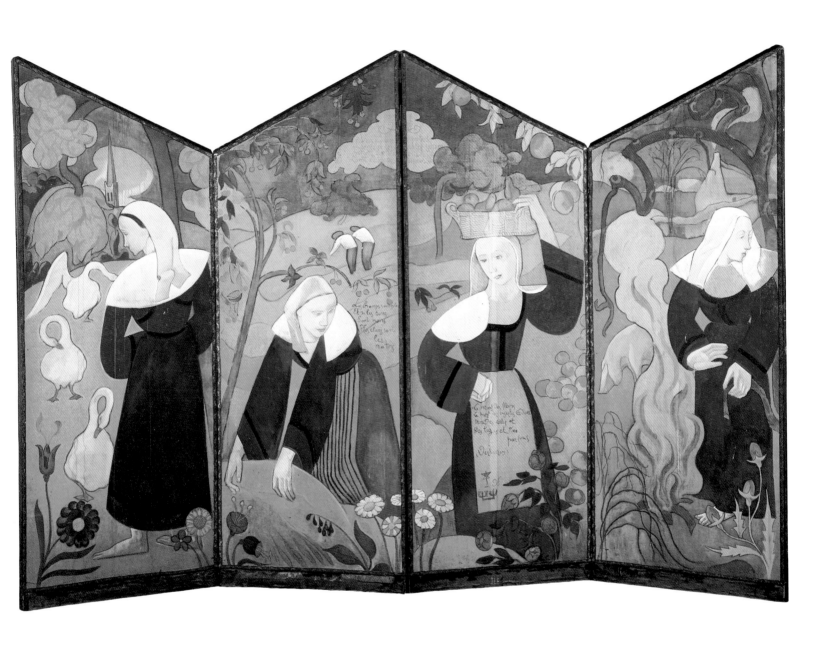

Taking a lead from works by the English Pre-Raphaelites that were shown at the 1878 World's Fair in Paris, the Symbolist generation was determined to bring easel painting and the decorative arts closer together. This screen by Émile Bernard, painted some years later than Gauguin's sculptured and human-shaped ceramics, shows the same Bretonizing style. The standing Breton peasant girls in each panel and the straightforward drawing are evidence of the same search for simplicity, a desire to return to old-fashioned craftsman-

ship. The reverse side of the screen, *Les Bûcherons Misérables* [The Poor Wood-cutters], demonstrates the same concerns.

The theme of the seasons, which appears almost simultaneously in works by several contemporary artists, especially Pierre Bonnard and Maurice Denis, was not handled in a sentimental manner. Like the lines of poetry taken from Émile Verhaeren's collection *Les Soirs* (1887), in which the theme of the salutary suffering of humble folk is tinged with a certain mysticism, the cabalistic signs found in Bernard's cycle of

the seasons suggest a loftier revelation. Bernard's pantheism was not unlike the creed of Gauguin, committed to breaking down the barriers between the sacred and the profane.

G.C.

530 (cat. 430)
Jan TOOROP
Apocalypse, 1892
Neuss, Germany, Clemens-Sels-Museum

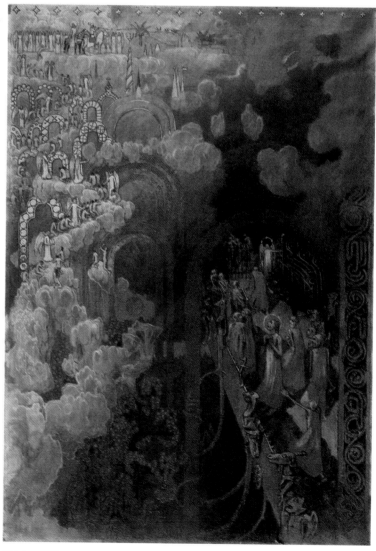

531 (cat. 307)
Gerhard MUNTHE
The Day of Judgement, 1900
Bergen, Rasmus Meyer Collection

532 (cat. 312)
Hermann OBRIST
Design for a Monument
About 1898-1900
Plaster
H.: 88 cm
Zurich, Museum Bellerive

Hermann Obrist's early training in the natural sciences roused his interest in the linear rhythms and fantastic organic forms of the biological world. Encouraged by such books as Ernst Haeckel's *Kunstformen der Natur* (*Art Forms in Nature*, Leipzig, 1899), which had a major impact on Symbolist artists and designers, Obrist drew upon these forms as a designer and craftsman. He studied in close detail the spiral shapes found in nature and recognized the symbolism inherent in the movement and tension of helicoidal lines.

In this plaster model, a spiral ridge ascends like a staircase around a leaning, sloped peak. On its summit kneels an angel who reaches down to help a struggling figure climb up to the top. The work clearly symbolizes man's triumph over all obstacles in his striving to attain the ideal, or to reach paradise. A powerful symbol of man's aspirations, this design directly inspired the Russian artist Vladimir Tatlin in 1920 to create the model for his "Monument to the Third International", a tower commemorating the October Revolution.

R. P.

The cosmos

533 to 557

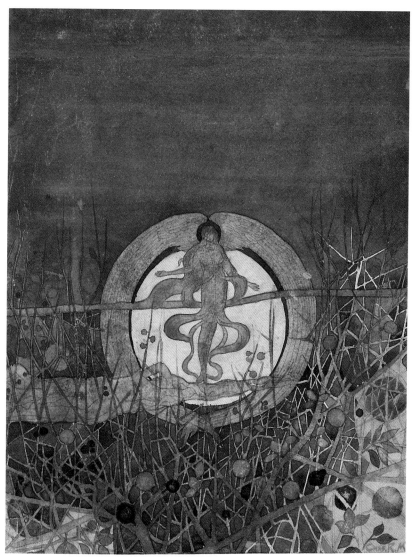

533 (cat. 254)
Charles Rennie MACKINTOSH
The Harvest Moon, 1892
Glasgow School of Art Collection

534 (cat. 146)
Ferdinand HAÜSER
Brooch, about 1910
Württembergisches Landesmuseum Stuttgart

535 (cat. 287)
Koloman MOSER
Light
About 1913-1915
Oil on canvas
123 x 180.5 cm
Vienna, Julius Hummel collection

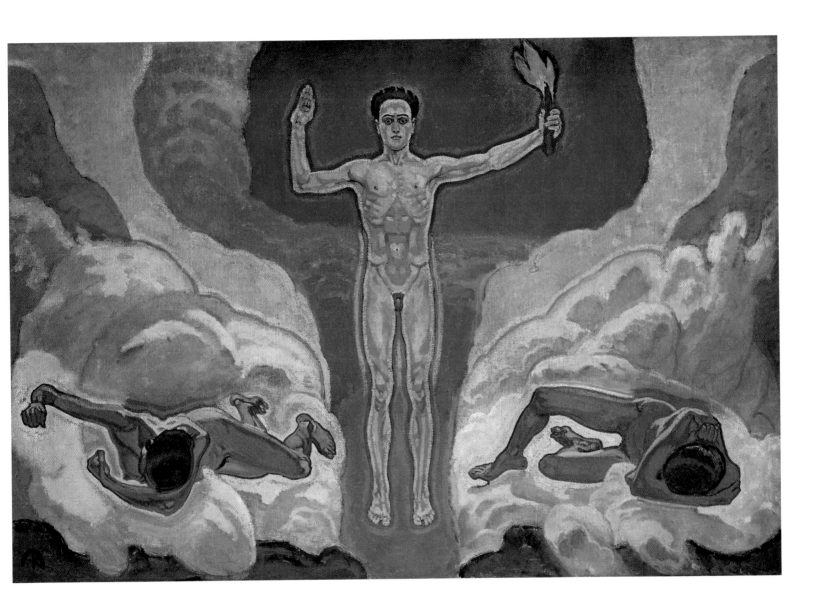

Koloman Moser, cofounder in 1897 of the Vienna Secession, is best known for his work in the decorative and applied arts at the Wiener Werkstätte between 1903 and 1907. After his resignation from the Werkstätte, however, he devoted his later career increasingly to painting. A great admirer of Hodler, whom he had met in 1903, and a convert to the anti-Newtonian theory outlined by Goethe in his *Theory of Colours* (1810), Moser fused these two sources in

creating this image heralding the advent of a pure and regenerated era of light. Like a modern Prometheus, symbolizing the Light that must triumph over Darkness, the floating figure of a young man bearing a torch breaks through the clouds and rises up through the heavens. Two symmetrically placed female figures representing Darkness are struck down by the intensely blinding light, from which they desperately try to shield their eyes. The use of a wide range of

brilliant colours reinforces the painting's symbolism and creates a theatricality rare in this artist's work. This picture symbolizes man's capacity to attain divine knowledge – a myth that at the turn of the century was central to Theosophy and Rosicrucianism.

C. N.-R.

536 (cat. 139)
Hector GUIMARD
Vase, 1900-1902
Richmond, Virginia Museum of Fine Arts

537 (cat. 22)
Thorvald BINDESBØLL
Large Plate, 1900
Copenhagen, Museum of Decorative Art

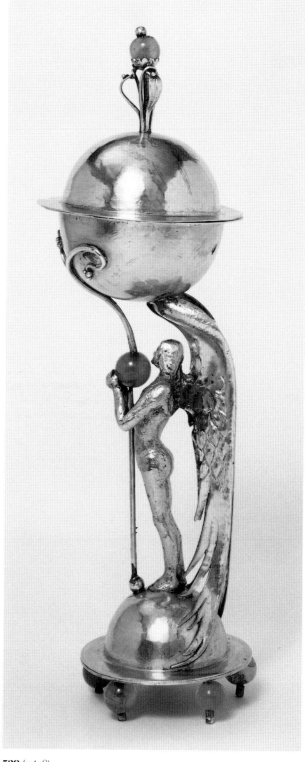

538 (cat. 8)
Charles Robert ASHBEE
Salt Cellar, 1899-1900
London, The Victoria and Albert Museum

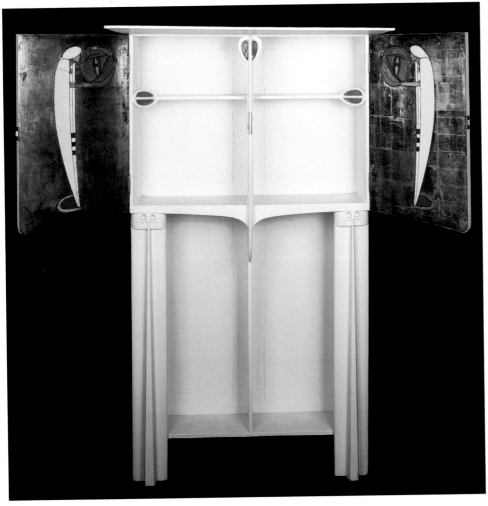
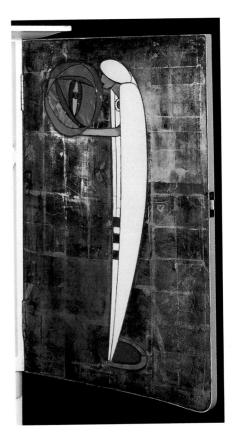

539 (cat. 253)
Charles Rennie MACKINTOSH
Cabinet, about 1904
Toronto, Royal Ontario Museum

540 (cat. 265)
Erich MALLINA
Study for "Procession of Angels", 1903
Vienna, Julius Hummel collection

541 (cat. 464)
George Frederick WATTS
The Sower of the Systems, 1902-1903
Toronto, Art Gallery of Ontario

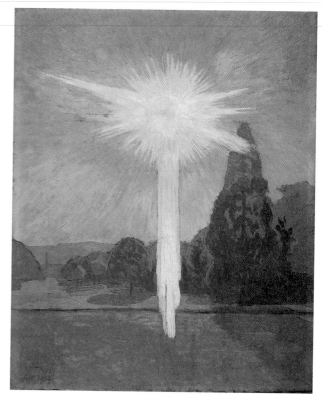

542 (cat. 477)
Jens Ferdinand WILLUMSEN
Sun over the Park, 1904
Frederikssund, Denmark, J.F. Willumsens Museum

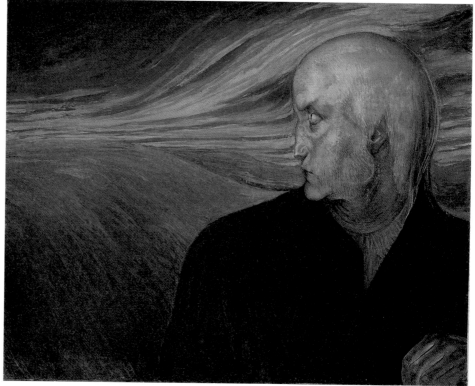

543 (cat. 108)
Émile FABRY
Man Contemplating His Destiny, 1897
The Montreal Museum of Fine Arts

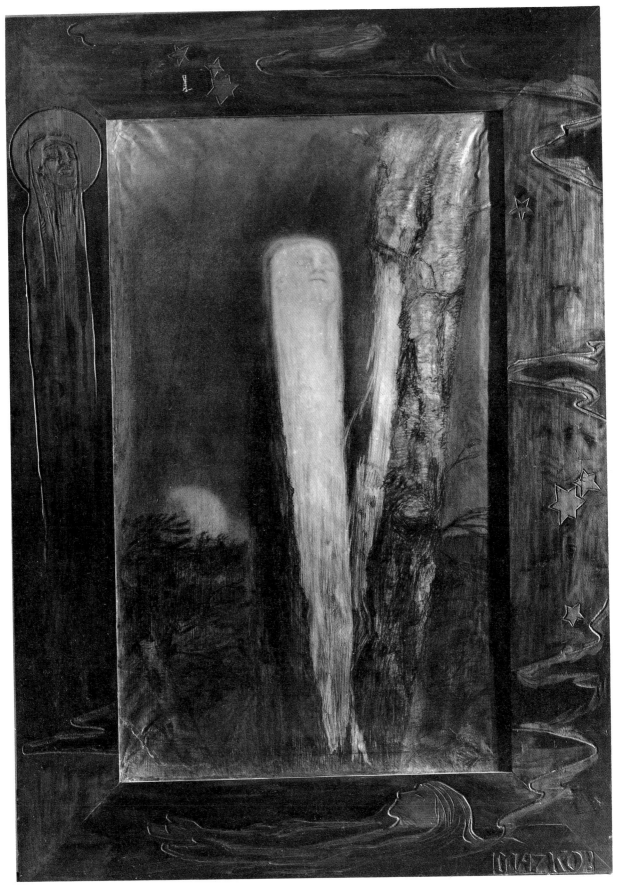

544 (cat. 20)
František BILEK
Oh Mother!, 1899
Prague, Národní galerie

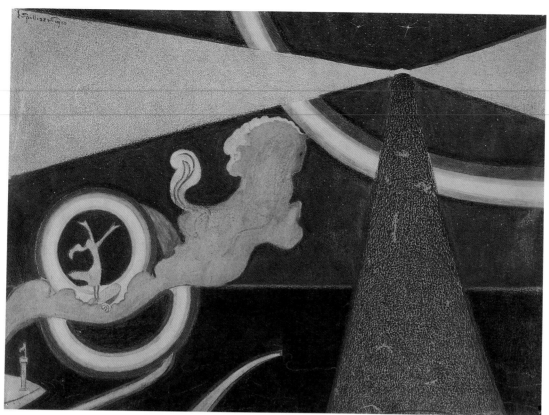

545 (cat. 407)
Léon SPILLIAERT
The Lighthouse, 1910
Ostend, Museum voor Schone Kunsten

546 (cat. 433)
Albert TRACHSEL
Lightning, 1898-1901
Kunstmuseum Solothurn, Dübi-Müller Foundation

547 (cat. 434)
Albert TRACHSEL
Lightning
1901
Oil on canvas
104.5 x 130.5 cm
Kunstmuseum Solothurn, Josef Müller Foundation

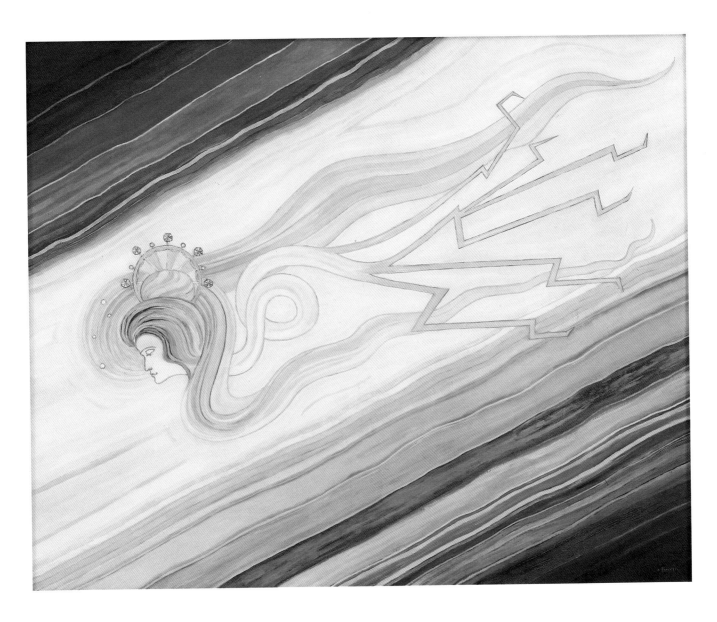

Albert Trachsel was, along with Ferdinand Hodler and Carlos Schwabe, one of the most important Swiss artists working within the Symbolist movement. This little-known painting of his was included in a complex and unusual three-part imaginary ensemble entitled "The Poem". The first part consisted of fifty utopian architectural plans designed for an extra-terrestrial world, called collectively "Les Fêtes réelles", which were shown at the first Salon de la Rose + Croix in Paris in 1892 and published in 1897 by Mercure de France as an album of plates. The artist had planned two other groups that were never completed: "Le Chant de l'Océan" and "Apparitions". In 1893, Trachsel published *Le Cycle*, a literary piece created concurrently with these pictorial works and dealing with the same theme. The later *Lightning* re-employs the central motif of a watercolour dating from 1895. As Harald Siebenmorgen explains,[1] Trachsel's universe was composed of visionary images representing "atmospheric events" that corresponded to "the personal experience of a representative of utopian humanity", the same Utopia for which the architectural projects (mostly temples) had been designed. The painting is a highly personal allegory of "lightning" streaking through the cosmos.

C. N.-R.

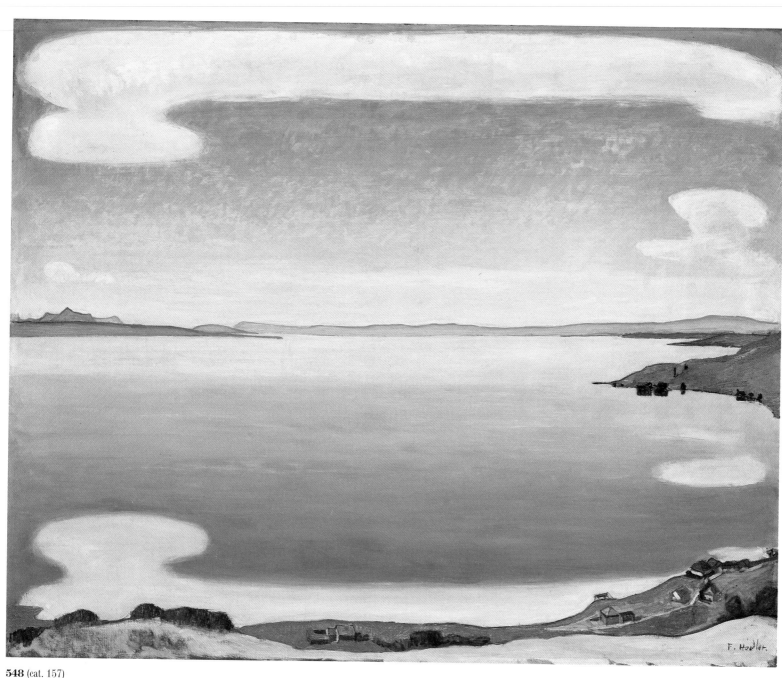

548 (cat. 157)
Ferdinand HODLER
Lake Geneva Seen from Chexbres, 1908
Geneva, Musée d'art et d'histoire

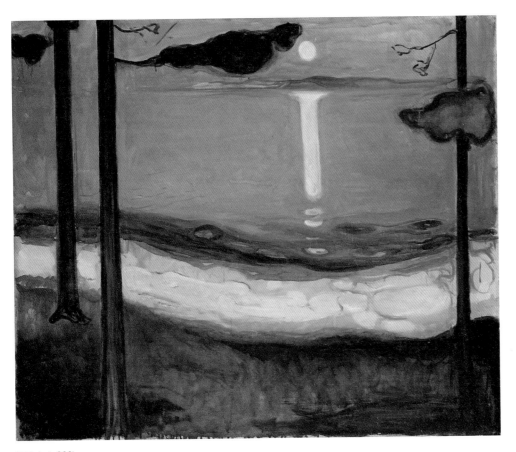

549 (cat. 300)
Edvard MUNCH
Moonlight, 1895
Oslo, Nasjonalgalleriet

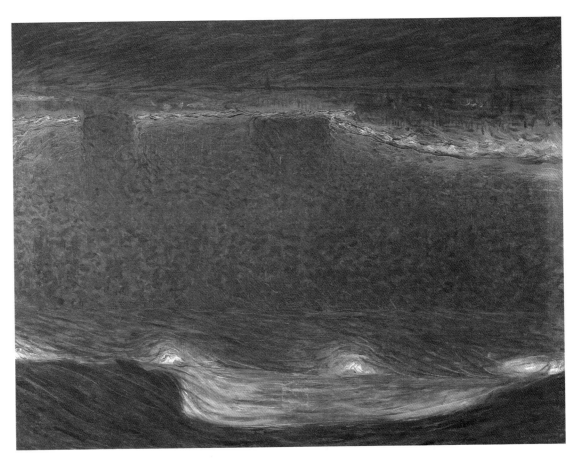

550 (cat. 172)
Eugène JANSSON
Nocturne, 1901
Stockholm, Thielska Galleriet

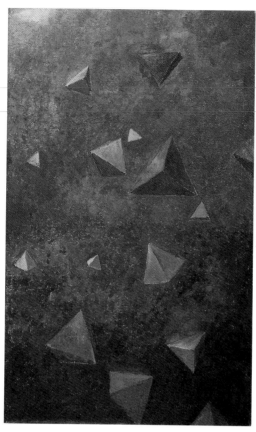

551 (cat. 394)
Paul SÉRUSIER
Tetrahedrons, about 1910
Paris, Guy Loudmer collection

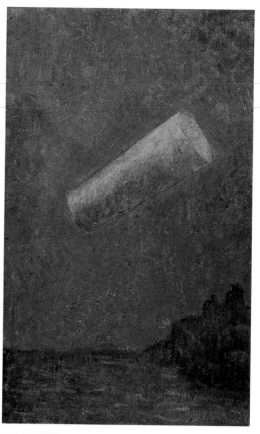

552 (cat. 392)
Paul SÉRUSIER
The Golden Cylinder, about 1910
Rennes, Musée des Beaux-Arts et d'Archéologie

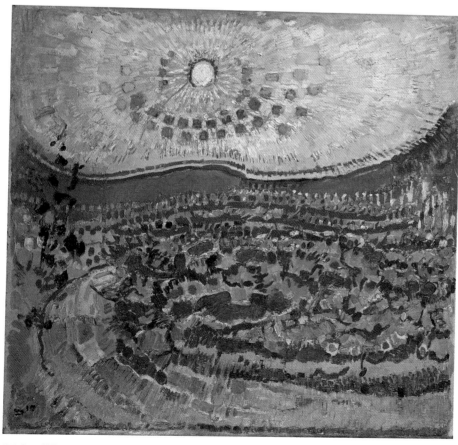

553 (cat. 397)
Jan SLUIJTERS
October Sun, Laren, 1910
Haarlem, Frans Halsmuseum

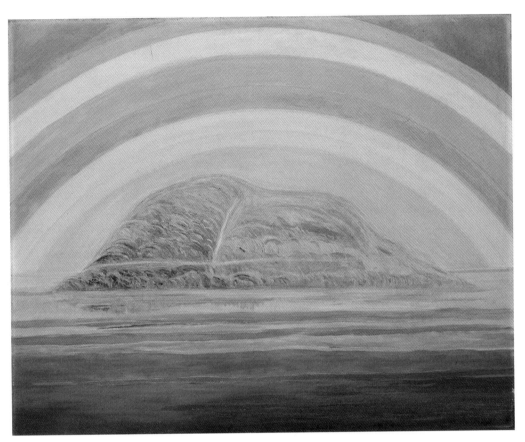

554 (cat. 435)
Albert TRACHSEL
Dream Landscape, about 1912-1913
Kunstmuseum Solothurn, Dübi-Müller Foundation

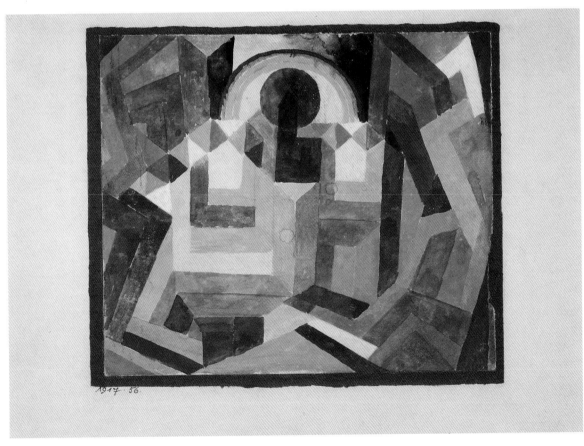

555 (cat. 202)
Paul KLEE
With the Rainbow, 1917
Bern, Felix Klee estate

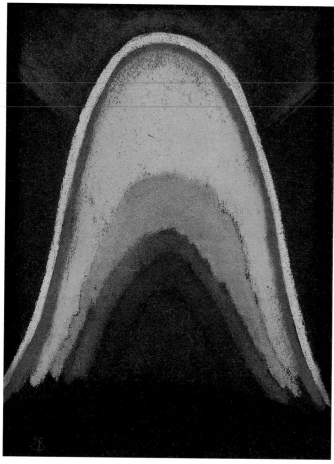

556 (cat. 442)
Theo VAN DOESBURG
Symbolist Composition, 1915
The Hague, Rijksdienst Beeldende Kunst, on loan to the Centraal Museum, Utrecht

557 (cat. 441)
Theo VAN DOESBURG
Cosmic Sun, 1915
Private collection

Perfumes, Colours, Sounds

558 to 583

558 (cat. 173)
Ernst JOSEPHSON
The Blessed Sacrament
1889-1890
Oil on canvas
127 x 76 cm
Stockholm, Nationalmuseum

This painting by the Swedish artist Ernst Josephson combines a precociously Expressionist and quite unprecedented use of colour with an extremely free handling. It is nevertheless among the works inspired by the widespread interest in the occult sciences that marked the late nineteenth century – an interest rooted in the possibilities occultism seemed to offer for communication with the cosmic forces of the Beyond. Josephson, unable to face criticism or deal with the hardships of the art worlds of Paris and Sweden, sought sanctuary in 1886 on the island of Bréhat, off the Brittany coast. There, he began to take regular part in spiritualist seances during which, powerfully influenced by the writings of the Swedish mystic Swedenborg, he would attempt to summon up characters from the Bible. His psychological stability, already weakened by the adversities of life and certain inherited traits, was severely shaken. Between 1887 and 1891, he produced a series of works that even today are astonishing in their modernity, though they are primarily a reflection of the mystical world in which the painter, cut off from reality, had taken refuge.

C. N.-R.

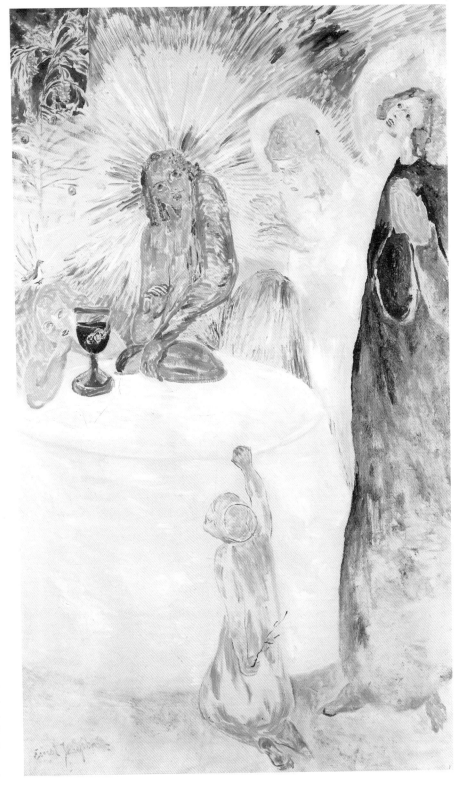

559 (cat. 175)
Wassily KANDINSKY
Scenic Composition "Noir et blanc", about 1909
Paris, Musée national d'Art moderne, centre Georges-Pompidou

560 (cat. 145)

Thomas von HARTMANN

Scenic Composition "Noir et blanc", after Kandinsky, about 1909

Paris, Musée national d'Art moderne, centre Georges-Pompidou

561 (cat. 145)

Thomas von HARTMANN

Scenic Composition "Noir et blanc", after Kandinsky, about 1909

Paris, Musée national d'Art moderne, centre Georges-Pompidou

562 (cat. 145)

Thomas von HARTMANN

Scenic Composition "Noir et blanc", after Kandinsky, about 1909

Paris, Musée national d'Art moderne, centre Georges-Pompidou

563 (cat. 145)

Thomas von HARTMANN

Scenic Composition "Noir et blanc", after Kandinsky, about 1909

Paris, Musée national d'Art moderne, centre Georges-Pompidou

564 (cat. 177)
Wassily KANDINSKY
Study for "Improvisation 8"
1909
Oil on cardboard mounted on canvas
98 x 70 cm
Volkart-Stiftung, on loan to the
Kunstmuseum Winterthur

In 1909, when he was working in Murnau
near Munich, Kandinsky undertook a series
of experimental works that would lead him
swiftly towards abstraction. According to
Jelena Hahl-Koch,[1] *Improvisation 8* was in
many ways a groundbreaking painting. It
was shown in Moscow at an exhibition of the
Jack of Diamonds. More clearly articulated
than the other works in the 1909 series, it
shows a "giant with a sword" positioned to
the left of a chaotic landscape. The monu-
mental form of the sword and its bearer
recall Stuck's *The Guardian of Paradise*
(cat. 457), which Kandinsky, who had
studied under Stuck at the Munich Academy
in 1900, had almost certainly seen. But the
signi cance of this painting is quite different:
leaving behind the nostalgia of Paradise
Lost, it focusses on the new Jerusalem.
Kandinsky derived much of his iconography
from Russian folk art, reformulating it in his
painting by reducing linear contours to a
minimum and allowing the areas of colour
to predominate. His aim in employing
religious themes with apocalyptic overtones
was to convey the impending downfall of
materialism and triumphant revival of
spiritual values.

C. N.-R.

1. Jelena Hahl-Koch, *Kandinsky* (New York:
Rizzoli, 1993).

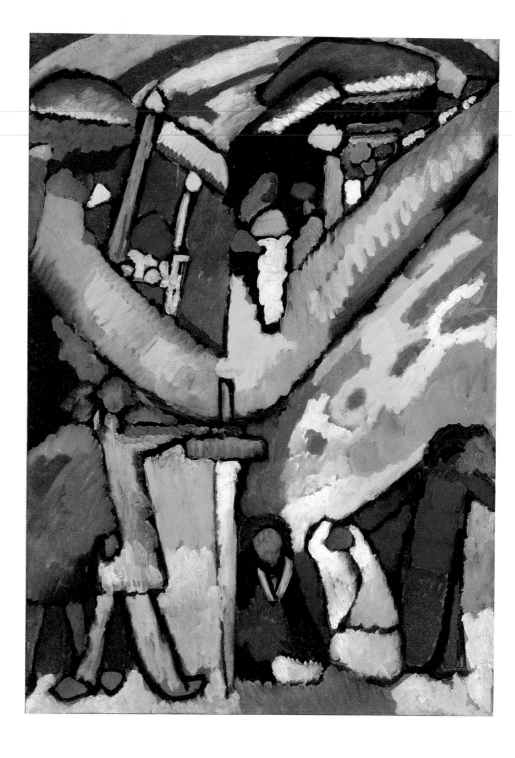

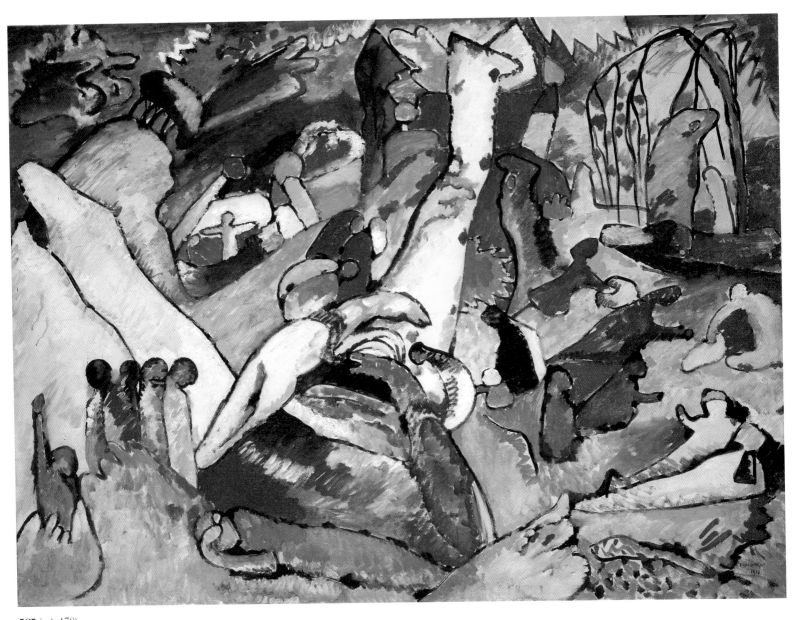

565 (cat. 178)
Wassily KANDINSKY
Study for "Composition II", 1909-1910
New York, The Solomon R. Guggenheim Museum

566 (cat. 180)
Wassily KANDINSKY
Study for the Cover of the "Blue Rider" Almanac
1911
Watercolour
27.7 x 21.8 cm
Munich, Städtische Galerie im Lenbachhaus

567 (cat. 179)
Wassily KANDINSKY
Study for the Cover of the "Blue Rider" Almanac
1911
Watercolour
28 x 21.7 cm
Munich, Städtische Galerie im Lenbachhaus

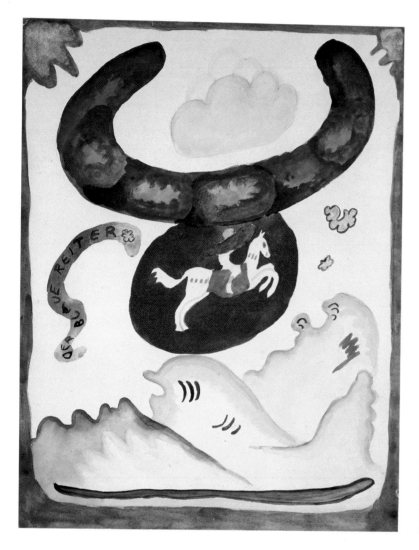

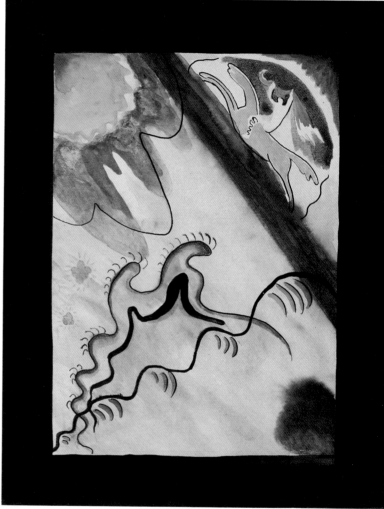

The 1912 publication by Piper of the *Blue Rider Almanac* in Munich was one of the major events in the dissemination of the ideas of Kandinsky and his friend Franz Marc regarding the importance of the artist's "inner necessity", which alone could ensure the authenticity of a work. The promulgation of this notion had a definite influence on the steady breakdown of barriers between the various art forms. The plan for a book bearing the same title as the two exhibitions held in the same year first took form in June 1911, and a number of sketches for the book's cover were executed. The principal motif of both the designs exhibited shows a horse rearing up from earth towards the heavens and carrying a rider flourishing a blue shawl. This motif symbolizes Kandinsky's ongoing quest. At the same period, he wrote in his essay *Concerning the Spiritual in Art and in Painting in Particular*: "The deeper the blue, the more it draws man towards infinity and awakens in him a nostalgia for the Pure and the supersensory ultimate. It is the colour of the sky, as we represent it to ourselves, in the sound of the word sky."

C. N.-R.

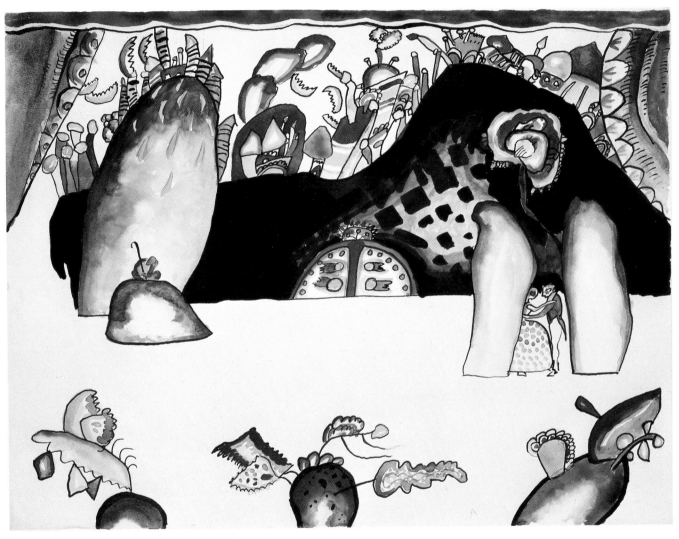

568 (cat. 176)
Wassily KANDINSKY
Scenic Composition "Violet", Tableau II, 1914
Paris, Musée national d'Art moderne, centre Georges-Pompidou

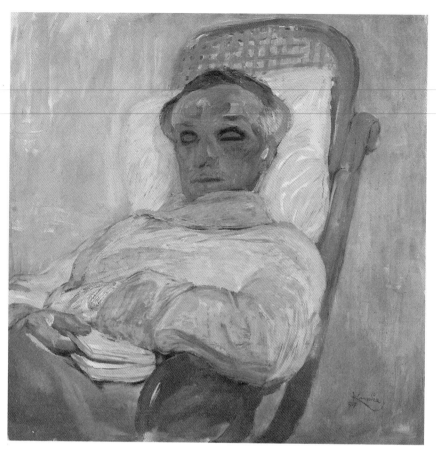

569 (cat. 230)
František KUPKA
The Yellow Scale, 1907
Paris, Musée national d'Art moderne, centre Georges-Pompidou

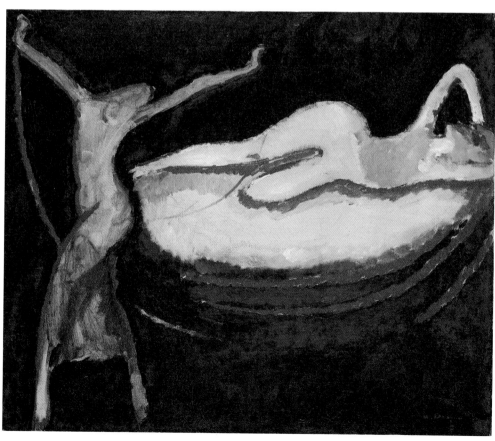

570 (cat. 444)
Kees VAN DONGEN
Souvenir of the Russian Opera Season, 1909
Ottawa, National Gallery of Canada

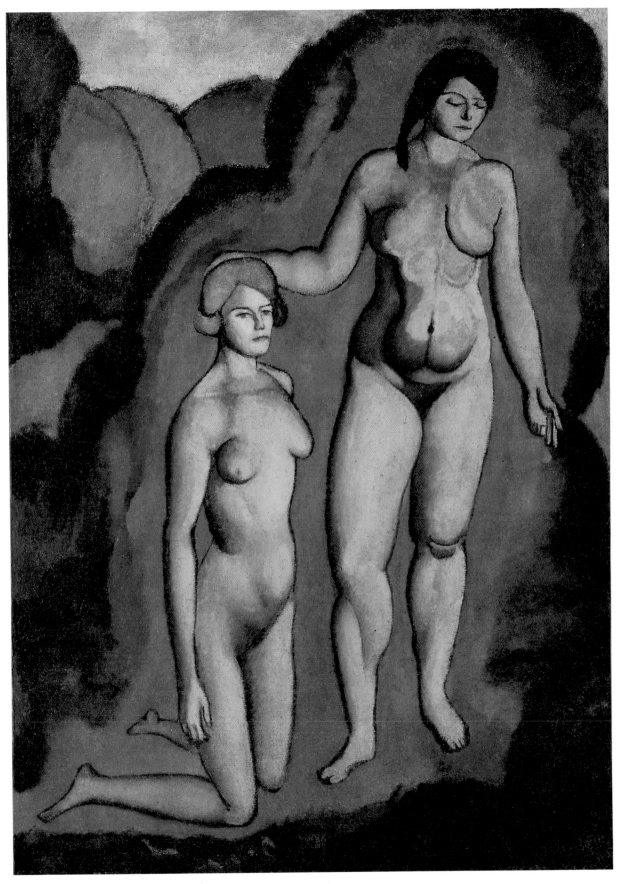

571 (cat. 90)
Marcel DUCHAMP
The Bush, 1910-1911
Philadelphia Museum of Art

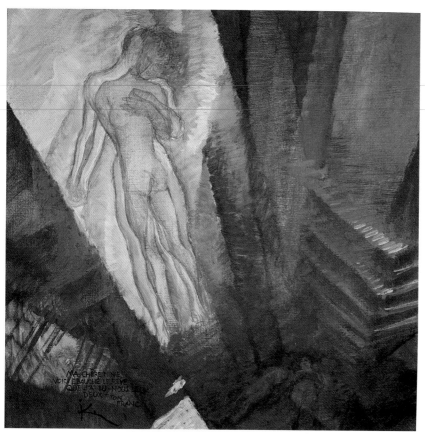

572 (cat. 232)
František KUPKA
The Dream, 1906-1909
Museum Bochum

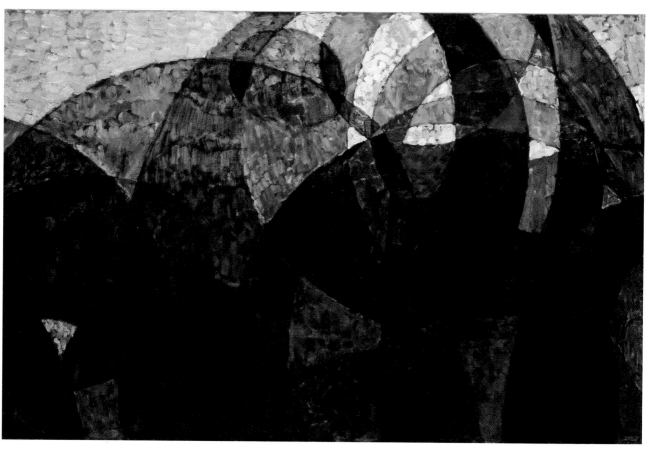

573 (cat. 229)
František KUPKA
Study for Amorpha, Fugue in Two Colours, 1911
Paris, Musée national d'Art moderne, centre Georges-Pompidou

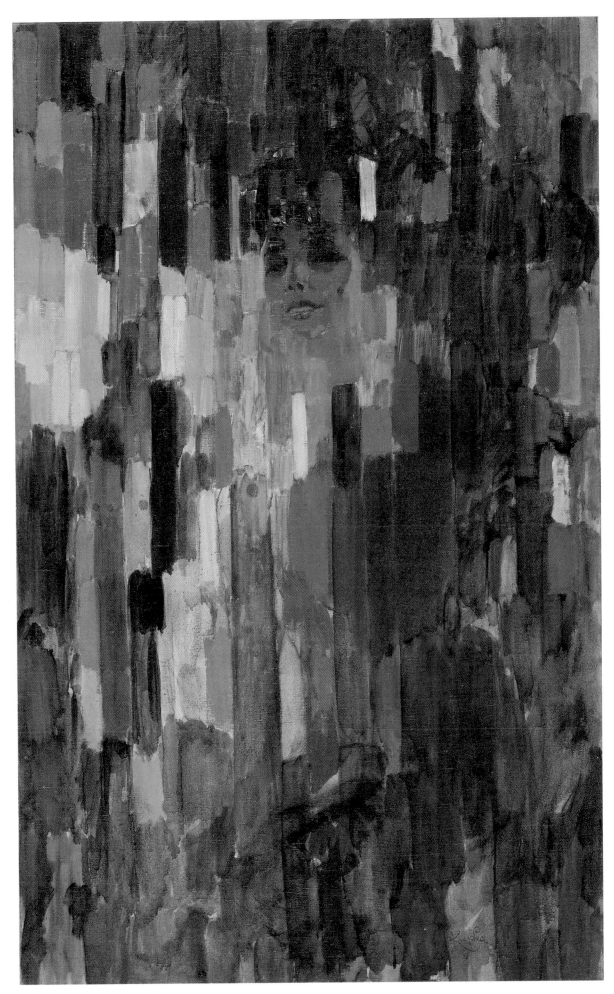

574 (cat. 231)
František KUPKA
Madame Kupka among Verticals, 1910-1911
New York, The Museum of Modern Art

575 (cat. 281)
Gustave MOREAU
Abstract Sketch, undated
Paris, Musée Gustave Moreau

576 (cat. 280)
Gustave MOREAU
Abstract Composition with Corners Cut Off, undated
Paris, Musée Gustave Moreau

577 (cat. 76)
Robert DELAUNAY
Three-part Windows
1912
Oil on canvas
35.6 x 91.8 cm
Philadelphia Museum of Art

In 1912, Delaunay, who had recently taken part in the first "Blue Rider" exhibition and was deeply interested in the group's investigations into the analogies between music and painting, wrote to Kandinsky: "I am still expecting to ease the laws I have discovered, based on my explorations into colour transparency, comparable to musical notes, which prompted me to recognize the *movement of colour*." An avid reader of Mallarmé, Delaunay undertook that same year a major series of paintings that he called "Windows", alluding to a poem by Mallarmé dating from 1863. Henceforth oriented towards "pure painting", in which the constructive and expressive powers of colour would be fused, Delaunay's approach showed its Symbolist antecedents in its use of the window motif as a means of communication between inner and outer experience. Through his simultaneously perceived variations on the prism, the artist brings us into contact with the whole Cosmos.

C. N.-R.

578 (cat. 112)
Charles FILIGER
Chromatic Notations, undated
Paris, Musée du Louvre

579 (cat. 113)
Charles FILIGER
Chromatic Notations, undated
Paris, Musée du Louvre

580 (cat. 428)
Louis Comfort TIFFANY
"Cypriote" Vase, about 1895
New York, The Museum of Modern Art

581 (cat. 429)
Louis Comfort TIFFANY
Vase, about 1900
New York, The Museum of Modern Art

582 (cat. 250)
Johann LÖETZ-WITWE
Vase, 1900-1901
Kunstmuseum Düsseldorf im Ehrenhof

583 (cat. 9)
Giacomo BALLA
Street Light, 1909
New York, The Museum of Modern Art

List of Works Exhibited

1 (ill. **59**)
John White ALEXANDER
1856-1915
Isabella and the Pot of Basil, 1897
Oil on canvas; 191.8 x 89.5 cm
Museum of Fine Arts, Boston, gift of Ernest
Wadsworth Longfellow

2 (ill. **439**)
Cuno AMIET
1868-1961
Hope (or *The Ephemeral*), 1902
Polyptych: (centre panel) tempera on cardboard,
64.5 x 47 cm; (upper panel) tempera on card-
board, 11.5 x 47 cm; (side panels) tempera on
wood, 79.5 x 19.5 cm (each)
Olten, Switzerland, Kunstmuseum

3 (ill. **202**)
Jean-Barnabé AMY
1839-1907
Crime Asleep, about 1870-1880
Terra-cotta; 60 x 50 x 9 cm
Marseilles, Musée des Beaux-Arts

4 (ill. **504**)
James Craig ANNAN
1864-1946
The Church or the World, 1893
Photogravure; 10.5 x 12 cm
New York, The Metropolitan Museum of Art,
Alfred Stieglitz Collection, 1933, inv. 33.43.243

5 (ill. **296**)
ANONYMOUS
Loie Fuller Dancing, undated
Kallitype print; 16.5 x 12 cm
Paris, Musée Rodin, inv. Ph1538

6 (ill. **297**)
ANONYMOUS
Loie Fuller Dancing, before 1906
Kallitype print; 15.5 x 11.4 cm
Paris, Musée Rodin, inv. Ph1674

7 (ill. **145**)
Ivar AROSENIUS
1878-1919
Self-portrait with Floral Wreath, 1906
Watercolour, gouache; 31 x 16 cm
Stockholm, Nationalmuseum

8 (ill. **538**)
Charles Robert ASHBEE
1863-1942
Salt Cellar, 1899-1900
Silver, amber; 17.1 x 5.6 cm
London, The Board of Trustees of the
Victoria and Albert Museum

9 (ill. **583**)
Giacomo BALLA
1871-1958
Street Light (Light Study), 1909
Oil on canvas; 174.7 x 114.7 cm
New York, The Museum of Modern Art,
Hillman Periodicals Fund, 1954

10 (ill. **372** to **386**)
Aubrey BEARDSLEY
1872-1898
*Fifteen Prints Illustrating Oscar Wilde's
"Salomé"*, 1907
Line block; 34.5 x 28 cm

 372 *The Woman in the Moon
 (frontispiece)*
 373 *Cover Design*
 374 *The Peacock Skirt*
 375 *The Black Cape*
 376 *A Platonic Lament*
 377 *John and Salome*
 378 *Enter Herodias*
 379 *The Eyes of Herod*
 380 *The Stomach Dance*
 381 *The Toilette of Salome I*
 382 *The Toilette of Salome II*
 383 *The Dancer's Reward*
 384 *The Climax*
 385 *Salome on Settle*
 386 *Cul de lampe*
Toronto, Royal Ontario Museum,
gift of W.C.C. Van Horne

11 (ill. **46**)
Aubrey BEARDSLEY
*Frontispiece for Volume I of "Le Morte
d'Arthur"*, 1893
 *How King Arthur Saw the Questing Beast
 and Thereof Had Great Marvel*
Pen and ink, wash; 37.8 x 27 cm
London, The Board of Trustees of the
Victoria and Albert Museum

12 (ill. **26**)
Aubrey BEARDSLEY
"Siegfried", Act II, 1893
Ink, wash; 40 x 28.6 cm
London, The Board of Trustees of the
Victoria and Albert Museum

13 (ill. **28**)
Aubrey BEARDSLEY
The Fourth Tableau of "Das Rheingold",
1896
India ink; 30.4 x 21.9 cm
London, The Board of Trustees of the
Victoria and Albert Museum

14 (ill. **27**)
Aubrey BEARDSLEY
The Third Tableau of "Das Rheingold",
1896
Pen and ink; 25.4 x 17.8 cm
Providence, Rhode Island School of Design,
Museum of Art, Museum Appropriation, 31.361

15 (ill. **529**)
Émile BERNARD
1868-1941
*"The Four Seasons" Screen ("Les Quatre
saisons")*, 1891
Tempera on canvas; four panels: 171 x 62 cm
(each)
Private collection

16 (ill. **135** to **140**)
Valère BERNARD
1860-1936
Six Engravings
 135 *The Sphinx*, 1896; 50 x 32 cm
 136 *A Man in Bed with a Skeleton
 (The Succubus)*, about 1897;
 20.5 x 26.8 cm
 137 *Figures (Medusa), (Infernal Proces-
 sion)*, about 1893; 63 x 40 cm
 138 *Nightmare*, 1897; 39.8 x 26.1 cm
 139 *Study for a . . . Lesson (A Lesson
 from the Devil)*, 1895; 36.7 x
 24.5 cm
 140 *Horned Woman with Claws (Perver-
 sion)*, undated; 15 x 10.6 cm
Marseilles, Musée des Beaux-Arts

17 (ill. **6**)
Pierre-Amédée MARCEL-BÉRONNEAU
1869-1937
Orpheus in Hades, 1899
Oil on canvas; 197 x 163 cm
Marseilles, Musée des Beaux-Arts

18 (ill. **304**)
Boleslas BIÉGAS
1877-1954
Chopin, 1902
Bronze; 148 x 90 x 40 cm
Paris, Galerie Elstir-Audouy

19 (ill. **82**)
František BÍLEK
1872-1941
Crucified, 1899
Wood; 163.5 x 60 x 18 cm
Prague, Národní galerie

20 (ill. **544**)
František BÍLEK
Oh Mother!, 1899
Charcoal; 139 x 83 cm
Prague, Národní galerie

21 (ill. **482**)
Thorvald BINDESBØLL
1846-1908
Beaker, about 1900
Silver; h.: 13 cm
Copenhagen, Museum of Decorative Art

22 (ill. **537**)
Thorvald BINDESBØLL
Large Plate, 1900
Glazed earthenware; diam.: 46.5 cm
Copenhagen, Museum of Decorative Art

23 (ill. **15**)
Arnold BÖCKLIN
1827-1901
The Silence of the Forest, 1885
Oil on wood; 73 x 59 cm
National Museum of Poznań

24 (ill. **367**)
Arnold BÖCKLIN
Dying Cleopatra, 1872
Oil on canvas; 76 x 61.5 cm
Kunstmuseum Basel, Oeffentliche Kunst-
sammlung

25 (ill. **178**)
Arnold BÖCKLIN
Ruins by the Sea, 1880
Oil on canvas; 100.5 x 142 cm
Gottfried Keller Foundation, on deposit at the
Aargauer Kunsthaus, Aarau

26 (ill. **141**)
Arnold BÖCKLIN
*Self-portrait with Death Playing
the Fiddle*, 1872
Oil on canvas; 75 x 61 cm
Berlin, Nationalgalerie, Staatliche Museen
Preussischer Kulturbesitz

27 (ill. **8**)
Luigi BONAZZA
1877-1965
The Legend of Orpheus, 1905
Oil on canvas; triptych: (centre panel) 146 x
166.5 cm; (side panels) 145 x 76 cm (each)
Società SOSAT, on deposit at the Museo d'Arte
moderna e Contemporanea di Trento e Roverano

28 (ill. **221**)
Paul BÖRNER
1888-1970
and Meissen Porcelain Manufactory
Head of a Woman: Awakening, 1911-1912
Porcelain; 27 x 19 x 21 cm
Badisches Landesmuseum Karlsruhe

29 (ill. **464**)
Anne W. BRIGMAN
1869-1916
The Heart of the Storm, about 1915
Gelatin silver print; 24.2 x 19.2 cm (image)
New York, The Metropolitan Museum of Art,
Alfred Stieglitz Collection, 1933, inv. 33.43.129

30 (ill. **115**)
Anne W. BRIGMAN
The Spider's Web, 1908
Gelatin silver print; 25 x 17.2 cm (image)
New York, The Metropolitan Museum of Art,
Alfred Stieglitz Collection, 1933, inv. 33.43.123

31 (ill. **511**)
Anne W. BRIGMAN
The Spirit of Photography, 1907
Platinum print; diam.: 19.4 cm
Bath, The Royal Photographic Society

32 (ill. **448**)
Ford Madox BROWN
1821-1893
Take Your Son, Sir, 1867
Oil on canvas; 70.5 x 38 cm
London, Tate Gallery, gift of Miss Emily Sargent
and Mrs. Ormond in memory of their brother
John S. Sargent, 1929

33 (ill. **71**)
Vladimír Jindrich BUFKA
1887-1916
Evening Train, 1911
Gum print; 35.1 x 23.7 cm
Brno, Czech Republic, Moravaská galerie

34 (ill. **280**)
Edward BURNE-JONES
1833-1898
Sketch for "The Baleful Head", about 1872
Red chalk; 80 x 60 cm (approx.)
New York, Stuart Pivar collection

35 (ill. **224**)
Edward BURNE-JONES
Souls on the Banks of the River Styx,
about 1873
Oil on canvas; 89 x 69.8 cm
London, Peter Nahum at the Leicester Galleries

36 (ill. **199**)
Edward BURNE-JONES
*The Prince Enters the Wood (The "Briar
Rose" Series)*, 1870-1873
Oil on canvas; 61 x 129.5 cm
Ponce, Puerto Rico, Museo de Arte de Ponce,
The Luis A. Ferré Foundation, Inc.

37 (ill. **270**)
Edward BURNE-JONES
The Love Song, 1868-1877
Oil, some gold paint, on canvas;
114.3 x 155.9 cm
New York, The Metropolitan Museum of Art,
The Alfred N. Punnett Endowment Fund, 1947

38 (ill. **23**)
Edward BURNE-JONES
The Sirens, 1870-1895/98
Oil on canvas; 213.4 x 305.9 cm
Sarasota, Florida, The John and Mable Ringling
Museum of Art

39 (ill. **19**)
Edward BURNE-JONES
*The Story of Perseus (Studies for the
decoration of Lord Balfour's music room)*,
1875-1876
Watercolour
 The Finding of Medusa, 25 x 23 cm
 Birth of Pegasus and Chrysaor,
 24.2 x 19 cm
 Death of Medusa, 25 x 38 cm
London, Tate Gallery, presented by the Trustees
of the Chantrey Bequest, 1919

40 (ill. **212**)
Julia Margaret CAMERON
1815-1879
The Dream, 1869
Albumen print; 30 x 24.5 cm
London, The Board of Trustees of the
Victoria and Albert Museum

41 (ill. **79**)
Julia Margaret CAMERON
The Shadow of the Cross, 1865
Albumen print; 27 x 36.5 cm
London, The Board of Trustees of the
Victoria and Albert Museum

42 (ill. **404**)
François Rupert CARABIN
1862-1921
Inkwell, 1900-1901
Bronze, onyx; 28.9 x 23.5 x 22.9 cm
Richmond, Virginia Museum of Fine Arts,
gift of Lloyd and Barbara Macklowe

43 (ill. **458**)
Eugène CARRIÈRE
1849-1906
The First Communion, about 1896
Oil on canvas; 65.4 x 53.4 cm
New York, The Metropolitan Museum of Art,
gift of Chester Dale, 1963

44 (ill. **153**)
Jean CARRIÈS
1855-1894
Self-portrait, 1889
Glazed stoneware; 27.8 x 17.8 x 13.4 cm
Museum für Kunst und Gewerbe Hamburg

45 (ill. **356**)
Jean CARRIÈS
Le Grenouillard, about 1891
Glazed stoneware; 31 x 36 x 38 cm
Paris, Musée d'Orsay

46 (ill. **478**)
Hans CHRISTIANSEN
1866-1945
Brooch, about 1901
Gold, diamonds, sapphire, enamel; 6.5 x 6 cm
Württembergisches Landesmuseum Stuttgart

47 (ill. **147**)
Alvin Langdon COBURN
1882-1966
*Portrait of F. Holland Day in the
Darkroom*, 1900
Gum-platinum print; 29.3 x 18.2 cm
Bath, The Royal Photographic Society

48 (ill. **159**)
Alvin Langdon COBURN
Self-portrait, about 1905
Platinum print; 24 x 19.1 cm
Rochester, New York, George Eastman House
collection

49 (ill. **169**)
Alvin Langdon COBURN
The Haunted House, 1904
Gum-platinum print; 18.7 x 23.2 cm
Bath, The Royal Photographic Society

50 (ill. **475**)
Edward COLONNA
1862-1948
Sugar Spoon, about 1900
Pierced, chased and gilt silver; 14.5 x 5 cm
Paris, Musée des Arts décoratifs

51 (ill. **116**)
Lovis CORINTH
1858-1925
Cain, 1911
Etching; 44.8 x 33.7 cm
The Montreal Museum of Fine Arts, purchase,
Mr. and Mrs. Gerald Bronfman Fund for Master
Graphics

52 (ill. **49** to **57**)
Walter CRANE
1845-1915
*Nine Illustrations for Edmund
Spenser's "Faerie Queene"*
Pen, brush and India ink over traces of pencil,
opaque white highlights, on heavy wove paper

51 *"Guyon encountreth Britomart: /
Fayre Florimell is chaced"* (Book III,
Canto i), before 1895; 27.3 x 22.8 cm

53 *"Where when confusedly they came,
they found / Their Lady lying on the
senseless ground"* (Book III, Canto i,
63.4), about 1895; 27.4 x 22.7 cm

49 *"The Redcrosse Knight to Britomart /
Describeth Artegall"* (Book III, Canto
ii), before 1895; 28.3 x 22.6 cm

52 *"Merlin bewrayes to Britomart / The
state of Artegall"* (Book III, Canto
iii), before 1895; 28.3 x 22.5 cm

50 *"In th'evening late old Glaucé thith-
er led / Faire Britomart, and that
same Armory"* (Book III, Canto iii,
59.7), before 1895; 28.3 x 22.9 cm

57 *"Artegall trayn'd in Justice lore /
Irenes quest pursewed"* (Book V,
Canto i), before 1896; 28.7 x 22.3 cm

55 *"The Spousals of faire Florimell, /
Where turney many Knights"*
(Book V, Canto iii), 1865(?)-1866;
28.7 x 22.4 cm

54 *"Artegall dealeth right betwixt /
Two brethren that doe strive"* (Book V,
Canto iv), before 1896; 28.4 x 22.3 cm

56 *"Artegall fights with Radigund, /
And is subdewed by guile"* (Book V,
Canto v), about 1896; 28.4 x 22.1 cm
Ottawa, National Gallery of Canada

53 (ill. **295**)
Walter CRANE
The Horses of Neptune, 1892
Oil on canvas; 86 x 215 cm
Munich, Neue Pinakothek, Bayerische Staats-
gemäldesammlungen

54 (ill. **487**)
Henry CROS
1840-1907
Incantation, 1892
Pâte-de-verre relief; 33.1 x 23 cm
The Cleveland Museum of Art, James Parmelee
Fund, inv. 69.24

55 (ill. **402**)
Pierre Adrien DALPAYRAT
1844-1910
"La Nuit" Jug, 1894
Glazed stoneware; 27.8 x 19.2 cm
Württembergisches Landesmuseum Stuttgart

56 (ill. **16**)
Arthur B. DAVIES
1862-1928
Unicorns, about 1906
Oil on canvas; 46.4 x 102.2 cm
New York, The Metropolitan Museum of Art,
bequest of Lizzie P. Bliss, 1932

57 (ill. **428**)
F. Holland DAY
1864-1933
Boy Embracing the Herm of Pan,
1905 or later
Platinum print; triptych: 23.8 x 19.5 cm (total)
Washington, Library of Congress, Prints and
Photographs Division

58 (ill. **88**)
F. Holland DAY
Christ's Entombment, 1898
Platinum print; two images mounted on one
sheet: 9.5 x 16.1 cm; 4.3 x 15.3 cm
Bath, The Royal Photographic Society

59 (ill. **494**)
F. Holland DAY
Ebony and Ivory, 1897
Platinum print; 18.3 x 20 cm (image)
New York, The Metropolitan Museum of Art,
Alfred Stieglitz Collection, 1933, inv. 33.43.166

60 (ill. **218**)
F. Holland DAY
Hypnos, 1896-1897
Platinum print; 16.1 x 11.3 cm
Bath, The Royal Photographic Society

61 (ill. **429**)
F. Holland DAY
Male Nude in Shadow, 1910
Platinum print; 24.2 x 19 cm
Bath, The Royal Photographic Society

62 (ill. **11**)
F. Holland DAY
*Untitled (Silhouetted Youth Standing
on Boulder at Shore)*, 1905
Combination print; 23.3 x 18.8 cm
Washington, Library of Congress, Prints and
Photographs Division

63 (ill. **10**)
F. Holland DAY
Nude Youth with Lyre in Grotto, 1907
Combination print; 23.7 x 19 cm
Washington, Library of Congress, Prints and
Photographs Division

64 (ill. **149**)
F. Holland DAY
Portrait of Maurice Maeterlinck with Crystal Ball, 1901
Platinum print; 12.6 x 8.2 cm
Bath, The Royal Photographic Society

65 (ill. **498**)
F. Holland DAY
Reclining Youth on Boulder with Tortoises, about 1905
Platinum print; 24.5 x 19.2 cm
Washington, Library of Congress, Prints and Photographs Division

66 (ill. **496**)
F. Holland DAY
Saint Sebastian, 1906
Platinum print; 19.9 x 16.6 cm
Bath, The Royal Photographic Society

67 (ill. **430**)
F. Holland DAY
The Prodigal, 1909
Platinum print; triptych: 19.5 x 31.7 cm (total)
Washington, Library of Congress, Prints and Photographs Division

68 (ill. **495**)
F. Holland DAY
The Storm God, 1905
Platinum print; 24.1 x 19.4 cm
Bath, The Royal Photographic Society

69 (ill. **9**)
F. Holland DAY
The Vision ("Orpheus" Series), 1907
Platinum print; 23.9 x 18.7 cm
Bath, The Royal Photographic Society

70 (ill. **497**)
F. Holland DAY
Youth with Staff Shading His Eyes, 1906
Platinum print; 23.5 x 19 cm
Washington, Library of Congress, Prints and Photographs Division

71 (ill. **87**)
F. Holland DAY
The Seven Last Words of Christ, 1898
Seven platinum prints; 13 x 10 cm (each)
Norwood, Massachusetts, Norwood Historical Society, F. Holland Day House

72 (ill. **288**)
Georges DE FEURE
1868-1928
Melancholy: The Voice of Evil, 1895-1896
Gouache on paper; diam.: 52 cm
Paris, Alain Lesieutre collection

73 (ill. **170**)
William DEGOUVE DE NUNCQUES
1867-1935
The Canal, 1894
Oil on canvas; 39.1 x 118.1 cm
Otterlo, The Netherlands, Kröller-Müller Museum

74 (ill. **99**)
Henry DE GROUX
1867-1939
The Auto-da-fé, undated
Oil on canvas; 127 x 90 cm
Toronto, Joey and Toby Tanenbaum collection

75 (ill. **80**)
Henry DE GROUX
The Mocking of Christ (Study), 1889
Lithograph, highlighted with charcoal, pastel, gouache and coloured pencil, mounted on canvas; 75 x 100 cm
Avignon, Palais du Roure, Fondation Flandreysy-Espérandieu

76 (ill. **76**)
Robert DELAUNAY
1885-1941
Three-part Windows, 1912
Oil on canvas; 35.6 x 91.8 cm
Philadelphia Museum of Art, The A. E. Gallatin Collection

77 (ill. **437**)
Jean DELVILLE
1867-1953
The Love of Souls, 1900
Egg tempera on canvas; 238 x 150 cm
Brussels, Musée d'Ixelles

78 (ill. **500**)
Adolph DE MEYER
1868-1946
Nijinsky in "L'Après-midi d'un faune", 1910s (printed about 1978 by Richard Benson)
Thirty-three palladium prints in bound portfolio; 46.5 x 40 cm (portfolio)
New York, The Metropolitan Museum of Art, John J. McKendry Fund, 1978, inv. 1978.573.2

79 (ill. **510**)
Adolph DE MEYER
Waterlilies, 1908
Platinum print; 16.4 x 22.4 cm
Bath, The Royal Photographic Society

80 (ill. **462**)
Maurice DENIS
1870-1943
Mystical Allegory, or *The Cup of Tea*, 1892
Oil on canvas; 46 x 55 cm
Private collection

81 (ill. **92**)
Maurice DENIS
A Tree-lined Road, about 1891
Oil on cardboard; 28 x 19 cm
Saint-Germain-en-Laye, Musée départemental Maurice Denis « Le Prieuré »

82 (ill. **461**)
Maurice DENIS
They Saw Fairies Landing on the Beaches, about 1893
Oil on cardboard; 22 x 30 cm
Private collection

83 (ill. **91**)
Maurice DENIS
The Sacred Heart Crucified, 1894
Oil on canvas; 131 x 61 cm
Private collection

84 (ill. **93**)
Maurice DENIS
Easter Morning, 1893
Oil on canvas; 35 x 27 cm
Private collection

85 (ill. **463**)
Maurice DENIS
"Dove" Screen, about 1896
Oil on canvas; four panels: 164 x 54 cm (each)
Private collection

86 (ill. **370**)
František DRTIKOL
1883-1961
Salome, 1912-1913
Bromide print; 27.6 x 19.7 cm
Museum of Decorative Arts in Prague

87 (ill. **121**)
František DRTIKOL
Study of the Crucifixion, about 1914
Bromide print; 22.5 x 17 cm
Museum of Decorative Arts in Prague

88 (ill. **72**)
Pierre DUBREUIL
1872-1946
Ferris Wheel, 1900-1905
Silver print; 20.6 x 18.9 cm
Paris, Musée d'Orsay

89 (ill. **89**)
Pierre DUBREUIL
The Entombment of Christ, 1900
Gum print; triptych: (centre panel) 24.9 x 30.7 cm; (side panels) 25 x 14.7 cm; 24.8 x 14.7 cm
Museum für Kunst und Gewerbe Hamburg

90 (ill. **571**)
Marcel DUCHAMP
1887-1968
The Bush, 1910-1911
Oil on canvas; 127 x 92 cm
Philadelphia Museum of Art, Louise and Walter
Arensberg collection

91 (ill. **210**)
Otto ECKMANN
1865-1902
"Pond in Moonlight" Wall Hanging,
1896-1897
Wool tapestry; 267 x 165 cm
Museum für Kunst und Gewerbe Hamburg

92 (ill. **274**)
Halfdan EGEDIUS
1877-1899
Play and Dance, 1896
Oil on canvas; 83 x 95.5 cm
Oslo, Nasjonalgalleriet

93 (ill. **501**)
Georg EINBECK
1871-1951
Silence, 1898
Blue-grey gum print; 45.5 x 33 cm
Museum für Kunst und Gewerbe Hamburg

94 (ill. **434**)
Magnus ENCKELL
1870-1925
Awakening, 1894
Oil on canvas; 113 x 86 cm
Helsinki, Ateneum, Antell collection

95 (ill. **157**)
Magnus ENCKELL
Head, 1894
Oil on canvas; 81.5 x 57 cm
Helsinki, Ateneum

96 (ill. **490**)
August ENDELL
1871-1925
Chest, 1899
Elm, iron; 45 x 136 x 74 cm
Munich, Münchner Stadtmuseum

97 (ill. **101**)
James ENSOR
1860-1949
*Demons Teasing Me (Poster for the Salon
des XX)*, 1889
Lithograph with watercolour; 25.5 x 14.5 cm
The Hearn Family Trust

98 (ill. **100**)
James ENSOR
*Satan and His Fantastic Legions
Tormenting the Crucified Christ*, 1886
Charcoal, black chalk and pencil on paper,
mounted on japan paper; 61.3 x 75.8 cm
Brussels, Musées royaux des Beaux-Arts
de Belgique

99 (ill. **250**)
James ENSOR
Skeleton Looking at Chinoiseries, 1885
Oil on canvas; 99.7 x 64.5 cm
New York, The Solomon R. Guggenheim Museum

100 (ill. **323**)
Prins EUGEN
1865-1947
The Forest, 1892
Oil on canvas, 150 x 100.5 cm
Göteborg, Sweden, Göteborgs Konstmuseum

101 (ill. **101**)
Frank EUGENE (Smith)
1865-1936
Adam and Eve, 1898
Platinum print; 16.9 x 11.9 cm (image)
New York, The Metropolitan Museum of Art,
Alfred Stieglitz Collection, 1949, inv. 49.55.250

102 (ill. **303**)
Frank EUGENE (Smith)
Dance Study of Fritzi von Derra,
about 1905
Platinum print; 18.8 x 14 cm
Munich, Fotomuseum im Münchner
Stadtmuseum

103 (ill. **272**)
Frank EUGENE (Smith)
Music (Summer), 1899
Platinum print; 19.7 x 7.3 cm
Munich, Fotomuseum im Münchner
Stadtmuseum

104 (ill. **519**)
Frank EUGENE (Smith)
Song of the Lily, 1897
Platinum print; 17 x 12.1 cm (image)
New York, The Metropolitan Museum of Art,
Alfred Stieglitz Collection, 1933, inv. 33.43.66

105 (ill. **228**)
Frank EUGENE (Smith)
The Lady of Shalott, about 1899
Platinum print; 23.8 x 17.7 cm
Munich, Fotomuseum im Münchner
Stadtmuseum

106 (ill. **182**)
Frederick EVANS
1853-1943
*A Sea of Steps (Wells Cathedral: Stairs
to Chapter House and Bridge to Vicar's
Close)*, 1900
Platinum print; 23.6 x 18.9 cm
Bath, The Royal Photographic Society

107 (ill. **158**)
Frederick EVANS
*Portrait of Aubrey Beardsley: "A face
like a silver hatchet"*, 1895
Platinum print; 13.1 x 9.6 cm
Bath, The Royal Photographic Society

108 (ill. **543**)
Émile FABRY
1865-1966
Man Contemplating His Destiny, 1897
Oil on canvas; 52.5 x 66 cm
The Montreal Museum of Fine Arts, Marjorie
Caverhill Bequest

109 (ill. **24**)
Henri Jean Théodore FANTIN-LATOUR
1836-1904
The Invocation of Erda, 1876
Lithograph; 28.6 x 37.3 cm
Paris, Bibliothèque nationale de France,
Cabinet des estampes

110 (ill. **25**)
Henri Jean Théodore FANTIN-LATOUR
Prelude to "Lohengrin", 1892
Oil on canvas; 102 x 71 cm
Private collection

111 (ill. **86**)
Charles FILIGER
1863-1928
Christ in the Tomb, about 1895
Gouache on cardboard; 18 x 35 cm
Saint-Germain-en-Laye, Musée départemental
Maurice Denis « Le Prieuré »

112 (ill. **578**)
Charles FILIGER
Chromatic Notations, undated
Watercolour and gouache over pencil traces;
23.6 x 29.5 cm
Paris, Musée du Louvre, département des Arts
graphiques (fonds du Musée d'Orsay)

113 (ill. **579**)
Charles FILIGER
Chromatic Notations, undated
Watercolour and gouache over pencil traces;
23.3 x 31 cm (sheet)
Paris, Musée du Louvre, département des Arts
graphiques (fonds du Musée d'Orsay)

114 (ill. **39**)
Alexander FISHER
1864-1936
"Wagner" Girdle (with plaques depicting
The Death of Tristan, Lohengrin, Siegmund and
Siegelinde, The Rhine Maidens, Fafner,
Tannhäuser, Tristan and Isolde, and The Love
Potion), 1896
Steel, enamel; 9.8 x 56.5 cm
London, The Board of Trustees of the
Victoria and Albert Museum

115 (ill. **309**)
Gustaf FJAESTAD
1868-1948
Running Water, 1906
Wool tapestry; 203 x 312 cm
Göteborg, Sweden, Göteborgs Konstmuseum

116 (ill. **421**)
E. Reginald FRAMPTON
1870-1923
Flora of the Alps, before 1918
Tempera on wood; 44.8 x 98.4 cm
Birmingham Museum and Art Gallery

117 (ill. **142**)
Léon FRÉDÉRIC
1856-1940
Studio Interior, 1882
Oil on canvas, mounted on panel; 158 x 117 cm
Brussels, Musée d'Ixelles

118 (ill. **364**)
Léon FRÉDÉRIC
Nature, 1897
Oil on canvas; 166 x 91 cm
Private collection

119 (ill. **368**)
Jacques GALLAND
d. 1922
Stained Glass Window, 1900
Stained glass; 225 x 92.5 cm
Zurich, Bellerive Museum

120 (ill. **352**)
Émile GALLÉ
1818-1904
"Dragonfly" Coupe, 1903
Blown colourless and polychrome glass, metal
foil and glass inclusions, hot glass and silver
nitrate applications, marquetry, wheel-carved
and engraved; h.: 18.3 cm; diam.: 19.7 cm
Corning, New York, The Corning Museum of
Glass, gift of Benedict Silverman in memory
of Gerry Lou Silverman

121 (ill. **481**)
Émile GALLÉ
Large Vase with Bursting Fruit,
1884-1889
Earthenware, polychrome decoration, gold
highlights; h.: 54 cm; diam.: 26 cm (opening)
Musée de l'École de Nancy

122 (ill. **350**)
Émile GALLÉ
"Hypocampes" Vase, about 1901
Blown and shaped layered glass, applied glass
decoration, patina; 18.7 x 15 cm
Kunstmuseum Düsseldorf im Ehrenhof

123 (ill. **311**)
Émile GALLÉ
"Les feuilles des douleurs passées" Vase,
1900
Blown three-layered glass, gold and platinum
inclusions, inlaid etched glass decoration,
patina; 14.3 x 12.8 cm
Kunstmuseum Düsseldorf im Ehrenhof

124 (ill. **361**)
Émile GALLÉ
"Orchid" Vase, 1900
Blown crystal, applied, engraved and cut decora-
tion, glued glass beads; 23.5 x 14.5 x 10.5 cm
Château-musée de Boulogne-sur-Mer

125 (ill. **177**)
Akseli GALLEN-KALLELA
1865-1931
Autumn, 1902
Oil on canvas; 75 x 144 cm
Private collection

126 (ill. **41**)
Akseli GALLEN-KALLELA
Lemminkäinen's Mother, 1897
Tempera on canvas; 85 x 118 cm
Helsinki, Ateneum, Antell collection

127 (ill. **330**)
Akseli GALLEN-KALLELA
The Defence of the Sampo (Sketch), 1895
Gouache on paper; 32.8 x 24.5 cm
Turku, Finland, Turku Art Museum

128 (ill. **492**)
Antonio GAUDÍ
1852-1926
Armchair, 1902-1904
Walnut; 96.5 x 64.8 x 52.1 cm
New York, The Metropolitan Museum of Art,
Hazen Fund, 1974

129 (ill. **81**)
Paul GAUGUIN
1849-1903
Young Christian Girl, 1894
Oil on canvas; 65.2 x 46.7 cm
Williamstown, Massachusetts, Sterling and
Francine Clark Art Institute, purchased in
honour of Harding F. Bancroft, Institute Trustee
1970-1987, President 1977-1987

130 (ill. **405**)
Paul GAUGUIN
Lust, 1890
Wood, partially painted, gilt; h.: 70 cm (approx.)
Frederikssund, Denmark, J.F. Willumsens
Museum

131 (ill. **310**)
Paul GAUGUIN
*The Drama of the Sea (Descent into the
Maelstrom)*, 1889
Lithograph on zinc, printed in black on yellow
paper; 49.7 x 64.9 cm
Northampton, Massachusetts, Smith College
Museum of Art, gift of Selma Erving '27, 1977

132 (ill. **107**)
Paul GAUGUIN
Parau na te varua ino (Words of the Devil),
1892
Oil on canvas; 91.7 x 68.5 cm
Washington, National Gallery of Art, gift of the
W. Averell Harriman Foundation in memory of
Marie N. Harriman, 1972

133 (ill. **450**)
Giovanni GIACOMETTI
1868-1934
*Mother and Child under a Blossoming
Tree*, 1900
Oil on canvas; 100 x 80 cm
Chur, Switzerland, Bündner Kunstmuseum

134 (ill. **119**)
Eugène GRASSET
1841-1917
Three Women with Three Wolves,
about 1892
Watercolour, gold; 54 x 40 cm
Paris, Musée des Arts décoratifs

135 (ill. **211**)
Eugène GRASSET
and **Maison Vever**
"Apparitions" Brooch, 1900
Repoussé gold, translucent and opaque
cloisonné enamel, ivory, topaz cabochons;
6.2 x 3.9 x 1.3 cm
Paris, Musée d'Orsay

136 (ill. **489**)
Hector GUIMARD
1872-1923
Balcony Railing, 1905-1907
Cast iron; 29.3 x 162.5 x 101.9 cm
New York, The Museum of Modern Art,
Phyllis B. Lambert Fund

137 (ill. **474**)
Hector GUIMARD
Brooch, about 1909
Gold, agate, pearls, moonstones; 6.7 x 9.5 cm
New York, The Museum of Modern Art,
gift of Laurent Oppenheim, Jr.

138 (ill. **491**)
Hector GUIMARD
Three-legged Side Table, about 1904-1907
Pearwood; 75.9 x 52.1 x 45.6 cm
New York, The Museum of Modern Art,
gift of Mme Hector Guimard

139 (ill. **536**)
Hector GUIMARD
Vase, 1900-1902
Bronze; 26.6 x 19.1 x 17.1 cm
Richmond, Virginia Museum of Fine Arts,
gift of Lloyd and Barbara Macklowe

140 (ill. **473**)
Gustav GURSCHNER
1873-1970
Table Lamp, undated
Bronze, *Turbo Marmoratus* shell; h.: 54.6 cm
New York, Barbara and Lloyd Macklowe
collection

141 (ill. **190**)
Vilhelm HAMMERSHØI
1864-1916
Dust Motes Dancing in the Sunlight,
1900
Oil on canvas; 70 x 59 cm
Copenhagen, Ordrupgaardsamlingen

142 (ill. **73**)
Melvin Ormond ("Ivanhoe") HAMMOND
1876-1934
The Hand of Man, 1909
Bromide print; 10.3 x 23.6 cm
Toronto, Art Gallery of Ontario, gift of Mr. Skip
Gillham, Vineland, Ontario, 1985

143 (ill. **471**)
Walter HAMPEL
1868-1949
Biedermeier Interior, 1900
Oil on canvas; 60 x 80 cm
Vienna, Österreichische Galerie

144 (ill. **471**)
Frida HANSEN
1855-1931
The Dance of Salome, 1900
Wool tapestry; 193 x 682 cm
Zurich, Bellerive Museum

145 (ill. **560** to **563**)
Thomas von HARTMANN
1885-1956
Scenic Composition "Noir et blanc", after
Kandinsky, about 1909
Pencil, gouache, India ink, crayon; four sheets
framed together: 11.7 x 15.2 cm; 11.7 x
15.4 cm; 11.6 x 15.5 cm; 11.6 x 14.8 cm
Paris, Musée national d'Art moderne, centre
Georges-Pompidou, bequest of Nina Kandinsky

146 (ill. **534**)
Ferdinand HAUSER
1864-1919
Brooch, about 1910
Gold, silver, enamel, moonstone; diam.: 4.3 cm;
length of pendants: 1.8-2.3 cm
Württembergisches Landesmuseum Stuttgart

147 (ill. **469**)
Louis Welden HAWKINS
1849-1910
The Innocence, about 1895
Oil on canvas; 73 x 50.4 cm
Amsterdam, Van Gogh Museum

148 (ill. **173**)
Louis Welden HAWKINS
Le Foyer, about 1899
Oil on canvas; 183 x 90 cm
Nantes, Musée des Beaux-Arts

149 (ill. **220**)
Louis-Philippe HÉBERT
1850-1917
The Nicotine Sprite, 1902
Gilt bronze, marble base;
53.20 x 26.40 x 15.30 cm
The Montreal Museum of Fine Arts, purchase,
Horsley and Annie Townsend Bequest

150 (ill. **108**)
Thomas HEINE
1867-1948
Angel, about 1905
Cast metal; h.: 45 cm
Frankfurt, Museum für Kunsthandwerk

151 (ill. **109**)
Thomas HEINE
Devil, about 1902
Bronze; h.: 41 cm
Private collection

152 (ill. **181**)
Hugo HENNEBERG
1863-1918
Villa Adriana, 1901
Gum print; 71.3 x 46.8 cm
Museum Folkwang Essen

153 (ill. **42**)
George HENRY
1858-1943
and **Edward Atkinson HORNEL**
1864-1933
The Druids: Bringing in the Mistletoe,
1890
Oil on canvas; 152.5 x 152.4 cm
Glasgow Museums, Art Gallery and Museum,
Kelvingrove

154 (ill. **423**)
Ferdinand HODLER
1853-1918
Adoration I (Standing Boy), 1893
Oil on canvas; 106 x 70 cm
Gottfried Keller Foundation, on deposit at the
Kunsthaus Zürich

155 (ill. **422**)
Ferdinand HODLER
Adoration III, 1895-1896
Oil on canvas; 84 x 37.5 cm
Gottfried Keller Foundation, on deposit at the
Kunsthaus Zürich

156 (ill. **234**)
Ferdinand HODLER
Augustine Dupin on Her Deathbed, 1909
Oil on canvas; 76 x 90 cm
Kunstmuseum Solothurn, Dübi-Müller
Foundation

157 (ill. **548**)
Ferdinand HODLER
Lake Geneva Seen from Chexbres, 1908
Oil on canvas; 80 x 100.5 cm
Geneva, Musée d'art et d'histoire

158 (ill. **278**)
Ferdinand HODLER
Song from Afar, 1906
Oil on canvas; 140 x 120 cm
Kunstmuseum St. Gallen

159 (ill. **277**)
Ferdinand HODLER
Silence of the Evening, 1904-1905
Oil on canvas; 100 x 80 cm
Kunstmuseum Winterthur

160 (ill. **209**)
Ferdinand HODLER
The Dream, 1897
Pencil, India ink, pastel, watercolour;
98.5 x 69.5 cm
Private collection

161 (ill. **237**)
Ferdinand HODLER
Tired of Life II, after 1892
Oil on canvas; 110.5 x 221 cm
Winterthur, Switzerland, Stiftung für Kunst,
Kultur und Geschichte

162 (ill. **235**)
Ferdinand HODLER
*Dark Genius (Study for "Disappointed
Souls")*, 1892
Graphite on beige paper; 42.9 x 24.1 cm
Montreal, Mr. and Mrs. Michal Hornstein
collection

163 (ill. **302**)
Bernhard HOETGER
1874-1949
Loie Fuller, about 1900
Bronze; 25.5 x 17.5 x 15.5 cm
Städtische Kunstsammlung Darmstadt

164 (ill. **165**)
Theodor HOFMEISTER
1868-1943
and **Oscar HOFMEISTER**
1871-1937
Night Walk (The Witch), 1900
Blue gum print; 64.5 x 92.5 cm
Museum für Kunst und Gewerbe Hamburg

165 (ill. **166**)
Theodor HOFMEISTER
and **Oscar HOFMEISTER**
The Solitary Horseman, 1904
Photogravure; 12.1 x 17.7 cm
Munich, Dietmar Siegert collection

166 (ill. **227**)
Edward Robert HUGHES
1851-1914
Oh, What's That in the Hollow?,
about 1895
Watercolour; 63.2 x 93.3 cm
London, The Diploma Collection of the Royal
Watercolour Society, on deposit at the British
Museum

167 (ill. **479**)
Henri HUSSON
1854-1914
Bowl, 1909
Hammered, repoussé and patinated copper,
silver granulation; 10 x 44.2 cm
Paris, Musée d'Orsay

168 (ill. **488**)
Henri HUSSON
Vase, about 1910
Hammered, chased and repoussé silver,
silver granulation; 22 x 16 x 11 cm
Paris, Musée du Petit Palais

169 (ill. **457**)
Vojtěch HYNAIS
1854-1925
*Winter (Study for the Decoration of the
National Theatre)*, 1901
Oil on canvas; 29 x 35 cm
Prague, Národní galerie

170 (ill. **197**)
Louis JANMOT
1814-1892
The Poem of the Soul: The Wrong Path,
about 1854
Oil on canvas; 110 x 142 cm
Lyons, Musée des Beaux-Arts

171 (ill. **198**)
Louis JANMOT
The Poem of the Soul: Nightmare,
about 1854
Oil on canvas; 113 x 143 cm
Lyons, Musée des Beaux-Arts

172 (ill. **550**)
Eugène JANSSON
1862-1915
Nocturne, 1901
Oil on canvas; 149 x 201 cm
Stockholm, Thielska Galleriet

173 (ill. **173**)
Ernst JOSEPHSON
1851-1906
The Blessed Sacrament, 1889-1890
Oil on canvas; 127 x 76 cm
Stockholm, Nationalmuseum

174 (ill. **203**)
Bohumil KAFKA
1878-1942
The Sleepwalker, 1906
Bronze; h.: 77.5 cm; base: 21.5 x 38 x 55 cm
Prague, Národní galerie

175 (ill. **559**)
Wassily KANDINSKY
1866-1944
Scenic Composition "Noir et blanc",
about 1909
Gouache on cardboard; 33 x 41 cm
Paris, Musée national d'Art moderne,
centre Georges-Pompidou, bequest of
Nina Kandinsky (1981)

176 (ill. **568**)
Wassily KANDINSKY
Scenic Composition "Violet", Tableau II,
1914
Pencil, India ink, watercolour; 25.1 x 33.3 cm
Paris, Musée national d'Art moderne,
centre Georges-Pompidou, bequest of
Nina Kandinsky (1981)

177 (ill. **564**)
Wassily KANDINSKY
Study for "Improvisation 8", 1909
Oil on cardboard, mounted on canvas;
98 x 70 cm
Volkart-Stiftung, on deposit at the
Kunstmuseum Winterthur

178 (ill. **565**)
Wassily KANDINSKY
Study for "Composition II", 1909-1910
Oil on canvas; 97 x 131.2 cm
New York, The Solomon R. Guggenheim
Museum

179 (ill. **566**)
Wassily KANDINSKY
*Study for the Cover of the "Blue Rider"
Almanac*, 1911
Watercolour; 28 x 21.7 cm
Munich, Städtische Galerie im Lenbachhaus

180 (ill. **567**)
Wassily KANDINSKY
*Study for the Cover of the "Blue Rider"
Almanac*, 1911
Watercolour; 27.7 x 21.8 cm
Munich, Städtische Galerie im Lenbachhaus

181 (ill. **468**)
Wassily KANDINSKY
The Night, about 1906-1907
Tempera on dark grey paper, white
underdrawing; 29.8 x 49.8 cm
Munich, Städtische Galerie im Lenbachhaus

182 (ill. **114**)
Gertrude KÄSEBIER
1852-1934
The Bat, 1902
Gum over platinum print; 20.5 x 15.5 cm
Paris, Musée Rodin, inv. Ph212

184 (ill. **449**)
Gertrude KÄSEBIER
The Heritage of Motherhood, 1904
Gum bichromate over platinum print;
23.5 x 31.6 cm
Washington, Library of Congress, Prints and
Photographs Division

185 (ill. **284**)
Gertrude KÄSEBIER
The Magic Crystal, about 1905
Platinum print; 24.3 x 19.2 cm
Bath, The Royal Photographic Society

186 (not illustrated)
Gertrude KÄSEBIER
The Manger, 1899
Photogravure; 32.4 x 24.1 cm
Ottawa, National Gallery of Canada

187 (ill. **179**)
Ferdinand KELLER
1842-1922
The Pool, 1911
Oil on canvas; 106.7 x 125.1 cm
Toronto, Joey and Toby Tanenbaum collection

188 (ill. **290**)
Fernand KHNOPFF
1858-1921
An Evening at Fosset, 1886
Oil on canvas; 40 x 58 cm
The Hearn Family Trust

189 (ill. **281**)
Fernand KHNOPFF
With Georges Rodenbach: A Dead City,
1889
Coloured crayon and ink on cream laid paper;
26 x 16 cm
The Hearn Family Trust

190 (ill. **216**)
Fernand KHNOPFF
White, Black and Gold, 1901
Charcoal, pastel and gold on paper, mounted on
canvas; 90 x 30 cm
Brussels, Musées royaux des Beaux-Arts de
Belgique

191 (ill. **326**)
Fernand KHNOPFF
Bruges: The Church of Our Lady,
about 1904
Oil on canvas; 44 x 86 cm
Neuss, Germany, Clemens-Sels-Museum

192 (ill. **217**)
Fernand KHNOPFF
Dream Flowers, about 1895
Oil on canvas; 48 x 18 cm
Paris, Lucile Audouy collection

193 (ill. **327**)
Fernand KHNOPFF
Memories of Flanders: A Canal, 1904
Coloured crayon, Conté crayon and pastel on
cream laid paper; 25 x 41.5 cm
The Hearn Family Trust

194 (ill. **279**)
Fernand KHNOPFF
*With Grégoire Le Roy: My Heart Longs
for Other Times*, 1889
Black chalk and pastel on blue paper;
25.5 x 14.5 cm
The Hearn Family Trust

195 (ill. **201**)
Fernand KHNOPFF
The Veil, about 1887
Charcoal, graphite; 40 x 21 cm
The Art Institute of Chicago, through prior
bequest, Mr. and Mrs. Martin A. Ryerson
collection

196 (ill. **175**)
Fernand KHNOPFF
*Souvenir of Bruges: The Entrance to the
Béguinage*, 1904
Coloured crayon, graphite, charcoal and pastel
on cream laid paper; 27 x 43.5 cm
The Hearn Family Trust

197 (ill. **282**)
Fernand KHNOPFF
Solitude, 1890-1891
Pastel on canvas; 150 x 44 cm
Gingins, Switzerland, Neumann collection

198 (ill. **346**)
Theodor KITTELSEN
1857-1914
The Monster of the Lake, 1904
Ink, pencil, watercolour, crayon; 47.5 x 70 cm
Oslo, Nasjonalgalleriet

199 (ill. **251** to **262**)
Theodor KITTELSEN
*"The Black Death" (Twelve
Illustrations)*, 1894-1896
Pen, pencil, black chalk, wash
 251 *Autumn Night*, 27.1 x 22.6 cm
 252 *Pesta's Coming*, 27.1 x 22.4 cm
 253 *Mummy, There's an Old Woman
 Coming*, 27.2 x 22.4 cm
 254 *The Pauper*, 27.1 x 22.5 cm
 255 *She Covers the Whole Country*,
 27.9 x 23.1 cm
 256 *Sweeping Every Corner*,
 27.3 x 22.4 cm
 257 *Pesta on the Stairs*, 27.3 x 22.8 cm
 258 *Pesta Departs*, 27.1 x 22.5 cm
 259 *Desolation*, 23.2 x 20.3 cm
 260 *Musstad*, 26.9 x 22.3 cm
 261 *The Old Church*, 28 x 23.4 cm
 262 *The Capercaillie Playing*,
 27.2 x 22.5 cm
Oslo, Nasjonalgalleriet

200 (ill. **156**)
Paul KLEE
1879-1940
Comedian (Invention 4), 1904
Etching; 15.9 x 17.2 cm
New York, The Solomon R. Guggenheim
Museum

201 (ill. **426**)
Not available for exhibition, for conservation
reasons

202 (ill. **555**)
Paul KLEE
With the Rainbow, 1917
Watercolour over chalk; 18.6 x 22 cm
Bern, Felix Klee estate

203 (ill. **20**, **21**, **154** and **398**)
Paul KLEE
Four Engravings
 20 *Pessimistic Symbol of the Mountains*,
 1904; 14.6 x 6.9 cm
 154 *Threatening Head*, 1905;
 19.7 x 14.5 cm
 21 *The Hero with a Wing*, 1905;
 25.7 x 16 cm
 398 *Woman and Animal*, 1904;
 20 x 22.8 cm
Kunstmuseum Bern, Paul Klee-Stiftung

204 (ill. **397**)
Paul KLEE
*Virgin in a Tree (Invention 3)
(Young Woman Dreaming)*, 1903
Etching; 31.8 x 42.4 cm
New York, The Solomon R. Guggenheim
Museum

205 (ill. **438**)
Gustav KLIMT
1862-1918
Hope I, 1903
Oil on canvas; 181 x 67 cm
Ottawa, National Gallery of Canada

206 (ill. **470**)
Gustav KLIMT
Nuda Veritas, 1899
Oil on canvas; 252 x 56.2 cm
Vienna, Österreichisches Theater Museum im
Palais Lobkowitz

207 (ill. **275**)
Max KLINGER
1857-1920
Abandoned, 1884
Etching with colour aquatint on laid japan
paper; 43.4 x 56.6 cm
Ottawa, National Gallery of Canada

208 (ill. **146**)
Max KLINGER
Bust of Nietzsche, 1904
Bronze; h.: 76.2 cm
Toronto, Joey and Toby Tanenbaum collection

209 (ill. **13**)
Max KLINGER
Prometheus Unbound, 1891-1894
Engraving, etching, aquatint, mezzotint;
27.7 x 36.2 cm
Leipzig, Museum der bildenden Künste

210 (ill. **369**)
Max KLINGER
The New Salome, after 1893
Bronze; h.: 46.5 cm (without base)
Badisches Landesmuseum Karlsruhe

211 (ill. **14**)
Max KLINGER
Prometheus Abducted, 1894
Engraving, etching, aquatint; 27.8 x 38.7 cm
Leipzig, Museum der bildenden Künste

212 (ill. **143**, **249** and **441**)
Max KLINGER
Three Plates from "Of Death, Part II"
 249 *On the Rails*, 1889; etching,
 aquatint; 26.4 x 19.2 cm
 441 *The Mother's Deathbed*, 1889;
 engraving; 44.5 x 34.7 cm
 143 *The Philosopher*, 1910; etching,
 aquatint; 49.5 x 33.7 cm
Leipzig, Museum der bildenden Künste

213 (ill. **408** to **417**)
Max KLINGER
"Paraphrase on the Discovery of a Glove", or *"The Glove"*,
about 1878-1880 (4th edition)
Engraving (ten plates)
 408 *Place*, 22.8 x 32.8 cm
 409 *The Act*, 25 x 19 cm
 410 *Desires*, 28.3 x 10.7 cm
 411 *The Rescue*, 14.4 x 10.5 cm
 412 *Triumph*, 11 x 24 cm
 413 *Homage*, 12.3 x 29.5 cm
 414 *Fears*, 11 x 24 cm
 415 *Tranquillity*, 11.1 x 23.5 cm
 416 *The Abduction*, 9 x 22 cm
 417 *Cupid*, 11 x 24 cm
Hamilton, Ontario, McMaster University
collection, Levy Bequest Purchase

214 (ill. **387** to **392**)
Max KLINGER
"Eve and the Future"
Etching, aquatint (six plates)
 387 *Eve*, 1880; 22.4 x 26.2 cm
 388 *The Serpent*, 1874-1877;
 29.5 x 16 cm
 389 *Second Future*, 1880; 29.8 x 26.9 cm
 390 *Adam*, 1880; 29.5 x 27.2 cm
 391 *Third Future*, 1880; 29.8 x 20.3 cm
 392 *First Future*, 1880; 39.7 x 26.9 cm
Leipzig, Museum der bildenden Künste

215 (ill. **486**)
Archibald KNOX
1864-1933
Made by W.H. Haseler, Birmingham,
for Liberty & Co. (Cymric) Ltd.
Box, 1903-1904
Silver, on a wooden carcass, set with opal matrix;
11.3 x 21.5 x 13 cm
London, The Board of Trustees of the Victoria
and Albert Museum

216 (ill. **29** to **38**)
František KOBLIHA
1877-1962
The "Tristan" Cycle, 1909-1910
Wood engraving (ten plates); 28.8 x 23 cm
(image); 44.4 x 34.1 cm (sheet)
Prague, Národní galerie

217 (ill. **236**)
Käthe KOLLWITZ
1867-1945
Life, 1900
Ink, chalk, graphite, wash; 32.5 x 92.9 cm
Staatsgalerie Stuttgart, Graphische Sammlung

218 (ill. **313**)
Nils KREUGER
1858-1930
Horse by the Shore, Summer Night, 1902
Oil on canvas; 99 x 128.5 cm
Stockholm, Prins Eugens Waldemarsudde
collection

219 (ill. **354**)
Alfred KUBIN
1877-1959
Fairy-tale Creature, about 1903-1904
Pen, brush, ink and watercolour on surveyor's
paper; 25.2 x 22.5 cm
Linz, Oberösterreichisches Landesmuseum

220 (ill. **231**)
Alfred KUBIN
Death's Fiancée, about 1900
Pen and ink, wash; 39.3 x 31.2 cm
Vienna, Graphische Sammlung Albertina

221 (ill. **110**)
Alfred KUBIN
The Moment, about 1899-1900
Pen and ink on surveyor's paper; 12.5 x
20.8 cm (image); 19.8 x 31.7 cm (sheet)
Linz, Oberösterreichisches Landesmuseum

222 (ill. **406**)
Alfred KUBIN
The Flame, about 1900
Pen and ink, pencil, white highlights, wash;
27.2 x 17.3 cm (image); 32.5 x 23.8 cm (sheet)
Vienna, Galerie Würthle

223 (ill. **399**)
Alfred KUBIN
Great Babylon, about 1902-1903
Pen and ink and wash on surveyor's paper;
22.5 x 30.3 cm (image); 30.3 x 37.5 cm (sheet)
Vienna, Galerie Würthle

224 (ill. **118**)
Alfred KUBIN
The Temptation of Saint Anthony,
about 1899
Pen and ink and wash on surveyor's paper;
17.8 x 17.5 cm (image); 20.3 x 22.8 cm (sheet)
Vienna, Galerie Würthle

225 (ill. **112**)
Alfred KUBIN
Cemetery Wall, about 1902
Pen and ink and wash on surveyor's paper;
24.2 x 18.3 cm
Linz, Oberösterreichisches Landesmuseum

226 (ill. **400**)
Alfred KUBIN
Earth, Mother of Us All, 1901-1902
Pen and ink and wash on surveyor's paper;
22.5 x 23 cm (image); 30.3 x 37.5 cm (sheet)
Vienna, Galerie Würthle

227 (ill. **401**)
Heinrich KÜHN
1866-1944
Female Nude, 1906
Bromoil print on japan paper; 28.7 x 18.8 cm
Museum Folkwang Essen

228 (ill. **454**)
Heinrich KÜHN
On the Hillside (A Study in Values),
before 1910
Gum-bichromate print; 23.2 x 29.2 cm
Gilman Paper Company Collection

229 (ill. **573**)
František KUPKA
1871-1957
*Study for Amphora, Fugue in Two
Colours*, 1911
Oil on canvas; 84 x 128 cm
Paris, Musée national d'Art moderne, centre
Georges-Pompidou, gift of Mme Kupka (1963)

230 (ill. **569**)
František KUPKA
The Yellow Scale, 1907
Oil on canvas; 79 x 79 cm
Paris, Musée national d'Art moderne, centre
Georges-Pompidou, gift of Mme Kupka (1963)

231 (ill. **574**)
František KUPKA
Madame Kupka among Verticals,
1910-1911
Oil on canvas; 135.5 x 85.3 cm
New York, The Museum of Modern Art, Hillman
Periodicals Fund, 1956

232 (ill. **572**)
František KUPKA
The Dream, 1906-1909
Oil on cardboard; 30.5 x 31.5 cm
Museum Bochum

233 (ill. **64**)
František KUPKA
The Way of Silence I, 1900
Colour aquatint; 47.7 x 38.5 cm (sheet)
Prague, Národní galerie

234 (ill. **65**)
František KUPKA
The Way of Silence II, 1903
Colour aquatint; 51.5 x 47 cm (sheet)
Prague, Národní galerie

235 (ill. **308**)
Georges LACOMBE
1868-1916
Yellow Sea, Camaret, about 1892
Egg tempera on canvas; 60.7 x 81.3 cm
Musée de Brest

236 (ill. **362**)
René LALIQUE
1860-1945
"Sabot de Vénus" Belt Buckle, about 1900
Gold, rubies, enamel; w.: 7.5 cm
Gingins, Switzerland, Neumann collection

237 (ill. **420**)
René LALIQUE
*Brooch (Woman's Head with Peacock
Wing and Serpent)*, about 1898-1899
Gold, enamel, natural pearl, limestone;
6.2 x 4.5 cm
Paris, Musée des Arts décoratifs

238 (ill. **476**)
René LALIQUE
Brooch-Pendant, 1898-1900
Gold, enamel, pearl; 6.8 x 7.1 cm
Schmuckmuseum Pforzheim

239 (ill. **418**)
René LALIQUE
Necklace, about 1900
Gold, enamel, Australian opal, Siberian
amethysts; diam.: 24.1 cm
New York, The Metropolitan Museum of Art,
jointly owned by the Metropolitan Museum of
Art and Lillian Nassau, 1985

240 (ill. **299**)
Raoul LARCHE
1860-1912
"Loie Fuller" Lamp, about 1900
Gilt bronze; h.: 46.3 cm
Norfolk, The Chrysler Museum, gift of
Walter P. Chrysler, Jr.

241 (ill. **214**)
Raoul LARCHE
"Rêves" Pair of Vases, about 1900
Gilt bronze; h.: 54 cm
Gingins, Switzerland, Neumann collection

242 (ill. **188**)
Georges LE BRUN
1873-1914
Interior: Man Passing Through, 1900
Charcoal; 47 x 61 cm
Verviers, Belgium, Musées communaux

243 (ill. **268**)
Ozias LEDUC
1864-1955
Erato (Muse in the Forest), about 1906
Oil on cardboard; 28 x 22 cm
Ottawa, National Gallery of Canada

244 (ill. **174**)
Ozias LEDUC
End of the Day, 1913
Oil on canvas; 50.8 x 34.3 cm
The Montreal Museum of Fine Arts, purchase,
Horsley and Annie Townsend Bequest

245 (ill. **230**)
Frederic LEIGHTON
1830-1896
Lachrymae, about 1895
Oil on canvas; 157.5 x 62.9 cm
New York, The Metropolitan Museum of Art,
Catharine Lorillard Wolfe Collection,
Wolfe Fund, 1896

246 (ill. **300**)
Agathon LÉONARD
1842-1923
and **Sèvres National Porcelain
Manufactory**
*Three Figures from the Series "Scarf
Dance"*, 1900
Biscuit hard-paste porcelain; h.: 40-50 cm
(approx.)
Sèvres, Musée national de Céramique

247 (ill. **176**)
Henri LE SIDANER
1862-1939
A Canal in Bruges at Dusk, undated
Oil on canvas; 49 x 65 cm
The visitors of the Ashmolean Museum, Oxford

248 (ill. **453**)
Henri LE SIDANER
Sunday, 1898
Oil on canvas; 112.5 x 192 cm
Douai, Musée de la Chartreuse

249 (ill. **289**)
Johann LÖETZ-WITWE (company),
Klöstermühle, Austria
Lamp, 1901-1902
Silvered bronze, glass; base: 58.1 cm;
globe: 17.8 cm
Kunstmuseum Düsseldorf im Ehrenhof

250 (ill. **582**)
Johann LÖETZ-WITWE (company),
Klöstermühle, Austria
Vase, 1900-1901
Glass; 16.7 x 22.8 cm
Kunstmuseum Düsseldorf im Ehrenhof

251 (ill. **427**)
Elena LUKSCH-MAKOWSKY
1878-1967
Adolescence, 1903
Oil on canvas; 172 x 79 cm
Vienna, Österreichische Galerie

252 (ill. **484** and **485**)
Margaret MACDONALD
1864-1933
and **Frances MACDONALD**
1874-1921
The Odyssey (Two Scenes from Book XI),
1899
Two repoussé white-metal plaques;
50.8 x 15.2 cm (each)
 485 *"A dark wave gathered mountain-
 high, curled over them . . ."*
 (line 242)
 484 *". . . and prevented any of the feck-
 less ghosts from approaching . . ."*
 (line 49)
Private collection

253 (ill. **539**)
Charles Rennie MACKINTOSH
1868-1928
Cabinet, about 1904
Painted wood, inlaid enamel, leaded glass;
154 x 85.1 x 32.4 cm
Toronto, Royal Ontario Museum, acquisition
made possible by a contribution from the
Government of Canada under the terms of the
Cultural Property Import and Export Act

254 (ill. **533**)
Charles Rennie MACKINTOSH
The Harvest Moon, 1892
Pencil, watercolour; 35.2 x 27.6 cm
Glasgow School of Art collection

255 (ill. **40**)
Rudolf MAISON
1854-1904
Wotan, 1890
Bronze; h.: 47 cm
Munich, Münchner Stadtmuseum

256 (ill. **493**)
Louis MAJORELLE
1859-1926
Cabinet, 1900
Oak, kingwood, marquetry; 180.3 x
68 x 23.5 cm
London, The Board of Trustees of the
Victoria and Albert Museum

257 (ill. **318**)
Jacek MALCZEWSKI
1854-1929
In the Dust Cloud, 1893-1894
Oil on canvas; 78 x 150 cm
National Museum of Poznań

258 (ill. **144**)
Jacek MALCZEWSKI
Self-portrait with a Paintbrush, 1914
Oil on canvas; 93 x 78 cm
National Museum of Cracow

259 (ill. **263**)
Jacek MALCZEWSKI
The Unknown Note, 1902
Oil on canvas; 41.5 x 63 cm
National Museum of Cracow

260 (ill. **331**)
Jacek MALCZEWSKI
Spring: Landscape with Tobias, 1904
Oil on canvas; 76 x 97 cm
National Museum of Poznań

261 (ill. **365**)
Jacek MALCZEWSKI
Moment of Creation: Harpy in a Dream,
1907
Oil on cardboard; 72.5 x 92 cm
Poznań, Jerzy Nowakowski collection

262 (ill. **312**)
Jacek MALCZEWSKI
Vicious Circle, 1895-1897
Oil on canvas; 174 x 240 cm
National Museum of Poznań

263 (ill. **226**)
Jacek MALCZEWSKI
Thanatos, 1898
Oil on canvas; 124.5 x 74 cm
National Museum of Poznań

264 (ill. **328**)
Jacek MALCZEWSKI
Thanatos: Death, 1902
Oil on canvas; 98 x 75 cm
National Museum of Warsaw

265 (ill. **540**)
Erich MALLINA
1873-1954
Study for "Procession of Angels", 1903
Tempera and oil on paper; 38.5 x 49 cm
Vienna, Julius Hummel collection

266 (ill. **306**)
Étienne Jules MAREY
1830-1904
*Time-lapse Photograph of a Running
Man Dressed in Black*, 1883
Geometric fixed-plate chronophotographs;
10 x 28.5 cm
Beaune, Musée Marey

267 (ill. **456**)
Matthijs MARIS
1839-1917
The Bride, about 1865-1869
Oil on canvas; 103 x 65 cm
The Hague, Museum Mesdag

268 (ill. **307**)
Clément MASSIER
1845-1917
Lucien LÉVY-DHURMER
1865-1953
Charger, or *Large Plate*, about 1895
Earthenware, metallic lustre glaze;
diam.: 49.5 cm
New York, Daniel Morris and Denis Gallion,
Historical Design Collection, Inc.

269 (ill. **219**)
Clément MASSIER
and **Lucien LÉVY-DHURMER**
Vase, about 1895
Earthenware, metallic lustre glaze; h.: 35.6 cm
New York, Daniel Morris and Denis Gallion,
Historical Design Collection, Inc.

270 (ill. **63**)
Charles MAURIN
1856-1914
The Dawn of Work, 1891
Oil on canvas; 79 x 148 cm
Saint-Étienne, Musée d'Art moderne

271 (ill. **292**)
Karl MEDIZ
1868-1945
Wisteria Fountain with Cypresses, 1900
Oil on canvas; 153.5 x 164 cm
Private collection

272 (ill. **293**)
Emilie MEDIZ-PELIKAN
1861-1908
Wisteria Fountain in a Birch Grove,
1900
Oil on canvas; 151 x 141 cm
Private collection

273 (ill. **347**)
Józef MEHOFFER
1869-1946
The Strange Garden, 1903
Oil on canvas; 222.5 x 208.5 cm
National Museum of Warsaw

274 (ill. **191**)
Xavier MELLERY
1845-1921
Interior with Open Doors, undated
Oil on canvas; 72.5 x 58 cm
The Hearn Family Trust

275 (ill. **319**)
Xavier MELLERY
Autumn, or *La Chute des dernières
feuilles d'automne*, undated
Watercolour, ink, charcoal and black chalk on
cardboard; 92 x 59 cm
Brussels, Musées royaux des Beaux-Arts de
Belgique

276 (ill. **440**)
George MINNE
1866-1941
Mother Grieving for Her Two Children,
or *Sorrow*, 1888
Bronze; h.: 66 cm
Brussels, Musées royaux des Beaux-Arts de
Belgique

277 (ill. **435**)
George MINNE
Standing Youth, 1900
Bronze; h.: 40 cm; base: 20 x 15 cm
Neuss, Germany, Clemens-Sels-Museum

278 (ill. **189**)
Carl MOLL
1861-1945
Studio Interior, about 1906
Oil on canvas; 100 x 100 cm
Vienna, Gemäldegalerie der Akademie der
bildenden Künste

279 (ill. **359** recto-verso)
Piet MONDRIAN
1872-1944
Chrysanthemum (recto) and *Young
Woman* (verso), about 1908-1909
Recto: charcoal on grey paper; verso: black
Conté crayon, graphite, charcoal and brown
crayon on grey paper; 62.9 x 38.4 cm
Northampton, Massachusetts, Smith College
Museum of Art

280 (ill. **576**)
Gustave MOREAU
1826-1898
*Abstract Composition with Corners
Cut Off*, undated
Oil on canvas; 120 x 135 cm
Paris, Musée Gustave Moreau

281 (ill. **575**)
Gustave MOREAU
Abstract Sketch, undated
Oil on canvas; 27 x 22 cm
Paris, Musée Gustave Moreau

282 (ill. **4**)
Gustave MOREAU
Fairy and Griffins, undated
Oil on canvas; 124 x 94 cm
Paris, Musée Gustave Moreau

283 (ill. **5**)
Gustave MOREAU
The Siren and the Poet, 1895-1899
Wool and silk tapestry; 349 x 250 cm
Paris, Mobilier national

284 (ill. **225**)
Gustave MOREAU
The Young Man and Death, about 1865
Watercolour; 27 x 16 cm
Paris, Alain Lesieutre collection

285 (ill. **97**)
Gustave MOREAU
The Angels of Sodom, about 1885
Oil on canvas; 93 x 62 cm
Paris, Musée Gustave Moreau

286 (ill. **3**)
Gustave MOREAU
Salome Dancing before Herod, 1876
Oil on canvas; 143.5 x 104.3 cm
University of California at Los Angeles,
Armand Hammer Museum and Cultural Center,
Armand Hammer Collection

287 (ill. **535**)
Koloman MOSER
1868-1918
Light, about 1913-1915
Oil on canvas; 123 x 180.5 cm
Vienna, Julius Hummel collection

288 (ill. **298**)
Koloman MOSER
The Dancer Loie Fuller, about 1900
Watercolour, ink; 15 x 21.7 cm
Vienna, Graphische Sammlung Albertina

289 (ill. **305**)
Koloman MOSER
Young Girl, 1903-1904
Silver; 15 x 15 cm
Historical Museum of the City of Vienna

290 (ill. **287**)
Gustav Adolf MOSSA
1883-1971
The Moon, about 1911
Watercolour, ink, gold paint; diam.: 20 cm
Paris, Lucile Audouy collection

291 (ill. **363**)
Alfons MUCHA
1860-1939
Bust: "Nature", 1899-1900
Gilt bronze, silver, marble; 69.2 x
27.9 x 30.5 cm
Richmond, Virginia Museum of Fine Arts, The
Sydney and Frances Lewis Art Nouveau Fund

292 (ill. **213**)
Alfons MUCHA
"La Nuit" Pendant, undated
Gold, *plique-à-jour* enamel, opal; 13 x 8 cm
Gingins, Switzerland, Neumann collection

293 (ill. **241**)
Edvard MUNCH
1863-1944
By the Deathbed, 1896
Lithograph; 39.5 x 50 cm
Oslo, Munch-museet

294 (ill. **357**)
Edvard MUNCH
Family Tree, 1894-1895
Pencil; 38.5 x 29.1 cm
Oslo, Munch-museet

295 (ill. **358**)
Edvard MUNCH
Family Tree, 1894-1895
Pencil, India ink; 38.6 x 28.9 cm
Oslo, Munch-museet

296 (ill. **239**)
Edvard MUNCH
Harpy, 1899
Lithograph; 36.5 x 32 cm
Oslo, Munch-museet

297 (ill. **164**)
Edvard MUNCH
House in Moonlight, 1895
Oil on canvas; 70 x 95.8 cm
Bergen, Rasmus Meyer Collection

298 (ill. **155**)
Edvard MUNCH
Jealousy, about 1897
Oil on canvas; 119.4 x 78.1 cm
Minneapolis Institute of Arts, The Lillian Z.
Turnblad Fund

299 (ill. **445**)
Edvard MUNCH
Madonna (Conception), 1895
Lithograph in black, red, blue and greenish
yellow, on japan paper; 60.5 x 44.5 cm
Oslo, Munch-museet

300 (ill. **549**)
Edvard MUNCH
Moonlight, 1895
Oil on canvas; 93 x 110 cm
Oslo, Nasjonalgalleriet

301 (ill. **371**)
Edvard MUNCH
Self-portrait (Salome Paraphrase),
1894-1898
Watercolour, India ink, pencil; 42.5 x 29.2 cm
Oslo, Munch-museet

302 (ill. **238**)
Edvard MUNCH
Self-portrait with Skeleton Arm, 1895
Lithograph; 46 x 31.5 cm
Oslo, Munch-museet

303 (ill. **242**)
Edvard MUNCH
Death and the Maiden, 1893
Casein on canvas; 128.5 x 86 cm
Oslo, Munch-museet

304 (ill. **150**)
Edvard MUNCH
The Scream, 1895
Lithograph; 35.2 x 25.1 cm
Oslo, Munch-museet

305 (ill. **240**)
Edvard MUNCH
The Urn, 1896
Lithograph; 45.8 x 26 cm
Oslo, Munch-museet

306 (ill. **366**)
Edvard MUNCH
Vampire, 1893
Oil on canvas; 80.5 x 100.5 cm
Göteborg, Sweden, Göteborgs Konstmuseum

307 (ill. **531**)
Gerhard MUNTHE
1849-1929
The Day of Judgement, 1900
Oil on canvas; 143 x 101 cm
Bergen, Rasmus Meyer Collection

308 (ill. **43**)
Gerhard MUNTHE
The Suitors, 1892
Watercolour; 77 x 94 cm
Oslo, Nasjonalgalleriet

309 (ill. **244**)
Ejnar NIELSEN
1872-1956
The Sick Girl, 1896
Oil on canvas; 111 x 164 cm
Copenhagen, Statens Museum for Kunst

310 (ill. **243**)
Ejnar NIELSEN
And in His Eyes I Saw Death, 1897
Oil on canvas; 137.5 x 188 cm
Copenhagen, Statens Museum for Kunst

311 (ill. **512**)
Karel NOVAK
1875-1950
Woman with Little Vase, about 1910
Gum print; 17.2 x 6.2 cm
Museum of Decorative Arts in Prague

312 (ill. **532**)
Hermann OBRIST
1863-1927
Design for a Monument, about 1898-1900
Plaster; h.: 88 cm
Zurich, Museum Bellerive

313 (ill. **180**)
Alphonse OSBERT
1857-1939
Moonlight, about 1896
Oil on canvas; 50.2 x 61 cm
New York, Stuart Pivar collection

314 (ill. **117**)
Jaroslav PANUSKA
1872-1958
Dead Man Hunted by Ravens, 1898
Charcoal; 63 x 72 cm
Pardubice, Czech Republic, Východočeská
galerie

315 (ill. **113**)
Jaroslav PANUSKA
Vampires, 1899
India ink on cardboard; 28.5 x 54 cm
Hradec Králové, Czech Republic, Galerie
moderního umění

316 (not illustrated)
Jaroslav PANUSKA
Water Demon, 1898
Tempera on cardboard; 49 x 70 cm
Hradec Králové, Czech Republic, Galerie
moderního umění

317 (ill. **314**)
Giuseppe PELLIZZA DA VOLPEDO
1869-1907
Ring a Ring O'Rosies, 1902-1903
Oil on canvas; diam.: 100 cm
Milan, Galleria d'Arte Moderna

318 (ill. **171**)
Giuseppe PELLIZZA DA VOLPEDO
The Bush, 1900-1902
Oil on canvas; 73 x 92 cm
Piacenza, Galleria d'Arte Moderna Ricci Oddi

319 (ill. **452**)
Giuseppe PELLIZZA DA VOLPEDO
The Mirror of Life, 1895-1898
Oil on canvas; 132 x 288 cm
Turin, Galleria Civica d'Arte Moderna e
Contemporanea

320 (ill. **269**)
Eilif PETERSSEN
1852-1907
Nocturne, 1887
Oil on canvas; 81.5 x 81.5 cm
Oslo, Nasjonalgalleriet

321 (ill. **395**)
Armand POINT
1860-1932
"Serpent" Casket, 1897-1899
Wood, chased and gilt bronze, polychrome
champlevé and cloisonné enamel on
background of dark green enamel, gold
highlights; 32.3 x 30.5 x 22.6 cm
Paris, Musée d'Orsay

322 (ill. **17**)
Armand POINT
The Lady and the Unicorn, 1896
Crayon, pastel highlights; 90 x 71 cm; with
frame (executed by the artist), 104.5 x 84.5 cm
Paris, Lucile Audouy collection

323 (ill. **425**)
Jan PREISLER
1872-1918
Black Lake, 1904
Oil on canvas; 257 x 176 cm
Prague, Národní galerie

324 (ill. **48**)
Jan PREISLER
The Adventurous Knight, 1898
Oil on canvas; 87 x 115 cm
Plzeň, Czech Republic, Zapodočeska Galerie

325 (ill. **459**)
Jan PREISLER
Fable, 1902
Oil on canvas; 101.5 x 79 cm
Ostrava, Czech Republic, Galerie výtvarného
umění

326 (ill. **70**)
Gaetano PREVIATI
1852-1920
Railroad on the Pacific, 1916
Oil on canvas; 200 x 125 cm
Milan, Camera di commercio di Milano

327 (ill. **222**)
Gaetano PREVIATI
Women Smoking Hashish, 1887
Oil on canvas; 80 x 150 cm
Piacenza, Galleria d'Arte Moderna Ricci Oddi

328 (ill. **66**)
Gaetano PREVIATI
The Dance of the Hours, about 1899
Tempera on canvas; 133.5 x 199 cm
Proprietà Cariplo S.P.A.

329 (ill. **321**)
Gaetano PREVIATI
Day Awakens the Night, 1905
Oil on canvas; 180 x 210
Trieste, Civico Museo Revoltella

330 (ill. **451**)
Gaetano PREVIATI
Motherhood, 1890-1891
Oil on canvas; 174 x 411 cm
Novara, Italy, Banca Popolare Di Novara

331 (ill. **204**)
Victor PROUVÉ
1858-1943
"La Nuit" Coupe, 1894
Bronze; 50.7 x 76 x 46.7 cm
Musée de l'École de Nancy

332 (ill. **516**)
Pierre PUVIS DE CHAVANNES
1824-1898
Inter artes et naturam, 1890
Oil on canvas; 40.3 x 113.7 cm
New York, The Metropolitan Museum of Art, gift
of Mrs. Harry Payne Bingham, 1958

333 (ill. **61**)
Pierre PUVIS DE CHAVANNES
The Balloon, 1870
Oil on canvas; 136.7 x 86.5 cm
Paris, Musée d'Orsay, gift of Galerie Acquavella,
New York, 1987

334 (ill. **267**)
Pierre PUVIS DE CHAVANNES
Meditation, 1867
Oil on canvas; 104 x 54.5 cm
Private collection

335 (ill. **447**)
Pierre PUVIS DE CHAVANNES
Maternity, 1887
Oil on canvas; 55.5 x 47 cm
Private collection

336 (ill. **90**)
Paul RANSON
1861-1909
Christ and Buddha, about 1890-1892
Oil on canvas; 72.7 x 51.4 cm
Private collection

337 (ill. **96**)
Paul RANSON
Nabi Landscape, 1890
Oil on canvas; 89 x 115 cm
Josefowitz collection

338 (ill. **403**)
Odilon REDON
1840-1916
Plate V from "To Gustave Flaubert",
1889
 The Sphinx: "My gaze, which nothing can
 deflect, passes through the things and
 remains fixed on an inaccessible horizon."
 The Chimera: "I am weightless and joyful."
Lithograph; 28.4 x 20.2 cm
Cambridge, Massachusetts, Fogg Art Museum,
Harvard University Art Museums, gift of
Charles Bain Hoyt

339 (ill. **185** and **186**)
Odilon REDON
Plates I and II from "The Haunted and
the Haunters", 1896
Lithograph
 186 *And Fancied I Saw on It a Pale Blue*
 Misty Outline of a Human Form,
 45 x 31.7 cm
 185 *We Both Saw a Large Pale Light*,
 45 x 31.3 cm
Ottawa, National Gallery of Canada

340 (not illustrated)
Odilon REDON
Plates I and III from "To Edgar Allan Poe", 1880
Lithograph
> *The Eye, like a Strange Ball that directs itself towards infinity*, 26.3 x 199.9
> *A Mask Sounding the Death Knell*, 26.1 x 19.3

Cambridge, Massachusetts, Fogg Art Museum, Harvard University Art Museums, gift of Philip Hofer

341 (ill. **403**)
Odilon REDON
Frontispiece and Plates I and III from "To Gustave Flaubert", 1889
Lithograph
> *Frontispiece*, 25.8 x 20.3 cm
> **403** *Saint Anthony: "Beneath her long hair, which covered her face, I thought I recognized Ammonaria"*, 28.7 x 23.2 cm
> *Death: "My irony surpasses all others!"*, 26.2 x 19.7 cm

Paris, Bibliothèque nationale de France, Cabinet des estampes

342 (ill. **206** to **208**)
Odilon REDON
Plates II, IV and V from "To Edgar Allan Poe", 1882
Lithograph
> **206** *Before the black sun of Melancholy, Lenore appears*, 16.8 x 12.7 cm
> **207** *On the horizon the angel of Certitude, and in the somber heaven a questioning eye*, 27.2 x 20.8 cm
> **208** *The breath which leads living creatures is also in the Spheres*, 27.3 x 20.9 cm

Paris, Bibliothèque nationale de France, Cabinet des estampes

343 (ill. **78**)
Odilon REDON
Gothic Window, 1900
Oil on canvas; 62.9 x 48.9 cm
Indianapolis Museum of Art, The Lockton Collection

344 (ill. **205**)
Odilon REDON
The Raven, 1882
Charcoal; 39.9 x 27.9 cm
Ottawa, National Gallery of Canada

345 (ill. **273**)
Odilon REDON
The Poet, about 1887
Charcoal; 51 x 36 cm
Antwerp, Museum Plantin-Moretus

346 (ill. **1**)
Odilon REDON
The Poet and Pegasus, 1891(?)
Charcoal; 48.1 x 37.8 cm
Ottawa, National Gallery of Canada

347 (ill. **196**)
Odilon REDON
Closed Eyes, after 1890
Pastel; 46 x 36 cm
Épinal, Musée départemental d'Art ancien et contemporain

348 (ill. **77**)
Odilon REDON
Mystical Flowers, undated
Pastel and charcoal on paper, mounted on cardboard; 64.8 x 53.6 cm
Iowa City, The University of Iowa Museum of Art, gift of Owen and Leone Elliott

349 (ill. **355**)
Odilon REDON
The Smiling Spider, 1887
Lithograph; 26 x 21.6 cm
Paris, Bibliothèque nationale de France, Cabinet des estampes

350 (ill. **215**)
Oscar Gustav REJLANDER
1813-1875
The Dream, about 1860
Albumen print; 14 x 19.6 cm
Rochester, New York, George Eastman House collection

351 (ill. **47**)
William REYNOLDS-STEPHENS
1862-1943
Guinevere's Redeeming, 1905
Bronze, silver, ivory, mother-of-pearl; 84 x 28 cm
Warrington Museum and Art Gallery

352 (ill. **120**)
Richard RIEMERSCHMID
1868-1957
Cloud Phantoms II, 1897
Tempera on cardboard; 88.5 x 113 cm
Munich, Städtische Galerie im Lenbachhaus

353 (ill. **12**)
Briton RIVIÈRE
1840-1920
Prometheus, 1889
Oil on canvas; 89 x 59 cm
The visitors of the Ashmolean Museum, Oxford

354 (ill. **229**)
Henry Peach ROBINSON
1830-1901
The Lady of Shalott, 1860-1861
Gold-toned albumen print; 31.9 x 52.5 cm
Bath, The Royal Photographic Society

355 (ill. **349**)
Pierre ROCHE
1855-1922
and **Alexandre BIGOT**
1862-1927
Plate, 1897
Glazed earthenware; diam.: 22.9 cm
Badisches Landesmuseum Karlsruhe

356 (ill. **98**)
Auguste RODIN
1840-1917
The Hand of God, 1898
Bronze; 68 x 44.5 x 54.6 cm
Philadelphia, The Rodin Museum, gift of Jules E. Mastbaum

357 (ill. **407**)
Félicien ROPS
1833-1898
The Incantation, about 1878
Colour engraving; 27.5 x 40 cm (plate)
Babut du Marès collection

358 (ill. **245**)
Félicien ROPS
Death at the Ball, 1865-1875
Oil on canvas; 151 x 85 cm
Otterlo, The Netherlands, Kröller-Müller Museum

359 (ill. **329**)
Félicien ROPS
The Temptation of Saint Anthony, 1878
Crayon, pastel, gouache highlights; 73.8 x 54.3 cm
Brussels, Bibliothèque royale Albert 1ᵉʳ, Cabinet des estampes

360 (ill. **122** to **130**)
Félicien ROPS
Illustrations for J. Barbey d'Aurevilly's "Les Diaboliques", undated
> **122** *Theft and Prostitution Dominate the World*, etching; 26 x 17 cm (platemark)
> **123** *The Sphinx*, heliogravure; 24 x 16.5 cm (platemark)
> **124** *Beneath the Cards of a Game of Whist*, etching; 8 x 5.6 cm (platemark)
> **125** *A Woman's Revenge*, etching; 30 x 21 cm (platemark)
> **126** *Women and Madness Dominate the World*, etching; 9 x 6 cm (platemark)
> **127** *The Crimson Curtain*, soft-ground etching; 22.5 x 16 cm (platemark)
> **128** *The Greatest Love of Don Juan*, soft-ground etching; 23 x 16 cm (platemark)
> **129** *Happiness in Crime*, etching, soft-ground etching; 23.5 x 16 cm (platemark)
> **130** *At a Dinner of Atheists*, etching; 24.5 x 16.5 cm (platemark)

Morlanwelz, Belgium, Musée royal de Mariemont

361 (ill. **131** to **134**)
Félicien ROPS
"The Satanic Ones", 1882
Retouched heliogravure; 20.1 x 28 cm
 Satan Sowing Tares (not illustrated)
 131 *The Abduction*
 132 *The Idol*
 133 *The Sacrifice*
 134 *Calvary*
Babut du Marès collection

362 (ill. **266**)
Dante Gabriel ROSSETTI
1828-1882
Study for Marianna, about 1895
Mixed media on paper; 44.1 x 44.1 cm
New York, Stuart Pivar collection

363 (ill. **264**)
Dante Gabriel ROSSETTI
Rosa Triplex, 1874
Red chalk; 51 x 73.5 cm
The Hearn Family Trust

364 (ill. **44**)
Dante Gabriel ROSSETTI
The Wedding of Saint George, 1864
Pastel, gouache; 25 x 40 cm (approx.)
New York, Stuart Pivar collection

365 (ill. **223**)
Santiago RUSIÑOL
1861-1931
The Morphine Addict, 1894
Oil on canvas; 87.3 x 115 cm
Sitges, Spain, Museo del Cau Ferrat

366 (ill. **2**)
Albert Pinkham RYDER
1847-1917
Pegasus, 1901-1917
Oil on canvas, mounted on fibreboard;
6.1 x 43.8 cm
Washington, National Museum of American Art,
Smithsonian Institution, gift of John Gallatly

367 (ill. **291**)
Théo van RYSSELBERGHE
1862-1926
Marguerite van Mons, 1886
Oil on canvas; 90 x 70.5 cm
Ghent, Museum voor Schone Kunsten

368 (ill. **393**)
Aristide SARTORIO
1860-1932
The Green Abyss, about 1895
Oil on canvas; 59 x 135 cm
Piacenza, Galleria d'Arte Moderna Ricci Oddi

370 (ill. **477**)
Hugo SCHAPER
1844-1915
"Erwachen" Brooch, 1902
Gold, ivory, enamel, pearl; 8 x 6.5 cm
Württembergisches Landesmuseum Stuttgart

371 (ill. **105**)
C. H. SCHMIDT-HELMBRECHTS
1871-1936
Empusa, 1896
Etching; 38.4 x 28.5 cm
London, The Board of Trustees of the
Victoria and Albert Museum

372 (ill. **151**)
Arnold SCHOENBERG
1874-1951
The Red Gaze, 1910
Oil on cardboard; 32 x 25 cm
Munich, Städtische Galerie im Lenbachhaus

373 (ill. **161** to **163**)
Carlos SCHWABE
1866-1926
Three Studies of Female Figures for
"The Wave", 1906-1907
Charcoal, black grease pencil, red chalk,
coloured crayon, pastel highlights, stump
 161 *Figure to the left*, 66.2 x 48 cm
 162 *Centre figure*, 100 x 67.5 cm
 163 *Figure to the right*, 66.4 x 48.2 cm
Geneva, Musée d'art et d'histoire

374 (ill. **233**)
Carlos SCHWABE
Sorrow, 1893
Oil on canvas; 155 x 104 cm
Geneva, Musée d'art et d'histoire

375 (ill. **94**)
Carlos SCHWABE
The Virgin of the Lilies, 1898
Watercolour; 57.2 x 31.8 cm
Amsterdam, Van Gogh Museum

376 (ill. **443**)
George SEELEY
1880-1955
Golden October, 1909
Coated pigment print; 44 x 53.8 cm (image)
New York, The Metropolitan Museum of Art,
gift of Marion D. Byron, 1981, and purchase,
Warner Communications Inc. Purchase Fund,
inv. 1981.1160

377 (ill. **513**)
George SEELEY
The Tribute, about 1907
Tinted bromide gelatin print; 42 x 34.5 cm
Paris, Musée d'Orsay

378 (ill. **184**)
George SEELEY
Landscape, about 1907-1910
Platinum print; 19.2 x 24.3 cm
Bath, The Royal Photographic Society

379 (ill. **286**)
George SEELEY
The Black Bowl, 1907
Gum-platinum print, 20.6 x 15.5 cm
Bath, The Royal Photographic Society

380 (ill. **466**)
George SEELEY
The Burning of Rome, 1906
Gum bichromate over platinum print;
48.9 x 36.2 cm (image)
New York, The Metropolitan Museum of Art,
Alfred Stieglitz Collection, 1933, inv.33.43.326

381 (ill. **509**)
George SEELEY
The Firefly, or **The Glow-worm**,
about 1907
Platinum print; 24.3 x 19.4 cm
Gilman Paper Company Collection

382 (ill. **499**)
George SEELEY
The Pines Whisper, 1904
Platinum print; 48.9 x 36.2 cm (image)
New York, The Metropolitan Museum of Art,
Alfred Stieglitz Collection, 1933, inv. 33.43.325

383 (ill. **232**)
George SEELEY
Untitled (à la Carlos Schwabe), 1906-1907
Photogravure on japan paper; 15.2 x 19.2 cm
Ottawa, National Gallery of Canada

384 (ill. **524**)
George SEELEY
The Guardian (Woman with Spear),
about 1905-1907
Platinum print; 23.9 x 19 cm
Bath, The Royal Photographic Society

385 (ill. **76**)
Giovanni SEGANTINI
1858-1899
Ave Maria in Transshipment, 1883
Pen and black ink; 31.8 x 24.5 cm
Private collection

386 (ill. **460**)
Giovanni SEGANTINI
Love at the Fountain of Life, 1896
Oil on canvas; 72 x 100 cm
Milan, Galleria d'Arte Moderna

387 (ill. **317**)
Giovanni SEGANTINI
The Angel of Life, 1894-1895
Coloured and gilt crayon, pastel; 59.5 x 43 cm
Saint-Moritz, Switzerland, Musée Segantini

388 (ill. **320**)
Giovanni SEGANTINI
The Annunciation of the New Word, 1896
Conté crayon, black chalk, highlights and
graphite traces on cardboard; 45 x 33 cm
Saint-Moritz, Switzerland, Musée Segantini

389 (ill. **526** to **528**)
Giovanni SEGANTINI
Triptych of Life, 1898
Charcoal, Conté crayon
 526 *Life*: 137 x 108 cm
 527 *Nature*: 137 x 127 cm
 528 *Death*: 137 x 108 cm
Winterthur, Switzerland, Stiftung für Kunst,
Kultur und Geschichte, on deposit at the Musée
Segantini, Saint-Moritz

390 (ill. **7**)
Alexandre SÉON
1855-1917
Orpheus, 1883
Oil on canvas; 45 x 30.5 cm
Saint-Étienne, Musée d'Art moderne

391 (ill. **433**)
Alexandre SÉON
Portrait of Sâr Péladan, 1891
Oil on canvas; 132 x 80 cm
Lyons, Musée des Beaux-Arts

392 (ill. **552**)
Paul SÉRUSIER
1864-1927
The Golden Cylinder, about 1910
Oil on cardboard; 38 x 23 cm
Rennes, Musée des Beaux-Arts et d'Archéologie

393 (ill. **95**)
Paul SÉRUSIER
The Daughters of the Philistim, 1908
Oil on canvas; 100 x 162 cm
Paris, Musée d'Orsay

394 (ill. **551**)
Paul SÉRUSIER
Tetrahedrons, about 1910
Oil on canvas; 91 x 56 cm
Paris, Guy Loudmer collection

395 (ill. **332** to **345**)
Hugo SIMBERG
1873-1917
Series of Fourteen Watercolours
Watercolour, gouache
 332 *Autumn II*, 1895; 12 x 18 cm
 333 *The Farmer's Wife and the Poor
 Devil*, 1899; 19 x 13 cm
 334 *Autumn I*, 1895; 30 x 14 cm
 335 *Dance on a Bridge*, 1899; 19.5 x
 25.5 cm
 336 *Wind Blowing*, 1897; 23 x 29 cm
 337 *By the River of Life*, 1896;
 23.5 x 14 cm
 338 *King Hobgoblin Sleeping*, 1896;
 20 x 28 cm
 339 *Death and the Peasant*, 1896;
 30.5 x 20 cm
 340 *Fantasy*, 1895; 24 x 32 cm
 341 *Autumn in the Forest*, 1895;
 28 x 33 cm
 342 *The Garden of Death*, 1896;
 16 x 17.5 cm
 343 *Frost*, 1895; 27 x 18 cm
 344 *Fairy Tale I*, 1895; 25 x 16 cm
 345 *Dream Regret*, 1900; 17.5 x 15 cm
Helsinki, Ateneum

396 (ill. **396**)
Joakim SKOVGAARD
1856-1933
Large Plate (Eve and the Serpent), 1899
Glazed earthenware; diam.: 61 cm
Copenhagen, Museum of Decorative Art

397 (ill. **553**)
Jan SLUIJTERS
1881-1957
October Sun, Laren, 1910
Oil on canvas; 50 x 55 cm
Haarlem, Frans Halsmuseum

398 (ill. **322**)
Léon de SMET
1881-1966
Interior, 1911
Oil on canvas; 121 x 111 cm
Ghent, Museum voor Schone Kunsten

399 (ill. **172**)
Harald SOHLBERG
1869-1935
Night, 1904
Oil on canvas; 113 x 134 cm
Trondheim, Norway, Trondhjems Kunstforening

400 (ill. **325**)
Léon SPILLIAERT
1881-1946
Boxes in front of a Mirror, 1904
Pastel; 57.5 x 39 cm
Brussels, Musées royaux des Beaux-Arts de
Belgique

401 (ill. **68**)
Léon SPILLIAERT
Dirigible in Its Hangar, 1910
India ink, pastel; 59.8 x 83.7 cm
Brussels, Musées royaux des Beaux-Arts de
Belgique

402 (ill. **69**)
Léon SPILLIAERT
Dirigible in Its Hangar, 1910
India ink, yellow pastel; 84.3 x 59.4 cm
Brussels, Musées royaux des Beaux-Arts de
Belgique

403 (ill. **193**)
Léon SPILLIAERT
The Bedroom, about 1908
Watercolour, coloured crayon; 63 x 48 cm
Brussels, Musées royaux des Beaux-Arts de
Belgique

404 (ill. **194**)
Léon SPILLIAERT
November 2, about 1907-1908
Watercolour, wash, red crayon; 50 x 65 cm
Ghent, Museum voor Schone Kunsten

405 (ill. **192**)
Léon SPILLIAERT
Table d'Hôte, 1904
Watercolour, pastel; 47.5 x 47.5 cm
Brussels, Musées royaux des Beaux-Arts de
Belgique

406 (ill. **160**)
Léon SPILLIAERT
Self-portrait in a Mirror, 1908
Watercolour, gouache, pastel; 48 x 63 cm
Ostend, Museum voor Schone Kunsten

407 (ill. **547**)
Léon SPILLIAERT
The Lighthouse, 1910
Watercolour, gouache; 54 x 74 cm
Ostend, Museum voor Schone Kunsten

408 (ill. **200**)
Léon SPILLIAERT
Vertigo: The Magic Staircase, 1908
Wash, ink, watercolour, colored pencil;
64.1 x 47.9 cm
Ostend, Museum voor Schone Kunsten

409 (ill. **508**)
Edward J. STEICHEN
1879-1973
Figure with Iris, 1902
Direct carbon print; 34 x 18.8 cm (image)
New York, The Metropolitan Museum of Art,
Alfred Stieglitz Collection, 1933, inv. 33.43.17

410 (ill. **183**)
Edward J. STEICHEN
Nocturne: Staircase of the Orangerie,
Versailles, about 1910
Gum-bichromate print; 28 x 35.5 cm
New York, The Museum of Modern Art, gift of
the photographer

411 (ill. **148**)
Edward J. STEICHEN
Richard Strauss, 1904
Direct carbon print; 46.7 x 32.7 cm (image)
New York, The Metropolitan Museum of Art,
Alfred Stieglitz Collection, 1949, inv. 49.55.168

412 (ill. **503**)
Edward J. STEICHEN
Profile of Rodin with "The Thinker",
Victor Hugo Monument in the
Background, 1902
Direct carbon print, engraving (?), reprinted
from gum; 26 x 32.2 cm
Paris, Musée Rodin, inv. Ph217

413 (ill. **506**)
Edward J. STEICHEN
Sadakichi Hartmann, 1903
Direct carbon print; 24.6 x 30.5 cm (image)
New York, The Metropolitan Museum of Art,
Alfred Stieglitz Collection, 1933, inv. 33.43.52

414 (ill. **167**)
Edward J. STEICHEN
The Pond: Moonrise, 1903
Platinum print; 39.7 x 48.2 cm (image)
New York, The Metropolitan Museum of Art,
Alfred Stieglitz Collection, 1933, inv. 33.43.40

415 (ill. **168**)
Edward J. STEICHEN
The Pool: Evening Milwaukee, 1899
Carbon print; 20.1 x 15.2 cm
Gilman Paper Company Collection

416 (ill. **502**)
Edward J. STEICHEN
The Silhouette (4 O'clock in the Morning:
Rodin's "Balzac", Meudon), 1908
Gum-bichromate print; 16.8 x 22 cm (image)
Paris, Musée Rodin, inv. Ph224

417 (ill. **67**)
Alfred STIEGLITZ
1864-1946
A Dirigible, 1910
Photogravure; 17.7 x 17.9 cm
Ottawa, National Gallery of Canada

418 (ill. **315**)
Beda STJERNSCHANTZ
1867-1910
Pastoral (Spring), 1897
Oil on canvas; 100 x 82 cm
Kokkola, Finland, K.H. Renlundin Museo

419 (ill. **58**)
Marianne STOKES
1855-1927
Mélisande, about 1895
Tempera on canvas; 87 x 52 cm
Cologne, Wallraf-Richartz-Museum

420 (ill. **103**)
Carl STRATHMANN
1866-1939
Design for a Plate (Serpent in Paradise),
about 1897
Ink, watercolour and enamel on cardboard;
72.8 x 72.8 cm
Munich, Münchner Stadtmuseum

421 (ill. **18**)
John M. STRUDWICK
1849-1935
Circe and Scylla, 1886
Oil on canvas; 99.7 x 69.8 cm
Liverpool, The Board of Trustees of the National
Museums and Galleries on Merseyside, Walker
Art Gallery

422 (ill. **442**)
Stanislav SUCHARDA
1866-1916
Treasure, 1897
Bronze relief; upper plaque: 76 x 35.5 cm;
lower plaque: 11 x 35.5 cm
Hradec Králové, Czech Republic, Galerie
moderního umění

423 (ill. **324**)
Ellen THESLEFF
1869-1954
Girl and Guitar, 1891
India ink wash; 36 x 30 cm
Helsinki, Ateneum

424 (ill. **104**)
Hans THOMA
1839-1924
Plate with a Harpy, about 1901
Lead-glazed earthenware; diam.: 38 cm
Badisches Landesmuseum Karlsruhe

425 (ill. **85**)
Johan THORN PRIKKER
1868-1932
Descent from the Cross, 1892
Oil on canvas; 88 x 147 cm
Otterlo, The Netherlands, Kröller-Müller
Museum

426 (ill. **84**)
Johan THORN PRIKKER
Laid in the Tomb, about 1892
Pencil, watercolour; 48.3 x 51.4 cm
Otterlo, The Netherlands, Kröller-Müller
Museum

427 (ill. **351**)
Tiffany Glass and Decorating Co.
"Dragonfly" Lamp, about 1900
Leaded glass, bronze; 71.1 x 55.8 cm
Richmond, Virginia Museum of Fine Arts, gift
of Sydney and Frances Lewis

428 (ill. **580**)
Louis Comfort TIFFANY
1848-1933
"Cypriote" Vase, about 1895
Favrile glass; h.: 43 cm; diam.: 16.5 cm
New York, The Museum of Modern Art,
Joseph H. Heil Fund

429 (ill. **581**)
Louis Comfort TIFFANY
Vase, about 1900
Favrile glass; h.: 16.6 cm; diam.: 13 cm
New York, The Museum of Modern Art,
Joseph H. Heil Fund

430 (ill. **530**)
Jan TOOROP
1858-1928
Apocalypse, 1892
Pencil, pen and brown and blue ink, with white
chalk on brown paper; 37.5 x 41.5 cm
Neuss, Germany, Clemens-Sels-Museum

431 (ill. **62**)
Jan TOOROP
Time and Eternity, 1890-1904
Oil glaze over black and red chalk; 79 x 66 cm
Neuss, Germany, Clemens-Sels-Museum

432 (ill. **301**)
Henri de TOULOUSE-LAUTREC
1864-1901
Mademoiselle Loie Fuller, 1893
Four- or five-colour lithograph, watercolour,
gold ink highlights; 38.1 x 25.6 cm
Ottawa, National Gallery of Canada

433 (ill. **546**)
Albert TRACHSEL
1863-1929
Lightning, 1898-1901
Watercolour; 62 x 48 cm
Kunstmuseum Solothurn, Dübi-Müller
Foundation

434 (ill. **547**)
Albert TRACHSEL
Lightning, 1901
Oil on canvas; 104.5 x 130.5 cm
Kunstmuseum Solothurn, Josef Müller
Foundation

435 (ill. **554**)
Albert TRACHSEL
Dream Landscape, about 1912-1913
Oil on canvas; 105 x 130 cm
Kunstmuseum Solothurn, Dübi-Müller
Foundation

436 (ill. **483** to **486**)
Phoebe TRAQUAIR
1852-1936
The Progress of the Soul
Silk and gold thread embroidery on linen
Four panels:
 483 *The Entrance*, 1893-1895;
 180.7 x 71.1 cm
 484 *The Stress*, 1895-1897;
 180.7 x 71.1 cm
 485 *Despair*, 1897-1899;
 184.8 x 74.9 cm
 486 *Victory*, 1899-1902; 188.3 x 74.3 cm
Edinburgh, National Gallery of Scotland

437 (ill. **102**)
Josef VÁCHAL
1884-1969
Invokers of the Devil, 1909
Oil on canvas; 95 x 94 cm
Hradec Králové, Czech Republic, Galerie
moderního umění

438 (ill. **436**)
Ville VALLGREN
1855-1940
"Lotus Leaf" Vase, 1893
Bronze; h.: 22 cm
Helsinki, Ateneum

439 (ill. **246**)
Ville VALLGREN
Tear Bottle, 1892
Bronze; h.: 20.7 cm
Helsinki, Ateneum, Antell collection

440 (ill. **480**)
Henry VAN DE VELDE
1863-1957
Abstract Plant Composition, 1893
Pastel; 47.5 x 51.0 cm
Otterlo, The Netherlands, Kröller-Müller
Museum

441 (ill. **557**)
Theo VAN DOESBURG
1883-1931
Cosmic Sun, 1915
Pastel; 24 x 32 cm
Private collection

442 (ill. **556**)
Theo VAN DOESBURG
Symbolist Composition, 1915
Pastel; 31.8 x 24.2 cm
Rijksdienst Beeldende Kunst, The Hague, on
loan to the Centraal Museum, Utrecht

443 (ill. **444**)
Kees VAN DONGEN
1877-1968
In Praise of Guus and Dolly, 1905
Oil on canvas; 73 x 92 cm
Private collection

444 (ill. **570**)
Kees VAN DONGEN
Souvenir of the Russian Opera Season,
1909
Oil on canvas; 54 x 65 cm
Ottawa, National Gallery of Canada

445 (ill. **74**)
Elihu VEDDER
1836-1923
*The Sorrowing Soul between Doubt and
Faith*, about 1887
Oil on canvas; 40 x 53.5 cm
Ithaca, New York, Cornell University, Herbert F.
Johnson Museum of Art

446 (ill. **348**)
Ludwig VIERTHALER
1875-1967
Bowl, 1906
Repoussé copper, inset mother-of-pearl;
diam.: 30.5 cm
Minneapolis, Norwest Corporation

447 (ill. **248**)
Gustav VIGELAND
1869-1943
Anxiety, 1892
Bronze; h.: 29.5 cm; base: 0.8 x 10 x 9.7 cm
Oslo, Nasjonalgalleriet

448 (ill. **353**)
Wilhelm Lucas VON CRANACH
1861-1918
"Octopus and Butterfly" Brooch, 1900
Gold, enamel, diamonds, rubies, amethysts,
topaz, pearls; 9.8 x 8.3 cm
Schmuckmuseum Pforzheim

449 (ill. **419**)
Wilhelm Lucas VON CRANACH
Medusa Head Brooch, 1902
Opal, red jasper, green nephrite, glass, gold,
pearl; 9 x 13.7 cm
Staatliche Museen zu Berlin, Kunstgewerbe-
museum

450 (ill. **432**)
Wilhelm VON GLOEDEN
1856-1931
Boy with Palm Branch, about 1900
Albumen print; 11.5 x 20 cm
Berlin, Christoph Niess collection

451 (ill. **431**)
Wilhelm VON GLOEDEN
Young Sicilian (Hypnos), 1904
Silver print; 21.9 x 16.1 cm
Bath, The Royal Photographic Society

452 (ill. **517**)
Wilhelm VON GLOEDEN
*Ruins with Pond and Two Youths
Dressed in the Antique Style*, about 1900
Silver bromide print; 38.3 x 26.7 cm
Frankfurt, Uta and Wilfried Wiegand collection

453 (ill. **22**)
Hans VON MARÉES
1837-1887
Sketch for "The Rape of Ganymede",
1886
Red chalk; 43 x 57.5 cm
Staatliche Kunstsammlungen Dresden,
Kupferstich Kabinett

454 (ill. **521**)
Hans VON MARÉES
*Woman, Child and Men in an Orange
Grove*, about 1876
Pencil over charcoal, white highlights on brown
paper; 34.5 x 26.4 cm
Munich, Staatliche Graphische Sammlung
München

455 (ill. **522**)
Hans VON MARÉES
Men with Orange Trees, about 1876
Pencil over charcoal, white highlights on brown
paper; 29.9 x 23.6 cm
Munich, Staatliche Graphische Sammlung
München

456 (ill. **507**)
**Albert Freiherr VON SCHRENCK-
NOTZING**
1862-1929
Eva C. and a Phantom Face, 1911
Photoprint; 18 x 24 cm
Freiburg im Breisgau, Institut für Grenzgebiete
der Psychologie und Psychohygiene

457 (ill. **525**)
Franz VON STUCK
1863-1928
The Guardian of Paradise, 1889
Oil on canvas; 250 x 167 cm
Munich, Villa Stuck

458 (ill. **394**)
Franz VON STUCK
Sin, 1899
Oil on cardboard; 32.5 x 77 cm
Cologne, Wallraf-Richartz-Museum

459 (ill. **83**)
Franz VON STUCK
Golgotha, about 1917
Oil on canvas; 100.3 x 101.5 cm
The Brooklyn Museum, gift of Alfred W. Jenkins

460 (ill. **523**)
Franz VON STUCK
The Lost Paradise, 1897
Oil on canvas; 200 x 290 cm
Staatliche Kunstsammlungen Dresden,
Gemäldegalerie Neue Meister
Not available for exhibition, for conservation
reasons

461 (ill. **195**)
Édouard VUILLARD
1868-1940
Mystery Interior (The Kerosene Lamp),
about 1895
Oil on cardboard; 36 x 38.1 cm
Geneva, Galerie Jan Krugier

462 (ill. **294**)
Édouard VUILLARD
The Dressmakers (Desmarais Screen),
1892
Tempera on linen glued to canvas
Four panels:
 The Dressmaker, 95 x 38 cm
 The Fitting, 120 x 38 cm
 The Apprentices, 120 x 38 cm
 The Lost Spool, 95 x 38 cm
Geneva, Galerie Jan Krugier

463 (ill. **265**)
John William WATERHOUSE
1849-1917
The Lady of Shalott, 1894
Oil on canvas; 142.2 x 86.3 cm
Leeds City Art Galleries

464 (ill. **541**)
George Frederick WATTS
1817-1904
The Sower of the Systems, 1902-1903
Oil on canvas; 122.6 x 91.4 cm
Toronto, Art Gallery of Ontario, gift of Joey and
Toby Tanenbaum, 1971; donated by the Ontario
Heritage Foundation, 1968

465 (ill. **60**)
George Frederick WATTS
Time, Death and Judgement,
about 1865-1886
Oil on canvas; 243.8 x 166.4 cm
Ottawa, National Gallery of Canada, gift of the
artist, London, England, 1887, on the occasion
of Queen Victoria's jubilee

466 (ill. **271**)
George Frederick WATTS
with assistants
Hope, 1886
Oil on canvas; 142.2 x 111.8 cm
London, Tate Gallery, presented by George
Frederick Watts, 1897

467 (ill. **467**)
Clarence H. WHITE
1871-1925
Morning, 1905
Gum-bichromate print; 24.5 x 19.5 cm
Princeton, The Art Museum, Princeton
University, The Clarence H. White Collection
assembled and organized by Professor Clarence
H. White, Jr., and given in memory of Lewis F.
White, Dr. Maynard P. White, Sr., and Professor
Clarence H. White, Jr., the sons of Clarence H.
White, Sr., and Jane Felix White

468 (ill. **446**)
Clarence H. WHITE
Nude with Baby, 1912
Gum print; 25.4 x 17.3 cm
Washington, Library of Congress, Prints and
Photographs Division

469 (ill. **455**)
Clarence H. WHITE
Spring, a Triptych, 1898
Platinum print; centre panel: 41 x 20.7 cm;
side panels: 38.2 x 6 cm (each)
New York, The Museum of Modern Art, Lily
Auchincloss Fund

470 (ill. **283**)
Clarence H. WHITE
Still Life (Crystal Ball), 1907
Platinum print; 22.2 x 19.2 cm
Bath, The Royal Photographic Society

471 (ill. **285**)
Clarence H. WHITE
Symbolism of Light, 1907
Platinum print; 19.4 x 24.8 cm
Washington, Library of Congress, Prints and
Photographs Division

472 (ill. **518**)
Clarence H. WHITE
The Faun, 1907
Platinum print; 24.1 x 18.7 cm
Bath, The Royal Photographic Society

473 (ill. **465**)
Clarence H. WHITE
The Fountain, 1907
Gum-platinum print; 24.1 x 19.3 cm
Bath, The Royal Photographic Society

474 (ill. **276**)
Clarence H. WHITE
The Sea, 1909
Platinum print; 24.6 x 18.6 cm
Princeton, The Art Museum, Princeton
University, The Clarence H. White Collection
assembled and organized by Professor Clarence
H. White, Jr., and given in memory of Lewis F.
White, Dr. Maynard P. White, Sr., and Professor
Clarence H. White, Jr., the sons of Clarence H.
White, Sr., and Jane Felix White

475 (ill. **505**)
Clarence H. WHITE
and **F. Holland DAY**
Portrait of Holland Day, about 1897
Platinum print; 24.2 x 18.8 cm
Gilman Paper Company Collection

476 (ill. **247**)
Jens Ferdinand WILLUMSEN
1863-1958
Funerary Urn with Poppies, 1897
Stoneware; h.: 36.5 cm
Frederikssund, Denmark, J.F. Willumsens
Museum

477 (ill. **542**)
Jens Ferdinand WILLUMSEN
Sun over the Park, 1904
Tempera, possibly some oil, on canvas;
41 x 34 cm
Frederikssund, Denmark, J.F. Willumsens
Museum

478 (ill. **75**)
Henry WILSON
1864-1934
Brooch-Pendant, about 1900-1905
Gold, enamel, sapphires, ruby; 5.8 x 4.6 cm
London, The Board of Trustees of the
Victoria and Albert Museum

479 (ill. **152**)
Stanisław Ignacy WITKIEWICZ
1885-1939
Self-portrait, 1912
Vintage print; 16.5 x 12 cm
Stefan Okolowicz collection

480 (ill. **316**)
Witold WOJTKIEWICZ
1879-1909
Parting (from the "Ceremonies" Cycle),
1908
Tempera on canvas; 90 x 100 cm
National Museum of Poznań

481 (ill. **45**)
Philippe WOLFERS
1858-1929
"Monnaie du pape" Cup, 1899
Silver, enamel, marble; h.: 20.7 cm
Ghent, Museum voor Sierkunst

482 (ill. **472**)
Philippe WOLFERS
1858-1929
"La Parure" Jewel Box, 1905
Silver, ivory (medaillon); enamel work on silver,
pearls, opals (frieze); 42 x 30 x 20.2 cm
Brussels, Musées royaux d'Art et d'Histoire

483 (ill. **111**)
Philippe WOLFERS
The Swan Song, 1898
Bronze, marble, oak, mahogany; 157.5 x 66 x
134.5 cm; base: 88.8 x 96.5 x 134.5 cm
Richmond, Virginia Museum of Fine Arts,
The Adolph D. and Wilkins C. Williams Fund

484 (ill. **106**)
Vilmos ZSOLNAY
1828-1900
Dante's Inferno, about 1900
Ceramic; h.: 42.5 cm
Ghent, Museum voor Sierkunst

485 (ill. **360**)
Vilmos ZSOLNAY
and **Lajós MACK**
b. 1876-d. after 1930
Vase, about 1900
Glazed stoneware with lustre decoration;
h.: 31 cm
Private collection

Numbering of the books and magazines follows the order in the French edition of this catalogue.

Books

1. ANONYMOUS
Niebelungen dem Deutschen Wolke
Retold by Franz Keim
Vienna: Ch. Reitzer & Sons for Gerlach and Wiedling, (1908)
1 vol., 18mo, square, 15 x 13.8 cm, with sixteen full-page colour illustrations and black-and-white vignettes by Carl Otto Czeschka
Paris, private collection

11. APULEIUS
Amor und Psyché
Munich: Kunstverlag Theo Stroefer, (1881)
Translated from the Latin by Reinhold Jachmann
1 vol. (68 pp.), 27 x 36 cm, with forty-six original etchings and decoration by Max Klinger
London, The Board of Trustees of the Victoria and Albert Museum

2. Edward BURNE-JONES
The Flower Book
London: Henry Piazza et Cie for the Fine Art Society, 1905
1 vol., 33.5 x 27.5 cm, with reproductions of thirty-eight watercolours (roundels)
London, Peter Nahum at The Leicester Galleries

3. Geoffrey CHAUCER
The Works of Geoffrey Chaucer Now Newly Imprinted
Hammersmith: Kelmscott Press, 1896
1 vol., folio, 42 x 28 cm, with eighty-seven woodcut plates by Edward Burne-Jones, and woodcut frames, borders and ornamental initials by William Morris and Edward Burne-Jones
Kingston, Ontario, Queen's University, Stauffer Library, Special Collections

4. J. DEML
Le Château de la mort
1912
1 vol., with woodcuts by Josef Váchal
Museum of Decorative Arts in Prague

5. Gustave FLAUBERT
La Tentation de Saint Antoine
Paris: Ambroise Vollard, 1933 (plates printed by Auguste Clot in 1896, after Redon's series "The Temptation of Saint Anthony")
1 vol., folio (xiii + 206 pp.), 44 x 33 cm, with cover, twenty-two lithographic plates and fifteen drawings by Odilon Redon (printed by Aubert in 1910)
London, The Board of Trustees of the Victoria and Albert Museum

6. Paul GAUGUIN and Charles MORICE
Noa-Noa. Voyage de Tahiti
Munich: R. Piper & Co, 1926
1 vol., 16mo (204 pp.), 25 x 32 cm, handwritten, with colour and black-and-white collotype reproductions (printed by Marées Gesellschaft, Dresden)
London, The Board of Trustees of the Victoria and Albert Museum

7. André GIDE
Le Voyage d'Urien
Paris: Librairie de l'art indépendant, 1893
1 vol., 8°, square (110 pp.), 20 x 21 cm, with cover and thirty two-colour lithographs by Maurice Denis
London, The Board of Trustees of the Victoria and Albert Museum

8. Remy de GOURMONT
Phocas, avec une couverture et trois vignettes
Paris: Mercure de France, "Ymagier" collection, 1895
1 vol., 18mo, square, 15 x 15.5 cm
Paris, Bibliothèque nationale de France

9. Edmond HARAUCOURT
L'Effort
Paris: Les Bibliophiles contemporains, 1894
1 vol., 4°, containing four short stories: "La Madone", with eighteen original colour lithographs by Alexandre Lunois; "L'Antéchrist", with thirty-eight illustrations by Eugène Courboin; "L'Immortalité", with thirty-two illustrations by Carlos Schwabe; and "La Fin du monde", with forty-six symbolic drawings by Alexandre Séon. Cover by Léon Rudnicki
Paris, Bibliothèque nationale de France

10. Adolphe JULIEN
Richard Wagner, sa vie et ses œuvres
Paris: Jules Rouam; and London: Gilbert Wood & Co., 1886
1 vol., 4°, with fourteen original lithographs by Henri Fantin-Latour, fifteen portraits of Wagner, four etchings and one hundred and twenty engravings
Ottawa, National Library of Canada, Music Division

12. Oskar KOKOSCHKA
Die träumenden Knaben
Vienna: Wiener Werkstätte, 1908
19.3 x 17 cm, poem with eight colour lithographs
Historical Museum of the City of Vienna

13. Maurice MAETERLINCK
Douze chansons
Paris: P.V. Stock (printed by Louis van Melle, Ghent), 1896
1 vol., 4°, 25 x 32.5 cm, with cover and twelve woodcut plates by Charles Doudelet
Paris, Bibliothèque nationale de France

14. Sir Thomas MALORY
The birth, life and acts of King Arthur, of his noble knights of the round table . . .
London: J.M. Dent and Co., Aldine House, 1893-1894
Text after the Caxton edition of 1485, with spelling modernized and an introduction by Professor Rhys
2 vols., 8° (lxiv + 455 pp. and xxv + 532 pp.), 24 x 19.5 cm, with black-and-white woodcut borders, frames, ornamental initials and vignettes by Aubrey Beardsley
University of Toronto, Thomas Fisher Rare Book Library

15. Camille MARTIN
"La Mélancolie"
1893
Portfolio, tooled mosaic leather lined with cotton rep, inscribed on both boards, 51 x 33 cm
Musée de l'École de Nancy, exhibition committee purchase, 1894

16. Manuel ORAZI
Calendrier magique
Paris: L'Art nouveau, 1896
1 vol., 49.6 x 17.5 cm (with case), with leather spine
Paris, private collection

17. Joséphin PÉLADAN
Istar (Le Vice suprême)
Paris: G. Edinger, 1888
1 vol., 16mo, 19 x 12.4 cm, with frontispiece (soft-ground etching) by Fernand Khnopff
Paris, Bibliothèque nationale de France

18. Edgar Allan POE
Tales of Mystery and Imagination
Undated
1 vol., 4°, 25.3 x 19 cm, with illustrations by Harriet Clarke
Ottawa, National Library of Canada

24. Georges RODENBACH
Les Tombeaux
Paris: S. Bing, 1895
1 vol., 4° (unpaginated), 25.5 x 17.5 cm; conceived (at Christmastime) by Joseph Rippl-Ronaï and James Pitcairn-Knowles; story by Georges Rodenbach; three original woodcuts by James Pitcairn-Knowles
Paris, Bibliothèque nationale de France

25. Dante Gabriel ROSSETTI
La Damoiselle élue
Paris: Librairie de l'art indépendant, 1893
Translated from the English by Gabriel Sarrazin; set to music by Claude Debussy
1 vol., 4°, 36.5 x 23.5 cm, with colour frontispiece by Maurice Denis
Paris, Biliothèque nationale de France

26. Marcel SCHWOB
La Porte des rêves
Paris: Henry Floury/Les Bibliophiles
indépendants, 1899
1 vol., 4°, 29 x 22 cm, with fold-out colour
frontispiece and illustrations by Georges
de Feure
Paris, Bibliothèque nationale de France

27. J. SIMANEK
Le Voyage d'un petit elfe
1911
1 vol., 31.5 x 24.5 cm, with woodcuts by
Josef Váchal
Museum of Decorative Arts in Prague

28. W. G. VAN NOUHUYS
Egidius en de Vreemdeling
Haarlem: De Erven F. Bohn, 1899
1 vol., 4° (vii + 46 pp.), 20 x 28 cm, with cover
and three plates by Jan Toorop
London, The Board of Trustees of the Victoria
and Albert Museum

29. Paul VERLAINE
Sagesse
Paris: Ambroise Vollard, 1911
With colour woodcuts by Maurice Denis
(printed by Beltrand in 1910)
France, private collection

30. Oscar WILDE
The Sphinx
London: Elkin Mathews and John Lane, 1894
1 vol., 8°, 22 x 17.4 cm, with decorations by
Charles Ricketts and vellum-covered boards
decorated with gold
Montreal, McGill University Libraries,
Department of Rare Books and Special
Collections

Magazines

19. *L'Image*
Paris: Fleury, 1896-1897
Twelve fascicules bound together, 4° (384 pp.),
with covers by Mucha, Auriol, de Feure,
Darbour, Verneuil, Drogue, Bellery-
Desfontaines, Berthon, Prouvé, Belleville,
Toulouse-Lautrec and Lenoir, and illustrations
by Vallotton, de Feure, Denis, Jeanniot, Lepère
and others
Literary directors: Roger Marx and Jules Rais;
art directors: Tony Beltrand, Auguste Lepère
and Léon Ruffe, with contributions from the
Society of Wood Engravers of France
Montreal, McGill University, Blackader-
Lauterman Library of Architecture and Art

20. *L'Ymagier*
1894-1896
Vol. 1: no. 1 (October 1894) - no. 4 (July 1895);
vol. 2: no. 5 (October 1895) - no. 8 (December
1896)
Quarterly review (eight issues), 4°,
27.5 x 22.5 cm; literary and art directors:
Alfred Jarry and Remy de Gourmont (the latter
alone for nos. 6-8)
Saint-Germain-en-Laye, Musée departemental
Maurice Denis « Le Prieuré »

21. *La Jeune Belgique*
January 15, 1890, issue, 8°, 18 x 13.5 cm,
illustration by George Minne
Brussels, Bibliothèque royale Albert 1er,
Archives et Museé de la littérature

22. *The Yellow Book*
1894
"The Wagnerites", vol. 3, October issue, with
illustrations by Aubrey Beardsley
Ottawa, National Library of Canada

23. *Van Nu en Stracks*
1893
1 issue, 4°, 27.5 x 22.5 cm, with illustrations by
Jan Toorop, Johan Thorn Prikker and Henri Van
de Velde
Paris, private collection

List of Figures

Compiled by Caroline Fréchette and Pierre Rannou

The present bibliography focusses mainly on the artists represented in the exhibition. It includes books and exhibition catalogues published between 1984 and 1994; however, magazine articles and earlier publications are cited when they are all that is available on a given artist.

For titles published before 1984, the reader should consult the bibliography complied by Patty Chelap, "Bibliography: Symbolist Art, 1974-1984", *Art Journal*, vol. 45, no. 2 (1985), special issue on "Symbolist Art and Literature", pp. 171-180, as well as the one by David L. Anderson, *Symbolism: A Bibliography of Symbolism as an International and Multi-disciplinary Movement* (New York: New York University Press, 1975), which encompasses material from the nineteenth century.

References for photographers and photography are given in the footnotes to Ulrich Pohlmann's essay in this catalogue (p. 428), as well as scattered through the list of General Works below.

General Works

ANDERSON, David L. *Symbolism: A Bibliography of Symbolism as an International and Multi-disciplinary Movement*. New York: New York University Press, 1975.

ARWAS, Victor. *Glass Art Nouveau to Art Deco*. New York: Harry N. Abrams, 1987.

AURIER, Georges Albert. *Le Symbolisme en peinture : Van Gogh, Gauguin et quelques autres*. Caen, France: L'Échoppe, 1991. Texts selected and introduced by Pierre-Louis MATHIEU.

BARTRAM, Michael. *The Pre-Raphaelite Camera: Aspects of Victorian Photography*. Boston: Little, Brown and Co., 1985.

BASCOU, Marc, Marie-Madeleine MASSÉ and Philippe THIÉBAUT, eds. *Catalogue sommaire illustré des arts décoratifs*. Paris: Ministère de la culture et de la communication/Réunion des musées nationaux, 1988.

BECKER, Ingeborg. *Berliner Porzellan vom Jugendstil zum Funktionalismus, 1889-1939*. Berlin: Bröhan-Museum, 1987. Texts by Ingeborg BECKER, Karl H. BRÖHAN, Peter WEX, Jürgen BRÜCKNER and Dieter V. TRESKOW.

BECKER, Vivienne. *Art Nouveau Jewellery*. London: Thames and Hudson, 1985.

BLOCK, Jane. *Les XX and Belgian Avant-gardism, 1868-1894*. Ann Arbor, Michigan: UMI Research Press, 1984.

BORISOVA, Hélène Andreevna, and Gregory STERNINE. *Russian Art Nouveau*. New York: Rizzoli, 1988. Originally published as *Art nouveau Russe*. Paris: Éditions du Regard, 1987.

BORSI, Franco, and Ezio GODOLI. *Vienne, architecture 1900*. Paris: Flammarion, 1985.

BOUILLON, Jean-Paul. *Art nouveau, 1870-1914*. New York: Skira/Rizzoli, 1985. Originally published as *Journal de l'Art nouveau, 1870-1914*. Geneva: Skira, 1985.

BRETTELL, Richard R. *Post-Impressionists*. Chicago: The Art Institute of Chicago; New York: Harry N. Abrams, 1987.

BUCHANAN, Wiliam, ed. *J. Craig Annan: Selected Texts and Bibliography*. Oxford: Clio Press, 1994, "World Photographers Reference" series, vol. 6.

BUERGER, Janet E. *The Last Decade: The Emergence of Art Photography in the 1890s*. Rochester, New York: International Museum of Photography at George Eastman House, 1984.

CASTERAS, Susan P. *English Pre-Raphaelitism and Its Reception in America in the Nineteenth Century*. Cranbury, New Jersey: Farleigh Dickinson University Press; London: Associated University Press, 1990.

CHARPENTIER, Françoise-Thérèse, and Christian DEBIZE. *Art nouveau. L'École de Nancy*. Paris: Denoël; Metz: Serpenoise, 1987.

CLAUSEN, Meredith L. *Frantz Jourdain and the Samaritaine, Art Nouveau, Theory and Criticism*. Leiden: E. J. Brill, 1987 (text in English and French).

COGEVAL, Guy. *Les Années post-impressionnistes*. Paris: Nouvelles Éditions françaises, 1986.

DANKL, Günther. *Die "Moderne" in Österreich: zur Genese und Bestimmung eines Begriffes in der österreichischen Kunst um 1900*. Vienna and Cologne: H. Bohlaus, 1986, "Dissertationen zur Kunstgeschichte" series, no. 22.

DA SILVA, Jean. *Le Salon de la Rose+Croix (1892-1897)*. Paris: Syros-Alternatives, 1991, "Zigzags" series.

DEBENEDETTI, Jean Marc, and Serge BAUDIFFIER. *Les Symbolistes*. Paris: Henri Veyrier, 1990.

DENVIR, Bernard. *The Late Victorians: Art, Design & Society, 1852-1910*. New York: Longman, 1986.

DIERKENS-AUBRY, Françoise, and Jos VANDENBREEDEN. *Art nouveau en Belgique : architecture et intérieurs*. Paris: Duculot, 1991.

DIJKSTRA, Bram. *Idols of Perversity: Fantasies of Feminine Evil in Fin-de-siècle Culture*. New York: Oxford University Press, 1986.

DONATI, Annalisa, and Sissi ASLAN. *Dalla Belle Époque allo stile aerodinamico: cento schede utili per riconoscere e datare manifesti, grafica e illustrazioni, oggetti, mobili, moda e mode*. Florence: Giunti, 1992, "Leggere immagini" series, no. 1.

DORRA, Henri, ed. *Symbolist Art Theories: A Critical Anthology*. Berkeley: University of California Press, 1994.

DUNCAN, Alastair. *Fin de Siècle Masterpieces from the Silverman Collection*. New York: Abbeville Press, 1989.

DUNCAN, Alastair, and Georges de BARTHA. *Art Nouveau and Art Deco Bookbinding: French Masterpieces, 1880-1940*. New York: Harry N. Abrams, 1989.

EADIE, William. *Movements of Modernity: The Case of Glasgow and Art Nouveau*. London and New York: Routledge, 1990.

ESCHMANN, Karl. *Jugendstil: Ursprunge, Parallelen, Folgen*. Göttingen, Germany: Muster-Schmidt, 1991.

FABER, Monika, and Josef KROUTVOR. *Photographie der Moderne in Prag 1900-1925*. Schaffhausen, Switzerland: Stemmle, 1991.

FANELLI, Giovanni. *La linea viennese: grafica art nouveau*. Florence: Cantini, 1989.

FANELLI, Giovanni, and Ezio GODOLI. *Dizionario degli illustratori simbolisti e art nouveau*. Florence: Cantini, 1990.

FANELLI, Giovanni, and Rosalia FANELLI. *Il tessuto art nouveau: disegno, moda, architettura*. Florence: Cantini, 1986.

FÁROVÁ, Anna. *František Drtikol Photograph des Art Deco*. Munich: Schirmer; Paris: Mosel, 1986.

FARR, Dennis. *English Art, 1870-1940*. New York: Oxford University Press, 1984.

FATEJEW, V. *Phantastische Werke russischer Künstler*. Saint Petersburg: Aurora, 1989.

FORSTHUBER, Sabine. *Moderne Raumkunst. Wiener Ausstellungsbauten von 1898 bis 1914*. Vienna: Picus, 1991.

FRANZKE, Irmela. *Jugendstil. Glas, Graphik, Keramik, Metall, Möbel, Skulpturen und Textilien von 1880 bis 1915*. Karlsruhe: Badisches Landesmuseum, 1987.

FRÈCHES-THORY, Claire, and Antoine TERRASSE. *The Nabis: Bonnard, Vuillard, and Their Circle*. New York: Harry N. Abrams, 1991. Originally published as *Les Nabis*. Paris: Flammarion, 1990.

GERE, Charlotte, and Geoffrey C. MUNN. *Artists' Jewellery: Pre-Raphaelite to Arts and Crafts*. Woodbridge, England: Antique Collectors' Club, 1989.

GIBSON, Michael. *Le Symbolisme*. Cologne: Taschen, 1994.

___. *The Symbolists*. New York: Harry N. Abrams, 1988. Originally published as *Les symbolistes*. Paris: Nouvelles éditions françaises, 1984.

GRADOWSKA, A. *Sztuka Mlodej Polski* [The Art of Young Poland]. Warsaw: WAF, 1984.

GULLÓN, Ricardo, *et al. El Simbolismo: soñadores y visionarios*. Madrid: J. Tablate Miquis, 1984, "Oval" series, no. 1.

HASLAM, Malcolm. *In the Nouveau Style*. Boston: Little, Brown and Co., 1990.

HAMMOND, Anne, ed. *Frederick H. Evans: Selected Texts and Bibliography*. Oxford: Clio Press, 1992, "World Photographers Reference" series, vol. 1.

HARKER, Margaret F. *Henry Peach Robinson: Master of Photographic Art, 1830-1901*. Oxford and New York: Basil Blackwell, 1988.

HELMS, Cynthia Newman, A.D. MILLER and Julia HENSHAW, eds. *Symbolism in Poland: Collected Essays*. Detroit: Detroit Institute of Arts, 1984. Texts by Wieslaw JUSZCZAK, Maria PODRAZA-KWIATKOWSKA, Roman TABORSKI, Jan ZIELINSKI, Janusz ZAGRODZKI, Andrzej ROTTERMUND, Lukasz KOSSOWSKI, Lija SKALSKA-MIECIK, Jan CAVANAUGH and Marek ROSTWOROWSKI.

HIRSH, Sharon. *From Imagination to Evocation: Symbolist Drawings and Sketches*. Carlisle, Pennsylvia: The Trout Gallery/Dickinson College, 1984.

HOFSTÄTTER, Hans H. *Jugendstil et Art nouveau. Œuvres graphiques*. Paris: Albin Michel, 1985. Originally published as *Jugendstil – Graphik und Druckkunst*. Holle Verlag, 1983.

HOUFE, Simon. *Fin de Siècle: The Illustrators of the 'Nineties*. London: Barrie & Jenkins, 1992.

INGWERSEN, Faith, and Mary Kay NORSENG, eds. *Fin(s) de siècle in Scandinavian Perspective*. Columbia: Camden House, 1993, "Studies in Scandinavian Literature and Culture" series.

JAY, Bill, and Margaret MOORE, eds. *Bernard Shaw on Photography*. Salt Lake City: Peregrine Smith Books, 1989.

JOUVE, Séverine. *Les Décadents. Bréviaire fin de siècle*. Paris: Plon, 1989.

JUSZEZAK, Joseph. *Les Sources du symbolisme*. Paris: Sedes, 1985.

KALLIR, Jane. *Viennese Design and the Wiener Werkstätte*. New York: Braziller, 1988.

KAUFHOLD, Enno. *Bilder des Übergangs. Zur Mediengeschichte von Fotografie und Malerei in Deutschland um 1900*. Marburg, Germany: Jonas, 1986.

KEARNS, James. *Symbolist Landscapes: The Place of Painting in the Poetry and Criticism of Mallarmé and His Circle*. London: The Modern Humanities Research Association, 1989.

KEMPE, Erika, Fritz KEMPE and Heinz SPIELMANN. *Die Kunst der Camera im Jugendstil*. Frankfurt: Umschau, 1986.

KING, Julia. *The Flowering of Art Nouveau Graphics*. London: Trefoil, 1990.

KOCH, Michael, *et al. The Belle Époque of French Jewellery, 1850-1910*. London: Thomas Heneage & Co, 1990. Texts by Michael KOCH, Évelyne POSSÉMÉ, Judy MUNN, Marie-Noël de GARY, Barbara FURRER, Cathérine ARMINJON and Alexander Herzog von WÜRTTEMBERG.

KOPPEN, Erwin. *Literatur und Photographie. Über Geschichte und Thematik einer Medienentdeckung*. Stuttgart: J.B. Metzler, 1987.

KOSINSKI, Dorothy M. *Orpheus in Nineteenth-century Symbolism*. Ann Arbor, Michigan: UMI Research Press, 1989, "Studies in the Fine Arts. The Avant-garde" series, no. 61.

KRAUSS, Rolf H. *Jenseits von Licht und Schatten. Die Rolle der Photographie bei bestimmten paranormalen Phänomenen – ein historischer Abriß*. Marburg, Germany: Jonas, 1992.

LE RIDER, Jacques, *Modernity and Crises of Identity: Culture and Society in Fin-de-siècle Vienna*. New York: Continuum, 1993. Originally published as *Modernité viennoise et crises de l'identité*. Paris: Presses universitaires de France, 1990.

LEVIN, Miriam R. *Republican Art and Ideology in Late Nineteenth-century France*. Ann Arbor, Michigan: UMI Research Press, 1986.

LUCIE-SMITH, Edward. *Symbolist Art*. London: Thames and Hudson, 1985, "World of Art" series.

MAKELA, Maria. *The Munich Secession: Art and Artist in Turn-of-the-century Munich*. Princeton, New Jersey: Princeton University Press, 1990.

MARLAIS, Michael. *Conservative Echoes in Fin-de-siècle Parisian Art Criticism*. University Park: Pennsylvania State University Press, 1992.

MARSH, Jan. *The Pre-Raphaelite Sisterhood*. New York: St. Martin's, 1985.

——.*Pre-Raphaelite Women: Images of Femininity in Pre-Raphaelite Art*. London: Weidenfeld and Nicolson, 1987.

MASINI, Lara-Vinca. *Art Nouveau*. London: Thames and Hudson, 1984.

MATHIEU, Pierre-Louis, *The Symbolist Generation, 1870-1910*. New York: Rizzoli, 1990. Originally published as *La Génération symboliste 1870-1910*. Geneva: Skira, 1990.

MEECH-PEKARIK, Julia, and Gabriel P. WEISBERG. *Japonisme Comes to America: The Japanese Impact on the Graphic Arts, 1876-1925*. New York: Harry N. Abrams; New Brunswick, New Jersey: Jane Voorhees Zimmerli Art Museum, Rutgers, The State University of New Jersey, 1990.

MICHAELS, Barbara L. *Gertude Käsebier: The Photographer and Her Photographs*. New York: Harry N. Abrams, 1992.

MICHEL, Pierre-Frank. *Jugendstilglasmalerei in der Schweiz*. Bern: Haupt, 1986.

MICINSKA, Anna. *Stanisław Ignacy Witkiewicz Life and Work*. Warsaw: Interpress Publishers, 1990.

MILLER, Judith, and Martin MILLER, *Art Nouveau*. London: M. Beazley, 1992, "Miller's Antiques Checklist" series.

MILLMAN, Ian. *Georges de Feure, maître du symbolisme et de l'Art nouveau*. Courbevoie, France: ACR, 1992.

NASGAARD, Roald. *The Mystic North: Symbolist Landscape Painting in Northern Europe and North America, 1890-1940*. Toronto: University of Toronto Press/Art Gallery of Ontario, 1984.

NEUWIRTH, Waltraud. *Bluhender Jugendstil. Österreich/Art Nouveau in Blossom, Austria*. 2 vols. Vienna: Waltraud Neuwirth, 1991 (text in English and German).

PABST, Michael. *L'Art graphique à Vienne autour de 1900*. Paris: Mercure de France, 1985.

PAQUE, Jeannine. *Le Symbolisme belge*. Brussels: Labor, 1989.

PETERSON, Christian A. *Alfred Stieglitz's Camera Notes*. Minneapolis: Minneapolis Institute of Arts; New York: W. W. Norton & Co., 1993.

——."*Camera Work*": Process and Image. Minneapolis: Minneapolis Institue of Arts, 1985.

PETERSON, Ronald, ed. *The Russian Symbolists: An Anthology of Critical and Theoretical Writings*. Ann Arbor, Michigan: Ardis, 1986.

PIERRE, José. *L'Univers symboliste. Décadence, symbolisme et Art nouveau*. Paris: Somogy, 1991.

PINET, Hélène, ed. *Ornement de la durée. Loïe Fuller. Isadora Duncan. Ruth St-Denis. Adorée Villany*. Paris: Musée Rodin, 1987.

POHLMANN, Ulrich. *Wilhelm von Gloeden – Sehnsucht nach Arkadien*. Berlin: Nishen, 1987.

POINTON, Marcia, ed. *Pre-Raphaelites Re-viewed*. Manchester and New York: Manchester University Press, 1989, "Cultural Politics" series.

POIVERT, Michel. *Le Pictorialisme en France*. Paris: Hoebeke/Bibliothèque nationale, 1992.

PYNSENT, Robert, ed. "*Decadence and Innovation*": Austro-Hungarian Life and Art at the Turn of the Century. London: Weidenfeld and Nicolson, 1989.

QUATTROCCHI, Luca. *La Secessione a Praga*. Trento, Italy: L'Editore, 1990.

REED, John Robert. *Decadent Style*. Athens, Ohio: Ohio University Press, 1985.

REYNOLDS, Dee. *Symbolist Aesthetics and Early Abstract Art: Sites of Imaginary Space*. Cambridge, England, and New York: Cambridge University Press (to be published in 1995).

RIZZO, Eugenio, and Maria Cristina SIRCHIA. *Il Liberty a Palermo*. Palermo: Dario Flaccovio, 1992.

SARAJAS-KORTE, Salme. *Suomen varhaissymbolismi ja sen lahteet; tutkielma suomen maalaustaiteesta, 1891-1895*. Helsinki: Otava, 1966. Published in Swedish as *Vid symbolismens kallor: den tidiga symbolismen i Finland 1890-1895*. Jakobstad, Finland: Jakobstads tryckeri och tidning, 1981.

——.*Uuden taiteen lahteilla taiteilijoita Pariisissa, Berliinissa ja Italiassa*. Helsinki: Otava, 1966.

SCHWEIGER, Werner J. *Aufbruch und Erfüllung. Gebrauchsgraphik der Wiener Moderne 1897-1918*. Vienna: Christian Brandstätter, 1988.

——.*Wiener Werkstäte: Design in Vienna, 1903-1932*. New York: Abbeville Press, 1984. Originally published as *Meister Werke der Wiener Werkstätte: Kunst und Handwerk*. Vienna: Christian Brandstätter, 1982.

SCOTTI, Roland. *Kunst + Dokumentation 9: die Internationaler Kunst-Ausstellung 1907 in Mannheim*. Mannheim, Germany: Städtische Kunsthalle, 1985.

SEKALOVA, Helena, and Tomas VLCEK, eds. *Ceské secesní sklo/Böhmisches Jugendstilglas/Bohemian Glass of the Art Nouveau Period*. Prague: Ustav teorie a dejin umeni CSAV, 1985 (text in English and German).

SEMBACH, Klaus-Jürgen. *Art Nouveau. Utopia: Reconciling the Irreconcilable*. Cologne: Taschen, 1991.

SILVERMAN, Debora L. *Art Nouveau in Fin-de-siècle France: Politics, Psychology, and Style*. Berkeley, Los Angeles and London: University of California Press, 1989.

SMITH, John Boulton. *The Golden Age of Finnish Art: Art Nouveau and the National Spirit*. Helsinki: Otava, revised edition, 1985.

SPENCER, Stephanie. *O. G. Reijlander: Photography as Art*. Ann Arbor, Michigan: UMI Research Press, 1985.

STERNIN, Gregory. *Hudozestvennaja zizn' Rosii 1900-1910* [Artistic Life in Russia, 1900-1910]. Moscow: Iskusstvo, 1988.

STOPCZYK, S. *Malarstwo polskie od realizmu do abstrakcjonizmu* [Polish Painting from Realism to Abstract Art]. Warsaw: Krajowa Agencja Wydawnicza, 1988.

SZABADI, Judit. *Art Nouveau in Hungary*. Budapest: Corvina, 1989. Originally published as *A magyar szecesszio muveszete: festeszet, grafika, szobraszat*. Corvina, 1979.

SZABÓ, Júlia. *Nineteenth-century Painting in Hungary*. Budapest: Corvina, 1988. Originally published as *A XIX. szazad festeszete Magyarorszgon*. Corvina, 1985.

TOMMILA, Päiviö, and Maritta POHLS, eds. *Herää Suomi: suomalaisuuliikkeen historia*. Kuopio, Finland: Kustannuskiila, 1989.

HANSEN, Traude. *Wiener Werkstätte. Mode, Stoffe, Schmuck, Accessoires.* Vienna and Munich: Christian Brandstätter, 1984.

ULMER, Renate, and Klaus WOLBERT. *Museum Künstlerkolonie Darmstadt.* Darmstadt: Institut Mathildenhöhe, 1990.

VARNEDOE, Kirk. *Vienna 1900: Art, Architecture and Design,* exhib. cat. New York: The Museum of Modern Art, 1986.

VLCEK, Tomas. *Praha 1900: studie k dejinam kultury a umeni Prahy v letech 1890-1914.* Prague: Panorama, 1986.

WAISSENBERGER, Robert, ed. *Vienne 1890-1920.* Paris: Seuil, 1984.

WEAVER, Mike. *Alvin Langdon Coburn, Symbolist Photographer, 1882-1966.* New York: Aperture, 1986.

WEBER, Eugen. *France, Fin de Siècle.* Cambridge, Massachusetts: Harvard University Press, 1986.

WEISBERG, Gabriel P., and Yvonne M.L. WEISBERG. *Japonism: An Annotated Bibliography.* New York: Garland; New Brunswick, New Jersey: Jane Voorhees Zimmerli Art Museum, Rutgers, The State University of New Jersey, 1990.

WEST, Shearer. *Fin de Siècle: Art and Society in an Age of Uncertainty.* London: Bloomsbury, 1993.

WHITELEY, Jon. *Pre-Raphaelite Paintings and Drawings.* Oxford: Phaidon, 1989, "Ashmolean-Christie's Handbooks" series.

WICHMANN, Siegfried. *Jugendstil Art Nouveau: Floral and Functional Forms.* Boston: Little, Brown & Co., 1984. Originally published as *Jugendstil, floral funktional in Deutschland und Österreich und den Einflußgebieten,* exhib. cat. Schuler Verlagsgesellschaft, 1984.

WIGGINS, Colin. *Post-Impressionism.* London and New York: Dorling; Stuttgart: Kindersley, 1993.

WITTLICH, Petr. *Art Nouveau : peinture, orfèvrerie, bibelots, sculpture, architecture.* Paris: Éditions Cercle d'art, 1985.

___.*Prague Fin de Siècle.* Paris: Flammarion, 1992.

WOOD, John. *The Art of the Autochrome: The Birth of Color Photography.* Iowa City: University of Iowa Press, 1993.

ZUROWDKA, Joana, *et al. Le Symbolisme en France et en Pologne : médiateurs et résistances.* Warsaw: Publications du Centre de Civilisation française de l'Université de Varsovie, 1989. Texts by Joana ZUROWDKA, Maciej AUROWSKI, Gérard BEAUPRETRE and Jean GURGOS.

Exhibition Catalogues

Nabis, 1888-1900. Paris, Galeries nationales du Grand Palais, September 21, 1993-January 3, 1994. Published by Réunion des musées nationaux, Paris, 1994. Texts by Ralf BEIL, Ursula PERUCCHI PETRI, Claire FRÈCHES-THORY, Jean-Paul BOUILLON, Fritz HERMANN, Rudolf KOELLA, Thérèse BARRUEL, Anne-Marie SAUVAGE, Anna SZINYEI MERSE, Caroline BOYLE-TURNER, Geneviève AITKEN and François FOSSIER.

The Naked Soul: Polish Fin-de-siècle Paintings from the National Museum, Poznań. Raleigh, North Carolina Museum of Art, May 1-August 1, 1993; Chicago, The Polish Museum of America, September 24-December 4, 1993. Published by North Carolina Museum of Art, Raleigh, 1993. Texts by Agnieszka ŁAWNICZAKOWA, ed., and Maria GOLAB.

Decorative Arts 1900: Highlights from Private Collections in Detroit. Detroit, Detroit Institute of Arts, November 7, 1993-January 7, 1994. Texts by Mary Ann WILKINSON.

Symbolismen i dansk kunst. Nivaagaards malerisamling, September 4-December 12, 1993. Text by Hanne HONNENS DE LICHTENBERG.

The Waking Dream: Photography's First Century. Selections from the Gilman Paper Company Collection. New York, The Metropolitan Museum of Art, 1993. Published by Harry N. Abrams, 1993. Texts by Maria MORRIS HAMBOURG *et al.*

Les XX. La libre esthétique. Cent ans après/ Honderd Jaar Later. Brussels, Musées royaux des Beaux-Arts de Belgique, November 26, 1993-Febraury 27, 1994. Text by Gisèle OLLINGER-ZINQUE, ed. (in French and Flemish.)

Le Salon de photographie. Les écoles pictorialistes en Europe et aux États-Unis vers 1900. Paris, Musée Rodin, 1993.

Tournant de la peinture, entre la seconde moitié des années 1880 et les années 1890 – théories artistiques et peinture française. Gifu, Japan, Museum of Fine Arts, February 4-March 21, 1993; Gunma, Japan, Museum of Modern Art, April 10-May 16, 1993.

High Art and Low Life: The Studio and the Fin de Siècle. London, Victoria and Albert Museum, June 23-October 31, 1993.

Les XX and the Belgian Avant-Garde. Prints, Drawing, and Books ca. 1890. Ghent, Museum voor Schone Kunsten, October 31-December 12, 1992; Lawrence, Kansas, Spencer Museum of Art, University of Kansas, January 24-March 21, 1993; Williamstown, Massachusetts, Sterling and Francine Clark Art Institute, April 12-June 13, 1993; Cleveland, The Cleveland Museum of Art, July 13-September 5, 1993. Published by Spencer Museum of Art, University of Kansas, 1992. Texts by Jane BLOCK, Susan M. CANNING, Donald FRIEDMAN, Stephen H. GODDARD, Sura LEVINE, Alexander MURPHY and Carl STRIKWERDA.

Silver of a New Era: International Highlights of Precious Metalware from 1880-1940. Rotterdam, Museum Boymans-van Beuningen, February 23-April 26, 1992; Ghent, Museum voor Sierkunst, May 26-July 27, 1992. Published by Museum Boymans-van Beuningen, Rotterdam, 1992. Texts by Annelies KREKEL-AALBERSE, Joh R. ter MOLEN and R. J. WILLINK.

Prager Jugendstil. Dortmund, Germany, Museum für Kunst und Kulturgeschichte, May 19-August 16, 1992; Berlin, August 2-27, 1992. Published by Braus, Dortmund, 1992. Text by Barbara SCHEFFRAN, ed.

Kopenhagener Porzellan und Steinzeug: Unikate des Jugendstil und Art Deco. Cologne, Museum für Angewandte Kunst, September 13-December 8, 1991. Text by Gisela REINEKING-VON BOCK.

Europäischer Jugendstil. Cracow, National Museum, May 10-July 28, 1991. Published by Museum für Kunst und Gewerbe, Hamburg, 1991. Text by Rüdiger JOPPIEN (in German, English and Polish).

Les Symbolistes et Richard Wagner/Die Symbolisten und Richard Wagner. Berlin, Akademie der Künste zu Berlin, August 15-September 29, 1991; Brussels, Maison du Spectacle – La Bellone, October 7-November 24, 1991; Brussels, Goethe-Institut, September-October, 1991. Published by Hentrich/ Akademie der Künste zu Berlin, Berlin, 1991. Texts by Wolfgang STORCH *et al.* (in French, German, Russian and English).

Twilight of the Tsars: Russian Art at the Turn of the Century. London, Hayward Gallery, March 7-May 19, 1991. Published by South Bank Centre, London, 1991. Texts by Alla GUSAROVA, Marina SHUMOVA, Tatyana KONDADOVA, Yuliya ZABRODINA, Olga STRUGOVA, Galina SMORODINOVA and Tatyana SABUROVA.

100 femmes 1900 à l'affiche. Marseilles, Affaires culturelles/Chambre de commerce et d'industrie Marseille-Provence, 1991.

Die Künstler von Pont-Aven und Le Pouldu. [Worpswede, Germany], Grosse Kunstschau Worpswede, November 8, 1990-January 31, 1991.

Symbolismus in den Niederlanden. Von Toorop bis Mondrian. Kassel, Germany, Museum Fridericianum, July 7-September 29, 1991. Published by Museum Fredericianum, Kassel, Germany; Weber & Wiedemeyer, 1991. Text by Carel BOTKAMP.

Stanisław Ignacy Witkiewicz 1885-1939. Slupsk, Poland, Muzeum Pomorza Stodkowego, May 27-July 1, 1990. Published by Neue Gesellschaft für bildende Kunst, Berlin, 1990. Texts by Elzbieta MANTHEY and Barbara von SCHLEYER.

Simbolismo en Europa. Néstor en las Hespérides. Las Palmas de Gran Canaria, Centro Atlántico de Arte Moderno, December 18, 1990-February 13, 1991.

Divisionismo italiano. Trento, Italy, Palazzo delle Albere, April 21-July 15, 1990. Published by Electa, Milan, 1990. Texts by Gabriella BELLI, Annie-Paule QUINSAC, Aurora SCOTTI, Gianfranco BRUNO, Gianna PIANTONI, Marco ROSCI, Ester COEN, Luciano CARAMEL and Fortunato BELLONZI.

Impressionisten, Post-Impressionisten und Symbolisten ausländische Künstler: vollständiger Katalog. Munich: Hirmer, 1990, "Gemäldekataloge" series, no. 7. Texts by Christoph HEILMANN, ed., Christian LENZ, Susanne NEUBURGER, Thea VIGNAU-WILBERG and Peter VIGNAU-WILBERG.

El Modernismo. Barcelona, Museu d'Art Modern, Parc de la Ciutadella, October 10, 1990-January 13, 1991. Published by Olimpíada Cultural SA, Barcelona, 2 vols., 1990. Texts by Albert Garcia ESPUCHE *et al.*

Malczewski: A Vision of Poland. London, Barbican Art Gallery, May 10-July 8, 1990. Text by Agnieszka ŁAWNICZAKOWA.

Au temps des nabis. Paris, Galerie Huguette Bérès, 1990. Texts by Anisabelle BÉRÈS, Geneviève AITKEN and Brigitte LETONTURIER.

Czech Modernism, 1900-1945. Houston, The Museum of Fine Arts, October 8, 1989-January 7, 1990; Brooklyn, Brooklyn Museum, March 2-May 7, 1990; New York, International Center of Photography, March 2-May 13, 1990; New York, Anthology Film Archives, March 18-May 13, 1990; Akron, Ohio, Akron Art Museum, June 23-August 26, 1990. Published by Museum of Fine Arts, Houston; Bulfinch Press, Boston, 1989. Texts by Jaroslav ANDEL, ed., Hvezdoslav STEFAN, Alison DE LIMA GREENE, Miroslav LAMAC, Frantisec SMEJKAL, Zdenec KIRSCHNER, Antonín DUFEK, Willis HARTSHORN, Michal SCHONBERG and Pavel TAUSSIG.

Europäische Moderne: Buch und Graphik aus Berliner Kunstverlagen, 1890-1933. Berlin, Kunstbibliothek, May 12-July 2, 1989. Published by D. Reimer, Berlin, 1989. Texts by Lutz S. MALKE, Michael HENNING and Christoph JOBST.

Russische Malerei im 19. Jahrhundert: Realismus, Impressionismus, Symbolismus. Zurich, Kunsthaus Zürich, June 3-July 30, 1989. Texts by Marianne KARABELNIK-MATTA and Guido MAGNAGUAGNO.

Seeking the Floating World: The Japanese Spirit in Turn-of-the-century French Art. Yokohama, Sogo Museum of Art, August 9-27, 1989; Fukui, Fine Arts Museum, October 29-November 23, 1989; Nara, Nara Sogo Museum of Art, January 24-February 12, 1990; Kyoto, Daimary Museum Kyoto, March 29-April 10, 1990; Fukuoka, Prefectural Museum of Art, May 8-27, 1990; Tokyo, The Shoto Museum of Art, June 12-July 22, 1990. Published by Sogo Museum of Art, Yokohama, 1989. Text by Phylis FLOYD.

English Romantic Art, 1850-1920: Pre-Raphaelites, Academics, Symbolists. New York, Shepherd Gallery, October 18-November 18, 1989.

The Last Romantics: The Romantic Tradition in British Art: Burne-Jones to Stanley Spencer. London, Barbican Art Gallery, Febuary 9-April 9, 1989. Published by Lund Humphries/Barbican Art Gallery, London, 1989. Texts by Mary Anne STEVENS and John CHRISTIAN, ed.

A Golden Age: Art and Society in Hungary, 1896-1914. London, Barbican Art Gallery, October 25, 1989-January 14, 1990; Miami, Center for the Fine Arts, March 16-May 27, 1990; San Diego, San Diego Museum of Art, November 10, 1990-January 5, 1991. Published by Barbican Art Gallery, London; Corvina, Budapest; Center for the Fine Arts, Miami, 1989. Texts by T. Iván BEREND, Lajos NÉMETH, Ilona PARSONS-SÁRMÁNY and Gyongyi ÉRI.

Dessins de l'école de Pont-Aven. Paris, Musée d'Orsay, March 21-May 28, 1989. Published by Réunion des musées nationaux, Paris, 1989, "Dossiers du Musée d'Orsay" series, no. 32. Text by Arlette SÉRULLAZ.

Kunstphotographie um 1900. Die Sammlung Ernst Juhl. Hamburg, Museum für Kunst und Gewerbe, June 23-August 27, 1989, "Dokumente der Photographie" series, no. 3. Texts by Margret KRUSE and Jens JÄGER.

Le Symbolisme dans les collections du Petit Palais. Paris, Musée du Petit Palais, October 21, 1988-February 19, 1989. Published by Paris-musées, 1989. Text by Alain DAGUERRE DE HUREAUX.

The Nabis and the Parisian Avant-garde. New Brunswick, New Jersey, Jane Voorhees Zimmerli Art Museum, December 3, 1988-February 14, 1989; Amsterdam, Rijksmuseum Vincent van Gogh, March 23-May 28, 1989; Budapest, Magyar Nemzeti Galeria. Published by Jane Voorhees Zimmerli Art Museum, Rutgers, The State University of New Jersey, New Brunswick, 1988. Texts by Patricia Eckert BOYER and Elizabeth Anne PRELINGER.

Le Japonisme. Paris, Galeries nationales du Grand Palais, May 17-August 15, 1988; Tokyo, Musée national d'Art occidental, September 23-December 11, 1988. Published by Réunion des musées nationaux, Paris, 1988.

Impressionismo, simbolismo, cubismo: arte a Praga, arte a Parigi. Rome, Palazzo dei Conservatori, March 23-May 8, 1988. Published by Electa, Milan, 1988.

Schmuckkunst im Jugendstil. Berlin, Bröhan-Museum, December 20, 1988-February 19, 1989. Published by Bröhan-Museum, Berlin/Dietrich Reimer Verlag, 1988. Text by Ingeborg BECKER.

Art Nouveau in Munich: Master of Jugendstil. Philadelphia, Philadelphia Museum of Art, September 23-November 27, 1988; Los Angeles, Los Angeles County Museum of Art, December 22, 1988-February 19, 1989; Saint Louis, The Saint Louis Art Museum, March 30, 1989-May 8, 1989; Munich, Münchner Stadtmuseum, June-July 1989. Published by The Philadelphia Museum of Art, Philadelphia; Prestel, Munich, 1988. Text by Kathryn BLOOM HIESINGER.

Dusa i oblik: madarska umetnost, 1896-1914/Lelek es forma: magyar muveszet, 1896-1914/Soul and Form: Hungarian Art, 1896-1914. Belgrade, Narodni muzei-Beograd, 1988. Texts by Bendi ERI, Zuza O. JOBADI and Jevta JEVTOVIC.

Lumières du Nord. La peinture scandinave, 1885-1905. Paris, Musée du Petit Palais, February 21-May 17, 1987. Published by Association française d'Action artistique, Paris, 1987. Texts by Thérèse BURROLET, Knut BERG, Salme SARAJAS-KORTE, Matti KLINGE and Gunnar BROBERG.

Terres d'inspiration des peintres de Pont-Aven, nabis et symbolistes. Tokyo, Isetan Art Museum, April 2-14, 1987; Niigata, City Art Museum, April 18-May 17, 1987; Osaka, Daimaru Museum, May 20-June 8, 1987; Shizuoka, Prefectoral Museum of Art, June 13-July 9, 1987; Himeji, City Museum of Art, July 25-August 23, 1987; Yamanashi, Prefectural Museum of Art, August 27-September 27, 1987. Published by Isetan Art Museum, Tokyo, 1987.

I Giacometti e gli altri: Segantini, Giovanni Giacometti, Amiet, Alberto Giacometti. Bellinzona, Italy, Villa dei cedri, Civica Galleria dell'arte, April 10-July 8, 1987.

Berlin, 1900-1933: Architecture and Design/Architektur und Design. New York: Cooper-Hewitt Museum; Berlin: Schloß Charlottenburg, 1987. Texts by Tilmann BUDDENSIEG, ed., Fritz NEUMEYER and Angela SCHONBERGER.

Le Symbolisme et la Femme. Paris, Mairie du 9e arrondissement, February-April, 1986; Toulon, May-June, 1986; Pau, July-August, 1986; Marcq-en-Baroeul, Fondation Septentrion, September 7-November 30, 1986. Published by Délégation à l'action artistique, Paris, 1986. Text by Béatrice de ANDIA.

Dreams of a Summer Night: Scandinavian Painting at the Turn of the Century. London, Hayward Gallery, July 10-October 5, 1986. Published by Arts Council of Great Britain; Nordic Council of Ministers, 1986. Texts by John HOUSE, Knut BERG, Salme SARAJAS-KORTE and Matt KLINGE.

Flemish Expressions: Representational Painting in the Twentieth Century. Newport Beach, California, Newport Harbor Art Museum, December 12, 1986-February 22, 1987; Fort Lauderdale, Fort Lauderdale Museum of Art, March 12-May 25, 1987. Published by Newport Harbor Art Museum, Newport Beach, California, 1986. Texts by Robert HOOZEE and Jean F. BUYCK.

Intimations & Imaginings: The Photographs of George H. Seeley. Pittsfield, Massachusetts, Berkshire Museum, May 3-June 29, 1986; Northampton, Massachusetts, Smith College Museum of Art, October 16-November 23, 1986; Urbana, Illinois, Krannert Art Museum, University of Illinois, January 23-March 1, 1987; Manchester, New Hampshire, Currier Gallery of Art, April 5-May 3, 1987. Published by Berkshire Museum, Pittsfield, Massachusetts, 1986. Texts by George DIMOCK and Joanne HARDY.

Art Nouveau Bing, Paris Style 1900. Washington, Smithsonian Institution Traveling Exhibition Service; New York, Harry N. Abrams, 1986. Text by Gabriel P. WEISBERG.

Vienna 1900: Art, Architecture and Design. New York, The Museum of Modern Art, 1986. Text by Kirk VARNEDOE.

Vienne 1880-1938. L'Apocalypse joyeuse. Paris, Centre Pompidou, 1986. Texts by Jean Clair, ed., et al.

Aspecten van het Symbolisme. Tekeningen en Patels/Aspetti del Simbolismo in Belgio. Disegni e pastelli. Antwerp, Museum voor Schone Kunsten, 1985; Caserta, Italy, Palazzo Reale, January 25-March 2, 1986. Published by Arti grafiche Salafia, Capua, Italy, 1986. Texts by Salvatore ABITA, Giorgio AGNISOLA, Sabine BOWN-TAEVERNIER and Claudio MARINELLI (in Flemish and Italian).

Traum und Wirklichkeit Wien, 1870-1930. Vienna, Künstlerhaus, March 28-October 6, 1985. Published by Museen der Stadt Wien, Vienna, 1985. Texts by Carl E. SCHORSKE, Robert WAISSENBERGER, Renata KASSAL-MIKULA, Gerbert FRODL, Jutta PEMSEL, Peter HAIKO, Eduard F. SEKLER, Elisabeth SCHMUTTERMEIER, Burkhardt RUKSCHCIO, Hans BISANZ, Marian BISANZ-PRAKKEN, Ivo HAMMER, Manfred KOLLER, Hans HOLLEIN, Dieter BOGNER, Barbara LESAK and Walter FRITZ.

Antwerpen 1900, Schilderijen en tekeningen 1880-1914. Antwerp, Koninklijk Museum voor Schone Kunsten, 1985. Text by Jean F. BUYCK.

The Swedish Vision: Landscape and Figurative Painting, 1885-1920. New York, Shepherd Gallery, 1985.

Jugendstil-Bluten: florale Dekorationen im Kunsthandwerk des Jugendstils. Berlin, Bröhan-Museum, June-September, 1985. Texts by Ingeborg BECKER and Rosewith BRAIG.

1880-årene i nordisk maleri. Oslo, Nasjonalgalleriet, August-October, 1985; Stockholm, Nationalmuseum, 1985-1986; Helsinki, Amos Anderssons Konstmuseum, 1986; Copenhagen, Statens Museum for Kunst, 1986. Published by Nasjonalgalleriet, Oslo, 1985. Texts by K. BERG, S. RINGBOM, B. LINDWALL, O. THUE and H. WESTERGAARD.

Symboles et réalités: la peinture allemande, 1848-1905. Paris, Musée du Petit Palais, October 12, 1984-January 13, 1985. Published by Association française d'Action artistique, Paris, 1984. Texts by Werner HOFMANN, Günter BUSCH, Thérèse BUROLLET, Renée DAVRAY-PIEKOLEK and Jorg von UTHMANN.

Artists of La Revue blanche: Bonnard, Toulouse-Lautrec, Vallotton, Vuillard. Rochester, New York, University of Rochester, Memorial Art Gallery, January 22-April 15, 1984. Texts by Bret WALLER and Grace SIEBERLING.

Le Arti a Vienna dalla Secessione alla caduta dell'impero asburgico. Venice, Palazzo Grassi, March 20-September 16, 1984. Published by La Biennale, Venice; Mazzotta, Milan, 1984.

Der Westdeutsche Impuls 1900-1914: Kunst und Umweltgestaltung im Industriegebiet. Die Deutsche Werkbundausstellung Köln, 1914. Cologne, Kölnischer Kunstverein, March 23-May 13, 1984. Texts by Dirk TEUBER, ed., Wulf HERZOGENRATH and Angelika THIEKOTTER.

Symbolism in Polish Painting, 1890-1914. Detroit, Detroit Institute of Arts, July 30-September 23, 1984. Text by Agnieszka MORAWINSKA.

The Pre-Raphaelites. London, Tate Gallery, March 7-May 28, 1984. Published by Tate Gallery, London; A. Lane, London, 1984. Introduction by Alan BOWNESS.

Tschechische Kunst 1878-1914. Auf dem Weg in die Moderne. Darmstadt, Mathildenhöhe, 1984. Texts by Jirí KOTALÍK, ed., Bernd KRIMMEL, ed., Vladimír SLAPETA, Zdenek LUKES, Jan ROUS, Alena ADLEROVÁ *et al.*

Grotesker Jugendstil: Carl Strathmann 1866-1939. Bonn, Rheinisches Landesmuseum, March 25-May 2, 1976.

Le Symbolisme en Europe. Rotterdam, Museum Boymans-van Beuningen, November 1975-January 1976; Brussels, Musées royaux des Beaux-Arts de Belgique, January-March 1976; Baden-Baden, Staatliche Kunsthalle, March-May 1976; Paris, Grand Palais, May-July 1976. Published by Museum Boymans-van Beuningen, Rotterdam; Réunion des musées nationaux, Paris, 1976. Texts by Hans H. HOFSTÄTTER, Franco RUSSOLI and Geneviève LACAMBRE.

Periodicals – Special Issues on Symbolism

Art Journal, vol. 45, no. 2 (1985), special issue, "Symbolist Art and Literature". Texts by Sharon HIRSH, ed., Diane LESKO, Beth Rae GORDON, Evert SPRINCHORN, Lynne PUDLES, Susan M. CANNING, Peg WEISS and Reinhold HELLER, bibliography by Patty CHELAP.

Revue de l'art, no. 96 (1992), special issue, "Symbolisme". Texts by Jean-Paul BOUILLON, Dario GAMBONI, Richard SHIFF, Philippe JUNOD, Rodolphe RAPETTI, Ted GOTT, Milly HEYD, Georges ROQUE and Günter METKEN.

Studio International, vol. 201, no. 1022/1023 (1993), special issue, "High Art and Low Life: The Studio and the Fin de Siècle". Texts by Clive ASHWIN, Peter ROSE, Lionel LAMBOURNE, Bill NORTH, Tomoko SATO, Frank GRAY, Stephen CALLOWAY, Janet McKENZIE, Emmanuel COOPER, Katherine COOMBS, Barbara MORRIS and Geoffrey SQUIRE.

Monographs and Catalogues on the Artists Represented in the Exhibition

John White ALEXANDER
Catalogues
John White Alexander, 1859-1915: Fin-de-siècle American. New York, Graham Gallery, October 21-December 13, 1980. Text by Sandra LEFF.
John White Alexander (1859-1915). Washington, National Collection of Fine Arts, Smithsonian Institution, December 22, 1976-July 4, 1977. Text by Mary Anne GOLEY.

Cuno AMIET
Catalogues
Cuno Amiet: Hoffnung und Vergänglichkeit. Aarau, Switzerland, Aargauer Kunsthaus, April 28-June 16, 1991. Text by George L. MAUNER.
Cuno Amiet. Locarno, Casa Rusca, September 9-October 28, 1990. Text by Mario BARZAGHI-NI, catalogue by Pierre CASE.
Cuno Amiet: Werke aus oberaargauer Privatbesitz. Herzogenbuchsee, Switzerland, Kornhaus, January 25-March 9, 1986. Published by Einwohnergemeinde, Herzogenbuchsee, 1986. Texts by Urs ZAUGG and Peter KILLER.

Books
KILLER, Peter. *Cuno Amiet: eine Leidenschaft. Die Sammlung Eduard Gerber Bern*. Stäfa, Switzerland: Rothenhausler, 1988.
MAUNER, George L. *Cuno Amiet*. Zurich: O. Füssli, 1984.
ZAUGG, Urs. *Cuno Amiet – Hellsauer Jahre*. Herzogenbuchsee, Switzerland: U. Zaugg, 1991.
___.*Cuno Amiet in fotografischen Dokumenten*. Herzogenbuchsee, Switzerland: Schelbli, 1985.

Jean-Barnabé AMY
Catalogues
Jean-Barnabé Amy 1839-1907: masques et profils. Marseilles, Musée des Beaux-Arts, July 4-October 4, 1992.

Ivar AROSENIUS
Catalogues
Ivar Arosenius. Borås, Sweden, Borås konstmuseum, November 20, 1988-January 29, 1989. Text by Tomas LINDH.

C. R. ASHBEE
Books
CRAWFORD, Alan. *C. R. Ashbee: Architect, Designer & Romantic Socialist*. New Haven, Connecticut: Yale Universty Press, 1985.
STANSKY, Peter. *William Morris, C. R. Ashbee, and the Arts and Crafts*. London: Nine Elms Press, 1984.

Aubrey BEARDSLEY
Catalogues
Aubrey Beardsley, 1872-1898. Rome, Galleria Nazionale d'Arte Moderna, March 13-April 28, 1985. Published by Fratelli Palombi, Rome, 1985.

Books
BELL, Daniel O. *A Pious Bacchanal: Affinities between the Lives and Works of John Flaxman and Aubrey Beardsley*. New York: Peter Lang, 1994.

BOGNER, Ute, ed. *Zeichnungen. Aubrey Beardsley*. Munich: Delphin, 1984.
FLETCHER, Ian. *Aubrey Beardsley*. Boston: Twayne Publishers, 1987, "Twayne's English Authors" series.
HEYD, Milly. *Aubrey Beardsley: Symbol, Mask and Self-irony*. New York: Peter Lang, 1986, "American University Studies" collection, series IV, "English Language and Literature", vol. 35.
KURYLUK, Ewa. *Salome and Judas in the Cave of Sex: The Grotesque – Origins, Iconography, Techniques*. Evanston, Illinois: Northwestern University Press, 1987.
LANGENFELD, Robert, ed. *Reconsidering Aubrey Beardsley*. Rochester, New York: University of Rochester Press, 1989, "Nineteenth-century Studies" series.
READ, Brian. *Beardsley Re-mounted*. London: Eighteen Nineties Society, 1989.
STANFORD, Derek. *The Vision and Death of Aubrey Beardsley*. Bristol, England: Redcliffe Poetry, 1985.
ZATLIN, Linda Gertner. *Aubrey Beardsley and Victorian Sexual Politics*. Oxford: Clarendon Press, 1990, "Clarendon Studies in the History of Art" series.

Émile BERNARD
Catalogue Raisonné
LUTHI, Jean-Jacques. *Émile Bernard: catalogue raisonné de l'œuvre peint*. Paris: SIDE, 1982.

Catalogues
Émile Bernard 1868-1941: A Pioneer of Modern Art/Ein Wegbereiter der Moderne. Mannheim, Germany, Städtische Kunsthalle Mannheim, May 12-August 5, 1990; Amsterdam, Rijksmuseum Vincent van Gogh, August 24-November 4, 1990. Published by Waanders, Zwolle, The Netherlands. 1990. Texts by Roland DORN, Vojtech JIRAT-WISIUTYNSKY, Caroline BOYLE-TURNER and Christian VOGELAAR (in English and German).
Émile Bernard, 1868-1941: The Theme of Bordellos and Prostitutes in Turn-of-the-century French Art. New Brunswick, New Jersey, Jane Voorhees Zimmerli Art Museum, Rutgers, The State University of New Jersey; Amsterdam, Rijksmuseum Vincent van Gogh, April 3-May 31, 1988. Published by Jane Voorhees Zimmerli Art Museum, Rutgers, The State University of New Jersey, 1988. Text by Bogomila WELSH-OVCHAROV.

Books
WASCHEK, Matthias. *Eklektizismus und Originalität: die Grundlagen des französischen Symbolismus am Beispiel von Émile Bernard*. Constance, Switzerland: Hartung-Gorre, 1990.

Pierre-Amédée MARCEL-BÉRONNEAU
Catalogues
Marcel-Beronneau, 1869-1937. Peintre symboliste. Paris: Galerie Alain Blondel, 1981.

Boleslas BIÉGAS
Catalogues
Boleslas Biégas. Geneva, Galerie J. Krugier, 1980.
Boleslas Biégas. Paris, Galerie J.C. Gaubert, October 15-November 9, 1974.

František BÍLEK
Books
BÍLEK, František. *Tomase ze Stitneho dokonanje kneh sesterych*. Brno, Czech Republic: Zvlastni vydani, 1992.

BÍLEK, František. *Sigismund Bouska Frantisku Bilkovi, Korespondence 1895-1916*. Prague: Česká expedice, 1992.

Thorvald BINDESBØLL
Books
NIGGL, Reto. *Thorvald Bindesboll: Keramik und Silber*. Starnberg, Germany: Helga Schaefer Verlag, 1989.

Arnold BÖCKLIN
Catalogues
Spitzweg: Begegnungen mit Moritz von Schwind und Arnold Böcklin und die kleine Landschaft. Munich, Bayerischen Staatsgemäldesammlungen; Munich, Haus der Kunst. Published by Lipp, Munich, 1985. Text by Siegfried WICHMANN.

Books
CHRIST, Dorothea, and Christian GEELHAAR. *Arnold Böcklin: die Gemälde im Kunstmuseum Basel*. Basel, Switzerland; Öffentliche Kunstsammlung/Eidolon, 1990.
LINNEBACH, Andrea. *Arnold Böcklin und die Antike: Mythos, Geschichte, Gegenwart*. Munich: Hirmer, 1991.
ZEGLER, Franz. *Arnold Böcklin. Die Toteninsel: Selbstheroisierung und Abgesang der abendlandischen Kultur*. Frankfurt: Fischer Taschenbuch Verlag, 1991.

Luigi BONAZZA
Catalogues
Luigi Bonazza (1877-1965). Trento, Italy, Palazzo delle Albere, January 12-March 24, 1985; Vienna, Palais Liechtenstein, April 3-May 3, 1985. Published by Servizio beni culturali, Trento, 1985. Texts by Rossana BOSSAGLIA, Oswald OBERHUBER and Gabriella BELLI (in German and Italian).

Books
PERILLI, Giorgio, and Marco PERILLI. *Luigi Bonazza*. Trento, Italy: Publiprint, 1992.

Ford Madox BROWN
Books
NEWMAN, Teresa, and Ray WATKINSON, *Ford Madox Brown and the Pre-Raphaelite Circle*. London: Chatto & Windus, 1991.

Edward BURNE-JONES
Catalogues
Burne-Jones 1833-1898. Dessins du Fitzwilliam Museum de Cambridge. Nantes, Musée des Beaux-Arts de Nantes, May 7-July 27, 1992; Charleroi, Palais des Beaux-Arts de Charleroi, September 5-October 15, 1992; Nancy, Musée des Beaux-Arts de Nancy, October 20-December 21, 1992. Published by Musée des Beaux-Arts, Nantes, 1992. Texts by Jane MUNRO, Hilary MORGAN, John CHRISTIAN, Laurent BUSINE and Claude ALLEMAND-COSNEAU.
Burne-Jones, the Pre-Raphaelites and Their Century. 2 vols. London: Nahum, 1989. Text by Hilary MORGAN.
Burne-Jones: dal preraffaellismo al simbolismo. Rome: Galleria Nazionale d'Arte Moderna, 1986. Published by Mazzotta, Milan, 1986. Texts by Maria Teresa BENEDETTI and Gianna PIANTONI.

Books
ASH, Russel. *Sir Edward Burne-Jones*. London: Pavilion; New York: Harry N. Abrams, 1993.

BURNE-JONES, Sir Edward Coley. *Letters to Katie: From Edward Burne-Jones*. London: British Museum Publications, 1988.
DEAN, Ann S. *Burne-Jones Drawings*. Malvern, England: Heritage Press, 1993.
Burne-Jones & William Morris in Oxford and the Surrounding Area. Malvern, England: Heritage, 1991.
HARRISON, Martin. *Burne-Jones*. London: Barrie and Jenkins, 1989.

François Rupert CARABIN
Catalogues
François Rupert Carabin 1862-1932. Strasburg: Les Musées de la Ville de Strasbourg, 1993. Texts by Nadine LEHNI and Étienne MATIN.

Jean CARRIÈS
Books
ALEXANDRE, Arsène. *Jean Carriès, imagier et potier. Étude d'une œuvre et d'une vie*. Paris: Librairies-imprimeries réunies, 1895.
VOGT, William. *Carriès le potier* Geneva: L'Éventail, 1918.

Hans CHRISTIANSEN
Books
ZIMMERMANN-DEGEN, Margaret. *Hans Christiansen: Leben und Werk eines Jugendstilkünstlers*. Konigstein, Germany: K.R. Langewiesche, 1985.

Edward COLONNA
Catalogues
Edward Colonna: Essay. Dayton, Ohio, Dayton Art Institute, October 29, 1983-January 2, 1984; Montreal, Musée des arts décoratifs, January 20-March 26, 1984; Washington, Renwick Gallery, National Museum of American Art, Smithsonian Institution, April 27-August 19, 1984. Published by Dayton Art Institute, 1983. Text by Martin EIDELBERG.

Lovis CORINTH
Catalogues
Lovis Corinth: Master Prints and Drawings from the Marcy Family and the National Gallery of Art. Washington, National Gallery of Art, September 12, 1993-February 21, 1994. Text by Christopher B. WITH.
Lovis Corinth, 1858-1925: Works on Paper. Chicago, R.S. Johnson Fine Art, 1993. Text by Ursula M. JOHNSON.
Lovis Corinth, 1858-1925: Prints, Drawings and Watercolors from the Family Collection/ Druckgraphik, Zeichnungen, Aquarelle aus dem Nachlaß des Künstlers. New York, National Academy of Design, May 14-June 28, 1992.
Lovis Corinth. Vienna, Kunstforum der Austria, September 2-November 22, 1992; Hannover, Germany, Forum des Landesmuseums, December 8, 1992-February 28, 1993. Published by Prestel, 1992. Texts by Klaus Albrecht SCHRODER and Evelyn BENESCH.
Lovis Corinth. 131 ausgewahlte Werke: Zeichnungen, Druckgraphiken. Berlin, Galerie Nierendorf, May 10-July 22, 1989.
Martin Luther aus der Sicht von Lovis Corinth. Göttingen, Germany, Staatlichen Lutherhalle, Lutherstadt Wittenberg, Alte Rathaus Göttingen, June 12-July 20, 1989. Text and catalogue by Jutta STREHLE.

Lovis Corinth, die Bilder vom Walchensee: Vision und Realität. Ratisbon, Germany, Ostdeutsche Galerie Regensburg, April 27-June 15, 1986; Bremen, Germany, Kunsthalle, June 22-August 17, 1986. Published by Ostdeutsche Galerie Regensburg, Ratisbon, 1986. Texts by Werner TIMM, Wilhelmine CORINTH-KLOPFER and Hans-Jürgen IMIELA.
Lovis Corinth 1858-1925. Arbeiten auf Papier: zum 60. Todestag. Wiesbaden, Germany, Museum Wiesbaden Kunstsammlungen, February 27-March 31, 1985. Text by Ingrid MOSSINGER.

Books
CORINTH, Wilhelmine. *Ich habe einen Lovis, keinen Vater. Erinnerungen*. Munich: Langen Muller, 1990.
UHR, Horst. *Lovis Corinth*. Berkeley: University of California Press, 1990.
ZDENEK, Felix, ed. *Lovis Corinth, 1858-1925*. Cologne: DuMont, 1985. Texts by Gerhard GERKENS, Friedrich GROSS and Joachim HEUSINGER VON WALDEGG.

Walter CRANE
Catalogues
Walter Crane, 1845-1915: Artist, Designer, and Socialist. Manchester, England, The Whitworth Art Gallery, University of Manchester, January 20-March 18, 1989. Published by Lund Humphries, London; The Whitworth Art Gallery, University of Manchester, 1989. Texts by Greg SMITH and Sarah HYDE.

Henry CROS
Articles
BELFORT, Anne-Marie. "Pâtes de verre d'Henry Cros (1840-1907)". *Cahiers de la céramique, du verre et des arts du feu*, 1967, pp. 176-187.

Pierre A. DALPAYRAT
Catalogues
Alphonse Voisin-Delacroix. Ou quand un sculpteur rencontre un céramiste 1892-1893. Besançon, France, Musée des Beaux-Arts et d'Archéologie, 1993.

Arthur B. DAVIES
Catalogue Raisonné
CZESTOCHOWSKI, Joseph S. *Arthur B. Davies: A Catalogue Raisonné of the Prints*. Newark, New Jersey: University of Delaware Press; London: Associated University Presses, 1987.

William DEGOUVE DE NUNCQUES
Catalogues
William Degouve de Nuncques. Stavelot, Belgium: Musée de l'ancienne Abbaye, 1963.

Books
RIDDER, André de. *William Degouve de Nuncques*. Brussels: Elsevier, 1957, "Monographie de l'art belge" series.

Henry DE GROUX
Articles
RAPETTI, Rodolphe. "Un chef-d'œuvre pour ces temps d'incertitude : le «Christ aux outrages» d'Henry De Groux", *Revue de l'art*, vol. 96 (1992), pp. 40-50.

Robert DELAUNAY

Catalogues

Sonia & Robert Delaunay. Künstlerpaare, Künstlerfreunde/Dialogues d'artistes, résonances. Bern, Kunstmuseum, 1991-1992. Published by Gerd Hatje, Stuttgart, 1991. Texts by Sandor KUTHY and Kunito SATONOBU (in French and German).

Delaunay und Deutschland. Munich, Staatsgalerie Moderner Kunst, October 4, 1985-January 6, 1986. Published by DuMont Buchverlag, Cologne, 1985. Texts by Suzanne BAUMLER and Mario-Andreas von LUTTICHAU.

Robert Delaunay, Sonia Delaunay. Paris, Musée d'Art moderne, May 14-September 8, 1985. Published by Musée d'Art moderne, Paris, 1985.

Books

HORNBOGEN, Ute. *Robert Delaunay*. Dresden: Verlag der Kunst, 1991, "Das Atelier" series, no. 1.

MOLINARI, Danielle. *Robert Delaunay, Sonia Delaunay*. Paris: Nouvelles Éditions françaises, 1987.

Jean DELVILLE

Books

FRANGIA, Maria Luisa. *Il simbolismo di Jean Delville*. Bologna: Patron, 1978, "Arte e dialogo" series, no. 1.

Maurice DENIS

Catalogues

Maurice Denis 1870-1943. Lyons, Musée des Beaux-Arts, September 29-December 18, 1994; Cologne, Wallraf-Richartz-Museum, January 22-April 2, 1995; Liverpool, Walker Art Gallery, April 21-June 18, 1995; Amsterdam, Rijksmuseum Vincent van Gogh, July 7-September 17, 1995. Published by Réunion des musées nationaux, Paris; Musée des Beaux-Arts de Lyon, Lyons, 1994. Texts by Jean-Paul BOUILLON, Guy COGEVAL, Ekkehard MAI, Gilles GENTY, Jane LEE, Dario GAMBONI, Thérèse BARRUEL, Anne GRUSON, Claire DENIS and Marianne BARBE.

Maurice Denis illustrateur, Granville, France, Musée Richard Anacréon, June-September 1994.

Maurice Denis. Paris, Galerie Huguette Bérès, June 5-July 22, 1992. Text by Anisabelle BÉRÈS.

Maurice Denis 1870-1943. Marcq-en-Barœul, France, Fondation Septentrion, October 22, 1988-February 12, 1989. Catalogue written by Dominique PAULETTE.

Maurice Denis et l'Italie, aspect de l'œuvre gravé. Rome, Centre culturel français de Rome, February-May 1988; Florence, Institut français; Edinburgh, Institut français. Published by Centre culturel français de Rome, 1988. Text by Thérèse BARRUEL.

Maurice Denis, Paintings, Drawings and Watercolours. London, J.P.L. Fine Arts, October 15-December 12, 1985.

Maurice Denis à Perros-Guirec. Perros-Guirec, France, Maison des Traouieros, July 13-August 20, 1985; *Maurice Denis et la Bretagne*, Morlaix, France, Musée des Jacobins, July 13-September 29, 1985. Published by Maison des Traouieros, Perros-Guirec; Musée des Jacobins, Morlaix, 1985. Texts by Geneviève LACAMBRE and Denise DELOUCHE, catalogue written by Claire DENIS and Anne GRUSON (two-part exhibition with a single catalogue).

Maurice Denis (1870-1943), 100 ans après Alençon. Alençon, France, Musée des Beaux-Arts et de la dentelle d'Alençon, July 6-September 29, 1985. Catalogue written by Sophie JANIN-JUVIGNY in collaboration with François MAURICE-DENIS.

Books

BOUILLON, Jean-Paul. *Maurice Denis, 1870-1943*. Geneva: Skira, 1993.

COLLET, Georges-Paul, ed. *Correspondance Jacques-Émile Blanche – Maurice Denis (1901-1939)*. Geneva: Droz, 1989.

Marcel DUCHAMP

Catalogues

After Duchamp. Paris, Galerie 1900-2000, April 14-June 1, 1991. Texts by Édouard JAGUER and Jean-Jacques LEBEL.

Marcel Duchamp als Zeitmaschine/Marcel Duchamp als tijdmachine. Utrecht, The Netherlands, Museum Hedenaagse Kunst Utrech, September 19-November 8, 1987; Stadtmuseum Ratingen, Germany, November 22, 1987-January 3, 1988. Published by W. Konig, Cologne, 1987. Text by Wouter KOTTE.

Marcel Duchamp, Florence, Galleria Vivita 1, March 14-May 9, 1987 (text in English, French, German and Italian).

Marcel Duchamp Plays and Wins/Marcel Duchamp joue et gagne. New York, Gallery Yves Armand, March 13-April 28, 1984; Paris, Galerie Beaubourg, November-December 1984; Geneva, Galerie Bonnier, March-April 1985. Published by Marval, Paris, 1984. Text by Yves ARMAN.

Books

BAILLY, Jean-Christophe. *Duchamp*. New York: Universe Books, 1986. Originally published as *Marcel Duchamp*. Paris: Hazan, 1984.

BEEKMAN, Klaus, and Antje von GRAEVENITZ, eds. *Marcel Duchamp*. Amsterdam: Rodopi, 1989, "Avant garde" series, no. 2 (text in French, English and German).

BONK, Ecke. *Marcel Duchamp, the Box in a Valise: de ou par Duchamp ou Rrose Selavy: Inventory of an Edition*. New York: Rizzoli, 1989.

CLEARWATER, Bonnie, ed. *West Coast Duchamp*. Miami Beach: Grassfield Press, 1991.

CAUMONT, Jacques, and Jennifer GOUGH-COOPER. *Effemeridi su e intorno a Marcel Duchamp e Rrose Selavy, 1887-1968*. Milan: Bompiani, 1993.

DANIELS, Dieter. *Duchamp und die anderen: der Modellfall einer künstlerischen Wirkungsgeschichte in der Moderne*. Cologne: DuMont, 1992.

DE DUVE, Thierry, ed. *The Definitively Unfinished Marcel Duchamp*. Cambridge, Massachusetts: MIT Press; Halifax, Nova Scotia: Nova Scotia College of Art and Design, 1991.

——. *Resonnance du readymade. Duchamp entre avant-garde et tradition*. Nimes, France: Jacqueline Chambon, 1989, "Rayon art" series.

——. *Pictorial Nominalism: On Marcel Duchamp's Passage from Painting to the Readymade*. University of Minnesota Press, 1991, "Theory & History of Literature" series, vol. 51. Originally published as *Nominalisme pictural. Marcel Duchamp. La peinture et la modernité*. Paris: Minuit, 1984.

D'HARNONCOURT, Anne, and Kynaston McSHINE, eds. *Marcel Duchamp*. Munich: Prestel, 1989.

DÖRSTEL, Wilfrid. *Augenpunkt, Lichtquelle und Scheidewand: die symbolische Form im Werk Marcel Duchamps: unter besonderer Berücksichtigung der Witzzeichnungen von 1907 bis 1910 und Radierungen von 1967-1968*. Cologne: W. König, 1989.

GERVAIS, André. *La Raie alitée d'effets. À propos of Marcel Duchamp*. LaSalle, Quebec: Hurtubise HMH, 1984, "Brèches" series.

GIBSON, Michael. *Duchamp, Dada*. Paris: Nouvelle Édition française/Casterman, 1991.

HULTEN, Pontus, ed. *Marcel Duchamp: Work and Life*. Cambridge, Massachusetts: MIT Press, 1993. Texts by Jennifer GOUGH-COOPER and Jacques CAUMONT.

JONES, Amelia. *Postmodernism and the Engendering of Marcel Duchamp*. Cambridge, England, and New York: Cambridge University Press, 1994, "Studies in New Art History and Criticism" series.

KUENZLI, Rudolf E., and Francis M. NAUMANN, eds. *Marcel Duchamp: Artist of the Century*. Cambridge, Massachusetts: MIT Press, 1989.

LEBEL, Robert. *Marcel Duchamp*. Paris: Pierre Belfond, 1985.

MOURE, Gloria. *Marcel Duchamp*. New York: Rizzoli, 1988. Originally published under the same title in French. Paris: Albin Michel, 1988.

PARTOUCHE, Marc. *Marcel Duchamp. J'ai eu une vie absolument merveilleuse. Biographie, 1887-1968*. Marseilles: Images en manœuvres, 1991, "Une vie d'artiste" series.

PAZ, Octavio. *Marcel Duchamp, Appearance Stripped Bare*. New York: Arcade, 1990. Originally published as *Apariencia desnuda, la obra de Marcel Duchamp*. Alianza, 1989.

SUQUET, Jean. *Le Grand Verre rêvé*. Paris: Aubier, 1991.

SCHWARZ, Arturo. *The Complete Works of Marcel Duchamp*. Delano Greenidge, 3rd edition revised and expanded, 1993.

ZAUNSCHIRM, Thomas, ed. *Marcel Duchamp Unbekanntes Meisterwerk*. Klagenfurt, Austria: Ritter, 1986.

Otto ECKMANN

Books

SCHLEE, Ernst. *Scherrebeker Bildteppiche*. Neumünster, Germany: K. Wachholtz, 1984, "Kunst in Schleswig-Holstein" series, no. 26.

SIMMEN, Jeannot. *Zeichnungen und Druckgraphik von Otto Eckmann: der Bestand in der Kunstbibliothek Berlin*. Berlin: D. Reimer, 1982, "Veröffentlichung der Kunstbibliothek Berlin" series, no. 89.

Halfdan EGEDIUS

Books

PARMANN, Øistein. *Halfdan Egedius. Liv og verk*. Oslo: Dreyer, 1979.

Magnus ENCKELL

Articles

SARAJAS-KORTE, Salme. "Magnus Enckell and Prometheus Bound", *Ateneumin Taidemuseo, Museojulkaisu*, no. 21, 1979, pp. 36-44.

——. "The Norwegian Influence in Finland in the Early 1890s, Discussion", *Ateneumin Taidemuseo, Museojulkaisu*, no. 21, 1979, pp. 45-48.

——. "Magnus Enckell's Melancholy", *Ateneumin Taidemuseo, Museojulkaisu*, no. 27, 1979, pp. 24-43.

August ENDELL
Catalogues

August Endell. Der Architekt des Photoateliers Elvira, 1871-1925. Munich, Museum Villa Stuck, February 9-April 24, 1977. Published by Stuck Jugendstil Verein, Munich, 1977. Texts by Klaus-Jürgen SEMBACH, Gottfried von HAESELER and Gabriele STERNER.

James ENSOR
Catalogues Raisonnés

TRICOT, Xavier. *Ensor: Catalogue Raisonné of the Oil Paintings*. 2 vols. London: Sotheby's Publications, 1993. Originally published as *James Ensor. Catalogue raisonné des peintures*. Paris: La Bibliothèque des arts, 1992.
DELTEIL, Loys. *Ensor, de Braekeleer and Leys: Catalogue Raisonné of Their Graphic Work*. San Francisco: Alan Wofsy Fine Arts, 1969; first published in 1925.

Catalogues

Radierungen. Bremen, Germany, Kunsthalle, November 3, 1992-January 3, 1993. Text by Heiderose LANGER.
James Ensor, Paris, Petit Palais, 1990.
Los grabados de James Ensor. De la colección del Instituto de Artes Gráficas de Oaxaca, Museo de Arte Carrillo Gil, August 29-October 10, 1990. Published by Asociación Civil José F. Gómez/Instituto de Artes Gráficas, Oaxaca, Mexico, 1990.
Ik James Ensor: Tekeningen en prenten. Ghent, Museum voor Schone Kunsten. Published by Ludion, Brussels, 1990. Texts by Robert HOOZEE, Sabine BOWN-TAEVERNIER and J. F. HEIJBROECK.
James Ensor, Belgien um 1900. Munich, Hypo-Kulturstiftung Kunsthalle, March 31-May 31, 1989. Texts by Lydia M. A. SCHOONBAERT, Dorine CARDYN-OOMEN and Herwig TODTS.
Moi James Ensor. Ghent, Museum voor Schone Kunsten. Published by Albin Michel, Paris, 1987. Text by Robert HOOZEE.
James Ensor. Hamburg, Kunstverein, December 6, 1986-February 8, 1987. Texts by Karl-Egon VESTER, ed., and Xavier TRICOT.
Ensor. Gravelines, France, Musée du dessin et de l'estampe originale en l'Arsenal de Gravelines, June 8-September 7, 1986; Troyes, Musée d'Art moderne de Troyes, October 1-December 15, 1986. Published by Musée de Gravelines, 1986. Text by Dominique TONNEAU-RYCKELYNCK, ed.
James Ensor. Ferrara, Italy, Gallerie civiche d'arte moderna, Palazzo Massari, June 30-October 12, 1986. Published by Assessorato istituzioni culturali, Ferrara; SIAE, Rome, 1986.

Books

HEUSINGER VON WALDEGG, Joachim. *James Ensor: Legende vom Ich*. Cologne: DuMont, 1991.
HOOZEE, Robert, Sabine BOWN-TAEVERNIER and J. F. HEIJBROEK. *James Ensor, dessins et estampes*. Antwerp: Fonds Mercator.
JANSSENS, Jacques. *Ensor*. New York: Crown, 1990.
LEGRAND, Francine-Claire. *Ensor*. Brussels: La Renaissance du livre, 1990. Originally published as *Ensor, cet inconnu*. La Renaissance du livre, 1971.
LESKO, Diane Marion. *James Ensor: The Creative Years*. Princeton, New Jersey: Princeton University Press, 1985.
MacGOUGH, Stephen C. *James Ensor's "The Entry of Christ into Brussels in 1889"*. New York: Garland Publishing, 1985.

SCHUMANN, Henry. *Ensor*. Dresden: VEB Verlag der Kunst, 1985.
TRICOT, Xavier. *Ensoriana*. Ostend: Le Hareng saur, 1985 (text in French and English).

Prins EUGEN
Books

NOREEN, Sven E. *Prins Eugen och Birgitta-stiftelsen*. Vadstena, Sweden: Birgittastift, 1993.
WIDMAN, Dag. *Prins Eugen, konstnär och kulturfurste*. Varberg, Sweden: Varberg museum, 1986.
ZACHAU, Inga. *Prins Eugen det öppna landskapets skildrare*. Lund, Sweden: Signum, 1991, "Böcker om konst" series.
——.*Prins Eugens monumentalmåleri 1896-1904*. Stockholm: Stockholm Institutionen för Konstvetenskap, Stockholms universitet, 1987.
——.*Prins Eugen nationalromantikern*. Lund, Sweden: Signum, 1989, "Böcker om konst" series.

Émile FABRY
Catalogues

Rétrospective Émile Fabry. Woluwe-Saint-Pierre, Belgium, Hôtel communal, 1965.

Henri J.T. FANTIN-LATOUR
Catalogue Raisonné

FANTIN-LATOUR, Victoria Dubourg. *Catalogue de l'œuvre complet de Fantin-Latour*. Amsterdam: B.M. Israël; New York: Da Capo Press, 1969; first published in 1911.

Catalogues

Fantin-Latour. «Coin de table»: Verlaine, Rimbaud et les vilains bonshommes. Paris, Musée d'Orsay, November 30, 1987-February 28, 1988. Published by Réunion des musées nationaux, Paris, 1987.

Charles FILIGER
Catalogues

Charles Filiger 1863-1928. Strasbourg, Musée historique, June 16-September 2, 1990. Published by Musées de la Ville de Strasbourg, 1990. Text by Mira JACOB.
Charles Filiger, 1863-1928. Plougastel-Daoulas, France, Maison du Patrimoine, 1988. Texts by Jos PENNEC and Pierre TUARZE.

Books

JACOB, Mira. *Charles Filiger, 1863-1928. Filiger l'inconnu*. Paris: Le Bateau-Lavoir, 1989.

Gustaf FJAESTAD
Books

FJAESTAD, Agneta. *Gustaf och Maja Fjaestad – ett konstnärspar*. Karlstad, Sweden: NWT, 1981.

E. Reginald FRAMPTON
Articles

DIRCKS, Rudolf. "Mr. E. Reginald Frampton", *Art Journal*, October 1907, pp. 289-296.
VALLANCE, Aymer. "The Painting of Reginald Frampton, Roi", *Studio*, no. 75 (1918), pp. 67-77.

Léon FRÉDÉRIC
Books

JOTTRAND, L. *Léon Frédéric*. Antwerp: Sikkel, 1950.

Émile GALLÉ
Catalogues

Gallé. Paris, Musée du Luxembourg, November 29, 1985-February 2, 1986. Published by Ministère de la Culture/Réunion des musées nationaux, Paris, 1985. Texts by Françoise-Thérese CHARPENTIER and Philippe THIÉBAUT.
Émile Gallé: Dreams into Glass. Corning, New York, The Corning Museum of Glass, April 28-October 21, 1984. Text by William WARMUS.

Books

DUNCAN, Alastair, and Georges de BARTHA. *Glass by Gallé*. New York: Harry N. Abrams, 1984.
GARNER, Philippe. *Émile Gallé*. New York: Rizzoli, revised and expanded edition, 1990.
NEWARK, Timothy. *Émile Gallé*. Courbevoie, France: Soline, 1990.

Akseli GALLEN-KALLELA
Catalogues

Gallen-Kallela & Mannerheim: tutkimusmat-kailijat, ystavat, vaikuttajat. Forsknings-sresande, vanner, paverkar. Espoo, Finland: Gallen-Kallela museo; Helsinki: Mannerheim-museo, 1993. Texts by Kerttu KARVONEN-KANNAS and Tujia MOTTONEN.

Books

GALLEN-KALLELA, Kirsti, and Kaari RAIVIO. *Akseli Gallen-Kallela*. Porvoo, Finland: W. Soderstrom, 1992.
MARTIN, Timo, and Erja PUSA. *Akseli Gallen-Kallela 1865-1931*. Espoo, Finland: Gallen-Kallela Museum, 1985.
MARTIN, Timo, and Douglas SIVÉN, *Akseli Gallen-Kallela, National Artist of Finland*, 1985; adapted from *Akseli Gallen-Kallela. Elämäkerrallinen Rapsodia*, Watti-kustannus, 1984.

Antonio GAUDÍ
Catalogues

Antoni Gaudí (1852-1926). Brussels, Galerie CGER, October 4-December 1, 1985. Published by Fundacio Caixa de Pensions, Barcelona, 1985.

Books

BASSEGODA NONELL, Juan. *El gran Gaudí*. Barcelona: AUSA, 1989.
GUELL, Xavier. *Gaudí Guide*. New York: Rizzoli, 1992. Originally published as *Guide Gaudí: l'exaltation de Barcelone*. Paris: Hazan, 1991, "Les Guides visuels" series, no. 4.
LAHUERTA, Juan José. *Antonio Gaudí, 1852-1926: architettura, ideologia, e politica*. Milan: Electa, 1992.
ROJO ALBARRAN, Eduardo. *Antonio Gaudí, ese incomprendido: la crispa Guell*. Barcelona: Los Libros de la Frontera, 1988, "Papeles de ensayo" series, no. 2.

Paul GAUGUIN
Catalogue Raisonné

MONGAN, Elisabeth, *et al. Paul Gauguin: Catalogue Raisonné of His Prints*. Bern: Galerie Kornfeld, 1988. Texts by Elisabeth MONGAN, Eberhard W. KORNFELD, Harold JOACHIM and Christine E. STAUFFER.

Catalogues

Le Cercle de Gauguin en Bretagne. Pont-Aven, France, Musée municipal, June 25-September 26, 1994.

Gauguin et les nabis. Tokyo, Parthenon Tama, October 31-December 2, 1990; Niigata Daiwa, January 2-15, 1991; Osaka, Navio Museum, March 8-April 7, 1991.

Gauguin and the School of Pont-Aven: Prints and Paintings. London, Royal Academy of Arts, September 9-November 19, 1989; Edinburgh, National Academy of Arts, December 4, 1989-February 4, 1990. Published by Weidenfeld and Nicolson, London, 1989. Texts by Caroline BOYLE-TURNER and Samuel JOSEFOWITZ, introduction by Douglas DRUICK.

The Art of Paul Gauguin. Washington, National Gallery of Art, May 1-July 31, 1988; Chicago, The Art Institute of Chicago, September 17-December 11, 1988; Paris, Galeries nationales du Grand Palais, January 10-April 24, 1989. Published by National Gallery of Art, Washington, 1988. Texts by Françoise CACHIN, Richard BRETTELL, Charles F. STUCKEY and Claire FRÈCHES-THORY.

1886-1986 : 100 ans, Gauguin à Pont-Aven. Pont-Aven, France, Musée de Pont-Aven, June 28-September 3o, 1986. Published by Musée de Pont-Aven. Text by Catherine PUGET.

The Prints of the Pont-Aven School: Gauguin and His Circle in Brittany. Washington: Smithsonian Institution Traveling Exhibition Service, 1986. Text by Caroline BOYLE-TURNER and Samuel JOSEFOWITZ.

Le Chemin de Gauguin : genèse et rayonnement. Saint-Germain-en-Laye, France, Musée départemental du Prieuré, October 7, 1985-March 2, 1986. Published by Musée départemental du Prieuré, Saint-Germain-en-Laye, 1985. Texts by Marie-Amelie ANQUETIL, Michel HOOG, Georges GOMEZ Y CACERES, Olivier MICHEL, Yann LE PICHON and Jean-Marie CUSINBERCHE.

Autour de Gauguin à Pont Aven 1886-1894. Marcq-en-Barœul, France, Fondation Septentrion, March 24-June 23, 1985.

Gauguin og Danmark: en udstilling i anledning af 100-aret for Paul Gauguins ophold i Danmark vinteren 1884-85 [Gauguin and Denmark: An Exhibition on the Centenary of Gauguin's Stay in Denmark during the Winter of 1884-1885]. Copenhagen, Ny Carlsberg Glyptotek, January 11-March 10, 1985.

Books

AMISHAI-MAISELS, Ziva. *Gauguin's Religious Themes.* New York: Garland, 1985.

CACHIN, Françoise. *Gauguin.* New York: Abbeville Press, 1992. Originally published under the same title in French. Paris: Flammarion, 1988.

CAHN, Isabelle. *Gauguin.* Paris: Larousse/Éditions du Montparnasse, 1991, "Les Plus Grands Peintres" series.

——.*Gauguin et le mythe du sauvage.* Paris: Flammarion/Arthaud, 1988.

CLEMENT, Russell T. *Paul Gauguin: A Bio-bibliography.* New York: Greenwood Press, 1991, "Bio-bibliographies in Art and Architecture" series, no. 1.

DAIX, Pierre. *Paul Gauguin.* Paris: J.-C. Lattes, 1989.

DELOUCHE, Denise, Catherine PUGET and Wladyslawa JAWORSKA. *Gauguin et ses amis à Pont-Aven.* Douarnenez, France: Le Chasse-Marée/ArMen, 1989.

ESTIENNE, Charles. *Gauguin.* Paris: Nathan, 1989, "Les Grands Peintres" series.

FRÈCHES-THORY, Claire. *Gauguin.* Paris: Adam Biro, 1988, "La Bibliothèque des expositions" series.

FRECHKO, Irina. *Paul Gauguin : Musée de l'Ermitage, Musée des Beaux-Arts Poutchkine.* Paris: Cercle d'art, 1988.

GIBSON, Michael. *Paul Gauguin.* New York: Rizzoli, 1993.

GRAVELAINE, Frédérique de. *Paul Gauguin : la vie, la technique, l'œuvre peint.* Lausanne: Édita, 1988.

GREENFELD, Howard. *Paul Gauguin.* New York: Harry N. Abrams, 1993, "First Impressions" series.

HOOG, Michel. *Paul Gauguin: Life and Work.* London: Thames and Hudson, 1987. Originally published as *Gauguin, vie et œuvre.* Paris: Nathan, 1987.

HOWARD, Michael. *Gauguin.* New York: Doris Kindersley, 1992.

LE PICHON, Yann. *Sur les traces de Gauguin.* Paris: Robert Laffont, 1986.

LEYMARIE, Jean, *Gauguin: Watercolors, Pastels, Drawings.* New York: Rizzoli, 1989. Originally published as *Gauguin : aquarelles, pastels et dessins.* Geneva: Skira, 1988.

LOIZE, Jean. *Comment le peintre Paul Gauguin fit une merveilleuse découverte de la Martinique : ses tableaux, dessins de 1897, estampes : comment ce séjour écourté avec Charles Laval fera épanouir tout son art jusqu'au Pacifique.* Martinique: Anse Turin, Musée mémorial Paul Gauguin, 1990.

MALINGUE, Maurice. *La Vie prodigieuse de Gauguin.* Paris: Buchet Chastel, 1987.

METKEN, Günter, ed. *Gauguin in Tahiti: The First Journey.* New York: W.W. Norton, 1993, "Schirmer's Visual Library" series.

PRATHER, Maria, and Charles F. STUCKEY. *Gauguin: A Retrospective.* New York: H.L. Levin, 1987.

ROHDE, Petra-Angelika. *Paul Gauguin auf Tahiti: etnographische Wirklichkeit und Kunstlerische Utopie.* Rheinfelden, Switzerland: Schauble, 1988.

TEILHET-FISK, Johanne. *Paradise Reviewed: An Interpretation of Gauguin's Polynesian Symbolism.* Ann Arbor, Michigan: UMI Research Press, 1988, "Studies in the Fine Arts. The Avant-garde" series, no. 31.

THOMSON, Belinda. *Gauguin.* London and New York: Thames and Hudson, 1987, "World of Art" series.

——.*Gauguin by Himself.* Boston: Little, Brown and Co., 1993.

VANCE, Peggy. *Gauguin.* Paris: Hazan, 1991.

WALTHER, Ingo F. *Paul Gauguin, 1848-1903.* Cologne: Taschen, 1988.

Alberto GIACOMETTI
(not represented in the exhibition)

Catalogues

Alberto Giacometti : sculptures, peintures, dessins. Paris, Musée d'Art moderne, November 1991-March 5, 1992. Published by Paris-musées, 1991. Texts by Yves BONNEFOY, Pierre SCHNEIDER, Jean CLAIR, Rosalind KRAUSS, Georges DIDI-HUBERMAN, Christian DEROUET, Danielle MOLINARI, Franz MEYER, Rémy ZAUGG, Christian KLEMM, Jean-Louis PRAT and Germain VIATTE.

Alberto Giacometti, 1901-1966. Washington, Joseph H. Hirshhorn Museum and Sculpture Garden. Published by Smithsonian Institution Press, Washington, 1988. Texts by Valérie J. FLETCHER, Sylvio BERTHOUD and Reinhold HOHL.

Books

BONNEFOY, Yves, *Giacometti.* New York: Abbeville Press, 1991. Originally published as *Alberto Giacometti. Biographie d'une œuvre.* Paris: Flammarion, 1991.

DU BOUCHET, André. *Alberto Giacometti, dessin.* Paris: Maeght, 1991.

DUPIN, Jacques. *Alberto Giacometti, textes pour une approche.* Paris: Fourbis, 1991.

JULIET, Charles. *Giacometti.* Paris: Hazan, 1985.

KLEMM, Christian. *Die Sammlung der Alberto Giacometti-Stiftung.* Zurich: Zürcher Kunstgesellschaft, 1990.

LAMARCHE-VADEL, Bernard. *Alberto Giacometti.* New York: Tabard Press, 1989.

LORD, James. *Giacometti: A Biography.* London: Faber, 1985.

LUST, Herbert C. *Giacometti: The Complete Graphics.* San Francisco: Alan Wofsy Fine Arts, revised edition, 1991.

SCHEIDEGGER, Ernst. *Traces d'une amitié : Alberto Giacometti/Ernst Scheidegger.* Paris: Maeght, 1991, "Photo-cinéma" series.

SCHNEIDER, Angela, ed. *Alberto Giacometti: Sculptures, Paintings, Drawings.* Munich: Prestel, 1994. Texts by Lucius GRISEBACH, R. HOHL, D. HONISH, K. VON MAUR and Angela SCHNEIDER.

SOAVI, Giorgio, and Peter KNAPP. *Giacometti : la ressemblance impossible/Resemblance Defeated/unerreichbare Ahnlichkeit.* Paris: André Sauret, 1991 (text in French, English and German).

SOLDINI, Jean. *Il Colossale, la madre, il sacro: l'opera di Alberto Giacometti.* Bergamo, Italy: P. Lubrina, 1991.

Eugène GRASSET

Catalogues

Eugène Grasset. Lausanne 1841-Sceaux 1917. Paris: Yves Plantin & Françoise Blondel, 1980.

Books

ARWAS, Victor. *Berthon & Grasset.* London: Academy Editions, 1978.

MURRAY-ROBERTSON, Anne. *Grasset : pionnier de l'Art nouveau.* Paris: Bibliothèque des arts, 1981.

Hector GUIMARD

Catalogues

Guimard. Paris, Musée d'Orsay, April 13-July 26, 1992; Lyons, Musée des Arts décoratifs et des Tissus, September 25, 1992-January 3, 1993. Published by Réunion des musées nationaux, Paris, 1992. Texts by Philippe THIÉBAUT, Marie-Laure CROSNIER LECONTE, Claude FRONTISI and Georges VIGNE.

Books

RHEIMS, Maurice, and Felipe FERRE. *Hector Guimard.* New York: Harry N. Abrams, 1988. Originally published as *Hector Guimard architecte.* Paris: Bibliothèque des arts, 1985.

VIGNE, Georges. *Hector Guimard et l'Art nouveau.* Paris: Hachette/Réunion des musées nationaux, 1990, "Guides Paris – Musée d'Orsay" series.

Vilhelm HAMMERSHØI

Books

VAD, Poul. *Hammershøi and Danish Art at the Turn of the Century.* New Haven, Connecticut: Yale University Press, 1992. Originally published as *Hammershøi: værk og liv.* Gyldendal, 1988.

Frida HANSEN

Books

THUE, Anniken. *Frida Hansen en europeer i norsk tekstilkunst omkring 1900.* Stavanger, Norway: Universitetsforlaget, 1986.

Thomas HEINE

Books

FILIPPOW, Johannes Konstantin. *Die Medezin in der Karikatur bei Thomas Theodor Heine.* Düsseldorf: Triltsch, 1978, "Düsserldorf Arbeiten zur Geschichte der Medezin" series, no. 49.

HILES, Timothy W. *Thomas Theodor Heine: Fin-de-siècle Munich and the Origins of Simplicissimus.* New York: Peter Lang, "Literature and the Visual Arts" series, vol. 9 (to be published in 1995).

STUWE, Elisabeth. *Der "Simplicissimus" – Karikaturist Thomas Theodor Heine und als Maler : Aspekte seiner Malerei*, Frankfurt, Bern and Las Vegas: Peter Lang, 1978, "Europäische Hochschulschriften" collection, series 28, "Kunstgeschichte", no. 7.

George HENRY and Edward HORNEL

Catalogues

Mr. Henry and Mr. Hornel Visit Japan: An Exhibition and Inventory of the Paintings Produced as a Result of Their Visit in 1893-1894. Glasgow, Glasgow Art Gallery, December 2, 1978-June 15, 1979. Published by Scottish Arts Council, Edinburgh, 1978. Texts by William BUCHANAN and Ailsa TANNER.

Ferdinand HODLER

Catalogues

Ferdinand Hodler und Wien. Vienna, Österreichische Galerie, Oberes Belvedere Wien, October 21, 1992-January 6, 1993. Texts by Sabine GRABNER and Elisabeth HULM-BAUER.

Zeichnungen der Reifezeit 1900-1918 : aus der Graphischen Sammlung des Kunsthauses Zürich. Ferdinand Hodler. Zurich, Kunsthaus, Graphisches Kabinett, September 11-December 13, 1992. Texts by Bernhard von WALDKIRCH and Anna BALINT.

Ferdinand Hodler. Locarno, Switzerland, Pinacoteca di Casa Rusca, March 22-May 10, 1992. Text by Bernhard von WALDKIRCH.

Ferdinand Hodler. Martigny, Switzerland, Fondation Pierre Gianadda, June 13-October 20, 1991. Text by Jura BRUSCHWEILER.

Ferdinand Hodler: vom Frühwerk bis zur Jahrhundertwende: Zeichnungen aus der Graphischen Sammlung des Kunsthauses Zürich. Zurich, Kunsthaus, Graphisches Kabinett, November 9, 1990-February 3, 1991; Hannover, Germany, Landesgalerie im Niedersächsischen Landesmuseum, March 22-May 5, 1991. Published by Kunsthaus Zürich, 1990. Texts by Bernhard von WALDKIRCH, Rudolf SCHINDLER and Christina STEINHOFF.

Das Engadin Ferdinand Hodlers und anderer Künstler des 19. und 20. Jahrhunderts. Chur, Switzerland, Bündner Kunstmuseum, March 31-June 10, 1990; Saint-Moritz, Switzerland, Segantini Museum, June 29-September 15, 1990. Published by Bündner Kunstmuseum Chur/Segantini Museum, Saint-Moritz, 1990. Text by Beat STUTZER.

Ferdinand Hodler. Collection Adda et Max Schmidheiny. Vevey, Switzerland, Musée des Beaux-Arts de Vevey, March 25-June 17, 1990. Published by Institut suisse pour l'étude de l'art, 1990. Texts by Oskar BÄTSCHMANN and Hans A. LUTHY, catalogue written by Marcel BAUMGARTNER.

La Chorégraphie du geste. Dessins de Ferdinand Hodler/The Fine Art of Gesture. Drawings by Ferdinand Hodler. Montreal, Montreal The Museum of Fine Arts, 1988. Text by Sharon L. HIRSH.

Ferdinand Hodler: Zeichnungen. Munich, Galerie von Abercron, 1987. Text by Jura BRUSCHWEILER.

Ferdinand Hodler: Landscapes. Frederick S. Wight Art Gallery; The Art Institute of Chicago; National Academy of Design. Published by Swiss Institute for Art Research, Zurich, 1987. Texts by Stephen F. EISENMAN, Oskar BÄTSCHMANN and Lukas GLOOR.

Ferdinand Hodler. Zurich, Galerie Römer, June 12-July 31, 1986. Text by Jura BRUSCHWEILER (in German and English).

Books

BECKER, Jorg. *Ferdinand Hodler.* Bergisch-Gladbach, Germany: J. Eul, 1992, "Kunstgeschichte" series, no. 6.

DESCOMBES, Marc. *Ferdinand Hodler.* Geneva: L'Unicorne/Slatkine, 1992.

RIVAZ, Michel de. *Ferdinand Hodler, Eugene Burnand, und die schweizerischen Banknoten.* Bern: Benteli, 1991.

Bernhard HOETGER

Catalogues

Bernhard Hoetger: sein Werk in der Böttcherstrasse Bremen. Bremen, Germany, Paula-Becker-Modersohn-Haus, 1994. Published by Worpsweder, [Worpswede, Germany], 1994. Text by Nils ASCHENBECK.

Licht und Schatten. Bernhard Hoetger: Majoliken 1910-1912. Bremen, Germany, Bremer Landesmuseum für Kunst und Kulturgeschichte, April 16-June 13, 1993. Published by Bremer Landesmuseum für Kunst und Kulturgeschichte, Bremen/Focke-Museum, 1993. Text by Uta BERNSMEIER.

Books

ENGEL, Frauke, and Thomas HIRTHE. *Bernhard Hoetger: Bildwerke 1902-1936.* Hannover, Germany: Niedersächsisches Landesmuseum, 1994, "Galeriehandbuch" series, no. 2.

GOLUCKE, Dieter. *Bernhard Hoetger: Bildhauer, Maler, Baukünstler, Designer.* [Worpswede], Germany: Worpsweder, 1984.

THIEMANN, Eugen. *Bernhard Hoetger.* [Worpswede], Germany: Worpsweder, 1990.

WEHNER, Dieter Tino. *Bernhard Hoetger: das Bildwerk 1905 bis 1914 und das Gesamtkunstwerk.* Alfter, Germany: Datenbank für Geisteswissenschaften, 1994.

Vojtěch HYNAIS

Books

MZYKOVA, Marie. *Vojtěch Hynais.* Prague: Odeon, 1990, "Mala galerie" series, no. 43.

Louis JANMOT

Books

HARDOUIN-FUGIER, Elisabeth. *Louis Janmot : 1814-1892.* Lyons: Presses universitaires de Lyon, 1981.

Louis Janmot : le «Poème de l'âme». Lyons: Musée des Beaux-Arts, 1976.

Le «Poème de l'âme» par Janmot. Étude iconographique. Lyons: Presses universitaires de Lyon, 1977.

Eugène JANSSON

Catalogues

Eugène Jansson. The Bath-house Period. London: Julian Hartnoll Gallery, 1983. Text by Claes MOSER.

Ernst JOSEPHSON

Catalogues

Poesi i sak: fran Josephson. Stockholm, Moderna museet, June 21, 1992-January 31, 1993. Published by Moderna museet, Stockholm, 1992. Texts by C.J.L. ALMQVIST and Nina OHMAN.

Vor der Zeit. Carl Fredrik Hill. Ernst Josephson. Zwei Künstler des späten 19. Jahrhunderts. Hamburg, Kunstverein Hamburg, October 13-November 25, 1984; Munich, Städtische Galerie im Lenbachhaus, December 19, 1984-February 10, 1985; Stuttgart, Kunstverein, March 6-April 14, 1985. Published by Frölich & Kaufmann, Berlin, 1984. Texts by Marina SCHNEEDE and Uwe M. SCHNEEDE.

Books

BRUMMER, Hans Henrik. *Ernst Josephson: malare, romantiker och symbolist.* Stockholm: Carlsson bokforlag, 1991.

EVERS, Knut. *Ernst Josephson.* Stockholm: Samfundet Sverige-Finland, 1990.

Bohumil KAFKA

Catalogues

Bohumil Kafka, 1878-1942. Prague, Národní galerie, 1976. Text by Vaclav PROCHAZKA.

Wassily KANDINSKY

Catalogues Raisonnés

BARNETT, Vivian Endicott, ed. *Kandinsky Watercolours: Catalogue Raisonné, 1900-1921.* 2 vols. Ithaca, New York: Cornell University Press, 1992.

ROETHEL, Hans K., and Jean K. BENJAMIN. *Kandinsky: Catalogue Raisonné of the Oil Paintings, 1900-1915.* vol. 1. Ithaca, New York: Cornell University Press, 1982.

Kandinsky : Catalogue Raisonné of the Oil Paintings, 1916-1944. vol. 2. Ithaca, New York: Cornell University Press, 1984.

ROETHEL, Hans K. and Jean K. *Kandinsky, das graphische Werk.* Cologne: 1970.

Catalogues

Wassili Kandinsky: tra Oriente e Occidente: capolavori dai musei russi. Florence, Palazzo Strozzi, April 24-July 11, 1993. Published by Artificio, Florence, 1993. Texts by Nicoletta MISLER, ed., John E. BOWLT and Laura LOMBARDI.

Theme and Improvisation: Kandinsky and the American Avant-garde, 1921-1950. Travelling exhibition organized by the Daytona Art Institute, November 19, 1992-August 1, 1993. Published by Little, Brown and Co., Boston, 1992. Texts by Gail LEVIN and Marianne LORENZ.

Wassily Kandinsky: Gemälde, Aquarelle, Graphiken. Munich, Galerie Thomas, May 17-July 27, 1991. Texts by Gabriele KARPF and Christiane SCHULZE.

Kandinsky. Paris, Grande Galerie, November 1, 1984-January 28, 1985. Published by Centre Georges-Pompidou/Musée national d'Art moderne, Paris, 1984.

Books

BARNETT, Vivian, and Armin ZWEITE. *Kandinsky: Watercolors and Drawings.* Munich: Prestel, 1992. Originally published as *Kandinsky: kleine Freuden: Aquarelle und Zeichnungen.* Kunstsammlung Nordrhein-Westfalen/Staatsgalerie Stuttgart, 1992.

CALNEK, Anthony, ed. *Watercolors by Kandinsky at the Guggenheim Museum: A Selection from the Solomon R. Guggenheim Museum & the Hilla von Rebay Foundation*. New York: Solomon R. Guggenheim Museum, 1991.

DEROUET, Christian, and Jessica BOISSEL, eds. *Kandinsky. Œuvres de Vassily Kandinsky (1866-1944)*. Paris: ADAGP/Centre Georges-Pompidou/Musée national d'Art moderne, 1984.

ELLER-RUTER, Ulrika-Maria. *Kandinsky: Bühnenkomposition und Dichtung als Realisation seines Synthese-Konzepts*. New York: Olms, 1990.

FINEBERG, Jonathan. *Kandinsky in Paris, 1906-1907*. Ann Arbor, Michigan: UMI Research Press, 1984, "Studies in the Fine Arts. The Avant-garde" series, no. 44.

HAHL-KOCH, Jelena. *Kandinsky*. New York: Rizzoli, 1993.

HAHL-KOCH, Jelena, ed. *Arnold Schönberg, Wassily Kandinsky: Letters, Pictures, and Documents*. London and Boston: Faber & Faber, 1984. Originally published as *Arnold Schönberg, Wassily Kandinsky: Briefe, Bilder und Dokumente einer aussergewöhnlichen Begegnung*. Taschenbuch-Verlag, 1983.

HENRY, Michel. *Voir l'invisible. Sur Kandinsky*. Paris: F. Bourin, 1988.

HOBERG, Annegret. *Wassily Kandinsky and Gabriele Münter*. Munich: Prestel, 1994.

LACOSTE, Michel C. *Kandinsky*. New York: Crown, 1988.

LINDSAY, Kenneth C., and Peter VERGO, eds. *Kandinsky: Complete Writings on Art*. New York: Da Capo, 1994.

LE TARGAT, François. *Kandinsky*. New York: Rizzoli, 1987. Originally published under the same title in French. Paris: Albin Michel, 1986.

ROSKILL, Mark. *Klee, Kandinsky, and the Thought of Their Time: A Critical Perspective*. Urbana, Illinois: University of Illinois Press, 1992.

SCHREIER, Christoph. *Wassily Kandinsky, Bild mit schwarzem Bogen: eine Kunst-Monographie*. Frankfurt: Insel, 1991.

THURLEMANN, Felix. *Kandinsky über Kandinsky: der Künstler als eigener Interpret*. Bern: Benteli, 1986.

TIO BELLIDO, Ramon. *Kandinsky*. New York: Portland House, 1988. Originally published under the same title in French. Paris: Hazan, 1987.

VALLIER, Dora. *La Rencontre Kandinsky-Schönberg*. Caen, France: L'Échoppe, 1987.

VERGO, Peter. *Kandinsky: Cossacks*. Seattle: University of Washington Press, 1986, "Tate Modern Masterpieces" series.

VEZIN, Annette, and Luc VEZIN. *Kandinsky et le Cavalier bleu*. Paris: P. Terrail, 1991.

VOLBOUDT, Pierre. *Kandinsky*. New York: Universe Books, 1986. Originally published under the same title in French. Paris: Hazan, 1984.

WEISS, Peg. *Kandinsky and Old Russia: The Artist as Ethnographer and Shaman*. New Haven, Connecticut: Yale University Press (to be published in 1995).

Ferdinand KELLER

Catalogues

Ferdinand Keller, 1842-1922: Gemälde, Zeichnungen. Karlsruhe, Germany, Staatliche Kunsthalle, July 18-October 4, 1992. Text by Eva-Marina FROITZHEIM.

Fernand KHNOPFF

Catalogue Raisonné

DELEVOY, Robert L., Catherine De CROËS and Gisèle OLLINGER-ZINQUE. *Fernand Khnopff. Catalogue de l'œuvre*. Brussels: Cosmos Monographie/Lebeer Hossmann, revised and expanded edition, 1987.

Catalogues

Rétrospective Fernand Khnopff. Tokyo, Bunkamura Museum, 1990. Texts by Shunsuke KIJIMA, Shinya NISHISAWA, Émile VERHAEREN, Catherine De CROËS and Gisèle OLLINGER-ZINQUE.

Fernand Khnopff et ses rapports avec la Sécession viennoise. Brussels, Musées royaux des Beaux-Arts de Belgique, October 2-December 6, 1987. Published by Centre international pour l'étude du XIX^e siècle/Lebeer Hossmann, Brussels, 1987. Texts by Philippe ROBERTS-JONES, Émile VERHAEREN, Hermann BAHR, Ludwig HEVESI, Josef ENGELHART, Catherine De CROËS and Gisèle OLLINGER-ZINQUE.

Theodor KITTELSEN

Books

HELLIESEN, Sidsel. *Th. Kittelsen. De lyse årene i Sigdal*. Åmot, Norway: Stiftelsen Modums Blaafarveværk, 1980.

OSTBY, Leif. *Theodor Kittelsen: tegninger og akvareller/Drawings and Water Colours*. Oslo: Dreyer, 1993; first published in 1975 (text in Norwegian and English).

Paul KLEE

Catalogue Raisonné

FREY, Stephan, and Josef HELFENSTEIN, eds. *Paul Klee. Verzeichnis der Werke des Jahres 1940*. Bern: Fondation Paul Klee/Kunstmuseum Bern; Stuttgart: Gerd Hatje, 1991; in collaboration with Irène REHMAN.

Catalogues

A Piece of the Moon World: Paul Klee in Texas Collections. Houston, Menil Collection, February 23-June 5, 1994. Texts by Susan E. DAVIDSON and Paul WINKLER.

Paul Klee in Gersthofen: Zeichnungen und Aquarelle von Paul Klee. Gersthofen, Paul Klee-Gymnasium, 1992. Texts by Günter UTZ and Wilfried WURTINGER.

Paul Klee. Verona, Italy, Galleria d'arte moderna e contemporanea. Published by Mazzotta, Milan, 1992. Text by Giorgio CORTENOVA, ed.

Paul Klee: Konstruktion, Intuition. Mannheim, Germany, Städtische Kunsthalle, December 9, 1990-March 3, 1991. Published by Gerd Hatje, Stuttgart, 1990. Texts by Manfred FATH and Hans-Jürgen BUDERER.

Paul Klee: 50 Werke aus 50 Jahren (1890-1940). Hamburg, Hamburger Kunsthalle, April 13-May 27, 1990. Text by Karin ORCHARD.

Paul Klee: Spätwerk. Stuttgart, Württembergischer Kunstverein, 1990. Published by Gerd Hatje, Stuttgart, 1990. Texts by Angelika WESSBECHER and Sabine WEISSINGER.

Paul Klee: Späte Zeichnungen von 1939. Essen, Germany, Museum Folkwang Essen, September 10-October 29, 1989; Kassel, Germany, Museum Fridericianum Kassel, November 5-December 30, 1989. Published by Museum Folkwang Essen, 1989. Texts by Ann TEMKIN, Gottfried BOEHM and Erich FRANZ, ed.

The In-between World of Paul Klee. San Francisco, Museum of Modern Art, February 11-July 31, 1988. Text by Charles MIEDZINSKI.

Paul Klee, 1879-1940. Saint-Étienne, France, Musée d'Art moderne, 1988.

Paul Klee. New York, The Museum of Modern Art, February 12-May 5, 1987; Cleveland, The Cleveland Museum of Art, June 24-August 16, 1987; Bern, Kunstmuseum Bern, September 25, 1987-January 3, 1988. Published by The Museum of Modern Art, New York/Little, Brown and Co., Boston, 1987. Text by Carolyn LANCHNER.

Klee. Martigny, Switzerland, Fondation Pierre Gianadda, May 24-November 3, 1985. Published by Cosmopress, Geneva, 1985. Text by André KUENZI, ed.

Books

BENZ-ZAUNER, Margareta. *Werkanalytische Untersuchungen zu den Tunisien-Aquarellen Paul Klees*. New York and Frankfurt: Peter Lang, 1984.

BISCHOFF, Ulrich. *Paul Klee*. Munich: F. Bruckmann, 1992.

BOULEZ, Pierre. *Le Pays fertile : Paul Klee*. Paris: Gallimard, 1989.

BONFAND, Alain. *L'Ombre de la nuit. Essai sur la mélancolie et l'angoisse dans les œuvres de Mari Sironi et de Paul Klee entre 1933 et 1940*. Paris: La Différence, 1993, "Mobile matière" series.

___. *Paul Klee, l'Œil en trop*. Paris: La Différence, 2 vols., 1988.

COMPTE, Philippe. *Klee*. Woodstock, New York: Overlook Press, 1991. Originally published as *Paul Klee*. Paris: Nouvelles Éditions françaises, 1989.

CRONE, Rainer, and Joseph KOERNER. *Paul Klee: Legends of the Sign*. New York: Columbia University Press, 1991.

FRANCISCONO, Marcel. *Paul Klee: His Work and Thought*. Chicago: University of Chicago Press, 1991.

GLAESEMER, Jurgen, ed. *Paul Klee: The Colored Works in the Kunstmuseum Bern*, 1979. Originally published as *Paul Klee. Die Farbigen Werke im Kunstmuseum Bern*. Bern: Kornfeld, 1976.

___. *Paul Klee. Handzeichnungen I, Kindheit bis 1920*. Bern: Kunstmuseum Bern, 1973.

___. *Paul Klee. Handzeichnungen II, 1921-1936*. Bern: Kunstmuseum Bern, 1984.

___. *Paul Klee. Handzeichnungen III, 1937-1940*. Bern: Kunstmuseum Bern, 1979.

GROHMANN, Will. *Paul Klee*. Cologne: DuMont, 1989, "DuMont's neue Galerie" series.

GROHMANN, Will. *Paul Klee*. New York: Harry N. Abrams, 1985, "Masters of Art" series. Originally published under the same title in French. Gennevilliers, France: Ars Mundi, 1985.

HOPFENGART, Christine. *Klee, vom Sonderfall zum Publikumsliebling: Stationen seiner öffentlichen Resonanz in Deutschland 1905-1960*. Mainz, Germany: P. von Zabern, 1989.

HOPPE-SALLER, Richard. *Paul Klee: Ad Parnassum*. Frankfurt: Insel Verlag, 1993.

JARDÍ, Enric, and Robert MARRAST. *Paul Klee*. New York: Rizzoli, 1991. Originally published under the same title in French. Paris: Albin Michel, 1990.

JORDAN, Jim M. *Paul Klee and Cubism*. Princeton, New Jersey: Princeton University Press, 1984.

KAGAN, Andrew. *Paul Klee at the Guggenheim Museum*. New York: Solomon R. Guggenheim Museum, 1993.

KERSTEN, Wolfgang. *Paul Klee, Übermut: Allegorie der künstlerischen Existenz.* Frankfurt: Fischer Taschenbuch Verlag, 1990.

LE BOT, Marc. *Paul Klee.* Paris: Maeght, 1992.

NAUBERT-RISER, Constance. *Klee.* New York: Portland House, 1988. Originally published under the same title in French. Paris: Hazan, 1988.

PARTSCH, Susanna. *Paul Klee 1879-1940.* Cologne: Taschen, 1990.

PRANGE, Regine. *Das Kristalline als Kunstsymbol Bruno Taut und Paul Klee: zur Reflexion des Abstrakten in Kunst und Kunsttheorie der Moderne.* Hildesheim, Germany, and New York: G. Olms, 1991.

REWALD, Sabine. *Paul Klee: The Berggruen Klee Collection in The Metropolitan Museum of Art.* New York: Harry N. Abrams/The Metropolitan Museum of Art, 1988.

ROSKILL, Mark. *Klee, Kandinsky, and the Thought of Their Time: A Critical Perspective.* Urbana, Illinois: University of Illinois Press, 1992.

SCHMALENBACH, Werner. *Paul Klee: The Düsseldorf Collection.* Munich: Prestel, 1986.

VERDI, Richard. *Klee and Nature.* New York: Rizzoli, 1985.

WERCKMEISTER, Otto Karl. *The Making of Paul Klee's Career, 1914-1920.* Chicago: University of Chicago Press, 1989.

Gustav KLIMT
Catalogue Raisonné
NOVOTNY, Fritz, and Johannes DOBAI. *Gustav Klimt: With a Catalogue Raisonné of His Paintings.* New York and Washington: Frederick A. Praeger, 1968.

Catalogues
Gustav Klimt. Zurich, Kunsthaus Zürich, September 11-December 13, 1992. Published by Gerd Hatje, Stuttgart, 1992. Texts by Toni STOOSS and Christoph DOSWALD, eds., Laura ARICI *et al.*

Gustav Klimt: 100 Zeichnungen. Villingen-Schwenningen, Germany, Städtische Galerie "Lovis-Kabinett", July 25-September 27, 1992. Text by Christa E. HARTMANN.

Gustav Klimt 1862 – Wien – 1918. Zeichnungen aus Privatbesitz. Düsseldorf, Geschäftsräumen in Düsseldorf, October 1-20, 1987. Published by C.G. Boerner, New York and Düsseldorf, 1987. Text by Alice STROBL.

Gustav Klimt: Disegni. Palazzo Pepoli, Campogrande, Italy, May-June 1985. Published by Nuova Alfa, Bologna, 1985.

Gustav Klimt. Zeichnungen aus amerikanischem Privatbesitz und Serge Sabarsky und Beständen des Historischen Museum der Stadt Wien. Vienna, Historisches Museum der Stadt Wien, June 7-September 16, 1984; Munich, Villa Stuck, November 29, 1984-January 27, 1985; Linz, Wolfgang-Gurlitt-Museum, February 5-April 8, 1985. Published by Historisches Museum der Stadt Wien/Eigenverlag der Museen der Stadt Wien, Vienna, 1985. Texts by Serge SABARSKY, ed., and Hans BISANZ.

Gustav Klimt. Zeichnungen aus amerikanischem Privatbesitz und Beständen des Historischen Museum der Stadt Wien. Hannover, Germany, Kestner-Gesellschaft, September 28-November 25, 1984. Text by Carl Albrecht HAENLEIN.

Books
BELLI, Gabriella. *Gustav Klimt, Masterpieces.* Boston: Little Brown & Co., 1990.

BOUILLON, Jean-Paul. *Klimt: Beethoven.* New York: Skira/Rizzoli, 1987. Originally published under the same title in French. Geneva: Skira, 1986.

BRANDSTÄTTER, Christian. *Gustav Klimt und die Frauen.* Vienna: Christian Brandstätter, 1994.

CLAIR, Jean. *Le Nu et la norme : Klimt et Picasso en 1907.* Paris: Gallimard, 1988.

DI STEFANO, Eva. *Il complesso di Salome: la donna, l'amore e la morte nella pittura di Klimt.* Palermo: Sellerio, 1985.

DOBAI, Johannes. *Gustav Klimt: Landscapes.* London: Weidenfeld and Nicolson, 1988.

DUCROS, Françoise. *Klimt.* Paris: Hazan, 1992, "Les Chefs-d'œuvre" series.

FISCHER, Wolfgang Georg. *Gustav Klimt and Emilie Flöge: The Painter and His Muse.* Woodstock, New York: Overlook Press, 1992. Originally published as *Gustav Klimt und Emilie Flöge: Genie und Talent, Freundschaft und Besessenheit.* Vienna: Christian Brandstätter, 1987.

FRODL, Gerbert. *Klimt.* New York: Holt, 1992.

HUICI, Fernando. *Klimt.* New York: Arch Cape Press, 1989.

KALLIR, Jane. *Gustav Klimt: Twenty-five Masterworks.* New York: Harry N. Abrams, 1989.

NEBEHAY, Christian Michael. *Gustav Klimt: From Drawing to Painting.* New York: Harry N. Abrams, 1994. Originally published as *Gustav Klimt. Von der Zeichnung zum Bild.* Vienna: Christian Brandstätter, 1992.

SABARSKY, Serge. *Gustav Klimt: Drawings.* London: G. Fraser, 1984.

SARMANY-PARSONS, Ilona. *Gustav Klimt.* New York: Crown, 1987.

STROBL, Alice. *Gustav Klimt. Die Zeichnungen.* Salzburg: Verlag Galerie Welz, 3 vols., 1980-1984.

WHITFORD, Frank. *Klimt.* London: Thames and Hudson, 1990, "World of Art" series.

Max KLINGER
Catalogues
Max Klinger, 1857-1920. Frankfurt, Städtische Galerie im Städelschen Kunstinstitut, February 12-June 7, 1992; Hamburg, Kunsthalle, June 26-August 16, 1992. Published by Leipzig Verlag, 1992. Texts by Dieter GLEISBERG, Eberhard ROTERS, Georg BUSSMANN, Günter METKEN, Karl-Heinz MEHNERT, Klaus GALLWITZ, Friedrich GROSS and Renate HARTLEB.

Max Klinger, 1857-1920: Radierungen. Stuttgart, Institut für Auslandsbeziehungen, 1991. Text by Eduard BEAUCAMP.

Max Klinger (1857-1920): graphische Zyklen. Aachen, Germany, Suermondt-Ludwig-Museum/Museumsverein Aachen, April 22-June 16, 1990. Text by Carola SCHNEIDER.

Max Klinger, Weg zum Gesamtkunstwerk. Hildesheim, Germany, Römer-und-Pelizaeus-Museum, 1984. Texts by Manfred BOETZKES, Dieter GLEISBER, Ekkenhard MAI, Ulrike PLANNER-STEINER, Hans-Georg PFEIFFER and Hellmuth Christian WOLFF.

Books
HARTLEB, Renate. *Max Klinger.* Berlin: Henschelverlag, 1985.

HUBSCHER, Anneliese, ed. *Malerie und Zeichnung: Tagebuchaufzeichnungen und Briefe.* Leipzig: Reclam, 1985.

MICHALSKI, Martin. *Max Klinger: künstlerische Entwicklung und Wandel weltanschaulicher Gehalte in den Jahren 1878-1910.* Augsburg, Germany: AV-Verlag, 1986.

TAUBER, Henry. *Max Klingers Exlibriswerk.* Wiesbaden, Germany: C. Wittal, 1989.

WINKLER, Gerhard. *Max Klinger.* Gütersloh, Germany: Prisma, 1984.

Archibald KNOX
Books
TILBROOK, Adrian J. *The Designs of Archibald Knox for Liberty & Co.* London: Ornament Press, 1976.

František KOBLIHA
Catalogues
František Kobliha (1877-1962). Cracow, Kraj galerie, 1973.

Books
VRBATA, Peter. *František Kobliha.* Nuremberg, Germany: R. Johanna Ricard, 1975.

Käthe KOLLWITZ
Catalogues
Three Berlin Artists of the Weimar Era: Hannah Hoch, Käthe Kollwitz, Jeanne Mammen. Des Moines, Iowa, Des Moines Art Center, April 23-July 17, 1994. Texts by Louise R. NOUN, ed., Annelie LUTGENS, Maria MAKELA and Amy NAMOWITZ WORTHEN.

Käthe Kollwitz. Bergamo, Italy, Palazzo della Ragione, September 10-October 10, 1993. Text by Catherine KRAHMER, catalogue written by M. MATASCI, E. DE PASCALE and M. SNIDER.

Käthe Kollwitz. Washington, National Gallery of Art, May 3-August 16, 1992. Published by National Gallery of Art, Washington; Yale University Press, New Haven, 1992. Texts by Elizabeth PRELINGER, ed., Alessandra COMINI and Hildegard BACHERT.

Käthe Kollwitz, Druckgraphik. Grafenau, Germany, Galerie Schlichtenmaier, Schloß Datzingen, June 29-August 24, 1991; Museum des Landkreises Waldshut, Schloß Bonndorf, September 8-October 6, 1991. Published by Schlichtenmaier, Grafenau, 1991. Texts by Bert SCHLICHTENMAIER, ed., Kuno SCHLICHTENMAIER, Günther THIEM and Michael WALZ.

Käthe Kollwitz, Druckgraphik, Handzeichnungen, Plastik. Hannover, Germany, 1989; Ratisbonne, 1989. Published by Gerd Hatje, Stuttgart, 1990. Text by Herwig GURATZSCH, ed.

Die Kollwitz-Sammlung des Dresdner Kupferstich-Kabinettes: Graphik und Zeichnungen, 1890-1912. Cologne, Käthe Kollwitz Museum, January 26-March 29, 1989. Published by Käthe Kollwitz Museum/DuMont, Cologne, 1988. Text by Werner SCHMIDT, ed.

Käthe Kollwitz, Druckgraphik: Sammlung der Akademie der Kunste der Deutschen Demokratischen Republik. Recklinghausen, Germany, Vestisches Museum Recklinghausen, May 4-June 5, 1988. Published by Ruhrfestspiele, Recklinghausen, 1988. Texts by Harri NUNDEL and Martina WEINHEIMER.

Käthe Kollwitz: The Power of the Print. New York, Galerie St. Etienne, November 17, 1987-January 16, 1988. Text by Jane KALLIR.

Käthe Kollwitz, 1867-1945: Zeichnungen, Druckgrafik, Skulpturen. Berlin, Galerie Pels-Leusden, February 17-March 28, 1985. Published by Die Halle, Höchst, Germany, 1985.

Books

BACKHAUS, Annie, *et al. Käthe-Kollwitz-Sammlung der Kreissparkasse Köln: Katalog der Handzeichnungen.* Cologne: Kreissparkasse, 1985.

BOHNKE-KULLWITZ, Jutta, ed. *Briefe an den Sohn, 1904 bis 1945.* Berlin: Siedler, 1992.

FECHT, Tom, ed. *Käthe Kollwitz: Works in Color.* New York: Schocken Books, 1988. Originally published as *Käthe Kollwitz: das farbige Werk.* Elefanten Press, 1987.

GOETZE, Irmgard. *Du wiesest einen Weg: Gedichte Käthe Kollwitz zum Gedenken.* Frankfurt: Zyklam, 1984, "Hauspoesie" series, no. 12.

JANSEN, Elmar. *Ernst Barlach, Käthe Kollwitz: Berührungen, Grenzen, Gegenbilder.* Berlin: Mann, 1989.

KOLLWITZ, Hans, ed. *The Diary and Letters of Käthe Kollwitz.* Evanston, Illinois: Northwestern University Press, 1988.

PRELINGER, Elizabeth, ed. *Käthe Kollwitz.* New Haven: Yale University Press, 1988.

SCHNEEDE, Uwe M., and Karl J. RIVINIUS. *Käthe Kollwitz: Grafiken, Plastik.* Stuttgart: Institut für Auslandsziehungen, 1990.

SEYS, Raf. *Käthe Kollwitz in Vlaanderen.* Koekelare, Belgium: De Rumberg, 1990 (abstract in German).

Nils KREUGER

Books

BOSTRÖM, Kjell. *Nils Kreuger.* Stockholm: A. Bonnier, 1948.

Alfred KUBIN

Catalogues

Alfred Kubin: Zeichnungen und Druckgraphik aus der Sammlung der Neuen Galerie der Stadt Linz/Wolfgang-Gurlitt-Museum. Quadrat Bottrop, Germany, Josef Albers Museum, June 9-August 11, 1991. Published by Josef Albers Museum, Bottrop; Neue Galerie, Linz, 1991. Texts by Peter BAUM, ed., Elisabeth THALLER and Angelika GILMAYR.

Alfred Kubin. Munich, Städtische Galerie im Lenbachhaus, October 3-December 2, 1990; Hamburg, Hamburger Kunsthalle, December 14, 1990-January 27, 1991. Published by Spangenberg, Munich, 1990. Texts by Annegret HOBERG, ed., Peter BAUM *et al.*

Alfred Kubin: Traumgestalten. Hundert Meisterwerke aus dem Besitz der Graphischen Sammlung Albertina. Munich, Spangenberg, 1990. Text by Erwin MITSCH.

Alfred Kubin: zur Wiederkehr des 30. Todestages. Salzburg, Galerie Altnoder, 1989.

Alfred Kubin, 1877-1959 : 136 dessins du Musée national de Haute Autriche de Linz/Alfred Kubin, 1877-1959: 136 Zeichnungen aus dem Besitz des Oberösterreichischen Landesmuseum Linz. Paris, Musée-galerie de la SEITA, March 8-June 4, 1988. Text by Wilfried SEIPEL (in German and French).

Alfred Kubin, 1877-1959: le nautonier du rêve au réel. Mons, Belgium, Musée des beaux-arts, September 26-December 16, 1987. Texts by Frank VANHAECKE, ed., André BOUGARD *et al.* (in French, Flemish and German).

Alfred Kubin. Winterthur, Switzerland, Kunstmuseum Winterthur, September 14-November 9, 1986. Published by Kunstmuseum Winterthur, 1986. Texts by Rudolf KOELLA and Dieter SCHWARZ.

Alfred Kubin : vingt dessins. Paris, Galerie Berggruen, 1986.

Alfred Kubin, der Traum vom Böhmerwald. Ratisbon, Germany, Ostdeutsche Galerie Regensburg, August 1-September 22, 1985. Published by Spangenberg, Munich, 1985. Text by Werner TIMM, ed.

Alfred Kubin, Leben ein Abgrund. Linz, Oberösterreichisches Landesmuseum. Published by Jugend und Volk, Vienna, 1985. Text by Klaus Albrecht SCHRODER.

Books

MEISSNER, Karl-Heinz. *Alfred Kubin, Ausstellungen 1901-1959.* Munich: Spangenberg, 1990.

NIGRO, A., and M. CACIARI. *Alfred Kubin, profeta del tramonto.* Rome: Officina, 1983, "La coscienza e l'altro" series, no. 2.

RHEIN, Phillip H. *The Verbal & Visual of Alfred Kubin.* Riverside, California: Ariadne Press, 1989, "Studies in Austrian Literature, Culture, & Thought Translation" series.

SCHREMMER, Ernst. *Alfred Kubin: Aquarelle, Zeichnungen, Lithographien, illustrierte Bücher.* Esslinger, Germany: Kunstlergilde, 1985.

SEIPEL, Wilfried. *Alfred Kubin der Zeichner 1877-1959.* Vienna: Christian Brandstätter, 1988.

VAN ZON, Gabriele. *Word & Picture: A Study of the Double Talent in Alfred Kubin and Fritz von Hermanovsky-Orlando,* vol. 2. New York: Peter Lang, 1992, "Studies in European Throught" series.

František KUPKA

Catalogues

Kupka: Paintings and Gouaches. New York, Claude Bernard Gallery, October 9-November 10, 1990. Text by Charlotta KOTI.

František Kupka 1871-1957. Ou l'invention d'une abstraction. Paris, Musée d'Art moderne, November 22, 1989-February 26, 1990.

František Kupka: Padiglione d'arte contemporain. Ferrara, Italy, P. Palazzo Massari, July 27-October 4, 1987. Published by Commune di Ferrara, Assessorato istituzioni culturali, Ferrara, 1987.

Books

FAUCHEREAU, Serge. *Kupka.* New York: Rizzoli, 1989. Originally published under the same title in French. Paris: Albin Michel, 1988.

LAMAC, Miroslav. *František Kupka.* London: Collets, 1984. Originally published as *František Kupka.* Odeon, 1984.

Georges LACOMBE

Catalogue Raisonné

SALMON, Blandine, and Olivier MESLAY. *Georges Lacombe : sculptures, peintures, dessins.* Paris: Charles et André Bailly, 1991.

Catalogues

Georges Lacombe 1868-1916. Ballades en forêt d'Écouves. Alençon, France, Musée des beaux-arts et de la dentelle, July 4-September 27, 1992. Texts by Joëlle ANSIEAU, Georges MALDAN and Aude PESSEY-LUX.

Georges Lacombe. 1868-1916. Versailles, France, Musée Lambinet, May 28-July 8, 1984. Published by Musée Lambinet, Versailles, 1984. Texts by Joëlle ANSIEAU and Catherine GENDRE.

René LALIQUE

Catalogue Raisonné

MARCILHAC, Félix. *René Lalique 1860-1945, maître-verrier. Analyse de l'œuvre et catalogue raisonné.* Paris: Éditions de l'amateur, 1989.

Catalogues

René Lalique. Bijoux. Verre. Paris, Musée des Arts décoratifs, October 22, 1991-March 8, 1992. Published by Musée des Arts décoratifs/Réunion des musées nationaux, Paris, 1991. Texts by Yvonne BRUNHAMMER, Philippe THIÉBAUT, Maria Teresa GOMES FERREIRA, Évelyne POSSÉMÉ, Anne VANLATUM, Nadine GASC, José PIERRE, Marie-Noël de GARY, Jean-Luc OLIVIÉ and Félix MARCILHAC.

René Lalique, 100 vases. Paris, Galerie Doria, November 4-December 3, 1988. Published by Sujet libre, Paris, 1988. Text by Denis DORIA.

Lalique: Schmuckkunst des Jugendstils. Munich, Bayerisches Nationalmuseum, December 4, 1987-February 21, 1988. Published by Schmuckmuseum Pforzheim, Pforzheim, Germany, 1987. Texts by Fritz FALK and Michael KOCH.

Art Nouveau Jewelry by René Lalique. Washington, travelling exhibition organized by the International Exibitions Foundation, 1985-1986. Texts by Maria Teresa GOMES FERREIRA, Maria Isabel PEREIRA COUTINHO, Maria Fernanda PASSOS LEITE and Mary P. PRODDOW.

Books

BARTEN, Sigrid. *René Lalique: Schmuck und Objets d'art 1890-1910.* Munich: Prestel, 1989.

BAYER, Patricia, and Mark WALLER. *The Art of René Lalique.* London: Bloomsbury, 1988, "Chiefly" series.

DAWES, Nicholas M. *Lalique Glass.* New York: Crown, 1986.

LALIQUE, Marie-Claude, and Odette BOULENGER, eds. *Lalique.* Lausanne: Édipop, 1988. Texts and captions by Catherine HYDEN.

MORTIMER, Tony L. *Lalique Jewellery and Glassware.* London: Octopus, 1988.

PERCY, Christopher V. *Lalique: A Collector's Guide.* New York: Random House, 1989.

UTT, Mary Lou, Glenn UTT and Patricia BAYER. *Lalique Perfume Bottles.* New York: Crown, 1990.

Georges LE BRUN

Catalogues

Georges Le Brun 1873-1914. Ixelles, Belgium, Musée d'Ixelles/Museum van Elaene, December 12, 1975-January 11, 1976 (text in French and Flemish).

Ozias LEDUC

Catalogues

Les Paysages d'Ozias Leduc, lieu de méditation/Contemplative Scenes: The Landscapes of Ozias Leduc. Montreal: The Montreal Museum of Fine Arts, 1986. Text by Louise BEAUDRY (in French and English).

Books

GLADU, Paul. *Ozias Leduc.* La Prairie, Quebec: Marcel Broquet, 1989, "Signatures" series.

STIRLING, J. Craig. *Ozias Leduc et la décoration intérieure de l'église de Saint-Hilaire.* Quebec City: Ministère des Affaires culturelles, 1985.

Frederic LEIGHTON

Books

NEWALL, Christopher. *The Art of Lord Leighton.* Oxford: Phaidon, 1990.

Henri LE SIDANER

Catalogues

Henri Le Sidaner : 1862-1939. Paris, Musée Marmottan, May 2-July 16, 1989. Paris, Bibliothèque des Arts, 1989. Text by Marianne DELAFOND.

Books

FARINAUX-LE SIDANER, Yann. *Le Sidaner. L'œuvre peint et gravé*. Paris: André Sauret, 1989 (text in French and English).

Lucien LÉVY-DHURMER

Catalogues

Autour de Lévy-Dhurmer. Visionnaires et Intimistes en 1900. Paris, Grand Palais, March 3-April 30, 1973. Published by Réunion des musées nationaux, Paris, 1973. Text by Geneviève MONNIER, catalogue written by Antoinette FAY, Jacques FOUCART, Jean LACOMBE and Geneviève MONNIER.

Johann LÖETZ-WITWE

Catalogues

Löetz: böhmisches Glas 1880-1940. Düsseldorf, Kunstmuseum, February 12-April 30, 1989; Frankfurt, Museum für Kunsthandwerk, May 25-July 16, 1989; Prague, Kunstgewerbemuseum, August 10-September 24, 1989. Published by Prestel, Munich, 1989. Text by Helmut RICKE, ed.

Löetz Austria 1900: Glas/glass/verre/vetri. Vienna, Österreichisches Museum für angewandte Kunst, May 23-July 6, 1986; Linz, Oberösterreichisches Landesmuseum, November 20, 1986-January 31, 1987. Published by Waltraud Neuwirth, Vienna, 1986. Text by Waltraud NEUWIRTH, ed. (in French, English, Italian and German).

Löetz Austria, 1905-1918: Glas/Löetz Austria, 1905-1918: Glass. Linz, Oberösterreichisches Landesmuseum, November 20, 1986-January 31, 1987. Published by Waltraud Neuwirth, Vienna, 1986. Text by Waltraud NEUWIRTH, ed. (in English and German, preface and captions in French and English).

Elena LUKSCH-MAKOWSKY

Books

LUKSCH, Maria, ed. *Kindheits- und Jugenderinnerungen, 1878-1900. Elena Luksch-Makowsky*. Hamburg: Hower, 1989.

Margaret MACDONALD MACKINTOSH

Catalogues

Margaret Macdonald Mackintosh, 1864-1933. Glasgow, Hunterian Art Gallery, November 26, 1983-January 7, 1984. Published by University of Glasgow, 1983.

Charles Rennie MACKINTOSH

Catalogues

Charles Rennie Mackintosh, Architectural Drawings. Glasgow, Hunterian Art Gallery, University of Glasgow, July 7-October 28, 1990. Text by Pamela ROBERTSON.

Books

BILLCLIFFE, Roger. *Charles Rennie Mackintosh: The Complete Furniture Drawings and Interior Designs*. New York: E.P. Dutton, 3rd edition, 1986.

——.*Mackintosh Furniture*. Cambridge, England: Lutterworth Press, 1984.

BRETT, David. *C. R. Mackintosh: The Poetics of Workmanship*. Cambridge, Massachusetts: Harvard University Press, 1993.

BUCHANAN, William, James McAULAY and Andrew MacMILLAN. *Mackintosh's Masterwork: Charles Rennie Mackintosh and the Glasgow School of Art*. San Francisco: Chronicle Books, 1989.

COOPER, Jackie, ed. *Mackintosh Architecture: The Complete Buildings and Selected Projects*. London: Academy; New York: St. Martin's Press, 1984.

GARCIAS, Jean-Claude. *Mackintosh*. Paris: Hazan, 1989, "Architecture" series.

GRIGG, Jocelyn. *Charles Rennie Mackintosh*. Salt Lake City: Peregrine Books, 1988.

HOWARTH, Thomas. *Charles Rennie Mackintosh and the Modern Movement*. London and New York: Routledge, 1990.

Hunterian Art Gallery. *Estate and Collection of Works by Charles Rennie Mackintosh at the Hunterian Art Gallery, University of Glasgow*. Glasgow: Hunterian Art Gallery, 1991.

JONES, Anthony. *Charles Rennie Mackintosh*. 1990.

LAGANÁ, Guido, ed. *Charles Rennie Mackintosh, 1868-1928*. Milan: Electa, 1988.

LOWREY, John, ed. *Architectural Heritage III: Mackintosh and His Contemporaries*. Edinburgh: Edinburgh University Press, 1992.

MACAULAY, James. *Glasgow School of Art, Glasgow, 1897-1909: Charles Mackintosh*. Oxford: Phaidon, 1993.

MOFFAT, Alistair, and Colin BAXTER. *Remembering Charles Rennie Mackintosh: An Illustrated Biography*. Lanark, Scotland: Colin Baxter Photography, 1989.

NEAT, Timothy. *Part Seen, Part Imagined: Meaning and Symbolism in the Work of Charles Rennie Mackintosh and Margaret Macdonald*. Edinburgh: Canongate Press, 1994.

NUTTGENS, P., ed. *Mackintosh and His Contemporaries in Europe and America*. London: John Murray, 1987.

ROBERTSON, Pamela, ed. *Charles Rennie Mackintosh: The Architectural Papers*. Cambridge, Massachusetts: M.I.T. Press, 1991.

Louis MAJORELLE

Books

BOUVIER, Roselyne. *Majorelle. Une aventure moderne*. Paris: Bibliothèque des arts; Metz: Serpenoise, 1991.

DUNCAN, Alastair. *Louis Majorelle, Master of Art Nouveau Design*. New York: Harry N. Abrams, 1991.

Erich MALLINA

Catalogues

Erich Mallina. Vienna, Hochschule für angewandte Kunst, December 10, 1980-January 30, 1981.

Clément MASSIER

Catalogues

Clément Massier, Delphin Massier, Jérôme Massier. Vallauris, France, Musée municipal de Vallauris, July 21-September 30, 1979.

Charles MAURIN

Catalogues

Charles Maurin: The Vaporizer Watercolors, a Hitherto Unknown Development of the 1890's. New York, Lucien Goldschmidt, April 9-May 3, 1986. Published by Lucien Goldschmidt, New York, 1986. Text by Colin T. EISLER.

Karl MEDIZ and Emilie MEDIZ-PELIKAN

Catalogues

Emilie Mediz Pelikan 1861-1908, Karl Mediz 1868-1945. Vienna, Hochschule für Angewandte Kunst, 1986; Linz, Oberösterreichisches Landesmuseum, April-June 1986. Published by Hochschule für Angewandte Kunst, Vienna; Oberösterreichisches Landesmuseum, Linz, 1987. Text by Sophie GERETSEGGER.

Józef MEHOFFER

Catalogues

Grafika Józefa Mehoffera [Józef Mehoffer: Engravings]. Plock, Poland, Muzeum Mazowieckie, 1983. Text by K. CZARNECKI.

Books

ADAMOWICZ, T. *Witraze fryburskie Józefa Mehoffera: monografia zespalu* [Józef Mehoffer's Stained Glass in Fribourg: A Monograph]. Wroclaw, Poland: Ossolineum, 1982, "Studia z historii sztuki" series, no. 33 (abstract in French).

Xavier MELLERY

Articles

HOUBART-WILKIN, S. "La Maison du peintre Xavier Mellery", *Bulletin des Musées royaux des Beaux-Arts de Belgique*, 1964.

George MINNE

Catalogues

Wilhelm Lehmbruck, George Minne, Joseph Beuys. Ghent, Museum voor Schone Kunsten, March 2-May 5, 1991. Published by Stad Gent, Ghent, 1991 (text in Flemish and French).

George Minne en de kunst rond 1900 [George Minne and Turn-of-the-century Art]. Ghent, Museum voor Schone Kunsten, September 18, 1982-December 5, 1982. Published by Stadsarchief, Ghent, 1982. Texts by Robert HOOZEE, Monique TAHON-VANROOSE, Albert ALHDEFF and Jo HAERENS (in Flemish, French and English).

Carl MOLL

Catalogues

Carl Moll: seine Freunde, sein Leben, sein Werk. Salzburg, Verlag Galerie Welz, 1985.

Piet MONDRIAN

Catalogues

Mondrian in the Sidney Janis Family Collections, New York. The Hague, Haags Gemeentmuseum, February 19-May 29, 1988. Text by Herbert HENKELS, ed.

Mondrian: From Figuration to Abstraction. Tokyo, Seibu Museum of Art, July 25-August 31, 1987. Published by Thames and Hudson, London, 1987.

Mondrian, de la figuration à l'abstraction : œuvres du Haags Gemeentemuseum de La Haye. Saint-Paul, France, Fondation Maeght, March 23-May 16, 1985. Text by Jean-Louis PRAT, ed.

Books

CELAN, Germano, and Michael GOVAN. *Mondrian e De Stijl: l'ideale moderno*. Milan: Giorgio Cini, 1990.

CHAMPA, Kermit Swiler. *Mondrian Studies*. Chicago: University of Chicago Press, 1985.

HOLTZMAN, Harry, and Martin S. JAMES, eds. *The New Art – The New Life: The Collected Writing of Piet Mondrian*. Boston: G.K. Hall, 1986, "The Documents of 20th Century Art" series.

JAFFE, Hans Ludwig C. *Mondrian*. New York: Harry N. Abrams, 1986, "Master of Art" series.

LEMOINE, Serge. *Mondrian & De Stijl*. New York: Harry N. Abrams, 1987, "Master of Modern Art" series.

LÉVY, Bernard-Henri. *Piet Mondrian*. Paris: La Différence, 1992, "Les Anciens et les Modernes" series.

MEURIS, Jacques. *Mondrian*. Paris: Nouvelles Éditions françaises/Casterman, 1991.

MILNER, John. *Mondrian*. New York: Abbeville Press, 1992.

SHAPIRO, David. *Mondrian: Flowers*. New York: Harry N. Abrams, 1991.

THRELFALL, Tim. *Piet Mondrian: His Life's Work and Evolution, 1872-1944*. New York: Garland, 1988.

WISMER, Beat. *Mondrians ästhetische Utopie*. Baden, Germany: LIT, 1985.

Gustave MOREAU
Catalogue Raisonné
BITTLER, Paul, and Pierre-Louis MATHIEU. *Catalogue des dessins de Gustave Moreau*. Paris: Réunion des musées nationaux, 1983.

Catalogues
Gustave Moreau et la Bible. Nice, France, Musée national Message biblique Marc Chagall, July 6-October 7, 1991. Published by Réunion des musées nationaux, Paris, 1991. Texts by Guillaume AMBROISE, Geneviève LACAMBRE and Pierre-Louis MATHIEU.

Gustave Moreau. Heerlen, The Netherlands, Stadsgalerij, March 24-June 16, 1991. Published by Stadsgalerij, Heerlen; Imschoot, Ghent, 1991. Texts by Anke va der LAAN, Geneviève LACAMBRE, John SILLEVIS and Carlo SISI (in French and Flemish, abstract in English).

Maison d'artiste, maison-musée. L'exemple de Gustave Moreau. Paris, Musée d'Orsay, May 25-August 30, 1987. Published by Réunion des musées nationaux, Paris, 1987. Text by Geneviève LACAMBRE.

Gustave Moreau : Symboliste. Zurich, Kunsthaus Zürich, March 14-May 25, 1986. Texts by Toni STOOSS, Geneviève LACAMBRE, Pierre-Louis MATHIEU, Dorothy M. KOSINSKI and Andre Vladimir HEINZ.

Books
MATHIEU, Pierre-Louis, ed. *L'Assembleur de rêves. Écrits complets de Gustave Moreau*. Fontfroide, France: Bibliothèque artistique et littéraire, 1984.

MATHIEU, Pierre-Louis. *Gustave Moreau: The Watercolors*. New York: Hudson Hills Press, 1985. Originally published as *Gustave Moreau, aquarelles*. Fribourg, Switzerland: Office du livre, 1984.

___.*Tout l'œuvre peint de Gustave Moreau*. Paris: Flammarion, 1991, "Les Classiques de l'art" series.

Koloman MOSER
Books
BARONI, Daniele, and Antonio D'AURIA. *Kolo Moser, Graphic Artist and Designer*. New York: Rizzoli, 1986. Originally published as *Kolo Moser, grafico e designer*, exhib. cat. Mazzotta, 1984.

BASCOU, Marc. *Koloman Moser : un créateur d'avant-garde à Vienne (1897-1907)*. Paris: Réunion des musées nationaux, 1989.

FENZ, Werner. *Koloman Moser. Art graphique, art appliqué, peinture*. Liège: Pierre Mardaga, 1987.

Gustav Adolf MOSSA
Catalogues
Gustav Adolf Mossa : l'œuvre symboliste, 1903-1918. Paris, Pavillon des Arts, June 19-September 27, 1992. Published by Paris-musées, 1992. Texts by Jean FORNERIS, Anne-Marie CLAIS and Sylvie LAFON.

Books
LAFON, Sylvie. *Gustav Adolf Mossa : la scène symboliste*. Nice: Z'éditions, 1993.

SOUBIRAN, J.R. *Gustav Adolf Mossa*. Nice: Ediriviera, 1985.

Alfons MUCHA
Catalogue Raisonné
RENNERT, Jack, and Alain WEIL. *Alphonse Mucha: The Complete Posters and Panels*. Boston: G.K. Hall, 1984, "A. Hjert & Hjert Book" series.

Catalogues
Alfons Mucha: Meditation und Botschaft. Kassel, Germany, Museum Fridericianum, 1989. Published by Museum Fridericianum/Weber & Wiedemeyer, Kassel, 1989. Text by Roland NACHTIGALLER.

Alfons Mucha fotografem. Prague, Pamatnik narodniho pisemnictvi, 1988. Text by Jiri RAPEK.

Alfons Mucha. Amersfoort, The Netherlands, De Zonnehof, March 13-May 6, 1984. Published by Amersfoortse Culturele Raad, Amersfoort, 1984. Texts by Jiri KOTALIK, Jana BRADCOVA and Jiri MUCHA.

Books
ARWAS, Victor. *Alphonse Mucha: Master of Art Nouveau*. New York: Saint Martin's Press, 1986.

ELLRIDGE, Arthur. *Mucha : le triomphe du modern style*. Paris: Terrail, 1992.

KUSAK, Dalibor, and Marta KADLECIKOVA. *Mucha*. Prague: Artia, 1992.

MUCHA, Jiri. *Alphonse Maria Mucha: His Life and Art*. New York: Rizzoli, 1989. Originally published as *Alfons Mucha. Ein Künstlerleben*. Berlin: Verlag Volk und Welt, 1986.

RENNERT, Jack. *Mucha : la collection Ivan Lendl*. Paris: Syros-Alternative, 1989.

Edvard MUNCH
Catalogues
Edvard Munch Portretter. Oslo, Munch-museet, January 23-May 3, 1994. Published by Munch-museet, Oslo/Labyrinth Press, 1994. Text by Arne EGGUM.

Edvard Munch: Monumental Projects, 1909-1930. Lillehammer, Lillehammer bys malerisamling, June 3-August 22, 1993. Texts by Per Bj. BOYM and Gerd WOLL, ed.

Edvard Munch und seine Modelle. Stuttgart, Galerie der Stadt Stuttgart, April 17-August 1, 1993. Published by Gerd Hatje, Stuttgart, 1993. Texts by Johann-Karl SCHMIDT, ed., Marion KEINER and Ursula ZELLER.

Edvard Munch. The Frieze of Life. London, National Gallery, November 12, 1992-February 7, 1993. Texts by Arne EGGUM, Reinhold HELLER and Gerd WOLL.

Munch et la France. Paris, Musée d'Orsay, September 24, 1991-January 5, 1992. Published by Réunion des musées nationaux, Paris, 1991. Texts by Rodolphe RAPETTI, Arne EGGUM, Geneviève AITKEN and Gerd WOLL.

Edvard Munch Holzschnitte. Reutlingen, Germany, Städtisches Kunstmuseum Spendhaus Reutlingen, December 2, 1990-January 27, 1991. Text by Beate GRUBERT.

Edvard Munch: Master Prints from the Epstein Family Collection. Travelling exhibition, Washington, National Gallery of Art, 1990. Text by Sarah G. EPSTEIN.

Munch and Photography. Newcastle upon Tyne, England, Newcastle Polytechnic Gallery, May 2-June 16, 1989; Edinburgh, The City Art Centre, August 5-September 16, 1989; Manchester, City Art Gallery, September 23-November 5, 1989; Oxford, The Museum of Modern Art, January 14-March 18, 1990. Published by The Polytechnic Gallery, Newcastle upon Tyne, 1989. Text by Arne EGGUM.

Edvard Munch og hans modeller 1912-1943. Oslo, Munch-museet, December 12, 1988-February 15, 1989. Texts by Arne EGGUM, Bodil STENSETH and Alf BØE.

Edvard Munch: Sommernacht am Oslofjord um 1900. Mannheim, Germany, Städtische Kunsthalle Mannheim, February 27-April 17, 1988. Texts by Roland DORN *et al*.

Edvard Munch. Essen, Germany, Folkwang Museum, September 18-November 8, 1987; Zurich, Kunsthaus Zürich, November 19, 1987-February 14, 1988. Published by Folkwang Museum/Kunsthaus Zürich/Munch-museet, Essen, 1987. Texts by Guido MAGNAGUAGNO, Emil MAURER, Barbara SCHÜTZ, Arne EGGUM and Jürgen SCHULTZE.

Edvard Munch, aus dem Munch Museum Oslo: Gemälde, Aquarelle, Zeichnungen, Druckgraphik, Fotografien. Munich, Villa Stuck, April 28-July 5, 1987; Salzburg, Salzburger Landessammlungen Rupertinum, July 16-October 4, 1987; Berlin, Brücke-Museum, October 10-December 6, 1987. Published by Stuck Jugendstil-Verein, Munich, 1987. Texts by Gabriele FAHR-BECKER-STERNER *et al*.

Edvard Munch. Vancouver, Vancouver Art Gallery, May 31-August 4, 1986. Published by Vancouver Art Gallery, Vancouver/Munch-museet, Oslo, 1986. Texts by Arne EGGUM and Gerd WOLL.

Edvard Munch: Mirror Reflections. West Palm Beach, Florida, Norton Gallery of Art, February-April 1986. Text by Patricia G. BERMAN.

Edvard Munch. Sein Werk in Schweizer Sammlungen. Basel, Switzerland, Kunstmuseum Basel, June 9-September 22, 1985. Published by Öffentliche Kunstsammlung, 1985. Texts by Christian GEELHAAR, Dieter KOEPPLIN, Yvonne HÖFLIGER and Martin SCHWANDER.

Edvard Munch. Höhepunkte des Malerischen Werks im 20. Jahrhundert. Hamburg, Kunstverein in Hamburg, December 8, 1984-February 3, 1985. Published by Frölich & Kaufmann, Berlin, 1984. Texts by Arne EGGUM, Günther GERCKEN, Marina SCHNEEDE-SCZESNY and Uwe M. SCHNEEDE.

Munch and the Workers. Newcastle upon Tyne, England, Newcastle Polytechnic Gallery, October 8-November 30, 1984; Aberdeen, Aberdeen Art Gallery, January 12-February 2, 1985; London, Barbican Art Gallery, February 14-March 31, 1985; Edinburgh, City Art Center, April 18-May 18, 1985; Belfast, Ulster Museum, May 30-June 24, 1985; Liverpool, Walker Art Gallery, July 4-August 18, 1985. Published by Newcastle Polytechnic Gallery, Newcastle upon Tyne, 1984. Texts by Gerd WOLL and Mara-Helen WOOD.

Books

BJORNSTAD, Ketil. *Historien om Edvard Munch*. Oslo: Gyldendal Norsk Forlag, 1993.

BØE, Alf. *Edvard Munch*. New York: Rizzoli, 1989.

EGGUM, Arne. *Edvard Munch: livsfrisen fra maleri til grafikk*. Oslo: J.M. Stenersens Forlag, 1990.

——.*Edvard Munch. Paintings, Sketches and Studies*. London: Thames and Hudson, 1984. Originally published as *Edvard Munch. Malerei, Skisser og Studier*. J.M. Stenersens Forlag A.S., 1983.

——.*Munch and Photography*. New Haven, Connecticut: Yale University Press, 1989. Originally published as *Munch og Fotografi*. Gyldendal Norsk Forlag, 1987.

GRAEN, Monika. *Das Dreifrauenghema bei Edvard Munch*. Frankfurt and New York: Peter Lang, 1985.

HELLER, Reinhold. *Munch: His Life and Work*. London: John Calmann and Cooper, 1984.

LIPPINCOTT, Louise. *Edvard Munch: Starry Night*. Malibu, California: J. Paul Getty Museum, 1988.

SCHNEEDE, Uwe M. *Edvard Munch. Das kranke Kind: Arbeit an der Erinnerung*. Frankfurt: Fischer Taschenbuch, 1984.

——.*Edvard Munch. Les chefs-d'œuvre de jeunesse*. Munich: Schirmer; Paris: Mosel, 1988, "Bibliothèque visuelle" series, no. 2.

SKEDSMO, Tone. *Edvard Munch i Nasjonalgalleriet*. Oslo: Nasjonalgalleriet, 1989 (text in English, French, German and Norwegian).

Gerhard MUNTHE
Catalogues

Gerhard Munthe, 1849-1929: norwegische Bildteppische des Jugendstils aus dem Kunstgewerbemuseum Trondheim. Munich, Villa Stuck, 1989. Texts by Gabriele FAHR-BECKER-STERNER, Mark KUHRT and Ursula DELOURME.

Gerhard Munthe 1849-1929. Modum, Norway, Stiftelsen Modums blaafarvevaerk, May 21-September 30, 1988. Published by Blaafarveværket, Modum, 1988 (text in Norwegian, abstract in English).

Book

BERNHARDT, Borge, *et al. Kultur og natur: vandringer blant boker og bokfolk*. Oslo, Riksbibliotektjenesten, 1989 (text in Norwegian, Danish, English, German and Swedish).

Ejnar NIELSEN
Catalogues

Ejnar Nielsen. Copenhagen, Kunstforeningen, 1984. Texts by Annette STABELL and Otto Jørn HANSEN.

Hermann OBRIST
Catalogues

Hermann Obrist: Wegbereiter der Moderne. Munich, Villa Stuck, March 1968. Published by Stuck-Jugendstil-Verein, Munich, 1968. Text by Siegfried WICHMANN.

Books

LAMPE-VON BENNIGSEN, Silvie. *Hermann Obrist. Erinnerungen*. Munich: H. Post, 1970.

Alphonse OSBERT
Catalogues

Alphonse Osbert, 1857-1939. Paris, Galerie Coligny, 1980.

Alphonse Osbert, peintre symboliste, 1857-1939. Honfleur, France, Musée Eugène-Boudin, August 5-September 30, 1977.

Jaroslav PANUSKA
Catalogues

Jaroslav Panuska. Pardubice, Czech Republic, Vychodoces galerie, 1978. Text by Jitka BOUCKOVA.

Giuseppe PELLIZZA DA VOLPEDO
Catalogue Raisonné

SCOTTI, Aurora. *Pellizza da Volpedo: catalogo generale*. Milan: Electa, 1986.

Eilif PETERSSEN
Articles

WERENSKIOLD, Erik. "Eilif Peterssen og Gerhard Munthe", *Samtiden*, 1929, pp. 81-86.

Armand POINT
Books

MARIE, Gisèle, ed. *Élémir Bourges, ou l'éloge de la grandeur, correspondance inédite avec Armand Point*. Paris: Mercure de France, 1962.

Jan PREISLER
Books

WITTLICH, Petr. *Jan Preisler, kresby*. Prague: Odeon, 1988 (abstracts in English, French and Russian).

Gaetano PREVIATI
Catalogues

Gaetano Previati (1852-1920). Mostra antologica. Ferrara, Italy, Palazzo dei diamanti, Galleria Civica d'arte Moderna, July-October 1969. Texts by Palma BUCARELLI, Fortunato BELLONZI and Renato BARILLI.

Books

TORRESI, Antonio P., ed. *Gaetano Previati nelle memorie del figlio (1927)*. Ferrara, Italy: Liberty House, 1993.

Victor PROUVÉ
Books

PROUVÉ, Madeleine. *Victor Prouvé, 1858-1943*. Paris: Berger-Levrault, 1958.

Pierre PUVIS DE CHAVANNES
Catalogues

Pierre Puvis de Chavannes. Amsterdam, Rijksmuseum Vincent van Gogh, February 25-May 29, 1994. Published by Rijksmuseum Vincent van Gogh, Amsterdam; Waanders, Zwolle, The Netherlands, 1994. Texts by Aimée Brown PRICE and Geneviève JON WHITELEY.

Paul RANSON
Catalogues

Paul Ranson. Munich, Milan, Rome, Galleria del Levante, 1967. Published by Grafic Olympia, Milan, 1967. Text by Patrick WALDBERG.

Odilon REDON
Catalogues Raisonnés

HARRISON, Sharon R. *The Etchings of Odilon Redon: A Catalogue Raisonné*. New York: Da Capo Press, 1986.

WILDENSTEIN, Alec, ed. *Odilon Redon. Catalogue raisonné de l'œuvre peint et dessiné*, vol. 1, *Portraits et Figures*. Paris: Wildenstein Institute, 1992. Text by Agnès LACAU ST-GUILY.

Catalogues

Odilon Redon, Prince of Dreams, 1840-1916. Chicago, The Art Institute of Chicago, July 2-September 18, 1994; Amsterdam, Rijksmuseum Vincent van Gogh, October 20, 1994-January 15, 1995; London, Royal Academy of Arts, February 16-May 1, 1995. Published by The Art Institute of Chicago, Chicago; Harry N. Abrams, New York, 1994. Texts by Douglas W. DRUICK, Gloria GROOM, Fred LEEMAN, Kevin SHARP, Maryanne STEVENS, Harriet K. STRATIS and Peter Kort ZEGERS.

Odilon Redon. La collection Woodner. Lausanne, Fondation de l'Hermitage, May 22-September 22, 1992. Published by Fondation de l'Hermitage, Lausanne, 1992. Texts by François DAULTE and Jennifer E. JONES.

Odilon Redon. Tokyo, National Museum of Modern Art, March 17-May 7, 1989; Hyogo, Museum of Modern Art, May 14-June 25, 1989; Aichi, Aichi Prefectural Art Gallery, July 7-23, 1989. Published by National Museum of Modern Art, Tokyo, 1989. Texts by Kunio MOTOE and Masanori ICHIKAWA.

Odilon Redon, 1840-1916: Meisterwerke aus der Sammlung Ian Woodner. Munich, Villa Stuck, March 27-June 8, 1986. Published by Villa Stuck, Munich/Maander, 1986. Text by René HUYGHE (in German and French).

Odilon Redon, rencontres et résonnances. Gifu, Japan, The Museum of Fine Arts, October 1-November 10, 1985; Kumamoto, Prefectural Museum of Art, November 16-December 15, 1985; Hiroshima, Prefectural Museum of Art, January 4-26, 1986. Published by The Museum of Fine Arts, Gifu, 1985.

Odilon Redon, 1840-1916. Bordeaux, Galerie des beaux-arts, May 10-September 1, 1985. Texts by René HUYGHE and Robert COUSTET.

Odilon Redon, 1840-1916, Lithographien. Innsbruck, Austria, Galerie im Taxis-Palais, July 3-August 19, 1984. Text by Rainer Michael MASON.

La Donation Ari et Suzanne Redon. Paris, Musée du Louvre. Published by Ministère de la culture/Réunion des musées nationaux, Paris, 1984. Text by Roseline BACOU.

Books

EISENMAN, Stephen. *The Temptation of Saint Redon: Biography, Ideology & Style in the Noirs of Odilon Redon*. Chicago: University of Chicago Press, 1992.

BACOU, Roseline. *Odilon Redon: Pastels*. New York: George Braziller, 1987. Originally published under the same title in French. Arcueil, France: Anthèse, 1987.

COUSTET, Robert. *L'Univers d'Odilon Redon. Les carnets de dessins d'Odilon Redon*. Paris: H. Screpel, 1984.

FLORENCE, Penny. *Mallarmé, Manet, and Redon: Visual and Aural Signs and the Generation of Meaning*. New York: Cambridge University Press, 1986.

GAMBONI, Dario. *La Plume et le pinceau : Odilon Redon et la littérature*. Paris: Minuit, 1989, "Le Sens commun" series.

LEVY, Suzy, ed. *Lettres inédites d'Odilon Redon à Bonger, Jourdain, Viñes...* Paris: José Corti, 1987.

——.*Journal inédit de Ricardo Viñes : Odilon Redon et le milieu occultiste (1897-1915)*. Paris: Aux amateurs de livres, 1987.

SCHATZ, Mathias. *Der Betrachter im Werk von Odilon Redon: eine rezeptionsästhetische Studie*. Hamburg: R. Kramer, 1988, "Wissenschaft aktuell" series, no. 3.

TERRASSE, Charles. *Conversations avec Odilon Redon, 1914*. Paris: L'Échoppe, 1993, "Envois" series.

VIALLA, Jean. *La Vie et l'œuvre d'Odilon Redon*. Courbevoie, France: ACR, 1988.

William REYNOLDS-STEPHENS

Books

HUTCHINSON, G. Seton. *The Sculptor, Sir William Reynolds-Stephens, 1862-1943. A Biographical Note*. Nottingham, 1944.

KING, N. Pauline, ed. *Journal of Stephen Reynolds*. Honolulu: Ku Paa; Salem, Massachusetts: Peabody Museum of Salem, 1989.

Richard RIEMERSCHMID

Books

MENKE, Beate. *Die Riemerschmid-Innenausstattung des Hauses Thieme Georgenstrasse*. Munich: Tuduv, 1990, "Schriften aus dem Institut für Kunstgeschichte der Universität München" series, no. 37.

RAMMERT-GOTZ, Michaela. *Richard Riemerschmid. Möbel und Innenräume von 1895-1900*. Munich: Tuduv, 1987, "Schriften aus dem Institut für Kunstgeschichte der Universität München" series, no. 22.

Briton RIVIÈRE

Books

ARMSTRONG, Sir Walter. *Briton Rivière (Royal Academician), His Life and Work*. London: Art Journal Office, 1891.

Pierre ROCHE

Books

MARX, Roger. *La Loïe Fuller. Estampes modelées de Pierre Roche*. Paris: Cent Bibliographiles, 1904.

Félicien ROPS

Catalogue Raisonné

ROUIR, Eugène. *Félicien Rops. Catalogue raisonné de l'œuvre gravé et lithographié*, vol. 1, *Les Lithographies*; vol. 2, *Les Eaux-fortes*; vol. 3, *Les Eaux-fortes*, Brussels: Claude Van Loock, 1992.

Catalogues

Félicien Rops, 1833-1898. Warsaw, National Museum, April-May 1988. Texts by J. BIALOSTOCKI and I. DANIELEWICZ.

Félicien Rops, 1833-1898. Paris, Musée des Arts décoratifs, June 6-July 21, 1985; Nice, Musée des beaux-arts Jules-Cheret, July 31-October 15, 1985. Published by Flammarion, 1985. Texts by François MATHEY, Gilbert LASCAULT, Catherine De CROËS and Astrid MATTART.

Books

BRUHL, Georg, ed. *Die Botin des Teufels: Graphik. Félicien Rops*. Berlin: Eulenspiegel, 1988.

CUVELIER, Guy, Robert L. DELEVOY, Gilbert LASCAULT and Jean-Pierre VERHEGGEN. *Félicien Rops*. Brussels: Lebeer Hossmann, 1985.

HASSAUER, F., and P. ROOS, eds. *Félicien Rops: der weibliche Körper, der männliche Blick*. Zurich: Haffmans, 1984.

ROUIR, Eugène. *Félicien Rops. Les techniques de la gravure*. Brussels: Bibliothèque royale Albert 1er, 1991.

ZÉNO, Thierry, ed. *Les Muses sataniques de Félicien Rops*. Brussels: Jacques Antoine, 1985.

Dante Gabriel ROSSETTI

Catalogue Raisonné

SURTEES, Virginia. *The Paintings & Drawings of Dante Gabriel Rossetti: A Catalogue Raisonné*. 2 vols. Oxford: Oxford University Press, 1971.

Catalogues

Rossetti's Portraits of Elizabeth Siddal: A Catalogue of the Drawings and Watercolours. Oxford: Ashmolean Museum, March 5-April 28, 1991; Birmingham: Birmingham Museum and Art Gallery, May 16-July 7, 1991. Published by Scolar Press, Aldershot, England, 1991.

Dante Gabriel Rossetti. Milan, Accademia di Belle Arti de Brera, November 9, 1984-January 13, 1985. Published by Mazzotta, Milan, 1984. Texts by Daniela PALZZOLI, Corrado GIZZI, Mariano APA, Renato BARILLI, Fortunato BELLONZI, Maria Teresa BENEDETTI, Giuseppe BOLINO, Mario Manieri ELIA, Luigi Paolo FINIZIO, Ferruccio ULIVI and John WOODHOUSE.

Books

BASS, Eben E. *Dante Gabriel Rossetti, Poet and Painter*. New York: Peter Lang, 1990.

BENEDETTI, Maria Teresa. *Dante Gabriel Rossetti*. Florence: Sansoni, 1984.

CAINE, Hall. *Recollections of Rossetti*. London: Century, 1990.

FAXON, Alicia Craig. *Dante Gabriel Rossetti*. New York: Abbeville Press, 1989.

LANGLADE, Jacques de. *Dante Gabriel Rossetti*. Paris: Mazarine, 1985, "Biographie" series.

MARSH, Jan. *The Legend of Elizabeth Siddal*. New York: Quartet Books, 1989.

RIEDE, David G., ed. *Critical Essays on Dante Gabriel Rossetti*. New York: G.K. Hall; Toronto: Maxwell Macmillan, 1992.

RIEDE, David G. *Dante Gabriel Rossetti Revisited*. New York: Twayne, 1992.

Santiago RUSIÑOL

Books

COLL MIRABENT, Isabel. *Santiago Rusiñol*. Barcelona: AUSA, 1992.

CORNET I PLANELLS, Montserrat. *"Rusiñol" que vas a Franca: a la recerca d'un home i d'un temps*, Barcelona: Romanya/Valls, 1987 (text in Catalan).

PLA, Josep. *Santiago Rusiñol y su tiempo*. Barcelona: Destino, 1989 (text in Spanish).

SERRANO, Carlos, and Marie-Claire ZIMMERMANN, eds. *Santiago Rusiñol et son temps : actes du colloque international*. Université de Paris-Sorbonne (Paris IV), January 14-15, 1993. Paris: Éditions hispaniques, 1994, "Thèses, mémoires et travaux. Série Études catalanes" series, no. 4 (text in French and Catalan).

Albert PINKHAM RYDER

Catalogues

Albert Pinkham Ryder. Washington, National Museum of American Art, April 6-July 29, 1990; Brooklyn, Brooklyn Museum, September 14, 1990-January 8, 1991. Published by the Smithsonian Institution Press, Washington, 1989. Text by Elizabeth BROUN, catalogue written by Eleanor L. JONES, Matthew J.W. DRUTT and Sheri L. BERNSTEIN.

Books

HOMER, William Innes, and Lloyd GOODRICH. *Albert Pinkham Ryder, Painter of Dreams*. New York: Harry N. Abrams, 1989.

Théo VAN RYSSELBERGHE

Catalogues

Theo Van Rysselberghe : neo-impressioniste. Ghent: Pandora, 1993. Texts by Jane BLOCK, Adrienne FONTAINAS and Luc FONTAINAS, catalogue written by Robert HOOZEE and Helke LAUWAERT.

Aristide SARTORIO

Catalogues

Giulio Aristide Sartorio: figura e decorazione. Rome, Palazzo di Montecitorio, Sala della Regina, February 2-March 11, 1989. Published by F.M. Ricci, Milan, 1989. Texts by Bruno MANTURA and Anna Maria DAMIGELLA.

Books

GIOACCHINO, Barbera, and Anna Maria DAMIGELLA. *I bozzetti di Sartorio per il Duomo di Messina*. Palermo: Sellerio, 1989, "I Cristalli" series.

George SAUTER

(not represented in the exhibition)

Articles

The Count de Soissons, "George Sauter", *The Artist*, no. 30 (1901), pp. 169-180.

Arnold SCHOENBERG

Catalogues

Arnold Schönberg: das bildnerische Werk/Arnold Schoenberg: Paintings and Drawings. Vienna, Museum des 20. Jahrhunderts; Cologne, Museum Ludwig; Manchester, Whitworth Art Gallery. Published by Ritter Verlag, Klagenfurt, Austria, 1991. Text by Thomas ZAUNSCHIRM, ed.

Arnold Schoenberg's Vienna. New York, Galerie St. Étienne, November 13, 1984-January 5, 1985. Published by Rizzoli, New York, 1984. Text by Jane KALLIR.

Books

HAHL-KOCH, Jelena, ed. *Arnold Schönberg, Wassily Kandinsky: Letters, Pictures and Documents*. Boston and London: Faber & Faber, 1984.

SMITH, Joan Allen. *Schoenberg and His Circle: A Viennese Portrait*. New York: Schirmer Books; London: Macmillan, 1986.

VALLIER, Dora. *La Rencontre Kandinsky-Schoenberg*. Caen, France: L'Échoppe, 1987.

WHAM, Quincie Matalie. *Schönberg-Kandinsky: The Genesis of Atonality-Abstraction, 1908-1914*. Lubbock, Texas: Texas Tech University, 1987.

Carlos SCHWABE

Catalogues

Carlos Schwabe, 1866-1926. Catalogue des peintures, dessins et livres illustrés appartenant au musée. Geneva, Cabinet des dessins du Musée d'art et d'histoire, October 8, 1987-March 29, 1988. Texts by Marla H. HAND, Jean-David JUMEAU-LAFOND and Catherine KULLING.

Books

JUMEAU-LAFOND, Jean-David. *Carlos Schwabe*. Courbevoie, France: ACR, 1994.

Giovanni SEGANTINI

Catalogue Raisonné

QUINSAC, Annie-Paule, Gail SWERLING and Tilde Vitta ZELMAN. *Segantini: catalogo generale*. 2 vols. Milan: Electa, 1982.

Catalogues

Giovanni Segantinis Panorama und andere Engadiner Panoramen. Saint-Moritz, Switzerland, Segantini Museum, July 17-October 10, 1991; Innsbruck, Austria, Landes Museum Ferdinandeum, October 17-December 1, 1991. Published by Segantini Museum, Saint-Moritz, 1991. Texts by Regula BUCHELER and Dora LARDELLI.

Giovanni Segantini, 1858-1899. Zurich, Kunsthaus Zürich, November 9, 1990-February 3, 1991. Texts by Rainer E. GUT, Annie-Paule QUINSAC, Günter METKEN and Dora LARDELLI.

Segantini: trent'anni di vita artistica europea nei carteggi inediti dell'artista e dei suoi mecanati. Lecco, Italy: Cattaneo, 1985. Text by Annie-Paule QUINSAC.

Books

SGARBI, Vittorio. *Giovanni Segantini, i capolavori.* Trento, Italy: L. Reverdito, 1989.

Paul SÉRUSIER

Catalogues

Paul Sérusier et la Bretagne. Pont-Aven, France, Musée de Pont-Aven, June 30-September 30, 1991.

Books

BOYLE-TURNER, Caroline. *Paul Sérusier.* Ann Arbor, Michigan: UMI Research Press, 1983, "Studies in the Fine Arts. The Avant-garde" series, no. 37.

LE GOFFE, Michèle. *Sur les traces de Paul Sérusier dans son pays d'adoption.* Châteauneuf-du-Faou, France: Ar Garo, 1989.

MASSON, Henry. *Paul Sérusier : de Pont-Aven à Châteauneuf-du-Faou.* Saint-Brieuc, France: Presses bretonnes; Spezet, France: Nature et Bretagne, 1991.

Hugo SIMBERG

Books

LEVANTO, Marjatta. *Tonttukuningas kuoleman puutarhassa.* Helsinki: Otava, 1985.

MALME, Heikki. *Hugo Simberg, grafiikka.* Helsinki: Otava.

STEWEN, Riikka. *Hugo Simberg, unien maalari* [Hugo Simberg, Painter of Dreams]. Helsinki: Otava, 1989.

Joakim SKOVGAARD

Books

VELLEY, Jens. *Joakim Skovgaard.* Viborg, Denmark: Viborg Cathedral Publications, 1988.

Jan SLUIJTERS

Catalogues

Jan Sluijters, aquarellen en tekeningen. Zwolle, The Netherlands, Noordbrants Museum, June 8-August 25, 1991. Text by Anita HOPMANS.

Books

CLERCQ, Hannah de. *Jan Sluijters en tijdgenoten.* The Hague: Nederlands Bibliotheek en Lektuur Centrum, 1991.

Léon DE SMET

Books

MOREL DE BOUCLE ST-DENIS, Philippe. *Léon de Smet.* Antwerp: De Sikkel, 1951.

Harald SOHLBERG

Catalogues

Harald Sohlberg. Trondheim, Norway, Trondhjems kunstforening, 1985. Text by Oivind Storm BJERKE.

Books

BJERKE, Oivind Storm. *Harald Sohlberg: ensomhetens maler.* Oslo: Gyldendal Norsk Forlag, 1991.

Léon SPILLIAERT

Catalogues

Léon Spilliaert. London, Entwistle Gallery, 1989. Text by Francine-Claire LEGRAND.

Beda STJERNSCHANTZ

Books

STJERNSCHANTZ, Göran. *Konturena av ett liv. Alma Stjernschantz 1843-1921.* Lovisa, Finland, 1973.

Marianne STOKES

Articles

FORD, Harriet. "The Work of Mrs. Adrian Stokes", *Studio,* no. 19 (1900), pp. 149-156.

MEYNELL, Alice. "Mrs. Adrian Stokes", *Magazine of Art,* 1901, pp. 241-246.

MEYNELL, Wilfrid. "Mr. and Mrs. Adrian Stokes", *Art Journal,* 1900, pp. 193-198.

John M. STRUDWICK

Articles

George Bernard SHAW. "J. M. Strudwick", *Art Journal,* April 1891, pp. 97-101.

Stanislav SUCHARDA

Articles

JOHNSON, Joyce. "At Home in the Past (Sucharda House)", *Art & Antiques,* vol. 8 (December 1991), pp. 84-89.

Ellen THESLEFF

Catalogues

Ellen Thesleff. Helsinki, Ateneumin taidemuseo, 1969.

Books

BÄCKSBACKA, Leonard. *Ellen Thesleff.* Helsinki: Konstsamlongens, 1955.

Hans THOMA

Catalogues

Kraina Thomy: dziela Hansa Thomy (1839-1924) w zbiorach polskich. Warsaw, National Museum of Warsaw, 1990. Text by Anna KOZAK.

Hans Toma, Lebensbilder: Gemäldeausstellung zum 150. Geburtstag. Freiburg im Breisgau, Augustinermuseum, October 2-December 3, 1989. Published by K.R. Langewiesche, Konigstein, Germany, 1989. Text by Margaret ZIMMERMANN.

Hans Thoma, 1839-1924: Gemälde und Zeichnungen aus der Sammlung Georg Schäfer. Schweinfurt, Germany, Altes Rathaus der Stadt Schweinfurt, October 21-November 26, 1989. Texts by Barbel HAMACHER and Bruno BUSHART.

Books

BROCKER-LISS, Marianne, ed. *Skizzen aus dem Taunus. Hans Thoma.* Frankfurt: W. Kramer, 1989.

VON HELMONT, Christa. *Hans Thoma: Spiegelbilder.* Stuttgart: Klett-Cotta, 1989.

Johan THORN PRIKKER

Catalogues

Schritte nach draußen, Johan Thorn Prikker. Werke bis 1910. Krefeld, Germany, Kaiser Wilhelm Museum, September 19-November 28, 1982. Texts by Pierre Hubert DUBOIS and Julian HEYNEN.

De brieven van Johan Thorn Prikker aan Henri Borel en anderen 1892-1904. Nieuwkoop: Heuff, 1980. Text by Joop M. JOOSTEN.

Books

WEMBER, Paul. *Johan Thorn Prikker. Glasfenster, Wandbilder, Ornamente, 1891-1932.* Krefeld, Germany: Scherpe Verlag, 1966.

Louis Comfort TIFFANY

Catalogues

The Tiffany Collection at the University of Michigan Museum of Art. Ann Arbor, University of Michigan Museum of Art, 1992. Text by William J. HENNESSEY.

Masterworks of Louis Comfort Tiffany. Washington, Renwick Gallery, October 1989; New York, The Metropolitan Museum of Art, 1990. Published by Harry N. Abrams, New York, 1989. Texts by Alastair DUNCAN, Martin P. EIDELBERG and Neil HARRIS.

The Silver of Tiffany & Co., 1850-1987. Boston, Museum of Fine Arts, Boston, 1987. Texts by Charles H. CARPENTER, Jr., Janet ZAPATA and Katherine PARKER.

Books

DUNCAN, Alastair. *Louis Comfort Tiffany.* New York: Harry N. Abrams, 1992.

LORING, John. *Tiffany's: One Hundred & Fifty Years.* Garden City, New Nork: Doubleday & Company, 1987.

PAUL, Tessa. *The Art of Louis Comfort Tiffany.* London: Quintet, 1987.

ZAPATA, Janet. *The Jewelry & Enamels of Louis Comfort Tiffany.* New York: Harry N. Abrams, 1993.

Jan TOOROP

Catalogues

Jan Toorop. The Hague, Gemeentemuseum, 1989. Text by Victorine HEFTING.

Books

GERARDS, Innemie. *Jan Toorop en het Symbolisme in Nederland.* The Hague: SDU, 1993.

HEFTING, Victorine. *Jan Toorop, een kennismaking* [Jan Toorop, an Introduction]. Amsterdam: Bert Bakker, 1989.

VAN WEZEL, G.W.C. *Jan Toorop, 1858-1928.* Amsterdam: Prospectus, 1989.

Henri de TOULOUSE-LAUTREC

Catalogues Raisonnés

ADHEMAR, Jean. *Toulouse-Lautrec. His Complete Lithographs and Drypoints.* Secaucus, New Jersey: Wellfleet Press, 1987.

ADRIANI, Götz. *Toulouse-Lautrec, the Complete Graphic Works: A Catalogue Raisonné, the Gerstenberg Collection.* London: Thames and Hudson, 1988. Originally published as *Toulouse-Lautrec, das Gesamte Graphische Werk.* DuMont Buchverlag, 1986.

WITTROCK, Wolfgang. *Toulouse-Lautrec. The Complete Prints.* 2 vols. London: Wilson; New York: Harper & Row, 1985.

Catalogues

Tolouse-Lautrec et ses amis. Albi, France, Musée Toulouse-Lautrec, March 21-May 31, 1992. Text by Danièle COLLAS-DEVYNCK.

Toulouse-Lautrec. London, Hayward Gallery, October 10, 1991-January 19, 1992; Paris, Galeries nationales du Grand Palais, February 18-June 1, 1992. Published by South Bank Centre, London; Réunion des musées nationaux, Paris, 1992.

Toulouse-Lautrec. Les estampes et les affiches de la Bibliothèque nationale/Prints and Posters from the Bibliothèque nationale. Brisbane, Australia, Queensland Art Gallery, August 21-October 6, 1991; Victoria, National Gallery of Victoria, October 25-December 8, 1991; Paris, Bibliothèque nationale, February 18-May 15, 1992. Published by Bibliothèque nationale, Paris; Queensland Art Gallery, Brisbane, 1991 (text in French and English).

Toulouse-Lautrec: The M. Baldwin Collection. San Diego, San Diego Museum of Art, October 15-December 31, 1988. Published by San Diego Museum of Art, San Diego; University of Washington Press, Seattle, 1988. Text by Nora DESLOGE.

Toulouse-Lautrec. Martigny, Switzerland, Fondation Pierre Gianadda, May 16-November 1, 1987. Text by Pierre GASSIER, ed.

Toulouse-Lautrec: Gemälde und Bildstudien. Tübingen, Germany, Kunsthalle Tübingen, November 8, 1986-March 15, 1987. Published by DuMont, Cologne, 1986. Text by Götz ADRIANI.

The Circle of Toulouse-Lautrec: An Exhibition of the Work of the Artist and His Close Associates. New Brunswick, New Jersey, Jane Voorhees Zimmerli Art Museum, Rutgers, The State University of New Jersey, November 17, 1985-February 2, 1986. Published by Jane Voorhees Zimmerli Art Museum, Rutgers, The State University of New Jersey, New Brunswick, 1985. Texts by Phillip Dennis CATE and Patricia Eckert BOYER.

Pariser Leben: Toulouse-Lautrec und seine Welt. Hamburg, Hamburger Kunsthalle, December 12, 1985-February 3, 1986. Text by Gisela HOPP.

Henri Toulouse-Lautrec: Images of the 1890's. New York, The Museum of Modern Art, 1985. Published by Harry N. Abrams, New York, 1985. Text by Riva CASTELMAN, ed.

Books

ADRIANI, Götz. *Toulouse-Lautrec*. New York: Thames and Hudson, 1987. Originally published as *Toulouse-Lautrec: Gemälde und Bildstudien*. Cologne: DuMont, 1986.

ASH, Russell. *Toulouse-Lautrec: The Complete Posters*. London: Pavilion, 1991.

BEAUTÉ, Georges. *Toulouse-Lautrec vu par les photographes*. Lausanne: Édita, 1988, "Archives photographiques" series.

BRYANT, Jennifer Fisher. *Henri de Toulouse-Lautrec, Artist*. New York: Chelsea House, 1994.

CAZELLES, Jean. *Toulouse-Lautrec*. Fribourg, Switzerland: Hatier, 1985.

COLLAS-DEVYNCK, Danièle. *Toulouse-Lautrec*. Paris: Chêne, 1992, "Profils de l'art" series.

DENVIR, Bernard. *Toulouse-Lautrec*. London: Thames and Hudson, 1991, "World of Art" series.

DEVOISINS, Jean, and Christine GONELLA, eds. *Tout l'œuvre peint de Toulouse-Lautrec*. Paris: Flammarion, 1986, "Les Classiques de l'art" series.

DORTIGNAC-DIEGO, Geneviève. *Toulouse-Lautrec's Table*. New York: Random House, 1993.

DUROZOI, Gérard. *Toulouse Lautrec: Masterworks*. New York: Random House, 1992. Originally published as *Toulouse-Lautrec*. Paris: Hazan, 1992.

FEINBLATT, Erbia, and Bruce DAVIS. *Toulouse-Lautrec and His Contemporaries: Posters of the Belle Époque*. New York: Harry N. Abrams, 1986.

FREY, Julia Bloch. *Toulouse-Lautrec: A Life*. London: Weidenfeld and Nicolson, 1994.

GAUZI, François. *Lautrec mon ami*. Paris: Bibliothèque des Arts, 1992.

GIMFERRER, Pere. *Toulouse-Lautrec*. New York: Rizzoli, 1990.

JARASSE, Dominique. *Henri de Toulouse-Lautrec-Monfa : entre le mythe et la modernité*. Saint-Julien-aux-Bois, France: P. Sers; Marseilles: AGEP, 1991, "L'Esprit des arts" series.

LE TARGAT, François. *Toulouse-Lautrec*. Paris: Éditions Cercle d'art, 1988, "Les Grands Peintres" series.

MacORLAN, Pierre. *Toulouse-Lautrec, peintre de la lumière froide*. Brussels: Éditions complexe, 1992, "Le Regard littéraire" series, no. 51.

MELOT, Michel. *Les Femmes de Toulouse-Lautrec*. Paris: Albin Michel, 1985, "Les Albums du Cabinet des estampes de la Bibliothèque nationale" series.

MURRAY, Gale Barbara, ed. *Toulouse-Lautrec: A Retrospective*. New York: Hugh Lauter Levin Associates, 1992.

MURRAY, Gale Barbara. *Toulouse-Lautrec: The Formative Years, 1878-1891*. Oxford: Clarendon Press; New York: Oxford University Press, 1991, "Clarendon Studies in the History of Art" series.

___. *Toulouse-Lautrec : un peintre, une vie, une œuvre*. Paris: Belfond, 1991.

NERET, Gilles. *Toulouse-Lautrec*. Paris: Nathan, 1991.

O'CONNOR, Patrick. *Nightlife of Paris: The Art of Toulouse-Lautrec*. New York: Universe Publishing, 1992.

SAGNE, Jean. *Toulouse-Lautrec au cirque*. Paris: Flammarion/Arthaud, 1991.

___. *Toulouse-Lautrec*. Paris: Fayard, 1988.

SCHIMMEL, Herbert D., ed. *The Letters of Henri de Toulouse-Lautrec*. Oxford: Oxford University Press, 1991.

SIMON, Alfred. *Toulouse-Lautrec*. Paris: La Manufacture, 1990.

TOBIEN, Felicitas. *Toulouse-Lautrec*. Paris: Imprimerie des arts et manufactures, 1989. Text (in French) by Pierre CRÈVECŒUR.

Albert TRACHSEL
Catalogues

Albert Trachsel, 1863-1929. Geneva, Musée d'art et d'histoire, December 6, 1984-February 17, 1985; Solothurn, Switzerland, Kunstmuseum, March 9-May 5, 1985; Freiburg im Breisgau, Kunstverein, Städtische Galerie Schwarzes Kloster, November 16-December 15, 1985. Published by Musée d'art et d'histoire, Geneva; Kunstmuseum, Solothurn, 1984. Texts by Harald SIEBENMORGEN, Hans A. LUTHY, Maurice PIANZOLA, Jura BRUSCH-WEILER and Albert TRACHSEL (in German and French).

Phoebe TRAQUAIR
Catalogues

Phoebe Anna Traquair. Edinburgh, Scottish National Portrait Gallery, 1993. Text by Elisabeth CUMMING.

Josef VÁCHAL
Catalogues

Josef Váchal/Fotografie. Brno, Czech Republic, Moravská galerie, October 23-November 25, 1984. Published by Moravská galerie, Brno, 1984. Texts by Jan K. CELIS and Milos SEJN.

Books

BAJEROVA, Marie. *O Josefu Váchalovi*. Prague: Prazska imajinace, 1990, "Prazska imajinace" series, no. 118.

OLIC, Jiri. *Nejlepe tlaciti vlastni karu sam: zivot Josefa Váchala*. Prague: Paseka, 1993.

VÁCHAL, Josef. *Cirkev a bluznivci: historie sektarstvi a bludarstvi*. Prague: Volvox globator, 1992.

___. *Sedem textu Josefa Váchala*. Prague: Trigon, 1990.

Ville VALLGREN
Articles

BERNARD FOLLIOT, D. "Ville Vallgren", *Gazette des Beaux-Arts*, vol. 112, no. 1438 (November 1988), pp. 225-226.

Henry VAN DE VELDE
Catalogues

Henry Van de Velde: ein europäischer Künstler seiner Zeit. Karl-Ernst-Osthaus-Museum, September 6-November 8, 1992. Published by Wienand, Cologne, 1992. Texts by Klaus-Jürgen SEMBACH and Birgit SCHULTE, eds., *et al.*

Van de Velde. Tokyo, The National Museum of Modern Art, 1990.

Henry Van de Velde (1863-1957): Schilderijen en tekeningen/Paintings and Drawings. Antwerp, Koninklijk Museum voor Schone Kunsten, December 12, 1987-February 14, 1988; Otterlo, Kröller-Müller Museum, March 19-May 1, 1988. Published by Ministerie van de Vlaamse gemeenschap/Ministry of Flemish Community, Antwerp, 1988. Text by Susan M. CONNING (in Flemish and English).

Books

BECKER, Ingeborg, and Thomas FOHL. *Henry Van de Velde in Berlin*. Berlin: D. Reimer, 1993.

BRUHL, Georg. *Jugendstil in Chemnitz: die Villa Esche von Henry Van de Velde*. Munich: Bayerische Vereinsbank, 1991.

PLOEGARTS, Léon, and Pierre PUTTEMANS. *L'œuvre architecturale de Henry Van de Velde*. Brussels: Atelier Vokaer; Quebec City: Presses de l'Université Laval, 1987.

SEMBACH, Klaus Jürgen. *Henry Van de Velde. Ein europäischer Künstler seiner Zeit*. Cologne: Wienand Verlag, 1992.

___. *Henry Van de Velde*. New York: Rizzoli, 1989. Originally published under the same title in German. Stuttgart: Gerd Hatje, 1989.

VAN DE KERCKHOVE, Fabrice, *et al. Henry Van de Velde dans les collections de la Bibliothèque royale Albert 1er*. Brussels: La Bibliothèque, 1993.

Theo VAN DOESBURG
Catalogues

Theo Van Doesburg, Painter and Architect. Rotterdam, Museum Boymans-van Beuningen, December 1988-February 1989. The Hague: SDU, 1988. Text by Evert Van STRAATEN.

Books

DOIG, Allen. *Theo Van Doesburg: Painting into Architecture, Theory and Practice*. Cambridge, England, and New York: Cambridge University Press, 1986, "Cambridge Urban and Architectural Studies" series, no. 10.

LEMOINE, Serge, ed. *Theo Van Doesburg*. Saint-Julien-aux-Bois, France: P. Sers, 1990.

Kees VAN DONGEN
Catalogues

Van Dongen, le peintre. 1877-1968. Paris, Musée d'Art moderne de la Ville de Paris, Les Amis du Musée d'Art moderne, 1990. Text by Hans REYCHMAN, ed.

Kees Van Dongen. Rotterdam, Museum Boymans-van Beuningen, December 17, 1989-February 11, 1990. Published by Art Unlimited Books, Rotterdam, 1989. Texts by Jan van ADRICHEM and Hanneke de MAN (in English and Dutch).

Vincent VAN GOGH
(not represented in the exhibition)
Catalogues Raisonnés
DE LA FAILLE, J. B. *Van Gogh's Complete Works on Paper*. 2 vols. San Francisco: Alan Wofsy Fine Arts, 1992 (text in French and English).

WALTHER, Ingo F., and Rainer METZGER. *Vincent van Gogh, l'œuvre complète. Peinture*. 2 vols. Cologne: Taschen, 1993.

Catalogues
Van Gogh in England: Portrait of the Artist as a Young Man, London, Barbican Art Gallery, 1992. Published by Lund Humphries, London, 1992. Texts by Martin BAILEY and Debora SILVERMAN.

Vincent van Gogh. Amsterdam, Rijksmuseum Vincent van Gogh (paintings), March 30-July 24, 1990; Otterlo, Kröller-Müller Museum (drawings), March 30-July 24, 1990. Published by Rizzoli, New York, 1990, 2 vols. Texts by Evert Van UITERT, Louis VAN TILBORGH, Sjraar VAN HEUGTEN, Johannes VAN DER WOLK, Ronald PICKVANCE and E.B.F. PEY.

Van Gogh in Etten. Etten-Leur, The Netherlands, Raadhuis, April 7-July 29, 1990. Texts by J. A. ROZEMEYER, R. WOLS and A. Van GERRTRUY.

Van Gogh in Arles. New York, The Metropolitan Museum of Art, 1984.

Books
ARNOLD, Wilfred N. *Vincent van Gogh: Chemicals, Crises and Creativity*. Boston: Birkhauser, 1992.

BAILEY, Martin. *Van Gogh: Letters from Provence*. New York: Clarkson Potter, 1990.

BARIELLE, Jean-François. *La Vie et l'œuvre de Vincent van Gogh*. Courbevoie, France: ACR; Paris: Vilo, 1984.

BERNARD, Bruce. *Van Gogh*. New York: Dorling Kindersley, 1992, "Eyewitness Art" series.

____. *Van Gogh par lui-même : recueil de tableaux, de dessins et d'extraits de la correspondance du peintre*. Paris: Atlas, 1986.

BONAFOUX, Pascal. *Van Gogh*. New York: Holt, 1990. Originally published under the same title in French. Paris: Chêne, 1989.

____. *Van Gogh par Vincent*. Paris: Denoël, 1986.

BUMPUS, Judith. *Van Gogh's Flowers*. New York: Universe Publishing, 1991.

CABANNE, Pierre. *Qui a tué Vincent van Gogh?* Paris: Quai Voltaire, 1992.

CALLOW, Philip. *Vincent van Gogh: A Life*. Chicago: Ivan R. Dee, 1990.

DELAUNAY, Patrick. *Le Roman de Van Gogh*. Paris: Carrère/Kian, 1988

FEAVER, William. *Van Gogh*. Stamford, Connecticut: Longmeadow Press, 1993, "Great Artist" series.

____. *Van Gogh*. Paris: Hazan, 1990, "Les Chefs-d'œuvre" series.

GEMIN, Massimo. *Van Gogh*. New York: Arch Cape Press, 1989.

HAMMACHER, A. M., and Renilde HAMMACHER. *Van Gogh*. London: Thames and Hudson, 1990.

HULSKER, Jan. *The Complete Van Gogh: Paintings, Drawings, Sketches*. New York: Random House, 1984.

HULSKER, Jan, and James M. MILLER. *Vincent and Theo van Gogh: A Dual Biography*. Ann Arbor, Michigan: Fuller Publications, 1990.

JOUFFROY, Jean Pierre. *La Raison de Vincent van Gogh*. Paris: Messidor, 1990.

KŌDERA, Tsukasa. *Vincent van Gogh: Christianity versus Nature*. Amsterdam and Philadelphia: John Benjamins, 1990, "Studies in the Arts of the Low Countries" series, vol. 3.

KŌDERA, Tsukasa, and Yvette ROSENBERG, eds. *The Mythology of Vincent van Gogh*. Amsterdam and Philadelphia: John Benjamins; Tokyo: TV Asahi, 1993.

LASSAIGNE, Jacques. *Vincent van Gogh*. Paris: Bordas, 1988, "Les Impressionnistes" series.

LEYMARIE, Jean. *Van Gogh*. Geneva: Skira, 1989, "Skira-Flammarion" collection.

McQUILLAN, Melissa. *Van Gogh*. New York: Thames and Hudson, 1989.

NEMANNOVA, Miloslava. *Vincent van Gogh : aquarelles, gouaches et dessins*. Gennevilliers, France: Ars Mundi, 1987.

PICKVANCE, Ronald. *Vincent van Gogh: Irises*. Malibu, California: J. Paul Getty Museum, 1993, "Museum Studies on Art" series.

SCHNEEDE, Uwe M. *Van Gogh à Arles : tableaux 1888/1889*. Munich: Schirmer; Paris: Mosel, 1989, "Bibliothèque visuelle" series, no. 10.

____. *Van Gogh à Arles : tableaux 1889/1890*. Munich: Schirmer; Paris: Mosel, 1989, "Bibliothèque visuelle" series, no. 13.

STEIN, Susan A., ed. *Van Gogh: A Retrospective*. New York: H.L. Levin, 1986.

SUND, Judy. *True to Temperament: Van Gogh and French Naturalist Literature*. Cambridge, England, and New York: Cambridge University Press, 1992.

SWEETMAN, David. *The Love of Many Things: A Life of Vincent van Gogh*. London: Hodder & Stoughton, 1990.

VAN GOGH, Vincent. *Lettres à son frère Théo*. Paris: Gallimard, 1988. Introduction and biography by Pascal BONAFOUX.

VARENNE, Daniel. *Van Gogh : Zundert-Anvers*, Périgueux, France: P. Fanlac, 1989.

WILKIE, Ken. *In Search of Van Gogh: A Journalist's Revealing New Finding about the Artist's Life & Death*. Rocklin, California: Prima, 1992.

ZEMEL, Carol. *Vincent van Gogh*. New York: Rizzoli, 1993, "Rizzoli Art" series.

ZURCHER, Bernard. *Vincent van Gogh: Art, Life and Letters*. New York: Rizzoli, 1985.

Elihu VEDDER
Catalogues
Elihu Vedder: Mystic of the Nineteenth Century. Hempstead, New York, Hofstra Museum, February 14-March 23, 1989. Text by Gail GELBURD.

Gustav VIGELAND
Catalogues
Gustav Vigeland (1869-1943). Paris, Musée Rodin, 1981.

Gustav Vigeland og Henrik Ibsen. Oslo, Vigeland-museet, 1978. Text by Tone WIKBORG.

Gustav Vigeland: ungdomsarbeider. Bergen, Bergen billedgalleri, May 23-June 26, 1977.

Gustav Vigeland. Madrid, Palacio de Cristal, January-February 1978. Published by Patronato Nacional de Museos, Madrid, 1977.

Books
DURBAN, Arne. *Vigeland-portretter*. Oslo: Aschehoug, 1977.

HALE, Nathan Cabot. *Embrace of Life: The Sculpture of Gustav Vigeland*. New York: Harry N. Abrams, 1969.

WIKBORG, Tone. *Gustav Vigeland, mennesket of kunstneren*. Oslo: Aschehoug, 1983.

WIKBORG, Tone, ed. *Vigeland-museet. Katalog over utstilte arbeider*. Oslo: Oslo kommunes kunstsamlinger, 1982.

Hans VON MARÉES
Catalogues
Hans von Marées und die Moderne in Deutschland. Bielefeld, Germany, Kunsthalle, October 25, 1987-January 10, 1988; Winterthur, Kunstmuseum Winterthur, January 31-April 4, 1988. Published by Kunsthalle, Bielefeld, 1987. Texts by Erich FRANZ and Anne S. DOMM.

Hans von Marées. Munich, Bayerischen Staatsgemäldesammlungen, November 11, 1987-February 21, 1988. Published by Prestel, Munich, 1987. Texts by Christian LENZ, ed., Gottfried BOEHM, Helmut BÖRSCH-SUPAN, Sigrid BRAUNFELS-ESCHE, Lorentz DITTMANN, Alfred HRDLICKA, Peter O. KRÜCKMANN, Christa LICHTENSTERN and Eberhard RUHMER.

Hans von Marées, Zeichnungen. Munich, Staatliche Graphische Sammlung, November 11, 1987-February 14, 1988. Text by Gisela SCHEFFLER.

Hans von Marées, Zeichnungen. Wuppertal, Germany, Heydt-Museum, Kunst und Museumsverein, September 13-October 18, 1987. Text by Hans Günther WACHTMANN.

Books
DOMM, Anne S. *Der "Klassische" Hans von Marées und die Existenzmalerei Anfang des 20. Jahrhunderts*. Munich: Kommissionsverlag/UNI-Druck, 1989, "Miscellanea Bavarica Monacensia" series, no. 146.

DOMM, Anne S., ed. *Briefe*. Munich: Piper, 1987.

Franz VON STUCK
Catalogues
Franz von Stuck: Gemälde, Zeichnung, Plastik aus Privatbesitz. Passau, Germany, Museum Kunst Passau, Stiftung Worlen, March 19-June 27, 1993. Text by Michaela Dambeck.

Die Villa Stuck in München Inszenierung eines Künstlerlebens. Munich, Bayerische Vereinsbank, 1992. Texts by Jo-Anne BIRNIE DANZKER, Alexander RAUCH, Enno BURMEISTER and Eva HEILMANN.

Franz von Stuck und seine Schüler: Gemälde und Zeichnungen. Munich, Villa Stuck, June 7-September 3, 1989. Published by Stuck-Jugendstil-Verein, Munich, 1989. Texts by Horst LUDWIG and Gabriele FAHR-BECKER-STERNER.

Books
MENDGEN, Eva. *Franz von Stuck 1863-1928, "Ein Fürst im Reiche der Kunst"*. Cologne: Taschen, 1994.

PÖTTER, Jochen, ed. *Villa Stuck: Franz von Stuck, 1863-1928*. Munich: K.M. Lipp, 1984.

SCHWARZ, Hans-Peter. *Künstlerhäuser. Eine Architekturmuseum*. Frankfurt: M. Braun, 1989.

Édouard VUILLARD
Catalogue Raisonné
ROGER-MARX, Claude. *Vuillard's Graphic Work: A Catalogue Raisonné*. San Francisco: Alan Wofsy, 1990.

Photo Credits

Exhibited Works

A.C. Cooper Ltd., London

A.C.L., Brussels

Angela Bröhan Fotografie, Munich

Antonia Reeve Photography, Edinburgh

Armand Hammer Museum of Art and Cultural
Center, Los Angeles

Art Gallery of Ontario, Toronto
Carlo Catenazzi

The Art Institute of Chicago

Ashmolean Museum, Oxford

Roger Asselberghs, Brussels

Ateneum, Helsinki

Jean-Pierre Babut du Marès, Namur

Badisches Landesmuseum Karlsruhe

Banca Popolare Di Novara
Carlo Pessina

Bankside Gallery

Bergen Billedgalleri, Rasmus Meyer Collection

Bibliothèque nationale de France, Paris

Bibliothèque royale Albert 1er, Brussels

Birmingham Museum and Art Gallery

The Brooklyn Museum

Camera di commercio di Milano, Milan

Cassa di risparmio delle provincie Lombarde,
Milan

The Central Art Archives, Helsinki
Matti Janas
Jouke Könönen
Antti Kuivalainen
Matti Tirri
Museokuva
Jukka Romu

Andrzej Cheć, Cracow

The Chrysler Museum, Norfolk

Civico Museo Revoltella, Trieste

The Cleveland Museum of Art

Collection du Mobilier national
Ph. Sebert

The Corning Museum of Glass, Corning, New York

Dr. Paul Denis collection, Paris

Direktion der Museen der Stadt Wien, Vienna

Philippe R. Doumic, Paris

Edelstein, Northampton, Massachusetts

Flury, Pontresina, Switzerland

Fondation Flandreysy-Espérandieu, Avignon

Fotostudio Otto, Vienna

Frans Halsmuseum, Haarlem
Thijs Quispel

Galleria Civica d'Arte Moderna, Turin

Galleria d'Arte Moderna, Milan

Galerie Jan Krugier, Geneva

Galerie moderního umění, Hradec Králové
Photo Prokop Paul

Galerie výtvarnéko umění, Ostrava

Galerie Würthle, Vienna

George Eastman House, Rochester, New York

Gemäldegalerie Neue Meister, Dresden

Gilman Paper Company, New York

Glasgow Museums, Art Gallery and Museum

Glasgow School of Art

S. R. Gnamm, Munich

Göteborgs Konstmuseum, Göteborg, Sweden
Bahman Ebbe Carlsson

Gottfried Keller Foundation

Graphische Sammlung Albertina, Vienna

Gross, St. Gallen

Tom Haartsen

The Hearn Family Trust
Camerarts, inc., Ali Elai

Herbert F. Johnson Museum of Art, Cornell
University, Ithaca, New York

Historical Design Collection, Inc., New York

Kurt Hofmann

Julius Hummel collection, Vienna

J. Hyde, Paris

Indianapolis Museum of Art
Robert Wallace

J.F. Willumsens Museum, Frederikssund,
Denmark
Kit Weiss

Geir S. Johannessen, Bergen

The John and Mable Ringling Museum of Art,
Sarasota

Josefowitz collection

K.H. Renlundin Museo, Kokkola, Finland

Kiemer & Kiemer, Hamburg

Walter Klein, Düsseldorf

Kröller-Müller Museum, Otterlo, The Netherlands

Kunstgewerbemuseum Berlin

Kunsthaus Zürich

Kunstmuseum Bern

Kunstmuseum Düsseldorf im Ehrenhof

Kunstmuseum, Olten, Switzerland

Kunstmuseum Solothurn
Atelier Hegner

Kunstmuseum Winterthur

Laboratoires photographiques Devos,
Boulogne-sur-Mer

Peter Lauri, Bern

Ruth Lauterbach

Leeds City Art Galleries

Library of Congress, Washington, Prints and
Photographs Division

Barbara and Lloyd Macklowe, New York

Elli Manzotti di Milani Giovanni, Piacenza

The Metropolitan Museum of Art, New York

The Minneapolis Institute of Arts

The Montreal Museum of Fine Arts
Bernard Brien
Lynton Gardiner
Christine Guest

Moravská Galerie, Brno
Alena Urbánková

Münchner Stadtmuseum, Munich

Musée Bellerive, Zurich

Musée d'art et d'histoire, Geneva
M. Aeschimann
Bettina Jacot-Descombes
Yves Siza

Musée d'Art moderne de Saint-Étienne

Musée de la Chartreuse, Douai
Claude Theriez

Musée de l'École de Nancy

Musée départemental des Vosges, Épinal

Musée départemental Maurice Denis
« Le Prieuré », Saint-Germain-en-Laye

Musée des Arts décoratifs, Paris
L. Scully-Jaulmes

Musée des Beaux-Arts de la Ville de Nantes

Musée des Beaux-Arts de Rennes
Louis Deschamps

Musée des Beaux-Arts, Lyons

Musée des Beaux-Arts, Marseilles
Jean Bernard, Aix
Bourgey Montreuil

Musée d'Ixelles, Brussels

Musée d'Orsay, Paris
L. Scully-Jaulmes

Musée du Louvre, Cabinet des dessins
 (fonds du Musée d'Orsay), Paris
Musée Marey, Beaune
 Couval
Musée municipal, Brest
Musée national d'Art moderne, Paris
Musée national de Céramique, Sèvres
Musée national de Poznań
 Fel. Jerzy Nowckoweld
Musée Rodin, Paris
Musée royal de Mariemont, Morlanwelz, Belgium
Musées communaux, Verviers, Belgium
Musées royaux des Beaux-Arts de Belgique,
 Brussels
Museo Civico di Torino, Turin
 Gonella
Museo de arte de Ponce, Puerto Rico
 Antonio de Jesús
Museo del Cau Ferrat, Sitges, Spain
Museum Bochum, Kunstsammlung
Museum der bildenden Künste, Leipzig
Museum Folkwang Essen
Museum für Kunst und Gewerbe Hamburg
 Christoph Irrgang
 Karin Plessing
Museum für Kunsthandwerk, Frankfurt
Museum Künstlerkolonie (Städtische
 Kunstsammlung Darmstadt), Darmstadt
 Werner Bremen
Museum of Art, Rhode Island School of Design,
 Providence
Museum of Decorative Art, Copenhagen
 Ole Woldbye
Museum of Fine Arts, Boston
The Museum of Modern Art, New York
Museum Mesdag, The Hague
Museum Plantin-Moretus, Antwerp
Museum voor Schone Kunsten, Ghent
Museum voor Schone Kunsten, Ostend
Museum voor Sierkunst, Ghent
 Studio Clearhout, Ghent
Národní galerie, Prague
 Jan Diviš
 Milan Posselt
 Cestmir Síla
Nasjonalgalleriet, Oslo
 Jacques Lathion
National Gallery of Art, Washington
National Gallery of Canada, Ottawa
 L. V. Cave
 Clive Cretney
 John Sargent
National Gallery of Scotland, Edinburgh
National Museum of American Art, Smithsonian
 Institution, Washington

National Museum of Warsaw
National Museums and Galleries on Merseyside,
 Walker Art Gallery, Liverpool
 John Mills Photography Ltd., Liverpool
Nationalmuseum (Statens Konstmuseer),
 Stockholm
Neue Pinakothek, Bayerische
 Staatsgemäldesammlungen, Munich
 Blauel / Gnamm - Artothek
Neumann Collection, Gingins, Switzerland
M. Christoph Niess
Sven Nilsson, Bromma, Sweden
Norwest Corporation, Minneapolis
Norwood Historical Society, Norwood,
 Massachusetts
Jerzy Nowakowski, Poznań
Oberösterreichisches Landesmuseum, Linz
Oeffentliche Kunstsammlung Basel
 Martin Bühler
Stefan Okolowicz
Claus Ørsted, Frederikssund, Denmark
Oslo Kommunes Kunstsamlinger, Munch-museet,
 Oslo
Österreichische Galerie, Vienna
Österreichisches Theater Museum, Vienna
Marlen Perez
Peter Nahum Ltd at The Leicester Galleries,
 London
Hans Petersen, Copenhagen
Philadelphia Museum of Art
Photo d'art Speltdoorn et fils, Brussels
 Piet Ysabie
Photothèque des Musées de la Ville de Paris
The Piccadilly Gallery Ltd, London
Princeton University, The Art Museum
 Bruce White Photography, Upper Montclair,
 New Jersey
Prudence Cuming Associates Limited, London
Nathan Rabin
Réunion des musées nationaux, Paris
 J. G. Berizzi
 H. Lewandowski
 R. G. Ojeda
Rheinisches Bildarchiv, Cologne
Rijksdienst Beeldende Kunst, The Hague
Royal Ontario Museum, Toronto
The Royal Photographic Society, Bath
Sächsische Landesbibliothek Dresden
 Deutsche Fotothek
Schmuckmuseum Pforzheim im Reuchlinhaus,
 Pforzheim, Germany
Schweizerisches Institut für Kunstwissenschaft,
 Zurich
Miloslav Šebek, Prague
Smith College Museum of Art, Northampton,
 Massachusetts

The Solomon R. Guggenheim Museum, New York
 David Heald
S.O.S.A.T., Trento
Southampton City Art Gallery
Gary Spearin
Staatliche Graphische Sammlung, Munich
Staatliche Kunstmuseum Dresden
 Abteilung Foto / Repro, Schurz
Staatliche Kunstsammlungen Dresden
Staatliche Museen zu Berlin, Preussischer
 Kulturbesitz, Nationalgalerie
 Jörg P. Anders, Berlin
Staatsgalerie Stuttgart, Graphische Sammlung
Städtische Galerie im Lenbachhaus, Munich
David Stansbury, Springfield, Massachusetts
Statens Konstmuseer, Stockholm
Stauffer Gallery, Kingston, Ontario
Štěpán Bartoš Fotostudio
Sterling and Francine Clark Art Institute,
 Williamstown, Massachusetts
Studio Wolf Ag, Olten, Switzerland
Joey and Toby Tanenbaum, Toronto
Tate Gallery, London
 John Webb
Trondelag Kunstgalleri, Trondheim, Norway
Turku taidemuseo, Turku, Finland
 Vesa-Pekka Kinnunen
The University of Iowa Museum of Art, Iowa City
Van Gogh Museum, Amsterdam
The Victoria and Albert Museum, London
Virginia Museum of Fine Arts, Richmond
 Ann Hutchison
 Katherine Wetzel
Východočeská galerie, Pardubice, Czech Republic
Wallraf-Richartz-Museum, Cologne
Warrington Museum and Art Gallery, Warrington,
 England
Dr. Wilfried Wiegand, Frankfurt
Peter Willi
Württembergisches Landesmuseum Stuttgart
Zapodočeska Galerie, Plzeň
 Jan Brodsky
Teresa Zóltowska-Huszcza

Figures

A.C.L., Brussels
Albright-Knox Art Gallery, Buffalo
The Art Institute of Chicago
Bayerische Staatsgemäldesammlungen, Munich
Bibliothèque Forney, Paris
Bibliothèque J.M. Charcot, hôpital de la
 Salpêtrière, Paris
Bibliothèque nationale de France, Paris

The catalogue of the exhibition
LOST PARADISE: SYMBOLIST EUROPE
is a production of the Publications Service of
The Montreal Museum of Fine Arts

PRODUCTION CO-ORDINATOR
Denise L. Bissonnette

EDITORIAL CO-ORDINATION
Donald Pistolesi

REVISION
Katrin Sermat

TRANSLATION
Jill Corner
Pauline Cumbers
David Jones
Donald McGrath
Jeffrey Moore
Donald Pistolesi
Neville Saulter
Judith Terry
Diana Tullberg
Marek Wilczyński

PHOTO RESEARCH
Maryse Ménard
Micheline M. Poulin
Anne Troise

TECHNICAL ASSISTANCE
Majella Beauregard
Francine Lemieux
Sylvie Ouellet

PHOTOCOMPOSITION
Compo Em Inc.

PHOTO-ENGRAVING AND PRINTING
Litho Acme inc.

GRAPHIC DESIGN
Jean-Pierre Rosier